NORTHERN ARTS

NORTHERN ARTS

THE BREAKTHROUGH OF SCANDINAVIAN LITERATURE AND ART FROM IBSEN TO BERGMAN

ARNOLD WEINSTEIN

PRINCETON UNIVERSITY PRESS - PRINCETON AND OXFORD

Second printing, and first paperback printing, 2011
Paperback ISBN: 978-0-691-14824-3

The Library of Congress has cataloged the cloth edition
of this book as follows

Weinstein, Arnold L.
Northern arts : the breakthrough of Scandinavian literature
and art, from Ibsen to Bergman / Arnold Weinstein.
p. cm.
Includes bibliographical references and index.
ISBN 978-0-691-12544-2 (hardcover : alk. paper)
1. Arts, Scandinavian—19th century. 2. Arts, Scandinavian—
20th century. I. Title.
NX557.W45 2008
700.948′09034—dc22 200800864

British Library Cataloging-in-Publication Data is available

This book has been composed in Palatino
with Phaistos Roman display

Printed on acid-free paper. ∞

Printed in the United States of America

3 5 7 9 10 8 6 4 2

To Ann Cathrine Berntson Weinstein,
and to the Lönnies Sisters

Contents

List of Illustrations ix
Acknowledgments xiii

1 **Introduction** 1

2 **Power** 10
A. Speaking God: Kierkegaard and Lagerkvist 10
B. The Play of Patriarchy: Ibsen and Strindberg 41
i. Child's Play: The Cradle Song in Strindberg's *The Father* 45
ii. Metamorphosis in Ibsen's *Little Eyolf* 74
C. The Powers and the Self: Strindberg's *Inferno* and
Gustafsson's *Tennis Players* 111

3 **Boundary Smashing** 161
A. Going Through the Wall: Shakespeare, Strindberg,
Josephson, Bergman 161
B. The Child's Revenge: Kierkegaard, Ibsen, Lindgren,
Cronqvist 197
C. Hamsun's *Hunger* and Writing 246
D. Stories of Fusion: Vesaas's *The Ice Palace* and
Bergman's *Persona* 273

4 **Graphing Power** 313
A. Breakthrough, Time, and Flux in Edvard Munch
(the Cubist) 313
B. The Case of Ernst Josephson 352

5 **Concluding the Book** 439
Introducing Strindberg the Painter

Notes 461
Index 507

Illustrations

3.B.1. Lena Cronqvist, *The Mother*, 1975 229
3.B.2. Lena Cronqvist, *Doom's Day*, 1980 232
3.B.3. Lena Cronqvist, *Mother and I*, 1987 233
3.B.4. Lena Cronqvist, *Mother, Picture, Children*, 1988 234
3.B.5. Lena Cronqvist, *Girl, Daddy-doll, Mommy-doll,*
 Gorillas, 1992 236
3.B.6. Lena Cronqvist, *Girl with Papa-doll, II*, 1996–1997 237
3.B.7. Lena Cronqvist, *Two Girls with Mother*, 1999 240
3.B.8. Lena Cronqvist, *The Cage*, 2000 240
3.B.9. Lena Cronqvist, *Nurses*, 2001 241
3.B.10. Lena Cronqvist, *Marionnettes, II*, 2004–2005 243
3.B.11. Lena Cronqvist, *Pietà*, 2001. 244
3.D.1. Bergman's *Persona*, 1966 295
4.A.1. Edvard Munch, *The Sick Child*, 1886 318
4.A.2. Edvard Munch, *Death in the Sick Room*, 1893 320
4.A.3. Photo of Edvard Munch, 1910 322
4.A.4. Photo of Edvard Munch, 1938 323
4.A.5. Edvard Munch, *Separation*, 1893 325
4.A.6. Edvard Munch, *At the Deathbed*, 1895 328
4.A.7. Edvard Munch, *At the Deathbed*, 1896 328
4.A.8. Edvard Munch, *Dance of Life*, 1899–1900 329
4.A.9. Edvard Munch, *Puberty*, 1894 330
4.A.10. Edvard Munch, *Self-portrait with Skeleton Arm*, 1895 332
4.A.11. Edvard Munch, *Self-portrait between Clock and*
 Bed, 1940–1942 335
4.A.12. Edvard Munch, *The Scream*, 1893 338
4.A.13. Edvard Munch, *Anxiety*, 1894 340
4.A.14. Edvard Munch, *Jealousy*, 1895 341
4.A.15. Edvard Munch, *Mason and Mechanic*, 1908 343

4.A.16. Edvard Munch, *Drowned Boy*, 1908 344
4.A.17. Edvard Munch, *Uninvited Guests*, 1905 346
4.A.18. Edvard Munch, *Galloping Horse*, 1910 348
4.A.19. Edvard Munch, *Yellow Log*, 1911–1912 349
4.A.20. Edvard Munch, *Murderer in the Avenue*, 1919 349
4.A.21. Edvard Munch, *Red Virginia Creeper*, 1898–1900 350
4.B.1. Per Hasselberg, *Bust*, 1883 362
4.B.2. Ernst Josephson, *Godfrey Renholm*, 1880 363
4.B.3. Ernst Josephson, *Carl Skånberg*, 1880 365
4.B.4. Ernst Josephson, *Jeanette Rubenson*, 1883 366
4.B.5. Ernst Josephson, *Water Sprite*, 1882 371
4.B.6. Ernst Josephson, *Strömkarlen*, 1884 372
4.B.7. Ernst Josephson, *Autumn Sun*, 1886 376
4.B.8. Ernst Josephson, *La Joie de Vivre*, 1887 377
4.B.9. Ernst Josephson, *Homer*, 1888 382
4.B.10. Ernst Josephson, self-portrait signed Velasquez, 1888 386
4.B.11. Ernst Josephson, *J.P. Jacobsen*, n.d. 388
4.B.12. Ernst Josephson, *Satyr*, n.d. 394
4.B.13. Ernst Josephson, *Water Sprite and Maiden*, n.d. 396
4.B.14. Ernst Josephson, *Portrait of a Lady*, 1889–1890 397
4.B.15. Ernst Josephson, *Gåslisa* [*The Shepherdess's
 Vision*], 1888–1889 400
4.B.16. Ernst Josephson, *The Holy Sacrament*, 1889–1890 405
4.B.17. Ernst Josephson, *Jesus and Crown of Thorns*,
 1889–1890 408
4.B.18. Ernst Josephson, *Sun God*, 1889–1890 409
4.B.19. Ernst Josephson, *Ecstatic Heads*, 1889–1890 411
4.B.20. Ernst Josephson, *Jesus*, 1889 412
4.B.21. Ernst Josephson, *Mohammad*, 1889 413
4.B.22. Ernst Josephson, *Charles XVI*, 1889 415
4.B.23. Ernst Josephson, *Sven Duva*, n.d. 417
4.B.24. Ernst Josepshson, *Odin's Entry into Sweden* 420
4.B.25. Ernst Josephson, *Fjolner*, n.d. 421
4.B.26. Ernst Josephson, *Ingjåld Illrada*, n.d. 422
4.B.27. Ernst Josephson, *Weather God Niord*, n.d. 423

4.B.28.	Ernst Josephson, center image from *Three Drawings*, 1892	425
4.B.29.	Ernst Josephson, *Judgment of Paris*, n.d.	426
4.B.30.	Ernst Josephson, *David and Goliath*, n.d.	428
4.B.31.	Ernst Josephson, *Creation of Adam*, after 1893	430
4.B.32.	Photo of Josephson, early 1890s	431
4.B.33.	Ernst Josephson, self-portrait with palette, n.d.	432
4.B.34.	Ernst Josephson, *Beethoven*, 1905	433
4.B.35.	Ernst Josephson, portrait of stage director Ludvig Josephson, 1893	436
4.B.36.	Infra-red photo of Ernst Josephson portrait	437
5.1.	August Strindberg, *Lonely Mushroom*, 1893	446
5.2.	August Strindberg, *Underworld*, 1894	448
5.3.	August Strindberg, *Golgatha*, 1894	451
5.4.	August Strindberg, *High Sea*, 1894	452
5.5.	August Strindberg, *Wave, IX*, 1903	454
5.6.	August Strindberg, *Sunset over Sea*, 1903	456
5.7.	August Strindberg, *The City*, 1903	457

Acknowledgments

Among the books I've written, this is the one where there are the most debts but also the most gratitude.

My conversance with Scandinavian culture is of long duration, but it is not the normal academic story, since it has more to do with my marriage and ensuing personal/cultural choices than with my formal studies as such. Growing up in Memphis, Tennessee, then attending Princeton University and studying Romance Languages, going on to Berlin after college to do a year of Germanistik, leading to graduate work at Harvard with a focus on French, American, English and German literature, all culminating in a job at Brown that combined work in French and Comparative Literature: none of this has a whiff of Scandinavia.

But there is another story as well, and in some oblique fashion, this book tells that other story. It began when I met my (eventually-to-be) wife, Ann Cathrine Berntson, at Princeton, New Jersey, in 1961, having come from Sweden to the U.S. just a few months earlier. That encounter shaped my life: I knew this to be true emotionally, yet it is no less true intellectually, even academically, and that is remarkable.

It was at Harvard in graduate school that I began the formal study of Swedish—in order to speak to my in-laws, I then thought—under the able guidance of Professor Barry Jacobs, who went on to become a distinguished scholar of Scandinavian literature as well as a generous supporter of my own early forays in this area; he died tragically a few years ago, and one of my regrets is that I could not give him this book as a repayment for something he helped seed long ago.

The next chapter in this story dates back to 1980, when a few Brown undergraduates pleaded with my wife to give

them some kind of instruction in Swedish. It was at that point that she acquired her position as Lecturer at Brown, and that I began to revive the Swedish I had learned, so as to take the little I knew and see how I might deepen it, where it might go. Where it went—the gradual creation of literature courses on Scandinavian culture, the scholarly immersion into the field, the burgeoning essays published in *Scandinavian Studies*—says as much about the supple professional character of both Comparative Literature and Brown University as it does about me personally. Hence this book began to take inchoate form long ago, in the early 1980s, as I wrestled with Ibsen, Strindberg, Bergman, Munch, and the panoply of writers and artists studied in these pages.

Once my scholarly investigations were launched, I had the good fortune of garnering the support of many Scandina-vianists, both in Sweden and the U.S., as well as meeting a number of major cultural figures. I have fond and un-erasable memories of evenings spent with Lars Gustafsson talking phi-losophy, politics, and literature; with Liv Ullmann talking film and Bergman; with Max von Sydow talking about Gotland, children, and America; with Erland Josephson talking about Bergman and also about Ernst Josephson, his ancestor. The scholarly encounters were no less productive: Inge Jonsson, former rector of Stockholm University and distinguished Swedenborg scholar, lent his early support to this book; In-gemar Algulin, specialist in modern Swedish literature and impassioned student of all literatures, including American, gave unstintingly of his advice and advocacy; and others whom I have not met—Niels and Faith Ingwersen, and Steven Sondrup, former and current editors of *Scandinavian Studies*, advised me well at distinct phases of my Scandinavian re-search; Susan Brantly, who read this book in several different manuscript versions and offered me valuable suggestions for making it better—have aided me in substantive ways. I owe a debt also to Karen Lerheim at the Munch Museum who gave me key advice in making my final selections for the book. Fi-

nally, I am pleased to thank the National Endowment for the Humanities and the Office of the Dean of the Faculty at Brown University, who jointly made it possible for me, through their material support, to devote a semester of leave to the final process of research and writing. All these people have played their vital role in the realization of *Northern Arts*.

And once I had a book, I fell into the wonderful hands of Hanne Winarsky and her fine colleagues at Princeton University Press. Working with them does not qualify as work but as cooperative venture of a high order. Within the Princeton team, I extend a special word of thanks to Dimitri Karetnikov, whose vital assistance on the visual side of this manuscript has been exemplary. I have also been able to count, once more, on the resources of Brown University: the technical assistance offered by Charles Auger, the superb and arduous research assistance undertaken by Teresa Villa-Igacio (whose critical acumen has aided me yet again in my work), and the financial support offered by the Office of the Vice President of Research. I have had much help.

But my most profound sources are of a different stripe altogether. I quite realize that confessional histories are not much appreciated in the academy, and that this book will either stand or fall on its own merits, not on its "etiology" in my past. Yet I want to say a few words about that "gratitude" mentioned at the beginning of these pages. The story of what nourishes us is sometimes elusive, and I see its contours in my own life much more clearly now that I could have, earlier. Growing up in the South is vitally connected with my lifelong obsession with Faulkner, and I will be teaching and writing on him until I die. Spending my junior year in Paris led to a comparably vampirish relation to French culture, and France has become a second homeland for me, endlessly seductive and nurturing via its sane recognition of life's good things.

It is against that dual backdrop of the American South and France that I want to recognize what Sweden has meant to me, for it underwrites much of this book. What began with

my exposure to Swedish literature and culture and language through the good offices of my wife soon grew into something richer, more various and more mysterious. I grew to love the not-obvious sensuousness of the North, the vibrancy, vitality, and occasional madness and lunacy that are deeply but securely lodged underneath the stolid rational Scandinavian manner. Most profoundly, perhaps, I had the great good fortune of being welcomed—warmly and permanently—into my larger Swedish family, which immeasurably enriched my sense of what a culture actually means: from combing the woods in search of *kantareller* to the massive splendor of the *julbord*, from the pagan worship of the sun to the acceptance of the dark, from the elegance of its majestic capital city to the reverence for forest and sea. All cultures partake of such things, perhaps, but I encountered them in Sweden with an intensity and power I had not known earlier.

I close these risky tributes in still more personal fashion, for it is preeminently thanks to the special people who accepted me into their midst that my love and knowledge of Scandinavia came to be what they are. In my discussion of Astrid Lindgren's children's stories, I acknowledge, in a note, just how central these marvelous fables were in bringing up my children and grandchildren, and I admit freely to the poaching that has characterized my decades-long interaction with this literary tradition. I owe this to my wife, Ann, to whom the book is dedicated, and without whom I would know nothing about Scandinavia; she has been my guide, and I cannot help seeing in all of this a sort of dowry that she brought to our marriage. But the book is also dedicated to a line of strong women—I call them the "Lönnies sisters"—from whom my wife herself descends. (Their husbands were referred to, not entirely in jest, as the "Lönnies brothers.") These women— Mormor the wise matriarch and her daughters, Bibi who was kind when we were needy, Käthe who welcomed me to the Gotland home, Ulla who spoke English to me when I required it, the incomparable Tettan who embodied style, heart, wit,

and a genius for storytelling, and finally Svea, my wife's dead mother whom I never met but whose smiling but enigmatic figure seems to have stamped so very much in our lives—these are the Lönnies women from whom my wife derives her own inimitable spirit and stature. Of that older generation only Ulla still lives, but I would give very much indeed to be able to show this book to all of them: not that they might bestow praise but that they might know how their kindnesses have borne fruit.

NORTHERN ARTS

— 1 —

INTRODUCTION

Genombrott [breaking through] is a familiar term in Scandinavian literary history, designating a generation of writers appearing in the last few decades of the nineteenth century, linked loosely together by a common assault against the bourgeois values and assumptions of their age. In 1883 Georg Brandes coined the term "the modern breakthrough" to convey the profound new vistas and initiatives that we associate today with the names Ibsen, Strindberg, Jacobsen and Bjørnson. Derived from the language of military warfare, the term has a recognizable historical and sociological significance, even if it has been used in later periods to define emerging new artistic movements. Like all labels, indeed like reform movements themselves, the originary virulence and contestation seem to have faded through the passing of time.

This book is an effort to reconceive *genombrott*—breakthrough—in such a way as to illuminate the violence and reach of the concept, to shed light on the extreme performances and extreme stakes of Scandinavian literature: its obsession with power, its entangled view of God and Patriarchy, its search for freedoms at once artistic and moral. If we can see *genombrott* as a radical structural and thematic concept, rather than a strictly sociological one, then the boldest features of Scandinavian literature and art from Kierkegaard to

our day come startlingly into focus. These issues are stark and bristling: how to bring the godhead to language; how to graph the flowing currents—neural, affective, cultural, electric—that animate and link subject and environment; how to annihilate the old forms of behavior and expression that wall us in, so as to make something new; how to resist the father's law so that the children might be free.

Among the breakthroughs implied by this volume may be added yet another: the need to bring the often astonishing productions of Scandinavian art and literature to the attention of a larger literate public. Having studied, researched, and taught these Scandinavian materials for several decades now, I remain struck by the relative obscurity or exoticism that keeps them on the margins of both English-language and European literary discourse. Even the work of the most canonical figures—Ibsen, Strindberg, Munch, and Bergman—remains shockingly unrecognized and under-appreciated by the general public; all too often they are known for single isolated masterpieces—*A Doll House, Miss Julie, The Scream, The Seventh Seal*—or else dealt with only in specialist publications with a limited professional audience. Yet each figure of this quartet should be understood as absolutely seminal in the development of Western theater, painting, and film. Other figures such as Kierkegaard, Hamsun, and Lagerkvist are known in their distinct spheres but rarely get attention beyond that of scholars. And then there are others of absolutely first rank—the painters Ernst Josephson and Lena Cronqvist, the children's writer Astrid Lindgren, the poet-novelist Tarjei Vesaas—whose remarkable work demands wider recognition.

This book is not a history of Scandinavian literature and art, nor is it a full-scale account of the specific figures it treats. Instead, I have elected some of the most startling Scandinavian performances in literature, painting, and film over the past two centuries, and have tried to show how much is startling about them. *Startling* is not a term customarily associated with this culture; "brooding" or "melancholy" might more

2

quickly come to mind. But there is in this body of work an intellectual and artistic restlessness and daring that is so powerful, so varied in its forms yet insistent and even transgressive in its operation, that it constitutes a chapter in Western cultural history that we have yet to read. Each of the texts I study sets out to reconceive—often to explode—our most essential relationships: the religious, the social, the sexual, the marital, the familial, the personal, the representational. In every instance they break through forms and boundaries taken to be real or felt to be coercive. They record much ruin. They point beyond, elsewhere. They startle.

To substantiate my claims, let me offer a few words about Kierkegaard's *Fear and Trembling*, for it serves as something of a gateway into this book, as well as a model for much that follows. Kierkegaard's obsessive meditation about Abraham's covenant with God—a covenant that defines faith as a willingness to sacrifice/murder one's son—defies all standard codes, not just ethical but familial, tribal, and lingual. Here is a story one has thought one understood, but the Danish philosopher is at pains to show how fraudulent our "knowledge" is, how unspeakable these matters are, since they resist both logic and language. The most overt lesson I draw from Kierkegaard concerns the rupture between the human and the divine: God's entry into one's life is wreckage. Then there is the nature of His command: to sacrifice that which is most precious, as a sign of one's belief; in this requirement one sees an infanticidal injunction that not only runs in filigree throughout Ibsen's entire theater (a theater filled with dead or doomed children) but seems to constitute a paradigm of patriarchal power: the law of the father(s) versus the life/future/freedom of the child. In addition, quite intriguingly, Kierkegaard indicts our narrative habits as being unequipped to tell this story, that is, to tell it in such a way as to convey its violence and shattering power. We already know the outcome, he says, and therefore are blind-sighted to the actual ferocity and drama that went into this event on the "front side," that

constitute its ultimate significance. But the final significance of *Fear and Trembling* as regards both Scandinavian thinking and the book I have written is this: Kierkegaard reconceives "understanding" itself as not only subjective and affective but as grounded in terror and awe; in this sense, the very title of Kierkegaard's text is what is most eloquent and profound about it: *fear and trembling* are the signs of recognition, understanding, and truth. We shall have occasion to see just how far-reaching and unhinging this cognitive model is in the coming chapters.

All the chapters seek to unpack and play further the central issues Kierkegaard raises. Roughly speaking, they can be divided into three related categories. We begin with a nineteenth-century and a modern text that explore the impact of the divine as it crashes into the human: *Fear and Trembling* is our radical introduction to the Scandinavian mind-set, for it interrogates disaster, from beginning to end, as we seek to get our heads around infanticide-as-God's-will; Pär Lagerkvist's tale, *The Sibyl*, is seen as the twentieth-century counterpart to Kierkegaard's story of Abraham's covenant, but now bristling with gender connotations, so that the theoretical term "phallogocentrism" comes to us literally as the god's ravishing of a young woman. Both are extremist ventures, end-game performances of a sort, testing the limits of vision, ethics, and language in one's dealings with the godhead. It does not seem exaggerated to say that both texts have a terrorist dimension to them, inasmuch as divine injunction may be at war with moral life, inasmuch as the commanding deity may lodge within us as well as in the beyond.

I then discuss two canonical texts that stage the dynamics of patriarchal power: Strindberg's early masterpiece of 1887, *The Father*, and Ibsen's late, haunting play of 1894, *Little Eyolf*. Each of these dramas displays, in revolutionary theatrical fashion, the dying antics of father figures coming undone: ideologically in Strindberg, psychologically in Ibsen. Neither Strindberg nor Ibsen set out to humble fathers, quite the con-

4

trary. But what they wrought is a different matter, because these two plays stage a crisis in authority and belief, and the confident male of the play's beginning—confident in his power, in his self-knowledge—is altered almost beyond recognition when the curtain descends. Each stages a wreckage. I read these two key plays as emblematic of their authors' entire theatrical output: Strindberg's Darwinian, naturalist drama already beckons to the surreal works ahead, and Ibsen's progressive display of a man's inner wiring offers his richest portrayal of the hold of the past as the force that turns life ludic.

I close this first segment of the book by focusing on two works that reconceive Power altogether, by meshing the physical and the psychic and the moral, by crucially reminding us (in our ideologically driven culture) that the political is only one way (out of many) for understanding or measuring the coercive, sometimes inhuman forces that bathe and govern human life. Strindberg's tortured autobiographical *Inferno* (1897) takes place of pride as an unclassifiable, experimental "occultist" text that links alchemy and psyche, that foregrounds thinking/feeling and electricity (yes, electricity) as the motor forces of both machines and bodies. But Scandinavians are not as bereft of humor as they are often made out to be, and I turn to Lars Gustafsson's modern spoof, *The Tennis Players* (1977), a delicious retelling of Strindberg's story, still outfitted with metaphysics yet turned to whimsy, now located in the American heartland: Texas. But the swollen self-portraiture of the earlier text has now become a meditation on different machines such as computers and nuclear weapons. I have not used the term "breakthrough," but it is obvious that each one of these works is about boundary smashing, and the mix of destruction and new vistas that may follow from it.

Boundary smashing can be a motivated activity, and when the young do it against their elders, it can have distinctly Oedipal characteristics. The next segment of the book deals with quests for freedom and liberation. "Going Through the Wall"

takes an actual moment—the atelier of a Finnish artist in Paris in 1883 when carousing artists played the scene of Hamlet's ghost by literally *going through the wall*—and then goes on to unpack the ramifications of this echoing gesture in the work of four principal players: Ernst Josephson and August Strindberg who were there, Shakespeare's Hamlet who is the model, and Ingmar Bergman who recast exactly this story in his culminating film of 1982, *Fanny and Alexander*. All these figures make their peculiar bid for independence, enabling us to see that the "walls" betoken the law of the Fathers, the conventions of one's medium, and finally the confining surface of human flesh. It seems fair to say that this study of wall-smashing constitutes the purest version of my larger thesis about the exploratory energies and breakthroughs of Scandinavian literature and art.

Hamlet plays, Josephson goes mad, Strindberg celebrates virtuality, and Bergman's Alexander succeeds in his version of freedom via parricide. But Scandinavian literature rarely highlights the empowerment of children. The chapter on "the child's revenge" will rehearse the sacrificial plot seen in both Kierkegaard and Ibsen—a self-evident theme in the philosopher's text but an unilluminated, puzzling, and provocative issue in the playwright's works—in order then to sketch out what countermoves might be possible. I locate these countermoves in two quite different places: in the famous children's stories by Sweden's most beloved author, Astrid Lindgren, and in the paintings of the Swedish contemporary artist Lena Cronqvist. Whereas Lindgren's Pippi Longstocking is known all over the world, I focus instead on her more probing stories dealing with damaged children seeking some kind of freedom or maneuvering room: Mio in *Mio My Son*, Rusky in *The Brothers Lionheart*, and Ronia in *Ronia the Robber's Daughter*. As for Cronqvist (whose powerful work deserves far more recognition in this country), I begin with her depictions of parental dying in order to close with her strange and "emancipated" renditions of triumphant little girls, given to us as a bold war-

rior race that puts the old in their place, sometimes with a ferocity common only to children, in order to live and play.

Another chapter traces Oedipal longings in an altogether different way. Knut Hamsun's early ground-breaking novel of 1890, *Hunger*, prophetically stages a war against the laws of both God and flesh, seeking in writing, imagination, and performance, diverse ways to get clear of all constraints. This book, all too easily seen as either a rendition of the down-and-out artist or as an early stream-of-consciousness fiction, is better understood as a quasi-postmodern text, celebrating the powers of virtuality and imagination in their mad, hilarious joust with reality and necessity.

A fourth chapter about the insatiable will-to-freedom (and its disturbing consequences) focuses on two seminal works of the 1960s: Tarjei Vesaas's spellbinding novel, *The Ice Palace*, an account of love, fusion, death, and grieving as experienced between two eleven year old girls, and Bergman's most self-reflexive, Picasso-like opus, *Persona*, in which the boundaries that separate two women are transgressed in a fluid vampirish fantasia of merging and scripting. Whereas Bergman's film has achieved international canonical stature, Vesaas's book—at once lyrical and limpid, possessing the density and resonance of the Benjy section of *The Sound and the Fury*—may well be unknown to the English-reading public. In these two texts, the father/son anti-Oedipal dyad is no longer in play; but we now see the darker, death-dealing, and cannibalist dimensions of this absolute quest for freedom, and we are left to ponder what kind of hunger drives these figures past their own bounds.

A final chapter is devoted to the larger career and gestalt of two paramount Scandinavian artists, Edvard Munch and Ernst Josephson, for each of them "writes large" the dramas of subjecthood, power, and expression that have been at issue in this book. Munch is our premier painter of affective and psychic states, of moments when the subject is altered by forces that range from libido—"puberty," "jealousy," "anxi-

ety," "the scream" are among the names he gives to his paintings—to swirling water and convulsing sky. Munch, like Strindberg and Bergman, produces an art of siege, of takeover. Less well known is the radical way in which Time is figured in these paintings: the time of trauma as it moves from injury to art, the project of making visible the temporal dynamic of all somatic lives, the strange temporality of the works themselves, as Munch conceived them. As for the lesser known Josephson, his fateful trajectory from highly skilled portraitist to surreal visionary stands as the culminating emblem for "breakthrough" in Scandinavian art and literature. More than any of the other figures examined here, he illustrates—in his person, his sanity, and his legacy—the challenge, stakes, and consequences of going through the wall, of "genombrott." His late work, misleadingly termed "the sick period," replays the Kierkegaardian imperative of a covenant with the divine, so that the medley of forces governing life—affective, spiritual, aesthetic, historical, and ideological—moves into arresting visibility.

I elected to close my book by returning to its most vexed and virulent writer, Strindberg. The Strindberg who interests me here is neither playwright nor poet, but the painter who produced a series of works at the turn of the twentieth century that defy all classification. In them, the artist eschews all figurative and narrative logic, but instead lays the paint on the canvas in thick gobbets, producing landscapes and seascapes of rare beauty and power. These works were unfathomable (and un-sellable) when first seen, but today they speak to us with great immediacy. More modern than anything else in his oeuvre, these paintings may begin with a Turneresque sense of nature, but ultimately they point to Jackson Pollack and action-painting, to an art that no longer requires any referentiality whatsoever. All the grand themes dealt with in this book—God, Patriarchy, Libido, Nature, Revolt—receive here their purest and most naked form: art itself as making/revealing power.

This book has something of the unruliness and variety of culture itself: prose, theater, children's tales, painting, film. My texts are, albeit in differing ways, all extremist texts, all committed to storming the fortress of convention and received views, by reimagining the place and nature of the human subject, as well as its vexed relationship to the world that contains it. To be sure, this is a selective grouping of Scandinavian materials, and there are countless important works that I do not discuss. Nor is this traditional literary history with its movements and schools and trends; such studies have their place, and I have benefited from them in writing this book. But my aim here is different: my intention is to go for what seems to me most full-blooded and daring in this large, and largely unknown, culture. This book contains nothing exotic, nothing about trolls or the midnight sun; rather, my effort is to convey the reach and sheer power of this northern fare, by showing how pioneering and magisterial and, yes, startling these texts are. They are on a par with the most distinguished work produced in Europe and America over the past two centuries. The *genombrott* theme is our open sesame to these materials, for it makes visible their unity and boldness, as well as their powerful family resemblances.

~ 2 ~

POWER

A. Speaking God: Kierkegaard and Lagerkvist

It is no surprise that Kierkegaard, long considered a seminal figure in the modernist discourses of both philosophy and literature, casts a great shadow on nineteenth- and twentieth-century Scandinavian literature.[1] In particular, *Fear and Trembling*—which I take to be his most influential and far-reaching work—comes across as a truly prophetic text for the argument I draw in this book.[2] On the one hand, the great story of Abraham and Isaac, which Kierkegaard reveres as an illustration of the true and shocking nature of *faith*, is a profoundly sacrificial fable, an anti-Oedipal story about fathers killing (or being prepared to kill) children, about the old destroying the young. In this regard it is a story about *power* as well as faith, and it resonates in a great number of the most significant Scandinavian works of the past two centuries: in filigree throughout Ibsen's entire oeuvre; as subtext in Strindberg's drama of patriarchy and child control, *The Father*; even as invisible backdrop in later works, ranging from Astrid Lindgren's stories on to Ingmar Bergman's *Fanny and Alexander*, where the counterargument—empowered children, the fight against the authority of the elders—struggles toward expression. My reading of Kierkegaard's version of the Abraham story takes for granted the central matters of power and

sacrifice that are hard-wired in the original biblical fable, so as to explore more fully some of the equally potent narrative issues in play.[3]

Fear and Trembling is also a gateway text, because it seems preternaturally wise about its own interpretive future, about the evolving ways in which it might be seen. Kierkegaard is everywhere alert to how one *reads* such matters. He indicts the cozy and philistine culture of his own moment, by spelling out, with great clarity, how the great fables become, over time, dead letters. His own book is committed to recovering the originary violence of this event, a violence at once evaluative, perceptual, somatic, and representational. But that is not all: in eventually emphasizing the *absurd*, he opens the door to the more cautionary and even deconstructive critiques that might follow, so that a twentieth-century book, such as Pär Lagerkvist's *The Sibyl*, could, in staging its version of the wreckage entailed by the encounter-with-God, be seen today as a genuine successor, as a further installment in this series about "speaking God." Published in 1956, Lagerkvist's tortured novel enlists a good bit of the Kierkegaard rhetorical arsenal—using speakers who are confused by what they have seen, seeking to restore the indwelling violence of the events, insisting on the physicality of these transactions, asking what these old fables mean today, centuries later—but his account foregrounds even more powerfully the trauma entailed when God enters your life. Speaking God: what can his utterance be like? How can you know him to be the author? What use would a godly discourse have for language as we know it? These questions are, in more ways than one, riddles, inasmuch as they illuminate the insufficiency of both language and cognition, from any normative point of view.

But the most influential dimension of *Fear and Trembling* is doubtless the title itself: *fear and trembling* are to characterize not only the reality of faith, but they are to be seen as the very modality of knowledge itself, a modality on the far side of ordinary language, a modality having much to do with vi-

sionary experience and madness. Here would be the makings of a radical Scandinavian discourse, a kind of "Protestant Imaginary" that shimmers throughout the works studied in this book, at home in extreme states, in moments of takeover and collapse. Kierkegaard, seeking to illuminate the nature of faith, ushers in an entire discourse of madness-as-knowledge, of knowledge itself as radically *other*, and in this light he is the precursor to a host of extreme Scandinavian performances: the tortured seminal work of Strindberg, *Inferno*; the seismic and boundary-destroying paintings of Munch, the sought-after creative condition brought on by starving in Hamsun's *Hunger*; the revelatory surreal paintings of the Sick Period produced by the mad Ernst Josephson; the ecstatic and insane shrieks emitted by Lagerkvist's Sibyl, now seen as the very voice of the Oracle. Kierkegaard cannot have intended this; he sought only to do justice to the Abraham story.[4] But his unswerving emphasis on the private and the affective, his view of faith as unamenable to reason or language, his instrumentalizing of the absurd as grounds for belief, all this makes him a prophetic figure. Let us look more closely.

For Kierkegaard, the story of Abraham is a black hole. His countrymen, his religious leaders, and doubtless all his readers, including his readers to come, including you, probably believe that you know the meaning of Abraham and Isaac's story. We know from Genesis 22 that God commanded Abraham to bring his son Isaac—the long-promised son given to him by Sarah in old age, the son destined to be the very seed of Israel—to Mount Moriah, there to be offered in sacrifice. We know, too, that Abraham obeyed God's command. But, at the last minute, God arranged for a ram to appear and be sacrificed in Isaac's stead, so the *test* of Abraham's faith was over. He passed it; Isaac was returned; Israel's lineage was saved. It would seem to be a happy ending, illustrating the nature and rewards of belief, as well as the ultimate wisdom of God's plan.

Kierkegaard attacks this happy and benign view of things with all his might, in order to show just how many things it gets utterly wrong. His first target is *faith*, faith as it is comfortably understood by his peers and religious leaders. The philosopher claims that the "faith" his countrymen subscribe to is a watered down, emptied out, taken-for-granted thing, a relic of sorts, something "we" achieved a long time ago; moreover, he claims, the progressive spirit of the day enjoins us to move further, to move ahead, to go beyond. The story of Abraham is enlisted to show just how fierce and unhinging true faith actually is, how faith is never fully achieved but is something to be worked out every day of your life. Hence the title itself remembers, among other sources, Paul's words in *Philippians* 2, 12: "Therefore, my beloved, as you have always obeyed, so now, not only as in my presence, but much more in my absence, work out your own salvation in fear and trembling; for God is at work in you, both to will and to work for his good pleasure." Not only must one incessantly work out one's salvation—there is no "further" station conceivable—but one does so "in fear and trembling." Please note: "fear and trembling" are not merely the price tag or badge of faith; they may well be its only true indexes.

Kierkegaard labors mightily to show us how ineffable and terrifying faith itself is, and, in this respect, he is fierce in his critique of a mealy-mouthed rationalism that seems snugly at home in the culture he lives in.[5] Over and over, the text's pseudonymous narrator, John of Silence, tells us he cannot understand Abraham, that the covenant between Abraham and God is unamenable to language itself, and that the complacent and pious citizenry of nineteenth-century Europe who think (with the help of Hegel) that they have progressed well beyond the issue of faith have utterly failed to understand what is at stake. These matters—which, in Kierkegaard, can be quite abstruse at times—have the most profound ramifications. It will not do to regard John of Silence as a straw man whom the sufficiently enterprising reader can dispose of in

order to get at the "truth." Rational discourse itself is on the line here, for *Fear and Trembling* beautifully succeeds in exposing its limits, indeed its bankruptcy, when it comes to the most essential things. How does one access or express the sacred? Both normative language and normative values go up in smoke.

In theological and philosophical discourse, Kierkegaard's definition of Abraham's faith has become famous in its own right: *the teleological suspension of the ethical*. Here would be the doctrinal payload of *Fear and Trembling*, the carefully argued final move that sets Abraham's case—and perhaps all faith-based ultimacies—against other sacrificial stories of the past. In particular, John of Silence compares Abraham's dilemma to that of Agamemnon whom the gods also asked to sacrifice his child, but he quickly shows us how incommensurate these two stories are; Agamemnon is acting in the name of a higher good: the welfare of the State. To be sure, his act is grisly—Kierkegaard shrewdly sidesteps the can of worms Agamemnon opens with this sacrifice, namely, the revenge scenarios involving both Clytemnestra and later Orestes—but his deed is publicly recognized as socially and ethically valid. Further, it is cogent and amenable to language. Abraham, on the contrary, transgresses precisely the ethical, also known as the universal, and he does so on two levels: he is to kill his own son, and he is also to destroy the future of Israel. Not only that: he falls out of the verbal. We are told that this act is at once *private and ineffable*, but that does not prevent Kierkegaard from articulating and charting, nonetheless, the new (and terrifying) sphere to which it belongs: the *religious* sphere which is beyond the ethical, which does not admit of clear lingual access.

This is trouble. The authority Kierkegaard claims for the private and ineffable is distressingly resistant to proof or confirmation. Kafka famously choked on these matters as he wrote his variants of the Abraham story, always emphasizing its potential untrustworthiness: how can Abraham be *sure* that God requires this sacrifice? How can he be sure that it is God

in the first place? Or that he has heard the Lord aright? Woody Allen was later to offer his own pastiche of these matters, giving us an Abraham who is little more than a dupe, who believes that any "deep resonant" voice speaking to him in the middle of the night must indeed be God's voice. (In this version, Sarah lets him have it, making sure we realize what a schlemiel he is.) Yet Kierkegaard himself toyed with such nagging questions, and lets us glimpse, in his own notes, a Jehovah who reproves Abraham as foolish and gullible, a slightly deaf Abraham who failed to hear God's final order to desist. The story's unreliability borders on the slapstick.

It would be funny if it were not at the same time a murder story of the most gruesome sort. You prove your faith by sacrificing your son. This kind of faith is beyond the ken of John of Silence. To sidle up closer to it, he distinguishes sharply between *resignation* and *faith*, and posits two sorts of "knights" representing each of these beliefs. Knights of resignation are motivated by willpower, and in extreme circumstances they can rise to the final challenge: sacrifice of one's son, of "the best one has." This the narrator understands. It is a heroic act of the most extreme moral fiber. But knights of faith are a different breed altogether. On the surface they can resemble philistine bourgeois, for there is no stress, no trauma, no crisis entailed in their actions. They "swim," as Kierkegaard puts it in a striking metaphor, in faith. And John of Silence is awed by the serenity and totality of their belief: they believe—this is the kernel of their faith—that Isaac will be both sacrificed and restored, that God will both destroy him and return him. This is not posited as some kind of swap—which would appear to nullify its horror, since getting the child back would seem to cancel out losing him—but rather as the bottomless mystery of faith, according to which murder is at once real, final, revoked, and transcended. It is at this crucial juncture that their belief becomes incomprehensible, not only to John of Silence but also to human reason itself. This is the *absurd* that is offered as the final ground for

15

faith. But this ground is seismic in character: not only is this faith incommunicable to others, it is an unhinging mystery to the man who has it. As Mark Taylor rightly says, Abraham "cannot even make his trial comprehensible to himself. Faith involves an absolute paradox that shatters human reflection—shipwrecks understanding."[6]

Kierkegaard's place in intellectual history is tied, in part, to the faith argument just outlined. Yet I argue that his true power and his continued claim on our interest stem, in the last analysis, from what is *imaginative* and *writerly* in his work. It is here that he has no parallels in nineteenth-century culture. As readers of Kierkegaard know, *Fear and Trembling* is hardly a straightforward apology for faith. On the contrary, it can be poetic, digressive, learned, even chatty. And, most prophetic of all, it never ceases to be perspectival, that is, the ruminations of a pseudonymous narrator whom we are *not* to equate with Søren Kierkegaard; which means: we are hurled into a subjective labyrinth when we read this strange story. We are meant to experience the very *texture* of seeking-to-understand, of seeking-to-say, the incomprehensible, the ineffable. We watch John of Silence wrestling with these materials; we watch him spin out various scenarios in order to get closer to its truth; we listen to him exclaim, at regular intervals, that he still doesn't get it, that Abraham eludes his understanding.

The text's open-endedness is at once its most modern feature and its truest signature. Kierkegaard is not easily aligned with any specific school or program because he is intentionally elusive and slippery.[7] One can, uncharitably, chalk this up as evasiveness, as the nervous habit of a writer who refuses to be pinned down. But we are closer to the mark if we see in the text's very manner its richest significance: a rendition of what Philip Weinstein has, in writing about the general work of modernist literature, called *unknowing*.[8] Weinstein cites to great effect the famous "swimming" passage—"For my part, I can presumably describe the movements of faith, but I cannot make them. In learning to go through the motions of swim-

16

ming, one can be suspended from the ceiling in a harness and then presumably describe the movements, but one is not swimming"—in order to claim that this text's *honor* consists in never forgetting the distinction between "swimming" and swimming.[9] Writing has forever dished up "swimming" to us: a verbal confection that presumes to deliver the goods, a verbal confection that rarely acknowledges its fateful quotation marks, its lingual conventions, its distance from the real. Kierkegaard's genius consists in linking this linguistic charade with the ineffability of faith.

I said the ramifications are enormous, because this little book of Kierkegaard's flaunts both the insoluble mystery and the enduring terror of faith: its own subjectivism awakens us to the view that all profound beliefs are subjective and thus beyond the reach of either language or logic or proof. This strikes terror today, especially today, because our own age—terrorist-haunted, theologically driven in ways that bid to cashier the entire Enlightenment legacy—knows all too much about divine injunctions that flout all secular logic, exhortations from God to commit murder in His name. *Murder* as the condition of faith: how to get one's mind around this? Kierkegaard wants us to choke on this vision. He wants us to sense the enormity of this old fable. From both an intellectual and moral perspective, our experience of the divine is pure disaster. Put differently (Lagerkvist will make this startlingly clear): it is disaster that tells us we have encountered the divine. And disaster does have a language: fear and trembling.

It is hard to overstate the impact of these questions, and we will see that they bear on many different things at once: religious discourse, one's pact with God, reconceiving the task of narrative, refiguring the shape of a life. Each of these matters is stamped by its radical subjectivity and opaque phenomenology. To understand God's commands, to have faith, to write or to read a story: all this is defined as private, intimate, experiential, and geared to one great end—the creation of fear and trembling. No mediation, no laws, no social nexus: noth-

17

ing external is allowed to interrupt or modify the savage one-on-one project at hand here: man's encounter with the divine, and the wellsprings of both human doing and human utterance. We will see much of this in the chapters ahead: the "vastation" of Strindberg's Captain; the paroxystic setting of Munch's *Scream*; the going-through-the-wall of Ernst Josephson; the "outings" and phantasms of Hamsun's protagonist in *Hunger*; the unraveling of Vesaas's girl-child, Unn; the muteness of Bergman's Elisabet in *Persona*; even the exit scenario of Astrid Lindgren's damaged child in *Mio My Son*. Here is what I have called the Protestant Imaginary: a ferocious displacement of all human markers *inward*, a conviction that our affective states—fear and trembling, pain and pleasure, horror and desire—are the only gauge of truth, are the site for our essential transactions. Accompanying all this is a canny, writerly sense that this story—this inside story of affective personal knowledge—has not been told, and now must be told.

Hence Kierkegaard maliciously starts his account on a mercantile note: "Not just in commerce but in the world of ideas too our age is putting on a veritable clearance sale" (41). Faith, he goes on to argue, is now a commodity taken for granted, achieved long ago, thought measurable, safely inventoried and put away. Science and materialism have relegated these matters to the margins. Now is a time of progress, of great systems, of forging ahead. It is against this backdrop that the text produces, in the Attunement, its counterattack: a man whose great enduring passion is to understand the story of Abraham. First as a child, then as an adult, this man was infatuated with the story, and his "soul had but one wish, actually to see Abraham, and one longing, to have been witness to those events" (44). Kierkegaard goes on to say that this desire had nothing exotic to it, no longing to see the Promised Land, nor even the key players themselves. "What he yearned for was to accompany them on the three-day journey, when Abraham rode with grief before him and Isaac by his side" (44). It is a peculiarly *narrative quest*, a longing to have seen the actual

event unfold in time. *In time*: to restore the temporal density, the temporal open-endedness of all acts. The consequences of this move are going to be enormous.

At this point, as if to grant our man his request, the text explodes with four different scenarios of the fateful three-day journey, filling in that "black hole" left by Scripture, showing us what it might have been like, felt like, actually to be there, actually to be Abraham. These astonishing mini-narratives are at once the high point and the low point of *Fear and Trembling*, because each one of them goes horribly amok, shows you how, according to human logic, the Abraham story could and should have been a disaster. Kierkegaard—so often seen as a complex and hypersubtle dialectitian—emerges here as a poignant dramatist and portraitist, attuned to horror and the great effects they produce, sketching four unforgettably wrenching tragedies in so many pages.

In the first version Abraham is silent, but does not conceal from Isaac his fate, gives him his blessing, leads him up the mountain. Repeatedly we are told that Isaac, who pleads for his life, "could not understand him." At their destination, suddenly Abraham changes his face entirely—wild gaze, mien of horror—throws his son to the ground, and exclaims: "'Foolish boy, do you believe I am your father? I am an idolater. Do you believe this is God's command? No, it is my own desire'" (45). Isaac, anguished that he has lost his father, begs God to be his heavenly father. Abraham then mutters to himself: "'Lord in heaven, I thank Thee; it is after all better that he believe I am a monster than that he lose faith in Thee" (46). Kierkegaard possesses what Keats might have called "negative capability," for he has imploded the biblical fable, turned it to disaster, by following an all-too-human logic which converts God's horrible command into loss of faith, as if faith's *loss* were the ultimate stakes here, so ultimate that the father demonizes himself in order to salvage the son's belief. *Loss* is everywhere you look: Abraham is heroically trying to preserve what might still be preservable, in this impossible pass.

19

The second version, still briefer, follows the biblical line, has the father bind the son, draw the knife, see the ram—all in dead silence—but closes with a dreadful twist: Abraham returns home with Isaac, but broken rather than triumphant, his eye "darkened," seeing "joy no more" (46). Here too we go *inward*, realize how unsurvivable (spiritually) this "test" has to have been, how it destroyed the man who passed it.

The third version offers us a more familial Abraham, a man who reflects on Hagar and Ishmael whom he had cast out into the desert; this Abraham goes *alone* to Mount Moriah, begs God's forgiveness for having been ready to sacrifice his only son, and chokes ever more completely on the paradox he has been hurled into: proving his faith by sin, being prepared to kill what he most loved, and—most grievously—unable to comprehend that he could be forgiven.

The fourth variant is perhaps the most heartbreaking. Abraham carries out God's command, but cannot—despite his best efforts—conceal his anguish, cannot stop his hand from clenching, his body from shuddering, as he draws the knife. All takes place in silence. This time it is Isaac who loses faith, for, unbeknownst to his father, he has seen Abraham's horror, his "fear and trembling," and it poisons his life.

These brief, pungent accounts of a story we thought we knew are as harrowing as anything Kierkegaard ever wrote. Each one *opens* the story inward, drains the cup of miseries it contains, obliges us to see how venomous and unsurvivable it is, how implacably the divine injunction leads to human disaster. Each version dramatizes a rupture of belief. And, arguably, the strangest, most haunting feature of the entire sequence is the series of sibylline codas that Kierkegaard appends to these accounts, recasting their narrative of lost belief in shockingly somatic terms as a saga of *weaning*, as a set of strategies for separating the infant from its mother's breast. Here—and only here—does the body, the maternal body, make its way into the writing. In a move that feminist criticism has illuminated as operational throughout Western culture, the woman's body seems invoked—seems indeed indis-

pensable—as a locus for situating our most basic and primitive arrangements. One can scarcely fail to see that the putatively key drama of father and son—construed as either Abraham-Isaac or God-Abraham—is displaced onto a still more primitive exchange: that of mother-infant. Why? It is an issue never addressed. We are entitled at this juncture to reconsider whether that crucial, privileged off-limits *religious* sphere can ever be as immaculate a zone as Kierkegaard claims; once soma and gender are revealed in their instrumentality, then (patriarchal) ideology cannot be far behind. (Just how far-reaching these gender issues are will be spectacularly on show in Lagerkvist.) At issue, as well, is, I think, a profoundly anti-Pauline notion of flesh as prior, as bedrock, as the site where meaning happens. The cerebral Kierkegaard, who so often seems comfortable with the play of abstractions, stuns us by his depiction of the Ur-crisis of individual existence revolving around a withheld breast.

Thus, when Abraham "blackens" his own character in the first version in order to preserve Isaac's belief, we are told that the mother blackens her breast, so that the child sees but stops desiring the breast while still loving the mother; we should be grateful, Kierkegaard says, if weaning the child requires nothing more terrible than this. In the next account, where Abraham's own spirit is broken, the breast is covered entirely, and the child loses the mother; here, too, we are told to be grateful that the mother has been lost in no other way. The third version, relating Abraham's self-hatred that he could have been prepared to sacrifice his son, closes with a mother who grows increasingly distant from the child; yet this weaning too is praised, for not being still worse. The final variant, focusing on Isaac's loss of faith, speaks of weaning as the replacement of the breast by more solid food, expressing gratitude that more solid food might be at hand.

Each breast-coda closes with praise that weaning has occurred with so little damage, but it is hard not to read the entire sequence more darkly.[10] The repeated versions of loss of faith are brilliantly capped by their somatic counterparts

whereby the covenant with God is fissured and the human creature experiences radical severance, is hurled into the prison of self, is denied the prior nurturance that gave it life. Or, to use the term Philip Weinstein invokes in his account of the weaning passages, what is lost here is the familiar *anaclisis*, the experience of "leaning on," that buttresses not only the infant but the human subject in his place within time and space, within the cosmos. To lose the breast is what Heidegger might have called a first experience of *Geworfenheit*, of loss of all bearings, of discovering one's unsponsored condition. Loss of faith; loss of more still. This entire sequence is written by a tragic poet rather than a theologian, in an unbearably moving language of soul-destruction and somatic exile. A familiar parable has been drastically reconceived, so that its own drastic tidings might at last be seen. One is entitled to feel that nothing else in *Fear and Trembling* comes even close to the pathos and density of these few pages.

I believe that we experience these four tragic scenarios as *tests* of a peculiar sort, in keeping with Kierkegaard's severe logic: tests or exercises in which we plumb this story's unstated horror, see how badly it should have played out, and thereby begin to move closer to the incomprehensible Abraham, the mysterious figure who skirted these disasters by dint of his absolute faith. One wants to say that Abraham is approachable only by contrast, by being measured against a human scale that represents *our* likely behavior. Yes, Abraham passed the test, and perhaps—this is never altogether clear—we are to assume that his own belief never faltered, that he possessed the same ineffable grace that the knight of faith possesses. *This cannot be narrated.* What can be told is the monstrousness of this test on all human scales, both morally and emotionally. To put it still more baldly: Abraham may not experience fear and trembling. But all of Kierkegaard's rhetoric is geared to make sure that *we do.* And in doing so, we not only measure, we actually experience the chasm that separates us from Abraham.

This is not pleasant. It is arduous. We must, in some crucial and difficult sense, forget what we know. After all, *we know the outcome.* Conceivably the most brilliant observation in *Fear and Trembling* is this: we must never judge actions by their outcome. We must judge them "on the front side," as it were, before they were completed, before they succeeded. A test already passed is no test. Kierkegaard is intent on making us take the test, put ourselves in Abraham's place, that is, *before* the event. "What is left out of the Abraham story is the anguish" (58). It seems fair to say that the anguish—the fear and trembling—is what is left out of all recorded events. Kierkegaard is exposing the great fraud of both history and narrative: they convey results but ignore process. They propose "swimming" for swimming. They start from the end, not the beginning. Sartre was famously to pick up this argument in *la Nausée* almost a century later, by proclaiming that we cannot tell a story without knowing the ending, which dictates every move the storyteller makes. It follows that stories are therefore false to experience, for they are cued to a logic of causal sequence and are blind to the blindness of life, the open-endedness and tentativeness of all doing.

And Kierkegaard has little doubt as to who bears much of the blame for this state of affairs: professors. (It is odd that he does not go after historians or writers.) His critique is both searing and, in my view, irrefutable:

> They [professors, what Kierkegaard terms "lecturers"] live in their thoughts, secure in life, they have a *permanent* position and *sure* prospects in a well-organized State; they are separated by centuries, even millennia, from the convulsions of existence; they have no fear that such things could happen again: what would the police and the newspapers say? Their lifework is to judge the great, to judge them according to the outcome. (91)

If proof were needed that *Fear and Trembling* still speaks to us today, I would cite this broadside as key evidence of Kierkegaard's bite. He not only nails the complacency that (in mod-

ern times) tenure and job security confer on the professoriate, but his chief indictment concerns the gulf between teachers, on the one hand, and "the convulsions of existence," on the other. On this head, *teaching* removes the marrow, the existential drama, the living pulse from all the great events it purports to discuss.

Yet academicians cannot take all the blame, for the true culprit is narrative logic itself, a logic that confers inevitability on its materials and thereby robs them of all life, risk, and value. A massive (even if unwitting) deception is perpetrated under the name of reporting and instruction, and this quotidian form of counterfeiting—for that is what it is: it gives us false coins for real ones—takes place every day, in our books and newspapers and classrooms and conversations. Kierkegaard intends to roll back the damage, to start afresh, to make us recover the fear and trembling of Abraham's story by telling it in a different way altogether. Telling it, four separate times, as disaster rather than success, is one way of awakening us to the existential terrors it contains. Still another consists in taking the shocking measure of God's injunction by terming it a "teleological suspension of the ethical." But I believe the most radical device for getting us "in front" of the (deadening) labels that have packaged and sealed off the events of history and legend is the most straightforward one: to transport us imaginatively to the actual scene of the crime, to hurl us so forcefully into the maelstrom that we forget what we know, and actually recover the indwelling violence of the event, the originary unresolved bristling forces that constitute the ground zero of life as we live it rather than life as it is distilled and represented afterward with the serenity of hindsight.

It is impossible to overstate the significance of this move. It amounts to a time trip that is a radical trip inward, toward the subjectivity of Abraham, toward what it must have felt like to be who he was, where he was, how he was, and what he was. It is worth asking how often we acquire knowledge

of this sort. How often do we bracket the established contours of history and event in order to go "inside" them, "in front" of them, so as to discover the actual passions and challenges and pulsions that went into their making but disappeared in their telling? I suspect that such a move, if we were capable of it, would destabilize all that we think we know by imploding our archives and pointing to the miasmic reaches that subtend their docile accounts. Behind every important recorded deed lies a drama of fear and trembling that must be recovered, if we are to take any measures worth having. Not only is the "record" a truncated thing, but it follows that there are no shortcuts to human understanding. Thus John of Silence informs us how *he* would go about telling the story of Abraham, in such a way as to bring all this living drama to light:

> If I myself were to talk about him I would first depict the pain of the trial. For that I would suck all the fear, distress, and torment out of the father's suffering, like a leech, in order to be able to describe all that Abraham suffered while still believing. I would remind people that the journey lasted three days and well into the fourth; yes, those three-and-a-half days should be infinitely longer than the two thousand years separating me from Abraham. (81)

That, of course, is what Kierkegaard has done. It flies in the face of all "bottom-line" reasoning, all efforts to abbreviate and sanitize the bloody business of understanding. He sends us through Abraham's ordeal in every direction at once, makes us see it from the inside, from the angles, from the view of dialectics, against the story of Agamemnon. Only thus can we discern the horror and grandeur of this event.

Fear and Trembling is a restless, sometimes maddening book that does all it can to unseat, even unhinge its readers, by pointing out to them that they do not know what they think they know. He claims we have unwittingly taken the false coins for real, that we have been swindled—intellectually, morally, spiritually—by the clearance-sale scheme in which

all our data and information and knowledge have been pur-chased on a "cut-price" version, a version based on outcome alone. Hence we have a papier-mâché Abraham, just as our notions of all the other important deeds and acts are based on inert labels and tags. But the fault lies as much with us as with our professors and historians. We prefer the cut-rate version, the shortcut version, the version based on outcome. The facts, Ma'am, just the facts. Our schools promote this system, and our *tests*—so different from the test Abraham experienced—do not require us to go any further, to go inward and find the fear and trembling that bathed the original deeds themselves.

After all, the spiritual is hard. Kierkegaard has no illusions here. Early in his text he refers to the proverb, "only one who works gets bread," and he points out that in the "outward world" many people get bread without working, and many others work without getting bread. But, he says, in the world of spirit it is different:

> Here there prevails an eternal divine order, here it does not rain on the just and the unjust alike, here the sun does not shine on both good and evil, here only one who works gets bread, and only one who knows anguish finds rest, only one who descends to the underworld saves the loved one, only one who draws the knife gets Isaac. (57)

This austere logic, in which effort and reward are tied to-gether, may appear to describe Heaven, but I suggest that this law is still more deeply a law of understanding, a new kind of logic that insists on the labor required to measure all acts and deeds. On the face of it, it seems to be a punitive and sacrificial logic, claiming that Orpheus must go into Death in order to retrieve Eurydice, that Abraham must be prepared to murder his son to get him back, that you must be willing to die in order to live. But there is a rich and generous side to this injunction as well, for it rightly dismisses all shortcuts to understanding, all quick fixes for knowledge, all bottom-line accounts of being and doing; it dismisses them as super-

ficial, as doomed to the surface itself, and hence locked out of the hidden drama that parses all human data, that restores to the record the ethical and emotional dimensions of lived human experience.

Kierkegaard is seeking to right/write the record, so that its plenitude might be grasped. He seeks to recover the truer story so that we might at last move beyond the one-dimensional stick figures that populate our histories and fables. He speaks—surprisingly, it might seem—of Mary and tells us that, yes, she "bore the child miraculously," but that it went with her "'after the manner of women,' and such a time is one of fear, distress and paradox" (93), and that the angel did *not* go round to all the other young girls in Israel and say, "'Do not despise Mary, something out of the ordinary is happening to her'" (93). For a moment the maternal body reenters this story, reminding us that all birth is hard, that "virgin birth" must be—for all those around it—a scandal. Reminding us as well of the irremovable centrality of the body, not merely in our daily affairs where the rules of gravity apply but more crucially in our most extreme moments, moments of transcendence such as birth and death.

In his beautiful poem, "Le Musée des Beaux-arts," W. H. Auden wrote eloquently of the disconnect, the cleft, between the great spiritual events and the tide of common life: "How, when the aged are reverently, passionately waiting / For the miraculous birth, there must always be / Children who do not specially want it to happen, skating / On a pond at the edge of the wood: / They never forgot / That even the dreadful martyrdom must run its course / Where the dogs go on with the doggy life and the torturer's horse / Scratches its innocent behind on a tree." Kierkegaard, it seems to me, is telling us that the story of the god is enmeshed with our own story, that spiritual greatness ruptures everything we ever thought we knew about reality, that it radically challenges the way we see the world. We must forget what we "know." These events must be written about in such a way that their

"outcome" no longer obscures the fear and trembling that were testimony of their grandeur. Such writing will remove the floor we stand on:

> One is stirred, one harks back to those beautiful times, sweet tender longings lead one to the goal of one's desire, to see Christ walking about in the promised land. One forgets the fear, the distress, the paradox. Was it so easy a matter not to be mistaken? Was it not a fearful thought that this man who walked among the others was God? Was it not terrifying to sit down to eat with him? Was it so easy a matter to become an apostle? (94)

Kierkegaard's effort to take the measure of Abraham is a *genombrott* text, a project that goes, in multiple ways, off the charts that have heretofore imprisoned this story. He shows us how it should have gone wrong; he brings to it "the fear, the distress, the paradox" that must have attended it; he points to the ineffable covenant that links this man to his god but defines that pact negatively, as the absurd, as the bankruptcy of reason, as private, yet/therefore as holy, and as written-in-the-flesh. And he asks us how we, knowing this, might now imagine Christ. What would *his* story be like? How would you have seen it, had you been there?

It is no exaggeration to say that Pär Lagerkvist has, in book after book, taken up the gauntlet that Kierkegaard has laid down here. More even than John of Silence, Lagerkvist and his characters are both confused and haunted by the events of Scripture. A great deal of the literary output of Lagerkvist is inscribed under the sign of "fear and trembling": from the early signature poem, "Ångest" (Anguish) to the autobiographical prose pieces such as "Father and I" or *Guest in Reality*, his trademark emotions are anguish, pain, and the certainty of being outside the calm order of reason, by dint of a sensibility that can never find peace. But it is the great cycle of novels beginning with *Barabbas* and closing with *Pilgrim at Sea* that answers Kierkegaard's call. The central event in most

of these texts is the Crucifixion, but an enigmatic Crucifixion now witnessed and suffered by those who brushed up against it, who were on the sidelines, who brought to it the mere light of human reason: Barabbas, Ahasuerus, Tobias, all construed as pilgrims, unhinged by the encounter with the godhead. These spare narratives testify, as it were, despite themselves, to the power of the divine, for his pilgrims seem cursed rather than blessed, undone by what they have seen.[11] The richest and strangest of these pilgrimage texts is *The Sibyl*, where the cursed Ahasuerus meets the Greek pythia, enabling Lagerkvist to develop in contrapuntal fashion his polytheistic interests, with the result that we see human wreckage and confusion as the common ground between the Christian and pagan fates.[12] To be touched by the god is the calamitous event that Lagerkvist wants to illuminate: not as theological proposition but as savage dismantling.

It is easy, I think, to misread Lagerkvist's religious fables as formulaic efforts to rewrite the Old Stories, to invest them with modern psychology and questioning, or even to see them as postmodern performances so that the story of Barabbas, for example, could be aligned with that of Gardner's Grendel or Stoppard's Rosencrantz and Guildenstern: efforts to revisit the canonical fare, but to do so in oblique and scandalous fashion, so that meaning and acts of Christ or Beowulf or Hamlet would become to us as bizarre, incomprehensible, bereft of markers or illuminated from the margins, even absurd. This approach obviously makes some sense, but it robs Lagerkvist's best work of the actual pathos and reach that it possesses. *Scandal* is the best term I know for taking the measure of his real achievement: a scandal that he seems to have experienced every day of his life, as the indwelling wound and fissure of being human. The great religious tales matter because they offer him a familiar vocabulary for dramatizing the most intimate facts of his life, which have to do with alienation and exile. It is as if the story of the Cross underwent a terrible displacement, in which the love and suffering of Jesus

count for naught but function rather as an initiation into loss, into the abyss. And this is because Lagerkvist starts out in the abyss, starts out with the terrible certainty of being *unblessed*, of being condemned to bear witness. The breakthrough theme in his work is penal: the gods have broken through, and it is he who has been broken.

One therefore feels in much of his finest work a nostalgia for Eden. The famous poem "Ångest, ångest är min arvedel" (Anguish, anguish is my inheritance)—a signature poem taken to be a reference to the horrors of a brutal new age in the wake of the Great War—only makes sense against a backdrop of (lost) peace; more limpid and lyrical is his poem of the flowering almond tree that hinges on the cleft between the beautiful and pure loved one and the damaged lover whose very presence spells darkness. This rift is everywhere: on the one side a world of continuing innocence and harmony, inhabited by those at peace in the world and its ancient rhythms (nature, lover, mother, father), and on the other side, looking in, fissured, measuring the exile: the poet. One recalls the final stanza of his loveliest poem, "Det är vackrast när det skymmer" (It is most beautiful at twilight):

> Allt är mitt, och allt skall tagas från mig,
> inom kort skall allting tagas från mig.
> Träden, molnen, marken där jag går.
> Jag skall vandra—
> ensam, utan spår.
> (Everything is mine, and everything will be taken from me,
> soon everything will be taken from me.
> The trees, the clouds, the earth where I walk.
> I shall wander—
> Alone, without a trace.)[13]

Sunset is a daily reminder of one's status as "guest in reality," as foreigner to Nature, as witness to destruction. All these motifs are most perfectly fused together in *The Sibyl*, where the modern legacy of alienation and withering consciousness

is wedded to a story about the gods' shocking commerce with humans.

The novel opens with an account of the fate of Ahasuerus, the wandering Jew, who is punished for denying Jesus. His transgression: not to allow this "unknown man dragging himself along with his cross" to rest in his doorstep.[14] Why should he? Such men bearing crosses were not unusual. To let him lean against one's house could bring bad luck. One remembers Kierkegaard's cautionary remark: "Was it so easy a matter not to be mistaken? Was it not a fearful thought that this man who walked among the others was God?" Who among us is not benighted? Who would not be mistaken?[15] Ahasuerus is not an evil man, simply an ordinary man. But this is more than an issue of getting it right or wrong. In Lagerkvist's lexicon, getting it wrong means having to suffer through the actual meaning of the sacred, having to watch the utter collapse of one's quotidian logic and pleasure-in-life. "A sort of grey ash" settles on this man's life: he loses desire for his wife, becomes impotent, finds his child unreal, sees all that was solid become ghosted. It is as if he were becoming the man we know as Pär Lagerkvist, the exile-from-life. Why? Because an angry Jesus, a vengeful Jesus, decreed it so. Here is what would happen if the divine breaks through into your life. All tranquility is lost: logic, love, joy, connectedness. You are hurtled into anomie and neurosis, to endless wandering.[16] Is this the Christian legacy? Is this what happened to the Greco-Roman world after Christianity infected it?

As if to answer that question, Lagerkvist moves from the cursed Ahasuerus's trials into the still larger penal story he wants to tell: the story of the pythia, the sibyl. Here would be the pagan half of his theological diptych: the encounter of the human girl with the god of Apollo's temple. The modernity of Lagerkvist's rendition is immediately visible in the quasi-anthropological perspective he offers of the oracle-as-institution. The Temple is unmistakably presented as a political structure—much as the Vatican can be seen as political struc-

ture—where power is amassed and zealously guarded. The priests are seen as manipulative businessmen with no real connection to the matters they oversee, and there is a distinctly secular feeling to this account of the Temple as landowner, as provider of festivals and spectacles for the masses, as a kind of fairgrounds where rogues and cheats and whores abound, mixing with the temple bureaucrats, endowing the whole scene with an aura of sleaze.[17]

One feels a demystifying thrust here, close to a deconstructive critique, whereby the institution of the pythia comes across as a cynical, glitzy show for the uninformed and unenlightened, a trap for the naïve and gullible. Most especially for the simple country girls whose fate it is to be enlisted by the Temple as sibyl, as site and voice of the god's presence. The protagonist is such a girl, and Lagerkvist writes her induction into this scheme as highly suspicious: pious and ignorant peasant girl interviewed at the temple court by refined high priest, with implications that her prime credentials are her virginity and her simple-mindedness.

But things are more ambiguous than this model suggests. The priests—corrupt or not—know what they are doing, for this girl is truly different. For her family, god exists in "springs and trees and sacred groves," rather than in the grand Temple at Delphi, but she is not like her family. And she is not like other girls: "I saw visions and heard voices; this was when the signs of womanhood first appeared" (36). In typical Lagerkvist fashion, she is exiled from the simple things, the old rhythms and harmonies that define her parents' lives: "I went about my home like a stranger, filled with an unease of which they had no inkling and which, if they had, they would not have understood" (37). The key to this strange fable is already visible in the reference to the "signs of womanhood," as if one's sexuality were indeed a sign, a sign linked to visions and voices and, ultimately, to the mysteries of the Temple. For we can scarcely fail to see that the pythia's initiation and per-

formance have a profoundly sexual character. The rites of the priestess do not take place in the light-filled Temple itself, but rather in the dark pit to which she descends, a crevice, a cleft in the wet living rock, "believed by some to run right down into the realms of death" (48).

On the day of initiation, dressed as the god's bride, the pythia descends into this dark space, filled with snakes (oracle beasts, they are called) and with a stench of drugging smoke and fumes that is so strong and acrid as to make her giddy and close to fainting. Half-conscious, she "dimly saw one of the priests of the oracle leading forth from obscurity a he-goat with unusually large horns" (49). Lagerkvist then describes her first encounter with the godhead; the passage warrants citing in full:

But all at once everything changed. I felt relief, release; a feeling not of death but of life, life—an indescribable feeling of delight, but so violent, so unprecedented . . . it was he! He! It was he who filled me, I felt it, I knew it! He was filling me, he was annihilating me and filling me utterly with himself, with his happiness, his joy, his rapture. Ah, it was wonderful to feel his spirit, his inspiration coming upon me—to be his, his alone, to be possessed by god.[18] By his ecstasy, his happiness, by the wild joy that was in god. Is there anything more wonderful than sharing god's delight in being alive.

But the feeling mounted and mounted; it was still full of delight and joy but it was too violent, too overpowering, it broke all bounds—it broke me, hurt me, it was immeasurable, demented—and I felt my body beginning to writhe, to writhe in agony and torment; being tossed to and fro and strangled, as if I were to be suffocated. But I was not suffocated, and instead I began to hiss forth dreadful, anguished sounds, utterly strange to me, and my lips moved without my will; it was not I who was doing this. And I heard shrieks, loud shrieks; I didn't understand them, they were quite unintelligible, yet it was I who

uttered them. They issued through my gaping mouth, though
they were not mine . . . It was not myself at all, I was no longer
I, I was his, his alone; it was terrible, terrible and nothing else!
(49–50)

This astonishing passage is bolder and cuts deeper than any-
thing else in Lagerkvist's entire god-haunted work, because
it moves from the ungendered issues of pain and anguish—
familiar to us throughout his oeuvre—to something far more
explosive and unsettling: the revelation of the divine through
its penetration/filling up of the female body, an ecstatic en-
counter so fierce that it catalyzes a new language altogether.
The originality and force of *The Sibyl* are to be seen in pre-
cisely this constellation of forces: gender, penetration, ecstasy,
language. We are a far cry (as it were) from any garden variety
of Angst or religious questing, for Lagerkvist shocks us by the
sexual virulence on show in his strange rendition of encoun-
tering the god.

In insistently animalizing the pythia's encounter with the
god—snakes, goat smell, the huge-horned goat itself—La-
gerkvist allows us to code divine rapture as but a form of sex-
ual rapture, and we are free to understand the "filling up" of
the woman's body as the work of the god or the goat-god or
simply the goat. Unsettling indeed, and worth pondering.
Moreover, the ecstatic frenzy experienced by the sibyl—and it
happens repeatedly within the text—always closes with the
god's departure, leaving her hungry for what never comes:
tenderness, togetherness. We sense that sexual passion itself
is under scrutiny: rapture is inseparable from abandonment,
ecstasy is short-lived, unsharable, and unsustainable. More-
over, the initial delight frequently changes into something
more violent and destructive, bordering on encounters that
look like outright rape, leading us to realize that Lagerkvist
has revitalized the erotic materials of ancient myth: the male/
animal god takes his good pleasure by penetrating and, in-

deed, storming the female human target of his lust. Lagerkvist is telling us what it feels like on the receiving end.

The depiction of the god's commerce with the woman takes one of the extreme figures of modern theory—phallogocentrism—and actualizes it. God manifests himself through penetration of the female body. All divine revelation is hereby cued to an old male master plot. The woman's body is the docile, receptive field which the male plows, and where he disseminates his power and word. The entire priestly institution appears as a male fraternity constructed solely for this purpose. It is here that one needs, I think, to remember that crucial female breast (blackened, withheld, but indispensable nonetheless) in Kierkegaard's *Fear and Trembling*. From the child's suckling to the god's plowing, the female body emerges as the ground zero for "speaking God." There are grounds for reflection here. My interest is not in psychoanalyzing either Kierkegaard or Lagerkvist, but rather to investigate a figural logic of faith's very moves—bond with the godhead, severance of that bond, utterance of that bond—for which the woman's body is bedrock.

Extrapolating, I cannot help but think of those famous accounts of Charcot, surrounded by male observers, performing his experiments in hypnosis on female victims of hysteria. In Charcot's amphitheater, the woman's body was sovereignly and expertly acted on by the learned doctor, so as to induce the desired hysterical states, so as to make it speak its indwelling language. The contemporary press did not hesitate to compare these séances with the theater stage, and it is known that Sarah Bernhardt repaired to a cell in the famous Salpêtrière, to observe firsthand the *aliénées* lodged there, when she was preparing her performance of insanity in the play *Adrienne Lecouvreur* in 1884.[19] The parallels with Lagerkvist are striking: he presents, in mid-twentieth century, the very institution of the pythia as an ancient variant of hysteria, coded as the transmission of god's word, lodged in the hissing and raving of a female body brought—indeed drugged—to a parox-

35

ysmal state, whereby all human boundaries are broken through. In Lagerkvist, the theatrical trappings are those of Delphi itself: a holy place where the revelation of the god is enacted via a frenzied woman's flesh.

Yet, even this assessment is too tame. For the woman is not passive, nor is she merely vanquished. Nor is she "acting." On the contrary, she participates, she is brought to a pitch of ecstatic pleasure that surpasses all else, that seems to her the pinnacle of being alive. Most intriguing of all is the fashion in which the god's thrusting power becomes language itself: the woman's raptures issue into hissed, dreadful, anguished sounds that she herself cannot recognize, loud and unintelligible, indeed "hysterical" shrieks that nonetheless are coming from her. What does this mean? One remembers the ineffability of Abraham's vision; one remembers that it is not amenable to language at all. It is as if Lagerkvist elected to carry Kierkegaard's dark transcendent logic beyond the private sphere where the philosopher located it, in order to intensify the scandal even further: organized religion is now shown as complicitly managerial, while the ecstatic visionary state becomes at once exploitable and yet genuine.

Again, from an anthropological perspective, it is clear enough: the male priests will have no trouble "decoding" the woman's shrieks, for they will cast this as the very language and voice of the oracle. They are in control of the language, and they will translate these sounds to their liking; it is a familiar arrangement. But one can come at this from the other direction as well. This experience of divine rapture makes her other unto herself, makes her body speak a code that she cannot fathom, enunciates a discourse of alterity that seems to express her very pith and core but which she cannot "read." In his own way, Lagerkvist is reconfiguring Kierkegaard's "teleological suspension of the ethical," by showing us that the experience of the sacred ruptures all our frames, comes to us as the quintessence of the real but is indecipherable and unownable. Kierkegaard moves toward the absurd; Lagerkvist's

vision is more tragic as well as more ideological, for he is out to explore the all-too-human ramifications of this intercourse with the divine. A large vision is coming into focus here, whereby the more familiar intellectual angst of other Lagerkvist work is recast as something visceral, fierce, unplumbably somatic, but a language nonetheless, and not merely a script devised by the male priesthood.

As the story unfolds, the pythia recognizes ever more sharply her exile from the old life rhythms and security, and some moving scenes depict her pained alienation within her own family, seen most especially at the time of her mother's death and the subsequent stint with the father. The book asks if human love can possibly encompass or match the splendor and power of what the god offers, and its most tragic episode suggests: No. Living with her father, the sibyl enters into a kind of arcadian love affair with a one-armed man whom she has met—an illicit move proscribed by the Temple, one that will result in the lover's death—and we watch the relentless, unstoppable buildup of human feeling as it moves from tenderness to passion to frenzy to annihilation. The human lover is a man she can *see*, and their coupling initially brings delight and mutuality: "The marvel of embracing another and being myself embraced, and of feeling a profound, wild satisfaction in my powerful body which, without always knowing it, had always longed for this" (86). She seems to discover the rationale of her own body, as if it possessed a raison d'être that was a mystery up to now. She is being filled and fulfilled. But soon enough the very spectacle of absolute desire cannot be looked on, and the intensity of her sexual hunger overmasters her male lover:

> Shamelessly I betrayed my insatiable desire for him, showing him how blatantly, brazenly I loved him; and when I did so my eyes must indeed have been like those of one drowning, but I no longer cared—I let him look into them. I hid nothing. Did not wish to hide anything,

My passion was like a savage chasm that sought to engulf him.[20] And I saw that it frightened him. (94–95)

Much comes together when one reflects on this story. The passionate human lovemaking takes place by the roaring river, a thunderous noise that might be located either outside or inside, in the psyche or the body or the natural setting (just as the tumultuous overflowing forces of shriek, water, and sky in Edvard Munch's *The Scream* blend into one another). This universe of violent elemental forces cannot be domesticated, and the fate of the pythia is to be inducted into it, something that she has encountered over and over in the pit under Apollo's Temple. It cannot be domesticated, and its very sight cannot be borne: the lover shrinks before her voracious hunger, but he is still further undone when he comes secretly into the Temple itself and stares, "with horror-stricken eyes," at its key performance: the frenzied writhing hissing body of his beloved. How to assess this? Is sexual frenzy, located in the river as well as in the flesh, the revelation of the divine, and as such, forbidden to human sight? Or is the female's sexual rapture simply overpowering and annihilating to the fearful male gaze? One feels a sharp sense of taboo and undoing in this fable: the forces unleashed cannot be borne.

Kierkegaard wrote movingly of Mary's incomprehensible and incommunicable experience. Lagerkvist is no less interested in a divine birth, as if he wanted to tell Mary's story in a different key, insistently sexualized: to imagine what an impregnation by the god might be like, from conception to delivery. Lagerkvist plays out his animality theme right to the grisly end, as the pythia, pregnant, gradually understands that the child she has conceived comes not from her beloved—too much time has elapsed—but doubtless from the savage god, the goat-god who has made good on his insemination. Hence the exiled pregnant pythia, subject to hurled stones and community outrage—reminiscent of the treatment meted out to the man dragging his cross—is aided

in her search for refuge and especially in the delivery of her fetus by the gathering goats who are drawn to this strange event, "uttering strange, plaintive cries" that accompany her own screaming. The book's closing mystery focuses on the strange result of this insemination: a riddling silent creature who is thought, in human terms, to be an idiot, but who, at book's end, makes his miraculous goat-like/god-like exit from the world of the humans and ascends. Where? We are not to know.

The Sibyl is a daring, extremist work of art. Its fusion of Christian and pagan myth inverts utterly the familiar story of a birth in a manger, and challenges radically the sustaining matrix of that fable: God-turned-human-in-the-form-of-his-son-Jesus. No gospel, no tidings of a new ethos or a new dispensation, nothing ethical or spiritual in sight. Instead, we have an unforgettable depiction of the god's entry into human life—into human flesh—as horror story. Whether it be Ahasuerus's rejection of the man dragging a cross or the pythia's coupling with the goat-god in the pit, we see a rigorous devastation of all human values and norms. But the most provocative feature of this novel stems, I think, from its reversal and repudiation of the Pauline Christian doctrine regarding the equation between flesh and spirit, between the carnal and the sacred. Flesh, we have been taught forever, is perishable, corrupt, heir to a host of frailties and slated for ultimate disappearance. Spirit, on the other hand, is eternal and immortal, is not only the presumable core of our being but the spark of divinity within us, that which might align us with the gods.

Lagerkvist has annihilated this venerable binarism. I earlier said that he elects, scandalously, to literalize the notion of "phallogocentrism"; here I want to say that he goes further still, for he obliterates one of the West's most stubborn and endearing pieties: the superiority of spirit over flesh, the incompatibility of spirit with flesh. On the contrary, this brief tale turns that polite notion upside down, and tells us something rude and awakening about the whereabouts of the di-

vine, when it comes to human life: the god lives in our bodies, not our souls. God is to be found in our animality, not our tenderness. God is present in all moments of ecstasy, all moments where we exit the normal precincts of a measured life and experience something else, something anarchic and bestial and strange and irresistible. God is our savagery; he is at one with the roaring river and the raging storm; his presence shines in all those moments where reason and morality are suspended and cast—weightlessly—aside: lovemaking, orgasm, giving birth, dying. Unbridled, ecstatic sexual passion may well be unbearable to *look upon*, but it constitutes the god's hold on us.[21]

It is in this sense that *The Sibyl* moves well beyond the familiar existentialist queries about the place of humans within the world, or even the tug-of-war between flesh and spirit. Kierkegaard told us about a fated individual, Abraham, whose covenant with God outruns our capacity to comprehend or measure, inasmuch as logic, ethics, and language have no purchase on it. Lagerkvist is an altogether darker yet more democratic figure, for he also humbles our received notions about morality and behavior. I call him democratic, because his vision speaks to all embodied creatures, and it announces that they partake of the divine, but that this is as much curse as joy. This story resists deconstruction and irony. The gods are real. The god who fills us with rapture or curses us with despair is real. This is not an affair of displacement or projection. And the upshot is: we are other unto ourselves; and this immense other is god.

Breakthrough—*genombrott*—is the very signature move by which we learn of our emplacement within this broader scheme, because what is broken is the facade which we had taken to be real, the human scale which we had thought to govern our lives. Eden is forever behind us—as Lagerkvist said repeatedly in his finest lyrics—but the gods are responsible for it, not the humans. The gods turned Eden into a nostalgic myth, simply by dint of making their own appearance

onto the scene. For we are the scene where they appear. Even if we do not have the colossal ill fortune of colliding with them—as Ahasuerus and the sibyl have done—we bear their curse in our being. That discovery of our fissured state is what drives *The Sibyl*: not that we harbor evil but that we are the site of pulsions and fears and appetites and visions that assail us from the moment we draw breath. Wreckage is the central event in this body of work, and I can hardly claim that it gives readers great solace, but it does take its rightful place in the Scandinavian landscape as a nobler vision of the parameters within which we live and die.

B. The Play of Patriarchy: Ibsen and Strindberg

In the world's squinting, unprofessional eyes, *Ibsen and Strindberg* are seen as the Scandinavian tag-team that helped to create what we now call modern theater. Eugene O'Neill, Arthur Miller, and Edward Albee would unhesitatingly salute this duo as tutelary figures from whom they had much to learn. (They have indeed done so.) Of course, when you look more closely—or, indeed, if you are a student of either Scandinavian culture or theatrical history—then you know very well how odd this couple is, how utterly different from each other Ibsen and Strindberg are.[1] Ibsen the Norwegian iconoclast, the champion of individual freedom, the tireless campaigner against hypocrisy and complacency who remained private, close-to-the-vest, and embarked on a cycle of close-knit plays that would change theatrical conventions forever, this Ibsen would appear to be of a different species altogether from his Swedish counterpart Strindberg, the titan who seemed half-mad and plenty difficult to his publishers as well as his friends and contemporaries, and who seemed to dabble in "isms" of every stamp: world-class misogynist; student of myth and language; often God-haunted; often unbending atheist; publishing alchemist; experimental photographer; hero of the people; author of histories, fairy-tales, novels, and

41

poems; and peerless (albeit untaught) painter whose works are probably the most valuable paintings in Sweden today. The closer you look, the more opposed their legacies appear. Ibsen would be the funereal one, staging the death knell for his nineteenth-century bourgeois culture, showing how much rot existed in its foundations, displaying how its central conventions of marriage and work were riddled with disease, proving how *lying*—to others, to oneself—was the principal antic of creatures in culture. Strindberg, on the other hand, vicious though he often appears, would be the visionary one, the sometimes brutal, sometimes startling experimenter whose personal breakdowns were always fertile for his art, whose later work explodes with new horizons, making the stage hospitable to dream and displacement, cavalierly rearranging the laws of time and space, looking straight into Surrealism and the twentieth century itself, a time of both gutter wars and formal invention. Ibsen presides over a dying world; Strindberg heralds a new one.

Will this wash? It may indeed be the case that the squinty vision of the layperson has the lion's share of truth, that these two polar figures are indeed siblings of a sort. Each is, in his own way, of a moment with Freud (who followed them): Ibsen by dint of rememoration, the games of self-deception, and the project of diving into the wreck, and Strindberg via his discovery that the processes of the psyche—displacement, condensation, and so on—were first and foremost principles for playwriting, that the stage was a place of unheralded mobility and traffic, wrecking our notions of visibility. Each is obsessed with lies and cover-ups. Each is an anatomist of sorts. But—it might be objected—what about their *politics*? Their politics are utterly at odds, yes? Ibsen seems liberal; Strindberg can be reactionary. No doubt about it. But my argument goes the other way: each is displaying, willy-nilly, the collapse of Patriarchy: not as gospel, not as doctrine, not even as ideology, but rather as the stunning emerging truth of *theater*. The very reason these two towering figures matter to us in the twenty-first century is that they reinvented theater; this

they did almost unintentionally, I would say, because what is most alive in their work is not programmatic or attitudinal; it is rather a view of the human subject as histrionic, as what an earlier historian, referring to medieval culture, called Homo ludens. The best work of Ibsen and Strindberg has the same relation to our understanding of human behavior as *Hamlet* does, and for the same reasons; in these plays we see the shocking mobility of mind itself: mind as the prancing authority of life, prancing even when it prevaricates and fantasizes, prancing as it shows us what a roller-coaster we live on and are. Hamlet spends five acts going through his paces, exploring his limitless inner spaces, seeing and seeing through the cardboard figures who surround him, pirouetting the ostensibly sacred values of his time such as honor, revenge, even suicide, and applying a "what if?" attitude toward life and its seriousness. Such astounding muscularity and metaphysics are not quite to be found in Ibsen or Strindberg, but their works have nonetheless a distinctly circuslike character to them, a performative dimension, which makes a mockery of piety and principle. And we shall see that Homo ludens is the ultimate revolutionary figure, for his slithering and sliding and mutating makes it unmistakably clear that *politics* and *ethics* (and all the other big terms) are just words, just postures.

What does this have to do with Patriarchy or *genombrott*? Patriarchy, like any constellation of power, abhors *play*. Patriarchy posits fathers as lawgivers, as sources of authority, as genuine origins. Patriarchy is a pecking order. Patriarchy is the conviction of maturity, and is confident that its immaturity, its salad days, its period of dependency are behind it, definitively. To be sure, it benefits from the support of law and custom, and it unceasingly whispers to its adherents that such is the structure of reality: family and society play by the venerable established rules. But Ibsen and Strindberg make the epochal discovery that *playing by the rules* is an oxymoron, that *playing* cashiers the rules, turns everything topsy-turvy, reconceives power relations, decenters the existing arrangements, records a collapse of massive proportions. They dis-

cover, further, that playing is not optional; it is the modus operandi of being. Here, then, is the ultimate *punch* of their work—a body of plays that may seem to be grounded in the historical mesh of their time but that are actually far more audacious than that: they put onstage the wounded subject—the damaged "father"—in spectacular fashion, indeed as spectacle, as an event that the theater itself is uniquely equipped to render visible. One may liken these plays to the invention of new and more powerful telescopes, devices that radically extend our capacity to see. But, precisely as the ongoing joke in Strindberg's *Father* has it, these telescopes or spectroscopes are also microscopes, and the material that is now viewed up close in all its living antics and gestures and colors is a beleaguered male whose dominions are coming apart.

Even though Ibsen is several decades older than Strindberg, their most influential plays appear at the same time, during the final two decades of the nineteenth century. I have elected to focus my Strindberg argument on what I take to be his strongest early play of 1887, *The Father*, generally regarded as belonging to the Naturalist school, given its interest in heredity and genetics. Such a view seems reductive to me, since this startling text already hints at the more experimental and surreal works to come. And I want to pair this vigorous Strindbergian broadside (overtly against women, more deviously and provocatively against men) with what is arguably Ibsen's subtlest and most undervalued play, *Little Eyolf* of 1994, clearly affiliated with the Norwegian's late phase of symbolic psycho-dramas, and distressingly scanted by the critics and the reading public. These two dramas are *performative* in ways that need to be recognized, since their most virulent tidings are about Homo ludens, about fathers being types that strut and fret about the stage, about male authority itself as either an elaborate game of covers and signs or else an intricate set of props and crutches. In both cases we shall see where all the signs point, where the true action leads: to the indwelling child now fully illuminated and exposed—permanently

driven by regressive pulsions and crossed libidinal wires in one case, or brought back, systematically, to swaddling clothes in the other—who now appears as the unwelcome hidden truth behind male posturing and male pretensions.

These two texts display their authors' genius at the top of its form, and I believe they have as much to teach us today as they did for their audiences over a century ago. What we will learn from them is not limited to fin de siècle attitudes about patriarchy in the North, but rather a peculiar form of cultural and behavioral striptease, a peeling away of cover and alibi, a merciless unveiling of the male creature's actual makeup and composition. There is nothing diagnostic as such at hand here but rather a splendidly mobile scheme, on the order of moving chairs, of dancers going through their paces, yielding ever more of their murk to light. We all live, these plays seem to tell us, on a stage, and it does not stand still, but instead, like Galileo said of the earth itself, *it moves*. So, too, do its denizens. Metamorphosis is the rule. Theater is made to tell us these home truths: that our arrangements and our fixed identities are kinetic not static. That moving stage is best understood as a *Spielraum*—not unlike a billiard table or a moving weather system or the forces coursing through the atom—and when the game is completed, when the curtain finally falls, the old connections and the old contracts have been breached: a new dispensation is on show, rawer and less accommodating than the original family nest, expelling that familiar atomic figure we know as "the father" into a no-man's land, leaving us a vision of his last avatar: no-man.

I. CHILD'S PLAY: THE CRADLE SONG IN STRINDBERG'S *THE FATHER*

The Father, Strindberg's "naturalist" masterpiece of 1887, has long been seen as predominantly a war between the sexes: its gender conflicts loom so large that we cannot be surprised that much of the criticism addresses those issues. Is it possible

that we have failed to take this play's measure, to gauge its larger reach as a meditation about power, textuality, and self-hood? Strindberg's legendary misogyny is no secret to any-one, but this restless, exploratory, sometimes surrealist play is far less docile than it seems; in fact, it already appears to announce the radical theatrical experiments known as Strindberg's "post-*Inferno*" work. And, oddly enough, our surest route into these matters is to centralize the figure of the child, Bertha, as a conduit to the richer dimensions of Strind-berg's drama. This may seem an odd claim, for it is hard not to view the role of the child, Bertha, as something of a pawn. As is well known, the play revolves around the power strug-gle between husband and wife as to who will finally control the child's fate, and this nineteenth-century custody battle finishes with Laura's triumphal cry, "My child! My own child!" seeming to leave little doubt as to the central issues of the text: ownership, control.[1]

But does the child herself have a voice?

This question is not irrelevant. Voice is inseparable from subject status, and it will be seen that Strindberg is keenly interested in the glue that holds a person intact, in whether that glue can come undone. When first we meet Bertha, she bursts into the room where the Captain and Pastor are speak-ing, and she cries out for protection against the spirits, spirits who turn out to be disturbingly (and invasively) lingual in nature. The child's séances with the Grandmother, we under-stand, turn crucially on issues of language and voice, or—more pointedly—the very origins of language and voice.[2] The human child holds the pen over the paper, but the spirits are to do the writing; and they corral speech as well, since even to mention them orally is to invite revenge: "Grandma says the spirits get revenge if you tell" (17). This night Grand-mother is furious, however, because the child's writing turns out to be suspiciously recognizable, "cribbed" from else-where: "And tonight I thought I was writing well, but then Grandma said I got it out of a book, and that I had tricked

46

her" (17).[3] Strindberg is already hinting here at the scandal of textuality, the impossibility of being original in an always/already discursive world, a preformed network that precedes the human subject and governs both utterance and gesture. We shall see the full force of this view again, at the end of the play, when the Captain cites chapter and verse on the key topic of cuckoldry and the enigma of paternity, enlisting himself in a sort of serial parade of undone fathers. But what most strikes us in this initial scene is the riddling of the child's "own" voice, the presentation of the child as a mute stage for warring, alien voices, be they from Stagnelius (as the Swedish text specifies) or other spirits.

Later, in the second act, we again encounter the issue of a child's voice, only this time the spirits have taken over entirely:

Bertha: I don't dare sit up there alone. I think it's haunted.

Margret: I knew it! I knew it! Yes, take my word for it, it's not Christmas elves that are watching over this house. What happened? Did you see something?

Bertha: No, but I heard someone singing up in the attic.

Margret: In the attic? At this time of night?

Bertha: Yes, and it was so sad, the saddest song I ever heard. It sounded like it came from the storeroom, you know, to the left, where the cradle is. (25)

This sad song from the cradle—unlike any lullaby or *vagg-sång*—may be understood as the very voice of the disenfranchised child, a kind of originary language of infancy that precedes the work of culture or the designs of the Grandmother.[4] Coming to us as primitive music, it may be thought of as the *Ursprache* of Strindberg's play, a disembodied plaint that speaks of its severance and noises its hurt in ways that are hard to decipher, and hard to ignore. For *The Father* turns out to be, in ways I will show, child's play, and the cradle song represents a kind of pure rival discourse to the ongoing verbal exchanges of the play, as if Strindberg had wished to chal-

lenge the notion of *infans* as "speechlessness" and hence set out both to graph the homelessness of the child's voice and strangely to re-create that voice in cradle song and theatrical play. One might object that we never even hear this cradle song, but my argument goes the other way: we are attending, every minute of the performance, to its compelling music in the unfurling logic and displacements of the play itself. This is hardly to suggest that Bertha is the occulted center of the play but rather to establish that the *child's voice* is the figurative core of Strindberg's scheme. It is a peculiarly free-floating voice, and we are not to find it lodged securely in Bertha or even in the cradle in the attic; we shall see that its primary locus, its genuine hiding place inside (*därinne* as the Swedish insists), is in the Captain himself. The burden of the play is to broadcast that voice, to *telefonera* (yes, Strindberg's remarkably modern term) it to all the precincts of the stage, to bruit that voice with such power and pathos that all parties—not least the putative owner of the voice, the Captain—are subjected to its imperious governing authority.[5]

To read *The Father* as the emergence of the child's voice may seem drastically reductive and univocal, since Bertha herself is scarcely a major figure, but it should ultimately help us toward a view of the play's strange economy and poetry, its program of displacements and projections, its critique of the unified male subject. The great Sophoclean dilemma of origins—can a man know where he comes from?—is given an apparent turn of the screw in Strindberg's heatedly gendered version: can a male know his child? A considerable amount of fanfare surrounds this riddle, peaking in the Captain's outcry that his connection with the child is tantamount to a secular afterlife: "The child was my life to come. She was my immortality ["*evighetstanke*," concept of eternity, says the Swedish]—the only kind that's valid, perhaps. If you take that away, you cut off my life" (32).[6] This severance imagery recurs more than once, entailing cut-off arms and a full-scale botanical fantasia of grafted limbs and branches; a psychoanalytic

criticism would have no difficulty discerning a castration scenario in these utterances.[7] Strindberg very likely saw the play's central agon in these colors: a strong but dignified man is cast into a cage of women/tigers and is ultimately destroyed by them. Laura as antagonist wages a brutal Darwinian battle against her more refined husband, and her chief weapon is the corrosive power of doubt regarding paternity. Take this away, and the father's life is cut off at the roots. Here would be the overt warfare of the play, and our sense of Strindberg as grand (but anxious) misogynist accords perfectly with this assumption. Much of the scholarship devoted to the text toils in this vineyard.

Blockage, severance, and mutilation are hence sounded as the central dynamics of the play, but underneath this curbing/chopping scenario we shall see that something radically different is coming to life: a new circuitry, a finally released flow, a creatural itinerary that is at last completed and brought to light. The father is slated to lose his connection to the child, yes, but his deeper fate is to return to infancy. Nay, not return, but discover that he has never left. Fathering is to be exposed as a fiction in *The Father*, and only when all the sound and fury of foiled paternity are past does the actual, shocking condition of the Strindberg male stand exposed. This new male comes outfitted with a special voice: he has been dispossessed of the confident and independent patriarchal discourse he thought was his, but speaks, instead and increasingly, what may be thought of as cradle song, a poetic language of willessness and metamorphosis, a language of pure theater. Cradle song, will-lessness, metamorphosis, theater: this is what is new in Strindberg's play, and it has no truck whatsoever with "Naturalism's" business as usual. Strindberg is becoming Strindberg in *The Father*: decades before Freud, he is bent on displaying the mercurial and ever shifting nature of the ego, especially the male ego that thought itself a fortress, that is to discover its propensity for dissolving when subjected to

enough pressure. And however distressing such matters may be along ideological lines, they are irresistible as theater.

To fully appreciate this transformation, let us recall the Captain's initial proud posture. Free and impenetrable, he brags to the Pastor that "God's word" has no "bite" on him, and in this play of competing ultimacies and "isms"—closing emblematically with a doctor and a pastor disputing a dead man's exit—the Captain's integrity bespeaks a freedom of belief and self that Strindberg found at once admirable and illusory. A man of science and dignity, he prides himself on his intactness, his composure, his ability to decipher external signs such as meteors and heavenly bodies, his confidence in logical processes, such as cause and effect, by which the world is to be known and named. Just as receipts are to be kept, so the household economy can be assessed, and so, too, does "recent research" indicate that there is only one kind of woman.[8] This man professes to despise others who vacillate, and he understands his role in the social order to be one of authorized governance. About his daughter, he claims with utmost sincerity that he "should be making the decisions [owns the right to lead her nature, says the Swedish, portentously]," (4) it being naturally also the case that his wife "sells her rights when she marries. In return her husband supports her and her children" (9). Exemplar of the Cartesian scientific legacy, confident in his prowess as thinker and his station as owner and ruler over those entrusted to his care, Strindberg's genteel and *sympathique* Captain represents no less than Patriarchy itself, and the burden of the play is to chronicle and choreograph his spectacular fall.

At first, this fall rings Sophoclean and Shakespearean. Placed before the riddle of paternity, the Captain seems to be a nineteenth descendant of Oedipus confronting the Sphinx, a proud man destined to learn the dreadful limits of his knowledge, slated for an undoing of comparably massive proportions. The final exiting of the blind Oedipus, led out by his daughter, broadcasts the same kind of grim news about male

pretensions and power that will be exhibited at the end of *The Father*. But the intrigue of Strindberg's play is also reminiscent of *Othello*, with Laura playing the double role of Desdemona and Iago, the wife whose virtue can never be known and the "what-if?" monster who can drive an honest man mad with consummate ease. Like Shakespeare, Strindberg has significantly reversed the Cartesian *cogito*, has shown that *doubt* is at once corrosive and generative, that it dismantles what is given and goes on to build fantasies and "monomanier" of its own devising. At the height of his pain, the Captain exclaims to his brother-in-law that knowledge and belief are locked in a crazy dance: "You're never sure of anything. The only thing you can do is have faith, isn't that right, Jonas? Have faith and you'll be saved! Oh, yes! But I know that faith can damn you! That I know!" (41).[9]

The nineteenth-century tug-of-war between scientific knowledge and religious belief is reconceived here, as belief, no longer "faith" in the old sense, becomes bottomless private obsession, resulting not in grace but in misery. We know that Strindberg regarded *The Father* as an exemplary naturalist text, worthy of Zola's consideration (to whom he sent it, hoping for approval, but not getting it; the Frenchman found it too allegorical, too devoid of material particulars). But one also feels that Strindberg had a kind of large-souled emblematic drama in mind, that he endeavored to stage a nineteenth-century marriage in such a way as to mirror the great world forces at play in his time, not only the sweeping historical forces adumbrated by Hegel, but even more particularly the newer optics of Darwin, Nietzsche, and Marx.[10] Hence the play treats us to disquisitions on genetic inheritance, on the exercise of will as power, on modern marriage as a business transaction with joint bank account. We feel Strindberg's cultural agenda here, his desire to write a play that keeps covenant with what is most unsettling and explosive in the burgeoning intellectual world around him.

But the play that emerges keeps covenant as well with what is most explosive within the Captain, and this non-programmed drama is ultimately what is most riveting about *The Father*. The *plan* doubtless entailed writing a play in which the Father is overcome by the brutal forces he contends with, but the actual result is a dismantling rather than a collision, a disrobing of sorts by which Fatherhood—in all its guises: social, sexual, legal, epistemological—is shown to be a façade, a fraud. "Dismantling" and "disrobing" are themselves deeply theatrical, "striptease" gestures, because they hint at a kind of natural scheme behind our costumes and manners, while also acknowledging the power—indeed the magic power—of our robes and mantles. Just as Freud was to see the human psyche as a dramatic place, a *Spielraum*, so did Strindberg sense that the theater is a privileged locus for displaying these momentous "alterations," the donning and removing of garments that make up our cultural and libidinal dance. The play charts, at its deepest and most engaging level, neither the plight of the child nor the war between the sexes, but the song and dance of the Father, a performance that effectively renders Bertha and Laura unnecessary—redundant—since the Father is to be imploded and then revealed as precisely child/woman.[11] Ultimately this transformation displays, as we shall see, suggestive parallels with Lacanian thinking, especially regarding Strindberg's representation of the itineraries of the Mother and the Father—she from subaltern to mastery, he from lawgiver to infant—in strikingly lingual terms, as both a takeover of language and a weaning from language, expressible only in a new theatrical code, as a version of that referenced cradle song we never heard but are always seeing.

Let us consider first the traditional prerogative of Fathers: the bestowal of a name, the certitude of origin, the authority of decision making, the generative and ordering principle of Logos itself. This is all going awry in Strindberg's play. The Captain will lose control of his child because he will lose connection to his child: propriety and property are in trouble

here, and "his child" comes to be understood as a kind of linguistic joke. If one imagines (as Strindberg doubtless did, as his culture did) Fatherhood as a kind of vital center, an energy-producing sun in the social and familial solar scheme, then the play stages something of an eclipse, a power failure. Not only is Bertha lost, but all the Father's "outreach" efforts come to naught: communication with other scientists nullified, management of household affairs exposed as chaotic. Above all, the male as producer-origin is to be pronounced obsolete; Laura gives him the news: "Now that you've fulfilled your unfortunately necessary function as father and breadwinner, you're not needed anymore, so you can go" (36). Darwin could not have said it better.[12]

No reader or spectator of the play has ever been much in doubt about the fundamental cashiering of the father. But to view this struggle as essentially a clash of wills, a survival of the fittest—which is how Laura herself sees it, how Strindberg wants it to be seen—is to miss the darker and richer wellsprings of the father's collapse. His props are taken out from under him, yes, but the heart of the matter is to expose him, to expose the father, and patriarchy in general, as an affair of props. The deeper pathos of the play revolves around a man coming to understand that he is a construct, an assemblage, a mask. Thus, alongside the splendid *agon*—Laura battling the Captain, Laura systematically taking over his prerogatives, using his own principles and propositions against him, even to the tune of controlling the writing and examining the accounts—we also have the spectacle of an inside job, a creature being undone from within.

Of course, we have seen this all along. The role of Margret in the play is crucial because it incessantly highlights the child in the Captain. Ranging from "Master Adolf [little Master, says the Swedish], I want you to listen to your old Margret" (15)] to the chastising and altogether more fateful: "Shame on you! But old Margret is still fond of her great big boy. He'll return to her, like a good child, when a storm comes up" (16),

Margret's motherly solicitude tells us about a Captain who has never grown up, tells us that "growing up" is a cultural fiction, one that will fall apart "when a storm comes up."[13]

And so the storm comes, and with it the sad song from the cradle, the new discourse of a man who can be both sick and up (for a while) before going permanently mute and down. It starts with irony and learned condescension. The Captain suavely explains to the doctor how new research has demonstrated the "instinctively wicked [nature]" (28) of women, and with considerable dispatch ushers in his eavesdropping wife, so as to have it out at last. One is struck by the Captain's poise initially, as he drags forth his mate for a showdown. But, it is here that the play, with shocking rapidity, moves from confrontation to infantilization. With the lucidity of the wounded, at once gauging the damage and facing the powerful foe, the Captain urges Laura to leave him intact, out of her own self-interest, but his words betray a creatural vulnerability that nothing can assuage:

> Since you're so interested in my condition, here it is. My reason, as you know, is undisturbed, so I can handle my responsibilities both as a soldier and a father. As for my feelings, I can control them as long as my will is intact. But you've gnawed and gnawed away at my will until it's ready to slip its gears and spin out of control. (30)

This somewhat eighteenth-century mechanistic view of the person represents the peak of the scientific tradition to which the Captain aspires, but the animalism of human relationships, the "gnawing" of one's will by one's mate, bespeaks another regime, one closer to vampires and parasites than to formidable but delicate machines. The reference to slipped gears is crucial, but Carlson's translation misses entirely the *directionality* of things to come: coming unstuck leads to going backward; "the whole clock mechanism unwinds in reverse" says the Swedish. The self-awareness of this speech may be thought of as a high moment in European drama, a moment

54

where the dark savagery of Iago's torture of Othello is brought utterly into the light, yielding a clairvoyant warrior, one who sees exactly what is being done to him and how he is responding. There is dignity and pathos in the Captain's recognition, but that does not reduce his victimization one whit. Arguably the most mature line in the play is the Captain's request—request!—that he be allowed to stay sane: "That I can ["be allowed to" says the Swedish] keep my reason" (31)]. There is a startling recognition here about "coming apart," about discovering that one's equipment can be disassembled, and we shall see that this collapse of reason is like a curtain going up, a revelation of a prior self that has no cover any longer.[14] Hence, when the Captain laments the loss of his child as the removal of his afterlife, his "evighetstanke," he signals the crucial directional shift of the play: from the future to the past.

In a striking intertextual reference, the Doctor mentions, at one point, Ibsen's Captain Alving from *Ghosts*: "when I sat in the theatre the other night and heard Mrs. Alving in *Ghosts* talking about her dead husband, I thought to myself: what a damn shame the man isn't alive to speak for himself" (29). As Strindberg's Captain begins his descent into dementia, we are entitled to consider his plaint as the occulted material of Ibsen's text, as the generic discourse of fathers run amok, turned inside-out. (Strindberg's mix of admiration, jealousy, and contempt for Ibsen is well known, and he must have figured that it was his job to "complete" [by reversing] the Norwegian's text.) Well before Freud unveiled his reading of Oedipus, Strindberg saw that the poise, prowess, and knowledge of Homo sapiens were dreadfully two-tiered, that the male's secure station rested on an abyss, and that genuine scientific discovery—far from the realm of meteors and heavenly bodies—must consist in self-exploration, in turning the spectroscope "in," turning it precisely into the microscope, as the play's little joke would have it. Just as the information we can receive of Jupiter is located in the past—"Not what's happening, but

what has happened" (14)—so, too, the scrutiny of the Captain's life must now proceed thither. When one is sufficiently gnawed and can no longer "keep one's reason," the clockwork comes apart, and one simply unwinds, winds up backward, where it all began. Discredited as origin and originator, cut off from progeny, the Captain begins his journey inward, to his own origins, and we now begin to see what he is, as the cradle song and the child's play commence.

This action begins conventionally enough, as the Captain indicts his wife, by trotting out fragmentary memories surrounding Laura's pregnancy: his severe illness and feverish condition, overheard counsel between Laura and the lawyer, the crucial revelation that there must be a child if Laura is to inherit, and the cliff-hanging mystery as to whether Laura was or was not pregnant. With these elements of the *comédie de boulevard*, Strindberg makes the melodramatic case for a putative hidden crime, an illegitimate child for purposes of inheritance, but as if he sensed that the bristling issue of inheritance itself had been co-opted magisterially by his Norwegian competitor (precisely in *Ghosts*), Strindberg pushes his *grand guignol* scenario right to the limits: Laura crying in her sleep, and then, night before last: "It was between two and three in the morning and I was sitting up reading. You screamed as if someone was trying to smother you: 'Don't touch me, don't touch me!' I pounded on the wall because—I didn't want to hear any more" (32–33). Here is the direction the play could have taken: the Captain as calm, poised sleuth ("I was sitting up reading") and Laura as tortured libidinal outlaw.

But the Captain's control and decorum are not maintainable, and the sexual violence cargoed in this scene—"don't come, don't come!" says the Swedish—can no longer be kept at a distance. "I didn't want to hear any more," says the Captain, but the text shows him pounding on the wall, much as he is to batter the walls and break through the door later, as if the pounding on the wall were an ambivalent poetic code,

announcing its desire for silence while expressing an urgency all its own. It is here, at this precise instant, that the roles change, that the metamorphosis begins. The libidinal turmoil ascribed to Laura's nightmare quite simply moves into the Captain, and she will increasingly acquire his former control and mastery. It happens so quickly, so seemingly unprepared, even unmotivated—after all, the man barely puts up a fight—that one is stunned by this turnaround. Like it or not, everything is altered. The very notion of a fight, a conflict, seems misleading; we are closer to the mark if we think theatrically, in terms of a curtain now going up, and a new creature coming into view.

As for the father, he is, for all practical purposes, gone. "Can't you see that I'm as helpless as a child" (33), he fatefully says. And with this, the paternity plot disappears, along with its custody drama, and we see that the only child that counts, the one whose story must "out," is the child hidden inside the father, the child whose pretensions to manhood—husband, military career, scientific program—are placed on front and center stage, exposed as specious, and blown sky high. "Won't you forget that I'm a man, that I'm a soldier who gives orders? I ask only the pity you'd show a sick person. I surrender my weapon and beg for mercy" (33).

The male burdens are too heavy; the male charade is over; the masquerade—"min makts tecken" ("the signs of my power" which Carlson strangely left out of his rendering)— can be at last put aside. Maleness is shown to be an unsustainable construct, and Strindberg, (rather shamelessly) echoing Shakespeare's apology for Shylock, posits creatural vulnerability as the first and last truth, one that annihilates any pretensions to masculine power.[15]

Yes, I'm crying, although I'm a man. Doesn't a man have eyes? Doesn't a man have hands, limbs, senses, opinions, passions? Isn't he nourished by the same food as a woman, wounded by the same weapons, warmed and cooled by the same winter and

summer? If you prick us, do we not bleed? If you tickle us, do
we not laugh? If you poison us, do we not die? Why shouldn't
a man be able to complain, a soldier be able to cry? Because it's
unmanly? Why is it unmanly? (33)

Here is the first open breach in the male armor, and through
it still more devastating libidinal material is to emerge. The
Captain and Laura finally set the record straight about their
intimate sexual arrangements, and there is something almost
obscene, in the nature of violated taboo or transgression, in
these revelations, as if we were sharing, along with the central
parties themselves, the fierce affective truths of their sexual
makeup, home truths they are only now truly confronting. We
are not dealing with closely guarded secrets, with a known,
concealed past that is finally exposed; instead, we are dis-
covering only now how it has (actually, shockingly) always
been, and one feels that both the Captain and Laura are as
astonished at these eruptive tidings—each one's own as well
as that of the other—as the spectator is. This is generative
theater.

In Laura's eyes, the Captain, with his "big strong body,"
has ever been "a huge baby"—this is meant literally: the re-
gressed infant in swaddling clothes who will appear at play's
end is already visible—and the male agrees, tells us that he
came unwanted into the world, and hence came deprived of
will. Maleness is on the block. Inevitably, then, his connection
with Laura has always been, at heart, that of child to mother;
just as, inevitably, their sexual congress is and always was
transgressive: "each time your feelings changed and you
came to me as a lover, I felt strange. Our lovemaking was a
joy, but it was followed by the sense that my very blood was
ashamed. The mother became the mistress—ugh!" (33–34).
"Blodskam" in Swedish connotes incest or sodomy; we are
meant to realize how unnatural, indeed transgressive, sex be-
tween this man and this woman has been. At one point Laura

will suggest that she and her husband belong to two different species, which has triggered Darwinian readings; but the real thrust of these avowals is darker: conjugal sex is an oxymoron, because children are not supposed to fornicate with their mothers. Sophocles and Freud may have felt that all men desire (in their dreams if not elsewhere) just this, but Strindberg is not of their party. The exchange breathes disgust.

These revelations about their life in bed are dreadful but neither deniable nor denied. Not unlike the Emperor's new clothes, the Captain's prowess goes up in smoke, as if it had been an optical illusion all along; she has given him his true colors, and he agrees: "I saw but misunderstood. I thought you despised my lack of virility, and so I wanted to win you as a woman by proving myself as a man" (34). One feels that the very terms of the play are becoming increasingly specious and histrionic, that "lack of virility" [or "omanlighet" as the Swedish has it] and "as a man" are postures, perhaps impostures, that the elemental being is—trapped? fluid?—somewhere behind them, prior to gender markings, gradually coming into view. Childlike, will-less, extensionless, being systematically disempowered before our eyes, the *figure* of the Father emerges as a pure figure, a manikin, a construct.[16] That is why Strindberg's text may be regarded as "child's play," as the spectacle of impotence and infantilization, of a man coming to understand his fictive status, of an undoing.

We are far, here, from battle cries or what was termed by some "hjärnornas kamp" ("battle of brains"). Not the war between the sexes, but the dismantling of the male, the going-out-of-business of the patriarchy is what Strindberg is, perhaps unwittingly, dramatizing. In the richest, most astonishing passage in the play, he transforms this drama of de-masculinization, of unmanning, into a well-nigh cosmic landscape that darkly expresses the true ramifications of the bloody business at hand. Women, the Captain realizes, contain the life principle; what, then, is man's fate?

Yes, because she has her children, and he has none.—And so we lived our lives like everyone else, as unconsciously as children—filled with fantasies, ideals, and illusions. Then we woke up. We woke up, all right, but with our feet on the pillow, and the one who woke us was himself a sleepwalker. When women grow old and stop being women, they get beards on their chins. I wonder what men get when they grow old and stop being men. And so, the dawn was sounded not by roosters but capons, and the hens ["poularderna" says the Swedish, rather than "hönor," to emphasize infertility] that answered didn't know the difference. When the sun should have been rising, we found ourselves in full moonlight, among the ruins, just like in the good old days. So, it wasn't an awakening after all—just a little morning nap, with wild dreams. (34–35)

This remarkable outburst takes Strindberg's ostensibly naturalist play into an arena of figurative activity that constitutes a bold poetic landscape of surpassing eloquence; but that's not all: it puts us on notice that this somewhat claustrophobic domestic drama between husband and wife has a well-nigh cosmic dimension, and it is fueled by primitive elemental forces as basic as sunrise and semen, as well as their opposites: barrenness and dreams. Strindberg is talking about what lives and what dies, what is vital and what is virtual. Laura speaks for the commonsensical reader who has lost his bearings, as she mockingly brands the Captain "fiction writer" and refers to his words as "fantasier" and "visioner" (71–73).

But this tour-de-force declaration, however unrelated it may seem to the play's nitty-gritty custody battle, adumbrates the new Strindbergian dispensation, shows us what the world looks like when the male principle is quashed. It is a place that is turned inside-out, a time of slippage and transformation at work on the solid real world, a prodigious metamorphosis into dream and fantasy.[17] Ordinary life, the life the Captain has led until now, was unconscious, and its goals, we now know, were specious, based on "fantasies, ideals, and illu-

sions." We are witness here to a recognition that one is—has perhaps always been—severed from the life force, that all is factitious. I wrote earlier of the weaning at the heart of *Fear and Trembling*, as Kierkegaard depicts both subjecthood and loss of faith as the *loss of the breast*, as the rupture of our connection to origin. Something comparable is in play here, but Strindberg will not invoke merely breasts; instead, he paints an almost post-nuclear picture of impotence and barrenness, of discovering (one fine day, when one wakes up) that one is cast out of life, that one is among the dying, that one's doings are a shadow-play.

There is something large-scaled and outright metaphysical in this passage. Its creatural scheme of capons, bearded chins, eclipsed sun is a far cry from psychological notation, but rather seems to announce a kind of exile, a banishment from the Creation. At the same time we catch echoes of an anthropological sort, as if the *human race* had gone strangely amiss in evolution, as if it now had to make do with altered and artificial arrangements. One remembers earlier pronouncements about paradigm shifts, about art's connection to essence, such as Schiller's famous treatise "Über naive und sentimentalische Dichtung," with its special distinctions between subject and object, between innocent, seemingly direct renderings of the classics and the tortured, self-conscious mediated work of the (coming) romantics. In his own way, Schiller was signaling a comparable loss of vitality and immediacy. Closer to our time, one thinks of Benjamin's influential notion of the aura, the indwelling radiance of an earlier art and culture versus the lusterless and spiritless artifacts and facsimiles of the modern era. To be sure, Benjamin was contrasting the authenticity and uniqueness of the material historical artifact with the reproductions made available by photography and film, whereas Strindberg is drawn—and here is my central argument—to the crisis engendered by representation itself. Strindberg's Captain negotiates a fateful itinerary from vital integrity to facticity, facsimile, and fragmentation. His central

trope is that of awakening, but it is deeply elegiac, an awakening to emptiness and de-centeredness, an awakening that is ultimately a *wake*.

Here is what happens when "the whole clockwork winds down backwards": the creatural rhythms, the forward march of time ("we lived *forward* our lives," the Swedish says) are radically altered, put into reverse. One wakes up, but feet-first, with "feet on the pillow"; and one is awakened into deeper reaches of irreality rather than by the clear light of day, and the agent of awakening "was himself a sleepwalker." No less than one's connection with natural process is being sundered here, and we are issued into a post-sexual regime deprived of all vitality, condemned to imitation and histrionics. This new non-man is the partner for bearded women, and this reveille, sounded by capons, not roosters, is answered by "poularderna" rather than hens, so that we understand the new dawning to be an entry into facticity rather than truth, reflection rather than radiance, *Schein* rather than *Sein*. "Fantasier," "visioner," Laura has said, and she is dead right: her husband now understands his world to be, to have always been, a dreamworld. This dreamworld, untouched by the rays of the life-giving sun, is a place of ruins illuminated by the moon, and from this spectral artificial universe there can be no awakening.

Strindberg's play charts the collapse of the fathering principle: no siring, no vital origin, no full presence, no immediacy, no innocence. Three-quarters of a century before Derrida, he has dished up for us a portrait of *différance* and of the disinheritance that attends such a worldview. "There's a lot of illness in the district just now" (11), Laura has told the Doctor, and the reader has doubtless interpreted her words as mendacious and strategic, but there is indeed a sickness spreading out over this area, and—not entirely unlike the plague that beset Sophocles' Thebes—the disease is perceptual and ontological, as much as it is physical. An entire metaphysics is entering its death throes.

The Captain awakens to a world of facsimiles. And that is the news he brings, when he bursts through the tapestry door, in one of the heralded, melodramatic moments of the play, when the spectator expects all hell to break loose. The violence of breaking through the wall (the portentous follow-up to pounding on the wall) seems initially to fizzle out, seems out of phase with the calm book-bearing, reference-citing scholar who emerges, but Strindberg knows what he is doing. With its heavy overlay of Darwin, caged tigers, crossed horses and zebras, the play appears to trumpet animality as its dark secret, the hidden truth about human beings, the occulted violence *därinne* that must come out into the open and be seen. But the man who crashes through the door with books in his hand actually betokens the ultimate trauma and threat of this play. Citing with panache the prior words of Homer, Ezekiel, and Pushkin on the riddle of paternity (some of which the Swede invented), Strindberg's Captain announces the regime of textuality itself, a regime of models and precedents, an always/already scheme in which the pretense of origin or originality is doomed from the outset.[18] Those books indeed signal an epistemological Reign of Terror, because the aura of all things is gone, and there is no route back to genuineness and integrity. There are only copies, only appearances. The fierce comedy of generalized cuckoldry, of world history as the antics of gullible men, covers a still fiercer view of life as facsimile, of perception as groundless, of doubt itself as plague.

This deconstructive turn of events might be a rather arid piece of business on the stage. Of course, Derrida and company are interesting to think about, but how could there be a performative payoff, how could this work in the theater? In answering that question, we begin to measure the brilliance of Strindberg's conception. Like all great artists, he has an unerring sense of the quick and the dead, of what will *serve* his play; and now the fireworks begin, because that old tug-of-war between knowing and believing, *veta* and *tro*, coupled with this new profound awareness of the *hollowness* of our

postures and antics, all this starts to shimmer on the stage, as the play continues to shift its gears and spin out of control. It can be quite convulsive. With crudeness and pungency, the papier-mâché Captain drags his fellows into the carnival, exposes their ponderous complacency. The man of the cloth and the man of science each profess ultimacies, think themselves anchored and rock solid, but their professions and beliefs are no less illusory and inflammable than anyone else's.

> *Captain:* Listen, Jonas do you believe you're the father of your children? I seem to remember you had a tutor in your home—a handsome devil everybody talked about.
>
> *Pastor:* Adolf! Take care!
>
> *Captain:* Feel around under your wig and see if you don't find two little bumps there. Look at him—he's turning pale! Yes, yes, it was only talk, but how they talked! Well, we're all targets for that kind of ridicule, we husbands. Isn't that right, Doctor? By the way, how was your marriage bed? Wasn't there a certain lieutenant staying with you? Wait, let me guess. Wasn't he (whispers in the Doctor's ear)—Look, he's getting pale, too! Well, don't feel bad. She's dead and buried, so whatever she did can't be done again. Though as a matter of fact, I know the man and he's now—look at me, Doctor!—No, look me right in the eye!—he's now a major in the dragoons! By God, I think you have horns, too! (41–42)

Strindberg is pushing the comic givens of this situation in the manic, surreal direction Ionesco will take, as he transforms men into rhinoceroses. Cuckoldry is generative drama, par excellence, and this passage emphasizes transformation, emphasizes the monstrously active and shaping character of belief—fantasies and visions, as Laura called them—that has no truck whatsoever with facts. "She's dead and buried, so whatever she did can't be done again," but suspicion and doubt, like some radioactive materials, live forever.[19]

To move from suspicion to fantasy, from fantasy to obsession, is the recurring central fact of our affective lives, but it

has no truck with *facts* at all, since it is content to manufacture its own, indeed cannot help doing so. And marriage is the ideal arena for this kind of unstoppable traffic. How could *fathering* possibly weather such a storm? It can't. "Men vi ä allt ena löjliga kanaljer ändå vi äkta män" (or "we're all targets for that kind of ridicule" as the English has it) is arguably the very kernel of Strindberg's play. The rough-and-tumble of the line (in Swedish) is in keeping with the species that began on four feet before standing upon two, and what it does in between, supine, is simply not amenable to the proprieties of bourgeois discourse. But the Swedish term for "husbands"—"äkta män"—is richly overdetermined here, since the play is about the utter collapse of "genuine men." And it is fair to say that the spectacle of a man uncovering his "ungenuineness," his "oäkt" reality—as one might, in conjuring up one's wife's lovers, or in pondering who has sired one's child—is like waking up with your feet on the pillow: you can still see, but what you see is ruins, and the artificial light comes from the moon.

At the end of the play, nearing total collapse, the Captain reports on the peculiar warfare he has waged, a combat all the more lethal for being imaginary and driven by consciousness.

> Now there are only shadows, hiding in the bushes and sticking out their heads to laugh. It's like grappling with thin air, fighting with blank cartridges. A painful truth would have been a challenge, rousing body and soul to action, but now . . . my thoughts dissolve into mist, and my brain grinds emptiness until it catches fire. (47)

The old drama dealt with hand-to-hand combat, rather than fights with thin air; the old drama entailed real guns, not blank cartridges. But things have changed. A fascinating dramatic formula emerges here, a recognition of the energies that can be liberated by the struggle with shadows and effigies, and one feels that the fierce explosion noted here—the brain grinding emptiness until it catches fire (*grinding!*)—is a clear

stand-in for the missing sun, a way of saying that psychic disarray is a form of internal combustion, a generator that will fuel the antics on the moonlit stage.[20] This stage, this place of artifice, this arena of false awakening, hosts, we remember, "vilda drömmar," and those wild dreams may be thought of as precisely the passions of sleepwalkers, the sound and fury ("fantasies, ideals, and illusions") of the people at the wake. As we saw in the farce of the Pastor and the Doctor turning pale and feeling for horns, the power and energy of these "dreams" is irresistible, turns the most regulated beings into puppets. And this place with reflected light, wild dreams, and careening figures is, of course, the theater.

I have been arguing that Strindberg's gambit, in *The Father*, consists in moving beyond the war of the sexes in order to disassemble patriarchy itself, to expose the phallocentric worldview as a fictive construct, to depict a new regime of representation, textuality, and facsimile where there had been presence, origin, and aura. He can hardly, in a programmatic sense, have intended to do any of this. He must, indeed, have thought his play to be a vital blow against the encroaching feminist movement, indeed a last gasp of virulent male assertion.[21] But what he wrought tells a different story. To be sure, it may be that paranoia got the upper hand in writing *The Father*, that once he began to imagine a strong man's fall, he found himself mining rich ore, that he had only to consult his own fears and anxieties to imagine Laura's takeover. After all, the triumph of the matriarch is hardly a mystery for the patriarch: it is his intolerably precise nightmare.[22]

The point of this is not to psychoanalyze Strindberg; it is merely to indicate the obvious: *The Father* decimates its male protagonist. No wonder that feminist criticism has found Strindberg to be fertile ground: their concern with gender dynamics is surely no more urgent than his own concern, and the play is astonishingly fair-minded in its findings, underscoring the Captain's fatuous complacency, his legalistic bullying, and his serene sense of the centrality of his function

within the world order. Strindberg has not balked at any of this, and he has drained the cup of male humiliation to the dregs, as he takes this man apart, all the while thinking he's waging war against women.

Paranoia? Masochism? Perhaps it is wiser to look for answers not inside Strindberg but in the text itself. The playwright's motives, intriguing though they may be, pale in significance when we examine more fully the testimony and, especially, the modus operandi of the play itself. In doing so, we cannot fail to see that this initially agonistic play turns, at a certain moment, inside-out, as it seems to discover its deeper quarry: the exposure and undoing of the Father, as part of a general metaphysical collapse of staggering proportions. I suggest that that course of action, that turn of events, struck Strindberg first and foremost as theater, as the kind of story that theater was uniquely equipped to tell. The drama of the Father turns out to be a crisis of representation, a devastating discovery that there is only representation. To move from original to facsimile, from sunlight to moonlight, is to discover that reality is nothing but theater. Theater is the realm where belief has become cancerous—where *veta* becomes *tro*—and in the hands of Strindberg these convictions move back and forth with lightning rapidity. We remember the Captain taunting the Pastor and the Doctor, yielding a putative on-the-spot metamorphosis. Horns? Or no horns? Strindberg's "truth" is of this kinetic order: not whether paternity can be proven but the spectacle of doubt, belief, and transformation to which it gives rise. And at their best, these carnival scenes express something profound about psychic mobility and precariousness, about the roller-coaster world that lives inside of humans, waiting to be activated, waiting to take its ascendancy.

Nothing expresses more cleanly this shape-shifting than the Captain's simple tribute to Laura: "You could have given me a raw potato and made me believe it was a peach" (34). Potatoes becoming peaches is what theater is all about. This trou-

bling "new" world—invisible to the eye, echoing and dimensional, the very script and stage of interiority—can be entered only when things are divested of their surface unity, exploded into replicas, made to shimmer in their multiplicity. It is, in some respects, a magical world, inasmuch as it displays the surprising *reach* of things, their psychological and moral plenitude. Toward the end of this play a doll, a christening cap, and a child's rattle are removed from a drawer and brought into the light, and we can measure their meaning, their immense human and emotional extensions, only when we go beyond their apparent contours. Things and gestures echo, resonate, have dimensions. When a man throws a burning lamp at his wife, an entire life is illuminated.

That larger illumination entails bringing the full spectrum of psyche and temperament to light, and the "moonlight" of the theater outperforms the natural sun in this area. Theater is make-believe, the place where actors, clad in costumes, give speeches, and pretend to be what they are not. The spectator in the theater knows this, is constantly aware that they are playing onstage, that he is witnessing a spectacle, a performance, an act of representation. And it will not do to evoke Coleridge's "suspension of disbelief," because much more than credibility is at issue. We go to the theater to look into a mirror, to grasp more fully, via art's looking glass, our own traffic, our own games of musical chairs. It is here that we see how alien "naturalism" as a notion is to *The Father*, for naturalism is inhospitable precisely to the flowing metamorphic energies being graphed in this play. Naturalism believes that outside material forces impinge on human subjects; Strindberg believes this too, but he brings a virtually cubistic vision to these matters, so that his "players" are endowed with a malleability, alterability, and plasticity that even they cannot fathom (much less control). Strindberg has understood that role-playing, far from being limited to theater, constitutes the modus operandi of the human subject, that shape-shifting

is nothing less than business as usual in the cultural and libidinal arrangements meted out to the human species.

So it is that *The Father* closes with a crescendo of metamorphic activity, as if it wanted to expose, once and for all, that the central psychic dynamic in human life is an affair of potatoes becoming peaches, and that the theater is a privileged arena for such exposures and such transformations. Old Margret has the place of honor here, because she has always known that make-believe—our quotidian experience with semiosis and shape-shifting—governs human action; it is so with small children, and now she is to show us that it is so with grown-up children as well.

> *Margret:* All right, but you have to listen! Do you remember once how you took the big kitchen knife and wanted to carve wooden boats and how I came in and had to play a trick to get it away from you? You were such a silly boy, and we had to trick you because you didn't understand that we only wanted what was best for you. And so I said, "Give me that snake, or it'll bite you!" And then you dropped the knife. (*Takes the revolver out of his hand.*) And then there were the times you didn't want to get dressed. And I had to coax you by saying you were getting a golden coat and would look like a prince. And then I'd take your little green jacket, which was just ordinary wool, and hold it out in front of you like this and say: "In with your arms, both of them!" And then I'd say: "Sit nice and still now, while I button up the back." (*He is in the straitjacket.*) And then I'd say: "Stand up now, like a good boy, and walk across the floor so I can see how it fits . . ." (*She guides him to the sofa.*) And then I'd say: "Now it's time for bed!" (44–45)

It is arguable that Strindberg never surpassed this beautiful sequence, even though his later work is technically more innovative, as it moves toward the surreal. Pure ballet of tumbling forms and shifting shapes, the evoked knife turns into a snake, so that Margret can remove its latter-day stand-in,

the revolver. The choreography of displacement has become living theater. Sovereignly completing the snake dance is the central metamorphosis of the piece, the rhythmic waltz that caps the play, brings into the open, at last, the flowing current and libidinal circuitry of Strindberg's scheme: the rich mantle of the past is at last figured forth in the green wool jacket of the child that became the golden coat of the prince, and in this shimmering mantle of childhood, this coat of many colors, the Captain will, at last and definitively, cloak himself. Ensconced in his straitjacket, nearing the permanent silence of *infans*, completing his trek backward ("baklänges") into the past, the Captain makes good on his voyage home, achieves his final identity, not utterly unlike what Mallarmé wrote of Poe, "tel qu'en lui même enfin l'éternité le change." An entire figurative odyssey comes into view once we measure the avatars of that mantle. The itinerary we can sight moves at once from and toward childhood, and the theatrical language is at once exquisitely eloquent and dense, and also heading toward speechlessness, to the ultimate regressive state, a total eclipse of consciousness.[23] This is the true homing action of the play, and it can be termed child's play, for there is no other play imaginable for the psyche that has been center stage here. And this rich metaphoric plaint of displacement and hypnotism, with its gamut of snakes and gold, with its magic and mysterious capacity to move the human subject—could this play avoid outright violence and bloodshed any other way?— is what I have called "cradle song," is the theatrical, spectacular equivalent of that "sad song" that Bertha heard in the attic.

The beauty of *The Father* lies, at least in part, in the strange fullness and reach of its theatrical language, a fullness beyond the ken of any single character. The Captain himself, to be sure, sees his downfall as a result of female wiles—how could he not?—but what is most interesting is that he reaches all the way into classical mythology in order to find the right words for incriminating his wife: "Omphale! It's Queen Omphale herself! Now you play with Hercules' club while he spins

your wool!" (46). This key allusion, which gets quite an airing in the play's final minutes, is worth exploring. Omphale is the powerful woman who "overmanned" Hercules, forced him into servitude, indeed into female drag. The sexual humiliation (for Hercules, for males in general) in this role reversal could hardly seem clearer. But watch carefully, it is all on the move, and little remains fixed in Strindberg's swirling scheme. Hence Omphale reenters the scene, when the Captain, exposed as few theatrical characters have been, requests cover. Laura's shawl is spread out over him, and it occasions the softest, most lyrical outpouring of the play: warm, smooth flesh, vanilla-scented hair, birch woods, primroses, and thrushes.

But, following the laws of mobility we've been examining, this shawl is then transformed into a "cat," and the Captain orders it removed, to be replaced by his tunic (or "weaponcoat," "vapenrock" as the Swedish says), occasioning the last and most extended reference to Omphale:

> Ah, my tough lion's skin you wanted to take from me. Omphale! Omphale! You cunning woman who so loved peace you invented disarmament. Wake up, Hercules, before they take away your club! You wanted to lure us out of our armor, calling it nothing but decoration. But it was iron, iron, before it was decoration! That was when the blacksmith made the battle dress; now it's the seamstress! Omphale! Omphale! Brute strength brought down by treacherous weakness. Curse you, damned woman, and your whole sex! (47)

The familiar mythic tale, boldly reconceived now by the dying Father, casts a strange light of its own, hinting at the distant master plot that has been governing things throughout the play. To be sure, Strindberg's Captain once more reveals his emplacement in a textualized scheme (his fate is akin to that of Hercules, as well as that of Pushkin and the figures of Homer and Ezekiel), but most striking here is the interpretation that is given to the Omphale story.[24] The disarming of

Hercules turns out to be a fable about disarmament proper, and Omphale is presented as "peace loving," the founder of "avväpning" (or "un-weaponing"), of removing or rendering impotent all arms. We are in deep waters. How does one un-weapon a powerful male? By calling "armor" mere "decoration," "grannlåt." Female cunning is enlisted, once again, as the posited motivation—women will do anything to unman males, in Strindberg—but the strategy itself is mind-boggling in its boldness: *claim that armor is decoration*. The Father's arsenal—weapon, club, phallus, call it what you will—is "decoration," has become merely symbolic, has moved from fact to facsimile. Hercules' club and the Captain's armor are removable to the extent that Omphale can de-realize them, deprive them of essence, transform them into "grannlåt," into mere representation. The Captain's plaint is an effort to undo the damage, roll back the deception, return to the raw power that preceded the symbol, retrieve presence itself. Hence he speaks of iron and of blacksmiths, of substance rather than sign: "That was when the blacksmith made the battle dress; now it's the seamstress!" Something very grand is compressed into these strange lines, something virtually anthropological, entailing a shifting of cultures, a Kuhnian paradigm shift, a sighting of the fateful itinerary of power and belief, the moment they leave matter and move into effigy, leave the blacksmith to become the work of the seamstress.[25] Yes, this is a war between the sexes, if you will, but it is also an evolutionary fable, a passing of power from a primitive, integral material scheme to a culture of representation, based on difference and displacement.

This yearning for a return to substance and presence is mouthed by a man in a straitjacket on the edge of silence, and it is not going too far afield to see in it a nostalgia for the phallocentric order that the play has been smashing for some time now. But the boldness of the play lies in its multiple tongues, and its modernity lies in its vertiginous semiotic spectacle that converts "grannlåt' back into "vapenrock," showing that

"mere" decoration, "mere" effigy, has a rich potency of its own. This would be at once the first and the last trick that Strindberg is pulling out of his bag. If the philosophical burden of *The Father* consists in mapping the trajectory from substance to sign, the theatrical brilliance of the whole consort goes just the other way: to demonstrate the potency of signs, to show that "decoration" routinely outdoes "iron," not just on the stage but in life itself.

Dismantling the father has been posited as the ultimate agenda of the play: a fierce critique of Patriarchy-as-prop, but a critique that we have failed to see, because it hides behind an apparent plot of gender warfare. But it is high time to recognize that theater itself utilizes a power scheme of a radically different sort, that it discloses/invents its truths through mantling, through the covers and decorations by which we code our lives and show what we are. This is what Strindberg knows deep in his bones as playwright; this is a truth that is starker and deeper than any of his ideological beliefs (of which he had an endless number). The theater begins with the exit from the garden, and it has no interest in nakedness, since its gambit is "grannlåt," since it knows we are all clothed by culture. *The Father* is a play about mantles, about the astounding semiotic power they have, about the theater as a co-player in this war of "isms," this competition between clergyman and doctor. The central icon of the play is the Captain's coat of many colors, the garment that accommodates both the green wool jacket and the golden coat of the past, that is mirrored again, reflected over in the lion's skin and the shawl, the armor made of iron that becomes mere decoration. This mantle itself—not what is under it—is the text's truest "article of belief." Strindberg's dramaturgy consists in pirouetting this mantle, releasing its remarkable semiotic energies, showing how it broadcasts the life of its "occupant" in a theatrical code he himself cannot fathom. Longing for a return to origin and presence, the Captain is stranded in this new world

of simulacra and signs, and it is for us—readers and spectators—to see that his actual life is written in these mantles.

Hercules himself thought that womanly chores were a humiliation, a threat to his manhood, but the tale of Omphale can be read otherwise, as a revelation of what Hercules could never say, as the index of a womanly side that is no less real for being unavowable. *The Father* speaks of many mantles—of green wool and of gold, of shawls and of lion skin, of iron and of "grannlåt"—but it shows us only two: a Captain's uniform and a straitjacket.[26] We are accustomed to thinking that the second *undoes*, *destroys* the first, that the soldier/scholar is crushed back into madness and silence; but we are free, here as well, to read it otherwise, to grant the theatrical language its full due, to recognize that the uniform *is* the straitjacket. We then realize, that is what Strindberg has been telling us in his way, not openly in the ongoing warfare of the play but surreptitiously, hauntingly, in that cradle song of displacement that Bertha heard, that music of children whom culture mantles and then moves about, as long as they live, in child's play.[27]

II. Metamorphosis in Ibsen's *Little Eyolf*

For too long we have been told that late-nineteenth-century European drama is an affair of realism and naturalism, perhaps with a few symbolist works thrown in. When one thinks of the great trio—Ibsen, Strindberg, Chekhov—who are the towering figures here, one conjures up scenes of domestic interiors, of the antics of shifting, rising/falling political classes and groups, of a dense, solid material scheme anchored in social reality: Nora's carceral, soon-to-be-exited Doll House and Hedda Gabler's suffocating marriage *cum* middle-class arrangements as etched by Ibsen's surgical pen; the aristocratic Miss Julie's fateful sexual overtures to a hustling menial or the (later) rotting figures decaying and feasting on one another in Strindberg's claustrophobic family

renditions; and the specter of ennui, paralysis, and doomed longings in Chekhov's bittersweet end-stage dramas about people discovering that life has passed them by. One reads these plays today for their nuanced social notations, their portrait of a bygone era in which the bourgeoisie seemed to be either paralyzed or to enter into its death paces. We see a world beginning to go under, but the scenes presented for our inspection appear to be vivid, detailed, well-made and mimetic, unpuzzling, cued to that famous "slice of life" called for by the Naturalists. One would be forgiven for thinking of genre-painting.

This respectable, slightly stolid (and simplified) notion of theater needs to be turned on its head, if we are to see the stunning acrobatics and the destabilizing—indeed revolutionary—energies at work in many of these plays. This is most especially true of Ibsen. Even those prepared to acknowledge that he was a bell-toller for many of the received views of his time seem hard put to bring him out of his time, to make him a figure for our moment, for a time still to come.[1] How would one make the case for this new, fierce, off-the-charts Ibsen? Can he still surprise us?

I attempt to make such a case in this section, and I choose, as exemplum, his most under-recognized and brilliant play, *Little Eyolf*. In it, Ibsen displays a shockingly diverse set of registers, bringing raw folklore and would-be psychoanalysis together in a crazy dance. More than any of his other plays, this is the one that tracks the mobility of the psyche as it keeps house. *Keeps house*. Proust was to write that it is miraculous that each of us wakes up as the same person who went to sleep the night before, given the parade of selves we become in our dreams. Ibsen, ever the proper bourgeois, nonetheless knew that every life, looked at aright, had the makings of a circus, and that the theater was the ideal place to bring this kaleidoscopic vision to life. In this play such a vision is labeled "the law of change," but it is imperative to recognize how much boundary smashing, anarchy, and outright meta-

morphosis are cargoed in that stately phrase. No less stunning is the economy of Ibsenian transformation: yes, one changes, but one also finds oneself arrested, frozen in time, still the child that one was, still bound to that child's fixations, still playing out that infantile script. These discoveries come fast and unbidden, and they suggest to us that we are never through learning who we are.

Let us begin where the wild things are. There is arguably no more remarkable scene in nineteenth-century drama than the entry of the Rat Wife in the first act of *Little Eyolf* (1894). What on earth is a "Rat Wife" doing in a so-called realist play? And, although we never actually see them, there is a good deal of talk about the *rats* themselves. Ibsen, we should realize, had been drawn to animals in his earlier work, as if he sensed, from the beginning, that his stories of subjects-in-culture were not fully sayable without bringing in the bestiary. We are so accustomed to declaring Ibsen the founder of modern psychological theater that we may forget just how fierce and mythic he can (also) be, underneath the flow of polite middle-class discourse. How does one assess the animals? There is the famous wild duck (in the play of that name), and there are the ghostly white horses of *Rosmersholm*; these beasts may carry a heavy metaphoric burden, but we remain assured that there is little risk of confusing them with the humans onstage. But what if these demarcations blur?

If one is to get one's bearings on *Little Eyolf*, one has to go back to the unforgettable troll household in the groundbreaking *Peer Gynt* (1867), Ibsen's rollicking version of Goethe's *Faust*, to find a comparably rich and disturbing mix of animals and people, a mix that goes a long way toward constituting the meaning of that epic comedy. In *Peer Gynt* Ibsen gives a spectacular dress rehearsal of all his major themes: the war with the troll, the significance of lying, the construct of self, the seduction of theater. After *Peer Gynt* come the famous prose plays that established Ibsen's reputation in Europe and

America. The folkloric and exotic treatment afforded the great themes of *Peer Gynt* was (regrettably?) to disappear forever from Ibsen's repertory, banished, along with much else, in the dramatist's principled farewell to poetry.

But the themes and issues themselves are there to stay, and although we may move from the lair of the Mountain King to the middle-class drawing room, the troll is never far away, seen wherever sexuality weighs heavily (and it never weighs lightly in Ibsen); the lying will shift from the exuberant fictions of the trickster to the transactions of sober burghers with themselves, the masquerading onion self (as Peer famously styled himself) becomes a darker affair of duplicity and displacement, and the theatrical extravaganza of ships and deserts and pyramids moves into more cramped, but no less echoing, reaches: sometimes attics, other times simply drawing rooms, most of all, bedrooms. In short, Ibsen never did sign on for the "prosed," suffocating, drearily modern precincts that we occasionally assign to him. We have known for a long time that his foreswearing of poetry was, in reality, a highly equivocal move; what goes out the door may well come in through the window. The earlier doggerel and folklore and historical trappings leave, but all the signifying energies that went into them were to be reconceived and refocused in the living rooms of his contemporaries. The visit of the Rat Wife to the living room of Alfred and Rita Allmers shows us just exactly what that reconceiving and refocusing entail.

First of all, the Rat Wife—or, actually, Rat Maid (*Rottejom-fruen*)—strains our modern notions of verisimilitude. Yes, we may be prepared to believe that the Norwegian fjords and villages were filled with old ladies ridding the community of rats, but this creature seems to come from another world altogether, a prior world of pulsions and dark reaches, a place beyond light. The grown-ups in the play are unfazed and seem to know all about her, but the child, Eyolf, is mesmerized. What can it mean to go after rats? Why would you do

it? How would you do it? For Eyolf's benefit, and for ours, the Rat Wife, after her opening remarks, obligingly describes exactly what she does. Listen:

Rat Wife: ... I play on my pipe. And when they hear that, they can't help themselves: up they come from the cellars, down they come from the attics, out they come from their holes—darling little creatures, all of them.

Eyolf: And then he [Mopsemand, her dog] bites them all till they are dead?

Rat Wife: Not at all. We make our way down to the boat, he and I. And they follow us. The big grown-up rats as well as the little baby rats.

Eyolf: And then what . . .? Tell me!

Rat Wife: Then we pull away from the shore. I work the oar and play on my pipe. And Mopsemand swims along behind. [*With flashing eyes.*] And all the little creepie-crawlies follow us out further and further into deep water. They can't help themselves!

Eyolf: Why can't they?

Rat Wife: Because really they don't want to do it. Because really they're horribly afraid of the water—that's just the reason that compels them to go on.

Eyolf: So they drown?

Rat Wife: Every single one.[2]

So it goes for the rats. What is Ibsen thereby trying to cargo into his play? One critic has suggestively claimed that the Rat Wife represents a "Munch-like amalgam of woman as goddess and crone."[3] And if we have some of the Munch repertory in mind, such as *Madonna* or *The Dance of Life*—paintings that depict the female as primitive siren figure whom no male can resist—then we are better able to gauge the aura of sexuality, now death-inflected sexuality, that bathes her account of rat killing. Critics have linked this passage to the entire romantic tradition of enthralling, magnetic sexual attraction, and the Rat Wife herself alludes to the fate of a former lover,

one who is now "[down] among the rats" (236). Ibsen's verb *vrikker*, meaning "scull" and rendered by McFarlane as "work the oar," has distinct sexual connotations.[4] These little creatures who are lured to their deaths display something of the actual operations of living beings. They hear the music and they cannot resist. They *must* go, Ibsen says ("Ja, for det må de!" reads the Norwegian); why must they, Eyolf asks, and the answer is "Just fordi de ikke vil." "Må" (must) makes a mockery of "vil" (want), turns it upside down. Rationality, control, discipline are of no value whatsoever at this pass. It is a shockingly brutal picture of libidinal tyranny. "Will" is cashiered.

At some level this notation of drowning rats following an irresistible call is how the Ibsen subject lives, even though his or her outward composure remains largely intact throughout the play. No one throws lamps at anyone else; no one is murdered or put in a straitjacket. But Ibsen never loses sight of the primitive reaches of his characters, and his finest plays revolve around the moments when those characters themselves gain sight of such reaches, discover their kinship with the rats. And then they discover that they have been negotiating with the rats forever. *Then they discover.* It might be said that Ibsen's great gift to theater is adumbrated in that line. Ibsen's best work is keyed to moments of revelation, but to even call this "moments" is to miss its larger ramifications, since what happens is more akin to doors opening or floors collapsing. And that only gets at the spatial side of it; the temporal issues are still more fascinating, since rat discovery scrambles all notions of sequence and itinerary, calling into play the past (the self one was, the self one thought one was), reorienting the future. These discoveries are sometimes melodramatic, but at times they are almost occulted. In all instances they confer a dimensionality to Ibsen's work that is fascinating, because we find that the world of the play has become an echo chamber, that what we thought was clear is multivalent, that the past is cancerously active in the present,

that the scene of the action is eerily expanded and moving spatially and temporally beyond those clearly marked parameters that seem to contain the play.

That initial moment of discovery, that intimation that the givens are mined and could explode, that the scene is not what one thought it was, is first signaled in *Little Eyolf* when the Rat Wife walks into the room. Until then we have witnessed a rather innocuous family gathering. True enough, Ibsen has presented the crippled Eyolf (does anyone question why he is crippled?) with a certain pathos; true, too, we can sense easily enough that all is not quite right between Alfred and Rita. But we are entitled (as reasonable people watching other reasonable people onstage) to believe the Allmers' well-appointed house will contain these domestic problems. But the Rat Wife, with her tidings of sex and death, puts us on notice that these assumptions just may not hold up. And if we are really canny readers or spectators, we may sense that we almost saw it coming, that the deck was more stacked than we realized.

Ibsen has taken great care to prepare this intrusion of myth into the living room. In fact, the *Rottejomfruen* is sighted, somewhat the way the Loch Ness monster is sighted, several times before she actually appears. Asta has seen her, and then Allmers chimes in to say that he, too, has caught sight of her, leading Rita to wonder whether "we" shall also get a look at her. We shall, of course, but not before Ibsen has had a chance to expatiate on the creature's name. Eyolf wonders why she is called the Rat Wife, and when his father states that her real name is "Mother Lupus" ("frøken Varg"), the child replies, "That means a wolf, doesn't it?" This name game—pointing already toward other, still more portentous name games to come—reaches its climax when Eyolf concludes, "Then perhaps it may be true after all that she turns into a werewolf ["varulv"] at night" (232). Such language makes it increasingly obvious that we have two sets of players onstage: the people and the animals. Or is there a difference? Or perhaps

each person conceals an animal. Or several. They are, in any event, "verbally" in that decorous living room, and they are a strangely fluid bunch—rat to lupus to wolf to werewolf—suggesting that the animal kingdom is somehow "freed" and "unfixed," on the move, ready to turn up at any moment, in any guise. Ibsen may be touching here on the common Scandinavian folkloric tradition of the *fylgja,* or spirit in animal form, but his interests seem, above all, expansive and metamorphic. Hence the profusion of names and labels endows the Rat Wife with multiple origins, makes her a representative of multiple realms, makes us wonder—by extension—just how many categories the Allmers might belong to.

Ibsen has his reasons for putting the animals in the salon. He is at pains to show that our so-called mental operations are visceral, even bestial in character. After the Rat Wife has been "named," the discussion turns, ostensibly, to other matters, to the taunting Eyolf receives at the hands of the town children. The pain of Eyolf's condition—especially as it is felt by his parents—is expressed by a central metaphor of the play: "How all this gnaws at my heart!" (45) ("hvor det nager mig i hjertet, dette her" [244]). But is it a metaphor? *Gnawing* mixes the registers, keeps the animal in sight; it does more still. Ibsen's people are poised and intact on the outside, but they are being literally eaten up within; we may understand guilt, repression, misery, and neurosis as an inner gnawing, as a bodily injury, as a form of self-cannibalism. So, now that the names have been uttered and the gnawing has been felt, the Rat Wife may appear. And appear she does. One knocks down doors and goes through the wall in Strindberg; one slithers in, in Ibsen, and it takes a moment to realize the invasion. Her opening lines to the Allmers are perfect:

> **Rat Wife** [*curtsies at the door*]: Begging your most humble pardon, ladies and gentlemen ... but have you anything gnawing in this house?
> **Allmers:** Have we ...? No, I don't think so.

> *Rat Wife:* Because if you had, I be glad to help you get rid
> of it.
>
> *Rita:* Yes, yes, we understand. But we don't have anything of
> that kind. (46)

There is a maniacal wit in this exchange. Not only does the
Rat Wife behave like an unctuous little public servant ("inder-
lig gerne," she tells them, "really and truly," I'd like to help),
but the episode also has the colors of a nineteenth-century sit-
com. The salesman enters the room, and we see the husband
question his wife: Uhh, do we need one of these, my dear?
No, she replies, we have no use for one of those. No, the All-
mers have no problems with gnawing.

Have you anything gnawing in the house? What a sweet mod-
ern question it is. Could anyone answer it in the negative?

The Allmers claim they need no help, but the little lady is
in the room, and is bent on showing her wares; it turns out
she saves whole communities. As the Rat Wife describes
her last job, we are treated to a panoramic description of
gnawings, taken now to "plague" dimensions;[5] the gnawers
are everywhere you look, including places where you don't
want to look:

> *Rat Wife:* Swarming with them. Teeming with them. [*Smiles
> with quiet satisfaction.*] In the beds, creeping and crawling all
> night long. Falling into the milk churns. Over the floors,
> scratching and scraping in all the corners. (47)

Much has been made over the author's seeming debt to the
story of the Pied Piper or Goethe's poem "Der Rattenfänger,"
although Ibsen steadfastly claimed as its origin a childhood
memory of such a woman in Skien. But Ibsen's folkloric epi-
sode achieves its power and horror precisely because we are
not dealing with a fairy tale; the rats have gotten loose from
the conventions of children's stories and have entered the
grown-up world, and the results are as grisly as they are in

Camus' rat-ridden novel, *La Peste* (1947). Camus' rodents have at least the manners to appear on doorsteps and thresholds; Ibsen's are insidiously on the inside, and they are causing damage: in the house, in the milk, in the beds. They have gone directly to where the action is, to the places of nourishment and intimacy, and they have taken over. Ibsen is touching on nerves and fears that are almost immemorial, conjuring a primitive scene of takeover that is unmistakable in its implications: what must remain pure is foul(ed); what must remain innocent is diseased. Even these formulations are too "removed" and abstract, have none of the horror and physical revulsion associated with rats in the bed and in the milk. The animal language is somehow "prior," rendering the feeling and meaning of the scene better than any gloss can convey.

The Rat Wife brings (with great force) Ibsen's animal register into the play, says something about the Allmers that they cannot say about themselves, that they cannot fathom about themselves. The primitiveness of her "calling" seems totally at odds with their civilized agenda of education, responsibility, and the like—and much of the play trumpets those civic virtues indeed, and for real—so the challenge of *Little Eyolf* consists in reading its multiple languages, perceiving the composite story they adumbrate. That story illuminates the Allmers, not unlike the way an MRI or CAT scan illuminates our bodies, pointing toward recesses and regions, perhaps even flora and fauna, beyond ordinary scrutiny, beyond anything we might suspect about (or inside) ourselves. It tells us that nurturance and intimacy might be at once the domain of high idealism and the realm of the rats, that our ostensibly purest transactions may turn out to be our most diseased.

This fusion of high and low, of idealism and animality, may surprise us in Ibsen, but it may be worth recalling that Shakespeare achieved something strikingly similar in finding a language for Othello's tortured feelings for Desdemona:

But there where I have garnered up my heart,
Where either I must live or bear no life,
The fountain from which my current runs
Or else dries up—to be discarded thence,
Or keep it as a cistern for foul toads
To knot and gender in (*Othello*, IV, ii)

As is well known, much of *Othello* is taken up with the besti-
ary. Beginning with Iago's taunt to Brabantio that his daugh-
ter and the Moor are "making the beast with two backs" and
continuing through Othello's jealous and murderous rage,
Shakespeare makes it abundantly clear that feeling pairs us
with the animals. Still more to the point, however, is the tragic
view that the human mind is the ultimate locus and breeder
of monsters, the mind as a place that can be defiled precisely
by thought itself, "As where's that palace whereinto foul
things / Sometimes intrude not" (*Othello*, III.iii). Ibsen's bour-
geois world is a far more timorous, fearful place than Shake-
speare's, and his people remain steadfastly buttoned up, right
to the end, in contrast to the anarchic developments in *Othello*.
But the palace is the same, and it is shown to contain foul
things that intrude.

There is, as James McFarlane has said, a crucial "sexual
nexus" in Ibsen's late plays, encompassing a considerable range
of behaviors: "marital, pre-marital, consummated and uncon-
summated, promiscuous and abstinent, invited and withheld,
sensualized and sublimated, overt and repressed, deviant and
incipiently incestuous" (Oxford Ibsen 10). McFarlane's adjec-
tives chart the course of libido and animality, constitute its
markers, testify to its incessant mobility. The Allmers' sunlit
garden room has rats, and when the Rat Wife literally brings
the strange Mopsemand out of her bag—"Up you come out of
the dark, my bonnie one" (47)—we actually see the yawning
mouth of the nether world, the fastness of the animals.

Rat Wife, rat, lupus, wolf, werewolf. The Rat Wife gives a
demonstration of her wares in both theory and practice. The-

ory consists of her little narrative on sex and death, as given to the Allmers onstage. Practice takes place offstage, after her exit, entailing the permanent exit of Little Eyolf for whom "vil" is replaced by "må," as he follows her prodigious call-to-the-rats, and goes into the deep waters. Offstage, yes, but it is arguably the most astonishing theatrical moment in all of Ibsen. How often does one expect the title character—and a child at that!—to die in the first act? It offends all dramatic propriety as well as all human propriety. No fanfare whatsoever: Eyolf slips, unnoticed, out of the living room, to slip out of life altogether. Or so it would seem. We will see just how stubbornly and tragically alive the dead little crippled boy remains, well after his disappearance from the scene.

But the animals never disappear for good, either, and we are to encounter the most dangerous one, the werewolf, soon enough. Enough of rats for the moment. The werewolf adds immeasurably to the prestige and threat of the animal family, for it is an animal that battens onto humans, needs human blood if it is to live. The werewolf devours in order to live, but this creature is less exotic than you might think, and you do not need to go to Transylvania or descend into a crypt to sight it. Ibsen has presented the Allmers' marriage in precisely those colors, as this depiction of Rita's hunger indicates:

> *Allmers* [*stares at her in astonishment*]: What? You mean you want to be rid of Asta?
> *Rita:* Yes, Alfred, yes!
> *Allmers:* But why in the world . . .
> *Rita* [*throws her arms passionately round his neck*]: Then at last I'd have you all to myself! Except that . . . No, not even then! Not completely to myself! [*Bursts out sobbing.*] Oh, Alfred, Alfred . . . I cannot let you go.
> *Allmers* [*gently frees himself*]: But my dearest Rita do be reasonable!
> *Rita:* No, I don't care a damn about being reasonable! All I care about is you! Nothing in all the whole wide world but you! [*Again throws herself round his neck.*] You! you! you!

Allmers: Let go! let go! You're choking me!
Rita [*releases him*]: God, if only I could! [*Looks at him with flash-ing eyes.*] Oh, if only you knew how I've hated you. (58)

It is altogether possible for the sophisticated reader to flinch at outcries like this, and to feel that Ibsen's heavy artillery is heavy indeed. One is tempted to laugh at Alfred's ever present mix of thickness and naïveté: What? You mean . . .? You want to get rid of Asta? (He's been married to this woman for many years now.) We'll have much more to say about Alfred, Ibsen's exemplary male figure, but Rita may come across as even more caricatural: "You! You! You!" is hard to take, and the Norwegian is no better: it's what Ibsen wrote.

But if we can see past this, if we are prepared to factor in rats and werewolves, this loaded sequence makes consider-ably more sense. Alfred and the reader are both learning that human feeling can be voracious and homicidal, that the link between sexually bound people is raw and savage, has a good bit of the animal in it. "I don't care a damn about being rea-sonable!" says this wife with her hands on her husband's throat. One thinks again of Munch, this time of *The Vampire* (1893) with its depiction of the woman enfolding the man and placing her mouth at his neck. Even granting that the were-wolf is traditionally a male creature, Rita's violence and hun-ger signal a craving of considerable proportions. She is also a version of the *troll* against whom Ibsen famously declared war, declaring that all writing was but a battle against the ani-mal forces. Nonetheless, and not infrequently, his wilder women have demonic tinges to them, as if inflected by the fiercer elements of Nordic mythology.[6] Rita Allmers is the most ravenous female in all of Ibsen, and she is paired with the most ineffectual, almost effeminate of his high-minded males.[7] This *mésalliance* has some pathos. One of the most au-dacious and spellbinding scenes in the play comes early when Alfred, returned home from his tour in the mountains, is in-quiring about domestic matters but remains as cold and

standoffish as ever, from a sexual perspective; Ibsen has Rita move into ever more languorous and seductive poses, finally lying down utterly supine, looking up at her husband, daring him to make the moves she expects, and thinks she deserves. He, instead, stonily, bitingly, refuses the offer. (In one performance that I have seen, Rita actually straddles Alfred at this juncture, to get across her need, but he is dismissive and limp as ever.)

Rita's hunger is great and, ultimately, pitiable, because its intensity bewilders her husband as much as it frightens him. Sexuality at large confuses and terrifies him, pulls him out of the sexless realm of "pure" feelings—read: the realm of childhood—where he is most comfortable, most protected. This is the deep core of the play. As we will see, Ibsen's Alfred has distinct parallels with Strindberg's Captain, different though they appear outwardly: each is slated for unwelcome tidings about the child-self hiding in grown-up clothes.

To see Rita Allmers as the werewolf her son had announced in the first act is to understand Ibsen's double registers. To see Rita as the werewolf is also to understand the fundamental reality of werewolves: creatures that are—at once? sporadically? intermittently?—human and animal. Lore has it that the change takes place at special moments, during the full moon, and so on. But, as we have been taught ad nauseam by the horror films of the past fifty years, the central attraction of such horror, its pièce de résistance, is the actual transformation itself, the awesome moment when the human figure alters before our eyes, becomes animal. Ibsen is not Bram Stoker or Carl Dreyer or Bela Lugosi. Perhaps he would not even have understood the words of the most famous "metamorphosist" of our century: "As Gregor Samsa awoke one morning from uneasy dreams he found himself transformed in his bed into a gigantic insect."[8] But, upon reflection, Ibsen certainly would have granted that such a monstrous transformation, if it must be, must be in connection with "bed" and "uneasy dreams," as a kind of literal manifestation of the

creatural and libidinal energies having their say and their play in bed, because denied and repressed during the day.

Metamorphosis is inherently shocking, for it annihilates any unitary, static scheme of the subject; it manifests, instead, a view of creatural duration as evolving and altering, and it obliges us to posit multiplicity where we had seen only one-ness. Metamorphosis forces us to make friends with change, to understand that the given moment and the given mani-festation are rife with alternative possibilities, are in fact scheduled for alteration. Those alternative possibilities, those alternative selves, endow Ibsen's plays with a scope and di-mensionality that dwarf any notion of photographic realism; his best work is mobile, keyed to slippage and displacement, filled with echoes and gleamings. Life is a morphological pa-rade; nothing is only what it seems.

This rather baroque, "Sein versus Schein" view of transfor-mation needs to be borne in mind if one is to come to terms with *Little Eyolf's* major philosophical refrain: "the law of change." Allmers consistently rebuffs his wife's advances throughout the play by referring to the law of change, "for-vandlingens lov," the all-powerful view of life as process rather than stasis, by which he means: our days of passion are over, sorry. Rita's voracious need for her husband is to be understood, in this light, as a secret denial of time, as an im-possible longing for immortality and imperishable bliss. Errol Durbach has offered a most sophisticated and convincing reading of *Little Eyolf* along these lines, and he has discussed Allmers's strategy of denial in light of the incest motif in European romantic literature, focusing on Byron and Emily Brontë; this thesis is especially illuminating with regard to Allmers's arrangements with Asta, his unmistakable tactic (Rita sees right through it, that's why she wants Asta out of there) of staying sexually "clean" by preferring Asta to Rita, the "sister" to the wife, and thereby finding refuge in the time-less purity guaranteed by the incest taboo.[9]

The problem with this model is that it absolves Allmers of all sexuality by playing to his desire for an ideal platonic love; one senses that Allmers would actually accept this characterization if it were put to him, since it is in keeping with his austere, virtuous, high-minded self-image. But, like Freud who followed him and who resembles him in so many ways, Ibsen has to have wondered whether any human subject can be absolved of libido; and, again like Freud, he has to have been fascinated with the subterfuges and displacements necessary for the high-minded to keep their slate clean, to steer clear of carnal involvement, at least on the surface, including the surface of the character's own mind. Ibsen knew that high minds could not be fully clear of low bodies, no matter how much psychic cleansing and white-washing goes on. (Can there be rat-free schemes?) Alfred Allmers, Ibsenian male par excellence, is going to be a prime exhibit for these complex and concealed psychic games, because *Little Eyolf* will ultimately display (for us, if for no one else) the catastrophic failure of all such dodges and protective schemes. In keeping with the play's central metaphor, these evasions will come to be seen as the "crutches" that allow the crippled and the wounded to get about.

But it is also necessary to see all of this—the "law of change" as well as the escape hatches and displacements and the other little psychic maneuvers our machine performs every day in order to stay afloat and to maintain its facade—for the remarkable dramatic vehicle that it is. Ibsen is wisest of all dramatists about the countless small deceptions and self-deceptions that make our daily composure possible, but he is especially drawn to those moments of crisis when we capsize, when the "house-keeping" strategy either fails or moves horribly toward the light. Allmers may enjoy professing his belief in impersonal process, producing such venerable, inflated lines as, "Our love has been a consuming fire. Now it must be extinguished" (83), but he's not going to get away with it, because the play is ultimately more wrenching and shocking,

more essentially undercutting than such Olympian wisdom allows. One plays one's game right up to the moment when the floor collapses. It is then that *theater* happens, by which I mean: only now does the character discover—remember that phrase?—his participation in the masquerade, his reality as a *player*. The characters may indeed all be on a treadmill—we all are: this goes by the name of "living"—but, at a certain point in the play, it is speeded up, and we begin to see the garishness of the real charade at hand.

Little Eyolf was, grotesquely enough, the prop that kept the entire Allmers consort in place. Many critics have linked his death to the disturbingly prevalent theme of *Kindermord* that runs like a filigree throughout Ibsen (and which will be the subject of a later chapter), but this particular child-death has a local propriety all its own.[10] Remove Eyolf from the scene, and the musical chairs begin to move. The first, predictable result of his death is the painful series of recriminations exchanged by Allmers and Rita. That Rita regarded her son as a rival and wanted him removed is obvious from the outset; we also learn that Allmers used Eyolf for his own ends, as a desperate, narcissist project, when he began to doubt his own intrinsic worth. They now see, with all the sharp-sighted, hind-sighted clairvoyance of guilt, that he was not, in any meaningful sense, their son, but rather "a little stranger boy" (79). Eyolf was never a person; he was, instead, a prop, a "crutch" that allowed his parents to maintain their equilibrium and personae.

The fixed persona cannot be maintained. Peer Gynt plays out every single phase of his onion repertory, and Captain Alving (in *Ghosts*) must be known in all his avatars: pillar of the community, dissolute rake, erring mortal whose joie de vivre was snuffed out by his wife and community. Their rainbow personalities wreak havoc socially and morally, but Ibsen cannot deny them, and he understands better, in play after play, that the theater is peculiarly equipped to display these prismatic figures: Old Ekdal (in *The Wild Duck*) shooting his

"bears" in his forest/attic, Ulrik Brendel (in *Rosmersholm*) spouting his multilingual absurdities, Hilda and Solness (*The Master Builder*) performing their pas de deux in a nowhere land that is both ten years ago and now, the Napoleonic Borkman (*John Gabriel Borkman*) wresting precious metals from the bowels of the earth.

And it is senseless to play the moralist here, just as it is senseless to fault Strindberg's Laura for the Captain's trip back to the cradle. What both Strindberg and Ibsen have to teach us today, well over a century after their work appeared, is the shimmering truth of Homo ludens, with the emphasis on "shimmering" rather than "truth." Both these playwrights find pay dirt in peeling away the facade of normative behavior so as to illuminate the dancing and the pyrotechnics underneath the surface. It is not a question of *secrets* or some other definitional bottom line, but rather a matter of staging the antics and moves of creatures we thought we knew, creatures who thought they knew themselves. I do not believe this is even intentional (on the authors' part), inasmuch as playwrights are as drawn to *play* as moths are to light. In the performance of Strindberg's Captain and Ibsen's Allmers, these two writers are uncovering the very life of the theater as well as the dance of the species. *Little Eyolf* has just as much seismic activity as *The Father*, but its austere surface and its rigorous armature keep us "out," at least for a while. Eyolf's death changes everything, catalyzes everything.

The revelations come. Eyolf's injury, we now learn (they have known it forever of course), is the result of Rita and Allmers's furious sexual passion, of their leaving him (as an infant) unattended in order to have sexual intercourse. Michael Meyer has convincingly argued that they have not had intercourse since, because Allmers has been impotent since that moment.[11] If so, we may understand why Rita is so voracious; but why is Allmers impotent? Shock alone? I am scarcely a specialist on impotence, and trauma may well be a possible cause. But there is something bristling in this dramatic situa-

tion: an infant neglected and injured as/because its parents have wild sex. What has happened?

The case has often been made that adults do not look at children in Ibsen; "look at the child," Gina urges Hjalmar in *The Wild Duck* (1884), and there is much truth in the claim that the child of that play, Hedwig (going progressively blind, no less) is tragically *unseen* by her parents. But one might actually title *Little Eyolf* "The Child's Revenge," and not be off the mark, not merely because so much grieving and misery come in the wake of his death, but, even more profound perhaps, because the child's own vision is discovered and vindicated in this text. And it is an intolerable vision. *Child's play* and *cradle song* were at the core of my Strindberg analysis; as is often the case with Ibsen, the focus is on *seeing*. At the end of the play Rita will imagine Eyolf's "great wide-open eyes staring at me" (95), and we see here a haunting indictment of the parents for not performing the elemental act of love that we do for the dead, what Barry Jacobs calls "the last service of love, no one to close his eyes."[12]

But those uncloseable eyes haunt in still other ways. In an extraordinarily prescient manner, Ibsen has depicted the fate of parental sexuality in the bourgeois family. In pure circular fashion, the infant "witnesses" the sexual intercourse that (earlier, yes) engendered him.[13] A genuine taboo is in play here—the infant came, saw, and fell—and one senses that this peering into one's origins is lethal and will spell (has spelled) doom; Eyolf's crippling comes as no surprise. But the witnessing of the child is also the crippling, prying light of consciousness itself for the civilized adults, and it makes their animal behavior specular in ways they cannot abide. Eyolf's injury is of a piece with Allmers's strategic evasions: sexuality is unacceptable, unownable, and it must not be brought to consciousness. One thinks of Victor Hugo's poem, "La Conscience," in which Cain's guilt is imaged as the eye of God that tracks him throughout the world and finally settles in with him in the coffin. The "evil eye" of this play indicts

the adults for their initial, primal transgression—sexual intercourse at all—not for their negligence in allowing Eyolf to go to the jetty.

But this is only the beginning, and Ibsen wants us to realize that Allmers's problems began before the siring and crippling of Eyolf. Bruised by the death of his son and the recriminations of his wife, Allmers understandably seeks solace in his half-sister, Asta. In one of the most haunting scenes Ibsen ever wrote, reminiscent of Poe even more than Byron, he evokes their strange childhood, revealing in a flash the psychic apparatus behind the double life they have (unwittingly?) been leading ever since. This scene must be cited in its entirety, if we are to plumb its depths:

[*She moves nearer to him and begins to sew.*]

Asta: Keep your arm still. So I don't prick you.

Allmers [*half smiles*]: This is like the old days.

Asta: Yes, isn't it?

Allmers: When you were a little girl you used to sit like this and mend my clothes.

Asta: As best I could, yes.

Allmers: The first thing you sewed for me . . . was also some black crape.

Asta: Oh?

Allmers: On my student cap. When father died.

Asta: Did I do that? I don't remember.

Allmers: You were still very little.

Asta: Yes, I was little.

Allmers: Then, two years later . . . when we lost your mother . . . you sewed me a big black armband.

Asta: I thought it was only right.

Allmers [*pats her hand*]: Of course it was right, Asta. Then when we two were left alone in the world . . . Are you finished already?

Asta: Yes. [*Gathers her sewing things together.*] Yet it really turned out to be a happy time, Alfred. The two of us alone.

Allmers: Yes, it did. Hard work though it was.

Asta: You worked hard.

Allmers [*more animated*]: You worked hard too, in your way . . . my dear, loyal . . . Eyolf.

Asta: Don't remind me of all that silly business about the name.

Allmers: If you had been a boy, you would have been called Eyolf.

Asta: Yes—if. Then when you became a student—[*Smiles involuntarily.*] Imagine your being so childish.

Allmers: Me childish?

Asta: I think you were, now I look back on it. You were ashamed of not having any brother. Only a sister.

Allmers: No, it was you. *You* were ashamed.

Asta: Perhaps I was, a little. And I also felt somehow sorry for you . . .

Allmers: Yes, you must have. You got out the old clothes I'd worn as a boy . . .

Asta: All your Sunday best. You remember that blue blouse and those knee breeches?

Allmers [*his eyes rest on her*]: How well I remember you when you put them on and walked about in them.

Asta: But I only did it at home when we were alone together.

Allmers: How seriously, how solemnly we took ourselves! And I always called you Eyolf.

Asta: Alfred, you haven't told anything of this to Rita, have you?

Allmers: Yes, I think I did tell her about it once.

Asta: Oh, Alfred, how could you?

Allmers: Well . . . doesn't one normally tell one's wife everything—or pretty nearly. (70–71)

It is a miraculous passage for many reasons, not least among them that the sixty-six-year-old playwright could capture the gentle sibling intimacy and childish play with such delicacy and tact (Meyer tells us that Ibsen was especially interested in sharing confidences with children at that juncture

94

in his life).[14] The sewing on of crape at the death of Eyolf leads gracefully to the earlier death scenes shared by this couple, revealing for us just how fully their joint lives are inscribed under the sign of death (first "their" father, then her mother—so Alfred believes; surprises to come). As we see these shared memories and sympathies that unite Alfred and Asta, no reader is so churlish as to wish to deny them this momentary respite from their pain and loss. This was their Eden, their lost happiness (Ibsen's term is "dejlig," connoting loveliness, even grace.)

The ultimate miracle is that this passage retains its poignancy and innocence long after one has dismantled it and reflected on its potent tidings. What is there to dismantle? you may ask. But in this touching, moving childhood reminiscence, we begin to see, firsthand, as it were, what Allmers harks back to, in his mind and heart. It is, of course, the romantic nostalgic dream of endless, sexless childhood bliss, of a brother-sister love so pure and so encompassing that total— and totally "safe" because sexually prohibited—fusion of souls seems possible. Later in the play Allmers will emphasize even further the crucial *innocence* of this relationship, especially when contrasted to the carnal arrangements with his wife, arrangements he can no longer bear. Let the man hold on to his dreams, one might say. To ascribe great emotional and spiritual weight to the passage may seem excessive, because Ibsen has made the conversation so artless, so whimsical, even so matter-of-fact. A man and his half-sister reminiscence as she sews crape on his shoulder: why see trouble here?

Because these facts, these precise details about their childhood relationship, are stupendous in their eloquence, in the narrative disclosure that Allmers and Asta cannot speak because it speaks them, it speaks of what mattered (matters) most for them, even though it spells out nothing. *It speaks them*: this is why we have art, why great writers are like great explorers and discoverers; they help us toward a richer grasp

of our own murky arrangements. This touching retreat to childhood, we will come to understand, is not the past of the play, brought in casually and anecdotally; rather, it is the living present of the play, the actual psychic terrain where Alfred and Asta live, the governing configuration that reveals the deepest allegiances of their lives. (Making us understand such things is Ibsen's genius.) Look closely: for whatever reasons—because Allmers sought refuge in an idealized sexless realm of deferred desire or simply because their joint experience of orphanhood and abandonment caused them to create a private world of their own, a place for retreat whenever threatened, a deliciously confirming mirror of what one "actually" thinks oneself to be, at bottom—these whimsical children's games illuminated, actualized, and gratified the deepest and most abiding needs of these two adults.

Where, you might again ask, does Ibsen flag this as trouble? My answer: now we're going to talk about names. We recall all the hullabaloo about the Rat Wife's sobriquets; now we're moving closer home. So it is that Asta cautions Allmers that Rita need not know that he called his "sister" Eyolf; we gather that she wouldn't "understand." Too late, however: "Yes, I think I did tell her about it once." "How could you?" she cries. Well, when did the husband talk to his wife about childhood names? When was this "once"? It was, we are to learn at the end of the act, something rather special indeed:

> *Rita:* You used to call her Eyolf, didn't you? I think you once told me that . . . in an intimate moment. [*Comes nearer.*] You remember that "devastatingly lovely" moment, Alfred?
> *Allmers* [*shrinks back in terror*]: I remember nothing! I don't want to remember!
> *Rita* [*follows him*]: It was the moment . . . when your second little Eyolf became a cripple. [84–85]

We are approaching dead center. Here, then, is the second, still more devastating revelation about Eyolf's crippling, a crippling that is more far-reaching, more paradigmatic than

we could have understood. Sexual passion is made intolerably conscious by the watching child, and that is bad enough. We now learn that sexual passion is made possible only by crucial substitutions, that "Eyolf" is the name doubtless uttered by Allmers at the moment of climax. There is obviously no way to prove my contention that this outcry comes via orgasm, but how else is one to imagine such a disclosure? It makes little sense to think of Allmers lighting up a post-coital cigarette and then telling Rita about the name games of the past; instead, *Eyolf* popped, as it were, out of his mouth at the crucial moment—yes, this is Ibsen—then mandating some kind of explanation.[15] This is hot stuff. The ever proper, ever zipped-up Ibsen has gotten right down to the basics: what noises a male makes when ejaculating. ("It was a devastatingly lovely moment," Rita says; "devastating" indeed.) It so happens we don't have much literature on these lingual/orgasmic matters, but even if we did, I doubt you'd ever find the word "Eyolf" on anybody's list.

The brilliance of Ibsen's dramaturgy is such that his revelations move insidiously backward and forward at the same time, illuminating and utterly recasting what we thought we had known. Nothing is what it seemed, and the most innocuous materials are now bristling with unavowable meanings. The play systematically "blows the cover" of its people, so that the very words and phrases take on new significance, virtually as if the language of the play changed midway in, and we realized that what we had taken to be Latin is in fact Greek. Furthermore, each discovery leads to more questions, opens up still further what had seemed closed and fixed. Who, then, is the "Eyolf" that Allmers names in a moment of passion? It will not do to say that he calls out to his "sister," Asta. He says "Eyolf," not "Asta," and we must come to grips with the fact that EYOLF is an extraordinary amalgam of signs, a code word in his psychic economy that conjures up not only the half-sister, but the sister-as-boy, the figure who walked around in the blue blouse and knee breeches.

This rich, dense cluster of names and bodies, of incestuous or transvestite longings, is what Ibsen wrought in his final version of the play, and it creates a verbal economy and psychic echo chamber of extraordinary power and beauty. What is one to make of this? Is the boy-in-the-blue-blouse a "narcissist re-creation" of Allmers as a young boy?[16] Is there a homoerotic fantasy at work here, in the desire Allmers expresses for "Eyolf"? Or is the sexual attraction for Asta merely—merely!—"re-routed" via transvestite trappings? Or is the longing for Asta—consistently imaged in the play in terms of sibling innocence and purity and stasis—Allmers's (failed) strategy for escaping sexual desire?[17] There are no answers given to these questions, and perhaps all these hypotheses have their own truth. Every one of them takes our notions of *husband* and *father*, and then implodes them out of all recognition, makes us realize how reductive and misleading they are as cover terms. Alfred Allmers is a walking exhibit of bogus labels, of the gap between our tags and our actual machinery. No less than Strindberg's Father, Ibsen's Father is deconstructed, turned inside out; the Captain goes backward out of business, whereas Allmers's very business, along sexual lines, is seen under the microscope as an affair of crossed wires and displaced energies.

And this is polite nineteenth-century theater where "types" are nailed down, and what you see is what you get? The one inescapable consequence of such revelation and innuendo is that every life is a shadow game, that the solid, finite figures we interact with have their ghostly counterparts, that the present scene in the drawing room is neither "present" nor in the "drawing room" but is instead an orchestrated arrangement of echo and double, present and past, licit and illicit.

Somewhere in *The Alexandria Quartet*, Lawrence Durrell has his character Pursewarden articulate a theory of sexual arithmetic the upshot of which is that at least four people are involved every time two people get in bed together. Nothing in this formulation would have shocked Ibsen, except the saying

of it. It takes all of *Little Eyolf* to achieve such a complex view of sublimation and displacement, and it is highly likely that none of the characters would be up to proclaiming it, even at the play's close. In the end, when Asta more or less announces her "real" eligibility to Allmers by informing him that she is no blood relation to him whatsoever—"their" father is, like so much else in the play, a misnomer, because Asta's mother had an affair with another man; the childlike idyll has no blood basis—he predictably holds onto the sibling fantasy that has kept him afloat up to now. She *must* remain sexless; she must. No matter that the entire play has illuminated her crucial reality for him as sexual conduit. Asta leaves with Borghejm, saying very little indeed, although we understand that she prefers a mediocre man who desires her as Asta to the desired man who prefers her as Eyolf.

Ibsen's play moves in concentric circles, like ripples caused by a pebble dropped in still water, ever wider in their reach, endlessly recasting our sense of what marriage and life entail. Allmers says "Eyolf" as he achieves climax with his wife, Rita, and we learn something about sexual performance, about how the equipment actually works. Much the way that James Joyce's Gabriel Conroy (in his story, "The Dead") comes to understand the (enabling?) presence of Michael Furey within the passional landscape of his wife, Gretta, so, too, does Ibsen show us that nothing is ever simple or unadulterated in the human psyche (and this may be why Joyce revered Ibsen). It is commonplace to say that the marriage between Allmers and Rita is flawed because of the sibling fantasy that connects the husband to his half-sister. Can one not also say the opposite: the marriage between Allmers and Rita is based on, made possible by, the sibling fantasy that connects the husband to his half-sister? Allmers is able to function "passionally" only in this way, only by means of this prior "hook-up" that governs his psychosexual energies, determines what scenarios are necessary to awaken and channel his desire. "Neither a borrower nor a lender be," says the fatuous Polonius to his son;

ha! says Ibsen, ha! ha! says Ibsen, because he knows that the psyche (and its somatic outlets) works entirely through the murkiest borrowing and lending, through substitutions and displacements, through a complex inner wiring and conduits that no engineer or electrician or plumber has ever seen.

The Allmers have a child, and they name it Eyolf. On the face of it, innocuous enough. By the time we have finished the second Act, the face of things covers very little indeed. The naming of a child, like the engendering of a child, calls into play an entire set of complex and complexed energies. *Little Eyolf* reminds us of nothing so much in this regard as of Faulkner's *The Sound and the Fury*, it, too, a meditation on incest and the fear of sexuality, it, too, a tale of tortuous naming (tortuous for the reader), because of Caddy who "two months pregnant with another man's child which regardless of what its sex would be she had already named Quentin after the brother whom they both (she and the brother) knew was already the same as dead."[18] Faulkner, like Ibsen before him, was tracking the flow of energy that animates human feeling, and these conduits link present and past, living and dead, now and then. Faulkner and Ibsen knew something about living ghosts.

Ibsen is out to show that displacement and sublimation not only characterize the working of the psyche in its dealings with reality, but that they are structural principles from which drama has much to learn. Our simplest transactions are ineffably complex, because our very functioning depends on strategic choices and game plans that are devised in the dark, far from our rational consciousness, but nonetheless geared to keep us moving, keep us on our feet. The energy required to get out of bed—much less to perform sexually—draws on wellsprings that lie far back, enshrouded in darkness. From play to play the Ibsen formula consists of bringing more and more of this occulted material to the light, so that the long and tortuous temporal curve of life becomes at last visible. Mrs. Alving re-experiences her marriage in *Ghosts* (1881), achieves

a second, fuller look at the role she herself has played in the Alving horror show; in *Rosmersholm* (1890) the light beam is placed on Rebecca West, and Rosmer and the reader watch her inchoate form achieve its full figure, encompassing incest and calculations for murder and marriage along the way. But nowhere is this fleshing-out procedure more gripping than in *Little Eyolf*, because Ibsen has presented, in the progressively exposed inner wiring of Allmers, a programmatic rendition of "normalcy" as a balancing act, a precarious equilibrium of past trauma and current ersatz, issuing in a view of the modern subject as, literally, one of the walking wounded. Allmers can function, can stay on his feet, by keeping covenant with his childhood fantasies, by persistently molding the events of his life to fit those fantasies.

And this is why it will not do to "straighten him out" through criticism that "tells the truth" about his dodges and subterfuges. James McFarlane has written very suggestively about the exquisite and almost maddening postures that make up this play, and his view of irony is useful in accounting for the ongoing duplicitousness of Ibsen's major characters in *Little Eyolf*.[19] But it is not clear that even "irony" will suffice as a term for gauging what Ibsen has put onto the stage. Allmers must be allowed his dishonesty, his puffery and evasiveness, because therein lies, paradoxically, his profoundest truth. His evasions—not so much the known ones but the unknown ones, the ones that take place in the dark and move his machine—are a thing of theatrical beauty. His mobility, indeed his alterity, is what Ibsen has made visible to us.

Need I add that this is a lethal truth, when it comes to the claims of an order I have not once called by its name: Patriarchy? Ibsen wrote many plays that tackled, in far more direct and aggressive fashion, the stature of Fathers: Captain Alving in *Ghosts*, the puffed up Hjalmar in *The Wild Duck*, and, above all, the virile, guilt-ridden, charismatic yet doomed Solness, hero of *The Master Builder*. Against this backdrop, Alfred

Allmers comes across as mild-mannered, perhaps effeminate, certainly unprepossessing. Yet his is the odyssey worth watching, because in him Ibsen has choreographed the systematic undoing of male pretensions. He will never write his Great Book, and whatever sexual power he once had is now exposed as the residue of childhood infatuation with his sister, a residue that can be activated only by dint of displacement and denial.

We see nothing overtly ideological in *Little Eyolf*. Ibsen *can* be aggressive on this front: witness *A Doll House* or *Enemy of the People* or *Rosmersholm*. Without being in the least didactic, the example of Alfred Allmers has a resonance that goes far beyond the psychological as such. On the contrary, he—no less than Strindberg's Captain—seems programmed for an epochal dismantling, for being exposed as a child who never grew up, as a creature living in disguise, as a "poor player strutting and fretting his hour upon the stage." No political proclamation is required here, since the spectacle of a man being turned inside out and put into reverse gear tells you all you need to know, not merely about his own precariousness but about the artifice of the system itself. Ibsen's genius is to have bequeathed us that shimmering vision as the hidden story of culture, of the ostensibly powerful symbolic order as a facade behind which we see tumbling forms and serial substitutions: Allmers seems almost a living allegory.

No single item of *Little Eyolf* is more portentous than the child's crutch, the prop he used to stay erect, the prop that stays hideously afloat even though the child has sunk to the bottom of the water. Eyolf's crutch we see retinally; by now we have gotten a close look at Alfred's crutch as well, even though it does not materially appear onstage. It is a dreadful metaphor of Ibsen enterprise: deep inside, we are maimed and would sink, but we skillfully do the patchwork and propping, the substitutions and displacements that are required to stay erect and stay afloat, and the "we" that does it does it in the dark, but with an unerring sense of aim and direction.

Here is a version of Freud's unconscious, but Ibsen doesn't bother to theorize these matters; he doesn't need to. The Ibsen subject is always on crutches, although he often does not know it when the play begins; when it is over, however, we (at the very least) have learned all there is to know about the fashioning and use of crutches, the materials (of a lifetime) that go into them, and the high drama of concealing or, more perilous yet, discarding them. The crutch floats, is visible, and Ibsen relentlessly focuses on it, examines it with the loving care of a scientist using his microscope to show us what familiar things really look like.

Given Ibsen's obsession with the dialectic between light and dark, my figure of the microscope is scarcely a figure at all. Peering through these lenses means perceiving a world absolutely teeming with creatures and formations that ordinarily do not show. One of Ibsen's most famous speeches, that of Mrs. Alving in *Ghosts*, is cued entirely to the *sightedness* that the play brings into being, a sightedness into which she is initiated:

> When I heard Regina and Oswald in there, it was as if I saw ghosts. I almost think we are all ghosts—all of us, Pastor Manders. It isn't just what we have inherited from our father and mother that walks in us. It is all kinds of dead ideas and all sorts of old and obsolete beliefs. They are not alive in us; but they remain in us none the less, and we can never rid ourselves of them. I have only to take a newspaper and read it, and I see ghosts between the lines. There must be ghosts all over the country. They lie as thick as grains of sand. And we're all so horribly afraid of the light.[20]

To the English ear, the word "ghosts" evokes creatures in white sheets to be seen at Halloween, or perhaps more Gothic types à la Stephen King or our horror movies, but we get it dead wrong, because Ibsen's term, "Gengångare" means "returnees," that is, the living dead who have never left, who inhabit the scene and require our taking note of them. Hence

Mrs. Alving looks at the newspapers—at the docile regime of black print on a white page, presumably recording the events of yesterday—and she sees something exotic and strange and teeming with life, something "as thick as grains of sand," telling us about far more than current events, but rather denoting something cancerously larger, longer-lived: the antics of the living dead who go through their paces in everything we say or do, who can never relinquish their grasp. This is why she says we are so "horribly afraid of the light"; but Ibsen has written something stronger still, for he claims we are all "gudsjammerlig lysrædde allesammen," actually inventing the adjective he needed—*lysrædde*, "afraid of the light"—so as to signal how much terror these vistas can bring. We have always known that humans are "afraid of the dark," and a casual glance at the bedrooms of children (and adults) will confirm this old fear: phantoms and ghosts lurk in the dark. Ibsen strikes the quintessentially modern note by insisting that it is the *light* that terrifies us, and it does so because it makes visible the horrible company (the living dead, our own dead selves, vital as ever, coercive still) that we keep.

From a theatrical point of view, this is simply revolutionary. There is a fabulous perspectival drama at work here, a transformation of our tired phenomenal world into something haunted, animate, and entrapping that can now actually be *seen*. Ibsen's project is to cargo this material into visibility, thereby creating a multilayered, palimpsest-like perceptual scheme, one that accommodates the living and the dead, the present and the absent, the tangible partners and the intangible phantoms, the woman with the gold and green forests and the "boy" with the blue blouse and knee breeches. This larger field picture comes into focus only when we do justice to the unseen motors that run the machines of our lives, and Ibsen's best work has a reach and a range that one finds in few writers, in such novelists as Proust and Joyce, and almost never in the theater, where the curve of time and the transactions it has occasioned are much harder to express, where the

public stage itself militates against the landscape of dream and fantasy.

Early on, I said that *Peer Gynt* prophetically announces much of Ibsen's subsequent agenda, and although the folkloric motifs are abandoned, the fundamental issues remain the same. But Peer's onion self is played out "laterally," scene after scene, career after career, country after country. This "horizontal" enterprise becomes rigorously "vertical," indeed collapsed upon itself in *Little Eyolf*, as the epic sweep of the earlier play is compressed and telescoped into the later one. Allmers and Rita and Asta turn out to be as multiple, as chameleon-like as Peer, and the burden of the play is essentially to "unpack" them, to display their wares, their earlier lives, their alternate selves. Allmers has been the focal point for this essay, but it is easy to see that Asta would "open up" to the same kind of reading. Early on, Henry James regarded her role as the role of the play, and when we do the required backtracking and "retrospecting," when we realize that Asta "knows" from the outset of the play that she is not blood kin to Allmers and is therefore "available," we then see what a shifting and muffled role hers really is, how much she must intimate before saying it—at the end of the second act. She, too, is on the move, iridescent, living under cover.[21]

Even Rita, seemingly the most unified and static of the major figures, evolves and alters, displays multiple kinships. Ibsen devises a surprisingly rich composite language for depicting these doubles and charades, and he has at his disposal a more diverse palette than he is usually given credit for, a palette that can range from the delicate reminiscences of childhood to the brutal antics of the bestiary. He is forever opening up the scene, forcing us to see that the tight, closed, apparently airless precincts of his Norwegian interiors are shot through with immense vistas. His ostensible realism was perfectly understood by Virginia Woolf, who claimed that, in his work, "the paraphernalia of reality have at certain moments to become the veil through which we see infinity."[22] It is

a keen comment, because it tells us of a visionary Ibsen whose measure has not been taken.

This expanding vision, when put into the service of the theater, has a peculiar generosity inherent to it, for it proclaims that there is more to us than meets the eye, that we are active in times and spaces beyond the here and now, that we are coupled and paired in ways the eye cannot easily see. This vision also commits the individual to a brotherhood of creatures, on the order, sometimes, of a distorting hall of mirrors in which the most freakish apparition may still be a self-reflection. Ibsen's drama, at special charged moments, is properly metamorphic, for it rings the changes and transformations that a human can undergo. When the curtain first goes up, the inhabitants of Ibsen's drawing rooms are rarely prepared for such adventures in kinship and identity. In *Little Eyolf* the first clear instance of a rent in the veil, of collapsing walls, occurs, as we have seen, with the entry of the Rat Wife. Rat, lupus, wolf, werewolf: she announces the animal family and the law of metamorphosis, and she puts us—if not the Allmers—on notice that fierce events are in the offing. The Rat Wife leaves, and Eyolf follows her to his death. We see her again in the werewolf-Rita who is strangling her husband in a frenzy of hunger.

And, as we move toward the close of this argument, I insist that we see the Rat Wife one final time at the end of things, when Asta has gone and Rita and Allmers are left alone with their emptiness and their ghosts. The final Act of *Little Eyolf* has been much maligned, from Henry James to contemporary Ibsen critics. It is felt, with good reason, that the final transformation of Rita and Allmers into good Samaritans is simply too hollow and bloodless to ring true. But the decimations encountered in acts 1 and 2 are so total—the loss of the child and the loss of the crutch—that there would seem to be room for nothing but death or some form of rebirth. Rita feels the change coming, and she says that it hurts, that it feels "almost like giving birth" (99). How, one might ask, could Ibsen possi-

bly render this "afterlife" without wrecking his play or sliding it into some mawkish never-never land. But once again, even now at the far side of things, we are to understand that nothing ever quite stops, is ever fully quiescent. And we watch Rita change, gather strength, become the man of the house, take on authority in a scheme of things in which women have so little of it, find gratification in ways she had never found it before. Ibsen's solution is a stroke of genius, and it is wonderfully "natural" at the same time: he casts this final metamorphosis in a figural language that we have already seen:

Rita [*slowly and deliberately*]: The moment you are gone, I shall go down to the waterfront and bring all those poor deprived children up to this house. All those uncouth boys . . .

Allmers: What will you do with them here?

Rita: I'm going to look after them.

Allmers: You what?

Rita: Yes, I am. The day you leave they'll all move in here—as if they were mine.

Allmers [*agitated*] : In our little Eyolf's place.

Rita: Yes, in little Eyolf's place. They shall live in Eyolf's room. Read his books. Play with his toys. Take turns at sitting in his place at table.

Allmers: But this is sheer madness! I can think of nobody— nobody at all—less suited to that kind of thing than you.

Rita: Then I shall have to rise to it. Teach myself to do it. Instruct myself. Train myself.

Allmers: If you are really serious about what you've just said, there certainly has been a change in you.

Rita: There has, Alfred. You have seen to that. You created a great emptiness within me. And I must try to fill it with something. Something perhaps resembling love.

Allmers [*stands for a moment in thought looking at her*]: In fact we haven't done much for those poor people down there.

Rita: We've done nothing for them.

Allmers: Hardly even given them a thought.

Rita: Never a sympathetic thought.
Allmers: We—with all "our gold and the green forests."
Rita: How tight-fisted we've been. And hard-hearted. (103–104)

There is no happiness in these lines, but it is as close to a rendering of grace as any Ibsen play ever came. At last the generosity of the Ibsen vision—a generosity that knows the self to be a large container, to be linked and checked everywhere—has become ethical. The archetypal unit of measure of the bourgeois world, the closed and integral self, has finally opened up to an awareness of relation and responsibility. It seems to me impossible to overstate the significance of this expansion of vision, because almost everything in this section has been cued to an ever deepening perception of *self*, an ever richer sense of its echoing reaches. In this final transformation of husband and wife, the closed hands and the closed hearts—Ibsen writes "lukkede," locked—are finally unclosed. All the metamorphoses are beneficent: the lost Eyolf becomes the poor deprived children; they will be in his place, they will take his place. Brand, we may recall, forced Agnes to give the last remaining clothes and relics of her dead child to the gypsy woman, but Ulf is little more than a pawn in that play, and Brand's murderous charity chills our blood. Here, in *Little Eyolf*, the motif of the "dead child," the theme of *Kindermord* that is central to so much of the Ibsen repertory, at last moves beyond the precincts of closure and doom. It is as if the evil eye had finally been transformed from private consciousness to public vision.

Ultimately and by way of conclusion, we are struck by the remarkable propriety of it all. Ibsen has kept covenant with his materials but has reconceived their ultimate relevance. The gold and the green forests have been put to use in a new way. And, last but hardly least, in the final metamorphosis of the play, our friend, the Rat Wife, has returned. "I shall go down to the waterfront and bring all those poor deprived children up to this house," Rita informs Alfred, and, in so

doing, she beautifully assumes and reverses the career of the *Rottejomfruen*, the creature of myth who lured rats and children to their destruction, for Rita has changed the terms of the fable from sacrifice to redemption. Desire is supplanted by love, being lost by being found, the individual by the community. At long last, we are to see that the work of human responsibility—so dear to Allmers, so suspicious to the reader—belongs in the province of life, not of books.[23] In this twilight ending, the gnawing is over, because all that was twisted and repressed has gone through the light of day to the coming of night, and the Allmers' union has finally been seen under the aspect of eternity. The searing passional drama is over, but life is more than libidinal drama, and the community is more than one husband and wife. Ibsen has opened up his nuclear family much the way the nuclear scientist opens up the atom, by liberating the extraordinary energies that have been contained within its armature; and those energies are at last free to move outward, into the larger world beyond.[24]

Wounded, the Allmers still live, and they make, together, a journey even more remarkable than Alfred's ghostly prome-nade with death, more unsettling than Peer's encounter with the Boyg: they leave the precincts of the self. It is as though Ibsen—partisan of ghosts and hidden selves—were pointing the way out of his own theatrical realm, beyond those stifling interiors where his people have been carrying out their living deaths. Eyolf dies, so that the children may live. The beast who drowned children and devoured adults may be exorcised only through selfless love. It is not a joyous occasion, but there is an undeniable maturation in the final actions of the chas-tened parents. And that is why Ibsen's metaphoric logic is so right: Rita must reappear to us in the colors of the *Rottejom-fruen* if we are to measure the distance she has traveled. Meta-morphosis? The law of change? We will perhaps be truer to Ibsen if we say that great suffering may transform human life, that hunger may die so that generosity can be born. Rita will

save the children, and she will open those closed doors to them, bring them in, and share with them the private icons of her life: Eyolf's books, Eyolf's toys. Who knows? They may even play with his crutch.

In writing that last paragraph, I have no illusions about how unpersuasive the resolution of *Little Eyolf* has proved to be, in the minds of Ibsen's critics. There is an almost unanimous feeling that the ending is forced, that Rita and Alfred are spectacularly unequipped to carry out the program they articulate. Some have claimed even that the text closes with the same dosage of self-deception that we encounter at the end of *The Wild Duck*, where it is all too clear that Hjalmar and Gregers have learned nothing from Hedwig's death.[25] But I will stick with my claim. The lovely figurative logic of Rita as an altered, nurturing, redemptive version of the Rat-wife speaks to what is most poetic and profound about the play. And please note: I make no bones about the bittersweet tenor of this final metamorphosis. No, Rita and Alfred are not to be imagined as converted figures who are now happily on the right path toward salvation, riding off into the sunset. They are wounded, and they remain very imperfect beings locked in an imperfect marriage; in addition, as we would say today, at this pass, they do not have very many good options. But Ibsen knew that moral good can come from such damaged creatures. Even if we construe their final efforts as "crutches" or as their version of a "life lie," what they bid to do is not only meaningful but outright revolutionary, in the Ibsen scheme of things. They do indeed *break through*: out of their emotional cocoon, into the social. That they must first be broken tells us about costs, about the price one pays, about final perspectives in lives that are wrecked but not undone nor over.

Let us not forget just how severe and nearly apocalyptic this play is: the death of a child (in life not art) is frequently the unfurling death of all the relationships around that child, including the marital one of its parents. Ibsen has tackled all

this, including the relentless stripping bare of each adult's illusions and fantasies, including those famous "life lies" that enable all of us to marshal what energies we have. One does not scamper out of such a crucible. Even though they are not old, Alfred and Rita come across as autumnal, as permanently injured, at play's end. Of course they are still playing the game of substitutions and projections. One cannot not play; Ibsen has learned that one does not, ever, get clear of the theater. That they do not die, that they do not separate, that they put the frail pieces of their house and their ego together to serve the needs of others: this testifies to a maturity on Ibsen's part that warrants more than skepticism.

C. The Powers and the Self: Strindberg's *Inferno* and Gustafsson's *Tennis Players*

How many guises does *power* have? It can be, and has been, figured in countless shapes: gods, spirits, elements, animals, blood, kings, patriarchs, machines, the economy, the psyche, genes, ideology, bombs. Even poetry is saturated with it. Emily Dickinson likens her passion and heat to Vesuvius, to a loaded gun; Adrienne Rich's poem "Power" focuses on the figure of Marie Curie whose body is destroyed by the great radioactive forces she discovered. In today's critical culture, however, we seem locked into a view of power-as-ideology. My two most canonical figures, Ibsen and Strindberg, can indeed be profitably read as students of troubled Patriarchy, as heralds of a changing order. My discussion of *The Father* and *Little Eyolf* toils in precisely that vineyard.

But Scandinavian literature's fascination with power goes beyond the social and the political, and some of the boldest texts discussed in this book position the human subject in a force field that reaches up to the divine (God's injunction to Abraham that he sacrifice his son) and down into the chtonic reaches of the turbulent material world we inhabit. Consider birth, death, disease, flood, drought, hurricane: nothing politi-

111

cal here, on the face of it, even if the ramifications move clearly into the social. And what about the *elements*? I close this book with a look at Strindberg's paintings of tumult in sea and sky, with nary a glance at the human subject. Can we be surprised that literature investigates the full range of power relations? Nietzsche memorably said of Oedipus that his twin deeds of parricide and incest violated the natural cycle, constituted a "crime against Nature," ("ein Verbrechen an der Natur"). One could argue that *science* itself is an invasion of nature, a quest to discover and harness the secrets of the universe. It often follows from such transactions that the human subject's position is thereby altered for good. A new constellation, a new eco-system, comes into view. Quite often, cozy anthropocentric models get bruised by these revelations.

Much of Scandinavian literature is scientific along these lines. Kierkegaard's (ready-to-murder) Abraham goes right off the social map, thereby transfiguring a number of key ethical and relational givens. Ibsen's megalomaniac John Gabriel Borkman seeks to wrest the precious elements out of the bowels of the earth, feels destined to do so, happily sacrifices all those in his entourage while pursuing this goal. Hamsun's delirious novel *Hunger* explores the limits of flesh and matter, in order to imagine a freedom beyond them, on the far side of measurable "doing." Edvard Munch paints a swirling sky and raised waters as co-players in the prodigious *scream* that issues from the mouth of his most famous painting's protagonist. Ernst Josephson, sweetly mad, is out to make visible our dread commerce with the lost gods. Vesaas's two little girls find that their mutual infatuation leads them to exit the known world: one is initiated into a structure of ice, the other is altered psychically, comes close to being weaned from the world. Bergman's *Fanny and Alexander* stages a battle about competing institutions of magic: the Church, the effigies, the feelings; he had done much the same thing in earlier films such as *The Magician* or even *Smiles of a Summer Night*. Lind-

gren's Lionheart brothers are called to a place beyond death, not once but twice. So much for social realism.

But it seems fair to award the laurel to Strindberg's amazing text, *Inferno*: a psychotic version of the Faustus story cut with Swedenborgian "correspondences." In this prescient, unclassifiable book that graphs Strindberg's nervous collapse in the mid-1890s, we are confronted with a kind of Occultist fantasia, a world of flowing forces and frequencies that seem located everywhere: in the natural scheme, in the mind, in the body, in the cosmos. *Inferno* is largely unknown outside Sweden, and much of the commentary it has garnered has to do with Strindberg's troubled life, with the psychological stresses that tore him apart. We can, however, read this book in a different way altogether, by focusing on the brave new world that it ushers into being, a world where the customary anchors of time, space, and ego have been lifted. To see *Inferno* as the radical text it is, I pair it with a modern sequel written by the contemporary author Lars Gustafsson; I do this in the service of emergent pattern. One remembers Borges's claim that Kafka's writing brought into visibility a prior chain of precursors whose conflated work gestured to a place that was unreadable . . . until Kafka appeared. The swollen-headed Gustafsson helps us to read the swollen-headed Strindberg; each refigures the subject's place in the world. More surprising, each charts a scheme—if we can see it—that threatens to cancel out the subject altogether. Hence my gambit is to cleanse both these books of their autobiographical trappings, to lift the veil of "self" so that we might then perceive the bold and evolving story of power that this duet of texts makes visible.

Lars Gustafsson's reputation as lyric poet and philosophical novelist is well established in both Scandinavia and Europe, where he has won many prizes. His 1977 novel, *Tennisspelarna*, hardly seemed an epoch-making book, and many have assumed that New Directions brought it out in 1983 in English essentially because the story is an American one, a

(barely) fictionalized account of Gustafsson's 1974 stint at the University of Texas as professor of Scandinavian literature. When Verne Moberg reviewed it for the *Scandinavian Review* in December 1983, she understandably placed the brief novel in the tradition of travel literature, in the subspecies of the Scandinavian author returning from American campus replete with bag of tall tales. And, indeed, *The Tennis Players* is so overtly autobiographical that it was inevitably treated as a kind of fantasy report on life in the U.S. as experienced by Lars Gustafsson. Among the fantasies mentioned were those he presumably entertained about his own popularity and centrality at the University of Texas. Perhaps he even inflated his prowess in tennis. The cover photo of the author "serving" in long pants and buttoned shirt seems suspiciously unprofessional, homemade, indicating still more strongly that his trip to America may have been some kind of ego trip as well, a self-indulgent self-portrait that hardly deserves more than the cursory reading Verne Moberg gave to it.

Readers familiar with this work may recall, however, that Gustafsson's academic pièce de résistance in his Texas seminar was no less than Strindberg's *Inferno* (1897), arguably the most swollen piece of self-portraiture in Swedish literature, the case study of another Scandinavian intellectual abroad, but at the end of the nineteenth century. One may even discern parallel professorial trappings in this pairing: Gustafsson as "the real thing" at Austin, and Strindberg as "instructor in alchemy at the occult University of Paris," in the words of the early Strindberg scholar Martin Lamm; it is true that Strindberg never quite knew where his university was located.[1] It is well known that an entire critical industry surrounds *Inferno*, and no small charm of Gustafsson's Texas story consists in the fact that an American black graduate student presents an explosively new "*Inferno* thesis" that will obliterate the Swedish scholarly work put together over the years to account for Strindberg's breakdown and persecution mania. Gustafsson himself has persistently argued that

Strindberg criticism is blinded by its obsession with the psychology of the author, and that the later work, from *Inferno* on, has been *misread as autobiography*, as the personal drama of August Strindberg, whereas it should be seen as something larger, as a pathbreaking kind of modernist writing: "what is often perceived as 'subjectivity' in Strindberg's works from *Inferno* onward is more than a personal peculiarity: it is a compositional principle."[2]

In short, *Inferno* must be granted its own new logic, freed from the empirical subject, August Strindberg, if it is to be properly understood; so, too, I argue, must *The Tennis Players* be liberated from the "Gustafsson memoir" category, if it is to be appreciated as a work of art in its own right. Each text has the guise of a confessional narrative, but ultimately *Inferno* and *The Tennis Players* have larger, mythopoeic aims, relating to no less than the changing of the gods and the shifting of power in their respective cultures. Lamm long ago demonstrated the evolving character of "the Powers," "Makterna" in Strindberg's mind in the 1890s, and he has articulated a progression from "elementals" on to higher spirits and "puissances invisibles"; however, it is possible to reconceive "power" in a non-religious fashion: power as energy, electricity, even as writing.[3] Rather than consign such notions exclusively to the Occult movement of the 1890s, however, one would do well to recognize an ambitious discourse about science, mind, and even parallel universes that is with us still today, in popular films such as *The Matrix*. Not surprising, then, that the modern film and the Swedish text both find that the locus of power is as much in our neural circuits as in our political institutions.

One is struck that so much of the criticism of *Inferno* is either genre-based or autobiographical; to be sure, Strindberg's cavalier presentation of these strange events in his life—which critics have thoroughly exposed as "doctored," as *truqué*—challenges most views of reliable reportage. And the text's obsessive concern with psyche and perception, with the

mind's take on what it sees, leads all too easily to "corrective" fact-finding critical moves, whereby one documents what "really" happened, as opposed to what August wrote. But it is time to turn this positivist model on its head: the seemingly swollen, tyrannical, mendacious ego that parades through *Inferno* is stunningly precarious, is witness to encroachments of every sort, is en route to being leveled, even dissolved, and that is the spectacle we will want to interrogate.[4] In the comparative discussion that follows, I attempt to show why Strindberg's text is more than "personal"; why Gustafsson's book deserves more attention, especially in America, than it has received; why, also, Gustafsson chose *Inferno* for his crucial "intertext"; and why, finally, we have much to gain in viewing them together, as a kind of "metatext" wherein each redefines the other.

Let it be said, at the outset, that *Inferno* and *The Tennis Players* are vastly dissimilar works. Perhaps nothing so much differentiates them as their respective tonalities: the agonizing and melodramatic account of near-madness in Strindberg's war with the "Powers," and the whimsical, nostalgic evocation of Gustafsson's Texas idyll. But *Inferno* is such a seminal modernist text that Gustafsson had his reasons for highlighting it in his American story some eighty years later, and the following commentary may suggest some of those reasons. One of the most striking features of *Inferno* is that it prophetically mythicizes the Scientist as the central power figure of modern society; I say this despite the fact that Strindberg's name rarely makes it into the pantheons of science (today). But, from a historical perspective, Strindberg's withdrawal from literary production and his dogged determination to establish himself as an alchemist in Paris in the mid-nineties have a paradigmatic quality to them; his life, as Spinchorn has put it, "became the burning glass of an epoch."[5]

Of course, the Faustian image is close at hand, but Goethe's truth seeker seems scholarly and glamorous compared to the figure we encounter in *Inferno*: begging funds to perform ex-

periments, publishing articles and entering the alchemist debate, displaying hands cracked and bleeding (so he claimed) by the heat from ovens.[6] But, if the elegance of Goethe's hero is absent, the enterprise is as metaphysical as ever: Strindberg's goal is to erase the boundary between matter and spirit. The monism he subscribed to goes beyond the confines of the elements themselves: "Meanwhile, whereas all were agreed in recognizing the unity of matter and called themselves monists without really being so, I went further, drew the ultimate conclusions of this doctrine, and eliminated the boundaries between matter and what was called the spirit."[7] It is easy to smile here (at the sweeping claims put forth) and to question the seriousness of Strindberg's scientific interests. But one needs to bear in mind the traditional aims of alchemy: not merely the mutation of the elements and the making of gold but also the restoration of a Golden Age via the ennobling of the human spirit.[8] We may doubt whether Strindberg points to genuinely Utopian vistas, but it will be clear that he does delineate a new kind of human subject, and a new kind of traffic in which that subject is caught. Hence one needs to imagine the actual consequences of eliminating the boundaries between matter and spirit: one—the protagonist of *Inferno* but also the reader—is thrown into an oddly and disturbingly egalitarian regime, in which phenomena that we have taken to be different and roped off from one another are now coexisting, intersecting on the same plane.

Inferno has often been read as the mirror of a diseased mind, but it deserves to be looked at as a visionary text. We are reminded, to some extent, of Blake's program: "If the doors of perception were cleansed every thing would appear to man as it is, infinite. For man has closed himself up, till he sees all things thro' narrow chinks of his cavern."[9] Behind Blake, of course, there stands the same figure of Emmanuel Swedenborg whose "correspondence theory" was to be crucial for many of the greatest nineteenth-century writers and poets, not only Strindberg but also Balzac and Baudelaire,

even Emerson; Swedenborg is clearly the seminal figure here, and it is no accident that Strindberg "discovers" the mystic's writings at a crucial turning point in *Inferno*, and he claims to find, now theorized, the vision of "Hell on earth" that he's been encountering for some time. Nonetheless, for the purposes of this argument, let us concentrate on the "perceptual" rather than the "religious" dimension of the Swedenborgian vision at work here, a vision that paradoxically must seem to be double-vision as it incessantly yokes together matter and spirit, finds that it can no longer even separate matter and spirit. We know that Strindberg intended his book to be a spiritual testament—"Le retour de l'âme" is how he put it to his then wife, Frida—but most fascinating about the text is the new dispensation it ushers in.[10] And we shall see that the "cleansed" doors of perception may be experienced more as a curse than a blessing.

What seems particularly striking about *Inferno* is its relentless pursuit of "energy," of the forces that move both the material and the moral world. Strindberg is delivering a picture of things where everything is suddenly alive, where the ordinarily discrete realms of physics and religion and personal history are seen to coexist in the same force field. Sensory perceptions are doubled by a strange spiritual aura; the phenomenal world is bristling with pattern for the person who knows how to read; the individual (wittingly or not, like it or not) is attuned to forces and powers ranging from cyclones of hatred to full-fledged Doppelgänger who appear in cafés and bars, implicating the protagonist's life in a strange relational mesh that mocks empirical logic. Such a view of things in the 1890s, especially in Paris (as Lamm, Brandell, and Lindström have shown), was not unique to Strindberg, and much of the literature and thinking of the times reflected a concern with the spiritual aura of the phenomenal world, a concern shared by alchemists, the Parisian occultists, the Symbolists, and the religious thinkers of the period. Lamm, not surprisingly, has interpreted Strindberg's "double vision" along reli-

gious lines: "there was a need, repressed by atheism but sub-consciously of a religious nature, that found expression in this effort to trace the infinite patterns that lay behind the apparent disorder."[11]

But one could also say that Strindberg was forging a new kind of perceptual grammar here, in that he refused (was unable) to abide by the Western divisive notions of here vs. there, spirit vs. matter, now vs. then; instead he saw himself, as it were, at the center of a circle where incessant radii move both out and in, casting him in the role of both subject and object. It is hard to overstate the stakes here: subject (the source of this traffic) or object (the target of this traffic); and if he is both, what does that mean? *Difference* (spatial, temporal) disappears from this scheme, inasmuch as the narrating voice registers a massive NOW, a new composite of forces and energies. Inside/outside, self/world, emotion/fact: all is coming together. Further, this force field may be understood in a way comparable to McLuhan's famous argument about media as the extension of the human nervous system, with just one major difference: McLuhan conceives of technology as forms of enhancement and empowerment, as means of furthering our reach, but what happens if the traffic goes in reverse? If the world bombards you with its frequencies? Consider, in that light, an exemplary letter written to Hedlund during the height of the *Inferno* crisis:

Hallucinations, fantasies, dreams, seem to me to possess a high degree of reality. If I see my pillow assume human shapes those shapes are there, and if any one says they are only (!) created by my imagination, I answer—you say only? What my inner eye sees means more to me! And what I see in my pillow, which is made of birds' feathers, once bearers of life, and of flax, in whose fibres vitality has traveled, is soul, creative power, and reality, as I can draw those shapes, show them to others.

And I hear a sound in my pillow, sometimes like a cricket. The noise that grasshoppers make in the grass has always

seemed magic to me. Like a ventriloquist, for I have always fancied that the sound came from an empty hall under the earth. Suppose that the grasshopper has sung in a field of flax, don't you think that Nature or the creator can make a phonograph from its fibres, so that his song resounds for my inner ear when, by suffering, self-denial, and prayer, this has been prepared to receive more distant sounds than it normally does? But this is where your "natural explanations" fail us, and I abandon them forthwith.[12]

There is something very special in this eco-system, this insistent mix and mingling of the material and the psychic, which Strindberg depicts, and one is struck by the insistence that suffering is what initiates us into this new cosmos, a cosmos that everywhere flaunts coherence and interrelationship. One's dreams are now readable as a text in the "higher" physics. We are reminded of the requirements of traditional alchemy: to descend into the underworld in order to wrest the precious elements into light.[13] Above all, we see a kind of "tracking" in these lines, an uncanny apprehension of energy and life in all its guises, and a generous sense of opened channels and strange new thoroughfares. There is something undeniably grand in the still-living birds' feathers, the still-echoing grasshopper's song; we glimpse the lineaments of a poem of the earth. I see Strindberg the mapmaker here, but his map charts and registers frequencies that erase the traditional boundaries we are accustomed to, so that hitherto invisible forces and connections now show up, as if we were dealing with a new flowchart or the exposure due to infra-red light or an electron microscope. All of this is to say that Strindberg's famous monism is very much the monism of a poet, a man willing to act on his belief in unity, in that he is willing to imagine just what a unified, related world would look like.

To be sure, there is an unmistakable religious cast to *Inferno*. The new map can be shot through with suffering; don't forget: suffering has already been posited as the door-opening mech-

anism to these larger perceptions. That's not all: the man who invades the elements is not just a scientist; he runs the risk of being damned. But the punishment is exquisitely attuned to the crime; monism puts us in an ecosystem that never stops coming at us. With the aid of Dante and Swedenborg, Strindberg comes to view his trials and travails as a living Hell—a perceptual, affective, and structural reality that *is* Hell—and some fifty years before Sartre proclaimed, "l'Enfer, c'est les autres," Strindberg defined Hell as a relational straitjacket: "It is the earth itself that is Hell, the prison constructed for us by an intelligence superior to our own, in which I could not take a step without injuring the happiness of others, and in which my fellow creatures could not enjoy their own happiness without causing me pain" (211).[14]

The systolic/diastolic between pleasure and pain is a familiar (albeit grisly) refrain in Strindberg's later work, especially *A Dream Play*. This view of life can be so dark—any pleasure I experience must come at your (or someone's) expense, and vice-versa (don't forget)—that we may miss its ecological punch, its insistence that discrete phenomena are not discrete, that the air I exhale is indeed the air you inhale, that all my moves are figural in ways that elude perception while cashiering hegemony. Strindberg's late plays give a virtually ballet-like form to this vision, but here, in *Inferno*, we are struck by its aptness as a kind of cubistic portraiture, as a way of taking the subject's fuller measure. One can, of course, invoke traditional morality and simply label such matters the work of *conscience* or its more punitive sibling, *remorse*. There is but a short step to take from this view of Hell to its "privatist" corollary that we live in a Hell of our own devising, that we are paying for our transgressions throughout our lives.[15] A familiar notion.

Strindberg himself often took this step, and so, too, does much Strindberg criticism; and when the psychologizing explanation doesn't cover, then a medical one is introduced, establishing a more acceptable causal relationship between our

deeds and our visions. Hence theories abound as to what actually was producing the hallucinations chronicled in *Inferno*, and we have been treated to a series of explanations ranging from schizophrenia, persecution complex, toxic poisoning (through alcohol and absinthe) to downright lying (on the part of Strindberg).[16] Even Brandell's carefully reasoned and scholarly study of *Inferno*, to which one is indebted for the fullest picture available of what went "into" the text, leads ultimately to a thesis of sublimated guilt, and once again, one feels that more attention should be given to the actual topography of Strindberg's "dreamscapes" and less to the so-called causes of which they are the so-called symptoms.[17]

Thus my central argument is that the beauty and significance of *Inferno* lie on the far side of any explanatory myth. Two stark, amazing theses emerge from *Inferno*: (1) matter and spirit are inseparable; and (2) explanations fail. Let us examine both these premises in more detail, beginning with the latter. As Strindberg and his friend, the American painter (suspected, naturally enough, to be a Doppelgänger for the faith healer Francis Schlatter), compare their respective visionary encounters, commenting on the distinctly human shapes formed by pansies in the window or the cupola of the Hôtel des Invalides, we hear the inevitable rationalist question: "'How are you going to explain these phenomena?'"(149]). Strindberg's answer is arguably the most modern statement in his book, but it is also of a piece with the poetic truth of the book: "'Explain it? Has anyone ever explained anything except by paraphrasing one set of words by another set?'" (149). Not only are visions more compelling than explanations (and this cannot fail to count for the writer), but explanations themselves are never more than a sleight-of-hand, a form of translation, a shuffling from one set of signifiers to another set, an effort to deny the bold unitary logic of vision by breaking it up and down into a cause-effect paradigm.

One might say that the world has always been multiple, living and spontaneous, a place of untrammeled power and

energy; in this light, causality (even history) is nothing but the successive explanations tossed at the spectacle. It is highly significant that the Swedenborg "master-plan" does not close the text but rather that Strindberg remains stubbornly true to his conviction that all explanation is provisional, even futile.[18] The tone of *Inferno* toward its close is not far from that of *Lear*, because it is the chastened vision of a world in which men are sport for the gods, especially insofar as they presume to understand their cosmos. This leads to the famous "joke theory" which describes the exceptionally vicious circle of Strindberg's successive beliefs:

> Fantastic, but exactly the vicious circle that I foresaw in my twentieth year when I wrote my play *Master Olof*, which I now see as the tragedy of my own life. What is the good of having dragged out a laborious existence for thirty years only to learn by experience what I had already anticipated? In my youth I was a true believer and you made of me a free-thinker. Of the free-thinker you made an atheist, of the atheist a monk. Inspired by the humanitarians, I extolled socialism. Five years later you showed me the absurdity of socialism. You have cut the ground from under all my enthusiasms, and suppose that I now dedicate myself to religion, I know for a certainty that before ten years have passed you will prove to me that religion is false.
>
> Are not the Gods jesting with us mortals, and is that why we too, sharing the jest, are able to laugh in the most tormented moments of our lives?
>
> How can you require that we take seriously something that appears to be no more than a colossal jest? (261–262)

In this passage we see the preeminently causal, sequential logic of conversion, discovery, and belief *flattened* out into the plane of one's life, a pattern of cyclical change, almost an embroidery, or motifs on wallpaper or an Oriental carpet. We all know the expression, "what goes around comes around," but this is a tough logic to live by, for it de-realizes,

123

brackets all the so-called choices and decisions and milestones and markers of a life. As Beckett is to say, "It can't matter, it must matter."

Note that Strindberg references his early breakthrough play, *Master Olof*, but we are entitled to perceive the makings of newer work that will draw ever more provocatively on the mechanics of this new nonlinear, discourse, this bitter recognition that kronos cancels kairos. The great late plays, *To Damascus* and *A Dream Play*, each display a virtually Cubist rendition of time, juxtaposing separate events, creating its own weave. Strindberg's chronicle of evolving/returning/altering beliefs and deceptions, much like that of Flaubert's Saint Antoine, is both personal and emblematic, mirroring the feverish quest for "master plans" that marks the latter nineteenth century.[19] But Strindberg's narrative has more pathos than Flaubert's and also, one is tempted to add, more economy. The exquisite focal point of Strindberg's cosmology is precisely the self, the quester who experiences in his person the unfolding workings of the world, who suffers the world's carnival of "ism's" and shifting ideologies.[20] Here would be the forces of culture on the move, existing as seismic tremblings, as moving tectonic plates; but they make their final appearance (and thereby become known) only on the surface; that is, on and in the human psyche. Life is a merry-go-round, and we are the moving horses. Of our movements the dance is made. The same person is successively true believer, free thinker, atheist, monk, socialist, and back again to believer. But we must not forget that none of these appellations "works," that each is an effort to account for something beyond logic, an effort to grasp and to house one's experiential knowledge of the world's unceasing impact, while yet knowing this too will pass. That is the knowledge that comes home to us in the flesh, but no amount of explanatory name calling will suffice.

It might be thought that these matters are abstruse, but they are not. Strindberg's corrosive vision exposes the sneaky but deadly lie in much of our daily agenda, ranging from getting

out of bed and going to work, on to those obscene narrative constructs that we call résumés. And the mendacity of it all is not the nastiest part: belief itself is what is sapped by such a perspective: belief and the enabling energies that move us through the chapters of our life. All this is unforgettably on show in those episodes of *A Dream Play* where fond notions such as "maturity" are plucked out for inspection, spun around, and exploded.

The joker thesis is one of bitter retrospect, and, mercifully, it does not stamp the whole of *Inferno*; on the contrary, this text intrigues and moves us most when it represents the perceptual invasion itself, the moments when all those "radii" home in, make themselves felt, release their tidings. The "present" goes out of business. Like Dickinson, Strindberg could rightly claim that he was a haunted house. But his gaze is more diagnostic; he wants to graph what is actually transpiring:

> Enter your room alone at night-time and you will find that someone has got there before you. You will not see him, but you will sense his presence. Go to the lunatic asylum and consult the psychiatrist. He will talk to you of neurasthenia, paranoia, angina pectoris, and the like, but he will never cure you.
>
> Where will you go, then, all you who suffer from sleeplessness, and you who walk the streets waiting for the sun to rise?
>
> The Mills of the Universe, the Mills of God, these are two expressions that are often used.
>
> Have you had in your ears the humming that resembles the noise of a water-mill? Have you noticed, in the stillness of the night, or even in broad daylight, how memories of your past life stir and are resurrected, one by one or two by two? All the mistakes you have made, all your crimes, all your follies, that make you blush to your very ear-tips, bring a cold sweat to your brow and send shivers down your spine. You relive the life you have lived, from your birth to the very day that is. You

suffer again all the sufferings you have endured, you drink again all the cups of bitterness you have so often drained. You crucify your skeleton, as there is no longer any flesh to mortify. You send your spirit to the stake, as your heart is already burned to ashes.

Do you recognize the truth of all this?

There are the Mills of God, that grind slow but grind exceeding small—and black. You are ground to powder and you think it is all over. But no, it will begin again and you will be put through the mill once more. (pp. 263–264)

Much of the force of *Inferno* is caught in these harrowing lines, and one could conceivably write an entire study of Strindberg focused exclusively on this passage. In Strindberg's direct address to the reader, he claims common cause with humanity, insisting that what the critics claim to be private and aberrant is actually public and widespread. (This, in itself, says goodbye to the autobiographical model, for it insists on the exploratory and exemplary character of deranged perceptions, as if one's story were an altruistic laboratory experiment.) All of us, he seems to be saying, are afflicted with symptoms and signs that cannot be accommodated by medical explanations.[21] All of us are visited.

To be sure, one's own past is held accountable for these manifestations, but even the past is shown to be anything but past or over; rather, one's deeds and—perhaps more important—one's desires (acted on or not) are still alive and potent, shaping one's environment long after they are presumably over or forgotten. Yet, perhaps most striking about the passage, beyond its Gothic trimmings of a man finding his own ghost in his room at night, is its extended focus on the very *equipment* of memory and feeling, the actual network of conduits that cargo past into present, thereby opening up the subject in siege-like fashion. The humming and the water mill suggest the fluidity of energy itself, seen in the pulsating life of one's past, seen earlier in the shapes and sounds discovered

126

in one's pillow. Foreshadowing Proust's magisterial episode of the madeleine, whereby the sunken past arises through the offices of a pastry dipped in tea, Strindberg presents this experience of "memory" in remarkably material, neurological fashion. Even if Strindberg thought of this as "soul" (and maybe it is), he nonetheless *represented* it as an engineer or physicist might, as a force field, as coursing power. (As we shall soon see, *writing* is itself on the line here.)

The dominant image, of course, is the Mills of God, and Strindberg takes care to emphasize its status as image, expression, metaphor. Traditional though the image is, it recovers some of its disturbing power in the use Strindberg makes of it: we see not only the crushing punishment and annihilation meted out by the gods, but equally important, we are struck by the mechanics of it all, the mill as generator, as producer of energy and power. Strindberg invites us to see in the humming (inside) and the water mill (outside) the very generative source of the memories and symptoms that are to come. The human psyche is here defined as a power system, a network of channels and circuits through and over which energy flows.[22] To be sure, he is not speaking of neural synapses and the like, but, nonetheless, we are not all that far from the materialist, pharmacological view of the subject that stamps modern psychology. But, unlike modern psychology, one senses that all this machinery is in the service of a *haunting*, as if Strindberg were out to show the company we keep (the company we cannot keep out), as well as evoking the transportation system that gets them there, and the various fuel sources that drive the whole consort.

Strindberg is remarkably keyed to the genesis of thought and memory, and he approaches these matters as much like a scientist as a poet. We find a further version of such musings in the magnificent final stanza of one of his urban poems, "Street Scenes, 3" or "Gatubilder 3," which brings us even closer to the "power station" inside us that never stops producing:

127

Dark is the hill, dark the house—
but darkest is its cellar—
subterranean, windowless—
the staircase serves as door and window—
and down there deepest in the darkness
stands a humming dynamo,
sparks flying around its wheels:
black and horrifying, hidden,
it grinds light for the entire neighborhood.[23]

Again, I am reminded of Dickinson's evocations of herself as a haunted house, but Strindberg bypasses ghosts and other paraphernalia so as to illuminate the *engine* itself, the power source that you must approach in the dark cellar of yourself. Gustafsson himself has offered an eloquent commentary on this poem, emphasizing both the Freudian and the linguistic features of the piece. The image of the dynamo is thus assessed as a metaphor for the unconscious, for the incessant libido production that neither asks our permission nor yields itself to our scrutiny.

But Gustafsson's most interesting observation, striking the anthropological note that is so fascinating in Strindberg, has to do with the astonishing metaphor of grinding light ("mal han ljus" says the Swedish). You may recall that the Captain, in *The Father*, evoked the very same image: "my brain grinds emptiness until it catches fire." How close are we to the Mills of God? What can it mean to grind light, to grind emptiness? What is produced? An old verb in a new role, Gustafsson says, and he points out that whereas his parents still say, "Tänd ljuset" ("light the light"), his children now say "slå på ljuset" ("turn on the light").[24] Our metaphors are dense with historicity, and Strindberg has intentionally mixed his registers, giving us an agrarian verb for an electrical phenomenon. One is not too far here from the logic of Thomas Kuhn's conceptual revolutions, the shifting of paradigms from one age

to another. Strindberg wants us to see that a new era is at hand, that the power from this dark room makes our collective light, as if to signal the societal reaches of his art. Hence Freud seems close here, but not only Freud, for the poem centralizes the shift in the production and dispersal of energy, leaving us ultimately with an image of the human mind as "public utility" in the most rigorous sense of the term. The mills and the dynamo speak for what is most modern in Strindberg's text. *Inferno* ushers in a new vision of power, a view of energy and current that simply outruns any traditional notion of psychology or religion or ideology.

But if the poem represents the mind generator as the producer of current, we see, in *Inferno*, a drastic picture of things the other way around. The mills that grind exceeding fine, that purify the subject into black dust, seem to have eroded all the defenses and barriers that usually keep the world at bay. (How often Strindberg makes us realize that the world usually is kept at bay, for most of us; his dark work tells us of breeched defenses, of levies or dikes that crumble. One would be forgiven for thinking of tsunamis and hurricanes.) Instead, *it* rushes in, unstoppable, on currents and in channels against which there is no defense: the ears hum, the heart palpitates, the objects and the people seen are figures from one's past, from one's dreams. Here is the imperious new eco-system that Strindberg has depicted, a view of psychic entrapment that is infinitely more fascinating in its workings than it might be in terms of any critical explanation offered for it. Lamm and Brandell have pointed out Strindberg's interest in figures like Rochas and Guaïta, both of whom advanced theories of telepathy and invisible currents, resulting in the capacity to strike people from afar. Indeed, as Hans Lindström has shown in *Hjärnornas Kamp* (1952), one could find figures all over Europe evincing interest in mesmerism, hypnotism, suggestion psychology, hysteria, and the like, but it would not be

easy to find any major artist who transformed those materials into art quite the way Strindberg did.[25]

Inferno is a nodal text because it offers us a radically new picture of man's place in his world. Opened and invaded, coextensive with the world, the Strindberg self resembles nothing quite so much as the prodigious creature drawn by Munch in *The Scream*, a figure of pure victimization, a medium in the most awful sense of the word. The scream of Munch's painting is fed by the tumultuous, paroxystic river and sky, every bit as much as it is by erupting psychic materials. So many of the figures in this book—Ernst Josephson, Knut Hamsun, Tarjei Vesaas, Ingmar Bergman—are committed to an art of siege, of *breaking through*. Nineteenth-century assumptions, and a good many of the twentieth century as well, are coming to an end in these texts, and a new worldview is being adumbrated, one considerably closer to our own Einsteinian, "wired," and psychotropic scheme of things. But the collapse chronicle in *Inferno* remains special, and even has a gallows humor that needs remembering (when one indicts Strindberg for Scandinavian gloom). Let us take a closer look.

Early on, *Inferno* informs us of a potent spirit world. Above all, we see a world of energized signs: street names seem annunciatory; portentous initials (such as A. S.) and numbers or letters denoting crucial chemical compounds appear at dramatic moments; "chance" accidents are quickly seen as tailor-made humiliations and punishments.[26] The outside world increasingly loses its randomness and alterity, as it becomes increasingly yoked into some preordained scenario, some mysterious teleology where everything fits and is locked into a damning pattern.[27] But note: the outside world is more present than ever, even as it is annexed into the protagonist's scheme. There is precious little freedom in such a realm, and we can anticipate that each and every event will be gruesomely overdetermined, calling into play some earlier deed or misdeed on Strindberg's part. At a certain point, however, the pace and the density of these episodes begin to alter,

and this is initially signaled by the entry of "doubles" onto the stage. The following passage shows us what Strindberg is able to do with these "bristling" situations:

Disquieting things happened in the hotel. The day after my arrival I found, on the board in the vestibule upon which the keys of the rooms were hung, a letter addressed to Mr X, a student whose name was the same as my wife's. The stamp bore the postmark Dornach, the name of the Austrian village where my wife and child were living. This was mysterious, as I was quite certain that Dornach had no post office.

This letter, displayed in a way that was obviously intended to attract attention, was followed by several more. The next one was addressed to Dr Bitter and postmarked Vienna. A third one bore an assumed Polish name, Schmulachowsky.

Clearly the Devil now had a finger in the pie, for that name was pure fabrication. I realized where my thoughts were being directed, namely to one of my mortal enemies who lived in Berlin.

Yet another that arrived had on it a Swedish name that reminded me of an enemy in my native land. Finally came a letter posted in Vienna, on which was printed the name of Dr Eder's firm of analytical chemists. In fact, someone was spying on my synthesis of gold.

I had no doubts left. This was a plot, but the Devil himself must have shuffled the cards for the tricksters. No ordinary mortal could have hit on the idea of sending my suspicions roaming to the four quarters of the globe; it was altogether too contrived.

When I asked the waiter to tell me about Mr X he artlessly replied that he was an Alsatian. I could get nothing more out of him. Once, when I returned from my morning walk, there was a card in the rack just by my key. For one moment I was tempted to solve the riddle by having a look at it, but my good angel immobilized my hand at the very instant that a young man appeared from his hiding place behind the door.

I looked at his face. He was like my wife. We bowed to each other without uttering a word, and walked off in opposite directions.

I have never been able to get to the bottom of this plot and still do not know who the conspirators were, as my wife has neither brothers nor male cousins.

This was a state of suspense and the perpetual threat of vengeance was torment and enough for half a year. I bore this, like everything else, as a punishment for sins known and unknown. (137–138)

Quoted in its entirety, this "uncanny" episode displays the elaborateness and the fastidiousness with which Strindberg "re-scripts" the events that befall him, thrusting them all into a private psycho-drama, drenched with intentionality: disguised names, devil's control, plots, hiding places, and the like. The fine sense of certainty conveyed by Strindberg's authoritative tone—"säker" ("certain"), "i avsikt att bli observat" ("obviously intended to attract attention"), "falska polska namnet" ("assumed Polish name"), "intet tvivel mera" ("I had no doubts left"), "alltför sinnrikt" ("altogether too contrived")—must give the reader pause, for there is something unsettling in any narrative voice that is so oddly and intuitively sure of its findings. This so-called evidence is being manufactured as we watch it; paranoia works along exactly these lines. The outside world—keys, Mr X, Dornach, Dr Bitter, Vienna, Schmulachowsky, Berlin, Dr Eder, waiter: a whole cosmos—is being swallowed up, ingested as self-portrait. It is especially worth noting the role accorded to language as conduit: letters, names of villages and people, these are the harbingers of that newer vision which *Inferno* announces, a vision of ceaseless cohering, since nothing can be random or innocuous in such a scheme.

This peculiar type of "feathering one's nest" lays bare the supreme domestic, "homing" instinct of the self: to "personalize" the discrete details that come one's way, to insert them

into one's private narrative, to endow them with a quasi-tele-
ological purpose. Such activity—the basic ordering strategy of
all subjects making their way in a scheme that is not theirs,
the routine, incessant projects of domestication that both
elude and constitute our "knowing"—borders on comedy in
the passage just quoted, as we see Strindberg reaching far and
wide in his interpretations, yet remaining significantly un-
touched by it all, bowing wordlessly to the mysterious Mr X,
as safe and distant in his speculations as a character in a tale
by Henry James. Proust and Joyce will later show just how
far this projective/assimilative logic can go.[28] But, in *Inferno*,
somewhat like a cautionary algebraic tale, the blank spots, the
"unknowns," the Mr X's all become filled in, take on the spec-
ificity of doom itself. It all begins with the sound of a piano:

> I pricked up my ears like a charger at the blast of a trumpet. I
> straightened my back, drew a deep breath, my whole self meta-
> morphosized. It was Schumann's Aufschwung. And what was
> more, I was sure that it was he who was playing it. My friend
> the Russian, my pupil who had called me "Father" because I
> had taught him all he knew, my famulus who had called me
> "Master" and had kissed my hands because his life had begun
> where mine had ended. He had come from Berlin to Paris to
> kill me, just as he had killed me in Berlin, and for what reason?
> Because Fate had decreed that the woman who was now his
> wife had been my mistress before he had known her? (151–152)

Thus begins the saga of Strindberg haunted by the Pole
Stanislaw Przybyszewski, called Popoffsky in the text, al-
ready hinted at in the assumed Polish name, "Schmulachow-
sky," and obscurely lurking behind Mr X, now rendered in-
creasingly and pathologically present within the narrative.
Strindberg persistently interprets these unsettling experiences
as some personal punishment meted out for his past sins, both
"known and unknown," and a good deal is known about the
relations between Strindberg, Przybyszewski, Dagny Juel,
and Munch in the tumultuous Berlin adventures that pre-

ceded his arrival in Paris.[29] But, once again, one needs to distinguish sharply between the harrowing psychic phenomena depicted in *Inferno* and all explanatory theses that might account for them, including Strindberg's own hypotheses. What is rendered indelibly in *Inferno* is the transcendent power of spirit, the agonizing discovery that the world is filled with ghosts, avenging angels that speak in countless tongues and signs. Where they come from counts less than the fact that they are there. They cannot be explained (away):

> Enter your room alone at night-time and you will find that someone has got there before you. You will not see him, but you will sense his presence. Go to the lunatic asylum and consult the psychiatrist. He will talk to you of neurasthenia, paranoia, angina pectoris, and the like, but he will never cure you. (263)

In the haunting, lurking presence of Popoffsky, we may discern the beginning of a veritable psychic invasion. He now knows he is a target, because the external signs pile up: spilled absinth, filth in his glass, his being taken for a beggar, unaccountably striking terror into Munch (whom he visits, all the while referring to him as "the Danish artist"), staring at Munch's portrait of Przybyszewski in which the Pole's head seems cut off (just as Strindberg had recently dreamed it), his encountering the written words "mård" ("marten") and "gam" ("vulture")—bringing to mind the Pole and his wife— hearing that the Pole has poisoned his wife and children (*sic*, it will turn out) and fearing that he has come to Paris to do the same to Strindberg himself. This sense of vampirism and encroachment is finally expressed in a crucial image central to this entire study: "since his arrest, the Russian's hatred is causing me pain such as one might feel from the current of an electric machine" (163).

We have already seen the "humming" and the water-wheel and the mill; these images can be said to constitute a coherent iconography of power and energy, and they invariably appear

as conduits for the visitations Strindberg is to receive. But the dominant metaphor (if it is a metaphor) is electricity, and as the poem "Street Scenes, 3" makes evident, electricity betokens the energy of the mind, the flowing current between poet and community, a current that can insidiously flow upstream as well as downstream. Hence it comes as no surprise that the stranger, who kept his distance as Mr X, now reappears in a far more invasive fashion:

> At the beginning of July all the students left for the holidays and the hotel was unoccupied. My curiosity was therefore aroused by the arrival of a stranger, who was put into the room adjacent to my writing desk. This unknown man never uttered a word; he seemed to be occupied in writing something behind the wooden partition that separated us. All the same, it was odd that he should push back his chair every time I moved mine. He repeated my every movement in a way that suggested that he wanted to annoy me by imitating me.
>
> This went on for three days. On the fourth I made the following observation. When I went to bed the man in the room next to my desk went to bed too, but in the room on the other side, next to my bed. As I lay in my bed I could hear him getting into his on the other side of the wall; I could hear him lying there, stretched out parallel to me. I could hear him turning the pages of a book, putting out the lamp, breathing deeply, turning over and falling asleep.
>
> Complete silence then reigned in the room adjacent to my writing desk. This would only mean that he was occupying both rooms. How unpleasant to be besieged on both sides at once! (172–173)

Although the passage stresses physical separation (wooden partition, other side of the wall), a form of ghostly, wordless intercourse is clearly taking place. Whoever or whatever is there is beginning to fuse with Strindberg, through repetition of movements and gestures. Once again, we cannot fail to see that this fusion is intricately related to writing (he is next to

the writing desk, he is writing something, he is reading a book), and writing itself seems linked to sleeping or dreaming, as if all these activities were privileged modes of communication, unstoppable, even transgressive and penetrative.[30] We see, ultimately, two men going to bed together ("besieged on both sides at once" [or "belagrad från två håll" as the Swedish has it] has a disturbing ring to it), but this intimacy is soon to become pure pain. Strindberg now experiences being "subjected to an electric current, passing between the two rooms on either side of mine," and he shrieks, "Someone is killing me! I will not be killed!" (175). It is an utterance Strindberg will make more than once in his life, and it compresses all the logic of paranoia into one sweet phrase: *you* (whoever you are) are doing this to me, and I won't let you get away with it. The logic of paranoia is indeed a social logic, inserts me into the world, establishes me as target.

Strindberg leaves the fateful Hotel Orfila in all haste, but the famous chase (famous for Strindberg fans) is now on. In the next hotel, near the Jardin des Plantes, strange lodgers again appear, the servant girl looks at him with pity, and he knows that the execution has been decreed. But why? *But why?* Ever since the story of Job, this question has accompanied human suffering; but once you remove God from the cast of characters—and this is not easy; Strindberg will later, with the help of Swedenborg, ascribe all these miseries to just such a figure—you have nothing but narrative left: the narrative of your own comings and goings, the whole mesh of human contacts that only *seemed* over and done with, stored away in the past and harmless. In this case—don't forget: this man could hear the grasshoppers singing in the flax that was to become the feathers of his pillow—the actual machinery for the job is audible if not visible.

In the room above mine they had set up a wheel that went round and round all day. Condemned to death! I was convinced of it. But by whom? By the Russians? By the devout, by the

Catholics, the Jesuits, the theosophists? For what reason? As a sorcerer or a practitioner of the black arts? Perhaps it was by the police, as an anarchist? That is a charge very commonly employed for getting rid of personal enemies. (178–179)

Note, once more, the folly of explanations. The "powers" that have been offended are legion, and one's crimes are endless, but the punishment never varies. That night, after Strindberg has ceremoniously made his adieux and prepared himself for death, that wheel which goes round and round, hums and grinds, goes again into action:

I awoke. A clock in the house struck two, a door was shut, and I was drawn from my bed as if by a vacuum pump that was sucking at my heart.

Hardly had my feet touched the floor than a stream of electricity was discharged upon the nape of my neck, pressing me to the ground. I struggled up, grabbed my clothes, and tore out into the garden, a prey to the most horrible palpitations. (182)

He flees Paris for Dieppe and is again waylaid:

But now a discharge like a cyclone fell upon me and tore me from my bed. The hunt was on once more. I hid behind walls, I lay down close to doorways, in front of fireplaces. Wherever I went, the furies sought me out. (186)

Then, in Ystad, he seeks asylum at the home of his friend, Dr. Eliasson, and once again the fateful icons reappear, regrouped:

The doctor installed me in a small flat in his house. My attention was immediately attracted to an American bedstead of iron, whose four uprights were surmounted by brass knobs that resembled the conductors of an electric machine. In addition there was a flexible mattress, the springs of which were made of copper wire, twisted into spirals like those of a Ruhmkorff induction coil. You may judge of my fury when I found myself faced by this piece of devilish bad luck. (189)

With this formidable equipment in place, the outcome is certain: execution. The grand finale orchestrates all these "elements" into the most spectacular alchemist performance of the novel, a moment of pure transformational energy, pure metamorphosis, in which all the disparate images and forces fuse together, and the locus of their fusion is the besieged self.

Yet we *know* that "I" cannot die, cannot be fully snuffed out, while recording his story, that all first-person narratives testify to continued life. But the interest of *Inferno* lies well *within* these grim ultimacies, because its gambit is to illuminate "I's" fateful intercourse with the world (imagined? isn't it always imagined?), "I's" ongoing dramatization of its losing battle with the "Powers" that are bent on its destruction. But in Strindberg's culminating notation of encroachment and doom we may be surprised by what we find. It is as if the puzzle were at last completed.

> I was also much disturbed by what sounded like the steady roar of a machine. As it happened, I had been plagued by a buzzing in my ears ever since I left the Hotel Orfila, a noise that resembled the pounding of a water-wheel. I was therefore doubtful whether the roaring noise I heard was real or not, and inquired about it.
>
> "The press in the printing house next door."
>
> There was a simple and natural explanation for everything, but it was just this simplicity in the means employed that so much alarmed me and drove me mad.
>
> Then came night with its terrors. The sky was overcast, the air heavy; there was thunder about. I did not dare to go to bed and spent two hours writing letters. Annihilated by weariness, I undressed and crept between the sheets. An awful silence reigned over the house as I put out the lamp. In the gloom I could feel someone watching me, someone who touched me lightly, groped for my heart and sucked. (190)

To one's amazement, the author never explains the possible connections between these electrical disturbances and writing; indeed, the printing press seems to him an innocuous

source of the roaring noise. But the reader—trained now to be something of a monist in these matters—can hardly mistake the bold logic of this text, a principle of linkage and connection that is so imperious that the protagonist even puts his ear to a telegraph post whose humming noise (language itself, now audible current) intrigues him, and listens "as if bewitched" (196). On the one hand, the writhing, buffeted figure who is hurtled out of bed by massive jolts of current is undergoing what every modern reader recognizes as electrocution, or at the very least, an epileptic seizure, which is also an electrical overload in the brain. We know that Strindberg experienced *writing* as a form of outbreak, of eruption; Frida has reported how "it burned inside him until it exploded."[31] We know as well of his proclamation that writing is for him a kind of *ferment*, or even a "fever" that comes when *it* wishes, takes over, but cannot be controlled or summoned.

Strindberg's view needs to be understood generically, not personally: writing is a form of independent and mysterious power. As far back as *The Father* (1887), Bertha's failed automatic writing and the always/already presence of textuality signal something of the indigenous authority of the *word*. But these matters reach a crescendo in *Inferno*. The presence of generators, printing presses, writing, and dreaming indicates a communications network of extraordinary proportions, and we sense that these two systems are faces of each other: electric current is the neural conduit for human thought, not only one's own thoughts, but—and this is frightening—the thoughts of others as well; writing, too, we see, is a flowing current, a channel that connects minds divided by time and space, a circuit not only of energy but also of power: psychic power, moral power, sexual power.

Power is everywhere imaged in terms of language and electricity in Strindberg's work. Lagercrantz has demonstrated Strindberg's extraordinary interest in language studies at the very end of his life, but one can find evidence throughout his work of the peculiar potency with which language and its vehicles can be vested.[32] Whereas everyone remembers

the Count's boots in *Miss Julie* (1888), the speaking tube (through which orders are transmitted) is perhaps more intriguing still as an icon of authority, suffused with the kind of energy that fetishes and sacraments possess; it is here the voice of the gods is to be heard, and, at a critical moment, it will be heard, at least by Jean if not by the spectator, and we realize that we are seeing a nineteenth-century "hi-tech" version of the Oracle. In some strange way, "language" is always entering the world of Strindberg's protagonists, and we may view the post office in *To Damascus* (1898) in a similar light, for there, too, the protagonist receives fateful messages, containing either money or humiliation, functioning almost like the classical messenger in Greek tragedy. *Dance of Death* (1901) offers a similarly magic apparatus in its telegraph, that system of communication which Alice is forbidden to use, the visible network that links this enclosed tower-prison to a larger world.

Things flow in Strindberg, and he obliges us to see the etymological purity of our dry term "influence," which comes to mean precisely "flowing into"; this flow is easily sexualized as well, so that he can refer to the impact of Nietzsche's writings on him in terms of a seed that has entered the uterus of his mind and impregnated it. Indeed, for such a mind, jealousy is tantamount to a fear of invasion, since the woman's intercourse with another man is experienced as one's own sexual defilement. (The displacements and telepathy in play here are mind-boggling; it would seem there is no kind of bad news the Strindberg subject fails to take in.) The flip side of Strindberg's well-known ego-mania is a paranoid logic that de-centers and displaces power, that thinks in terms of conspiracy because it knows itself to be vulnerable and permeable and fundamentally passive in the face of the potent machinations of others. Boundaries do not exist. Reading others, thinking about others, desiring others; or their opposite numbers, being read, being thought about, being desired: these are all two-way circuits through which energy travels

and arrives, creating palpable and sometimes unhinging encounters or fusions. No surprise that Strindberg references sexual congress when he describes Nietzsche's impact. Little is more revealing, on this heading, than the remarkable passages in his *Ockulta Dagboken*, where Strindberg recounts the frequent nightly visitations of his estranged wife, Harriet Bosse, outright sexual encounters yet experienced alone and quite helplessly. What does one make of these "encounters," these strangely moving experiences that simply do not conform to any notion of masturbation or even dream, as we usually conceive it?[33]

It is essential to bear in mind this strange "availability" that characterized Strindberg, when one tries to assess his notion of "self." We can thus perceive the radical defensiveness of his project, and the following much-cited passage from *Inferno* acquires the resonance it deserves:

> All that I know, little as that may be, springs from one central point, my Ego. It is not the cult but the cultivation of this which seems to me to be the supreme and final goal of existence. My answer to his objections was always given in the same decisive form: to kill the Ego is to commit suicide. (168)

Not the cult but the cultivation of the ego: that would appear to be a reasonable goal, but in the bizarre dispensation of the Strindbergian perceptual scheme we can see just how difficult such a move might be, akin, if you will allow the simile, to Lear's building a card-house out on the heath.

Strindberg the egoist, the egomaniac, is a man we know all too well, and Strindberg criticism has, understandably enough, been mightily taken up either with the all-too-available biographical data provided by the man himself or with his formulations regarding "the Powers," and it has been too inattentive to the audacious re-definition of "power-as-language," which informs so much of his work. He experienced the writing of others as infectious, and he wanted the spectators of his plays to leave the theater "pregnant with the seed

141

of [his] soul."[34] The combination of Strindberg's monistic beliefs and his peculiar temperament led to the making of an artistic universe that is astonishingly unified by channels and circuits of psychic and spiritual energy. Whereas the prevalent critical view (represented ably by Spinchorn) seems to be that *To Damascus* (1898) and *A Dream Play* (1901) are the most fully successful artistic embodiments of Strindberg's painful discoveries and obsessions, it is nonetheless *Inferno* that succinctly and most provocatively makes the prophetic link between energy and writing, between power and language. Yet, "language-as-power" is a profoundly troubling proposition, and it by no means elevates or empowers the artist who uses it, no matter how much Strindberg desired such verbal clout; on the contrary, it leads to a radically de-centered view of verbal energy, as if the humming wires and grinding mills and neural circuits themselves somehow preexisted, antedated the fated individuals who become the helpless receivers.

This is why the electricity metaphor is so apt. Electricity revolutionizes the older concepts of cause-effect and Newtonian force; electricity is a force field where contacts and connections are instantaneous and immediate, where the individual receiver "suffers" the power of the system. To call this simply "paranoia" is to miss the larger picture: a picture of the human subject forever "plugged in." Plugged in to what? To his or her own coursing past, to the inrushing traffic of what one apprehends (shapes, markers, faces, sounds), but also—via language, via writing—to the living text of the world, to its flowing power. Electricity connotes, in Strindberg, a universe that is literally charged and flowing, where those who are cursed with vision must record the violent frequencies of which the world is made. Choice does not exist in such a scheme. Nor is protection possible, since one comes to know the world in one's flesh, through the shocks one has received. Finally, such a view is, strangely enough, more anthropocentric than one might suspect, because it sees Mind itself as the great wheel, the mill, the generator, the origin of these forces.

Alchemy is a heavy, freighted topos. Strindberg falls, often enough, into histrionics and breast-beating, as he performs his double role of explorer and lightning rod. Yet, Mona Sandqvist is right in remarking that *Inferno* is ultimately a playful, half-parodic form of alchemical quest; it is, indeed, on the way toward being postmodern.[35] And the best way to measure that trajectory is to look at its provocative if goofy successor, *The Tennis Players*, a delicious little spoof that would easily convince American readers that Scandinavians are a funnier lot than we realize. It is not and need not be known exactly what Lars Gustafsson saw in *Inferno*. But the purpose of the remainder of this section is to show how *The Tennis Players* picks up those various threads which Strindberg laid out, and reworks them into a strange tapestry of its own. To be sure, we have no "electro-hysteria" here, no "plugged-in" human subject. But the contours of the classical bounded self are in trouble once again. In Gustafsson's text we see a dazzlingly postmodern, fully computerized version of *Inferno*'s energy system, now become flagrant and highly unsettling in its implications of power in the New World.

Lars Gustafsson would doubtless be the first to recognize that Austin, Texas, in 1974, is unlike late-nineteenth-century Europe. Pedaling on his ten-speed up the steep Texas hills shortly before dawn, Gustafsson used to whistle "Siegfried's Rhine Journey" from Wagner's *Götterdämmerung*, but no American could have heard more than "a faint peep"—not only because pedaling makes whistling hard, but also because "'Siegfried's Rhine Journey' deals with a Norse hero on his way down a dark, foggy river toward strange Germanic adventures in the gathering gloom, while I journeyed, in light that steadily increased in strength and brightness, toward the tennis court in a part of town on the other side of Lamar Boulevard."[36] Texas is sunrise; Wagner and Nietzsche and Strindberg are all part of a dying world, a twilight of the gods. The only link between these two realms is, of course, Visiting Professor extraordinaire Lars Gustafsson, who must bring to

his Austin students "Friedrich Nietzsche and Nineteenth Century Scandinavia" (3).

As will become clear in this argument, Gustafsson's slim American memoir is a resonant book, rich in historical perspective. But now, some three decades after its publication, *The Tennis Players* intrigues an American reader with its peculiar view of Texas, Texas-as-seen-by-a-Swede, Texas long before September 2001 and the Bush presidency. Texas, already then, appears to be a world unto itself, and everything outside it is quaintly "meant for war and tourism" (15). Americans cannot possibly comprehend Nietzsche's *Übermensch*, because when translated as "Superman," he is "nothing but a character in the comics whose adventures we have all followed in our childhood at some kitchen table or other, a Fascistoid policeman who changes into tights in telephone booths and takes part in all the big police actions" (5). The widely mythologized view of America as Never-Never Land, a place without a past, a haven of total freedom and immediacy is unforgettably imaged in the central physical and poetic activity of the novel: tennis.

Gustafsson's philosophical mettle, his sheer intellectual freshness, are on show in the fine descriptions of this game we thought we knew. Looking at the speeding ball coming toward you, "a wordless challenge in a world beyond words" (9), you realize that there are no antecedents, no history, not even a self: "In reality you are no one" (9). "Not unlike a visitor from another planet" (36), the tennis ball announces an America that is ever new; in such a scheme, "you are no one," and Gustafsson's character Abel's law of an endless present holds true: "There's never any ball except the one you've got in front of you" (63). This is the heady stuff of myth, and Lars Gustafsson of Sweden is drawn to this promise of a new life, a vita nuova. Superior athlete, tennis freak of no mean stamp, tanned, in great physical shape, attuned to all sports, the Swedish professor remembers a Texas self that would have

been unrecognizable in Stockholm; America's sunrise, he sees now, long afterward, was also his own.

But the seductive appeal of America the New, the Now, the Only, must, like the song of the sirens, be resisted. The visiting professor fully knows how alien his nineteenth-century European material is to his American audience, and a concerted effort of will is necessary for him to "leave" Texas and reenter the past:

> Tanned and fit as a young god, with my racket in one hand and a pile of books in the other, I climbed my lectern, making a springboard dive, a violent somersault, into another continent, another century, into a world where Nietzsche still walks with Lou Salomé, where summer comes across the Starnbergersee, where Strindberg's guitar twangs in the smoke of Zum Schwarzen Ferkel in a Berlin so filled with genius and coal smoke that the sky is as dark as the darkness in the black eyes of the Polish writer-in-exile Przybyszewski, a time of false dogma, disappointments, heterodoxy, and strange elitist theories: a time when intellectuals are getting tired of beating their foreheads bloody against the wall of lies and instead start asking themselves if perhaps lies and truths come to the same thing in the end. (3–4)

The professor must bridge the apparent chasm between these realms because that time of revolutionary fervor and despair and hope—distant and alien though it may appear—casts a dark shadow and a great light on America itself. At first, one notes only how quaint and faraway it all seems: "A time of coal smoke and absinthe, when Europe starts to give up hope, when every moral obligation is being questioned by brave souls in sepia attics and during walks along the idyllic shores of Lago Maggiore, lined with health resorts." (4). But this picturesque, history-book, scrapbook past conceals a great secret: it leads to us: "A time when our own catastrophes are being prepared" (4). The serious burden of this whimsical

book consists in making visible those lines of force that connect the Old World to the New, that make us see in the upheavals of nineteenth-century Europe a sign and origin of our own conflicted state.

Where the historian might proceed in linear fashion, Gustafsson the novelist works more stealthily, more subversively: his Texas memoir is to be at once a story of Texas and of Europe, a series of anecdotal personal reminiscences and also an anatomy of the sociopolitical scene eighty years after *Inferno*. To achieve this simultaneity, Gustafsson needs to do two separate things: inject past history into a living narrative and write the story of the present in such a way that it resonates with alternative scenarios and metaphoric extensions.

Hence Gustafsson weaves into his account the accounts of others, in particular, the circuitous journey of Bakunin the anarchist from Siberia to Japan to San Francisco to New York to London to Alexander Herzen's apartment; thus Herzen says in 1861 that the past is not over: "'At that moment . . . we understood that the year 1848 never died in our hearts'" (79). And this, in turn, triggers the recognition that 1968, the year of the last revolution, is still, strangely enough, playing in Texas in 1974. The American view that the present is unique and autonomous is a cyclopic and tone-deaf view; no nation can escape history, and no event is without echo. The professor's story is more stereophonic than it appears, and the individualist cult of the here and now must be inscribed into the ecosystem of history. It is not true that "in reality you are no one," that "there's never any ball except the one you've got in front of you." To be sure, the tennis metaphysic is indeed that of a fabled New World, a blank slate, a timeless present: "Empty, happily empty, like a zero, like a sign without meaning, the ball just hung there" (27); but the entire thrust of *The Tennis Players* goes the other way, shows us that the moment is full rather than empty, that the sign can never, even in Texas, be without meaning.

146

The spectacle of Gustafsson's life in Austin is as richly met-
aphoric and echoing as that of Strindberg's stay in Paris. The
contentious choice of what music the university will cham-
pion (between Verdi and Wagner) is, as everybody comes to
see, a clash of potent symbols, each profoundly rooted in a
cultural and political history, involving Democrats and Re-
publicans, Fascists and Communists, trustees and faculty. No
event in this book is as discrete and single as it looks; things
signal other things, hint at their own history, show themselves
to be embedded and enmeshed in ways we had not expected.
This is nowhere more in evidence that in Gustafsson's treat-
ment of Strindberg's *Inferno*, for it is in that treatment that we
see the true Strindberg legacy.

In informing us of how popular he was at the university,
Gustafsson mentions another visiting professor, an Indian
guru, who is a kind of rival for the Swede. These two Strang-
ers are linked even more closely when Gustafsson "inadver-
tently tried to put a seminar on Strindberg's 'Inferno' in the
same time slot as his" (6), which, we are assured, "almost
caused a campus riot" (6). It is tempting to see this Indian as
a dark double for the Swede, and hence to see the Indian's
featured theme song "that all of reality is an illusion created
by ourselves" (6) as an alternative reading of *Inferno* itself. In
this light, Strindberg's book would be a mystical, perhaps
paranoid, self-contained case study in illusion. But now
things in the seminar heat up as Gustafsson informs us of his
black graduate student Bill's great new archival discovery:
Zygmunt I. Pietziewskoczky's *Mémoires d'un Chimiste*. This
new piece of evidence (sublimely invented [I have to believe]
by the author Gustafsson) has an amazing impact on all that
seemed self-contained: far from being "an illusion," *Inferno* is
the account of "real" anarchists seeking real "Power." Strind-
berg may have thought he was recounting his private experi-
ence, but he was writing History; the doctors and critics may
have thought he was suffering from "neurasthenia, paranoia,
angina pectoris, and the like," but he was a more sensitized

recorder of the age than they ever understood. Bill's discovery places *Inferno* within a fascinating cultural web, and we see the nineteenth century come to life:

> To get to the point: in one of its last chapters, this strange memoir contains a complete confession of how it all happened. August was on the right track to begin with: both he and his readers turned out to be mistaken. There was a group of anarchists, Poles in exile, friends of Przybyszewski's, who gathered in the apartment above Strindberg's in the Hotel Orfila. Their aim was not to kill him but to find the secret behind his alchemy. They wanted to overturn the social order by throwing huge amounts of gold francs on the French market. That August was almost killed was simply due to their experiments with some kind of gas which, introduced into his apartment from the one above through a ventilator, was intended to put him into a sleep just deep enough so that they could make off with his notes.
>
> They had carried on this questionable activity almost throughout the Inferno Crisis. Zygmunt ascribes the fact that they had eluded detection to nothing more than August's naïve conviction that he was the center of the universe, and so he naturally had to assume the Powers were persecuting him. (21–22)

How sweet this is. Strindbergian psycho-drama collides with gritty political plot. But both scenarios are true. *Mémoires d'un Chimiste* plays off of *Inferno*, just as *The Tennis Players* plays off of *Inferno*, and each text must be seen as a widening of the other one, an opening of what seemed closed and done. Nothing is as simple as it looks, and the person-centered vision—whether it be that of Strindberg himself, of the critics of *Inferno* or *The Tennis Players*, or of the athlete tensed to encounter the rocketing tennis ball—is liable to miss the show.

So it is time to reconsider Professor Gustafsson's encounter with Austin, Texas, but to widen our angle of vision, to see that apparently empty signs are in fact full. "Yes. It was a happy time" (1), we are told at the outset, and this is perhaps

because Gustafsson's America is, in a profound way, free and mobile—not so much socially as ontologically. In fact, the compositional principle that Gustafsson admired in Strindberg would appear to be put in use in *The Tennis Players*, so that the customary boundaries of person and event can be blurred, can be seen to cover a good bit of traffic. The musical chairs and Doppelgänger of *Inferno* come right into Austin, Texas. These Americans are wonderfully multiple folks: the appealing student Doobie is also the Lou Salomé who captivated Nietzsche and Rilke; the thin, elegant Polly is revealed to be an American goddess at the end, "by showing herself for a moment in her true shape" (90); the more philosophical one, Chris, is the brilliant, precarious cyberneticist, the Doctor Strangelove of the group, who plays with the fate of the universe; and Abel, Gustafsson's likeable tennis partner, is the philosopher king, winner of the Australian Open and metaphysician of tennis.

Even more crucial in terms of the metamorphic logic and ideologic punch of the story, the tennis court is a true American Court, open to commoners and royalty, Americans and Swedes, a place of unparalleled mobility, where the laws of time and space and rank are overcome. Sun-lit, it is an American paradise, unlike the dark gloomy place where Wagner's Norse hero is headed, and the Swedish professor experiences a sense of pleasure in those precincts that is peculiarly American; no wonder that the "other" book, the one about "a hero who had lost his way in the bureaucratic labyrinth of 1960s Sweden" (49), does not make much progress. Gustafsson's Texas is a world of light and change, radically unlike the tightly structured Sweden he has left: "the more difficult things got for the protagonist of my novel in his winter-dark, tangled, and increasingly incomprehensible and frightening Sweden, the calmer and more idyllic I felt in my dry, clear Texas morning" (50).

Austin, Texas, changes the Swede as neatly as if it were an experiment in alchemy, but the change is spiritual as well as

149

physical. "The tennis serve is a window to the unknown" (7), and much like the looking-glass that Alice enters, that window opens onto the unknown, hidden selves who are in him. "There's really only one way [to make a serve], and that is to commit yourself to the dark, wordless side of your personality" (7), the professor tells us, and when he later mentions that his "tan was dark as a black man's" (7) ["solbränd som en neger" (15) significantly, if offensively, says the Swedish], we can begin to see that the American visit is an exercise in metamorphosis, that the social and ethnic and racial diversity of the United States is strangely encountered and "realized" on the tennis court.

But there are other, still darker Americas to be recorded, and Gustafsson is able to take their measure just as he moves into his own outer reaches. In the grand tradition of Tocqueville's portraiting of American, or Lévi-Strauss evoking the *tristes tropiques*, Gustafsson's slim volume has genuine ethnographic aims. What, we ask ourselves, must Texas be for the visiting European? Cowboys, of course. But in 1974 there is a new breed on hand:

> The cowboy moved with determined gait. When the clock high up in the bell tower struck five, he looked at his own silver turnip pocketwatch and put on speed. Naturally the gleaming black-leather holster on his belt didn't contain a Colt or a Peacemaker but an SR-51 from Texas Instruments. It had taken quite a long time for me to grasp that all those people on campus who carried heavy black-leather holsters on their belts kept minicomputers in them. Fabulous little gadgets that can calculate arcs, hyperbolic tangents, logarithms, permutations, the square root of five, and the immediate compound interest of whatever number you like before you even have a chance to turn around. (11)

The familiar icon of the cowboy is still there, but updated in such a way that we ponder the transition from Colt to SR-51, ponder also the linkages between revolvers and computers.

Gustafsson is as surely working with American mythology when he describes the cowboy as Strindberg is with French when he examines the Hôtel des Invalides. And we are meant to keep both guns and computers alive in our mind, each as a figure of the other, even though the power evolution would seem to have abandoned one for the other. We note, as well, the discrete presence of the bell tower which authoritatively registers time for Austin; Gustafsson then zeroes in on the tower, investing it with multiple significances, evoking its connection with the German past in Beethoven's Ninth and Schiller's *Ode to Joy*, mentioning as well that it houses both the library and the university administration, and closing with the tradition of illuminating it with red lights after each football victory, "which definitely make it look like a stiff, erect, male member, an ecstatic phallus which was even visible from the air as you came in for a landing" (13).

The reader, sensitized to the multiple roles of the tower, momentarily "air-borne" by the last phrase, is nonetheless unprepared for the paragraphs that follow, which begin innocuously enough: "At that time eight students had jumped from the tower. This was something which had started in 1966, more precisely on a beautiful 100-degree June day" (13). We are plunged into 1966, and the Renoir-like scene opens onto another Texas tradition: violence and massacre. Seemingly out of nowhere, Gustafsson describes the gunning down of thirteen people by a (crazed?) gunman from the top of the tower, and it becomes clear that the reference to cowboys and their revolvers has, as it were, "triggered" this scene. To make absolutely certain that the reader fully gauges the American material at hand, Gustafsson adds, almost cavalierly, "I often think sadly of how many beautiful young people like them had to be buried in foreign Asiatic soil because of an insane, criminal war" (14).

Tennis may be Gustafsson's private myth for America, but the Vietnam War certainly takes honors as the major American fact of life in the post-1968 European mind. The Austin

idyll is replete with national nightmare, and the scene begins to look as charged and poisonous as Strindberg's Paris hotel room. Indeed, one may not be going too far afield by entertaining still another speculation, by moving associatively to another Texas shootout, this one in Dallas in 1963, equally prominent an element of the American psychic landscape. Open to such resonances, we can even find surprises in Gustafsson's depiction of Frisbee, the great American charmer that the professor wants to introduce to his Swedish audience; he refers to it as "the game of the future" (101) and adds, "when all our European ballgames have died out, Frisbee will dominate the world" (10). Harmless enough, such language, but it doesn't stop: the flight of the Frisbee is described with scientific precision: "It rises, falls, swings in gentle parabolas according to initial speed, angle, positive or negative spin at launching, and six or seven other variables that I'm not familiar with" (10). As if this were not enough, he caps the description with a telling simile: "This behavior of those lids is almost as remarkable as that of elementary particles" (10); it is hard not to do a double-take here at Gustafsson's double-talk, hard not to discern rockets and missiles in all this chatter about parabola, launching, dominating the world and elementary particles. Yvonne Sandström is right, I think, to translate "bågar" as "parabolas" and "utgångsläget" as "launching" in the American version of the novel. The gambit of *The Tennis Players* is to energize its language, to make us see metaphoric extensions of single things, to see the past living in the present, to see the American tradition of violence and imperialism lurking outside the tennis court, to see the modalities of Power. Strindberg ground light; Gustafsson is drawn to machines.

We are expected to keep these alternative meanings afloat in our minds, and therefore, when Chris, the tennis player—computer jock who happens to work at the Strategic Air Command, introduces his professor to his lodgings, the language is telling: "It was a tower room, hexagonal, with lots of

bookshelves and a real astronomical telescope, a Questar aimed at the balcony doors" (41). On the face of it this is syntagmatic narrative, straightforward descriptive prose, but the "face" of things doesn't cover much any more, and we cannot fail to see metaphors falling into place: the tower recalls all the power scenarios that have been mentioned: sexual, political, financial, athletic, intellectual, and homicidal. We are not far from *Inferno* at its hottest here, because the unseen world, the realm of spirit that is behind appearances, is becoming so cogent and despotic that its message is intolerably clear; thus we know that Chris is (albeit unwittingly) an element of a larger power configuration, a larger mythic system that rules over our own world. The ironic distinction between revolvers and computers has now borne fruit, and one sees that the great guns of the present are made and controlled by computers; one sees, as well, that Gustafsson has been true to Strindberg, that he is engaged in the same meditation about power and energy, and that he, too, is inquiring about the twilight of the gods.

In the most fascinating episode of the modern *Inferno* text, Chris plays Virgil to Gustafsson's Dante, and he escorts him into the holy realm of the New World, no longer the tennis court but the true court where the real power figures reign. The journey to this realm is mythical, as the two humans descend into the bowels of the earth, after traveling long hours in a wasteland setting. Two elevators are needed for this descent, and what follows is a visit to the underworld. The narrow door slides open, and the citadel is entered: "The room we entered may have been very large, but it was so faintly illuminated by weak, dotlike lights and terminal screens which shimmered bluish white that it was impossible to see the walls" (52). Hades, Inferno, what you will, here is the Grand Laboratory that Strindberg merely yearned for in Paris; Gustafsson has found it in the Strategic Air Command in Texas. At the heart of the labyrinth we find nothing less than the great Machine, the modern minotaur:

This was evidently where the monster had been set up. An endless row of lamps that flickered and died, magnetic memory tapes rolling back and forth inside protective glass shields, writing terminals and screens. (54)

Far now from the sunlit tennis court, we are dead center in that dark earlier "gathering gloom" (2), and there is no Siegfried in sight. If Strindberg's text shows a revolutionary new sense of humans inscribed into a force field that links them violently to one another and the world via language, thought, and feeling, then Gustafsson comes at still a further nodal point, at a moment in history when the electric circuits that the individual suffered in the past have now been reassembled in their ultimate impersonal form: the computer. Here, if ever, is an instance in which the recent book recalls the earlier one, but it is well to measure the differences that such a comparison brings to light.

The flowing energies of the world come to Strindberg as telepathy and torture, as Mind. The electric currents that invade him are broadcasting the story of his life, showing him that it is not over, never over. Tracked psychically by the powerful forces he was pursuing chemically, Strindberg is a tragic figure of sublime economy: nothing is extraneous or alien in what he sees or encounters, because it is revealed as a sign of his life, an annunciatory emblem of his endless involvement with others. Moreover, we may say that the channels of *Inferno* figure forth the neural circuitry of the human brain, including the complex network of human sensations, the pathways of feeling as well as of thought. Strindberg apprehends the extended contours of his life through suffering, and he is made to see that human emotions—guilt, hate, desire—have common cause with electricity, cyclones, and water-wheels. The individual may be shattered by all these affinities and linkages, but he is nonetheless central to their entire scheme, since his mind and body are the very screen and stage on which it all happens.

With all these factors in mind, we may begin to measure what has happened in the eighty years between Strindberg and Gustafsson. The individual is an outmoded unit of scale in the cybernetic scheme that Gustafsson presents. Anonymous crew-cut figures gaze at a huge screen that represents a big chunk of the western hemisphere, and anything that moves in Western skies is immediately sighted and then "locked" by a ground-missile device. We are very far from the individualist scenarios of power seen in Strindberg's ghostly visitations or even the gunning down of thirteen people by a crazy person on the bell tower. The planet itself is now a target, but there are no hard feelings involved, nothing personal whatsoever. And there is no sense of the all-important past, no human memory at all, since the "magnetic memory tapes rolling back and forth inside protective glass shields, writing terminals and screens" (54) have taken over that function. Strindberg understood the mythic appeal of the Scientist as powerbroker, but in Gustafsson the electric genie has left the old bottle of the human mind and has moved into newer, larger, more impersonal quarters. "This whole death machine" [56]), anonymous and universal though it is, is not unlike that great wheel that haunted Strindberg, that intolerable source of power against which there is no protection, and Gustafsson's evocation of these surroundings amply proves that his interest in America is more than that of a tourist; rather, it is that of a historian-mythologist, a writer who knows that the gods have stopped coming from machines but have instead become the very machines themselves.[37]

For Strindberg, the humming in the ear and the humming of the telegraph line and the electric forces pursuing him like the Furies were inevitably linked to the Mills of God. He had charted, at the end of *Inferno*, the absurd itinerary of his spiritual career, moving from believer to free thinker to atheist to monk to socialist and back again. In *The Tennis Players*, all these positions are equally senseless, because the relationship of man to God has become an obsolete issue. When the Swed-

ish professor asks the giant computer, "DOES EVIL EXIST?" the answer makes it patently clear that such queries are meaningless in 1974: "INSTRUCTIØN INCØMPLETE." But the culminating revelation comes when the machine asks Gustafsson for a signature; he writes, "GØD," and the immediate response is "SIGNATURE UNSATISFACTØRY." Strindberg had depicted the individual as pure receptor, wired into a pulsing system that pours the world into the self and annihilates any pretences of sanctuary, whereas Gustafsson moves full tilt into our era, prophetically taking *Inferno* to Austin, Texas, and showing that the energy system discovered by Strindberg is alive and well, swollen to nuclear proportions and processed by computers, possessed of "powers" ("Makterna") so awesome that the "self" becomes a quaint, outdated relic, its adventures little more than antiquated fables chronicled by a latter-day Brandes on tour.

In *The Tennis Players*, the new god has spoken, and it refuses to acknowledge the name of the older one. Is this a time for despair or for hope? When the professor sees the student agitation in 1974, he thinks that 1968 is still alive, and when he hears the orchestra doing its bit by playing "Tam-ti- ti-tam-ti- ti-daaa," his hopes rise that this may indeed be a threshold moment: "I wonder how many realized that it was the Siegfried Motif and that this was a way of saying that the old gods were dead and that all the old contracts had been cancelled" (80). One thing is certain: the god-in-the-machine points to a world where nothing is organized as it was. In the Old Dispensation, death loomed large, but it came individually, first for the one, then for the other. Now, however, it can come simultaneously for everyone. In the Old World, if you experienced humming in the ears and knew that someone was in your room when you got there, they called it paranoia (even if you knew better); in the New World, it is the planet not the room that is being taken over, but the machines offer no more protection than the doctors did, and academic psychiatry is absurdly unequal to the task: "Anyway, could it be considered

consonant with modern psychiatry to build gigantic nuclear rockets into underground bunkers and allow them to be governed by suspect electronic brains far under the earth?" (68).

Gustafsson's novel closes in ludic fashion. The professor feeds his two great texts—the "real" Strindberg's *Inferno* and the invented Pietziewskoczky's *Mémoires d'un Chimiste*—into the Great Computer, in hopes of a "final truth" a "final solution." It is a brave gesture. Let the machine work for literature, for history, he seems to be saying, let language trump guns. We return to the fateful analogy that Strindberg so often experienced: *language as power*. But this sought-after machine-generated discourse, freed at last from the living beings at the origin of the chain, may have precious little resemblance to the narrative forms and narrative logic of the past. The professor is a tad uneasy:

> But the thought of that lone computer, buried one hundred and fifty feet underground in the Texas desert, equipped with the experience of a corporal and the mathematical genius of an Einstein and a Kepler combined, desolately ruminating year in and year out on August Strindberg's Powers and running through, over and over again, the drama that once was acted out at the Hotel Orfila in Paris, in the 1890s, the whole drama with all its variants, with all the alternative dramas and possible complications—sometimes that thought gives me a twinge of bad conscience. (92)

On the face of it, Gustafsson seems to have had his cake and eaten it, to have written *The Tennis Players* much the way the computer would have done it, playing out all its variations, "alternative dramas and possible complications" (92), showing thereby the limitless permutations of his materials, the rich possibilities of semiosis itself, the seductive appeal of such an aesthetic for any writer who loves language and parallel universes.

But Gustafsson has also taken that crucial final step and taken the measure of his materials, recounted via his playful

·strategy an American story of power. That story is, ultimately, inscribed in history. Strindberg's egomaniacal bout with the Powers and Gustafsson's ludic first-person memoir turn out to be reflecting mirrors in which we espy the movement of time and the mesh between subject and world. We read these texts *outward* as well as inward. And their concern with poly-semousness and shape-shifting has unmistakable parallels with the act of literary criticism, indeed with its responsibili-ties. The critic, too, is drawn to all the endless permutations of language and meaning that the verbal consort of the text will entertain, and there seems to be an implicit preference for the text that "authorizes" the largest number of "variants."

Yet attention to the play of language need not be blind to history or the workings of power. Nor need it be blind to our ongoing need for special patterns that we are willing to privi-lege, because those patterns help us to see not only where we are, but where we have been and where we are heading. Swol-len-headed or not, Gustafsson's professor tried to do just that, when he taught his students in Austin. Comparison is an in-tellectual procedure that is especially attuned to this quest for pattern, a pattern that satisfies. To look for the seeds of the present in the past, to espy the shadow of the past in the pres-ent, to argue that Gustafsson's America story of the 1970s picks up and replays the issues of Strindberg's *Inferno*-crisis— all this is to express a belief (or, at least, a hope) in human continuity. This study, it should be quite clear by now, is an Old World essay, a comparison of two books, written (at least in part) by a person not a machine, written in the service of those Old World virtues: feeling, self, memory, and history.

When first written and published, this essay closed with those last lines, but now, a good number of years later, a few words may be in order regarding the relevance of Strindberg's Parisian misfortunes and Gustafsson's Texas chronicle. The Strindbergian self who functions as a lightning rod for the pulsing forces—electric, neural, moral, emotional—that bind him to his past and his world is a far cry from the wired

denizens of today who are no less hooked up to incoming sounds and messages, via Ipod, cell phone, and an entire battery of digitalized, miniaturized machinery that is as intimate a part of the "person" as watch or eyeglasses. A similar force field in some respects—after all, the modern subject in Western culture is the recipient/producer of messages, information, music, and images in ways that would have been inconceivable in the past, that seem, in some respects, to have upped the ante in *Inferno*—but the storm is over and the anguish is gone.

And one may question—especially if one is old and looking in from the outside—whether this massive and diverse information stream tells anyone's individual story. In Strindberg, the fuller (frightening) estate of the Self was being graphed—replete with spooks as well as sights and sounds—and the affective results were harrowing. The man was being stretched to his fullest dimensions, not entirely unlike being put on the rack in the old days, and considerable sound and fury resulted. But today? Our contemporary streets are filled with people who seem to be speaking in midair, who are absorbing an unceasing barrage of wireless stimuli, as they pass blithely by their fellows, unfazed, taking in and putting out; *where*, one wonders, are they? Even the egomaniacal Strindberg, the "homing" fellow who interpreted most signs as A. S., presented a more sociable profile. And when one looks at the cancerously central human activity of today's modern bureaucratic world, one sees nothing but heads looking at screens, reading what they see there, responding in kind. Strindberg's Parisian trials look outright picturesque in comparison, for we see a man positioned—spatially and temporally—among his fellows and his material setting.

As for Gustafsson's book of 1977, much has changed now. The twilight of the gods seems to be in a further and more manic phase, and the bloodletting taking place in the modern world would challenge even a Wagner to make it into art. But, since 9/11, Texas has shown itself to be a center of power well

beyond anything shown in *The Tennis Players*. The cowboys have evolved. The Cold War is over, but the new era of targeting machines and information gathering has yet to be mapped. The nuclear nightmare holds sway more than ever, while the arsenal of revolvers and computers has now received a low-tech new entry: the suicide bomber. But Gustafsson's prophetic sense of the dawning era of the computer-god is on target, as it were. Whether it be in the bowels of the earth or in the digital arsenal of everyday life, the machines are quietly shaping and reshaping our lives.

And the alchemical project may still be alive, even if oil (and, soon, water) are replacing gold as the object of the quest. The enduring question raised by *Inferno* and *The Tennis Players*—what is the relation between the self and the powers?—is with us still, as our information age of immediate access blurs and erodes ever further the contours of the human subject. But the notion that an individual story, such as that of a Strindberg-in-Paris or a Gustafsson-in-Texas, might record the lines of force of an entire age seems to make much less sense today. Each of these figures felt the human subject to be enmeshed by flowing currents, making the project of autobiography a special challenge. Yet one wonders what the self-obsessed Strindberg would have thought, had he encountered a personal Web site, or what the culturally attuned, alive-to-history Gustafsson thinks of Google searches with their form of information gathering. What kind of portraits are these? Where is history? Everything, we are told, is just a click away. Yet how different this "traffic" is from the vectors and exchanges recorded by our two writers. Tomorrow's Strindberg will have much to say.

— 3 —

BOUNDARY SMASHING

A. Going Through the Wall: Shakespeare, Strindberg, Josephson, Bergman

1

The Finnish artist Ville Vallgren has left us a remarkable account of a scene that took place in his atelier in Paris in 1883, a theatrical improvisation that was to have prophetic significance for two of the participants, August Strindberg and Ernst Josephson, themselves part of a larger group of joyous and rowdy Scandinavians in Paris, including Spada, Pelle Ekström, Per Hasselberg, and others. Occasionally, when the gods elect to smile, one comes upon a historical notation that seems to be bursting with prophecy and significance, that seems to contain in a nutshell an entire psychic and artistic drama, ready to unfurl. Vallgren's little narrative does just that. To understand his story, we need to realize that he had constructed a paper wall in the atelier, so as to create a private living space within cramped quarters. Just what kind of life might take place within and through paper walls is the central question and central conceit of this section. Let us listen to Vallgren:

> About midnight we all decked ourselves out. Josephson got hold of a Japanese outfit and a copper pot on his head. Pelle

Ekström wrapped a fiery red stocking around his black hair. With his deep set dark eyes and his hook nose, he had an unbelievable resemblance to Dante. He declaimed à la Dörum, who had appeared in the 60s in Stockholm's Dramatic Theater in the role of Hamlet's father. When Pelle Ekström exclaimed with stentorian voice: "I am thy father's spirit; / Doomed for a certain term to walk the night, / And for the day confined to fast in fires," then Josephson bursts forth from the wall with staring glazed eyes and a sword in his raised hand. He did not declaim and said nothing, but emitted a horrible roar or howl, which sounded like a bull's bellowing, which went right through marrow and bone. A minute later he turned around entirely, cut with his long sword a deep hole through the paper wall and disappeared through the hole. That was the first tableau improvised in haste.

The impact was gripping. Strindberg struck his forehead and stood up from his chair, with his right arm raised in a gesture, saying, "Tremendous! this is the tragedy of the future. One must use this immediately." And then added: "Damn, that was great!"[1] (My translation)

The second "tableau" consisted of the entire group more or less disrobing, painting their faces, and carrying out a frenzied attack against the remains of the paper wall, hacking away with wooden swords, covered with sweat, and even magnified by the large mirror that stood over the living room sofa. What might we see in this story? What might we learn?

"Puerile outbreaks" ("Burschikosa upptåg") is the term that the Josephson scholar Erik Blomberg gently assigns to this release extravaganza, and it is indeed that. Yet it is also more than that. The purpose of this section is to mull over and unpack that histrionic happening at Ville Vallgren's, especially in light of the subsequent careers of both Strindberg and Josephson, and then to invoke Ingmar Bergman's final masterpiece, *Fanny and Alexander*, as the closing chapter in this saga of Hamlet's ghost, paper walls, and the key struggle for lib-

erty and revolt that undergirds the resonant term at the core of this book, *genombrott* (breakthrough). As we know, it customarily evokes a cluster of initiatives—all aimed in some sense against nineteenth-century moral and social pieties—but, bearing in mind this peculiar Parisian performance of 1883, could *genombrott* entail something outright vehicular, a kind of "ec-static" liberation from the closed precincts of tradition and normative thinking into a free space (artistically, behaviorally), an *other* realm altogether. Where does *breakthrough* go? Might there be, on the far side of the wall, of the phenomenal scheme we all know, modes of perception and production, even living, that flaunt the customary constraints of time, space, and flesh? What would it take to get there? Could you come back? In short, what does *genombrott* mean for each of these artists? What does it mean for us?

This inquiry into the future implications of an improvised *sortie* among carousing artists is not to be understood in any genetic sense. I am investigating a *figure* that seems, especially in hindsight, big with meaning. This little histrionic event of 1883 is absolutely bristling with signifying energies, as if life not merely copied art but was, for a few hours, prismatic and prophetic, a road map of sorts, a kind of material poem that wants decoding. The cluster of motifs at hand—the Hamlet predicament, paper walls, breaking through, the tragedy of the future—signals something rich and strange about the freedoms of life and art, freedoms that lie at the heart of the Hamlet story and are to be brilliantly reconceived and reenacted in key moments of artistic maturity in all three of these Scandinavian artists. We will be both tracking and unpacking a central metaphor: crashing through the paper wall is the very heart of *genombrott*, and the fateful reaction of Hamlet to his father's ghost may be thought of as an emblematic clash of generations, indeed a paradigmatic scene of artistic threat, revolt, and emancipation. Shakespeare's play is about redefining human doing: expected to revenge his father's murder, Hamlet spends five acts crafting a new form of *action*, en-

listing the potency of words, appearances, and playacting, gesturing toward a world of virtuality where the ludic might stand in for the actual. Strindberg, Josephson, and Bergman are all to be invested in this same exploratory quest. What was on show at Ville Vallgren's atelier speaks to all of this.

Strindberg watches Josephson strike through the wall in response to the ghost, and his words, "this is the tragedy of the future" ("detta är framtidens tragedi"), are to be taken quite seriously. Let us consider, in particular, the astounding moment in his own "breakthrough" play of 1887, *The Father*, when the Captain virtually repeats Josephson's *geste*: he crashes through the wall.[2] This scene occurs late in the play, and although it is "prepared" by the strange noise of sawing and other ominous sounds offstage, we are nonetheless initially confused by this turn of events.[3] One expects, at this juncture, given the inexorable buildup of rage and antagonism between husband and wife, to see a mad, homicidal Captain crashing through the door—a door that is papered over—bidding violence and mayhem for his shrewish mate (who has robbed him of all certainty regarding his status as father). Murder seems nigh; the other characters expect no less. It looks like a "high noon" moment of action.

Instead, Adolf appears with a stack of books in his hand— texts of Homer, the Old Testament, Pushkin—and proceeds to cite chapter and verse relating to his tragic condition of paternal uncertainty. Telemachus, Jeremiah, and others are enlisted to document the case that *fatherhood* is unprovable, unknowable.[4] As we know, this riddle is the nexus on which Strindberg's play hinges, and the quasi-Darwinian combat between Laura and the Captain derives all its punch from the epistemological abyss into which the Captain (man of science; gentleman and scholar) is hurtled. Much is at stake here, and Strindberg has not failed to display the plenitude of the Father's fall, a cashiering of patriarchal prerogatives that ranges from child custody to belief in an afterlife, from stewardship of property to economic collapse, from centered and confident

sexual identity to infantilization, straitjacket, and death (as discussed in detail in an earlier chapter of the book).

To be sure, the entire play trumpets these issues, but the Captain's crashing through the door has a kind of theatrical, kinetic, plastic energy that marks this moment as special. I argue that it is here, rather than in the quite shameless cribbing from *The Merchant of Venice* when Adolf steals Shylock's lines, that Strindberg truly remembers Shakespeare, recalls that evening in Paris when Ernst Josephson responded to the hounding voice of Hamlet's ghost—the symbolic voice of all fathers who bequeath the law to their sons, script their son's identity and behavior—by bellowing like a bull and crashing through the paper wall. Josephson has acted out the dilemma of all trapped sons, and his gesture is a bid for freedom and agency. But Adolf, Strindberg's Captain, has crashed through into a new territory, one that turns out to be a "no-man's land" where all notions of doing/acting go up in smoke. And, sure enough, the burden of the play is to show both us and him that he is indeed "no man."

Strindberg's uncanny brilliance is most perfectly on show in the very mechanics of the scene. No sword in sight here, unlike the event at Vallgren's. Just books. In fact, one could say that *The Father* hinges precisely on whether or not Adolf has a functional sword. In the astounding scene with Laura where his sexual anxieties and insecurity are unmasked and brought front and center, we witness the utter collapse of traditional machismo. Strindberg's father acknowledges, à la Shylock, his softness, his vulnerability, his pretence at manhood. We see here the emergence of the child, the infant who never grew up, the large male body that postures virility but ultimately seeks a mother, as is so evident in the role and rationale of Old Margret as well as Laura herself. We know that Strindberg was an overt misogynist all his life, but when you look at the plays themselves you find an astonishing sense of female power, coupled with a growing perception that male

165

authority is not only a mirage but a construct waiting to be dismantled.

The male principle—origin, siring, authority—is going out of business here, and Strindberg becomes truly Strindberg, becomes visionary, in his grasp of what it means when our walls are made of paper and our swords have disappeared. Josephson's performance at Vallgren's has become a meditation on power and male prerogatives: the raving Captain reaches back into myth in order to express his undoing. Hercules' sword, he tells us, has been taken by Omphale, and the hero is now dressed in women's clothes; Adolf himself will end up mad, in swaddling clothes, as we see in the final grisly transformation of the play: the officer's tunic is now the madman's straitjacket. The old equipment of warriors—shields, swords, implements of doing—is lamented as obsolete, as is shown in the play's nostalgic tribute to armor and potency in the last scenes.

Let us return again to the man bursting through a wallpapered door, breaking through the patterned mesh in which he is bound. Yes, we see this, but is it truly possible? Can it be done? Where do you end up? Is this not also what Strindberg must have sensed in watching Josephson: that such breakthroughs are illusory? that the yearned-for freedoms are not to be had? that the tragedy of the future cashiers *doing* as we know it? The Father cites famous examples of cuckolded fathers, and he thereby inscribes himself—shows himself ever to have been inscribed—within textuality, within an always/ already dispensation that banishes all notions of origin, originality, and independence. The ghost of old Hamlet commanded his son to act, but the son could not heed the call. Now, in Strindberg's play of 1887, a seemingly intact father discovers his factitiousness, moves steadily "backward," finishes up as *infans*. All human doing turns out to be ghosted, de-realized, an affair of props than can and will be undone. Late in the play we have a surreal evocation of sleepwalkers and capons replacing actors and roosters, of moonlit ruins re-

placing the sunny earth, speaking to us of a realm where agency, action, *genombrott* of any kind, are unthinkable. The Captain is ushered into irreality, into citizenship in a world of facsimile and effigy, into a condition that Lyotard and others, almost a century later, were to label "postmodern." Strindberg has understood that the walls which enclose us are notional paper walls, that we are trapped within conceptual frames no less paralyzing than straitjackets.

"Detta är framtidens tragedi." What a remarkable statement. This is the kind of tragedy we will *write* in the future? Or: the future will be this tragedy? And whose future: ours or Strindberg's? Strindberg, as the notation of "future" implies, espies a peculiar sustenance here, a displacement of "doing," a way of writing conflict, coercion, and freedom in a new key. Strindberg is finding his way into the bracing paradox known in French as *qui perd gagne* (loser wins). It is not a question of a pyrrhic victory but rather of reversing the signs, of transforming loss into gain. Hence this seemingly "naturalist" battle between a man and a woman hints at a kind of new life that could be tapped into, making it possible for the splendid energy of conflict and war (and doom) to be kept alive, getting him free of even the always/already textual bind that is coming into view. That is the goal: to get clear. Strindberg, once he sees how to turn agon into something elastic, is to be peculiarly nourished by the dynamic he exposes in *The Father*. The dying of the father shades into the birthing of the playwright. Admittedly, the Captain is emptied of agency, potency, even language, in front of our eyes; he is becoming ghosted, turned inside out, obsolete (as Laura informs him, "Now you have fulfilled your calling as a regrettably necessary father and provider. You aren't needed any longer, and you can go"). He is becoming the paralyzed son, the brooding Hamlet who can reach no certainty, who will be eaten up by consciousness.

But how vital this can be on the stage! Strindberg, like a demonic engineer, charts the Captain's course "baklänges" ["backward"], as if the spectacle of patriarchy's collapse (a

collapse he could hardly envision in reality, but which he could indeed *imagine*, and then go on to represent onstage) entailed a horrible reverse gear, reversing fathers into sons, and sons into infants. But it is still kinetic. The ostensibly forward, progressive thrust of *genombrott* has been throttled and reversed here, and the course of action is from illusory presence to documentable factitiousness, from roosters to capons, from authentic action to the heat of brain fever. But heat it is, and rousing good theater. And one senses that Strindberg is reflecting on the kinds of energy in play here, on the way in which theater itself is hospitable to fantasy and desire and virtuality (however much they complicate the notion of "doing"), so much so that they tend to become strange new forms of action.

The theatrical gains are only part of the story, however. Seeing Josephson penetrate a paper wall with a wooden sword is a luminous example of action that is figural, ludic, endgame, enabling. "Framtidens tragedi," but also "framtidens komedi." There is something stunningly healthy and vigorous about the rhythms of Strindberg's work, as if the most dreadful decimations were secret acts of creation and fulfillment. In play after play we see torture, undoing, failure, and collapse, yet there remains an undeniable *Heiterkeit* about it all. True enough, it can sometimes end in death, but only in partial death: Adolf is cashiered, turned into comatose infant (a man who cannot speak is a dead man on the stage), but Laura—and, indeed, Bertha—have a future that shines in on us at play's close, as the wife takes over the affairs and the daughter stands by her side. Julie (in *Miss Julie*) goes to her suicide (to go through the eye of a needle is a form of *going*), while Jean (hampered though he is) has plenty of hustle left in him. In *A Dream Play* Indra's daughter returns to the heavens, but the dream will continue forever, the cycle will outlive even destruction. Perhaps one could go through the wall endlessly; perhaps going through the wall is a kind of theatrical life-of-the-cell, a version of diastolic-systolic

play that can dance on forever. The cadaver-filled *Hamlet* and even the comatose Captain—resonant with the gravity of flesh and the severity of death—are to yield the stage to something freer, airier, utterly elastic, making use of a totally new sort of energy.

Most revealing here are those plays that refuse closure, that flaunt the comic principle of repetition and continuity. These plays attain their most perfect form in the marriage dramas, because it is there, in the realm of human interactions, that Strindberg has most profoundly understood that conflict, agon, is much more than a tragic collision or impasse: it can be an enlivening rhythm, it is a dialectic, it might be the modus vivendi of human relationships. There is an astounding economy coming into view here, inasmuch as the playwright will now have it gloriously both ways: his characters will seem inscribed in a death-haunted, "realist" logic, the sort of thing that finishes with a winner and a loser, a survivor and a corpse, but then, amazingly enough, this stranglehold loosens up, is shown to be make-believe, evaporates. I said there is an *economy* in play here because the mileage made possible by this scheme is very considerable: death throes and threats are still undeniably there, parsing the events with their old familiar logic and squeeze, but they can, incredibly enough, be transcended, thrown over. Thrown over so that one is free to start afresh. Afresh with what? With more death threats, more conflict, more crisis. A new kind of *machine infernale* is coming into view.

The Dance of Death, part 1 is the crowning jewel in this series, because the acrobatics of Edgar and Alice—who lacerate each other endlessly—come to us at play's end as life-sustaining, as a kind of affective aerobics. Is this not what every reader or spectator remembers: nonstop repartee, repartee punctuated by threat and crisis yet sublimely free-standing? The title itself speaks volumes: a dance of hatred and war that is nonetheless a dance, a performance, a balettistic pas de deux (it takes two to dance). To be sure, the play itself is

larded with musical and dance references, and both Edgar and Alice have their moments when they kick up their heels and move into a frenetic higher gear.[5] But Strindberg's genius consists in realizing that *marriage* is first and foremost a set of moves, a rhythmic proposition that turns the old coercive view of agon into something far more musical and elastic, something outright playful. Hence we must not be misled by the play's flirtation with "exposure" of some crime (embezzlement, in this case), recalling that similar moment in *The Father* when there are dark references to Laura's "crime" of pregnancy—because Strindberg, in the last analysis, casts this positivist sleuthing logic (the logic of hermeneutics, of traditional plots, of all of Ibsen) to the winds. Death and exposure, in Ibsen, are real, immovable, saturated with gravity; in the new Strindberg, they may turn out to be decoys, mirages, even thresholds. Here is why he is so devilishly hard to stage, why a veteran actor like Laurence Olivier claimed to have discovered *only in performance* that *Dance of Death* is comic, not tragic, that all talk about embezzled money is so much froth, as real as the white burgundy in this couple's nonexistent wine cellar: just verbal sparring. We are moving ever more fully into the imaginary, through the wall, breaking through "elseward."

Edgar goes a far piece toward articulating this model when he tells us that his great secret in life is (and has been) to "go on," to cashier the humiliations and reverses that come your way by dint of pure imagination and will, liquidating them as you dance your way forward, having deposited the dross in that big sack you then throw away. The play's most brilliant scene is an utterly wordless intermezzo consisting of Edgar's systematic junking of all the accoutrements of his physical and emotional past, by literally, as if in a trance, throwing things out of the window or onto the floor or into the fire: cards, whisky bottles, cigar boxes, eyeglasses, key to the piano, portraits, love letters. The scene is at once tragic and comic, depending on one's perspective. We can see it as evi-

dence of a Swedenborian type of self-erasure, "vastation"; we can also see it as a crucial moment of Pauline illumination, whereby the fleshly vision yields to the spiritual.[6] But we are also free to see it in a more vaudevillian, postmodern fashion, as a way of saying: the things you know me by, the things I know myself by, are mere soap bubbles that can evaporate or be disposed of, not entirely without parallels to the magic yet whimsical program of erasure and transformation that Mallarmé's haunting line suggests: *abolis bibelots d'inanité sonore.*

In this sense, perhaps, Strindberg may be called Darwinian: his plays are about continuation and survival, about the complex duels and skirmishes that constitute social and sexual life (not death: life).[7] A life together over time, Strindberg shows us, is a form of military history, replete with battles fought, but strangely without corpses, since the enterprise is a serial one, as much vampire-like and cannibalistic (i.e., nourishing) as it is adversarial or homicidal. Let no one term this a "fantasy"; in real life and in real marriage, continuum is far more common than death, even than divorce. One fights and claws and empties one's sack ... and then goes to bed or forgets or readies oneself for the morrow. After their no-holds-barred knockout battle, with its seeming threat of real annihilation or undoing, Edgar and Alice terminate their (military) exercises with the sublime recognition that they are now ready for another twenty-five years. It is hard to overstate the modernity and breakthrough at hand here. One feels that the entire Ibsen repertory of *hard facts*—rotten marriage, hatred, desire for freedom, lure of explosive revelations such as financial embezzlement and sexual betrayal, combat with the least malleable thing of all: death that approaches, that goes about touching and undoing Edgar throughout the play—is altered, *defanged,* turned into something weightless, into a joke, into just so much spice and piquancy before our eyes.[8]

Yes, I know, I know that Edgar dies of a stroke at the end of part 2 of *Dance of Death,* but the canonical text is part 1, and it has its own wonderful logic. This man Edgar would be dead

three times over in any other play. Mind you, these histrion-ics—for they are that—can be immensely moving, calling forth tears, but followed by laughter, and closing with a view of things that seems at once Olympian and vaudevillian. Edgar seems to be dying before our eyes (he collapses repeat-edly), then asks what is for dinner in the next line, only to conclude by *erasing* these vulgar hindrances as papier-mâché, as walls you can crash through. Affective aerobics, I said; just words, words as the breath of life, words as enduring and vital beyond anything they might ever signify, even though their signification adds spice to the stew. Edgar and Alice go at it tooth-and-nail, nonstop, in a veritable orgy of defamation and disclosure, giving it all they can, awash in verbal warfare, headed toward catastrophe. But there is no catastrophe. One feels that the pretence of meaning itself is on the line. It has to matter; it can't matter.[9] Beckett is to inherit Strindberg's tragi-comedy of disunion, of disarray turned grotesque and ludic, but the Irish writer's emphasis on entropy and countdown differs radically from the vitalism at the core of Strindberg's vision.[10] Perhaps Albee's *Who's Afraid of Virginia Woolf?* with its final transvaluation of everything into game, is the ulti-mate vista that Strindberg is pointing toward. One wipes out and goes on.

Even *The Ghost Sonata*, one of Strindberg's darkest evoca-tions of relationship as a viper's nest, is a tribute to the sus-taining power invested in the horrible games we play; at it for decades now, these diseased spooks and monsters still meet and perform their deathly dance. In such theater, *genombrott* can hardly exist, at least not in the cheeky, linear sense of vic-torious breaking through which the term implies. But it does suggest a strange survivalist logic, a strategy that enables self-furthering via self-annihilation, converts all closing gambits (exposure, death) into weird feats of replenishment. This zero-sum game, this *qui perd gagne*, not only constitutes a quantum leap beyond realist fences (or through realist walls), it also il-lumines the shocking resources of art, its stunning advantages

in crisis management: crisis is a springboard for action, dead end is a trigger, the reach of art and the nine lives of consciousness depend on the apparent limitations and *huis clos of* "reality." Through the mind and through the text, in these kinds of works every trap or *huis* springs open. Strindberg has discovered the wonderful, eminently exploitable thinness of logic itself when it comes to human maneuvering, to the play of human energies. I sense here a weird parallel with the sinuous sacral logic that Kierkegaard conferred on Abraham, but whereas Abraham's faith is a double-barreled conviction that God will both kill Isaac and "return" him, Strindberg remains secular, bypasses all recourse to the divine, moves past death and closure via fantasy, game, and repetition, as if he were inventing a kind of theatrical *subjunctive tense*. Back to *Hamlet*. The ghost calls out with his damning, fateful call, and the son who cannot act goes under and around, around and under, dancing his way through. Dance of death, dance of life.

The tragedy of the future is to be virtual, ludic, a set of figural exercises that only appear to be anchored in reality. The shocking chiasmic form of *To Damascus*—in which the narrative sequence is, at play's exact center, turned into reverse— testifies to a kind of formalism that is more existential than aesthetic. Remember the fate of the Captain in *The Father*: he is slated to move into reverse gear all the way to swaddling clothes and extinction; but "going through the wall" has opened things up, and Strindberg is now a suppler kind of guy, one who senses that all traffic is ultimately two-way traffic, that directionality is, yes, real, but also (if you know what you're doing) alterable, reversible. In the most interesting work, turning inside-out becomes business as usual for the Strindberg psyche. Hence an experimental teaser like *The Stronger* is little more than a tug-of-war (the title tells us as much), set not so much to music or even logic as to the contrapuntal rhythms of sound and silence. In this brilliant one-act piece, one talks, the other is silent, and you realize (eventually) that both are speaking, that silence can be a form of

speech, at least onstage where someone else is receiving it head-on. Take a step back and you see it as an exercise in physics, where two kinds of forces play against each other. Can we be surprised that Artaud, ever on the lookout for theatrical power, saw in Strindberg the kind of nonverbal vitalism and gestural punch he was seeking? Further, can we be surprised that Bergman shamelessly replicated *The Stronger* in his most exploratory film, *Persona*, in which silence is explosive, and virtuality rules the day (as well as the night), takes over the screen, stunning us with its rage and force?

The "guinea pig" thesis that Strindberg scholar Everett Spinchorn posited for the playwright has this to be said for it: the most awful disclosures and transgressions can be vitalizing, come to be seen as the necessary machinations of a libidinal and aesthetic economy that is always, at text's end and day's end, in the black. Shakespeare himself, as theorized by James Joyce's inimitable Stephen Dedalus, lived out the same dialectic: "But, because loss is his [Shakespeare's] gain, he passes on toward eternity in undiminished personality, untaught by the wisdom he has written or by the laws he has revealed."[11] This zero-sum libidinal/artistic model fuels the plays, keeps the marriages going, constitutes the affective sleigh ride at the core of human living. What may initially seem like an aesthetic breakthrough is actually a light that shines in on our most basic and mundane doings. Strindbergian theater announces that playacting is the core truth of human relationships over time, for it repackages and reconceives time itself by getting ever more life out of crisis, battening on to its fine, vicious energies, but skillfully avoiding its closure. How could Strindberg know all this? Perhaps we have marriage to thank for such ludic wisdom, such survivalist zest. Who before Strindberg had grasped the incalculable *value* we derive from emotional and sexual war? Who before Strindberg realized that our true history is a history of virtuality, of "clashes by night" that never make it into the history books, never even draw real blood? Strindberg watched

Josephson, "the old Syrach" as he is known to his friends in Paris, bellow like a bull, slash holes in a paper wall, and disappear into the holes he has slashed. And Strindberg saw. This is action, but it is virtual action; this is a way of responding passionately to the Father's call, but it is make-believe. This is ludic, but it is also our most intimate form of behavior; Strindberg will transform it into a new theater.

Nowhere is Strindberg's triumphant *genombrott* more visible than in *A Dream Play*, where the oneiric logic of free association is turned into stage magic, dishing up a kinetic, metamorphic new theater: a man waiting for his beloved at the theater yields to a lawyer's office, then to a stifling apartment, then to Fingal's cave. One feels that this could go on forever, and that is because the end-stop logic that dominates most human (and theatrical) gestures has been robbed of its finality, of its closure. Again, the economies are remarkable: we watch this man wait for his beloved, and in the scope of a few pages we see him go through all the phases of life, from youth to age, as if desire itself were the only constant in human life, the thread that links all our chapters and personae, but that desire lives most fully through postponements and obstacles. One remembers the "Joker thesis" put forth in *Inferno*: we go forever through the same motions, only the vocabulary changes. The shimmering, evolving stage alone seems real, whereas those who strut and fret upon it are phantasms. No surprise that the energy that fuels this play (the same energy that fuels our psyches) is occulted, behind closed doors, beyond scrutiny but operational nonetheless. One could argue that all of *A Dream Play* is devoted to this primal energy system, whether it be thought of as oneiric or alimentary or sexual or theatrical.[12]

Flowing power is the key to Strindberg's work and life; we see this most graphically in his tortured autobiographical work, *Inferno*, where these matters are at once surreal and pathological; that harrowing text gives a provocative technological label to this flow: *electricity.* Electricity: a two-way cur-

rent that can move you physically, emotionally, and psychi-
cally. Staging Strindberg requires a love of electricity, a grasp
of the fluid element that breaks through the walls of time and
space, and one could wish that Robert Wilson—who captured
the Strindberg music unforgettably in his epochal Stockholm
rendition of *A Dream Play* in 2000—would try his hand at *The
Dance of Death*, *To Damascus*, and *The Ghost Sonata*. One feels
he would succeed, even more than Bergman has in his own
magisterial Strindberg productions, in freeing these magic
texts from their realist shackles, so as to celebrate their shock-
ing sinuousness and kinetic power. In the face of every obsta-
cle, every trajectory of linear desire or conflict, something in
Strindberg crashes through the wall, murmuring, "Fan vad
det var bra!" ("Damn, that was great!")

<div align="center">2</div>

But what about Ernst Josephson himself? A fuller account of
his vexed life and career is given in a later chapter, but here I
focus on the prophecy on show at Ville Vallgren's atelier in
Paris in 1883. What can it have meant to roar like a bull while
slashing through the paper walls? Strindberg only watched,
and then devised his own brilliant breakthrough kind of the-
ater, awash in "subjunctive" venues, cued to the survivalist
dialectic that was his genius, both personally and artistically.
Josephson's case is more tragic. He acted. He acted: not via
the stage or even the imagination, with their joint resources
of virtuality and make-believe, but with all the passion of
body and soul. His career, indeed the significance of his life
work, is weirdly prefigured in the raucous improvisation at
Vallgren's atelier. Nothing survivalist in sight about Joseph-
son, unless, at the end of the day, we are prepared to say that
the mind-boggling work of the Sick Period, done between his
breakdown in 1888 and his death in 1906, is itself a testimony
to survival. The work has survived, and we will not be amiss
in saying that Josephson had to crash through the wall in

order to produce the great work of his sick years; we shall see, as well, that he was horribly true to the Vallgren charade: he was literally to disappear into the hole.

The paper walls, the sword, the roaring of the beast: these motifs are to deepen in hue as we examine Josephson's career, moving from "childish outbreaks" to the very shape of destiny. We can begin by saying that the paper walls being slashed are the walls of Tradition—a tradition the painter negotiates all his life—and that Josephson's furious attack on them in 1883 is of a piece with his role as leader of the rebellious Scandinavian artists seeking to overthrow the Stockholm academic establishment. This establishment was also the source of Josephson's own training as artist—he was a good student, a docile and appreciative student, back then— but in the Paris of the early 1880s, under the influence of Courbet and the new prestige of *plein-air* painting, Josephson has become the unquestioned spokesperson for the "Opponenterna," the rebellious "Parisian boys" (including Carl Larsson, Karl Nordström, Per Hasselberg, Pelle Ekström, Richard Bergh, and numerous others). This is not a self-evident development: few would have anticipated that the shy young Josephson would become the fiery, charismatic, eloquent spokesman for the New, calling for a freer, more liberal, and more exalted view of painting, challenging the academy's mode of instruction, irrepressible in his turbulent critique, compelling in his new-found authority. The Josephson we see at Ville Vallgren's is, in some sense, at the peak of his career, admired by his young peers, the producer already of some remarkable portraits, dazzling in their mastery of color (drawn from the Renaissance greats, inflected by Manet and the Parisians), and splendid in their psychological subtlety. Already the renditions of Geoffrey Renholm, Carl Skånberg, and others have garnered praise and achieved recognition, even in the Paris Salon. All this is to change.

Josephson is to fall from grace, to lose the support of his young brethren in the emerging Konstnärsförbund, to become

pariah, ultimately to go mad. Why? The short answer would be that the Josephson of 1883 was already a precarious figure, a man of great personal conflicts, prone to moodiness and even paranoia, suspicious that his peers were betraying him, subject to fits of depression and utter inwardness, sexually repressed as well, given his acquiring of syphilis and his subsequent (fateful) fear of sexual involvement and commitment, unable to reconcile his powerful affective nature with the severe (repressive) idealism urged on him by his mother. These would appear to be adequate grounds for the tragedy that is to come—indeed, "framtidens tragedi" as Strindberg uncannily sensed—but they are not. We need a longer view, if we are to understand the Josephson career, if we are to see what is truly at stake in his slashing through the wall, his scene of *genombrott*.

We return to those paper walls, still viewing them as the Tradition, but let us broaden our view here by defining "tradition" in a less political and more deeply artistic sense: the painterly discourse which preceded, nourished, and, in some sense, "constructed" Josephson, a stream of precedents and continuities no less authoritative and echoing than the talking textual heads that Strindberg's Captain brings through the wall, to cite, not so much their authority as their *priority*. The extraordinary devotion that the young Josephson felt toward Rembrandt, Velasquez, Michelangelo, Raphael, and others, so evident in the exquisite, highly wrought imitations he did of their work in the 1870s, reflects much more than schoolboy admiration. "Vara Sveriges Rembrandt eller dö" ("Be Sweden's Rembrandt or die"), writes the enthusiastic Josephson to friends (at the ripe age of 20), and there is something frighteningly prophetic in this *boutade*. In some real sense, he will die, will have to die, in order to become his country's Rembrandt.

Or Velasquez. Consider, for example, the enigmatic self-portrait done on Bréhat, in 1888, at the onset of his madness, which he signs "Velasquez" and adds, at the bottom,

"through Ernst Josephson" (see figure 4.B.10). What kind of slippage do we have here, as Josephson is "visited" and "occupied" by the spirits and hand of the dead? What kind of walls are gone through, when you "do" a self-portrait but sign it "Velasquez"? Might "creation" always be a form of secret-sharing? We know that Josephson saw himself, at this fateful juncture of his life, literally as a *medium*. His companion, Allan Österlind, has left us an account of their joint experiments with spiritism, but we need not conjure up only images of séances and table-rapping to understand such mediations and such traffic (for Österling quote, see chapter 4, section B); we will better grasp the odd "breakthrough" at work here if we see such work as an illustration of the artist's relation to the Tradition. Not entirely unlike the thesis later argued by T. S. Eliot in "Tradition and the Individual Talent," Josephson's self-portrait speaks to us of the commerce and exchange that underlie artistic creation, and on this view, all notions such as integrity and agency go up in smoke. One's prior intact self also goes up in smoke, and one has to die a bit, if the collaboration with the gods is to happen. To die a bit? To be reborn a bit? To become pregnant with "another"? One remembers Strindberg writing to Nietzsche that the German's words entered the uterus of his soul.

It is more than a question of being "inhabited" by Velasquez. Might one's engagement with Culture itself take place along such invasive lines? Perhaps the "wall" of self is a porous membrane. Consider, in the same vein, the astonishing series of drawings, *Andeprotokollen* (*The Spirit Protocol*) in which Josephson—mad—plays the role of St. Peter, receiving the pleas and confessions of all the greats of his world—kings, bards, writers, warriors, even relatives—so that he, Josephson, might pass judgment on them, decree whether or not they enter Paradise. The dead come to him; he is entered. Although of dubious artistic merit (Josephson's spirits all resemble one another; perhaps spirits look alike), this document has proven of great interest to psychologizing critics, who have

persuasively argued that the scabrous confessions made by the penitent spirits visiting Josephson, confessions especially of a sexual nature such as incest or pedophilia or homosexuality, are veiled projections of Josephson's own repressed libidinal wants.

So be it. What has gone unassessed is the enormity of Josephson's scheme, as well as its rationale. Yes, here is where the hounded, unrecognized, isolated Josephson—too poor even to afford paint and canvas, cast off by his former artist friends, living in a primitive cottage on a desolate island off the coast of Brittany—has his glorious reversal and revenge. He becomes the grand power magnate—aided, one must add, by the mediation of the other powerbroker in question, Emmanuel Swedenborg, who directs Josephson's hand, fills the drawings with his own nervous and despotic scrawl, so different from the fine characters of Josephson's "own" hand—presiding over the ultimate judgment call of existence: the spiritual *genombrott* from limbo or purgatory to paradise. It is hard to conceive of a "through-the-wall" trajectory bolder than this. But we also need to interpret this scenario along artistic lines, to see this return of the Old Masters as an intimate family reunion, the final link in a chain that started in Josephson's school days, but with Josephson now (madly) in command, deciding *their* fate. *The Spirit Protocol* writes large for us the commerce we sustain with the Greats, our intercourse with the gods, and in that sense Josephson is making visible to us a kind of astonishing cultural and ideological geography, of a sort unavailable to realist or mimetic praxis. One thinks of CAT scans and MRIs, but along cultural, aesthetic, and psychic lines, displaying the actual traffic taking place inside us.

On Bréhat, in 1888, Josephson has gone through the wall, but has disappeared in the process. The work that is to appear on the far side of this trajectory may properly be regarded as "breakthrough" art, in the sense that it is virtually unlike anything produced in nineteenth-century Europe. But let us recall

the Hamlet scenario. Hamlet hears the fateful call of the ghost, of the Father, and all of Shakespeare's genius goes into the psychic and philosophic explosion that is occasioned in the young prince. Unable to act (according to the dictates of an older revenge code), eaten up by consciousness, paralyzed by ambiguities and dread, Hamlet postures, prevaricates, and plays. Especially he plays: not only with Ophelia, Claudius, Polonius, Rosencrantz and Guildenstern, and virtually all those who engage him; but most profoundly through the auspices of theater itself, comprising both his own performance and that of the professional players as well. Play comes to us here as a form of action, of virtuality, a what-if proposition of shocking power, a way of having your cake and eating it.

And, as we have seen, it is more than evident that Strindberg also has tapped into the resources of "play," seeing in them the very pulse of human relationship as well as a theatrical modus operandi in which "truth" and "consequences" are stripped of the tyrannical power they possess in daily life (or scientific/logical/economic/practical affairs), yielding the kind of brazenly self-sufficient, "unverifiable" histrionic bytes such as the paternity of Bertha, the quality of hotel life at Lake Como, and the later, fully oneiric "independent" materials of *To Damascus* and *A Dream Play*. The point here is that Strindberg has common cause, both in his life and his art, with the elasticity and poaching possibilities of the Hamlet strategy: play gives you maneuvering room, enables you to avoid both corners and collisions, creates a virtual space where much living is possible although no scales can take its measure.

One needs to appreciate Strindberg's uncanny genius for transforming damage into gain, for reconceiving agon altogether as the life-giving soul of theater. There is something peculiarly fail-safe about Strindberg's enterprise, and it is here that the comparison with Josephson is so illuminating: Ernst Josephson is utterly without these ludic or playacting resources. His deck of cards contains no jokers, and he has none of the histrionic mastery or strategic maneuvering room we

have been discussing.[13] All this is to say that Josephson crashes through the wall for good. He is to move fully—without brackets, without fingers crossed behind his back, without return—into that "undiscovered country" that Hamlet mentions, not so much death as a world of flowing spirits and roving ghosts. When he hears Hamlet's ghost calling to him in Vallgren's Paris atelier in 1883, it is a grisly premonition of the fateful annunciations that are to come on Bréhat in 1888; it is advance notice of the specter community in which he is soon enough to take up permanent residence.

This is a trajectory we can follow. Josephson's impending exit seems already visible, at least in hindsight, in the two most well known paintings he ever did, done right at the time of the Vallgren *soirée*: *Näcken* (1882) and *Strömkarlen* (1884) both known in English as *The Water Sprite*. One hardly need be Dr. Freud to see in these two astonishing depictions of a naked young man, playing a magic fiddle in the rushing water, patently yearning for some kind of release, elements of Hamlet's filial predicament. There is a whole host of drawings and sketches done by Josephson on this motif, a motif that had been with him ever since his journey to Eggedal in Norway back in 1871. Näcken obviously harks back to a pre-Christian Scandinavian past, and educated Swedes are familiar with Stagnelius's famous poem of 1819 in which the taunting of the pagan fiddler by the Christian boy leads to a sorrowful disappearance, approaching something like the "death of Pan." But if we factor in, as well, other connotations of Näcken (see figure 4.B.5), especially those concerning the figure as older man, as master fiddler and consummate artist (who could drive people into frenzy by the power of his music), then we can measure the fuller symbolic resonance of these two paintings.

The earlier piece is moody and romantic in its dark colors and lyrical disposition, whereas *Strömkarlen* (see figure 4.B.6) explodes with a kind of harsh, almost shattering light, all of which flaunts the exhibitionistic white flesh and stretched

body of the beautiful boy in the water. Both these pieces were ridiculed at the time of their appearance, not only by the critics but even by Josephson's artist friends. Even Prince Eugen (future owner of the piece, slated to put it immortally in the center of his palace living room where one goes to see it, still today) was not wild about the painting back in 1885 when he first saw it. Yet each version of *The Water Sprite* testifies to the desire to go through the wall, the desire to create beauty and magic with the golden fiddle; beyond that, they tell us about desire itself, since the expression on the face of the water sprite is one of ecstasy, and the libidinal underpinnings of this work are not hard to guess at. Critics have sensed homosexual longings in these pieces, but even more explicit is the later drawing, *Satyr* (see figure 4.B.12), which spells out the connections between fiddling, masturbation, and castration.[14] With the blithe yet startling economy that art often possesses, these paintings speak volumes to us about Josephson's feelings as pariah, as misunderstood, as performing for an audience that can neither see nor hear, and as sexually repressed creature for whom art is forbidden self-pleasuring, replete with its own disabling punishment. The sword we saw at Vallgren's atelier has now been turned on himself.

Yet he does go through the wall, and he does succeed in showing us what he saw on the other side. Whereas it is true that the drawings of *The Spirit Protocol* are not aesthetically compelling (regardless of their pathological interest), the body of work that the sick Josephson is to produce, in spurts, during the second "sick" half of his life testifies indeed to an artistic *genombrott* of singular power. We see here visionary work that has a niche all its own in nineteenth-century European painting, and it deserves to be better known even in Scandinavia, much less in the larger world. The old obsession with power, seen in the early worship of the Old Masters, recurring in a stranger, far more virulent form in the invasion of the spirits depicted in the *Andeprotokolllen*, now plays out in a wider, more various, more spectacular series of works.

Some are overtly religious, such as *The Shepherdess's Vision* (see figure 4.B.15) and *The Holy Sacrament* (see figure 4.B.16), which rank among Josephson's most astonishing work. *Gås-lisa* (as it is titled in Swedish, referring simply to the girl who tends the geese) is cued entirely to divine revelation: the shepherdess, almost dazed in her kneeling heiratic posture, with right arm strangely protecting her (against the vision?) while her fingers caress the luminous, silky, sensual hair, seems to signal to us what our own response should be to the Christ child who is pure radiance, seemingly spawned by the spokes of white and ochre light, he, too, in a hieratic position with both arms infolded over his chest, a crown of thorns covering his beautiful innocent face, his feet already marked by the stigmata. This religious motif is all the more mysterious by being placed in a legendary landscape of magic birds, swaying, protecting plants, as if all of nature were transfigured by this vision, so that fauna and flora played out their roles too in the Passion Play that is prefigured.

Or consider the no less specular dimension of *The Holy Sacrament*; a dazzling mix of whiteness, light, and air seems to characterize Jesus with the bread and wine, rendered as pure luminosity once again, as the players take in the vision: the enigmatic, elongated figure in green who seems to frame the scene, and the small angels with their own radiance who look on, mysterious twigs and offerings in hand, along with a disturbing Mary who seems to be chastising her divine son as he caresses the very phallic-like bread. Critics have spoken of Josephson's identification with the suffering Christ, but no psychological reading quite takes the measure of the splendor of these two pieces, carried out in a color palette completely at odds with the earlier realist work, closer in spirit to the Synthesist paintings being done by Gauguin at this very same time in Brittany. These two paintings render a shining universe of immanent spiritual forces, and they miraculously suggest that spirit—which must be immaterial—can be represented after all, can be felt in the radiance and

mystery of these revelations. The Christ child is aflame with tidings of suffering and sovereignty; the angels are frozen in awe at the spectacle of transubstantiation. Matter and spirit are shown to be transformable into each other. It is as if the "monist" discourse of Strindberg's *Inferno* were translated into visual terms, turning the familiar Old Stories into revelations, making the material scheme into something liminal and beckoning.

Astonishment marks each of these pieces, as well it should, because they attempt nothing less than the revelation of spiritual power, the stupendous *genombrott* of divine light into our world of matter. It is senseless to speak of some religious conversion on the part of the artist; what has happened is quite different: his art no longer respects the surfaces as it did, but rather seeks to capture the flowing energy that animates life, that fuels all religious systems, that connects the human subject to the great sources, whether they be named fire, sun, air, water, or Jesus. One senses something akin to disarray or panic or stupefaction in these paintings, all the more emphasized by the defensive postures of figures seeking to ward off, as well as announce to the world, the startling visions they have encountered. Having seen these paintings, one returns to *Näcken* and *Strömkarlen* with a more chastened sense of what they entail; a garlanded naked youth playing a golden fiddle for all he is worth, amid a tempest of swirling waters, is an explosive composition, a Faustian warning about potentially unbearable frequencies, about impending annihilation.

On the other side of the wall, the mad Josephson sees power as never before. And he sees it in ways that remind us of the great political philosophers, ranging from Machiavelli and Hobbes on to Marx and Freud. Striking testimony is provided by the tiny yet monumental sequence called *Triptych*, featuring Jesus (figure 4.B.20) and Mohammad (see figure 4.B.21) flanking "Charles XVI" (Josephson's chosen sobriquet) (see figure 4.B.22). Using a palette of brilliant oranges, reds, and browns—evoking once again the work of figures like

Gauguin and Sérusier—Josephson offers us the regal but brutal Oriental monarch, *superbe* in his reclining posture (like Roman emperors of old), at once rakish and Michelangelesque in his physical grandeur (albeit mocked by the peacock flourishing a mirror); Mohammad's opposite number is, of course, Jesus, crushed by the huge cross, by Simon of Cyrene there to help him, and not least by the orange apocalyptic sky, lost in his mission, looking out at us with dreadlocks and Semitic characteristics, as if to close a scene of historic fiasco. Centering this pair is the enigmatic Charles XVI, presented as Renaissance dandy, replete with stylish red hat, huge plume, filmy gauze-like robe, stiff and vacant expression, frozen into a posture so hieratic that it recalls Mme Tussaud. The most insidious feature of this triptych is the corrosive parallelism that informs it, because Josephson has, with great insight and malice, equated the grandeur of religion, politics, and haute couture, as if to say, these chaps are cousins after all.

Power is representable in still other, no less extravagant ways. Consider the planned series of Nordic gods for which Josephson has left us drawings. Resembling Renaissance medical drawings in their acute physiological detail, these pieces are among the most tumultuous of Josephson's works, showing the human body to be a locus for pure violence. One thinks back to both Michelangelo and Rabelais when assessing the untrammeled energy and appetite of these figures, but they are terrifying in their propensity for murder and rape, shown in their various brutal exploits. These arched, splayed, exhibitionistic bodies look forward as well as backward, reminding us of a later moment of our own body-building, iron-pumping culture of bicep development and muscle worship. Yet these virulent renditions are checked by a kind of residual fear, an anxiety that can be downright sexual, as in the strained, sinewy figure of Niord (4.B.27), who seeks to shield himself against threat while placing his hand on a penis-like rudder, or the primitive, gargantuan Fjolner (see figure 4.B.25) whose rippling torso is thrown back so that a

huge drink-filled horn can slake his thirst, and this stunningly abbreviated body (with a face consisting only of lips, tongue, teeth, and part of one eye) seems to have projected its genitals onto another plane altogether, in the shape of the fanciful "F" which the artist draws, phallus-like, on the bottom of the piece. These insolent and disturbing drawings also constitute a sort of *genombrott*, a *nec plus ultra* of physiological mania, that makes us feel that Josephson, in his sickness, has discovered, with both amazement and horror, what a body is and, by the same token, that his earlier fine portraits have been window dressing, have simply failed to see the originary somatic turbulence at home. Conflating the physiological and the spiritual pieces, one is obliged to say that Josephson's crashing through the wall has led to a new vista in which both body and soul are—at last and only now—on show.

Josephson's crowning achievement during the Sick Period is unquestionably the portrait of his uncle, Ludvig Josephson, painted in 1893 (see figure 4.B.35). Shakespeare is once again at hand, since the famous theater director is shown during a rehearsal of *A Midsummer Night's Dream*. Against a rich backdrop of browns and oranges, textured and seemingly marked by hieroglyphics, Ludvig appears as a final figure of power, holding the Shakespeare text in one hand and ringing his bell (to assemble the actors) with the other. The ecstatic, exalted face of the theater czar seems to announce the absolutism of art, with something of the brutal grandeur of Mohammad and the hush and revelation of Jesus now appearing as the miracle of the living text, the word of the dead playwright that is now to be transformed into reality via the flesh and voice of living actors. This, too, is a form of holy sacrament, a miracle of transubstantiation, a breakthrough that annihilates barriers of time and space. The son Joseph portrays the uncle/father Ludvig in an act of filial piety and reverence that is also, unmistakably, an act of rivalry and competition, for we can hardly fail to see that Ernst's own powers of creation and artistic potency are enlisted in this homage to Ludvig. Nowhere

is this more vivid than in the liberties Ernst has taken: the transfigured face (that Ludvig disapproved of), the bursting forth of the human figure with bell and text from a background so grizzled and ancient that it might be the Past itself. And, most beautiful, the enigmatic portrayal of Ludvig's right hand that seems to emerge ex nihilo, to surge from the director's shoulder without any intervening arm or other debt to human anatomy. Here is the hand of the artist, Ernst's hand as much as Ludvig's, and it seems to explode through the canvas, indeed to crash through the wall, like a creation myth.

But that is not all. Josephson has painted this portrait directly—brutally, with paint applied head-on from the tube—over an earlier canvas, representing a historical execution motif. Ernst has simply turned the earlier piece upside down and painted over it, and we can easily make out the figure of the executioner in red if we turn our heads, or if we see an infra-red version of the painting (which is prominently hung in the National Museum in Stockholm). When we do so, we perceive the astonishing logic of this masterpiece, for we note that the director's hand—a cubist hand that appears thirty years before cubism—emerges directly from the two legs of the executioner, and one is struck by the aptness of this conjunction. Between the legs of the death-dealing executioner sprouts, not a penis—certainly not the penis of the guilt-stricken, syphilitic Ernst Josephson whose earlier love for Ketty Rindsdorf went aground because of sexual guilt—but a hand. The creative organ of the artist, we realize, is the hand, and in this Baroque celebration of a final powerful father, Ernst has finally achieved his own *genombrott*. That cubist hand that transforms death into life, that takes the earlier academic canvas into the annals of modern art, is Ernst's way of crashing through the wall.

Whereas Strindberg arises, phoenix-like, from each crisis and curtain call, Josephson's fall into madness is permanent. Breakthrough in art, yes; in life, who knows? Little captures more perfectly the pathos of his sick years than the photo-

188

graph we have of the artist, decked out with toy sword and wearing the drapes of his apartment as cape, marching proudly down the streets of Stockholm following the Royal Guard. We remember Strindberg's Captain, infantilized before our eyes, a man whose sword has been taken. We recall the fun-and-games at Ville Vallgren's atelier, when the roaring Josephson penetrated the paper walls with his sword, while the admiring Strindberg watched and reflected. Josephson responded with all his being to the Father's call, with tragic results. This is a Hamlet soon to be mired in his own play, utterly without Strindberg's capacity for mixing realms and coming out alive. Paired against the supple, life-affirming Strindberg-trajectory, Ernst Josephson's fate testifies to the corrosive, annihilating power of Power: plaything of the gods (much as Strindberg also thought himself to be), Josephson is undone, but his work shines an unforgettable light on the forces that beset him. Early in his career, he defined, much as Rimbaud had done, the purpose of art as the liberation of the senses. He could scarcely have known how total and devastating this liberation would be, for him personally.

3

Our story could close here, as a reflection on two responses to Hamlet's plight. But I intend to go further. This dilemma of ghostly commands and imprisoning walls is arguably the secret story of all artistic genesis, and, of course, I see its parallels with Harold Bloom's well-known theory about the anxiety of influence. The call of Hamlet's ghost will carry through the millenia, will doubtless catalyze explorations and breakthroughs that are now unimaginable. But one twentieth-century Scandinavian variant of the Hamlet predicament is so operatic and instructive that it warrants inclusion. Hence my argument will be brought to a close by examining a final, particularly rich instance of artistic emancipation and *genombrott*: the case of Ingmar Bergman's great, last, and Shakespearean

film, *Fanny and Alexander*.[15] To consider a filmmaker's closing work as "formative" would be senseless, but this sumptuous drama of ghosts and magic has not been adequately assessed for its revolutionary power.[16] We have easily understood it to be a kind of Bergman *summa*, a roll call of earlier ventures now synthesized into a more generous, warmer, Baroque format, constituting a peculiarly congenial final statement. We need also to realize the extent to which *Fanny and Alexander* caps Bergman's meditation on film itself, how fully it realizes the potential of this medium to refigure our relations with one another, to bring to light the strange but potent linkages that shape and reshape, form and deform, individual life. Put most succinctly, this film constitutes a breakthrough in its own right—something hard to see, because it appears much less abrasively experimental than the work of the sixties—in that it actualizes the spiritist *Weltanschauung*: a universe of flowing forces in which spirit is alive and the contours of human doing are radically reconceived.

Bergman's interest in ghosts is of long date. The figures of the past return to the scene in *Wild Strawberries*; *The Magician* stages Bergman's classic warfare, that between scientific rationalism, on the one hand, and varieties of belief engendered by mysticism, magic, and desire, on the other; *Persona* dwells beautifully and maddeningly in a twilight zone where consciousness and event shade into each other; a late, underestimated film such as *Face to Face* is still more operatic and oneiric in its sumptuous tracking of spirit life. Going through the wall, lifting the veil: Bergman's career is stamped by such imperatives, despite the dictates of "realism." From the beginning right up to the end, Bergman has known that magic is real as well as bogus, that belief creates its own indigenous realms, that the heart and the imagination operate incessantly and ring changes on the phenomenal world we inhabit. One thinks of the so-called magic potion that is ceremonially served up in *Smiles of a Summer Night*: it will indeed catalyze

momentous things, but we realize that these transformations have been brewing an entire lifetime.

But in *Fanny and Alexander* Shakespeare's *Hamlet* is repeatedly invoked and exploited as Bergman's crucial and enabling intertext, and this time the magic is different. Much is glaringly obvious: Alexander's father, Oscar, suffers a stroke during rehearsal of *Hamlet* (playing the role of the ghost, needless to say), and at his death bed he tells Emilie that he will be with her and the children even more palpably in death than in life. And he is. We see him return, frequently and helplessly, as spectator of the ensuing mess that his family has become, much to the disgust of his son. Here is one of the film's easiest trumps: it can produce ghosts on the stage far more effortlessly than theater can, and we have no trouble with the convention that only the initiated can see this dead man; we certainly can.

Yet the Hamlet scenario comes into focus fully only when the film's sinister second plot unfurls: the bishop Edvard's courting and marrying of Emilie, and the subsequent battle-to-the-death between Edvard the stepfather-king and Alexander, the film's dreamy and rebellious Hamlet. There can also be no doubt that Bergman is deeply and personally invested in this plot that vacillates between infanticide and parricide, and we feel that "killing the father" is increasingly understood as the only avenue for the son's artistic/sexual emancipation. Of course, this formula brings us back to Strindberg and Josephson as well; our two nineteenth-century figures felt the need to break through, to reinvent the genres they had inherited. (One feels that the ceaselessly experimental Strindberg somehow devised his breakthrough; it may be closer to the mark to say that Josephson was assaulted, almost canceled out, by his.) With Bergman, as noted, the Oedipal battle seems especially intimate, and the filmmaker's own pastor/father (and the Lutheran god standing behind him) do not seem far away in this scenario. In addition, this film is unquestionably a meditation on the part of the now old Bergman over his own

coming of age, a process that starts to smack of murder and/
as artistic apprenticeship. In Alexander we see the vital forces
of imagination, fantasy, and narrative—easily spilling over
into fictions and bald lies—making common cause with the
mechanics of film, as seen in the early (signature) episode of
the magic lantern. The very projection of moving image on
the wall comes to us as an exercise in power and *genombrott*,
as the young boy controls his peer audience, weaves his spell,
injects into the reality of others his own artistic concoctions.
Bergman is on familiar ground here, keeping covenant with
the great *Künstlerromane* of modernism, Proust's *Recherche*
(which features its own magic lantern scene), Joyce's *Portrait*
and even Mann's "Tonio Kröger."

But there is a crucial turn of the screw in Bergman's han-
dling of this material. The young artist's fictions now possess
an uncanny life of their own, script events for others, become
more than a little frightening. Hamsun's *Hunger* (as we shall
see) takes such a vision right into hysteria, but Bergman
weaves it into a thick social mix, shows us what the artistic
temperament wreaks when placed in a family, when located
in a child. It is innocuous enough when we encounter this im-
pulse in the schoolboy palaver that Alexander spreads about
joining the circus and running away with the gypsy girl Ta-
mara. But things are far more disquieting in the fateful narra-
tive that Alexander delivers of Edvard's murder of wife and
daughters. Bergman seems to be measuring the limits of the
artist's freedom, and Edvard's fierce punishment of such fa-
bulation is not hard to understand. Yet every viewer of the
film has felt the power of Alexander's account of a man lock-
ing up his wife and children, forcing them to flight and death,
and no one can fail to appreciate the grisly (even if displaced)
accuracy of the boy's fable, since what we have before our
eyes is precisely the truth of the story: a woman and her chil-
dren being held prisoner by the Bishop. Emilie tells Alexander
to put the Hamlet scenario aside, that the Shakespearean
schema of evil uncle and fated prince is not relevant, but of

course we feel just the opposite: Edvard is presented as a monstrous, murdering Claudius, a man who kills children. What arms can Alexander/Hamlet enlist against such power?

"The play's the thing / Wherein I'll catch the conscience of the king." Art, theater, play, mask, effigy: these are the resources and materials for the counteroffensive. Edvard earlier rebuked Alexander for lying, and asserted that God has created artists as caretakers. But the film takes a far more aggressive view of the matter. Artists are incendiaries, and their mission is to transfigure the conventional world, by liberating libidinal energies but then launching these energies—the way you would launch a missile or a torpedo—into the mix. The Ekdal's theater and the Jew's lodging—both crammed full of masks, costumes, dolls, puppets, even a mummy—become the film's authentic holy places, in sharp contrast to the bare, Spartan (Lutheran) quarters of the Bishop. Bergman's camera dwells lovingly on these Baroque objects and surfaces, because it understands them to be containers of energy, launch pads for violent happenings, suffused with a kind of pulse and life that wants only to be allowed out, not unlike the famous genie in the bottle. Alexander's progress as artist is measured in terms of his increasing mastery over this arsenal. Strindberg would have understood these arrangements, as is beautifully evident in the semiotic spectacle of the Captain's tunic and uniform in *The Father* (could Bergman have gotten his own totemic beliefs here?); or, one remembers Josephson's *Gåslisa* and *Holy Sacrament*, or indeed the charged portrait of Ludvig Josephson where Shakespeare's spirit is being summoned. Once again, we are dealing with a territorializing art that delights in knocking down walls, a bellicose art devoted to the coercive and reshaping power of belief (as well as the power system which delivers it to the world). We are about to see how film becomes a privileged medium for representing this explosive commerce.[17]

One of the film's most unforgettable episodes along these lines is the magnificent scene where Isak the Jew *spirits away*

(there is no other way to say this) the two imprisoned children from the Bishop's palace. Much is happening in this sequence; among other things we grasp the depths of anti-Semitism that lurk under the Bishop's suave demeanor, as he falls into a rage and throttles Isak, charging him with trying to steal Christian children.[18] The scene also remains in our minds as a bravura performance by the actor Erland Josephson, outfitted with cape and fez and made up for all the world as the spitting image of his own distant relative Ludvig Josephson, as portrayed by his no-less-distant forbear, Ernst Josephson.[19] Bergman is at the top of his form in this sequence, beginning with the stunning arrival of Isak in a horse-drawn sled that is rushing directly at us, reminding me visually of what Munch has conveyed in the painting, *Galloping Horse* (see figure 4.A.18), so as to let us know that (demonic) forces are on the move. But the ante is upped still further in the hallucinatory moment when Isak stares, exalted and ecstatic, at the ceiling and then shrieks—shrieks no less than Munch's infamous figure does in *The Scream* which is also about shape-shifting power of human feeling—with the result that reality is altered: the two children are alive, hidden, in the trunk (we have just seen this, we know this is so), and they are *also* "replicated," "facsimilied" in their bedroom as sleeping (dead?) figures on the floor. How, you may ask, you should ask, is this possible? Human passion is the great shape-shifter, transforming our so-called givens, showing them to be prismatic, malleable clay in the hands of the artist-magician. This scene is demiurgic, and it simply smashes through walls we have thought real.[20]

Alexander and Fanny are rescued, so that Alexander may at last avail himself of just these armaments. And that is what he does in the crescendo-finale scene with Ishmael at the heart of the labyrinth. We are now dead center. Hamlet's revenge is about to be taken. Very little in the Bergman corpus—very little in European film—can match the intensity and poetic grandeur of the encounter between Alexander and the hermaphro-

ditic Ishmael.[21] It is here that all the breakthroughs occur.[22] As Ishmael caresses Alexander's pubescent body while "directing" his feelings, every spectator senses, with amazement, that, yes, this is also a story of sexual coming of age.[23]

Above all, we are aware of slippage and fluidity, of the collapse of old boundaries and demarcations. Alexander writes his name, "Alexander Ekdal," but it comes out as "Ishmael Retzinsky," much the way Ernst Josephson's self-portrait is signed "Velasquez." The spirits are on the move. This is the very cosmology that Aaron, Isak's other nephew, has spelled out to Alexander, a universe of poltergeists, ghosts, and coursing spiritual forces, a kind of occultist parade, a spiritist Walpurgisnacht. Within this dispensation, Alexander's final and terrifying steps are taken. "A scream goes through the house," repeats Ishmael as he coaxes forth Alexander's burning hate for Edvard, and we actually hear a scream, a scream that we have, in fact, heard once already, that of Emilie keening in front of the dead Oscar as the two children looked on in terror and fascination, the scream that replays Isak's shriek, transmuted into feeling that courses through the house, that is about to torch the house. This time there is a terrible potency at hand, a lethal agency coming into being, as Alexander starts to kill his stepfather, as Hamlet at last acts.

But whereas Shakespeare requires swords and cadavers, it all goes very much faster in Bergman, as if revenge were a form of homicidal neural energy, and powerful feeling could achieve the immediacy and accuracy of electronic circuits. Bergman's brilliant cutting and splicing here—from the fused figures of Ishmael and Alexander, the older caressing the younger, midwifing and delivering his rage, the younger at last unleashing the load of hatred he harbors, on to the bedroom where the sick aunt knocks over the lamp, where the flames engulf her, where Edvard goes to her aid and is initiated into the fire, scorched to death—constitute the final *genombrott* to be discussed. Film—cutting—makes us see the clear but gruesome causality at work, the direct hit scored by

hate, the on-target violence that annihilates the enemy, the re-vealed umbilical cord that links humans by dint of feeling. Feeling goes through the wall, surpasses today's smart weapons, exposes the world to be a network. One feels that Bergman has intuited the explosive power adumbrated in Strindberg's *Dream Play*—the startling claims in the prologue where we are told that time and space no longer bind, that the world of the dream is porous, fluid, and metamorphosing—so much so that the closing moments of the film, in which Helena reads these very words, reveal the very nature of artistic insemina-tion: Bergman salutes his great predecessor, and goes on to show that *film* (the film we have just seen, the reality principle that has been on show for some time now), even more than *theater*, constitutes an ideal site for this new dispensation.

Josephson slashed holes in a paper wall, and then later dis-appeared himself into the hole, in order to break through to the visions of the sick work. Adolf crashed through a wallpap-ered door, carrying books, broadcasting his fate as victim of textuality, shorn from origin, unable to seed. But now we see the act of crashing through the wall in its most basic yet trans-figured sense: to crash through human skin, to bind you to me, to obliterate all conventions of bounded self. Liberating the murderous power of feeling may seem like an occultist extravaganza—Strindberg claimed, in *Inferno*, to feel the ha-tred of others as rays projected on him; it was spiritist busi-ness-as-usual, you might say—but we are closer to the mark if we compare this act to nuclear fission, to a liberation of un-heard of energies that have cracked their armature and now cross all thresholds to assert their awesome will. Artists are caretakers, Edvard claimed; Bergman shows us not only that they are incendiaries but that they transform feelings—those sensations that a lazy ontology deems "inner"—into weapons of destruction, into guided missiles. An entire new ecosystem comes into sight here, as the contours and limits of the indi-vidual subject go up in smoke, are seen as mere bases from

196

which feeling emerges, acts, and dreadfully coheres the world. Discrete individuals no longer exist; instead, there is an awful mesh, a concatenation of linked, twinned, and interactive souls with all the dreadful economy of marriage *à la* Strindberg.

There is little to celebrate in this vision. Alexander is to be remembered not as murderer or empowered agent but as the child who is felled, at film's end, by the still living ghost of Edvard who prophetically says, "Mej slipper du inte" ("You won't get away from me"). No one is free and clear in a world of ghosts. But there is indeed something grand in the creative acts that respond to the claims of the ghostly fathers. Hamlet's efforts to engender himself, to come of age, to reconceive *action* in such a way as to transcend the older codes: all this goes into the very rationale of *genombrott*. Strindberg, Josephson, and Bergman ventured through the wall, and their efforts have reshaped the art forms in which they worked. Theater, painting, and film enable us to get a new sighting of our arrangements, and these three artists have recharted our own living space. They did so by breaking through the older forms, for that is the law of *genombrott*: to cross the threshold, to take a way of seeing, representing, and making into new territories, new dimensions.

B. THE CHILD'S REVENGE: KIERKEGAARD, IBSEN, LINDGREN, CRONQVIST

1

Let me begin with a broadside: Scandinavia is not a culture of youth.

A phrase much heard in Sweden in the 1970s was "Jantelag," and it spelled out a view of childhood and socialization that was specifically at variance with the American model. I recall a particularly mythic parallel that was often

trotted out, having to do with the first notions implanted in the minds of the young, from infancy on: the American child received, as a version of mother's milk, the sacrosanct dictum that life was an affair of personal fulfillment and gratification, that the future was open for one's self-development, one's self-construction; but the Swedish child absorbed a very different gospel, namely, that it was part of a larger group, that it was born with allegiances and responsibilities, that maturation consisted in recognizing one's place. I am presenting each of these models in jingoist form, but I believe they reveal a significant truth, and that they reflect divergent political and ideological orientations that go well beyond the culture of the 1970s, that they limn the views of their respective societies on both individual freedom and the stakes of growing up.

My book is about Scandinavian literature and art, not about social philosophy as such. But it is no secret that the American myth of endless and unchecked personal mobility and gratification is not at home in Scandinavia. As is true of Europe in general, Scandinavian culture over the past two centuries displays a sharp sense of the societal forces that inform, leaven, and sometimes destroy the individual's desire for freedom and success. The phenomenon of the nineteenth-century Bildungsroman—as is seen in the work of authors as distinct as the German Goethe and Swiss Keller, the French trio of Balzac—Stendhal—Flaubert, the English Brontë and Dickens—charts the trajectory of the young as they enter a social world not of their making. Each of these writers has his or her own inflection: Goethe and Keller tell stories of renunciation and self-discipline, Balzac and Stendhal are drawn to the drama of selling out or falling short, Flaubert's Frédéric Moreau is compromised to his very core, Jane Eyre moves toward a twisted success, and Pip comes to measure his errors and blindness. These fables are about education and maturation, but they register the fierce limits of individual autonomy, and they are all, in their different ways, bent on chastening or reorienting desire. They are un-American.

2

How, then, do children fare in Scandinavian texts? One might begin by evoking the figure of the Ash Lad in the folk tales that were well known in the nineteenth century. Often represented as the younger child, as the child who comes up shortest when parental aid is given, the Ash Lad gets by strictly by dint of his quick wits. Many stories focus on his encounter with either trolls or with a series of severe challenges (where he is confronted by daunting odds or grim circumstances), but he invariably copes his way to success: he overcomes obstacles; he solves puzzles and riddles; he wins the princess's hand; he slithers and slides toward managing his environment. Wit would seem to be his only endowment. There is little talk of desire. One has no sense of some individual form of manifest destiny but rather of pluck paying off in a rough world. If the tales collected by Asbjørnsen and Moe present the Ash Lad as a survivor, the realist depictions of children in genres such as the novel are far more austere.

A number of major nineteenth-century Scandinavian narratives yield gloomy pictures of socialization and maturation, whether it is Jacobsen's canonical *Niels Lyhne* or Bang's *Families without Hope*, each imbued with a sense of biological decline, thanks no doubt to the impact of Darwin's ideas. But the social obstacles are no less daunting. One can evoke Nexö's classic, *Pelle the Conqueror*, as emblematic in this regard: good will, wit, endurance, and pluck suffice just barely—and sometimes not at all—to enable Pelle to keep his head above water, given the severity of the living and working conditions in which he, as hapless immigrant child-worker, is positioned: exhausting and inexhaustible manual labor, feckless (if loving) father, sadistic superiors, a social hierarchy that is as real and unbudging as the stone in the name of the farm where he's billeted. The beautiful film that Bille August made of this novel wisely closes with Pelle's exit from the Stone Farm, an exit that takes him over the snow and ice

toward the beckoning sea, toward the wide world where he longs to make his mark. One remembers the hapless Erik's earlier ringing exhortation to Pelle: "hela världen, Pelle, hela världen!" ("the whole world, Pelle, the whole world!"). Yes, the novel yearns for the great spaces of freedom and autonomy. But Erik himself, at the very moment when he challenges the brutal hierarchy, is to be struck down and infantilized. And we know from Nexö's fuller novel that Pelle will not get very far in his quest for freedom: he will suffer pain and injustice in his encounters with love and with authority. He will not conquer much.

<p style="text-align:center">3</p>

In considering the fate of children in Scandinavian literature, we have already noted the anti-Oedipal dimensions of Kierkegaard's *Fear and Trembling*; further, one senses, considering the ample biographical evidence concerning the dark, brooding legacy of Kierkegaard *père*, that the author himself knew a good bit, firsthand, about the weight of father power and, consequently, the child's need for wiggle room. But the story is unremittingly coercive. Prepared not only to sacrifice his son, but also (in doing so) the seminal figure for the children of Israel, the text's Abraham—no matter how obedient he is to a higher power—acts as pure patriarchal force.

The hapless Isaac can be seen as not only victim but "tool," even "guinea pig" through whom the negotiations between father and God are carried, through whom they are "realized." In some rather nasty way he "instances" the power of his superiors; he is their indispensable medium. To be sure, the notion of "child's rights" as such has little authority in this text, but it certainly has a pathos of its own. This pathos is related, I believe, to the complex narrative dynamics at hand, so that John of Silence's multiple speculations about Abraham, his incessant circling around his patriarchal subject, constitute willy-nilly an Isaac weave as well, even if it exists

largely as aporia. And, further afield, we might want to invoke Kafka here, as parallel instance of a comparably weird, twisted, half-occulted discourse of "sonship," shown exclusively through the text's own dodging and weaving, as if the only resources of son-Søren and son-Franz were writerly, as if all other self-assertions were taboo. (One might fruitfully explore Kafka's "Judgment" and "Metamorphosis" along just these lines.) A stark libidinal economy comes into focus here: the damaged father-obsessed child writes—thereby rights—his undoing; could this be revenge? *Fear and Trembling* will allow such hypotheses, but it will scarcely document them, given that Isaac himself is so utterly marginalized, so ghostly a presence. Where might we go, textually, to see just how *fertile* child exploitation might be?

In answer, I would claim that the most provocative (and surprising) body of child-sacrificing work is that of Ibsen. I say "surprising," because Ibsen tirelessly championed individual freedom in his plays, even when the aspiring protagonists had great odds against them. One would not be far afield in claiming that the Ibsen enterprise is crucially about coming of age, about self-discovery and self-emancipation. Ibsen's people realize ever more completely, in play after play, the bondage in which they are held, the chains that must be broken, the need to break free into symbolic adulthood. The entire prose cycle seems to celebrate human potential at all costs, from Nora's efforts to extricate herself from an imprisoning and dehumanizing marriage to the old Rubek's campaign for truth and light at the end of his career.

Hence it is all the more surprising and disturbing to measure just how drastically children are instrumentalized—cut short, turned into sacrificial pawns, outright annihilated—in Ibsen's plays.[1] They embody, often in haunting and opaque fashion, the crises and failures of their parents, yet they possess little hope in their own right, and they rarely live very long. One knows that Ibsen's own childhood was bleak: father's bankruptcy when he was six years old, sent out as ap-

prentice apothecary at a tender age. He looked back on early years with little pleasure, remembering himself as undersized and under-endowed. Or it could be that Ibsen took his cues from the same text that I have invoked in this study: Kierkegaard's *Fear and Trembling*; one is entitled to feel that the sacrificial pawn, Isaac, the child who ends up being mere currency in the theological negotiations at hand, haunts Ibsen's plays. I am hardly claiming that Ibsen's dramatic children are literally derived from Kierkegaard's drastic text but rather that the strategic and tragic dimensions of the Abraham/Isaac story— a story of vexed and competing loyalties, of the weak and the strong, of sacrifice—are unforgettably played out in the Ibsen corpus.[2] *Kindermord* is one of the terms used by Ibsen scholars: the murder of children. They do not simply die, they are killed. Why?

One might begin with Brand's doomed little boy, Ulf. Victim of the harsh Scandinavian climate, Ulf is doubly victimized by the hubris of his pastor-father, and the parallels with Kierkegaard jump out at us: Brand must choose between saving his sick son (and moving to sunnier climes) and obeying his priestly call (seeking to convert his mealy-mouthed countrymen). "The child is weak," the doctor tells Brand, "Another winter here will kill him. / Go, Brand, and your son will live. / But do it quickly" (102). His wife Agnes stands ready to depart. To be sure, Brand debates within himself, but one senses that it is not even a contest. Brand stays. However, unlike in Kierkegaard, there is no escape-via-faith in sight, no sublime schema by which Ulf (like Isaac) might be both sacrificed and saved; this child goes under. And the play closes famously with a voice coming from the icy peaks, claiming that "God is love," thereby tightening the screw on our interpretation of Brand himself as murderer.

If we bear these issues in mind, then Nora's heroic exit from a rotten marriage at the end of *A Doll House* obeys the same ethical injunction of self-discovery and of fidelity—at whatever price—to the self one discovers. Surely the dominant

trope in this famous play is childishness, seen squarely and unforgettably in Nora's status as her husband's pet, her husband's cuddly little domestic animal. The macaroon-loving, much caressed Nora comes to realize that she has forever been a pawn in the hands of men, passed from father to husband via a ritual that was obscenely called "love." Middle-class households resemble dollhouses, as Ibsen shows us, filled with immature little creatures whose fate is regulated by the wise patriarch of the family. So far, so good. But Nora's infamous final gesture of closing the door on her past, on the dollhouse where she has kept house, does not conjure good things for the fate of her children; Ibsen's contemporaries were scandalized by Nora's behavior, and one should perhaps not be too quick to lampoon them for their dimness (as critics have enjoyed doing for almost a century now), since there really is a nagging correlation between Nora's emancipation and the abandonment of children. Yes, she tells Helmer that she is not fit to raise children, that she must first grow up herself and become a person, and one can scarcely argue with her logic. But one nonetheless blinks a bit at the cavalier dispatching of her three children, as one begins to sense a strange dialectic in Ibsen's freedom plots, as if personal growth and exit and closed doors and negated children were somehow locked in a crazy dance.

Ghosts, however, is where the plot thickens, since it is a relentless chronicle of a child's undoing. To call Oswald Alving—syphilitically doomed inheritor of his father's transgressions and dissolute habits—a child may seem exaggerated, since he does reach adulthood before going under; but the play's unswerving focus on the concealed sins of the past is meant to oblige all parties (Oswald, his mother, the reader) to journey back to this childhood and measure its venom. Most critics recognize that Helene Alving is the play's true protagonist, and it is she who must descend into the underworld and revisit all her earlier actions—marriage with Alving, covering up for Alving, sending Oswald away to protect him—and see

them for the rotten transactions they really were. She comes to understand herself as shamelessly marketed by her mother and aunts, and she even comes to realize that she herself contributed to Alving's deterioration by ignoring his "joie de vivre," by steadfastly preaching virtue and thereby locking him into his dissolute ways.[3] All this is very good, and makes her role into something courageous and Sophoclean, rich and evolving. But Oswald?

All the boy actually remembers of his father is that once he made him sick. He never does fully understand, or truly care, that his father has poisoned him permanently, as is made clear when he becomes impatient at his mother's much belated efforts to explain why he is so sick. What matters to him is not why all this happened but that he is doomed, en route to becoming a vegetable, and must therefore find someone strong enough to help him die when the time comes. He is indifferent about his father, suspicious about his mother, and manipulative toward Regina. A good production of *Ghosts* must reveal the desperate self-centeredness of this doomed young man. Whereas his mother moves ever further towards self-knowledge, he is headed for the pit, and he knows it. His dilemma incorporates the death sentence with which William Blake closed his most apocalyptic poem, "London": "How the youthful Harlot's curse / Blasts the new born Infant's tear / And blights with plague the Marriage hearse." Marriage is a hearse, children are doomed. Oswald who might have been a new Gauguin, whose Parisian paintings were glorious with color and life, is systematically regressed, infantilized before our eyes. There will be no generation, no future. This is Ibsen's most anti-Oedipal drama, the one where the child is annihilated, where the concept of maturation goes up in smoke as idle dream, and no amount of final "light"—whether acquired by Helene or by the reader—offers any relief.

Ibsen seems horribly dependent on slaughtered children, as if they were the only way for his adults to come to knowledge. In some queasy fashion one feels that Kierkegaard is paying

his way in Ibsen's subconscious, but these transactions stem from a dark space permanently beyond the scrutiny of Ibsenian light. In play after play the same dreadful economy reappears. Hedwig must die in *The Wild Duck* if Gregers is to see how lethal his "truth dogma" actually turns out to be; as for Hjalmar, his world of fatuous illusion seems sufficiently airtight for even this death not to penetrate it. But we who read this play and agree with Relling's injunction to see Hedwig as a vulnerable adolescent at a precarious stage of life are shocked by the seeming necessity of killing the child. To what end? At the risk of overstating it, her death is reminiscent of Cordelia's, yet Lear *knows* what he has lost, and it kills him. *The Wild Duck* ends with a cynical joke about thirteen at table, and no one leaves the theater feeling that the death of Hedwig possesses any redemptive value whatsoever. Try to imagine the future of the Ekdal family without the cohering presence of the child, and you realize how bleak things are, how punitive this plot has been. The Ekdals, however blind or unknowing, *were* a family—a richly evoked, moving trio of imperfect creatures, constituting one of Ibsen's finer evocations—but now they are nothing. Has something been learned?

Or consider the death of the twin babies in *The Master Builder*. Once again we sense the hideous dialectic in play: Solness could only become Master Builder via the destruction of his wife's home in general (and all it stood for), and of his own children in particular (and just what that might stand for). Still more pitiable, more grotesque, is Aline's own reaction to these pathetic deaths: yes, she misses the dead little boys, but the hardest blow of all was the loss of her childhood dolls, effigies more real to her than her flesh-and-blood offspring. In some horrible way, it is as if the dollhouse Nora exited turns out to be "unleavable," turns out to be a nest of dead children. One feels Ibsen's desperate desire to reorient matters through the way he has cast Hilda—the wild one who enters the play like a breath of fresh mountain air, come to emancipate Solness—as the returned "child," Hilda as the

Nietzschean free spirit who will fill up the empty nursery, where Ibsen unerringly suggests she sleep. But this strategy is also monstrous, inasmuch as Hilda must become the child executioner at play's end, sovereignly willing Solness's necessary exit from the stage, if harmony is to be restored. And can it be? The drama closes with Hilda in a trance (as she has been for most of the play), and Ragnar as the only young person left: prematurely old, embittered, hardly due for a long run of his own. Still, the image of Hilda-as-executioner strikes me as poetically right and even overdue. Might children strike back? Might they ever assert their power?

Doubtless the most concealed dead child in all of Ibsen is the fetus who is murdered when Hedda Gabler proudly takes her own life. It is an out-and-out infanticide, and it is dreadfully motivated, since one is entitled to feel that Hedda's truest enemy, her deepest reason for exiting the disgusting world she inhabits, is her sheer horror of the life instinct, of biology itself. Certainly Tesman and Brack and company are reason to find life unappealing, and the loss of her reputation (as it will emerge via investigation of Løvborg's death) does not help matters. But what she finally cannot bear is the despotism of her woman's body, a despotism by which marriage undoes all the hegemony she has (quaintly, movingly, grotesquely) desired, since even the feckless Tesman can seed her fall. Never before has Ibsen represented the death of a child in such garish and baroque fashion, inasmuch as we see it twice: once figuratively, and once as a consequence of a gunshot behind a curtain. I call this *garish and baroque* because Hedda's one sublime moment of agency in the play—the slow, delicious, crazed, logical burning of Løvborg's manuscript—has an unmistakable symbolic significance: "Now I'm burning your child, Thea! You, with your curly hair! (*Throwing another sheaf in the stove.*) Your child and Eilert Løvborg's. (*Throwing in the rest.*) Now I'm burning—I'm burning the child" (762). Note the evolving character of this burned child: from Thea's to Thea's and Eilert's and finally to its true generic identity: *the*

child. More than jealousy is in play here. Infanticide is Hedda's bid for freedom.

If Hedda's child is in utero, hence invisible, it would seem that the dark wisdom of Ibsen's masterpiece, *Little Eyolf*, is that even the children you see are in fact invisible. They only become visible when dead. Ibsen is reaching very deep into the pit here, for this indictment has a sobering validity in his plays, as if to say: we are blind to one another while we live. One reason for a dramaturgy of ghosts is to honor (at last) the lives one misconstrued or failed to see as they unfurled in "real time." But when this assessment is applied to our own flesh and blood, our own offspring, it is harsh going. But Ibsen seems to have no choice but to go there. Of course no one dies a "natural" death in art. Thus the darkest feature of this model is this: children are only dead—visible, knowable, "productive," catalyzing—when the playwright elects to "kill" them. I discuss *Little Eyolf* at length in chapter 2, but one should remember the painful scene of recriminations (following Eyolf's death) between Rita and Alfred, where the myth of the foundling comes into play, as both parents recognize that they never loved or even knew their own flesh-and-blood child while he lived. It is as if, Rita says, he were "a little stranger boy." Horrible, yes, but not deniable and not denied.

Could that be what all Ibsenian children are, at some level: foundlings? little stranger boys? Still—unsurprisingly, alas—this dead stranger is every bit as strategic for the plot of *Little Eyolf* as he is for other Ibsen works: his death opens the door toward an ever deeper self-knowledge on the part of both Alfred and Rita, as they become aware of the games they have played, the displacements and projections they have bought into, the marionette life they have led. As in *The Master Builder* Ibsen tries mightily to give children another chance at play's end, so we are presented with the spectacle of Rita and Alfred planning to be host parents to the ragtag poor children who have been living miserably around them for years and years, whose callousness may have been a factor in Eyolf's death. It

is moving. One wants to believe that a spiritual transformation has happened, but it is hard to forget the open-eyed child lying on the floor of the sea.

The list could go on. Ibsen seems to try harder and harder to save his children as he moves toward the end of his career, but the results seem weird. Erhart Borkman's emancipation at the end of *John Gabriel Borkman* may be thought of as a tragicomic stab at Oedipal freedom, but one feels that Ibsen's heart is not fully in it; the old playwright remains entranced by his trio of damaged old people (seen unforgettably at the end with the two sisters holding hands over a dead man), and has no recourse but to send Erhart out into the world, outfitted with both an older and a younger woman, blithely running over the girl's father as they explode southward in their carriage, leaving the icy sepulcher behind them. What will Erhart's future be? Who can believe that Ibsen cares? Or that he would be equipped to write it? The scenes devoted to Erhart and his bid for freedom ring both flat and false, as if Ibsen were pinching himself to do what I am trying to do in this section: to keep your eye on the child.

My final dead child is to be found in the Stephen King-like confection that is Ibsen's final play, *When We Dead Awaken*. Much revenge to be found here, to be meted out against the old male artist who has lived only for himself for so long. But note: his comeuppance arrives at the hands of a woman, Irene, his former model whose beauty he coldly exploited in his work, whose feelings he denied. Children? Yes: Ibsen has now found the most perfect way to sacrifice the child: to construe the child as a work of art, and then to defame the work of art. There is a fabulously twisted male logic at work here, one that posits the artwork as male progeny, as male fertility, but the twist comes via the insult and injury dealt to the work itself. This echoes throughout Ibsen's plays: Alfred Allmers initially treated his son Eyolf as "project"; Løvborg, in *Hedda Gabler*, goes much further still, by explicitly regarding his grand Opus as the "child" that he and Thea conceived together, a

child who is dirtied and defamed and finally incinerated. Hence the last gasp of the dead child is the great sculpture that Rubek did of Irene, a sculpture he has abandoned and defaced, and Irene has come back to kill him for this, as much as for his failure to love her.

The final avatar of the abandoned and sacrificed child is as artwork. Perhaps Ibsen's ultimate conceit is that the art will live forever, no matter how many murdered children litter his plays. But no matter how one gets one's head around this forbidding feature of the Ibsen landscape, the infanticidal Ibsen family romance, it has to be obvious that children are systematically taken apart, denied, undone, utilized. And one has trouble reconciling this deeply punitive streak in Ibsen's work with the search for freedom and self-determination that we rightly associate with his plays. It would seem that he could only fashion his self-fashioning protagonists—Brand, Helene Alving, Solness, Hedda, Allmers, Rubek—by strewing their path with the cadavers of the children they did in, to become who they were. A very harsh libidinal economy is on show. Granted that this is only the work of one author, it nonetheless casts its bleak light symbolically on the prospects for the young in Scandinavian literature, and seems to warn us that maturation, socialization, resisting the tyranny of one's elders, simply *surviving* will not be easy, may not even be possible.

4

Let me now shift gears, genre, time, and place: I fast-forward to a funeral in Stockholm in 2002, at the occasion of Astrid Lindgren's death. I was not present at this event, but it was televised, and I can only believe that the bulk of the Swedish population had their (tearful) eyes glued to the TV. One hundred thousand people lined the streets of the city to pay their respects. It seems no exaggeration to claim that Astrid Lindgren was the most beloved Swede of all time: more than their fabled kings such as Gustav Vasa or Kristina or Charles XII,

more than their greatest writers such as Bellman or Strindberg, more than slain leaders such as Olof Palme or Anna Lind, more than any other "extant" luminary (such as Björn Borg or Ingmar Bergman) could possibly expect to be. At this funeral, which filled Stockholm's Storkyrkan to overflowing, one saw the king of Sweden, and one heard speak the prime minister, and an entire host of prominent cultural figures, including several of the actors who had impersonated Pippi Longstocking, Jonathan Lionheart, and Ronia the Robber's Daughter in film versions over the past several decades. All these people paid tribute to the woman who was a living legend in her country: not only as author of children's stories read around the world and translated into almost as many languages as the Bible, but as a moral presence: champion of animal rights, champion of children, champion of the weak and vulnerable against the great and powerful. Dead though she was, she was having, one final time, her day in court, and the great and powerful were paying homage.

During her long life Astrid Lindgren had never disappeared from Sweden's eyes or hearts, and one watched her grow older and older, perhaps not wiser and wiser since she had seemed so remarkably wise already in 1945 when *Pippi Longstocking* first appeared, but it was a smiling, lined, luminous face one knew, and in the final years one also knew she could not last much longer.[4] I thought about all these matters when I saw the tearful actors who had played these unforgettable children's roles in films, because these same actors were now middle-aged, balding, and demonstrably showing the impress of time. They were adults. Pippi, Mio, Jonathan and Rusky, Ronia—not to mention Emil, Madicken, Nils Karlsson Pysling, Master Detective Blomquist, the denizens of Noisy Village, and so many others—will be children forever. They are the very spirit of childhood (as many of us want to conceive it): curious, adventurous, mischievous (how long has it been since you've seen that term used?), feisty, spontaneous, trusting, daring, decent, open to life.

Pippi is, of course, Astrid Lindgren's bid for immortality, known and loved as she is throughout the world, on every continent, in countless languages. Equipped with money and muscle and a good heart, she comes through as invincible in all her adventures, creating countless admirers both textually and in the real world.[5] There is an unmistakable *bonhomie* in these tales, and we know that the bad guys are not all that bad (as robbers and other villains are routinely bested), and that the rules of decency will always obtain: no (serious) blood, no dark emotions, much humor, much fine wit, little pathos. I do not want to overstate this: it is of supreme significance that Pippi is an orphan, that her mother is an angel, and her father is a "Negerkung" (which can mean both an African king and a ruler of blacks). Some of the most swashbuckling stories are devoted to Pippi's pursuit of this quasi-mythical father, but it can scarcely be said that Pippi comes across as emotionally damaged, or even as truly longing. Still: she has no parents, and that matters. Further, being an utter *outsider* to the System—something that Tommy and Annika marvel at, something that those early readers bristled at—is not always so easy. One senses in these stories that being "unacculturated" is no unalloyed gift: Pippi often doesn't *know* how to behave, nor does she know how the rituals of school and tea parties and other little daily routines are to be managed. One laughs at these episodes, but one is not free from a sense of Pippi's odd marginality, her cultural illiteracy, as it were. Her strengths come with a price tag, despite the upbeatness, humor and triumphalism of these stories.

I point to the more vulnerable side of Pippi in order to leave her altogether, so that we can now take a look at three of Astrid Lindgren's finest books, books of a different tonality altogether, darker, more painful, tension-ridden: *Mio My Son* (1956), *The Brothers Lionheart* (1973), and *Ronia the Robber's Daughter* (1981). These books deserve a wider audience, and they will serve to ground the argument I now want to make about the "child's revenge." There is, of course, no *revenge* in

Lindgren's work—the notion would be foreign to her—but the children in these more serious stories demand that we see them as cultural, even ideological figures who are called upon to perform remarkable deeds against remarkable odds. Their adventures take place on a stage quite different from that of Noisy Village or Pippi's environs; one cannot escape the view that Lindgren presents them as *saviors*, as heroes or heroines with a virtually epic charge: to save the community, to rid it from evil, to restore harmony to a fissured land. It is here we see a vision of empowered children that entirely reverses the murderous and sacrificial schema so evident in Ibsen's plays. But most moving and memorable about these stories is their bittersweet flavor, their pathos: Lindgren's child-heroes are all damaged goods, young people with injuries and hurt, children who seem at times as *tested*, as *tried* as is Kierkegaard's Abraham. That would be her signature: a threatened world that needs saving by children, yet a view of children that is painfully and unflinchingly aware of their frailties and powerlessness and pain. We are a far cry from Pippi.

The earliest of these three stories, *Mio My Son*, is at once the most mythical and—once we reflect on its indwelling logic and desperate ending—the most heartbreaking. It is the story of a "disappeared child," as the speaker Karl Anders Nilsson informs us on the first page. An orphan, brought up in a loveless and cruel household by Aunt Hulda and Uncle Olaf, forbidden to laugh or make noise or have friends over, told that his mother is dead and that his father was a good-for-nothing, Karl Anders learns early to rechannel his needs, to envy his friend Ben whose father made model airplanes with his son, to find scraps of warmth and affection from Mrs. Lundy at the fruit shop, from Charlie the old brewer's horse. The bleak Stockholm setting is described in the first chapter, and it announces everything to come: the great magic adventure about to happen—a metamorphosis that will alter Karl Anders's life by taking him to Farawayland, and will change his name to Mio, Prince Mio, now reunited with his Father the King—is

pointedly (and ultimately tragically) modeled on the ugly home truths that can be escaped in no other way. Hence we read this book in double fashion: we see the splendor of fairy-tale logic—a genie comes out of a beer bottle and escorts Karl Anders from a park bench in Stockholm to his "true" royal home—and we see as well how it has a Midas touch to it, how it gilds the mean and hurtful prior life into something rich and strange. Everyone is doubled: Ben reappears as Pompoo, Mrs. Lundy can be seen in Pompoo's mother, Charlie becomes the beautiful Miramis, Stockholm yields to Farawayland, and the most exalted and longed for figure of all—"my father the King"—resembles, we are told, Ben's father.

Much as Wallace Stevens was to do in his epochal poem, "Sunday Morning," Lindgren shows us that we can only imagine Paradise as a happier, more desirable version of our life here on earth; we furnish and stock our dreams with the realia of our lives, but now sea-changed. The magic story in Farawayland is crisscrossed with memories of Stockholm: Mio wishes repeatedly he could tell Ben about all the wonders that now come his way, that Hulda and Olaf might see how fine and regal his father is. But what makes the story special is that Farawayland—Paradise—has its own dirty secret: Evil, evil that needs to be fought and vanquished; and from time immemorial it has been decreed that Prince Mio is destined to undertake this mission. The yearned-for Father/god, even when he materializes, can neither protect his only son nor clean up his kingdom: the child is sent out to save the world. It is a familiar fable, reminding us both of Christ's fortunes and the Abraham story. Mio is progressively to find his way into the myth: he repeatedly finds that all those around him *know*, that his role has been foretold by the well that whispers fairy-tales, that he is taking his anointed place in a very old plot.

Lindgren's marvelous tact is such, however, that the "foretold" character of his adventures does *not* cancel out their terror. Mio's mission is to do battle with Evil-in-person, Sir Kato,

the despotic ruler of the Outer Lands, the figure whose very name (when spoken) produces icy winds and moaning and a hush throughout Nature. Sir Kato is the death principle incarnate: he is defined by the murder/abduction of the young—both human and animal—and he sports a claw of iron with which he removes people's hearts, to replace them with a heart of stone.

In characteristic fashion, Lindgren starts out softly, immersing Mio (now Prince Mio, no longer Karl Anders Nilsson) in his new paradisal life, where all the old debits are transformed into credits, as seen everywhere, both in people and in setting: his Father the King, the loyal friend Pompoo, his beautiful horse Miramis, the splendid Garden of Roses, the flute-playing shepherd boy Nonno and his granny, Totty and his siblings, the magical Bread That Satisfies Hunger, the Well That Quenches Thirst. Family, friends, nature and nurture: for the impoverished Karl Anders Nilsson, these are the ingredients of paradise. But the references to Sir Kato, to his murderous reign, appear over and over, via mention of stolen children (Nonno's brothers, the Weaver's daughter, Totty's sister, more still); and, shadowing Mio's new life of ease, we recurrently note the mournful sound of Sorrowbird whose arias punctuate this story, conferring on it a residual tonality of melancholy that nothing can remove. The great challenge moves ever more clearly into focus: Mio must leave the sheltered precincts of Farawayland and seek out Sir Kato, to kill him. Here is the hard logic of Lindgren's tale: magic may spirit you out of Stockholm and into Farawayland, but there, on the far side of things, you must risk everything and enter the dark.

Accompanied by Pompoo, Mio rides off to the Outer Lands. It is a classic rites-of-passage fable: "I knew I must go into the darkness . . . to pass through that dark gateway" (87). It is a voyage into death: the Dead Forest, the Bewitched Birds (this is what the dead children have become), the Blackest Mountain, the Dead Lake. Here are the landscapes that must

be traversed. Evil takes the shape of a blighted world, a scene of natural disaster where life has been despoiled, ravaged. Lindgren's favorite trope is to present Sir Kato's reign of death as not only apocalyptic and infanticidal but also as waiting for redress, revenge. Such revenge consists of the dead coming back to life, so as to protect Mio and Pompoo: all that is hard and closed turns soft and opening for the avenging child. The Dead Forest, we are told, hated Sir Kato, and thus the black tree trunk opens around the two boys to shelter them from the spies who seek to capture them. "Perhaps that dead tree had once been a healthy young tree with many little green leaves that could rustle when the wind breathed on the branches. Sir Kato's evil must have withered and killed them. I don't think a tree can ever forgive anybody who has killed its little green leaves" (106). Likewise, the Dead Forest was once covered with "soft green grass" which has withered and been destroyed by the evil ruler, and grass too cannot forgive the one who despoiled it; the earth will protect the young champion who comes to restore it. In similar fashion, the Dead Lake magically conveys the two boys to its shore past all the dangerous reefs, because it had once been a "happy little blue lake" (132) where "friendly waves lapped" (133) and "children bathed and played on the shores" (133).

Not only does Nature protect the crusading child, but Lindgren repeatedly deploys imagery of rescuing the young of all species from the dangers that would kill them. Each time Mio and Pompoo are in a tight corner, are on the verge of being caught and brought to Sir Kato, maternal nature saves them. Listen to the metaphors: huddled together in the hollow of the tree that magically opened for them, Mio and Pompoo "sat there trembling like two baby birds when the hawk comes" (106); hiding in the cave where the ground has magically opened for them, Mio and Pompoo are "huddled together . . . trembling like two baby hares when the fox comes" (108); standing inside the mountain where the rock face has magically given way, Mio and Pompoo are "trembling like

two lambkins when the wolf comes" (113); hiding from the spies as they are to make their way up the cliff to Sir Kato's mountain castle, Mio and Pompoo are, yes, huddled together and trembling "like two mice when the cat comes" (135). The cumulative force of these similes displays a concern for the survival of the young—the saving of the babies—that is outright generic.

It is worth emphasizing the weakness of these heroes: trembling, huddling. Even weeping, we learn, as Mio confesses to us, right after Miramis has been taken by Sir Kato's men; now Mio knows full well that he is a knight with a mission, that knights must be brave, that knights must not weep, however harsh the conditions might be. It is a vintage-Lindgren passage, double-edged, and it deserves full citation:

> So I didn't weep, though I saw the spies dragging Miramis to the lake and forcing him into a big black boat. I didn't weep, though Miramis neighed as if they were whipping him. I didn't weep when the spies sat down and took the oars. I heard the beating of the oars on the dark water. The sound became fainter and fainter, and I heard Miramis's last desperate neigh far out on the lake before the boat disappeared from sight; but I didn't weep. I was a knight, you see.
>
> Didn't I weep? Yes, I did. I lay there behind the rock with my forehead against the hard ground and wept more than I had in all my life. (101)

Likewise, when Mio and Pompoo are separated in the dark cave, Mio plays his flute, hears Pompoo answer him, keeps playing, and cries the whole while. What is so memorable about *Mio My Son* is Lindgren's wise knowledge that brave, even heroic children are still children, that—unlike Pippi with her wonderful sass—they remain small and vulnerable when pitched against the great muscular forces of evil and power.

Mio's weaknesses cut deeper still. Not only is he but a child, he is also a scarred child, a damaged child. Throughout his magic adventures we are reminded of the unloved Karl

Anders Nilsson, the orphan-boy from Stockholm. Lindgren does not spell this out; but she conveys it through the allusive mind-set of Prince Mio, homebound even when free, who likens his terrible ordeals in the Outer Lands to dreams with which he is all too familiar: "It was like riding through a dream—one of those horrible dreams that you awake from with a scream and that leave you lying in terror a long time afterwards" (88). Making his tortuous way through the Dark Mountain, Mio compares it to mountains one dreams about: "you walk and walk in strange, dark passages and you never find the way out" (114). Finally, dead center, in Sir Kato's castle, Mio and Pompoo creep up the dark stairs:

> In my dreams I sometimes used to walk in dark houses that were strange to me—dark, terrible houses. There were black rooms which shut me in, so that I couldn't breathe, and floors which opened to black depths just where I was going to tread, and stairs which gave way, so that I fell. But no dream house was so terrible as Sir Kato's castle. (138)

I have already claimed that Lindgren's story is contrapuntal, that Mio's paradise matches, person for person, thing for thing, his deprived earlier life, but now turned full instead of empty. But we begin to realize that that empty life was also, in its horrible way, full: full of unrecounted nightmares, injury, and pain. The dreamscape of the first half of the tale becomes the horrorscape of the second half, as Mio makes his way ever more completely into the dark.

I have wanted to emphasize the child's pain in order better to measure the ultimate triumph of *Mio My Son*. With the sweet bricoleur logic seen in the stories of the Ash Lad—whereby the little odds and ends and bits of things one has collected turn out to be the precise tools needed to solve the mystery or answer the riddle—Mio, locked in Sir Kato's prison, is to find that the few meager things in his possession are wondrous indeed: his "empty" spoon that once belonged to Totty's disappeared sister now produces the Bread That

Satisfies Hunger and the Water That Quenches Thirst, that the cloak given to him by the Weaver (whose daughter was also disappeared) is lined with fairy web and capable of turning you invisible, that the Magic Sword (which Sir Kato threw into the Dead Lake) is retrieved by the Bewitched Birds and given anew to the boy so that he might finally slay the man with the stone heart.

It ends as it must. Mio kills Sir Kato. The child slays the dark force of death. And the curse is at last removed: the Dead Forest produces a beautiful new little leaf, the black Dead Lake turns blue, the Bewitched Birds re-become the children they were. It is little less than a poem of the earth, an earth now returned to its life and beauty because of the courage of a child. Both environmental saga and fertility myth, the book closes with a parade of all the disappeared children returning home on white horses, without one child missing; and they are led by Prince Mio who is en route to his Father the King. I can scarcely imagine a more perfect contrast to the dark infanticidal logic of Ibsen's plays. Our world can only be saved by its children, by those who are its most vulnerable creatures.

It would be tempting to close on this note, but with Astrid Lindgren things are sometimes murkier and richer and more disturbing than they appear. Yes, Mio returns to his Father the King in Farawayland, but he closes his story with words that never fail to make my skin crawl (even though I have read this story aloud to my children, to my grandchildren, and they have never blinked an eye). His story is over, Sir Kato is dead, he is reunited with his Father the King: but instead of "The End," Mio seems fixated on his earlier broken life:

> Sometimes I think of Aunt Hulda and Uncle Olaf and I'm not angry with them any more. I'd like to know, though, what they said when I disappeared—that is, if they noticed that I disappeared. They didn't bother about me, so perhaps they don't even know that I'm gone. Perhaps Aunt Hulda thinks that she has only to go down to the park to look for me and she'll find

me there on a seat. Perhaps she thinks I'm sitting on the seat under the street light, eating an apple and playing with an empty beer bottle or some other rubbish. Perhaps that's where she thinks I am, watching the houses where there are lights in the windows and children are having supper with their mummies and daddies. And I suppose she's cross because I'm so long coming home with those buns.

But Aunt Hulda is wrong! She's absolutely wrong! There's no Andy on any seat in the park. He's here in Farawayland, you see. *He is in Farawayland, I tell you.* He's in a place where the silver poplars rustle . . . where the fires glow and warm at night . . . where there is Bread That Satisfies Hunger . . . and where he has his father the King who loves him and whom he loves.

That's how it is. Karl Anders Nilsson is in Farawayland with his father the King, and *all is well with Mio.* (178–179)

For me these final words cap this story as perfectly and mysteriously and darkly as Quentin Compson's desperate closing words about the South in Faulkner's *Absalom, Absalom!*: "I dont. I dont! I dont hate it! I dont hate it!" Every Faulkner reader thinks: Don't you? Hence we remember that the magic adventure to Farawayland started from a park bench and a genie in an empty beer bottle, and we are hard put not to consider that it also ends in lonely loveless Stockholm, that it has never gone anywhere at all. Mio, my father the King, Pompoo, Miramis, may be phantoms, creations of need and desire: a fictional, fantasized "faraway" place that the all too injured Karl Anders Nilsson has conjured up, dreamed of, and finally sought to enter, that he might finally be "home." And Sir Kato: is he not the ruling figure of the entire fiction: the reign of death and loss of love that are Stockholm's truth and the great challenge of Farawayland?

Did they even notice that I disappeared, Mio/Karl asks? It is the enduring question. You can disappear while sitting on a park bench. You can disappear by going so far *in*—to find

love—that you never exit. Remember the "disappeared" children of the fable itself. Mio's great mission was to save the children, but is he himself saved? The question is unanswerable, but even to pose it is to gauge how resonant and profound Astrid Lindgren's story is. My own dark reading[6]— that Mio has made his ultimate inward retreat, that he has finally disappeared for good, at once on a park bench in Stockholm and reunited with his father the King—is of a piece with her overarching view of children as the damaged, threatened but unique saviors of the death-haunted, cold world we inhabit. But they are only children, and we are never allowed to forget that.

Where is breakthrough, *genombrott*? It is in the wondrous exit from park bench to Farawayland. Can one go further than that: to explode and to refigure one's world? To break out of the loveless prison and turn it into adventure land? This is why the closing lines of *Mio* tug at your heart: after all the grandeur of the dream, all the courage of the adventure, all the beauty of the victory over death, we are obliged to wonder if it happened at all, if such things only happen in fantasy, if fantasy is our only resource against horror. What if Farawayland is the deepest (enterable but "unexitable") interior of the soul, the last, shimmering refuge for those whom life has permanently damaged?[7] The book, sweet though it may initially seem in its fable, is merciless in its rigor, in its wise sense that *getting clear* is a desperate proposition, that it may be unsustainable, worse yet, that it may be a fiction. *Genombrott*: breaking through, but also being broken through. Imagination and fantasy are two-way streets. One can repeat the same journey backward, as roundtrip, from fantasized desire to real-time squalor. One escapes misery by leaving life. This is the traffic Lindgren charts in *Mio My Son*.

And it is the same traffic she wants to trace in the even more macabre book of 1973, *The Brothers Lionheart*, a book consciously written about the issue of dying children.[8] Lindgren has reported that parents of mortally ill children often

220

asked her how to talk to them, whether to speak openly of the horror at hand: death, their own impending death. Her remarkable gambit is to offer us a pair of loving brothers— Jonathan the beautiful, the princely one, and his sickly dying little sibling Rusky—and then do astonishing things with this twosome. Rusky knows he is dying, and he tells Jonathan that it seems unfair for someone who's not even ten years old, but Jonathan's response is annunciatory of things to come: yes, he knows Rusky will soon die, but that death is illusory, because what really happens is that one then leaves the grey world of here and now and lands in Nangiyala, the place of endless campfires and fairy-tales and adventures. Rusky's great concern is how long he will have to wait before being reunited with his brother—the mother is virtually absent from this story, as indeed she seems to be in so many of Lindgren's texts—but Jonathan explains that time in Nangiyala is different, that even years of waiting will seem no more than a few days.

Then comes the surprise: Jonathan dies, not Rusky. A fire sweeps through the building, and Jonathan rushes in to save his bedridden little brother by hoisting him on his shoulders and leaping from the window . . . to his death. Soon enough the sick Rusky follows suit, wakes up in Nangiyala, sees Jonathan, rushes to his embrace, and quickly realizes that here, in this new place, he himself is altered: he can swim, his legs are straight, he is healthy. We are not far from the rhythm of *Mio*, the (early, heart-warming) escape from prison into paradise. But, alas, we soon see that things here (in Cherry Valley) are as bad, as threatened, as they were in Farawayland. There is evil once more, but in a far more recognizable modern political form than in the earlier tale: the beautiful valley next to them, Wild Rose Valley, is ruled over by the tyrant Tengil, and Jonathan himself is essentially a freedom fighter, one of the key patriots (under the leadership of Sophia) of Cherry Valley who is working to overthrow the evil dictator. This will not be easy because the great warrior of Cherry Valley, Orvar, is

held captive by Tengil, and without him the liberation will not succeed. In addition to the age-old conflict between good and evil, we also find elements of a disturbingly familiar geopolitical narrative, reminiscent of the divided Germany of the Cold War, of the divided Balkans and Middle East and other fissured regions of our own time. Yet elements of fable and folklore remain prominent, most especially in the figure of the monster Katla who is Tengil's super-weapon, a fire-spewing dragon who obeys the battlehorn held by Tengil, and whose fiery breath is lethal to all it touches.

The Brothers Lionheart is a far more complex and intricate narrative than *Mio My Son*: filled with memorable characters, possessed of a sinuous political plot of espionage and counterespionage, crammed with adventures and close calls, culminating in the heroic endeavor to find and free Orvar so that the battle against Tengil might be engaged and won. Central to its plot is the "underground" work of Jonathan—the beautiful boy emerging as the last hope of Cherry Valley's freedom fighters—sent out to achieve this mission. But Jonathan's military mission into Wild Rose Valley is little less than a second dying in the eyes of his brother Rusky who must stay behind, who once more suffers the loss of what he most loves. Thus it is that Rusky himself—ten years old and unheroic, seen as a child not a leader—sets out on his own to find his warrior-brother, moves (as Mio did) into the dark, on the other side of Paradise. That quest is filled with "hair-breadth 'scapes" and excitement, but it is fueled by the love that links brother to brother, and by the severe requirement that a little boy prove himself a hero, because his self-esteem, his ties to his brother, and the fate of his community depend on it.

Because this story has such parallels with its predecessor, I will pass over a good bit of the plot complications and twists and turns that lead to its remarkable dénouement. Rusky finds Jonathan, and the two of them ultimately find and free Orvar. In the doing of all this we see kinships formed, spies unmasked, as well as elaborate schemes of cunning, disguise,

and bravery, culminating in the arduous entry into—and through—the labyrinthine Katla Cavern where Orvar is kept, awaiting his death as fodder for the dragon. But the boys are victorious in freeing the captive and getting him home to Cherry Valley. Soon thereafter, with Orvar now in command, the battle is begun. It is bloody: people who have befriended, sheltered, and loved the two boys die; bodies litter the ground; Jonathan himself is paraded as moral leader even though he has no stomach for war, and has said that he is not made for killing. The forces of Cherry Valley are en route to a victory over Tengil but then comes the long awaited horror: the tyrant blows upon his battlehorn and the monster Katla appears, strewing fire and death in any direction Tengil indicates, routing the Cherry Valley fighters. All then watch in amazement as Jonathan spurs on his horse, flies toward Tengil in a final combat, and wrests the horn from the dictator. We know what will follow: Katla turns in rage on the man she had obeyed, and destroys him. Wild Rose Valley is free. The war is over.

But the story is not. What to do with a fire-spewing dragon? It is here that Astrid Lindgren reaches furthest into horror. Jonathan and Rusky are leading the monster back to Katla's Cavern, but Jonathan drops the horn, and the dragon realizes it is free, and now turns in raging pursuit of the two boys on their horses. This chase is not long but it comes to an end at Katla Falls, where Jonathan succeeds in pushing a boulder onto the dragon who then falls into the deep waters. And from these waters arises a second creature of myth, Karm the giant serpent, who locks himself into a death struggle with Katla, so that both go under for good.[9] We are now able to measure the damage caused by Katla before she dies: her fiery breath has killed the two horses who are felled and slowly destroyed. But today's reader may also sense that this dragon from the oldest folklore is eerily modern, is a dreadful look-alike for radioactive nuclear weapons, for a form of lethal power that kills all who come within its ambit,

a death-dealing fire that ravages all living flesh. As the two boys sit at the campfire on the mountain, Jonathan gently tells Rusky that "a little flame of Katla's fire" touched him during the chase; Rusky asks then the inevitable question of this strange story: "Are you going to die again, Jonathan?" There is something almost unbearable here: are you going to die *again*? No, the older boy replies, the injury will not kill him but instead do something no less awful: paralyze him from the inside, forever.

We thus come full circle: two boys, one intact, the other dying; this is how the narrative began, and it is how the narrative ends, but the roles are now reversed. Earlier Jonathan had told his sick brother that death was not the end, that it led to Nangiyala; he now adds a further installment: to die now "again" is to enter the final kingdom of Nangilima. And that is how the story ends. Little Rusky lifts his paralyzed brother—just as Jonathan had once lifted him when the fire was raging in the apartment in their earlier life—and the two of them leap over the cliff together en route to Nangilima. It is as beautiful and austere as any ending I know.[10] "The child's revenge" is the title of my chapter, and I confess to a queasiness about the damages inflicted on children in these moving stories. Yes, these two boys have saved an entire people. But they have had to die twice.[11] Here is a logic every bit as sacrificial as Ibsen's, even as it posits the child as the community's savior.

For all these reasons I wish to conclude my discussion of Astrid Lindgren by offering some brief remarks on *Ronia the Robber's Daughter*, where at long last a girl child appears on the scene, and where the heroic mission befalling children leads to life rather than to death, to an improved social order rather than an exodus. In some respects this third tale rings some significant changes on the Lindgren model we've seen. Gender enters the picture, even if it is not a strident or militant entry: Ronia fiercely asserts her independence, yet one feels that she does so as feisty child, as an evolved version of Pippi

in some respects, rather than as female challenging a male order. Most striking about this story is its absence of villains: there is no Sir Kato, no Tengil, no Katla. This is because the "divided state" background (so crucial to the earlier books) has been reconceived along political rather than ethical lines. Evil drops out of the equation, and this radically alters the quest-model we've seen up to now. Yes, the world of the robbers is one of fierce rivalries between Matt's gang and Borka's gang—and each construes the other as his arch-enemy—but one quickly understands that these feuding groups are akin to the Hatfields and the McCoys, the Shepherdsons and the Grangerfords, indeed the Serbs and the Croats, the Israelis and the Arabs, the Indians and the Pakistanis, the East and the West. Lindgren is at pains to show that both groups demonize the other, that their discord is the result of blindness and ignorance, but that they are ultimately mirror images of each other.

How better to get this across than to introduce a second child into the equation—Birk as son of Borka, Birk as enemy of Ronia the daughter of Matt—so that the children might bond and thereby expose the absurdity of their parents' warfare? It is an old device, going back as far as *Romeo and Juliet*, and Lindgren exploits it with much savvy. Blending Shakespeare with Thoreau, the author sends both her children-heroes out of the family and into the wilderness, yielding a fine-grained picture of youthful adventures and survivalist strategies in a wild setting, shot through with Nordic folklore and creatures of legend. Ronia and Birk will, at key junctures, save each other's lives, and the novel offers us a budding prepubescent love story possessed of humor and charm, as these two youngsters learn to take each other's measure, and thereby their own.

But the rites-of-passage narrative takes place against a significant political and emotional backdrop. The political equation is obvious: the union of the two children exposes, as nothing else could, the craziness of the grown-ups' enmity.

225

Lindgren offers some striking metaphors to support this view by having the very mountain where Matt and his gang live be riven by lightning, producing a huge chasm; somewhat predictably, the children early on defy their elders by jumping over the chasm onto the other (enemy) side, and doing so as child's game, as an impudent sign of how vapid and senseless the political divisions are. But I believe it is the emotional issues that cut most deeply in this story. We cannot miss the fact that Ronia is the *adored* girl-child of her rough, violent, but lovable father Matt. (Birk's relation to his parents is far more sketchy.) Hence Ronia's decision to bolt, to leave the parental enclave and live with Birk in the woods, is a direct repudiation of the Father's law, and it is experienced that way by both child and parent: as a transgressive move that brings such emotional pain that it cannot be gotten past. Matt is almost destroyed by his child's defiance: it alters him beyond recognition, makes him appear clinically depressed, a children's book version of the offended Lear, and confers a general funk to the Robbers' Lair. (I leave out of my discussion the wise presence of Lovis, the mother, who is the low-to-the-ground figure of the text, able to measure the extravagances of both husband and daughter but unable to intervene.) And Ronia herself is as damaged as her father: she loves her father with an intensity that is almost unavowable, but that shimmers through this story of youthful love as a potent and dark counterforce, as a deep-seated bind that no amount of emancipation is going to easily remove.

Perhaps the affective subcurrents of this story constitute its strongest bid on our interest. Lindgren has delivered herself of a Freudian tale that finally brings into the open much that was subliminal or repressed in the earlier narratives. Pippi's orphanhood simplified things a good deal, for now we see the nuclear family as a lovable but imprisoning unit, and we see that the child's survival consists in defying the law of the Father. In some murky displaced sense, the outright evil figures of Sir Kato and Tengil have metamorphosed into the vehement Matt, the father-tyrant whose will and power must be

challenged, broken, and transcended. But whereas warfare in the early books is morally a piece of cake—of course, you hate Sir Kato and Tengil—it is a more complex matter in this last book, since you also love the father you must battle, since you now realize that he is located deep inside your own mind and heart. I do not want to overstate these matters: Matt is scarcely a villain, and there is not much libido in the story. But it tugs on us in a special way, for we see the child's battle reconfigured as a different kind of courage, closer to maturation than daring, requiring a change of perspective, a change of self-image, rather than a magic sword or invisible cape or overt monster to be slain.

However one sees these matters, we must agree that Ronia and Birk install a new order. Lindgren posits them as the agents of change and progress. They alone have the pluck and vibrancy to alter the world. This is striking, because *Ronia the Robber's Daughter* is not lacking in wise adults such as Lovis or Noddle-Pete, but only the children can effect real change. In this regard, one can see in the suite of Lindgren stories I have discussed a remarkable article of belief: our children must save us. I call it "remarkable" because Astrid Lindgren's children are complex figures beset with emotions, sometimes with handicaps, sometimes with deep injuries. I do not think there is anything dewy-eyed about this body of work. It is filled with a tender yet plucky wisdom about the motivations and mental processes of the young—surely this is why her books are so beloved—but it also has a fierceness of vision that is unflinching about what is right and what is wrong with the world we inhabit. Many of her child protagonists are simply lovable rather than admirable—Pippi, Madicken, still others—but Mio and Rusky and Ronia seem to be fashioned for larger purposes, seem to have a Messianic dimension that we cannot ignore. In their stories we see a bold vision of children as both victims and heroes, of children as at once unprotected and called upon to change the world. In book after book they fight for agency, and they acquire thereby a strange dignity. One thinks, by way of contrast, of Ibsen's children—Nora's

abandoned children, Oswald Alving, Hedwig Ekdal, Sol-
ness's twins, Hedda's unborn infant, Eyolf, Erhart Borkman—
whose fate is to become strategic pawns in the hands of their
elders, to disappear, to die, to come to nothing. Lindgren's
children endure; they are potent and remain imprinted in our
minds as valiant, as actors in the world. They—unlike the
time-bound actors who portrayed them on screen and who
wept at their author's death—do not grow old.

<div align="center">5</div>

Let me return to my title: "The Child's Revenge." *Revenge* is
an edgy term, suggesting a kind of motivation and action on
the part of children that would be utterly different from the
lovable savior figures we find in Lindgren. How do children
get even? It is a question that countless parents throughout
the world could answer, but there is surprisingly little artistic
evidence for such forms of behavior. *Evil* children can be
found in stories ranging from *King Lear* to gothic texts such
as *The Bad Seed* or films like *The Exorcist*. But revenge entails
a righting of wrongs, an effort to undo the damage and estab-
lish a new dispensation. I suggested that Lindgren's best nar-
ratives contain germs of this salvational scheme, but here I
wish to go further and present, for your inspection, a series
of empowered children unlike any I have ever seen, in any
medium, namely, the strange little girls who appear in the late
paintings of Lena Cronqvist.[12] It may seem cavalier to move
from Ibsen's canonical plays to Lindgren's children's stories
and now to a different genre altogether: selected paintings of
a contemporary artist. My comparatist principles are front
and center in this move, for their chief article of belief is this:
the strategic conflation of plays, popular stories, and modern
paintings is legitimate if it produces results; that is, a constel-
lation that shows us a pattern we could not make out, if we
examined these materials "singly." I leave it to my readers to
determine how well this works.

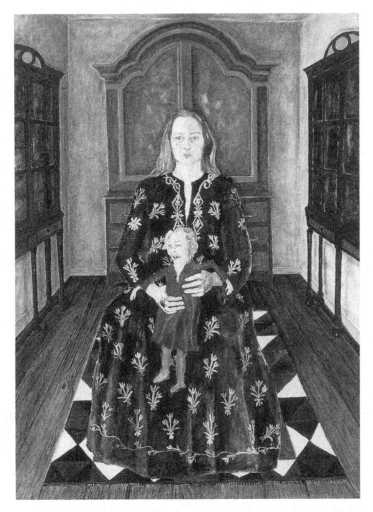

3.B.1. Lena Cronqvist, *The Mother*, 1975, 169 × 125 cm. © 2008 Artists Rights
Society (ARS), New York / BUS, Stockholm

Let me begin by saying that these children come late in
Cronqvist's work. By that, I mean that a significant portion
of her most compelling work focuses on the arduousness of
maturity and the reality of adult suffering. Arguably Cron-
qvist's most famous piece is *The Mother* (figure 3.B.1), done
in 1975 as a kind of rich and playful tribute to Renaissance
ceremonial painting with high decorum, classical perspective,

and outright regal trappings. Centered here is the serene if stony-faced Cronqvist, in brocade and regalia, positioned for eternity, yet holding on her lap (over her womb) a very different kind of creature: the "little mother," as it were, a miniaturized, restive, indeed flailing doll-mother whose presence inverts most of our traditional views of mothers and daughters. The adult woman is in a state of permanent parturition, birthing forever her own mother, while evincing an idealized composure that is notably absent from mom's twisted face. Much is announced here: we already see what will become signature postures in Cronqvist's oeuvre: that we go through life cradling others—whether caring for them or yoked to them—and that our freedom (if freedom there be) consists more in mood and attitude than in getting truly clear. Mood and attitude do open a good bit of space: we can torture as well as nurture those we cradle. It is as if Ibsen's *dollhouse* became a resonant and binding trope, an affective, structural, infantile space (after womb, before adulthood) that houses our actual emotional arrangements, extensions, and binds, consigning us to dollhouse effigies and antics forever.

Earlier Cronqvist pieces can be thought of as gesturing toward this mother/child gestalt. Satiric pieces about all-powerful generals with tiny underlings, depictions of fever-ridden patients in beds, of interlocked lovers whose boundaries are blurred, of family eating rituals turned strange and grotesque, and a series of paintings devoted to the Madonna theme in various bourgeois and suburban settings, always given as pathologized, primitive, off-balance couples (of mother and child) locked in severe pulsions that suggest variously hunger, nausea, alienation, and eclipse. Cronqvist seems especially alert to forms and feelings of interdependency, with occasional hints of cannibalism. Then came a more personal and urgent apprenticeship with the penal arrangements that we call "care" and "nurturance"; I am referring to the suite of powerful images of her internment at St. Jörgen's Hospital in 1971, following the breakdown she experienced after the birth

of a child. These disturbing paintings chronicle the utter loss of agency that "patienthood" bestows, as Cronqvist passes in review the routine indignities we suffer when hospitalized, ranging from forced shock treatment to the uncheckable reifications of diagnosis and surveillance, as well as the foiled efforts to break free. It seems scarcely figurative if I term the project outlined in these sequences a project of infantilization. Life returns us, not via fantasy or memory but through its trials and pains, to childhood.

The family returns as central motif in later work, seen first in sterile ritualized gestures such as ceremonial dinners where the absence of human contact is virtually palpable, but then evolving in richer and more mysterious ways in the 1980s as Cronqvist bears witness, first, to the dying of her father, and then, a few years later, to the dying of her mother. Once again she is the child, a child assaulted by the immeasurable blows of parental death(s). These pieces are not always easy to look at: Cronqvist renders her hospitalized dying father as a grisly grey block of bloodless flesh surrounded by the stranded surviving family for whom no gestures of farewell or assessment seem manageable. Perhaps the strongest of these pieces is *Domens dag* (misnamed in the English text as *Doom's Day*, since it actually invokes "Judgment Day") which records the exact "passing" of the father, measured with scientific and anatomical accuracy against a frozen sterile backdrop of automaton nurses and helpless family (figure 3.B.2). The almost black face of the dying/dead father suggests stone not flesh, and it conveys a kind of sheer weightiness that we feel to be the very mechanics indeed of "Doom," because this cold mass of inert tissue with open eyes is what will pass—unaltered, unlightened—into the living tissue, thoughts, and feelings of those who are left behind, possessing the kind of noxious, undying heft in our interior as we might ascribe to a malignant tumor, a mass of another sort. Children are scarred, are perhaps mortally infected and wounded, by the deaths of their parents. This is why the splendid little white bunny that sits

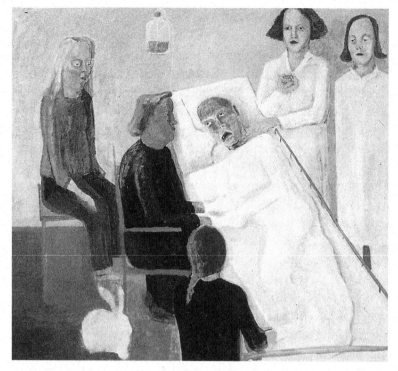

3.B.2. Lena Cronqvist, *Doom's Day*, 1980, 170 × 185 cm. © 2008 Artists Rights Society (ARS), New York / BUS, Stockholm

on the floor next to the dying man's bed—absurd, inappropriate, wonderful—is, for me, a tiny note of whimsy that is on life's side.

Then comes Mother's death, rendered with the same mix of anatomical realism and surreal imagery as in Father's death. Nothing registers the relative weights of these matters more effectively than *Mother and I*, offering us the mammoth sculptural demonic presence of Mother—purplish, made of stone, yet open-mouthed to emit a scream that is not soon to go away—and the no less stony face of daughter Lena, eyes brilliant red (in the original painting), frozen hieratically, doomed to live, holding her signature tiny paint brush in her hand (which is how I interpret the small implement), facing us and life (figure 3.B.3). A tiny brush versus a monumental keening shadow of one's dead mother: that is how the field is shaped

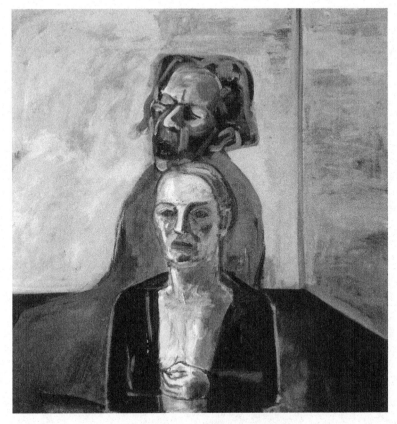

3.B.3. Lena Cronqvist, *Mother and I*, 1987, 120 × 105 cm. © 2008 Artists Rights Society (ARS), New York / BUS, Stockholm

in Cronqvist's scheme. The brush is the child's engine of both fidelity and survival. One paints one's horrors—St. Jörgens, the stultifying family, the deaths of Father and Mother—and one paints one's way through the horrors, out of the horrors. How? How can one possibly move from a landscape of injury and pain—the landscape, the treadmill to which life condemns the living, as the very price of living—to something we might call freedom?

I see her remarkable piece, *Mother, Picture, Children* (1988) as a gateway painting in just this sense (figure 3.B.4). Again we see the unforgettable, monstrously enlarged, violently contorted, face of the mother in her death-agony, a figure who

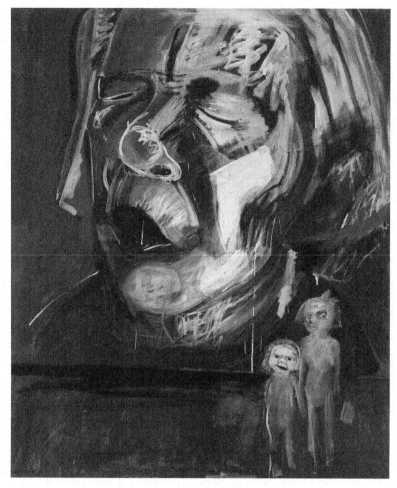

3.B.4. Lena Cronqvist, *Mother, Picture, Children*, 1988, 179 × 135 cm. © 2008
Artists Rights Society (ARS), New York / BUS, Stockholm

seems to leap from any frame or border that might contain it,
so as to send its message into the world. The painted face has
the intensity of Strindberg's tumultuous seascapes: a picture
of the elements worked up to paroxysmal fury. How, we ask,
will these two diminutive naked children fare? What counter-
force can they possibly exert? To answer this rhetorical ques-
tion, I now turn to the primary Cronqvist materials that

enact—finally—the child's revenge: her astonishing renditions of *two little girls*, done from 1990 into the first years of this century.

We watch Cronqvist find her way ever more fully into this chapter of her work. The initial pieces are relatively undemonstrative as we see the two little girls go through their paces: playing naked on the beach or in the water with their little animals, both real and stuffed. There is something acutely unadorned about these paintings right from the outset: not merely are the children often without clothing, but all sentimentalism and sweetness and received ideas have been removed from their presentation, on the order of a scientific experiment that removes oxygen from a container, leaving us with creatures so naked, so *other*, that we are hard put to label them. A curtain seems to have been lifted. There is something overwhelmingly honest, fresh, and un-illusioned about them, a tonic rendition of autonomous little beings that obey their own intrinsic laws, little beings that know nothing of morality's and decency's injunctions: we see them doing experiments with the animals and dolls, we see the larger one dunking the smaller one under water, we see a strong, cold, unabashed will (to what? to power?) in these renditions.

In some of the edgiest pieces there is an anthropological feeling of children as a different species altogether, mingling together in their own sphere, cohabiting (if need be) with other creatures (not utterly unlike what Tove Jansson achieves in her Moomintroll tales, but without Jansson's sweetness, as if Little My were in charge altogether); consider, for instance, the painting of 1992, *Girl, Daddy-doll, Mommy-doll and Gorillas* (figure 3.B.5). I sense a great wonder in this painting, a recognition of all the strange forms that crowd our world and inflect our behavior, much of which we share with the animal kingdom; "humanism" has no purchase here. One remembers Foucault's famous critique of the much-loved photographic text *The Age of Man* in which he attacked the universalizing principles that (falsely) undergird our sense of the human,

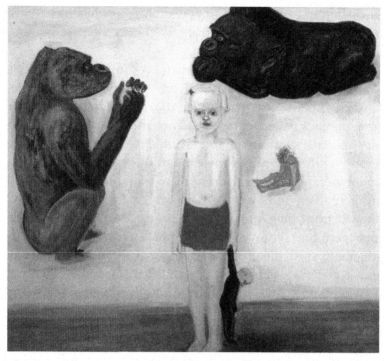

3.B.5. Lena Cronqvist, *Girl, Daddy-doll, Mommy-doll and Gorillas*, 1992, 150 × 168 cm.
© 2008 Artists Rights Society (ARS), New York / BUS, Stockholm

thereby blinding us to the sharp, unerasable or transcendable realities of difference (racial, cultural, economic, etc.). Cronqvist achieves something similar here, by going in the opposite direction: she breaks up a childhood gestalt by pairing her little figures with gorillas, not in order to make any Darwinian points but to peel away a certain humanist skin that prevents us from actually seeing what is in front of our eyes. But culture is not easily removable, and we are struck by the alteration and positioning of Mommy and Daddy: not merely as dolls themselves (and this itself is sublime, showing just how useful replicas can be, how magical they are, how wise and prudent it was to proscribe graven images) but as tiny, limp, manipulatable, exploitable objects subject to the whim of children. What a sweet metamorphosis. Our dollhouse is begin-

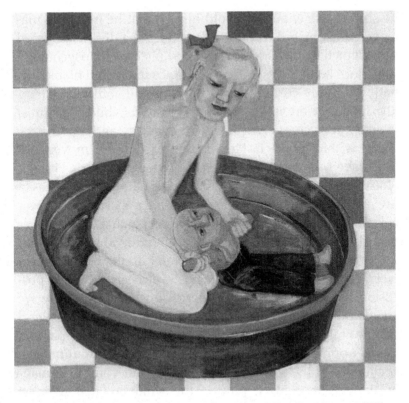

3.B.6. Lena Cronqvist, *Girl with Papa-doll, II*, 1996–1997, 135 × 165 cm. © 2008
Artists Rights Society (ARS), New York / BUS, Stockholm

ning to look like a Pandora's box, and we are almost ready to
see how the revenge story might play out.

For that we need to consult some of the later feistier pieces,
the ones with the most attitude. If a 1993 painting in the series
featured Father in the water with his two girls, it is instructive
to see how this scene of parental unity and hierarchy (a happy
family, big Father, little daughters, sunlit sea) can be im-
ploded, as we see in the *Girl with Papa Doll* from 1996–97 (fig-
ure 3.B.6). The naked girl kneels in her washbucket over the
supine figure of Papa, who looks up at his handler, and who
looks exactly like the real Father (the one in other paintings,
the one who sired Cronqvist). But much has altered: he is re-
duced in size and power; he has only stumps, not hands (yet

the stumps are enough to hold him so that he might be ma-
neuvered as the girl desires). What does she desire? As in all
these depictions, we are left stumped (as it were) psychologi-
cally, since her expression seems at once intent and blank, like
that of a mildly curious doctor (or animal handler) from an-
other planet. Here is the amoral curiosity of children, almost
scientific in its charge, exercised in observing and moving the
objects within its reach. Papa is the object being moved. All
of us have seen this emancipated look on children's visages,
a look that seems alien to any moral or emotional niceties, a
raw *prior* look, so to speak, from a higher species to a lower
or smaller or weaker one, similar perhaps to that of the Maker
toward his creatures. We are still in the dollhouse: he is her
toy. One could not invert Ibsen's famous play more effec-
tively: Nora complains that she has ever been a thing, a pos-
session handed down from father to husband, and now we
see what this story might look like in reverse: the child rules.[13]
It is the child's revenge. Not that there is any sign of passion
or anger or cruelty in the girl's face; its very equanimity—the
equanimity of the scientist with his rats, but you must imag-
ine the rats in control, putting the white-gowned scientist
through his paces—is its most striking, its most *egalitarian* fea-
ture. The painting breathes a kind of innocence that is slightly
terrifying.

Cronqvist has positioned this drama—is it a drama?—
against a blue checkerboard backdrop, as indeed she did for
a good many paintings during this period. Here, too, we may
perceive the ludic dimension of the piece, its wry awareness
that power is play, that power is a series of figural arrange-
ments, that power can therefore be refigured. This is what
dolls are for. They give children agency. They invert received
positions. They put parents in their place.

If Papa is hapless here, he fares still worse in other pieces.
He is choked, shoved into glass bowls, transformed into (even
more malleable) a clown. But not to worry, Mama comes in
for the same treatment, as we see in *Two Girls with Mother*

(1999), where the now familiar face of the keening Mother gets roughed up quite a bit. (figure 3.B.7). She, too, has only stumps, and she also now inhabits a glass bowl resembling a beaker, as if this were a version of keeping the genie in the bottle, which is just that: to stuff Mom and Dad into bottles is indeed a way of counter-imprisoning the genii who (customarily) rule over children. I argue that Cronqvist's earlier affective landscape of injury and loss—the clinical renditions of the deaths of both Mother and Father, the scar tissue that must be part of Cronqvist's psyche—has undergone a metamorphosis, that it has become child's play, and the dead are at last put down.

Children are inventive creatures. We've always known they play "doctor" and other little exploratory games, but how often have we considered who the patients might be? These particular little girls seem endlessly creative in doing things to Mom and Dad (or sometimes their clown look-alikes): they place them in filled bedpans, they amputate their limbs, they take their temperature (European style, ramming it in). One of the most beguiling pieces is titled *The Cage* (2000), where we see the progenitors smiling at us behind bars, while not only the two sisters look on approvingly (at their handiwork) but where miniature animals also witness the scene, tranquilly on our side of the bars, examining the olds folks at home (figure 3.B.8). Doubtless the most disturbing piece is *Nurses* (2001), where the two girls have a more malevolent and crazed expression on their faces as they *handle* their sick charges. Hence we see three old folks in varying stages of disarray, and two of them are unmistakably Mom and Dad, now subject to what one used to call "manhandling" but what Cronqvist teaches us to term "childhandling" (figure 3.B.9). Mom (still recognizably the old lady who died) is hoisted up by her face—have you ever watched how children sling their dolls around? have you imagined yourself as the flying cargo in question?—with the child's fingers gouging into her cheeks, while Dad is supine on his doll hospital bed, hooked

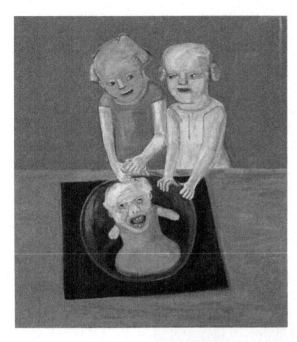

3.B.7. Lena Cronqvist, *Two Girls with Mother*, 1999, 150 × 140 cm. © 2008 Artists Rights Society (ARS), New York / BUS, Stockholm

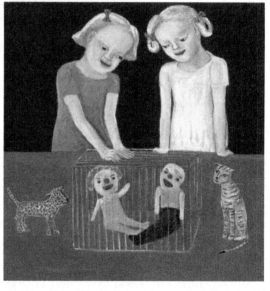

3.B.8. Lena Cronqvist, *The Cage*, 2000, 144 × 135 cm. © 2008 Artists Rights Society (ARS), New York / BUS, Stockholm

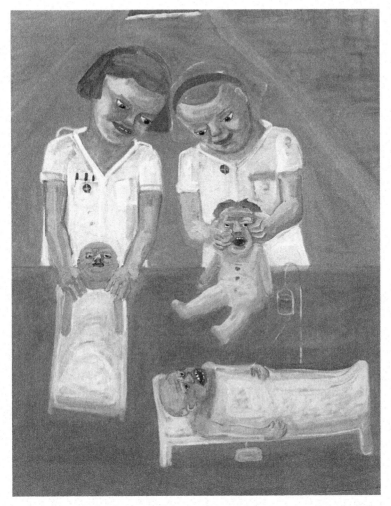

3.B.9. Lena Cronqvist, *Nurses*, 2001, 150 × 118 cm. © 2008 Artists Rights
Society (ARS), New York / BUS, Stockholm

up to an IV line, mouth wide open in pain and anger, teeth
showing for all they are worth, which is not much. How can
we look at this painting without remembering the antecedent:
Papa on his deathbed in the hospital?

How does one even begin to gauge the reversals enacted
by these paintings? If we credit the children alone, then we
indeed find spectacular evidence here of the child's revenge.

241

Revenge through play. I think this interpretation forces itself upon us, and we can see in these new power arrangements a stunning victory for children, a resounding turnaround of the sacrificial story seen in both Kierkegaard and Ibsen. And, yet, these little creatures do not make anyone delirious with pleasure, nor do they confirm any sense of justice in the world, whereby children might have more rights. On the contrary, these little girls seem to be a different race altogether, and even though it is a race that peoples the earth, few artists have led us to look carefully at its alterity: in these paintings Cronqvist has removed the veneer that coats our understanding of children, and has dared to present them as empowered indigenous figures, bent on their own unreadable pleasures, using the familiar/familial objects at hand, becoming little artist-gods in their own right by furnishing their dollhouse to their own taste.

The little girls display their agency through a spectrum of acts—playing, cutting, manipulating, observing, "handling" in all its guises—but they are never seen *painting*. They are not demiurgic but rather the product of Lena Cronqvist's imagination. In closing I acknowledge that Cronqvist's most recent work moves one step beyond the two little girls, and it does so by highlighting and centralizing the adult figure who conceived them in the first place. This is how it must be: children do not tell their own story, and even the most empowered children in art and literature have been *created* by adults. What moves me in the latest Cronqvist pieces is the ongoing presence of the child: seen as engendered by the artist, seen also as object of nurturance and care. Consider the piece *Marionnettes, II* (2004–2005), in which the two girls stand, somewhat awkwardly, presented for our inspection (figure 3.B.10). Behind them of course appears their puppeteer, Lena Cronqvist; but note that she is a shadowy figure, whereas they are in the limelight, as if *they* were the living and vital center of her work, even if she also needs to show that *hers* is the agency that produces them. Cronqvist did a series of paint-

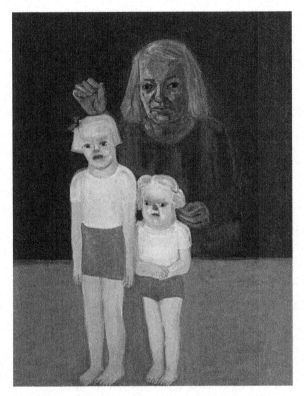

3.B.10. Lena Cronqvist, *Marionnettes, II*, 2004–2005, 127 × 78 cm. © 2008
Artists Rights Society (ARS), New York / BUS, Stockholm

ings titled *Marionnettes*, but especially striking about this ren-
dition is its absence of strings: there is the magician with her
poised hands, the two little creatures whom she (supposedly)
controls, but there are no strings, no wiring, no umbilical cord
between creator and creature. There is something fine, I think,
in this recognition of the child's ultimate autonomy: as art-
object with a life of its own, as creature with a will of its own,
as ultimate "free" extension of the shadowed older woman
who made it.

My final Cronqvist image is the immensely moving *Pietà*
(2001) in which the familiar dollhouse equipment and inhabi-
tants reappear: small chairs, a bed frame, a few little sheets.
Above these implements we see the figure of Lena Cronqvist

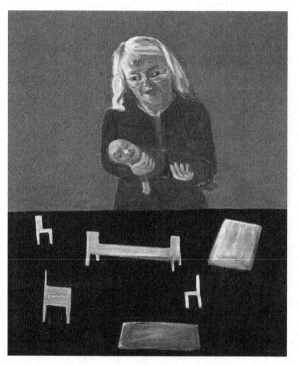

3.B.11. Lena Cronqvist, *Pietà*, 2001, 150 × 117 cm. © 2008 Artists Rights Society (ARS), New York / BUS, Stockholm

holding gently in her hands—*cradling* in her hands—the limp little Papa doll (figure 3.B.11). We have now come full circle. No children in sight. Instead of the unchecked, emancipated girls we have the caring, observing, hurting, nurturing portrait-of-the-artist who is embracing her dead, turning the dollhouse into something rich and strange, suffused with dignity and tenderness. *Pietà*: to lift the body of Christ from the cross as a gesture of maternal love, as the kindness owed to dead children. The Father is no longer the stony corpse in the hospital, nor is he the target of the girls' play; on the far side of all this, he has become an object of love, of the painter's devotion. (This piece is matched, just as movingly, by its counterpart, *White Sheets* [2001], in which Cronqvist gently cradles the miniaturized dead body of her husband, the famous novelist

Göran Tunström, manifesting the same ethos of nurturing kindness that is visible in *Pietà*.)

The suite of Cronqvist's paintings discussed here displays a kind of artistic and emotional pilgrimage: from injury and trauma to fierce freedom but closing with a kind of spiritual maturity, where one finally owns one's dead, takes them in to oneself, takes on the strange stewardship proper to both art and life. Is this not, in the last analysis, the ultimate moral truth of childhood and parenting: to see our loved ones as entitled to our nurture, to see our role-in-time as guardians of the family, to see ourselves as protectors of the vulnerable, as the still living source of tenderness and fidelity toward those who are no more. Nurturance would appear to be our last role.[14] I would be wrong to call this "the child's revenge," but the woman cradling her dead father seems to me a fitting image for closing this discussion of children's deaths and lives in Scandinavian literature and art. Remember the children: not merely Kierkegaard's Isaac or Ibsen's sacrificial children or Lindgren's valiant-but-injured protagonists, but the others as well, the child-pawn Bertha in *The Father* or the possibly divine idiot-child in *The Sibyl* or the dead Unn and the damaged Siss in *The Ice Palace* or Bergman's abused children ranging from *Persona*'s photographed Jewish child headed toward Nazi extinction and the doubly narrated unwanted fetus, on to the coerced Fanny and Alexander of Bergman's last film: all these severe works whisper to us that nurturance and love should be the first and last values. An ethos of kindness is the only way to move beyond the will-to-power, achieved either by Oedipal or anti-Oedipal regimes, that has regulated so much of our adult thinking and our adult history. To be sure, there is no pretense in this essay at a kind of sociological truth about the treatment of children in the Far North but rather the hope that a series of snapshots focused on depicted children's fates—Kierkegaard, Ibsen, Lindgren, Cronqvist—might, if seen together, disclose a story worth knowing.

C. Hamsun's *Hunger* and Writing

Hunger is a delicious book.

Published in 1890, *Hunger* marks not only Knut Hamsun's entry into literature, but it remains one of the most impudent and prophetic novels of the nineteenth century. Isaac Bashevis Singer has claimed Hamsun as the tutelary divinity for the great novelists of the early twentieth century—Mann, Schnitzler, Wasserman, Zweig, Bunin, D'Annunzio, Bang, even Fitzgerald and Hemingway—largely because of the Norwegian's depiction of consciousness.[1] I have no quarrel with this assertion, and I share Singer's conviction that the early Hamsum of *Hunger*, *Pan*, and *Victoria*, the writer of dark and brooding psycho-sexual skirmish, is the man who marked what was to come. But Singer does not go far enough when it comes to *Hunger*: this strange fiction beckons already to Kafka and beyond, anticipating much of what will be known as postmodernism. I see in this book the seeds of Borges and Robbe-Grillet and Calvino. It is, in more senses than one, a "breakthrough" text, a book that challenges limits and constraints in every arena: physiological, moral, psychological, linguistic.

Hence I want to say at once that this novel is *not* primarily the account of a starving writer, that is, the depiction of artistic suffering and misery. Nor is it predominantly a critique of the philistine bourgeois order that has no understanding of art. That familiar genre comes into existence with romanticism, and it is already something of a cliché by the end of the nineteenth century. To be sure, Hamsun's book can be read profitably along these lines, but its true richness and virulence are located elsewhere entirely. The book is inscribed under the aegis of *1848*. That is the strange number the protagonist writes mechanically, some twenty times, "crossways and intersecting and every possible way" (32) while waiting for inspiration; it is also the date he mistakenly puts on his job ap-

plication to Christie Food (and loses the position for that reason). The year 1848: a year of revolutionary upheaval throughout Europe, a year when efforts appear across the entire continent to overthrow the existing social order, to imagine life differently. The revolutions of 1848 largely failed, and the best novel we have about the dashed hopes of this chapter in European life, Flaubert's *Education sentimentale*, memorably depicts the manifold collapses of belief and change in the abiding figure of "sell-out," of the emotional and moral and political being transformed into commodities, tarnished commodities now found on the auctioneer's block. I propose to read Knut Hamsun's *Hunger* as a reprising of the revolutionary energies of 1848, but now reconceived and recast as a bid for freedom unlike anything hitherto seen in fiction.[2]

What exactly is *Hunger* at war against? At a late moment in the novel, Hamsun's anonymous protagonist imagines writing a play set in the Middle Ages about "a magnificent, fiery prostitute who had sinned right in the temple, not out of weakness or out of lust but from a sheer hatred of God, sinned right at the foot of the altar, with the altar cloth under her head, simply out of a delicious contempt for eternity" (200). This play will never be written as such (even though the final chapter of the book stages some pretty gruesome fornication), but the war with God seems to parse Hamsun's fiction, to furnish the elemental agon of the work. Over and over, the starving writer curses God, sees his plight as a kind of one-on-one against the Maker.[3] The easiest way to gloss this indictment is this: Why doesn't God give me food? God punishes me by withholding nourishment. But such a reading is perhaps altogether too easy. Consider the way Hamsun visualizes God's punishment:

> God had poked His finger down into my nerves and gently, almost without thinking, brought a little confusion among those threads. And God had pulled His finger back, and behold—there were filaments and fine rootlike threads on His

finger from the threads of my nerves. And there remained an open hole behind His finger which was the finger of God, and a wound in my brain behind the path of His finger. (22)

It is a remarkable passage. We learn that the hero's confusion or madness is the direct result of being "fingered" by God, as if a divine residue had been left inside the writer's brain, left there as a wound.[4] (God also seems to have a bit of the protagonist's brain on His own fingers, but that side of the story doesn't get told.) Our hero is, as they say, "touched." Yet, what most jumps out at us in this passage is the image of the *hole* which is God's legacy of penetration. As if to say, the signature feature of the human subject is an unfillable hole, an emptiness that can never be gratified. "Han lot mig gaa med det aapne Hul," writes Hamsun (22): "He let me go with the open hole." Is this not what "hunger" is: a craving to be filled, to be fulfilled? Let us put this in its most basic material terms: the human body is fashioned in such a way that it must feed itself to live, must ingest nourishment to survive. The experience of hunger is God's/Nature's message to us of our elemental life requirement; it is a law, a physiological law, that binds the human species. It seems to me that Knut Hamsun— following Lucifer, following the fiery prostitute, following 1848—has elected to challenge exactly this law, this servitude. His book is in quest of a freedom from the necessity of eating. It seeks to overthrow the physiological bondage of our kind.

No modern reader can approach *Hunger* without thinking of the brilliant, spare tale written by Kafka some thirty years later, "The Hunger Artist." Kafka, too, was in search of freedom, and his fasting hero has denied the flesh in order to celebrate a mad kind of autonomy, one that looks both spiritual and artistic.[5] One remembers that the emaciated dead body of the Hunger Artist is replaced, at story's end, by a panther, a splendid beast that seems to glory in its flesh, an animal far more to the public's liking than the poor fasting figure of the artist. Kafka's most haunting line is the Artist's dying confes-

sion to the Ringmaster: "Ich habe nie die Speise gefunden die mir geschmeckt hätte" (I never found the food that I might have liked).[6] All of Kafka's stories seem caught up in this insoluble dichotomy between flesh and spirit, and all are fueled by an unappeasable sort of desire for a fulfillment that is not of this earth. For just these reasons, Hamsun fascinates: his story goes, I feel, further than Kafka's, for it "deliciously" goes the full route, beginning with a rejection of flesh but ending, on the far side, with a discovery of something we have to call "freedom." Let's see what kind of freedom this can be.

We must first of all realize that *Hunger* cares little for food. Counterintuitive, this. But it can hardly be happenstance that parts 1 and 2 close precisely with the miraculous arrival of money so that the writer can stop starving. *Close*, I said. For the subsequent two chapters simply *bypass* the eating and spending. Part 1 closes with "And ten kroner!" (61), whereas part 2 opens with "A couple of weeks later I found myself out of doors one night" (65); likewise, part 2 closes with " 'I'll get at least five kroner for you.' And he pushed me in" (113), leading to the following words at the start of part 3: "A week went by in joy and gladness" (117). And that's it. *Eating* seems textually off-limits, uninteresting, irrelevant.[7] Of course, it does happen that the hero puts food into his mouth, but quite often this results in vomiting. "I simply couldn't take food, I wasn't made that way," he tells us (46). I suggest, moreover, that the "throwing up" is a peculiarly activist gesture, "ex-gesting" instead of ingesting, as if the protagonist were feeding the environment, rather than the other way around. (It is worth noting that *throwing up* is expressed in Norwegian by the same charged metaphor: *kasta op*; is this a creatural revenge? to *throw* nourishment back?) An interesting drama is at work here, as we see in this representative passage:

> It was three in the afternoon. My hunger began to be painful. I was weak, and walked along throwing up ["kastet op"] here and there on the sly. I took a swing down to the Steam Kitchen,

> read the menu and twitched my shoulders in case anyone was watching, as though to say corned meat and pork were not food for me; after that, I walked down by the railroad station. (50)

I called it "drama," because the real focus is on the writer's odd charade of eating, done for the benefit of passersby. *Corned beef and pork were not food for me* at first looks like pretense, but let's take it seriously. What matters is the little comedy of appearances, the pleasure of acting, the weird "production" of a self-beyond-food, a self constituted by twitching shoulders, a self who can have no truck with corned beef and pork. At other times the throwing up is not "on the sly," but fierce and, indeed, eloquent about the *inappropriateness* of food:

> I walked along emptying my mouth, in every dark crook I passed, fought against the nausea which was making me hollow all over again ["som uthulet mig" says the Norwegian (110), reminding us of that "hole" at/as the core], clenched my fists, steeled myself, stamped on the sidewalk, and swallowed again in a rage what was trying to come up—all in vain! I ran at last into a doorway, doubled over, blinded from the tears that sprang from my eyes, and vomited everything.[8] (135)

It won't do to call this simply a physiological revulsion; his body is teaching him a lesson about what it can and cannot use. If you cannot eat food, you can sink your teeth into other things: wood, orange peels, bone, your own hand.[9] Each of these objects is tried out, when hunger presses, and while some of them fail (orange peel and dog bone: no good), others soothe: "I sat gumming my wood chip, gay, happy as a child. I constantly felt for my manuscript" (85). It is hard not to see a connection here between gumming the wood and writing; we shall see just how bold that connection is.

The book is, moreover, as allergic to money as it is to food. Of course, our hero thinks constantly and feverishly about the kroner he is likely to get for the pages he writes. Sometimes

this relationship has an outright mathematical clarity: "I weighed the piece in my hand and assessed it on the spot with a rough guess as five kroner" (36). These are interesting terms: writing has a materiality of its own (you can *weigh* it), and the measure is given in kroner, not ounces or pounds. Nonetheless, when the money comes in—as it does, in regular installments, to close the chapter, to prevent outright starvation— the book registers what is close to a systemic reaction of rejection and revulsion, on the order of a person ingesting a substance that cannot be tolerated. Consider the episode when our hero receives, by serendipitous error, the change left over from someone else's five kroner note; he is dumbfounded; he tries to eat roast beef (with predictable results), he reconnects with the strange woman, Ylayali, and sets up a rendezvous, but, above all, he cannot bear the weight of these coins in his pocket. They portend dishonor. What does he do?

> I was drunk as a coot, I leaped up suddenly and started toward the cake seller near the Elephant Apothecary. I could still save myself from dishonor, it was not too late, far from it, I would show the whole world what I was capable of! On the way I got the money ready, got every øre into my fist. I bent over the woman's cake board as if I wanted to buy something and suddenly put the money into her hand. I didn't say a word, I turned and left instantly. (148)

Classic behavior in this text. For the dishonor in question does not stem from the fact that those kroner were stolen: it is the kroner themselves that are too hot to handle, that must be disposed of, rejected, "ex-gested." And that is what is so beautifully carried out in this wordless transfer of øre into the cake seller's hand. It appears that no exchange takes place—he does not take any cakes—but the true exchange is happening before our eyes: he is divesting himself of money, cleansing himself of it, displaying his independence from it.

There is much in *Hunger* that cannot be "stomached": not only food and money, but the overall sordidness of a physical

world that is presented with shocking immediacy. Hamsun's formula is clear: put this starving down-and-out man into Christiania, and he will register a good bit of garbage. The dregs of the modern city are on show in the boarding houses where he lives, the pawnshop he frequents, the walks he takes. And being incessantly hungry sharpens your vision, leads you to drop your guard so that the world rushes in, perceptually: "everything I saw obsessed me" (23).[10] This "everything" ranges from the grotesques he encounters—the woman with "the long yellow tooth [that] looked like a finger sticking out of her jaw" (7), the little old cripple who "looked like a huge humping insect" (9) and defines himself (wonderfully) as "welt binder," and of course the full-fledged horror show of part 4, consisting of children torturing their paralyzed grandfather by sticking straws into his ears, the grandfather responding by spitting into their faces, the pregnant landlady fornicating with the sailor on a bed next to her paralyzed father looking on, the small boy playing on the sidewalk and being spat on by "a grown man with a red beard who was leaning out of a second-story window" (218)—on to the sorry spectacle of his own emaciated body: pulsing feet, dropping hairs, inhabited by pains (chest, legs), visited by wounds (whipped ear, run-over foot, raw and bloody navel), causing our man to weep after self-examination. I suspect that most readers finish this novel with a distinct loss of appetite.

But can you banish the physical? What about libido? This question matters as much narratively as it does existentially, since sexual desire seems hardwired into *Hunger*'s scheme. I am referring to Ylayali and the entire erotic subplot.[11] *Ylayali* is the protagonist's fantasized name—it spells virtually the same backward and forward; in Norwegian it is "Ylajali"—for a very real flesh-and-blood creature whom the hero meets early on in the story. Hamsun's entire project hinges, I believe, on the outcome of this agon, for it is indeed an agon: is Ylayali a fantasized name, or is she a real person? When he first sees her walking with a friend, our hero follows her and evinces

the well-known Hamsun love psychology: "I felt myself possessed by a strange desire to frighten this woman, to follow her and hurt her in some way or another" (12–13); we find this same tortured sense of human relations in *Pan*, *Victoria*, and *Mysteries*, always bordering on insult, injury, and sado-masochism of one stripe or another. But what we do not find in subsequent novels is the degree to which this woman is no more than a fantasy, a name, a conceit. A good deal is on show when the protagonist repeatedly taunts her with this refrain: "'Miss, you are losing your book'" (14), an ejaculation she can make no sense of, whatever. Can we?

You are losing your book. But she has no book. Aha, all the better, she will be the material of a book, will be circumscribed by a book, will be eclipsed by a book. Note, as well, the odd behavior of our man as he follows her:

> My deranged consciousness ran away with me and sent me lunatic inspirations, which I obeyed one after the other. No matter how much I told myself that I was acting idiotically, it did not help; I made the most stupid faces behind the women's backs, and I coughed furiously several times as I went by them. (14)

There is no way to yoke this performance into some kind of love story as such. Instead, we witness a kind of *wilding*, a behavioral fantasia of pure excess. With this warning in mind, we can track the progress of the Ylayali story, for it constitutes the "high noon" of *Hunger*, the inevitable confrontation or shootout between a recognizable love interest and something else altogether, something unrecognizable, unlabelable, uncontainable. Down-and-outer meets prostitute with heart-of-gold. It's been done before, many times, most notably in Dostoevsky's *Notes from Underground* (which Hamsun has to have had in mind). But never quite like this. The woman—let's call her Ylayali—is drawn to our protagonist, walks up and down the Karl Johan with him, agrees to see him again, kisses him full on the lips. Here is the "road not taken," the direction *Hunger* might have gone.

We see this unmistakably in their fullest encounter, a meeting that is charged with different kinds of pulsions. Her mother is away, she invites him into her room, his heart is beating wildly, she teases him further, they grow more heated still, we think we know what is coming, he embraces her:

> I didn't know what I was doing any longer, I said some nonsense that she laughed at, mumbled sweet names at her lips, brushed her cheek, kissed her again and again. I opened a button or two in her bodice and glimpsed her breasts, white, swelling breasts that peeked out like two marvels behind her lace.
>
> "I have to see!" I said, and struggled with several more buttons, trying to make the opening larger. But my efforts were too rough, I couldn't make any headway with the last few buttons near her waist which were tight anyway. "But I have to see . . . a little more . . ." (175–176)[12]

Ylayali has been marked as full-breasted from the outset, and those "two marvels" are at the center of this scene; they are also its end stop. Both of them are aroused, he is now pressing his mouth "in toward one of her breasts" (176), but Ylayali, fearing she has gone too far, slows down the action, shifts terrain, and asks him why his hair is falling out. She assumes it is because he has led a dissolute life and wants him to tell her his story. And he obliges: "I took the opportunity and I told her everything, telling nothing but the truth" (177). It all comes out: the starvation, the "stolen" five kroner, in short pretty much everything that we have ourselves read, up to now. I called this episode "High Noon," because the move from sexual intercourse to storytelling is the emblematic move of this novel. It is not a dodge or an evasion; on the contrary, it is evidence of the novel's deepest and truest sources of energy. Those two breasts are the perfect embodiment of physical and sexual nourishment, a potential source of gratification that this desperate man would appear to have been seeking since the first page. But they are, in the final analysis, a decoy, because the hunger of this novel cannot be

assuaged physically or sexually or emotionally. But it might be, imaginatively, verbally.

For how could Ylayali-in-the-flesh possibly compete with the fantasized creature who preceded her in his longings? Many pages earlier, our man fell asleep and yearned for "Princess Ylayali's castle, where an undreamed-of happiness was waiting for me" (69), replete with blazing room, walls of amethyst, throne of roses, closing with entry into a red chamber with walls of ruby to be consummated at last: "'Welcome now, my sweet! Kiss me! Again ... again." (70). Here is a sumptuousness that stands in stark contrast to the mean setting of streets and taverns and dirty rooms. Likewise, the heat of aroused flesh and blood is no match for the fiery *visions* our man has had:

> Suddenly I remembered Ylayali ... Some light penetrated very weakly into my consciousness again, a tiny ray of sunlight, making me ecstatically warm. More sunlight flowed in, a gentle delicate silky light, which brushed so sweetly against me. Then the sun grew stronger and stronger, blazing brilliantly on my temples, piercing with heavy and burning heat into my emaciated brain. At the end a mad open fire blazed up before my eyes, a heaven and an earth ignited, men and animals of fire, devils of fire, a chaos, a wilderness, a universe on fire, a smoking final day. (157)[13]

Against such splendor, even those two marvelous breasts are insufficient. The protagonist has already acknowledged, somewhat wryly, that "there wasn't much spring left in me these days" (126), and we have to agree that the sap inside him is of a different sort entirely. It is this difference that stamps both the novel and its characters. As I said, Ylayali asks him for his life story, but the more she hears, the more disturbed and frightened she is, because his condition is not what she expects; a drunkard is something she can handle, but here is a story of compulsions and needs and performances and aberrations that go beyond anything she knows

or understands; little wonder she calls him "insane" (and offends him mightily by doing so).

Insane is often simply a dead-end term, a lazy code word for behavior that is incomprehensible, or behavior for which we have no key. But Hamsun's novel both whets our appetite and satisfies our hunger by outlining with great clarity and power and scope exactly what kind of new logic it is introducing, what kind of brave new world it seeks to chart. We have seen what this protagonist rebels against: the coercive tyrannies of hunger and money, the despotisms of body and culture. He will not have these; he vomits them up when they come to him. Like Kafka is to do several decades later, Hamsun is exploring the cul de sac of a materialist world scheme. He is looking for freedom, and he encounters constraint or soullessness everywhere. At one point, desperate to get help, he seeks spiritual counsel but finds a sign on the minister's door: "Office hours: 12–4" (98). Our man wants to break through; he wants to create a new regime. He wants to transform hunger into plenitude, not lack. Without food or money or work, he nonetheless tells an acquaintance that he has found a position: "'I am the bookkeeper at the Christie Foodstore'" (41). It is one of the novel's sweetest lines ("Bokholder hos Grosserer Christie" [37]), for it does announce a new dispensation altogether: yes *bookkeeping* will be his job— not trying to gauge the price of five-sixteenths of a pound of caraway cheese (the pedestrian test he is assigned and utterly flunks)—but *writing* as a form of heat, light, energy, and freedom. Writing and language as modes of fulfillment, sources of a spiritual nourishment found not in the old Christian world but in the new Christie Foodstore.

Hunger tells us, from its very first notations of a wall papered with newsprint, advertising both bread and shrouds, life and death, that language is the great elixir, the primal source of energy, stronger than the sun (because it knows no night), endlessly creative and demiurgic in its doings, sovereignly breaking through all the obstacles posed by the dictates

of flesh and culture.[14] There is yet another constraint that *Hunger* joyfully annihilates: the straitjacket of cogency, of unified personality, of a bounded self. Hamsun's protagonist is an ongoing set of explosions, cavalierly discoursing with and against God, firing off his wrathful sorties against all parties, including himself. I already noted his little carnival of gestures while following Ylayali, and we see this kind of manic outbreak into pure performativity more than once, as in the following passage: "With steadily increasing rage, I ground my teeth in despair, and with sobs and oaths I went on and roared wildly, paying no attention to the people going by" (104). You might be tempted to interpret this as cogent psychology (rage against hunger), but you would be wrong; at bottom it is a desire to get utterly unshackled, to open all the floodgates, to achieve what Rimbaud termed "un dérèglement de tous les sens":

> I felt an urge to pull off practical jokes, to do astounding things, turn the town upside down, and roar. All the way along Graensen Street I acted like a lunatic . . . I got the idea of going up to a city messenger—one who had not said a word to me— and telling him my age; then I would take his hands, look him intensely in the face, and leave again without a word of explanation. I could distinguish the nuances in the voices of the passers-by, and in their laughter; I made note of several small birds hopping in front of me on the street, and fell to studying the expressions on the cobblestones, in which I found all sorts of omens and wonderful signs. (149)

There is something prodigious in this circus of signs ("allehaande Tegn og underlige Figurer," says the Norwegian, insisting on semiosis [120]). All methods are good: roaring, soulful look-in-the-face, silence; and all sources are good as well, so that we now find "city messengers" everywhere: in the voices and laughter of passers-by, in the hopping of small birds, in the hieroglyphics of cobblestones. Strindberg will go much further down this route in his tortured story of break-

down, *Inferno*, where we see a kind of manic associative scheme that turns every public surface into a secret private sign, but Hamsun comes almost a decade earlier, proffering a far more egalitarian vision, one in which the hero himself is endlessly "signifying" as well as reading signs.

Endlessly signifying. Hamsun has realized that ordinary signification and communication are governed by constraints and rules of all stripes: intentionality, social setting, established conventions. Hamsun knows that the world he inhabits is "scripted" already, that we are agents in a setting we never made, a setting called "Culture." How, he has to have wondered, could you give this system a run for its money? How could you bust it wide open? thumb your nose at it? stick your tongue out at it? You might begin your war, your version of 1848, by creating a fully *ludic* character, not so much a trickster as an "unbound" figure, a figure unconstrained by logic or propriety. Such a chap, when it is two o'clock, insists to the policeman that it is "ten o'clock," while making it clear how he knows: "'Listen, take my word for it, it's ten o'clock'" (73); *take my word for it*—I must confess that this phrase is Bly's, not Hamsun's which merely repeats, "Hør, vet De hvad"; but Bly is right to take the liberty—tells us everything, for the final guarantor of all truths is not the sun or the church tower but indeed "my word." A ludic character will respond to an officer's query as to why he is sitting where he is, with the ludic-truth: "for fun" (97). This sort of a man resembles the well-known "Sorcerer's Apprentice" inasmuch as he enjoys transforming things he sees: "A wholesale grocer's cart came by, and I saw it was filled with potatoes, but out of fury, from sheer obstinacy, I decided that they were not potatoes at all, they were cabbages, and I swore violent oaths that they were cabbages" (221). What is the secret of metamorphosis? A violent oath. Endless signifying.

Hamsun's protagonist is nameless in much the same way the wily Odysseus, in order to trick Polyphemus, calls himself "Nobody." It is a ruse, a passport, even a hall of mirrors. Can

it surprise us that he tells the Officer on Duty that his name is Andreas Tangen, journalist, out a little too late tonight, sorry about that. Under that moniker he is granted a free bed for the homeless (in the reserved section, of course) and exits the next day, inwardly famished but outwardly "with my head high, millions in stocks and bonds, and my hands clasped beneath my coattails" (83). But between going to bed at night and exiting the next morning, our hero experiences what I take to be his "baptême du feu"; the lights go off and he is lost in pure blackness, with fears of being dissolved or even turned into darkness himself. He then feels a terrible tiny hole by his bed, of unplumbable depth, source of terror. We, as readers, are thus returned to the signature move of this novel, discussed earlier: God's act of poking a hole in his creature. What to make of this black hole? That is indeed the question. The black hole is the originary darkness from which all life emerges, and the challenge to the human creature is to produce such life. Our man, in his black cubicle, does just that:

> All at once I snapped my fingers a couple of times and laughed. Hellfire and damnation! I suddenly imagined I had discovered a new word! I sat up in bed, and said: It is not in the language, I have discovered it—*Kuboaa*. It has letters just like a real word, by sweet Jesus, man, you have discovered a word! . . . *Kuboaa* . . . of tremendous linguistic significance. (78)

The protagonist experiences a state of complete exaltation, a state he terms "the joyful insanity hunger was" (78), but we are, I believe, in a position to propose other terms altogether. The creation of *Kuboaa* is, in its shimmering way, an act of pure freedom, for it is a liberated word, a free word, a word emancipated from any and all semiotic binds.[15] We watch the writer prance through a list of possible meanings that he then delights in rejecting, one after the other, some high, some low, none good enough: *God, Tivoli Gardens, cattle show, padlock, sunrise, emigration, tobacco factory, yarn*; each time he tries out one of these terms, he exercises his godlike volition by dint of

259

veto power, sovereignly dismissing all these false claimants to the throne, these constraints on his signifying authority. No way. "I had discovered the word myself, and I was perfectly within my rights to let it mean whatever I wanted it to" (79).

This episode ushers us into the novel's dark hole—a dark hole that can seem bristling with monsters, with currents that will hold you fast and take you "through dark kingdoms no man had ever seen" (80)—but salvation is at hand, for this pit is no less than the Writer's camera obscura, the workplace of the gods, the empty virgin space that is filled by the simple act of naming. More than half a century before Derrida theorized deconstruction and informed us verbal creatures that we were shipwrecked in a scheme of *différance*, of deferral, of an "always/already" pre-coded, pre-scripted world in which actual presence and origin were nothing but myths, Knut Hamsun has already foreseen this dilemma and graciously offered us his solution: *Kuboaa*. For *Kuboaa* is to be the rallying call for the new 1848 that Hamsun is intent to bring about. He knows full well that body and society are enslaved by a spectrum of laws at once physiological (eat or die), social (behave or be termed "insane") and cultural (make money or starve). He also knows that language itself hardly seems all that free; after all, every word signifies something, does it not? You cannot get clear of dictionaries, can you? Or, as Nietzsche said, as long as there is grammar, we will not be free. Knowing all these things, Hamsun wages his counteroffensive: he will say NO to food and money and bounded identity and rational behavior; he will even say NO to the dictionary.

Saying no to the dictionary is tricky business. You stop making sense. You are indecipherable. You may have *Kuboaa* for the moment, but once you eventually settle on a meaning for it, you've cashiered its freedom and vitiated its power. But, Hamsun realized, you don't actually have to go that far. In fact, when you think about it, *Andreas Tangen* (who is Nobody, pure invention) is brother to *Kuboaa*, inasmuch as he is also a free agent, without responsibilities. Indeed, all language can

260

be deliciously subversive if you are willing to scuttle a few of the ordinary rules. Saussure and company may have been right that all words are systemic and differential in character, lodged in a semiotic mesh, so that no single one of them can possibly achieve "independence"; but, who is to prevent you from jostling the whole system, tweaking it gently or shaking it up riotously, making sneak attacks on it, even commandeering its arsenal, thereby restoring to words something of their indwelling explosive power and material heft? Who is to prevent you from showing just how mischievous and uncontrollable semiosis actually might be? *Hunger* is a stunningly prescient text because of its achievements in this area. It is a book about the anarchic power of words, the demiurgic power of words to engender their own world, a world that has no truck with trivial and vulgar details such as "proof" or "verisimilitude" or even "reality."

Once we see this dimension of Hamsun's novel, we realize that we have been seeing it all along, from the very beginning. Inspired writing is nothing but an explosion of words. Please note: an explosion of *words*, not concepts or arguments. This is beautifully evident in one of the book's early scenes of "inspiration":

> All at once, one or two remarkable sentences occurred to me, good for a short story or a sketch, windfalls in language, as good as I had ever come on. I lay saying the words over to myself and decided they were excellent. Soon several other sentences joined the two; instantly I was wide awake, stood up, and took paper and pencil from the table at the foot of my bed. It was like a vein opening, one word followed the other, arranged themselves in the right order, created situations; scene piled on scene, actions and conversations welled up in my brain, and a strange sense of pleasure took hold of me. I wrote as if possessed, and filled one page after the other without a moment's pause. Thoughts poured in so abruptly, and kept on coming in such a stream, that I lost a number of them from not

being able to write them down fast enough, even though I worked with all my energy. They continued to press themselves on me; I was deep into the subject, and every word I set down came from somewhere else. (35–36)

We are so accustomed to treating such passages as "romantic inspiration" that we may fail to see just how anarchic and autonomous, even "emancipated," Hamsun's view of writing actually is. Human volition, even human design and argument, mean nothing here. We have forever taught students to start with an outline, to conceptualize their topic, and only then to enlist words for doing the job; this doubtless works well enough for measuring the weight of Caraway cheese or offering name, date, and serial number. But beyond that? I submit that, in some deep sense, we in the schools and academies have it wrong and backward, that true writing of any stamp resembles the explosive and hypnotic process described in *Hunger*. The words come from somewhere else, or, as the Norwegian says, the words are placed in one's mouth, "blir lagt mig i Munden" (32). One sees in this passage why Plato banned the poets from his Republic. They lead with words, not reason or logic, and the still harsher truth is: words lead them. Lead them astray, the severe philosopher might retort. But Hamsun's sights are on the spectacular parade itself, the upwelling of words that gush forth with power and beauty, pirouette themselves, and then quickly disappear, so quickly that the hapless writer has captured only a portion of them. The writer does not summon; he follows.

Words come as miraculously, indeed as gratifyingly and fulfillingly, as manna. These markings (which we assume to be wispy and almost unreal) can possess great heft and material weight. One of the novel's most charming passages depicts the writer stubbornly trying to make the words come, and then noting, in a remarkable zoom shot, some flies and gnats sitting on his paper:

I breathed on them to make them go, then blew harder and harder, but it did no good. The tiny beasts lowered their behinds, made themselves heavy, and struggled against the wind until their thin legs were bent. They were absolutely not going to leave the place. They would always find something to get hold of, bracing their heels against a comma or an unevenness in the paper, and they intended to stay exactly where they were until they themselves decided it was the right time to go. (23)

One hardly knows what to admire most here: the stubborn little beasts who refuse to budge, or the microscopic vision of writing itself as a three-dimensional field where even a comma can be a palpable and usable bulwark. Can it be surprising that a good piece of writing is something you could weigh in your hands, to determine its value? This same material view of words—so unlike our abstract, differential schemes—is on show late in the novel when two small children are hurling curse words at each other: "Words like huge, cold-blooded reptiles poured out of their childish lips" (193).

Words have weight; they also have reach. They can be outright territorializing. What counts is to pick their locks, to tap into their semiotic potential, to open their Pandora's box of bristling energy, so as to liberate the genie that waits there. The most unforgettable and hysterical moments of *Hunger* center around instances when words simply take over and go on a rampage. Hamsun is already breaking new ground with a protagonist who bursts all molds in his war with necessity, but the novel goes a quantum leap further when its madcap hero moves from private musing into public action, takes his show, as it were, on the road, and actually pulls it off. Something large is gathering here, concerning the infectious and "real-world" power of language and imagination.

Consider, for instance, the saga of Happolati. Who, you may well ask, is Happolati? He is about as real as Andreas Tangen, which means: real enough. Sitting on a park bench, ensconced in an inane conversation with a little old man, our

hero wants to end this exchange, and he thus answers the old man's question concerning whom he rents from with a totally made-up, invented name, Happolati. The little old man doesn't miss a beat: "'Oh, yes, Happolati'" (26). So begins the epic tale of J. A. [Johan Arendt] Happolati, papier-mâché creature of words, comic version of Frankenstein, assembled out of a language-kit in front of our eyes, constituting a little allegory about the formation of "character" in fiction.

The little old man swallows everything, and is, as Hamsun writes, "already at home with" whatever the protagonist can come up with, no matter how far-fetched. It is a song and dance, a pas de deux, for the little old man does not shirk his own responsibilities; Happolati, he "seems to remember," "worked on a ship"; oh no, replies our hero, that is doubtless the "brother," whereas we are talking about the businessman (at which point "J. A." is affixed to his name). "'They say he's got quite a head on him,'" the old man adds, and this calls forth some serious particulars on the part of our man, concerning Happolati's business acumen and successes, including the selling of "Russian goosedown and chicken feathers, hides, pulpwood, ink . . ." (27). These dizzying details are offered in order to overcome the little old man, "to stuff him full of lies . . . and drive him like a knight from the field" (27), but fiction making and semiosis have a will of their own, a kind of forward drive that moves ever further into fable. With consummate tact, the protagonist references Happolati's most surprising invention: "the electric prayer book" (28). Critical commentary is, I believe, humbled in the face of such luminous lunacy; *the electric prayer book* is a prophetic figure, a kind of hi-tech fiction machine that coerces belief, a forerunner of hypertext (which is what this sequence looks like) in which all imaginative avenues are opened and traveled at will, at whim.

We learn further that this electric prayer book business really is a business: "'A fantastically big operation, a million kroner going into it, factories and printing presses working

264

now, mobs of engineers on contract already; I've heard some hundred men'" (28). This is heft. But, as I said, the more outrageous the specifics, the weightier and more august and more imposing the fictive creation becomes; hence the little old man is "not really surprised" by such feats on Happolati's part. The protagonist, hell bent on breaking (somehow) the illusion, on going on to such absurd lengths that "Happolati" will at last self-destruct as an elaborate hoax, finds his task to be difficult indeed, because it would appear that our capacity for belief is endless, and that the construction of J. A. Happolati is ultimately no more (or less) fanciful than that of either Hamlet or your brother-in-law. Faced with this difficulty, our hero has no choice but to throw Ylayali into the mix, to move overtly into fantasyland, so as to break the spell. But even this is harder than expected: Ylayali (the daughter of Happolati who is now prime minister of Persia), described as "enchanted," as "princess who owned three hundred slaves and slept on a bed made of yellow roses" (28), just adds more oomph to the fiction. Our man loads her up still further (eyes soft as silk, arms the color of amber, etc.), and at last the little old man seems to yield, not so much out of disbelief but, it seems, out of fatigue, out of exhaustion at playing this Rube Goldberg game. Still, to show his good faith, the little fellow suggests, as exit remark, "'this Happolati, if I'm not mistaken, is quite rich now?'" (29).

At this joint our hero finally balks, as if such dialogic madness were becoming too offensive to him—he wants to hog the field as madman—and thus adduces ever loonier details: J. A. stands for Johan Arendt, Happolati's wife is immeasurably fat. . . . The little old man retreats further, provoking, at long last, the following explosion:

> "Goddammit, man, I suppose you think I've been sitting here stuffing you full of lies?" I shouted, completely out of my mind. "I'll bet you never believed there was a man with the name Happolati! Never in my life have I seen such obstinacy and vi-

ciousness in an old man! What in the hell has got hold of you anyway? And you have probably been thinking to yourself, on top of all this, that I am actually broke, haven't you, and that this is my best suit, and that I haven't a cigarette case in my pocket at all? The way you have treated me is something I am not used to, I will tell you flatly, and I won't take it, so help me God, neither from you nor from anybody else, and you may as well know that now!" (30–31)

In my opinion the entire Happolati episode is one of *Hunger*'s most startling bids for freedom, for it boldly takes its ludic pocket game out into the world, onto the streets, erasing entirely our traditional distinction between *word* and *world*, showing that one's wildest inventions can become startlingly infused with flesh and blood, can take their rightful place among the so-called real people. In some sense, our hero "backs into" this discovery, for he initially believes that the old man will see through all this flimflam, but he then realizes that the bar for persuasive fiction making and belief is a low bar, not a high bar, that even the wackiest and most improbable confections and constructs will pass muster, will be assumed to be tax-paying citizens. The episode ends with the hero's angry decision to expose his own hand, to illuminate the strings pulling the puppet, but he makes quite clear what the stakes are for such verbal sorcery: if you see through my outlandish charade (and I'm doing everything I can to make sure you do, damn it), well then you are face to face with my meanness, my meagerness, my poverty and shame, and that is unbearable. It thus seems clear that the "naked truth" never fully loses its authority, even when the wildest kinds of pretensions and brouhaha are in play, as if the ultimate game of our hero were a punitive double one: to pepper the world with the most fantastical fictions, but then, as it were, to put salt on the parade, so as to expose it as a cheat; arguably both sides of this project (inflating/deflating) are, in their odd fashion, "affirmative." There is a sort of *qui perd*

266

gagne dialectic in play here, since as long as our man has the last word—and he always does—he even wins when he loses, since exposing one's own sham(e) ranks up there with all the other performances.

We have now seen the free word *Kuboaa* metamorphose into the free agent, Happolati. In these performances, our hero conducts his war against the laws of both god and nature, showing that human creativity has its own sovereign power, can bequeath its own regime, produce its own flag, and then enjoy the spectacle of folks saluting the flag it has stitched together. The novel reserves one more of these *wildings*, these moments of empowered semiosis whereby words become flesh, strut their stuff, command assent, take over the text. I am referring to the breathless pursuit of one Joachim Kierulf, a chase that starts right after our hero has been deciphering the movements of birds and the expressions of cobblestones, at which point he must have asked himself, where can I go after this? And the answer is, as both Poe and Baudelaire knew: anywhere, out of this world! N'importe où, mais hors de ce monde! So: off we go! Into the carriage, out with the address: Ullevaals Street, number 37![16] The driver is suspicious, but our man explains that it is absolutely urgent to meet the man who lives there; they arrive, he runs up the stairs, rings the bell knob on the third floor and delivers his tidings to the girl who (with a frightened look) opens up: "'I am looking for Kierulf, Joachim Kierulf, he is a wool buyer, if I might add that, not the sort of man you'd ever forget.'" (150). The girl refuses to play (our man actually thinks she is about to, but is just too lazy) and responds, "'No Kierulf living here'" (150).

No problem. The protagonist runs back to the carriage, explains that his man wasn't there, orders him now to go at once to Tomte Street, number 11. Again the chase is on, and the driver "was convinced it was a matter of life and death" (150); in some wonderful way, the driver is right: it is about the life of fiction, and soon we see (again) how communal and irre-

sistible such birthings are, how "interactive" verbal inter-
course really can be, how eager folks are to play. (Reading
Hamsun makes you realize that "truth" may matter in a law
court or a laboratory, but that it has zero purchase on conver-
sation and exchange.) Upon asking the name of the man
they are seeking, our hero replies, "Kierulf, the wool buyer,
Kierulf," and the "driver agreed that no one could make a
mistake about this man" (150). Driver then contributes a
"light-colored coat" to Kierulf (as in: didn't he usually wear
...?), which irks our man. Driver tries again: "'Doesn't he
have red hair?'" (151), and scores much better. Scores so well,
in fact, that our man, having weighed this over with consider-
able care, replies, "it would be an extremely rare thing if a
man like that did *not* have red hair" (151). Definition is com-
ing, big time. Driver allows that he has had Kierulf in his cab
several times, always with "a knobby stick," a detail so telling,
so on the money that our hero concedes that "'no one has *ever*
seen this man *without* that knobby stick in his hand!'" (151).

Many of us would be hard put to describe our nearest and
dearest with the amount of precision meted out to Joachim
Kierulf, phantom. This manic coach ride in search of a ghost
makes me think of the famous carriage ride in *Madame Bovary*
where Flaubert stages the (overdue, frenetic) lovemaking be-
tween Emma and Léon by describing only the activities and
trajectory of the coach itself. How much has changed, when
Hamsun takes over! The driver is intently seeking one Kierulf
while our man, inside the coach, is decomposing, disassem-
bling: *disassembling, not dissembling*: moving his mouth, chat-
tering idiotically with himself, laughing "for no reason what-
soever" (152). The entire construct/consort of character is
being jerked around, taken for a ride, hauled out for inspec-
tion and then blown sky high. Kierulf-protagonist-Hamsun-
Weinstein-you. So many letters, so many phantoms, so many
bubbles in the air. Sensing that this little escapade could finish
badly, our hero exits the cab on Tomte Street. He walks right
out of his fiction. And still further into ours. Hamsun has him

go through a complex series of doors, courtyards, anteroom, and rooms, finally through the opposite wall into another street altogether. The text reads: "I looked up over the door of the house I had just left, and read: *Food and Lodging for Travelers*" (152).

Hamsun himself does not italicize this final destination in the original, but Bly is right to do so, for this is *genombrott, passer outre*. He has arrived. And it is a semifinal destination, inasmuch as the hero will take up lodgings and remain there until the last page of the novel, when he will exit both Christiania and the book itself on the Russian ship *Copégoro* en route to Leeds, Cádiz, and parts unknown. *Food and Lodging for Travelers* has a ring of truth for this prancing, experimental text that seeks to break through all customary barriers of conduct and flesh and writing. The gratifications sought in *Hunger* are real enough: certainly they cannot be provided by either food or money, but they are richly and fulsomely present in the productions of language and imagination. One remembers the delightful moment when our man, starving as usual, carefully folds sheets of white paper into the form of a cornucopia "which looked as though swollen by shiny silver coins" (67), and then sets it out like a trap; this trap is fallen into by the policeman who sees it, stops, stares, and then picks it up, opens it carefully and peeks in. Here are the coins of the realm: not vulgar "real" kroner but rather the imagined coins to which folded blank paper gives birth; it is an allegory of all writing. Our man swells with pride at the success of his "art," and laughs, and laughs, "like a madman" (68). His show carries the day.

Hamsun's hero is a traveler in search of food and lodgings; like his creation, Andreas Tangen, he is a "homeless cabinet minister" (81). He is the self-proclaimed bookkeeper of Christie Foodstore, and all his most basic requirements—food, nourishment, lodgings—are unlike those of the familiar world of realist fiction and everyday life. On the contrary, he is waging his Revolution of 1848 and has elected to produce his own

elemental raw materials. He has newsprint for walls, and he is out to show us just how capacious and commodious such a space can be, how spectacularly you might be able to live in the realm of print and imagination. He walks up and down the streets of Christiania, tells folks that he lives "on St. Olaf's Place, number 2," exactly where, later, he is to locate Ylayali, herself also so profoundly a creation of desire that "real" sexual consummation cannot be sanctioned. Our man invents *Kuboaa*, rents from Happolati, and has a rendezvous with Kierulf. His powers of belief and desire are so compelling that others fall in line, do his bidding, print his words, offer even to share his bed. He makes them into fellow travelers.

What I have just described is, of course, the very modality of literature and art. Art is a form of nourishment and travel unlike any other. At its most intense, it is a source of energy that can outrival the sun. Thus there can be little surprise that our hero has been planning to write "an allegory about a fire in a bookstore" (188), and this grand opus evolves still further in his mind: "I wanted to give shape now to the really deep thought that it was not the books that were burning, it was brains, human brains, and I wanted to create a pure St. Bartholomew's Day out of these burning brains" (196). At this juncture, his heinous landlady steps into his room, tosses him out, and reminds him (and us) that the creations of the spirit can rarely be fully emancipated from the squalors of matter and flesh.

Burning brains are an appropriately incandescent figure for the generative energies that both go into and come out of art. Yet one reads *Hunger* with intensely polarized feelings, I believe. I have done my utmost to highlight the sheer joy and freedom, the *Heiterkeit*, of this prescient novel published in 1890, for it is a truly breakthrough text, announcing ventures and projects of a ludic and scriptural/writerly sort that will not be truly repeated until well after Hamsun's own death as an old man in the 1940s. But no one who reads it comes out entirely smiling, no matter how delicious the quests for

Happolati and Kierulf may be. Our laughter, like that of the protagonist, is more likely to be "feverish and silent," perhaps even "intense like a sob" (68). In closing, I want to say a few words about that sob, about the current of pain that subtends this ludic tale. You can say no to flesh and food, you can do without money, and you can even design a rich paper cornucopia of your own, but there is a price to pay. Not merely because of this man's obvious sufferings and travails. But, more profound, because of the bittersweet nature of his triumphs, the "zero-sum" game even he is obliged to play.

Yes, he is a traveler into realms of wonder and intoxication not easily found on most maps. And yes, he quite marvelously brings others into his orbit: the little old man, the cab driver, Ylayali, us. But in the last analysis, his form of travel and freedom is forbiddingly solipsistic, free because others have been "de-realized" and transformed into signs for him to play with. Even the frenzied performativity of this text is a trip into Nothingness: madly spawning the Ylayali of his dreams, our man knows he is also leaving the world: "I sailed off, and I made no move to stop myself" (85). One must wonder, at novel's end, just where our man's final exit-ship, the *Copégoro*, outfitted with Russian flag and headed for Leeds and Cadiz, is actually going. This nameless, void-driven figure is among the loneliest characters in literature. I am struck that even Ylayali has a sister and a mother, that the vicious pregnant landlady at book's end has children and a husband as well as a lover. The hero of *Hunger* is indeed a "homeless cabinet minister," last seen exiting a city and boarding a boat, a man of unforgettable creative powers, capable of making his own rival world and alternate self page after page but nonetheless a profoundly shipwrecked human being, a Faustian human being whose burning brains have created a "pure St. Bartholomew's Day" at the expense of all human connection.

The biographical connections are not hard to imagine: in the decade preceding the publication of *Hunger*, Knut Hamsun's extraordinary years "on the road" in both America and

Norway—lumberjack, preacher, auctioneer, streetcar conductor, barber, traveler, and commentator *extraordinaire*, not to mention author and lecturer who took on the Norwegian "greats"—have left us with the image of a restless, roustabout "Beat" writer some sixty years before Kerouac, Ginsburg, and company appeared on the scene. The real Hamsun's quest for adventure and authenticity, the real Hamsun's experience with starvation and illness, are hard to ignore when reading his fiction, *Hunger*. One senses in the Hamsun phenomenon something on the order of an unappeasable hunger, a voracious need to try out every form of self-enactment; one feels a kinship here with the experimental program of a Rimbaud, who approached the goal of transcendence and breakthrough with the lucidity of a scientist. *Passer outre* seems to apply to Hamsun's book as well, and we can hardly be surprised that human relationships fare rather poorly. The life of the quester is, of necessity, a lonely one.

But what we see in this brilliant novel goes, I think, further still. The terrain on which the events of *Hunger* play out is, in the last analysis, not Christiania at all but rather the huge dark reaches of human thought and feeling, the originary black hole that consciousness itself inhabits. The ludic, performative, revolutionary freedoms on show in this book are enacted on the far side of all human commerce, and there remains something both severe and searing about the portrait that emerges, for it displays to perfection the price that must be paid if *mind* is to set up its own indigenous regime. Our hero pays that price, over and over, in his ceaseless efforts of assertion, invention, and manic theater. We feel, in this book, the heat and vitality of burning brains, but however taken we may be by the demiurgic powers on show—the audacious "besting" of reality that is pulled off—we do not quite lose sight of the aching solitariness of the performance. In the end, it is precisely in the trade-off between autonomy and solipsis, between creation and homelessness, between play and tears, that we grasp the real integrity of *Hunger*.

D. STORIES OF FUSION: VESAAS'S *THE ICE PALACE* AND BERGMAN'S *PERSONA*

I

Tarjei Vesaas's beautiful novel *The Ice Palace* (1963) opens like this: "A young, white forehead boring through the darkness. An eleven-year-old girl. Siss."[1] At first glance this prose may not seem out of the ordinary, but look again. What we have is something on the order of a creation myth: a forehead bores through the darkness, and we are to understand that the darkness is the elemental, prior backdrop of life, the originary inhuman scheme against which human form and human projects take place. And we move from the generic to the specific: face, age, gender, name. An entire ontology of relative weights and measures is on show here, revealing the immensity of the dark setting and the puniness of individual performance.[2] This setting is "darkness" not only because it is night but because it is the black matrix that precedes (contains and outlasts) human doing, and we are to infer that individual assertion—such as having a self—is an affair of "boring through," of breaking through.

A pictorial analogue to Vesaas's notation, I propose, is Edvard Munch's mesmerizing *Self-Portrait with Skeletal Arm* done in 1895; it, too, is a kind of creation myth, whereby the representation of the artist's face explodes out of the surrounding blackness, framed by the registers of name and date (on top) and of the human skeleton (on the bottom), as if to show how evanescent and miraculous the human form is, how slight its authority might be, given the force field of time, place, and flesh in which it is located. Some have argued that the skeletal arm is a gothic touch, but it makes more sense to see it as a form of honesty, a clear appraisal of what lives and dies. There will be no skeletal arm in *The Ice Palace*, because even a skeleton would be too arrogant in Vesaas's scheme

273

where the cardinal law is fluidity and flux, where no fixed forms can long retain their authority. Munch's face explodes with light, conjuring almost a notion of Genesis, as if art and representation were ultimately a version of "let there be light." We shall see that light has a comparable demiurgic power in *The Ice Palace*: light as the medium of vision and photosynthesis, light as the primal force of knowledge and life. And death. Vesaas's world is, despite its familiar trappings, inhospitable to human design, incapable of being domesticated, fierce and magnificent. It hallows Wallace Stevens's view of our arrangements on earth and in our bodies as something unsponsored and free: "From this the poem springs: that we live in a place / That is not our own, and much more, nor ourselves / And hard it is, in spite of blazoned days."

Days are blazoned in Vesaas: filled with fierce light and regal splendor.[3] Humans partake of this at their risk, and even then they seem chosen rather than choosing. One of his most fascinating poems deals with a "friendly, ordinary man" who *burned*; the earth ignites him, as the community looks on: "The cracks came from underneath, / ran outward like snakes, / widened and burst / —while the ground thundered, / opened its floodgates, / so each person who heard / stood spellbound to his core, each person who witnessed it / knew guilt."[4] The community is mesmerized as the human subject becomes emancipated: "he burned, and called out in his distress, his liberation" (81). In Vesaas's dispensation, one feels that human life is clarified, purified, subjected to something like a crucible; and in these moments we witness the "revelation" of life's indwelling power and our own fateful fit within the spectacle. The poem closes with a return to normal that looks a great deal like a post-nuclear landscape:

> O, stiff dark, November ring of witnesses:
> such is the fire. Night did not fall if day waned,
> light shone from borrowed sources
> as long as he lasted.

Before too long, the yearning for fulfillment eased:
the cry of important messages grew fainter,
the rumbling of the ground weakened and vanished
and the heat cooled off in the wind.
His loved ones stood fast at their posts,
felt they were not crushed, but uplifted
—as the mountain of fire cooled and quieted down,
calmly became a dark hill of cinder. (85)

The Ice Palace, also a tale of initiation and fulfillment, replaces fire with ice, obeys the same savage and hypnotic logic.

These may seem like overblown claims for a simple story about two eleven-year-old girls. Apocalypse does not seem nigh; this world looks recognizable. Vesaas's tale *is* simple, but simple in the challenging, riddling way implied by Tom Lehrer's line about the "new math": "it's so simple that only a child can do it." The book puts adult thinking and adult categories on the line, makes us see not only the factitiousness of our "grown-up" schemes but also their poverty and blindness. And deafness. The book's next phrase is this: "It was really only afternoon, but already dark" (5), from which we learn that our categories ("afternoon") have little truck with the elements themselves ("dark"), despite our brave efforts to chronicle and "charter" (as Blake would have put it). You can say "really" all you want; Nature is not listening. Having bored through the dark, Siss makes her determined way; but she has company: "On each side was the forest, deathly still, with everything that might be alive and shivering in there at that moment" (5). Just a child's fantasies, you might say. But the stillness is shattered by living noise: "A loud noise had interrupted her thoughts, her expectancy; a noise like a long-drawn-out crack, moving further and further off"; a sentence later, Vesaas returns to the charge, offering us a set of similes that are meant to give pause: "It thundered like gunshot, blasting long fissures, narrow as a knife-blade, from the sur-

face down into the depths" (5).[5] There is a lot to hear, out there, and it can be menacing.

Critics have wrestled with terminology for Vesaas's worldview: primitivist, romantic, pantheist, animist, and the like. All these words point toward a regime in which our customary distinctions between subject and environment, between human and nature, are dissolved, as if these convenient binaries were merely anthropocentric ways of trying to rope off phenomena, to keep the world at bay, so as to keep the human subject at the center of the picture, still in the driver's seat. In *The Ice Palace*, with children protagonists and a natural setting invested with enormous power and mystery, it goes the other way: the frames no longer hold, but, instead of the crushing story we might expect (world wins, we lose), we encounter an odd and fascinating enhancement of the human drama, a magnified sense of human reach and resonance. There is great dignity in this fable of adventure, desire, death, and grieving. Our affairs are stranger and richer and larger than we had thought.

This is because we have forgotten. Forgotten just how dimensional and magic and charged the world was, when we were children, before the defining walls had gone up, separating mind and body, self and world. Even though this novel does not glorify children, it whispers to us nonetheless: growing up means growing smaller, as well as growing deaf and dumb. The world pulsates with frequencies that one learns not to hear. If you do hear them, you can be undone, as is hauntingly shown in Vesaas's poem, "The Voyage," in which fond notions of maturation and accomplishment are utterly inverted and imploded:

> We finally appeared again
> out of the night fog.
> And no one recognized anyone.
> Underway we'd forgotten how.

Nor did anyone demand:
Who are you?

We couldn't have answered,
we had lost
our names.

Far off there was thunder
from an iron heart
that was always at work.
We listened without understanding.
We had come
farther than far.[6]

Here is a trajectory utterly at odds with the educative paradigm that one has been taught to believe in. Life undoes us. It dismantles our categories. It despoils us of possessions. It erases understanding. Life is night fog. "A young, white forehead boring through the darkness. An eleven-year-old girl. Siss." Vesaas asks: How does life *undo* these forms? How might art follow suit? Reply: by showing how illusory and porous they are, by showing how much actual traffic goes on, by bringing the elemental forces themselves to visibility and audibility, by enmeshing us in the dance. This is what the life and death of eleven-year-old girls can show.

Siss's forehead bores through the darkness because she is en route to Unn. It is dark, and she knows she is not alone, "that even more alert ears were there, listening to her" (6). She is en route to Unn because she is infatuated with Unn: Unn the outsider, the reclusive newcomer. There is no age too young for desire, and Siss and Unn have felt it. Desire, it will be seen, has common cause with the other forces already adumbrated: the thunder of the forest and the ice, the thumping heart, the other ears. The two girls had discovered the force of their mutual attraction in the place where most of us make our first discoveries: school. It is there that Unn had appeared:

isolated, living with her aunt, shy, not joining in. But the current is there: "But they were quick to see that they liked each other. A curious look flashed between them: I must meet her!" (9).[7] We do not "generate" desire; like heat and cold and noise, it inhabits us, and then we look up, take note, and follow its dictates. It is a tyrant: I must meet her. Nothing volitional in sight.

And thus the dance starts. Siss feels Unn's eyes on her in school, feels it "as a peculiar tingling in her body" (10); the dalliance of eyes unfailingly produces "the sweet tingling," and, sure enough, it eventuates into language, the language of schoolchildren, notes surreptitiously passed from child to child. Here is a reading lesson unplanned by the teacher. The text is elemental: "'Must meet you, Siss.' Signed, 'Unn'" The elemental text triggers the play of elements: "A ray of light from somewhere." And the human body's light organs come into play again, lock on each other, bring tidings that bypass "mind" altogether: "She turned and met the eyes. They were at one with each other. Extraordinary. She knew no more than that, she could think no more about it" (11). The entire plot is adumbrated in these shimmering lines: infatuation, joined-through-the-eyes, eclipse of reason. Further notes ensue, passed from hand to hand:

> "Would like to meet you too." Signed, "Siss."
> "*When* can I meet you?"
> "Whenever you like, Unn. You can meet me today."
> "I'd like it to be today, then."
> "Will you come home with me today, Unn?"
> "No. You must come home with me, or I shan't meet you."
> (11–12)

The final agreement is that Siss will go to Unn later that afternoon, and that is why the book opens as it does, with Siss boring through the dark, magnetically drawn to her light-driven assignation. It is a plot as severe and magical as photosynthesis: they are following the dictates of light and desire.

The chapter of the rendezvous is appropriately titled "One Single Evening," and this account of two little girls in a small room is as dense a rendition of fateful human attraction, indeed of *Liebestod*, as anything I have ever read. *Liebestod* is a romantic trope that links union of lovers with death. Long ago Rougemont argued that desire itself is death-driven, that it harks back to the old cult of the Cathars which aims at the dissolution of all bonds. Vesaas belongs in this consort inasmuch as he is out to explore the desire for *fusion*: the irresistible force that shatters our frail boundaries by drawing us outward, toward and into the other, as a longing that can be neither denied nor gratified.

The scene opens with Auntie's sweet ministrations, greeting Siss, insisting on giving her something warm to drink, after her walk in the cold; yet the action moves inexorably into Unn's bedroom, and Vesaas tells us that, although Auntie seemed to want to go in as well, "she was clearly not allowed to do so" (15). We see the lineaments of this book's world order: children live in their own special precincts, and adults have no access. (As adult, as parent and grandparent, I am shocked by the wisdom of these lines, by their matter-of-fact recognition that grown-ups miss the parade, are *locked out*. Years of asking my children upon return from school, "how was it today?" and receiving as answer "OK" or "nice" or just a nod or grunt, come back to me, taunt me with my ignorance.) Once inside the closed bedroom, the girls set to work. It is not easy. They don't quite know how to begin. Unn then locks the door. The dance starts: they size each other up, note the relevant similarities (same age, same size), exchange small talk. Siss feels that the situation is dangerous, that some questions might be off-limits. Unn takes the lead, and says straight out that her mother was unmarried, that she died last spring, that she knows very little about her father but has a photograph. Further innocuous remarks about family ensue, but then comes the grand moment when the stage set is altered entirely, and the voyage begins.

It is launched with a mirror. The two girls sit on the bed, "side by side, almost cheek to cheek," and look into the mirror. Vesaas writes "What did they see?" And then he shows us. It is the book's richest single moment, I believe, for it displays the true dispensation at work in this novel, where the forms you know us by disappear, yielding something else entirely:

> Four eyes full of gleams and radiance beneath their lashes, filling the looking-glass. Questions shooting out and then hiding again. I don't know: Gleams and radiance, gleaming from you to me, from me to you, and from me to you alone—into the mirror and out again, and never an answer about what this is, never an explanation. Those pouting red lips of yours, no they're mine, how alike! Hair done in the same way, and gleams and radiance. It's ourselves! We can do nothing about it, it's as if it comes from another world. The picture begins to waver, flows out to the edges, collects itself, no it doesn't. It's a mouth smiling. A mouth from another world. No, it isn't a mouth, it isn't a smile, nobody knows what it is—it's only eyelashes open wide above gleams and radiance. (19)

Here is the new creature of the book: luminous, four-eyed and double-mouthed, otherworldly, opening and beckoning, *unownable*. There is something vertiginous at work, capsizing familiar boundaries, pulling both girls into its sway, not unlike a whirlpool or maelstrom. The emphasis on four eyes includes not merely the two girls whose features have merged, but seems to bring the reader as well into this specular force field.[8] It is an epiphanic moment, depicting both the ecstatic nature of fusion and the price paid to achieve it: bounded self. Note, as well, the kinetic force of this vision: tugged by gleams and radiance, the girls move into one another incessantly, on the far side of either logic ("never an explanation . . . nobody knows what it is") or volition ("We can do nothing about it"). Repeatedly, the language moves into erasure, so that what is posited is then undone: "no, they're mine," "no it doesn't,"

"No, it isn't a mouth." It is not possible to establish the ontology of this vision, since the words meant to corral it fail. The virtual space of the mirror serves as a revelation of what desire seeks, what desire feels like. It has been pointed out, as well, that the English term for the lips, "pouting," misses the erotic energy of the Norwegian "putande" which implies "well-rounded."[9]

But once the mirror is put down, one is again landlocked in one's body. How to get back to the fusion? Unn has an idea: "'Siss, let's undress!'" (20). It is the oldest strategy on record that humankind has come up with, to meet the challenge of desire, and, it works no better for these eleven-year-old girls than it arguably does for adults. Naked, shining, the two girls look at each other—and go no further. Siss notices something tense in Unn's face; Unn suggests they get dressed again. At this juncture, Unn seems about to confide some great and painful secret to Siss, one she wouldn't even have told to her mother: "'I've *never* said it to anyone'" (23). With exquisite tact, Vesaas recaptures the childhood language of feverish promises and trembling anticipation, but the expected revelation never comes. Unn never confesses her secret. I think one is led in a certain direction by dint of other utterances Unn makes, beginning with the acknowledgment that her mother was unmarried, followed by the ominous question put to Siss: "'Did you see anything on me just now?'" All this is capped by Unn's most unhinging avowal of all: "'I'm not sure that I'll go to heaven'" (24). We will never know the exact nature of this secret, and much of the novel's subsequent plot will hinge on this core mystery. But it seems plausible to think sexually here, whether it is a matter of Unn's illegitimacy or something graver still, such as some kind of sexual "encounter," ranging from puberty to intercourse to pregnancy to sexual abuse even, leaving an "imprint" on Unn that she thinks might actually be visible.[10]

But it is not visible. And it is not stated. And it never will be. One must ultimately ask: what does it matter? There is a

narrative brilliance here that is reminiscent of what Henry James achieved in *The Turn of the Screw*, and it works in similar fashion: we start hermeneutically, epistemologically, trying to ascertain what is missing, but we end up realizing that the mystery is bigger than this, that we are not dealing with a puzzle at all. James makes us see that the governess's hounding of the two children (for their secret, for them to confess their commerce with the ghosts) is itself a dreadful form of sexual encroachment; I think Vesaas works something comparable, for we are obliged to rethink our questions, obliged to understand that the true sexual secret has already been shown: it is the mutual infatuation that links the two girls, an infatuation that fuels the novel, much like a hidden fire, and not amenable to any kind of cognitive discourse.[11] Remember the poem: "We couldn't have answered, / we had lost our names." The tale turns on mystery, but the mystery is actually in plain view, and it is the mystery of fusion, of human connection. Siss and Unn have ventured into forbidden territory, and they will each pay the price. One will lose her life, and the other will barely escape the same fate. It is imperative that we understand this grim truth to be no different from what was already staring at us in the mirror: four eyes full of gleams and radiance. The armature of the person is no longer intact; it has been broken through, by the force of desire. All that remains is to chart its fierce consequences.

Gleams and radiance, shining nakedness, a terrible avowal almost made: the genie is out of the bottle, and neither child can really contend with it. Siss escapes, makes her way back, again hears voices at the side of the road—"It is I at the side of the road . . . I'm coming . . . We are at the side of the road . . . There was a deep, powerful thunderclap somewhere in the ice on the lake"—gets home, strikes her parents as altered, dodges their questions, soaks in the tub, goes to bed, is afire to see Unn in school the next day. We think we know what is coming in this text: some kind of fuller encounter between

these two intoxicated girls. Narrative logic seems to require as much. But Vesaas has surprises in store for us.

A rendezvous requires two people responding to the same force field. But what if the force field is expanded? Unn cannot face those eyes again, does not go to school. This may seem innocuous, but it follows the grisly logic of our vulgar English expression: "from the frying pan into the fire"; there will indeed be a rendezvous, a cataclysmic one, meant to illustrate the shocking dimensions and ramifications of what was actually birthed in that narrow bedroom with its two eleven year olds. The most harrowing sequence in the novel traces Unn's exit from the human community: it begins by leaving the road and it ends by leaving life. Her motivation seems tangled, as if Siss were located somewhere else altogether, so that the true way to meet her, to return to the mirror with its gleams and radiance, entailed a voyage of a different sort:

> No, she had only one thought today: Siss.
> This is the way to her. This is the way to Siss.
> Can't meet her, only think about her.
> *Mustn't think about the other now,* only about Siss whom I have found.
> Siss and I in the mirror.
> Gleams and radiance.
> Only think about Siss. (35)

In Vesaas, you leave the human community to enter a larger community. That larger community includes the mysterious *other* of her injured past, and it spills out into the physical scene, it too teeming with forces that now beckon to Unn. We realize here that our familiar notions of "human design" come up short, that the pulsions which drive us have nothing "inner" about them, but rather belong to the coursing elements, locate us in a landscape where we "play out." Lear on the heath, Faulkner's Bundrens amid the swollen waters: so many ways of writing those moments when the skin that

gloves us (that keeps me "me") is shed, and we take our place in the larger inhuman scheme.

Unn runs to the frozen lake, lies on its mirror-like surface, the "thick steel-hard ice," looks into the depths, sees a "totally black chasm" (37). She then remembers almost drowning once: wading and then finding nothing under her feet, and being miraculously snatched back by a rough hand "on to safe ground, back to her noisy companions" (39–40). This time she won't be so lucky. She comes to the outlet of the lake, and a sight streams toward her: "the great river coming noiseless and clear from under the ice, flowing through her and lifting her up and saying something to her which was just what she needed" (41). One can scarcely fail to see the expansion and magnification on show here: Unn is being initiated into a larger country, is not so much entering the depths as charting and assuming the depths, depths as much hers as the lake's or river's. The great river under her is of a piece with the dark forest and the voices that came to Siss: from the road, the woods, and the ice. Unn is entering her domains. The *other* which she seeks not to think about is inseparable from Siss whom she desires, and all these pulsions draw her ineluctably toward the novel's ultimate structure of desire which is to be her final home: the ice palace.

The children at school had been talking all fall about this astonishing natural phenomenon: an ice palace that was created at the waterfall where the lake plunges into the river. Unn looks down into it: "an enchanted world of small pinnacles, gables, frosted domes, soft curves and confused tracery" (43). Here is the consummate fusion between form and flux, between nature and art, and the waterfall "plunged into the middle of it as if diving into a black cellar" (44). Unn's entry into this magic place with "alcoves and passages and alleyways" may recall her early incident of near-drowning, but this time it is invested with a wild and irrepressible passion: "she was aware of nothing but her desire to enter" (45). This is the pure vehicular language of desire: a force that knows only one

thing: the "desire to enter." Unn's exploration of "the enchanted palace" is not only driven but enabled by desire: the openings she sees are tiny, and she has to squeeze her way through, but enter she does, and we recognize this as the trajectory of human longing: human longing understood as a propulsion that moves you into your ultimate estate, that seems indeed to create that estate. Note how cunning Vesaas's writing is, how the desire to enter is what opens up the space:

> And she found a way as soon as she looked for it: a large fissure between polished columns of ice . . .
>
> But she would soon forget about it [being cold] in the excitement of the next room, and the room was to be found, as surely as she was Unn . . .[12]
>
> And she found another fissure to squeeze through. They seemed to open up for her wherever she went . . .
>
> There was the opening! As soon as she wanted one it was there. (46–48)

We are at the metaphoric heart of the novel, yet I question whether my term "metaphoric" is appropriate for this fluid text. Each of these fabulous rooms seems different: one seems like a petrified forest, another has direct access to the blue sky, still another looks like a room of tears, another is a brightly lit hall. Unn feels that she is "bewitched and ensnared" (46), that she is looking at "a strange fairy tale" (47), that this is "the home of the cold" (47). But that does not mean this is a never-never land; on the contrary, it looks more like a strange homecoming, as if it *exteriorized* her inner landscape into an actual place, so that the drops she feels in the room of tears turn out to be her own tears, her own emotions—"her heart was heavy as lead"—actualized. Vesaas has found a language for displaying the staggering reach of the eleven-year-old child: she is taking inventory of her estate, exploring her domains, moving further and further *in* as well as *out*.[13]

The ramifications of this "entry" are unmistakable. Unn is being systematically weaned from the human world. She

loses all sense of orientation and directionality: "Forward or back meant nothing to her any longer" (47). The Newtonian regime of life fixed within a space/time continuum is yielding to another dispensation altogether: fluid, metamorphic, erasing all boundary lines. At a pivotal juncture, Unn confronts a new opening that is simply too narrow to admit entry. This is felt as unbearable: "she was wild with the desire to enter; it seemed to be a matter of life and death" (49). And it will be: she tears off her coat and satchel, to break through into the final space. She enters. She is at last free of all accoutrements.[14] Every reader shivers a bit at this point in the novel, for we know now, with certainty, that she will freeze to death.

Even that is a thing of arresting beauty, of integration. Initially the signs are grisly, as Vesaas writes the cold in terms that are all too familiar to us: "Now the cold could bore into her body as it liked" (51). Rape? Breaking through? A modern urban reader construes the threats to children along these social lines—do not talk to strangers, be careful of where you go—but that adult logic has no place in this fiction. The threats are, as it were, closer to home, indeed figured as home. Unn gradually makes her farewell: faint thoughts of her coat, of Auntie and Siss and Mother appear, then glide away. The drops, Vesaas writes, "began to play to her," as if this were nature's winter serenade. She plays back, shouts—"now she had a deep, black well of shouts if she should need them" (53)—but only once, for a vision appears: "It was clearly an eye, a tremendous eye" (54). The remaining two pages devoted to Unn's exit are luminous in every sense of the word and are open to many interpretations, both pagan and Christian, natural and psychological.

As if to illustrate the famous lines from Paul, "Corinthians 13"—"Now we see through a glass darkly, but then face to face"—the girl Unn is now seen by her Maker: "It grew wider and wider as it looked at her, right in the middle of the ice, and full of light" (54). Paul coded this final encounter as transparency, but in Vesaas it also smacks of indictment: "What are

you looking for? Here I am . . . I haven't done anything." Her last gesture is to raise her head and to meet the eye unflinchingly: "Here I am. I've been here all the time. I haven't done anything" (54). The room continues to fill with light, the eye continues its inspection, and it all reaches a fiery crescendo: "The fiery eye had been merely a warning, for now the room was suddenly drowned in flame. The winter sun was at last high enough to enter the ice palace" (55). The solar myth reaches its stately conclusion as the light makes "the sad room dance," and the icicles and the water drops "all danced together," embracing the child in nature's play, making her one with the elements.[15] Using imagery that seems a distillation of Ibsen's entire theater, Vesaas depicts a child initiated into pure light: "Unn had lost all ties with everything but light. The staring eye had burned up, everything was light" (56).

It is tempting to read these stunning pages as notations of guilt, of Unn's "secret," that *other* she wanted not to think about. "I haven't done anything" reads as a heartbreaking assertion of innocence. Yet I suggest that Vesaas's ultimate meaning transcends all notions of guilt or innocence, of secrets of any sort. We see a child becoming one with the elements. "Here I am" is staggering in its pathos, because *I* is no longer here at all, no longer a fixed proposition, but rather dissolved, unraveled, exposed in its facticity. I see a liberation, an apotheosis in these last notations of Unn's life: a liminal experience, an entry into the dance. Unn's life has opened out into the world. I insist on this interpretation because it does justice to the driving force of desire that animated Unn all along. Desire for Siss, desire to plumb the depths, desire to explore ever more passionately the ice palace and its fabulous recesses, desire to open the gates of self, cast off the shell, and enter the creation. In a poem from about this time, "A Little Disturbance," Vesaas had written of a child lost in a "mile-wide meadow," where it will eventually die and not be found until mowing time; however, this child "thinks it's moving in that strange world / it was in before it was born" (117), and

it dies "in quiet wonder," suggesting, as does Unn's death, a strange "return" to that larger natural ecosystem/homeland that our adult distinctions and categories have banished into invisibility. *Quiet wonder* ("stille forundring") is about as good a term for negotiating Vesaas's world as I can imagine.

The Ice Palace cannot possibly maintain the level of beauty and myth that it reaches in its account of Unn's fate.[16] The only direction to go, after pure light, is back to the murky mirror, the confused efforts of humans to sort out their arrangements and themselves. The remaining two-thirds of the novel does just that: it returns to Siss, the survivor, the one who approached the flame but was not consumed by it, in order to tell her story. Not consumed, but burned all the same, Siss is altered, for she experiences the continuing existence of the creature in the mirror, the four-eyed, two-mouthed creature of gleams and radiance. What happens to the project of fusion when one's partner is gone? I do not know whether Vesaas had much use for Freud, but the rendition of Siss's *Trauerarbeit*, her work of mourning, has an uncanny resemblance to the ideas expressed in "Mourning and Melancholia," most notably the view that successful mourning means a severing of one's ties to the loved object (in deference to the reality principle), but that melancholia can arise when the wires are crossed, and freed libido causes the ego to identify with the lost love object. There is nothing whatsoever doctrinal in *The Ice Palace*, because Vesaas writes these issues poetically: *Siss becomes Unn*. Is this not what fusion means?

We see this poignantly during the search for Unn that is instigated as soon as the community understands she is missing. A young man spies Siss among the searchers and pounces on her:

> "I was certain I'd find you—I felt I would."
> She understood.
> "But it's not me!"
> He laughed.

"Try to get me to believe that. But I must say I think you're
carrying this too far."

"I tell you it's not me! I'm helping to look for Unn too."

"Aren't you Unn? Said the stranger, his joy extinguished.

It sounded so wonderful, but she had to say, "No, I'm
Siss." (71)

But the fusing with Unn goes well beyond mistaken iden-
tity. On the contrary, the novel wants to show a crisis of iden-
tity, and hence Siss's loyalty to her dead friend exceeds all
conventional bounds. Hounded by the community to say
what she knows about the reclusive Unn, the infamous *secret*
resonates ever more powerfully. Her parents, Auntie, the
searchers: everyone wants to know what Unn may have *said*
to Siss on that fateful night of their rendezvous; Siss repeat-
edly claims that nothing was said—even while remembering
how close it came—and the weight of this legacy of intimacy
becomes asphyxiating, making Siss seriously ill. We watch
Unn's secret become Siss's secret, even though it remains a
mystery to Siss herself. Bit by bit, Siss takes on Unn's person-
ality and station: she moves from class leader to recluse, she
becomes isolated from her friends, she refuses to allow any-
one to sit at Unn's place in the schoolroom, she takes on a
pledge to be the one who will always think about Unn, the
one who steadfastly keeps Unn alive, whose union with her
is undissolved by death.

One doesn't know how to label such behavior. Siss is obey-
ing obscure laws that have nothing to do with clinical pathol-
ogies or labels. Late in the novel, Siss visits with Auntie who
explains that the doctor had forbidden the schoolchildren to
speak of Unn to Siss, who further says that Siss has been sick,
even depressed. *Depressed.* The term jolts us. (Not surpris-
ingly, the original Norwegian avoids such a clinical term; it
reads simply: "Du var langt nede," which means "You were
very low." Rokken would have done well to follow suit.) The
power of this novel stems from its refusal of all such medi-

calized language, and we are shocked into realizing that, yes, perhaps our terms such as "depression" really play us false, really fail to take the measure of what is actually transpiring. I myself have evoked Freud's notion of melancholia as another concept for describing Siss's behavior, but it, too, is far too thin and abstract to encompass these stark matters. Siss's devotion to her dead friend is not only the book's secret, but life's secret: individuation is a mirage, in a world of flowing currents and gleams and radiance. Fusion is the world's magnetic pull, on the order of gravity itself, and it comes into play as the goal of hunger and desire. Siss is indeed "sick unto death" in this text, for "I" is dying, is shedding its skin. The book records her season of pain, and it stages a battle between the adult forces of reason and order and form, on the one hand, and the inebriating call of desire on the other. Vesaas quite wonderfully codes that battle as seasonal: Unn is taken into the land of the cold, and as spring comes and the ice melts and the sap rises, Siss is pulled back away from the edge into the land of the living.

There is much one might say about the novel's plot. It can be seen as a rite-of-passage fable: two eleven-year-old girls open up to desire, and one dies while the other lives; two eleven-year-old girls fuse into each other, and one dies while the other "grows up" to return to the fold, even to appreciate the company of little boys; two eleven-year-old girls experience an infatuation, and one dies while the other learns to set limits and to let go of the dead. Late in the story, meeting another girl who might become intimate, considering a visit with each other, Siss panics, cries out that she cannot go to this girl's house: "'Or it will all happen all over again'" (159). Valuable life lessons? Perhaps. Frightening and sobering as well: relationship can be a death sentence. But the great achievement of the text is on the far side of any such caution, for it has to do with the book's new dispensation, in which the lives of children are part of a coursing world that cashiers all customary boundaries.

The fierceness of this book lies in its fateful and exalted view of childhood: a time when skins and forms are "soft" and might be shed or fissured. The form most under siege is of course the notion of bounded self, of integral identity, of being a *person*. The ultimate majesty of the book is located, materially and echoingly, in its most regal invention: the ice palace.[17] Here is the end stop of its narrative trajectory, the final goal of the *passage*. Unn enters, ecstatically and fatally, into this castle of desire, explores room after room, plays herself out entirely as she becomes part of the dance of elements. The adults in the community move unerringly to the fabled palace of ice during their search for Unn, and while they marvel at its grandeur and magic, they are denied entry into it; they strike against its surfaces, and find them hard, closed, impenetrable. One cannot fail to remember these same walls as fluid to Unn's desire, as opening up to her in response to her yearning to get *in*. The palace's immensity is negotiable only by children, as if its vast recesses intimated the dimensionality of childhood, the surprising territorial extension of an eleven-year-old girl.

And Siss herself is drawn irresistibly to the ice palace. She goes twice: once, by herself, where she is granted a terrifying view of the frozen Unn, "wreathed in glinting brightness, all kinds of shining streaks and beams, curious roses, ice roses and ice ornaments, decked as if for some great festivity" (118). Four times her normal size, part of nature's grand design, the altered Unn is too much for Siss, and she elects to call what she sees, "a vision," a vision that nonetheless haunts her at night, lying in wait, seizing her with terror. And Siss goes to the ice palace a second time, with all the schoolchildren, as an excursion with the unstated goal of domesticating this magnificent structure. The excursion, which Siss has foreseen in her mind's eye as apocalyptic, as a waiting catastrophe of mass death, is a pivotal moment in the story, for when the great palace emits its foreboding sound, its "crack," its "warning of death," the children scamper and make "for dry ground

on two legs or all fours, whichever was easiest ... they wanted to live" (166).

They wanted to live. Perhaps that is part of Vesaas's wisdom: that life sorts us out, even as children, and that those with the fewest defenses, with the frailest armature, perhaps with the fiercest longings, may go to their deaths. Unn's death is not glorified, but it is given to us as a kind of ultimate truth, as an entry into pure light, as an exit from all confining forms, including that of self. Siss is never to learn what kind of secret Unn may have harbored, but she does make knowledge of Unn's death, goes through the trial, and becomes a survivor: "It had been a time of snow and a time of death and of closed bedrooms—and she had arrived bang on the other side of it" (142).[18]

At novel's end, Auntie sells her house, takes a long walk with Siss, extracts a promise from the young girl to go into the houses of the community, to say thank you and farewell on the part of the older woman who has gone. It is in perfect keeping with the old rites-of-passage paradigm that closes with *reincorporation*, for Auntie does nothing short of threading this girl—who has been depressed and sick, who has been at risk—back into the community. But these fine outcomes—concluding necessarily with the eventual melting of the ice palace itself—neither veil nor soften the book's dark beauty. It proffers a picture of life inscribed in rhythms and pulsions that are unamenable to culture, perhaps even to survival, and it suggests that only in childhood do we fully inhabit this larger universe in which the voices at the side of the road, the flowing currents of river and desire, the cracking and exploding noise of the ice, are felt and responded to, as forces that may bathe or nourish or frighten or destroy us. At its most mythical and intense, *Ice Palace* explodes the fiction of a bounded self: the four-eyed face in the mirror, the unraveling in the castle of cold, the pledge of fidelity unto death, the morphing work of grieving. All in a story of two little girls.

II

Persona (1966) occupies a privileged place in Bergman's oeu-
vre as the most dazzling, experimental, and self-reflexive film
he ever made, thereby announcing a break with the more tra-
ditional, if highly theatrical, narrative films for which he was
earlier known. Signaling at once his kinship with the masters
of French, Italian, and Japanese film—Godard and Resnais,
Fellini and Antonioni, Kurasawo—*Persona* is an extremist
work, scrambling all our notions as to chronology and se-
quence, illusion and reality, private fantasy and public event.
Further strengthening its status as cult film-about-film is the
original title Bergman wanted for it: *Kinematographi*; this title
advertises Bergman's overt concern with his own medium,
something every viewer sees indelibly in the mysterious
opening shots that seem to review the very historicity of the
genre: from the cartoons and silent films on to baffling iconic
shots of sacrifice ranging from the sheep's entrails to the hand
that crucifies itself on to the eye approached by a razor; debts
to the genre itself are on show here: the silent fare, the early
talkies, the echo of older masterpieces such as Buñuel's *Anda-
lusian Dog*. This film remains baffling even today—as I know
from teaching it every year—despite the occasional brilliant
commentary it has generated, and the reader may wonder
why it is brought into this book about *breaking through*: what
does it offer to a literate but nonprofessional reader/viewer?[19]

The answer may be discerned in the shift of titles itself:
from *Kinematographi* to *Persona*. Yes, this may be the most self-
regarding and aesthetically challenging work in the Bergman
canon, but it has common cause with the great psychological
and ethical issues that are front and center in all of Bergman's
films: the nature of relationship, the modalities of power, the
play of desire, the maintenance/destruction of self-image, the
possibility of love. These are the staple items, indeed, the sta-
ple obsessions, of Bergman's films; they are on show as far

back as the fierce war of ego and image in *Sawdust and Tinsel* (1953), rivaling the quest theme in *The Seventh Seal* (1957) and at the core of haunting films such as the hallucinatory, "dismantling" *Wild Strawberries* (1957) or the brilliant spate of psychic explorations of the 1960s, such as *Through a Glass Darkly* (1961), *The Silence* (1963), *Hour of the Wolf* (1968), and continuing into the more accessible works of the seventies—the gorgeous and operatic *Cries and Whispers* (1972), the anatomical, Ibsen-like *Scenes from a Marriage* (1973), the lacerating *Autumn Sonata* (1978)—on to the culminating, warm, brilliant *Fanny and Alexander* (1983). And these same issues are no less central in the riddling *Persona*. For it is in *Persona* that Bergman seemed to realize that his compulsive human themes could be most richly and provocatively explored as *a meditation on cinema*, by which I mean: these powerful emotional and moral concerns were now seen as inseparable from the enabling, yet customarily occulted work of the camera. The great enduring question of Bergman's entire cinematic career is *What can we see? What does it mean to see?* In *Persona*, he went further than in any other film to dramatize that question, that injunction; the camera is now called upon to make visible to us the lineaments of things we have never before seen: the lines of force that unite and divide two people, the force field of desire or hatred in which all life is bathed, and which, when worked up sufficiently, can annihilate all notions of individual integrity or boundary, in short: the affective maelstrom we have always lived in but never actually perceived.

One of the film's most riveting images comes toward the close, and it depicts a face that no one has ever perceived: a *joint face* that conflates together half of Elisabet's (Liv Ullmann's) and half of Alma's (Bibi Andersson's) faces (figure 3.D.1). This is a monstrous face, and even though the camera can pull this off at will, most viewers shrink back from this "construct," for it seems to hint at heinous body amalgams that go back as far as the Frankenstein fable and suggest violence to the human form; it is not surprising that neither of the

3.D.1. Bergman's *Persona*, 1966

actresses recognized herself in this image.[20] Bergman wants us to understand that this double-face—which it has taken almost the entire film to arrive at—carries much of the power and venom of his story, as well as flaunting the creative power of film itself, since no retina is equipped to see such things. So, what exactly does this double-face signify?

295

Let us begin with the anecdotal. Bergman has famously quipped that he was initially struck by the physical resemblance between Bibi Andersson and the young Norwegian actress she introduced him to: Liv Ullmann. (We know that the two of them later married, that she has done her greatest acting in his films, that she bore his child, and that she even now remains not only his friend but has been given one or more of his manuscripts to turn into film.) In the film proper, Alma comments to Elisabet how much they look alike, and even introduces the critical issue as whether one of them could "play" the other.[21] In addition to this physical resemblance, Bergman has also drawn attention to the fact that he had recently had a serious hospital stint with an infection of the inner ear that gave him constant vertigo, and this comment matters: vertigo signals, I think, the crucial dislocating impetus of the film, its stunning fluidity and shape shifting, and it makes sense to think of vertigo as a neurological form of the boundary smashing and metamorphic activity that will stamp this story of two women who look alike.

We know, cerebrally, that the human world comes packaged in individual bodies. But we also know that some of the most powerful pulsions known to our species derive precisely from the *interactions* of individual bodies. Those pulsions go by many names: love, desire, hate, nurturance, vampirism, and the enacted relationships can range from caress to fornication to cannibalism to murder. *Persona* is intent on mapping this entire spectrum of relational possibilities, and even my word "mapping" is misleading, inasmuch as it suggests a static arrangement whereas the truth of the film is kinetic and fluid. It has not escaped notice that Bergman found a good bit of his quarry in Strindberg.[22] The following examples testify richly to the handy arsenal of ideas that Bergman was to tap into: the famous assertion in the prologue to *A Dream Play* that "time and space do not exist. Upon an insignificant background of real life events the imagination spins and weaves new patterns";[23] the division of the human race into nurturers

and bloodsuckers that stamps *The Ghost Sonata*; and the fascination with the special vision of "Sunday children" and even outright muteness as a powerful dramatic force—present in *The Ghost Sonata* but constituting the very modus operandi of the bizarre tug-of-war drawn in *The Stronger* (a monologue between two competing women, where one speaks, one is silent, yielding a stunning seesaw of assertion and humiliation, of fluctuating power). Yet one wants to say that Bergman has ultimately "liberated" Strindberg in *Persona*, inasmuch as he has found ways to transcend the binarisms of the earlier playwright, so that the familiar conflicts of love/hate, pleasure/pain, nurturance/vampirism are now turned fluid into what Strindberg would have recognized as a "dance."

If, for Strindberg, marriage was the fateful locus for such antics, Bergman moves beyond the domestic sphere and links realms as ordinarily discrete as medicine and art to tell his story of fusion and coming undone. Vesaas's two eleven-year-old girls looked longingly into a mirror and found "gleams and radiance" there, found that their individual contours had disappeared. Bergman begins his film about hunger and longing with the suite of disconnected images already referred to, but he then focuses on an abject boy-child who lives fitfully on a bed and gazes, hungrily, at the blurred enormous image of a woman whose face, we gradually realize, is altering, so that—in retrospect—we understand that the "mother" figure being gazed at is already an amalgam of Elisabet and Alma.[24] Above all, one feels the inaccessibility of the maternal figure(s), as if nurturance were an inconceivable fantasy, given the sheer scale of distance and size that separates us from all sources of gratification. You can't get there from here. This needy child will return to the screen at later junctures, but his symbolic role is already clear: to lead in to another narrative altogether where the same issues will be raised, now located between Elisabet the actress and Alma the nurse.

The medical setting of the hospital is among the many instances, I think, of the trompe-l'oeil effect of *Persona*. Bergman

invites us, at the outset, to pathologize the issues of his story—chief among which is the status of the mute Elisabet as sick and the speaking Alma as well—and also to grant considerable authority to the diagnostic acumen of the doctor who pronounces judgment on Elisabet at the virtual outset of the story. Many critics have hung their hats on the doctor's words, and they are worth quoting:

> I do understand, you know. The hopeless dream of being. Not doing, just being. Aware and watchful every second. And at the same time the abyss between what you are for others and what you are for yourself. The feeling of dizziness and the continual burning need to be unmasked. At last to be seen through, reduced, perhaps extinguished. Every tone of voice a lie, an act of treason. Every gesture false. Every smile a grimace. . . . And so you were left with your demand for truth and your disgust. Kill yourself? No—too nasty, not to be done. But you could be immobile. You can keep quiet. Then at least you're not lying. You can cut yourself off, close yourself in. Then you don't have to play a part, put on a face, make false gestures. Or so you think. But reality plays its tricks on you. Your hiding place isn't watertight enough. Life starts leaking in everywhere. And you're forced to react. No one asks whether it's genuine or not, whether you're true or false. It's only in the theater that's an important question. Hardly even there, for that matter. . . . I think you should keep playing this part until you've lost interest in it. When you've played it to the end, you can drop it as you drop your other parts.[25]

It is a stunning assessment of this beautiful woman who froze and went mute in mid-speech, during a performance of *Electra*. No one who hears this speech can avoid thinking: this is what the film is about; this is why Elisabet stopped speaking.[26] And the next obvious step to take is this: here is Ingmar Bergman thinking out loud about art and acting. About the conflict between art and truth, or role playing and authenticity. A life in the theater—Bergman had already put more than two de-

cades into theater and film—can, even must, lead to existential questions of this sort.[27]

Let me intrude a few personal reminiscences here. I know Liv Ullmann, and I can remember as if it were yesterday when she told me, in my living room while spending an evening with my wife and me, that she had not understood a word of *Persona* when she acted in it, not a word; she simply did as she was directed, by Bergman. But, she added, *now*—and this was in the late 1980s—she understood quite well why someone might go silent in mid-speech, why an actress would cease talking. I cite this only to show that this film deals with some very stubborn bottom-line issues, issues that its overt exoticism may veil, for a while. How not to lie? How to be true? How to *be* instead of *seem*? An actor is someone who is systematically caught up with these matters, since actors devote their lives to "mouthing" words that are not their own, but doing so in such a way as to make them seem utterly "real" to audiences. These issues have been much aired in theatrical discourse, going at least as far back as Diderot's marvelous *Paradoxe sur le Comédien* of the mid-eighteenth century, but Bergman puts his own twist on them, by importing (Strindbergian) vampirism into the equation as well, so that acting is seen to be at once inauthentic and exploitative. The actor has always been a dubious figure in Bergman's work, often figured as buffoon or charlatan or con man, as seen in early films like *Sawdust and Tinsel* or *The Seventh Seal* or *The Magician* and on show even in his final opus, *Fanny and Alexander*. But *Persona* constitutes, I feel, his deepest and most troubling exploration of these questions.

As the doctor persuasively argues, Elisabet's muteness is a bid for authenticity, or at least a refusal of lies. Which lies? The film answers: ALL lies. The lies of culture as well as those of language itself. When Alma first meets Elisabet in the hospital, we hear a love melodrama—"Forgive me, forgive me darling, you have to forgive me. All I want is your forgiveness. Forgive me so that I can breathe again—and live

again"—on the radio, and we see Elisabet smile: a smile of mockery and disbelief. I love you, I do not love you, you love me, you do not love me: here is the clichéd affective packaging that has been around forever, and Elisabet will not have it. These forms are specious. Feeling will not be corralled in this fashion, and the ramifications are huge: all the narrative frames that one takes for granted—marital, sexual, maternal, caregiving—are going to implode. The words themselves are factitious, but so, too, are the constructs in which the words are inserted. Elisabet has opted out. But the doctor's shrewd observation sticks: can you opt out? Will silence cleanse you of this coating of linguistic and behavioral sham? Is falseness avoidable? Your refuge, as she says, is not watertight; life seeps in.

Persona's plot seems to center, first and foremost, around this drama of authenticity. We can scarcely fail to see that the character roles themselves are drawn along just these lines: Elisabet the actress is in search of authenticity, and she is paired with Alma the nurse, Alma the "normal," Alma the authentic. Elisabet has aped the lines of others; Alma speaks her straightforward self. Alma has a normal love life, plans to marry Karl-Henrik and bear his children, identifies with her work as nurse, admires especially those older nurses whose lives were inseparable from their calling as caregivers. One is immediately struck by this basic contrast between actress and nurse, and Bergman pushes the conflict still further: Elisabet the artist *observes* the simple Alma, even *studies* her, as we learn from the melodramatic scenes involving the fierce recriminations following Alma's discovery, via an opened letter written by Elisabet to the doctor, of being toyed with, used, abused. We are not far from allegory here: the artist is the one who steps back from life, examines his or her fellows as aesthetic curiosities, as *material*, as an opportunity for learning. I think Bergman is offering some fierce and nasty home truths on this front, for he is highlighting the hard-wired egoism and exploitation of art, its lack of charity or feeling, its commit-

ment to observation and exploitation, its kinship with vampirism and cannibalism. The artist is a parasite who battens on to human flesh. A good bit of the film's ferocity inheres in its unflinching exposure of art's inhumanity. Elisabet Vogler may indeed play with Alma, but in the larger sense of things, she refuses to *play* the social game of human exchange. And Alma shows us how it feels to be on the receiving end.

But the doctor was right: you cannot not play. You cannot exit the game. Silence, observation, exploitation: two people together is still a dance. Elisabet and Alma are recognizable descendants of Strindberg's world of tortured couples. And yet, at the same time, this film is profoundly Ibsen-like as well, for it is driven by the same insatiable truth-seeking zeal that one finds in a play like *The Wild Duck*, and the disastrous consequences confirm the parallel. The brilliance of *Persona* stems from its willingness to take these intractable issues to their horrible logical conclusions. The quest for authenticity and truth will be not only toxic, but it will, as it were, metastasize, spread itself, do its corrosive work in every nook and corner of the film. And everywhere you look, you realize that the collapse of boundaries is a demiurgic proposition, that it gives birth to new things, that it spawns its own terrors. All this is what Bergman can reap from the prison-like intimacy of Elisabet and Alma.

As Sontag pointed out long ago, the neat binarism of sick artist and normal nurse quickly falls apart. As if it were a laboratory experiment, Bergman places the two women—one mute, one speaking—in a secluded cottage, so as to observe the resulting dynamic. Elisabet is silent, Alma talks. And talks. She spills out the details of her life with ever more frankness, and notes that no one before has ever really bothered to listen to her, to let her have her full say. To be sure, her disclosures are lubricated by wine and coffee and the catalyzing presence of the enigmatic Elisabet. We gradually understand that having your full say can be, as it were, a death sentence, because the creature that is trotted out with some

fulsome candor becomes increasingly incoherent and anar-
chic. Let yourself talk long enough, and you will not only lose
cogency but may well come apart. In short, Alma's *normalcy*
is seen to be a mask as artificial as any role played by Elisabet,
and that mask is fissured; it cracks. Here is why the title *Per-
sona* is relevant: the film is about the artifice of the bounded
self, the fiction that we call a *person*. Authenticity is a hopeless
fantasy; there is only role. This is what Alma herself must
have secretly feared, and it is why she so admires those nurses
who "identify" entirely with their work. But the collapse of
self is an unraveling that goes beyond matters of language.
Nowhere is this more evident than in the famous orgy scene
on the beach.

One reason this scene is famous is that we see no orgy and
no beach. Instead, we see Alma recounting to Elisabet—with
increasing urgency and distress—an incident from the past.
Viewers tend to agree that this episode is shockingly power-
ful, borders even on the outright pornographic, even though
(because?) we *see nothing* other than Alma talking to Elisabet;
if ever one needed proof that imagination is the key ingredi-
ent of arousal, this would be it, and it sweetly reverses that
old chestnut, "show don't tell," by suggesting that *telling* can
be visually far more potent than showing. Admittedly, Alma
has a lot to tell. While on holiday with Karl-Henrik, she had
gone to an isolated beach to sunbathe; there she was joined
by another girl, Katarina, who had come from a nearby island.
As both girls lay naked in the sun, she saw boys looking at
them from the rocks above, and, embarrassed, pointed this
out to Katarina, who said, "let them look," and turned over
on her back. Alma, still on her stomach, is intensely conscious
of Katarina's body. One of the boys approaches, Katarina tells
him to come closer, and she takes his hand, pulls him to her,
helps him remove jeans and shirt, and he mounts her, with
his swollen face next to Alma's. She then turns and asks him
to come to her, too, and "he pulled himself out of her and fell
over me, all hard, and took hold of one of my breasts so that

I shouted because it hurt, and I was all ready somehow and came almost at once, can you believe it?" (55). Aroused as never before, she describes how he "shot it" into her, how he held her shoulders and arched back, how "it felt as if it was never going to end" (55). When he was finished, Katarina "took him in her arms and made herself come with his hand. And when she came, she screamed like anything" (55). At this juncture the other boy, stunned, joins the fray: Katarina unbuttoned him, played with him, stroked him and took him in her mouth; at which point the first boy, aroused anew, started with Alma all over again: "It went very fast and it was as good for me as the first time" (55). They then all go for a swim, Alma returns home, has dinner and wine with Karl-Henrik, and goes to bed with him: "It's never been so good between us, before or since . . ." (56).

It is an amazing sequence. Needless to say, the scene would have been censored (even in Sweden, at that time) had it been shot "live." But it would never have possessed the same erotic power either. I would want to use my key term *breakthrough* to take the measure of what Bergman has done here. He has ruptured all our traditional frames. He has liberated a kind of "independent" sexual frenzy that knows no bounds or propriety or ownership.[28] In fact, displacement seems to govern the entire sequence, inasmuch as the two boys seem merely "go-betweens"—in Alma's account, their male bodies are not remotely as present or focused as Katarina's and Alma's—leading us to sense that the real libidinal current is somehow passing between the two naked girls, via the mediation of the boys. Moreover, the viewer *hears* this breathtaking story, while *seeing* only Alma and Elisabet—one talking, one watching—suggesting a further displacement, namely, that this story of sexual heat on a beach is serving to link the two women in a room onscreen, that the erotic violence is being proffered as a kind of confession/communication between speaker and hearer. I am stunned by the *economy* of this scene, the way in which Bergman has taken the genie out of the bottle, so that

the sexual theme runs wild, jumps its bounds, infiltrates all its players, including the audience of viewers/hearers who can scarcely remain unmoved by such a sequence. It is hard to imagine a sequence that is more promiscuous or kinetic.

But the most critical breakthrough of all is the one Alma herself confesses to, as she sobs to Elisabet: "It doesn't fit, nothing hangs together when you start to think. And all that bad conscience for things that don't matter. You understand what I mean? Can you be quite different people, all next to each other, at the same time?" (57). We are approaching dead center. The monstrous double-face is already in the wings: not yet as amalgam of Alma and Elisabet, but as startling, fractured self-image. What is cracking is Alma's sense of identity. She cannot "own" this episode. She is discovering the serial, "uncorralable" nature of the subject, a parade of selves that explodes any stable notion of *person*. And she discovers it just where you would expect: in the explosion of sexuality. Reconsider this beach scene that we never see: sun, sea, sky, two, then four naked bodies. An elemental scene that breaks down all *proper* notions: integrity, behavior. Like a chemical experiment, the elements re-form and are re-assembled. And there seems to be a tough lesson here about the very nature of sexuality: it does not have a name attached to it, not a private name such as Alma + Karl-Henrik, not a conceptual name such as "love." On the contrary, it has no truck whatsoever with identity or labels. Sexuality is a kind of indwelling violence that fissures all bounded contours when it erupts.

Most amazing is the constitutive role played by the camera: by filming this scene as a talk scene, Bergman has liberated its explosive force. And he has taken the first steps en route to displaying Alma's emerging "implosion." The duo of Alma and Elisabet becomes ever more charged with violent energy, an unfurling that is not easily anchored in what we think of as character. The intimate revelations about the beach orgy are followed by an exquisite scene of Alma, tipsy, heeding a voice that seems to be Elisabet's, going to bed, then seeing Elisabet

304

come into the room, exit, come back, culminating with an embrace by the two women.[29] Next morning, Alma asks Elisabet: "Were you in my room last night?" Elisabet smiles and shakes her head: No. For any viewer, this is a tight place: after all we've just *seen* Elisabet kiss Alma. But—we must ask ourselves—what did we see? Did it really happen? Or was this Alma's fantasy? Her desire? Here is where *Persona* becomes unchartable, since there is no way to establish the "ontology" of what the screen is depicting. Things go from bad to worse.

Understandably frustrated by the actress's unbroken silence, Alma gets her information in another way: she opens up Elisabet's letter to the doctor, and discovers that Elisabet is merely toying with her, letting her spill out all her various and sundry secrets. Alma feels violated, and she seeks revenge by putting a sliver of glass out on the terrace for the bare-footed Elisabet to step on, which she promptly does, then causing the film to "blow a fuse," as it were: the film burns up, the frame won't hold, the released libidinal venom works like fire. More violence follows: Alma tries to corner Elisabet, to force her to speak, to say anything at all: the actress refuses, the nurse explodes with hurt and anger, then grabs her patient and shakes her, leading to a fierce slap from Elisabet, all of which reaches its crescendo when Alma—hit again and bleeding—rushes at Elisabet with boiling water. The mute woman speaks at last: "No, stop it!" (77). Further recriminations ensue: "Does it have to be like this? Is it so *important* not to lie, always to tell the truth, always to have the right tone of voice? Is it necessary? Can you even live without talking as it comes?" (79). More silence, more mysterious smiles. The war continues.

But it moves to another sphere, as if the forces that produce orgasm or murder might have a life of their own, might actually take over the scene, thereby "enlisting" the human players as malleable conduits. In one of the film's strongest sequences we see Alma awake from a gripping nightmare because she has heard a voice calling "Elisabet"; she then goes

over to the apparently sleeping Elisabet, examines her fea-
tures, details her lack of glamour, and then goes to the door
to open it, so as to receive the night caller. Elisabet opens her
eyes, making us wonder if she was sleeping, making us won-
der what role she is going to play here. Forms now start to
tumble. The figure at the door, wearing dark glasses, is Mr.
Vogler; he has come to see his wife, Elisabet, but he persists
in calling Alma his wife. He tells her how much he's missed
her, longed for her, and she initially tries to keep things onto-
logically straight: "Mr. Vogler, I am not your wife." But it is
too late, les jeux sont faits, the dance is on. We see Elisabet
standing behind, smiling, taking Alma's hand, placing it on
Mr. Vogler; in the screenplay, Elisabet's own feelings are more
conflicted, but in the actual film, Elisabet comes across unam-
biguously as the controlling, scripting force here, staging
something to her liking. Alma is gradually won over to "be-
coming" Elisabet: she consoles Mr. Vogler, understands and
shares his tenderness, tells him she'll soon be back to comfort
their little boy; she receives his caresses and makes love with
him, afterward assuring him that he is a wonderful lover.

It is at this point she pops. He still lies next to her, but she
is sick with disgust: "Give me something to stupefy my
senses, or beat me to death, kill me, I can't do it any longer, I
can't. You mustn't touch me, it's a shame, a dishonour, it's
all counterfeit, a lie" (89). How does one assess this bizarre
interlude? Some earlier critics assumed Mr. Vogler may have
been blind and simply got the wrong wife; this seems a little
moronic. Bergman is again tracking the movements of that
genie who got out of the bottle. This sexual encounter builds
on the dissociative character of the orgy on the beach. After
all, ecstasy itself signals, etymologically, displacement, and
now we begin to see how far it might go. There is something
incestuous and vampirish at work in this sequence, as if one's
own sexual pleasure required the breaking of the self, of the
person, so that we are entitled to interpret coitus between
Mr. Vogler and Alma as something shared out: sex between

Alma and Elisabet, sex between Mr. Vogler and Elisabet.[30] We are always free to say that this event onscreen is not "really" happening, but where will that get us? It seems wiser to acknowledge that the entire film is invested in this kind of unmappable promiscuity, this fluid dance of desire and libido, that mocks and shuffles the forms you know us by. And that does not go far enough. Bergman seems to be saying: this is the actual reality of sex—it lives via displacement and projection, its energy is most fully actualized by dances of this sort. It is just that ordinarily, by light of day or by dark of bedroom, you cannot see it this way. We might not go astray by calling this *freedom*. A freedom on the far side of human agency or design.

These two women are becoming inextricably intertwined, yielding a mix of forces and vectors that beggar traditional psychology. They are invading each other. Alma has tried to hold onto her self, but the pull-into-the-other is vertiginous. Appetite is all: Alma claws her arm, blood appears, Elisabet stares at it mesmerized, her lips swell, she sucks it. Fixed forms fail. Words free themselves from grammar or meaning. The setting is ripe for the final contest, the last phase of the dance: Alma tells the story of Elisabet's maternity. It is at this juncture that Bergman brings together all the disparate motifs and issues of his film: we remember the boy of the opening, we remember the photograph of the boy, a photograph that Elisabet ripped in half, we remember Alma's earlier autobiographical recounting of orgy and abortion, and, finally, we remember the larger theme of nurturance and caring that are supposed to inhere in the nurse/patient relationship. All this feeds the poisonous tale that Alma tells: a tale of misery and disgust, of somatic processes gone amok, of forms savaged. According to this tale, Elisabet became pregnant out of boredom, but she got increasingly frightened as the fetus grew: frightened of responsibility, of leaving her work, of being bound, of her body.[31] She tried to abort but failed. She started to hate her unborn child. She wanted it to be born dead. But

it was born and survived. And it was sick and repulsive, in its needs. It developed a desperate violent love for its mother, disgusting her with its wants, with its "thick mouth and ugly body and wet appealing eyes" (97). As the tale is completed, Alma shudders, as if she were measuring the *dirtying* entailed by imagining/speaking another's intimacy, speaking it in the first-person, and she exclaims: "I don't feel like you, I don't think like you, I'm not you" (97).

This sequence is enshrined in film history because of the shocking way Bergman has shot it: twice. He does it twice. We see it the first time through looking at Elisabet's face as she "receives" the story. It is then replayed, verbatim, but this time we are looking at Alma's face as she "delivers" the story. Why is this? What is this? Perhaps the first immediate remark is technical: in good Brechtian fashion, Bergman has utterly destroyed any lingering illusions about immediacy or "slice of life," by rubbing in our faces how *constructed* any cinematic sequence is, how there is always a camera and a camera-person determining what we're seeing, at what angle we're seeing it, and—by extension—what we're not seeing. Smooth, unbroken linear narrative seems put out for good.

But quickly enough the technical turns into the existential (as it always seems to do in this film), so that we realize how utterly the power and valence of this diatribe are cued to angle of vision, are dependent on whether it is given or received. The first version focuses on the hurt and shock of Elisabet, whereas the second conveys the spite and venom of Alma. But soon enough still more puzzling and provocative questions emerge: how can Alma know what she is saying? How can Alma recount an intimate chapter in Elisabet's psychic history? Again we return to the issues of displacement and rupture between sentience and speaker, for it jumps out at us that Alma is fundamentally creating this monologue, that she is *scripting* Elisabet, creating and uttering Elisabet's "story." At this point, the final dance of positions and musical chairs seems completed and come full circle, because we real-

ize that Alma has become the artist, and that Elisabet is now her material; Alma is the actress, and Elisabet is the one acted on. And although the narrative appears to be about a dreadful failure of pregnancy, birthing, and mothering, I suggest that the real birth on show is that of the monstrous double-face with which we began this essay, but now an amalgam rich in meaning for us, for we know the amount of violence, vampirism, and outright cannibalism that are needed for it to be spawned.

Perhaps the single most important truth about this double-face is that it has destroyed the single-face, the bounded face, the integral person. In this sense, the fluidity of *Persona* is its most potent element, for it betokens the collapse of fixed contours, the eruption of a libidinal flow that is virtually lava-like in power but also dark in its nature. The best commentary we have of that darkness is that of Susan Sontag, whose brilliant analysis has paved the way for much of my own argument: "If the maintenance of personality requires safeguarding the integrity of masks, and the truth about a person always means his unmasking, cracking the mask, then the truth about life as a whole is the shattering of the whole façade—behind which lies an absolute cruelty."[32] There can be little doubt that Sontag herself derived this argument from Artaud's famous principles about renewing Western theater, particularly his claims about the founding myths: "And that is why all the great Myths are dark, so that one cannot imagine, save in an atmosphere of carnage, torture, and bloodshed, all the magnificent Fables which recount to the multitudes the first sexual division and the first carnage of essences that appeared in creation" (31), or his later lapidary claim: "Everything that acts is a cruelty" (85). Artaud's terms are intriguing, for we cannot fail to see that cruelty is inseparable from a kind of kinetic, dissociative energy. He speaks of sexual division and "carnage of essences," but it is no great step to move from there to the undoing of the *person*, along with all the proprieties and

coherences that shore up such a concept. Could *person* be a "mask"?[33]

Bergman, as man of the theater, has to have known the work of Artaud, but my argument has nothing to do with influence as such. Rather, I claim, as Sontag herself has, that *Persona* has large mythic aims, that it is as much at war with bourgeois psychological discourse (said by many to be Bergman's only theme) as was Artaud himself. Hence this film has a political, historical thrust that Bergman's critics have always denied. Elisabet Vogler's actions certainly have a "private" stamp at times: she rips apart the photograph of her child, and she smiles disdainfully at the melodramatic rhetoric played on the radio. Yet, as all viewers know, she also is fixated upon two of the most powerful iconic images of modern history—the photo of the Warsaw ghetto where the German soldiers are rounding up the children for the death camps, and the television footage of the Buddhist monk immolating himself by fire during the heyday of the Vietnam War (a war that is contemporaneous with this film). Why are they there?

As Sontag has suggested, there are several answers here. On the one hand, the carnage of history—recalling, strangely, the carnage Artaud had in mind—is not merely evidence of "life" that seeps into all crevices, proving that nothing can be watertight, but is more disturbingly evoked as the purest illustration of the violence that rips apart human form, the indwelling cruelty that has been liberated. (One thinks of the drastically altered forms of human and animal in Picasso's *Guernica* as a comparable artistic version of horror's legacy.) Elisabet stares mesmerized at these two images, and we are to realize that muteness makes some sense in a world where genocide can become the rule; the voice of the TV commentator who speaks of the day's munitions and body counts in Vietnam is no less eloquent an apology for muteness, for silence, since speech seems dirtied and co-opted when put to such uses. But, as this film has been showing for some time now, silence is not innocent either but rather possesses a

power all its own. Further, Sontag has to have been drawn to the sheer fascination exerted by the two famous images of human horror—images that cannot speak but that will speak forever—and her own last book testifies richly to her conviction that violence and destruction are never more obscene than in their awful hold as images that entrance us, invite us into a terrible voyeurist complicity.

But the sheer virulence and intensity of these matters, their virtually cosmic reach, may be best understood if we reach for a stark analogy in the sciences: the making of nuclear fission by bombarding the structure of the atom so as to liberate its unheard-of indwelling energy. In my view, this sensationalist parallel is rigorously apposite, for Bergman wants to show us what can happen when the armature of the atom—of the person—is invaded and fissured and cashiered. That protective structure—fictive though it may prove to be—is the only guarantor we have for belief in some kind of humanism, some kind of order that respects the human frame. The Warsaw ghetto and the Buddhist monk who immolates himself testify to a world where that measure no longer holds, where individual integrity and value have stopped being meaningful concepts. Here is a modern variant of the cruelty that Artaud located in the "great Myths," and Bergman wants us to see that it is fundamentally of a piece with the story of desire-become-vampirism that he stages in his story of an actress and a nurse. He is telling us that human History is larded with moments when the human form loses all value, when language is so degraded that it cannot be used; and the private version of such matters occurs when living creatures enter a dance that links desire to murder.

This story is enabled by the camera. Not in the obvious sense that all films are enabled by camera work, but that Bergman has wanted to use the power of film as his way of producing fissionable material. Looking at something or someone intensely enough will destroy either you or it. Placing a mute actress and a speaking nurse together will create a vor-

tex that swallows them both. We, too, are implicated, since the virulence of the "mergence" model lies in the fact that spectating is not safe, that the violence of this film reaches all the way into our own eyes and brains. Cannibalism is not some exotic trope. Our polite models of observer/observed implode into something far more grisly. Remember what Siss and Unn saw in the mirror: gleams and radiance. These gleams, that radiance, have common cause with the force field charted in Strindberg's *Inferno*, for they install a regime of porosity and exposure. Bad news for the hegemonic self. In all these instances, the boundaries that matter are smashed, and horrible new forms and forces—the ripped photo, the double face, the displaced libido, the cannibalist takeover—emerge into the light of day. The *person* has no integrity left; it is all broken through.

— 4 —

GRAPHING POWER

A. Breakthrough, Time, and Flux in Edvard Munch (the Cubist)

Edvard Munch's "breakthrough" as painter—as the Edvard Munch we know today—can be assigned a time and place: November 5, 1892, the opening of his invited one-man show at the Verein Berliner Künstler. To be sure, Munch had been producing significant work close to a decade already, and, as young partisan of the Christiana Bohême, had been repeatedly rebuffed by the Norwegian Art establishment as either hopeless neurotic or bumbler incapable of "finishing" his paintings. But Berlin was the explosion that mattered. Now famous pieces such as *Puberty*, *Despair* (the earlier version of *The Scream*), *Melancholy*, *The Kiss*, and others created the monumental scandal that launched Munch's career; all the right-thinking people—not merely the older painters of the Verein but heavyweights including the culture minister and the Kaiser himself—were so grievously offended by these insolent artworks that the Verein voted (120 to 105) to close the exhibition less than a week later.[1] The repercussions were enormous: newspapers throughout Germany covered the story, the forces of righteousness made known their violent rejection of Munch's art, yet Munch's international career was seeded at

that moment, as well as the nascent but intense interest of wealthy German collectors that would last throughout the painter's lifetime. The term given to this event is "Der Fall Munch," the Munch Affair.

What is the Munch Affair? Over a century later, I believe we are still trying to work out an answer to that question. The scandal at the Verein Berliner Künstler is simply the *scandal Edvard Munch*. Yes, in 1892 the young Norwegian painter succeeded admirably in Voltaire's famous injunction: *épater le bourgeois!* These paintings seemed to advertise both a mindset and an art praxis that could not be stomached. "Degenerate" (Hitler would later single out Munch as a target in his famous campaign against "Entartete Kunst"), "sick," "diseased," but also "unprofessional," "unfinished" and "crude" were among the terms thrown about. Certainly the reaction of offended piety is scarcely new in nineteenth-century Europe: Baudelaire and Flaubert ran into it, Oscar Wilde flaunted it, Ibsen's work routinely courted it, Strindberg ran afoul of it. Yet, in the "Munch Affair," one feels (as with Wilde) that the expletives and expressions of disgust apply as much to the man as to the work. Not that Munch the person was (in 1892) of dubious moral standing—he would become so, a decade later—but that the paintings inevitably conjured up a psychological gestalt, an image of emotional and psychic disarray and horror that went well beyond formal and aesthetic boundaries.

Munch was, of course, no little Lord Fauntleroy. He had sampled the Christiania Bohême (represented most memorably by Hans Jaeger, the cynical philosopher of the group), and in Berlin he was to continue his education in these matters much further still, via his involvement with the brilliant, carousing group of artists, writers, and musicians who frequented the "Schwarzen Ferkel" bar (the "Black Pig," as baptized by Strindberg).[2] It was here that Munch met Strindberg—an encounter that marked them both forever—and other boundary-smashing artists and thinkers: Stanislaw

314

Przybyszewski ("Staczu," philosopher, writer, pianist, Satanist; first to write on Munch, to see his genius, even to orient his career); Dagny Juel (the femme fatale of the group, introduced to the others by Munch himself, hailing from solid Norwegian background, renamed both Aspasia and Ducha, quickly becoming the stuff of legend via her erotic entanglements with the key regnant males within her purview, doomed by her choice to cast her lot permanently with Staczu); Christian Krohg and his self-flaunting wife, Oda; Richard Dehmel; and visiting Scandinavians such as Ola Hansson, Gunnar Heiberg, Holger Drachmann, Sigbjørn Obstfelder, and others.

But the pairing with Strindberg is what most fascinates: Munch, quick to sense something fateful here, got off a bristling portrait of the Swede even before the exhibit opened. Strindberg was the charismatic misogynist from the North, now on his second marriage, subject of scandal in Sweden, author of plays too bold to be staged but now undergoing a dry spell of sorts, hence trying his hand (as he was to do at select intervals in his life) at painting, producing remarkable results that were incomprehensible (and unmarketable) back then. He and Munch are a star-crossed couple; they *interpenetrate*—the verb is ugly but not too strong—and are each to be subject to a mutual haunting that shows up in their respective future works.[3] The Schwarzen Ferkel fireworks in Berlin left their mark on both these players. Strindberg's *Inferno* recasts, as we have seen, Munch as "Danish artist," as "bristling" co-player of the past with resonant memories; as for Munch, he never forgot that intense chapter of his life, as is sweetly on record in an incident that took place in Warnemünde, years after the two had last seen each other, when a sharp gust of wind blew Munch's easel and canvas onto the sand, leading to the obvious explanation: "That wind is Strindberg, trying to disrupt my work."[4] Of course, occultism and other exotic "ism's" such as monism, mesmerism, and the like, were thick in the air, but these two figures were kindred spirits in their view of the volatility and porousness of the human subject,

leading to extravagant depictions of enmeshment and secret sharing, to a new mapping of the Self.[5] Strindberg and Munch both produced work that has been judged *unhinged*: the protagonist of *Inferno*, like the central figure of *The Scream*, has lost all integrity and sense of boundary, is open to invasions of every stripe.[6] In their most far-reaching work, the atomic individual is shown to be hooked up to energy circuits beyond anyone's control. It would seem to be a bad day for Ego.

Yet each has also been seen as something of a megalomaniac, as self-absorbed mythmaker, as narcissist of epic proportions, as devoted to the lifelong labor of constructing his own self-image. *Inferno*, as I have argued, has been largely misread for just these reasons; dismissed as a record of Strindberg's private mental tumult, its bold articulation of the operation of *power* in both psyche and world has not been recognized. In similar fashion, Munch suffers from misprision. My Munch is, first of all, a deeply Strindbergian Munch, inasmuch as the core logic of his most fascinating paintings reminds one of the new dispensation on show in *Inferno*. But, above all, the Munch that interests me in the pages ahead needs to be freed from his persona, so that we may grasp what is revolutionary about his paintings, for his legacy (like Strindberg's) is to have drawn a new map of the human, to have *used* his own "sound and fury" as launch pad for an art that both terrorizes and "re-territorializes" the individual.

Can we get past Munch the man? The tumultuous life is amply documented, by himself as well as others. I am the first to agree with Munch's famous claim that the angels of disease, insanity, and death attended him from the cradle on. I also agree that the record shows just how unstable and precarious he was: hit by consumption from earliest childhood, influenza and bronchitis as regularly appearing maladies, fear of being sapped from within (*vermoulu* was his own term for it, having borrowed it from Oswald's self-description in Ibsen's *Ghosts*, having sensed the fit), prone to massive alcohol abuse, leading to serial breakdowns of dementia and paraly-

sis, the most extended an eight-month stint at Dr. Jacobsen's Clinic in Copenhagen in 1908.[7]

He was a sick man. So are we all. What matters is what he did: with his sickness, with his art. I especially want to underscore two specific "symptoms" in Munch's behavior: his peculiar *arrestedness* in time, manifesting itself in his obsessive return to the same motifs, the same traumas, over and over: Mother's death, Sophie's death, the erotic calvary (Millie, Dagny, Tulla); the second feature of Munch's mind-set that matters to me is his (Strindbergian) sense of imperious circuits, channels, flowing forces, all bathing/penetrating the individual subject and threatening to capsize him or alter him beyond all recognition. Why, if we are seeking to get some distance from the biographical Munch, should these arguably neurotic fixations count so much? Because they are the stunning new principles of force, the new dynamics—as if one were speaking of a new physics, as in Newton or Einstein—that shimmer through Munch's art, giving it a shattering coherence, if I may put it that way. But, transmuted into art, these psychic moves are no longer to be seen in pathological terms; on the contrary, they articulate a way of being that wrecks most of our received notions about stable settings and secure selves. These are paintings that breathe entrapment, arrestedness, time both frozen and gestating, neural and affective traffic, collapsing borders, spirit turned visible, life reordered. They do not send us back to Edvard Munch, Norwegian, but rather send us inward, through the looking glass of art, to our own arrangements, now transfigured; and they send out outward, toward a phenomenal regime, a material world that beckons to us, that inhabits us. The Munch Affair is our affair.[8]

Let us consider one of the defining traumas of Munch's early life—the death of his sister Sophie at the age of fourteen—in order to see how it became art, and what kind of strange claims it makes on us. The first major painting Munch produced, *The Sick Child* (1886) (figure 4.A.1) clearly harks

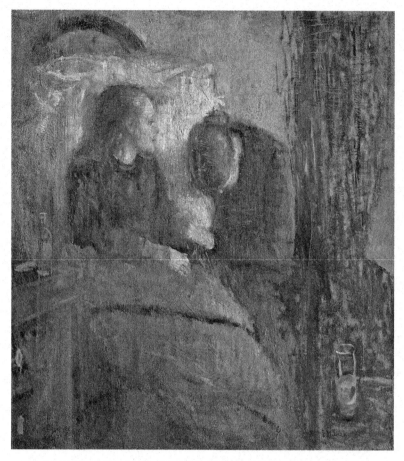

4.A.1. Edvard Munch, *The Sick Child*, 1886. The National Museum of Art, Architecture and Design, Oslo. Photographer: Jacques Lathion. © 2008 The Munch Museum / The Munch-Ellingsen Group / Artists Rights Society (ARS), New York

back to this early loss. It is a haunting picture of a haunting. Munch returned incessantly to this motif of the dying girl attended by the older woman, reworking it in lithograph, woodcut and drypoint, as well as recasting it in later painterly styles, but the early version has a rare tactile power: the impasto technique and scored surface convey a surface under attack, as it were, so that the gouged canvas and the invaded flesh are versions of each other. Munch worked feverishly on

this canvas, trying to recapture his memory of her actual death: "the pale transparent skin against the linen sheets, the trembling lips, the shaking hands";[9] the twelve-year-old model he used, Betzy Nielsen, was undernourished and consumptive, the mother figure was his beloved Tante Karen, his aunt who had come to live with them since the death (by consumption) of his mother, Laura, still earlier. The painting conveys at once the merciless onslaught of disease and approaching death, but the girl's wasted face has a rare and radiant spiritual beauty to it, as if all dross and weight were being removed (along with life), and only soul was left.[10]

This scene never left Munch. We can say this because he revisited and reworked it so many times. Let me put this another way: Sophie's death *lives* in him, requiring that he re-experience it, re-represent it.[11] Could death be a living thing? Could he himself be the site where her death takes place incessantly, where the experience of loss is never over, is as permanent as breathing?[12] A still more famous version of her dying is *Death in the Sickroom*, also done over and over in the 1890s (figure 4.A.2). This much-celebrated painting shows us the hieratic Munch, the creator of a frozen tableau in which the central (unseen) player is Death, now come to take the sister (also almost unseen) who is seated on the chair where she died. Everyone is mesmerized by this visitation: Tante Karen and Doctor Munch who look down at the child, brother Andreas who is halted forever at the door (trying/failing to escape), sister Inger who stares fixedly, sphinxlike, directly at us (as if to ask: what do you see? what do you make of this?), sister Laura seated, with folded hands, and looking downward, and (as third head of the sibling block) Edvard who gazes head-on at the mystery itself. The whole scene, albeit frozen and stylized, is tilted, precarious, barely held in place on a slanted floor from which you could fall off; perhaps that is what Death is: falling off, falling out. Edvard later wrote that his life was a narrow path next to a great precipice, that he knew himself destined to fall into the pit. Perhaps that is

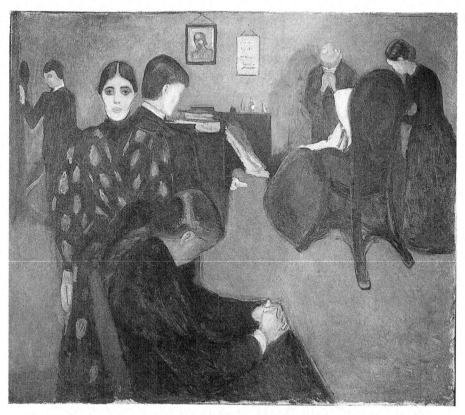

4.A.2. Edvard Munch, *Death in the Sick Room*, 1893. Munch Museum. © 2008 The Munch Museum / The Munch-Ellingsen Group / Artists Rights Society (ARS), New York

what the young Edvard of *Death in the Sickroom* sees: falling off and out.

What *we* see is a family portrait of people aged as they were in 1893 when the painting was made. But Sophie died in 1877, some sixteen years earlier. Edvard has painted them *in real time*. Sophie's dying is still happening in 1893, and that is why they are presented as they are.[13] What does it mean when something lives in you this way, like a succubus? Studying the vexed life of Munch, one initially comes away with the sense that it is miraculous that he lasted until 1944, that he should have been swept away—by sickness, by abuse, by

mania, by those "angels" attending him—decades earlier. Only then do you realize that Art kept Munch alive; and that he knew it. Let me rephrase this: Art itself is what *lives* in Munch, through Munch. And it is of a piece with his psychic and affective makeup, inasmuch as his art will become a *manifestation* of psyche and affect. Munch is a Freudian in reverse gear: his mind-set resembles those of Freud's damaged patients who cannot spring clear of their emotional injuries, but whereas Freud's job was to enable them to work through their earlier embedded traumas toward a form of health and independence, Munch seems to batten on to his injuries, to sense that they are his blood supply, his lifeline, his artistic and existential rationale for living.[14] Hence he upends all notions of pathology, of paralyzing wound, because damage is (for him) sustaining, is an endless fount of motifs that live on the canvas, that bid forever to be re-worked, re-imagined, and hence re-experienced.

Photographs of Munch are fascinating things: they reveal his classical and elegant features—he was referred to as the most beautiful man in Norway—but they keep mum about the inside: his lips are closed tight, and one is almost shocked by his marble-like composure, for it reveals as well the discipline and volition needed to achieve such composure (figures 4.A.3 and 4.A.4). This man who knew how available and precarious he was inwardly chose—I believe he did choose—to cargo all his fluidity and riot into his art. He famously refused marriage with the wealthy Tulla Larsen (who pursued him for years), alleging that he was not fit for it, that it would be genetically wrong for him to have children ("tainted blood," he called it), that Art was his life.[15] What did Munch call his paintings? his *children*. And they are. They are his truest family.[16] He had to be surrounded by them. He often begged his patrons to lend them back to him after purchase. A shocking percentage of the photographs we have of him display them as the backdrop. Numerous paintings also feature the "children," their siblings, in the background. But they are neither

321

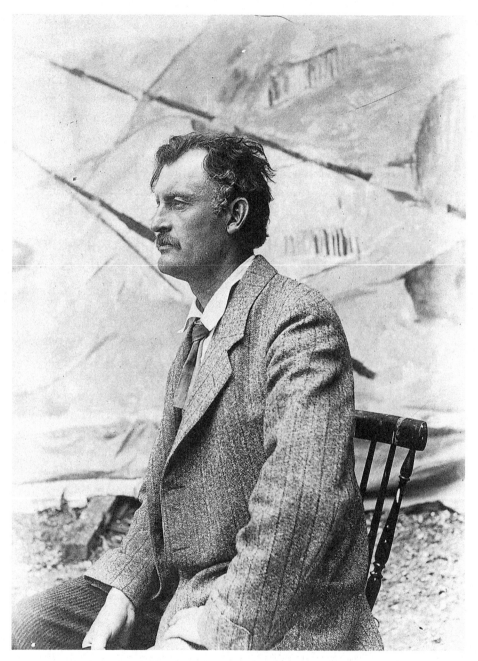

4.A.3. Photo of Edvard Munch, 1910. The Munch Museum Archives

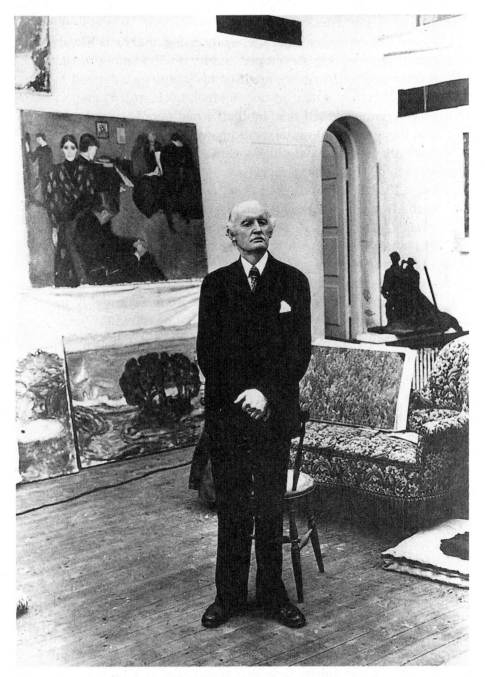

4.A.4. Photo of Edvard Munch, 1938. The Munch Museum Archives

backdrop nor background: they are the only ground, the weave, the ecosystem that keeps him going, that he endlessly contributes to. He developed, early on, his monumental scheme of a *life frieze*, arguing that his paintings belonged *together*, that they spoke to one another, beckoned to one another, complemented one another; when people complained that they could not understand his work, he replied that one had only to see the paintings together, "in relation," that they would then become comprehensible to any audience.[17] We know that he did a number of supremely beguiling portraits of children—the Esche children, the sons of Dr. Linde, the four girls in Åsgårdstrand—but one could argue that he is a "family painter" in a different sense as well: his own work was still attached to him, by an umbilical cord that was never cut. He knew fatherhood; I think he knew motherhood.

And how did he treat his children? Roughly, roughly indeed. They were the beneficiaries of what he called the "Hestekur," the "horse cure." This means: he not only walked among them, but he manhandled them, kicked at them when angry, tossed them about, spilled on them, punched them, and above all left them outside, exposed, in the elements, shat upon by birds, tossed into trees. It is even reported that he occasionally used them as lids for cooking pots on the stove. Visitors would often ask, in disbelief, why? Why would he go about destroying his own work? It's good for them, he said. They improve with age, they weather with the elements. It is as if he were speaking of old wines, but even there one is careful to store them safely in cellars; not so, here, these paintings *lived in the world*. Unframed, unvarnished, unhung, they were an integral part of the landscape; they assumed a strange permanence. Yes, they took their licks; we may even say they responded to the treatment. And who is to say he bet wrong? From earliest youth on, Munch despised gold frames, had contempt for varnish and glossy finishes which (he felt) not only buried his work but suffocated it, asphyxiated it. One thinks of the exquisite *Separation* (figure 4.A.5), which is, as it

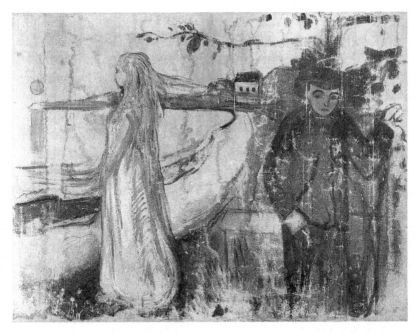

4.A.5. Edvard Munch, *Separation*, 1893. Munch Museum. © 2008 The Munch Museum / The Munch-Ellingsen Group / Artists Rights Society (ARS), New York

were, windswept and sunburned and rain-tested, showing the damage (is it damage?) wrought by the elements, by a lifetime of exposure outside; and, one feels, there is an evolved "weathered" beauty on the far side of "finish" that is unique and eloquent here, giving the piece a strangely autumnal feeling, as if the fragility of human connection between the man and the woman—linked though he is by her encircling hair—were of a piece with the battered and worn canvas, its weave and warp and weft showing through under the paint, contributing to the effect, broadcasting its own Shakespearean tidings of "ripeness is all." Fragile yet still here. Or, to quote Shakespeare still further: sea changed: "Full fathom five thy father lies, / Of his bones are coral made." We have always known that time decomposes; with Munch we realize also that it composes: the evolution of a canvas, the unfurling of a life. These pieces breathe, life breathes in them.

Proust once wrote that Time, in order to become visible, fastens onto human bodies. Time is splendidly visible, legible, in Munch: both in his mind and his art. The Munch family lives Sophie's death, year in and year out, as the repeated paintings tell us, but his "children" also live, age with their maker, suffer the slings and arrows of time, alter, ripen, age. But they do not die. Much food for thought here. Little wonder that the mortal artist surrounded himself with his living "children," his immortal progeny, his most intimate relations, his living shield. Ragna Stang has pointed out that, "apart from calling his pictures his 'children,' he also called them his 'soldiers,' his 'warriors,' whom he sent out to fight for him whenever necessary."[18] The spectacle of their ongoing life curve was mesmerizing to him. He saw in it the confirmation of his own most profound emotions: death and love marked you forever, stayed fresh even as one lived on. So, too, would the work live on, even as the body itself goes through its historical paces, is scheduled for its inevitable somatic station journey.

How would one go about making this tenacious work of time actually visible *in* the paintings? After all, human perception is structured in such a way that we cannot espy its passing. We are doomed to a snapshot world, locked in the here and now, able to access the movement of time only through photographs and memories. One solution is to return to the same motif, but, as we have seen, to paint *in real time*: the deathbed drama ripens, matures, as its players evolve—and change places. So it happens that Edvard inserts himself into the mortuary frieze, lies dying on the bed, sits dying on the chair, even photographs himself as "the sick child." Once that is possible, why not import the dead mother back into the frame as well, which is what he does in one version of *At the Deathbed* (figure 4.A.6); she now replaces Inger as the one who looks at/through us, with news of faraway places in her eyes; other versions of this piece make room for still other parties, such as the faces shimmering in the wall, informing us that

someone's death is a site of considerable traffic back and forth, sovereignly reshaping the givens we have been told are real (figure 4.A.7).

Munch knows that our love life is time-drenched, is an erotic career, even if (especially if) we stay with the same lover. Hence his monumental *The Dance of Life* offers us two versions of Tulla Larsen: the graceful, smiling figure on the left, in white gown with flowers, standing next to a flower plant that rises out of the earth, seems to offer her benediction to the entwined, entranced couple, whereas her counterpart, a stern, angular, black-clad judgmental figure with folded green hands tells us that the dance is soon over, that it cannot bear fruit, that sexual passion is at once irresistible, noxious, and short-lived (figure 4.A.8). This is certainly the work of time, but now compressed into one swirling drama of dancing figures obeying nature's law, offering us a before/after perspective, *framing* both the image and the life, yielding almost an allegory about the cost of desire.

Arguably his most unforgettable depiction of the workings of time is the famous *Puberty*, it too a motif to which he returned again and again (figure 4.A.9). How better to depict the awesome role of temporality in human affairs than to examine puberty? The young girl on the bed—eyes looking head-on at us with their strange expression, hands folded over her genitals but small breasts nonetheless on show—is subject to the generic takeover that somatic creatures undergo as they enter into sexuality. The ominous shadow extending from her womb announces, in more gothic terms, the tidings of fateful creatural change that we already see in her eyes, as if she were now—now as her first period comes, evidenced likely in the drops of blood on the sheet—registering her altered state, her exit from one life and her entry into another. This painting is as liminal as the depiction of Sophie's death, inasmuch as each represents a significant, time-cued trajectory of body and soul. When I said that Munch's paintings

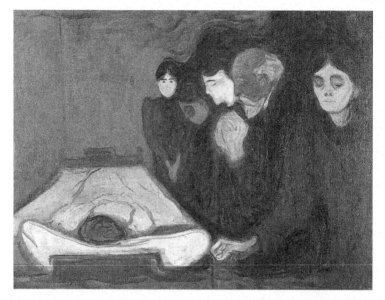

4.A.6. Edvard Munch, *At the Deathbed*, 1895. Bergen Art Museum. © 2008 The Munch Museum / The Munch-Ellingsen Group / Artists Rights Society (ARS), New York

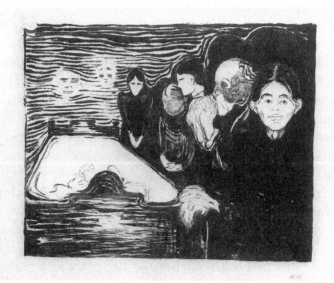

4.A.7. Edvard Munch, *At the Deathbed*, 1896. Munch Museum. © 2008 The Munch Museum / The Munch-Ellingsen Group / Artists Rights Society (ARS), New York

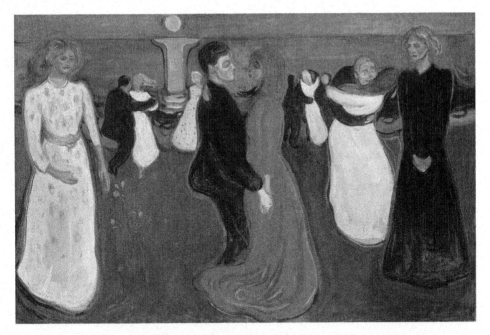

4.A.8. Edvard Munch, *Dance of Life*, 1899–1900. The National Museum of Art,
Architecture and Design, Oslo. Photographer: Jacques Lathion.
© 2008 The Munch Museum / The Munch-Ellingsen Group /
Artists Rights Society (ARS), New York

"lived," I meant more than some kind of romantic fixation on
the artist's part, concerning his work. We are now beginning
to see that the actual works themselves have a temporal den-
sity, and this is an astonishing feature, because pictorial art—
short of allegory—would seem to be restricted to spatial ar-
rangements, would seem to be unequipped for representing
time.[19] Munch's breakthrough is at once philosophical and
aesthetic: he makes kinetic paintings, he fashions a kind of
painterly logic that incorporates the work and drama of time,
he brings us into the pieces in such a way that we parse them,
gauge their projective power, *travel* them. The poet Ole Sarvig
once observed of Munch's work that he chose significantly to
hallow the human form, in sharp contrast with the tenets of
cubist practice that appear in the early twentieth century; I

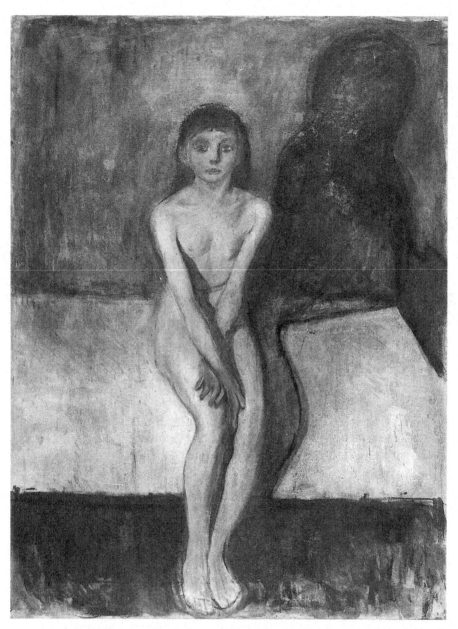

4.A.9. Edvard Munch, *Puberty*, 1894. Munch Museum. © 2008 The Munch Museum /
The Munch-Ellingsen Group / Artists Rights Society (ARS), New York

think Sarvig is of course right, but that Munch achieves oddly cubist effects without abandoning representation and narrative logic, and, in doing so, achieves a rare kind of pathos, for the human form in question is on the move, is placed in an interactive scheme, requires our intervention as spectators to take its unfurling measure.

If *Puberty* captures an early liminal stage in the career of the body/self, the lithograph, *Self-portrait with Skeleton Arm*, done in 1895, undertakes something comparable but closer to home: the rendition of the painter himself in the prime of life (it seems fair to term 1895 Munch's "anno mirabilis," given the sheer number of masterworks done in that single year) (figure 4.A.10). Sue Prideaux has referred to the form of this painting as "a sepulchral tablet" (154), but I argue that it makes equal sense to see it as a form of creation myth. From the depths of a deep yet brilliant black backdrop—Munch claimed that black is the greatest, most essential color, "the tabula rasa for pure expression"—emerges the finely rendered head of Edvard Munch, twenty-eight years old, outfitted with chiseled and sensitive features, refined yet slightly wistful gaze (rendered all the more disorienting by the difference in the two eyes: one looking straight ahead, one looking slightly down).[20] True, this lithograph posits a white countenance against blackness, eschews color, yet is nonetheless breathtaking in its capture of its living quarry: one can almost touch this shimmering face, still and hushed though it is. One feels that this face is *born* as you see it, that it presents its great ocular testimony of the beautiful Norwegian head against an ebony matrix of Nothing. In this regard, this painting speaks about its own genesis, about the supreme project of mimesis as something demiurgic rather than servile, as a combat against the void, as creation ex nihilo. This piece, like all art, enacts what Walt Whitman called "retrievements out of the night."

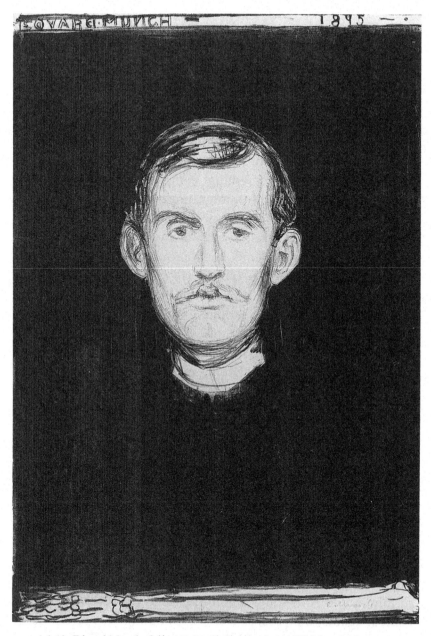

4.A.10. Edvard Munch, *Self-portrait with Skeleton Arm*, 1895. Munch Museum.
© 2008 The Munch Museum / The Munch-Ellingsen Group / Artists Rights Society
(ARS), New York

But of course the critics who call this piece death-haunted are not wrong, since the skeleton arm—reflecting the medieval injunction of *memento mori*—is, as it were, in our face (as well as in Edvard's face), insolently proffering its rival version of the handsome Norwegian. And who can deny it? Today, as we gaze at this portrait, we have to acknowledge that Munch himself has doubtless become that skeleton arm, that the subtle, handsome visage that looks out at us lies moldering in the earth now, that it had ceased to be fully accurate as soon as he had completed it, so that already in 1896 or 1897 it might have been recognized as a frozen image of the past. This painting stages the dance between the quick and the dead, as it goes about its simple interrogation: who am I? Thus the letters and numbers at the top of the piece—"Edvard Munch 1895" are also a rival code for saying/showing who we are, making us realize that most self-portraits are "named" outside the actual painting, whereas this one is fiercely interrogatory and destabilizing, promiscuous in its treatment of conceptual boundaries, putting into play four distinct modes of representation (letters, numbers, flesh, skeleton), requiring that we ponder the peculiar purchase of each one. This painting is a "frieze of life" inasmuch as it is insolently plural in its findings, intent on exposing the conventions of representation, no less intent on suggesting that the creature we know as Edvard Munch is producible in each of these formats, that each one contains life, that they belong together if we are to have a plenary account.

Munch was a tireless self-portraitist. One can easily follow his trajectory on life's treadmill—his changing body, often his changing psyche—by consulting the impressive memorials that he left via these paintings. It is as if he had a mission to leave a full record of his passing through. Nothing we can say about him, nothing that he wrote about himself (and he wrote copiously) matches the revealing eloquence of famous portraits such as *Self-portrait with Cigarette, Self-portrait in Hell, Self-portrait with Wine Bottle, Self-portrait* of 1909 at Jacobsen's

Clinic, and the mesmerizing renditions of increased age and infirmity, chosen to bear witness to each and every travail, test, or crisis, whether it is *Self-portrait with Spanish Influenza* (1919) with its poised, regal sick man defying nature, or the eerie *Night Wanderer* (1923) with its ghoulish sense of Munch the haunted-haunter, or the truly late pieces such as *Self-portrait at the Window* (1940) with its rigid, clinched, deeply carnate old man next to an icy wintry landscape of death, or the tremulous water color, *Self-portrait at 2 a.m.* (1940) depicting a decrepit, infirm, pallid, chair-bound, dressed-up figure looking anxiously up as the shadow of death enters the room, wondering if the moment has come.

The most famous of the unflinching, late pieces is doubtless *Self-portrait Between Clock and Bed* (1940) (figure 4.A.11), and it will cap my argument about the workings of time on the canvas. Munch shows his age in this valedictory painting: we see a frail, wispy, gaunt old man with his hands hanging lifelessly at his side, his feet oddly parted, his body at attention, and his timeworn face looking obediently up and out (as if responding to the call). This man possesses nothing of the brute vigor so present in many of the self-portraits (even the ones about sickness), and he casts a dark light on the Hestekur, making it quite clear that the work of time does not merely ripen us, but that it saps us, erodes us, wears us down, and finally kills us. One feels that Munch is virtually propped up in this piece, as if his legs could scarcely support him on their own, as if he were quite incapable of stepping forward on his own. The painter has had the great wit and impudence to position his corpselike figure between a clock and a bed, the two grisly symbols of impairment and mortality, yielding once again a painting of remarkable *traffic*, obliging us to assess this odd "frieze," this dance of life/death that stages the upright against the supine. We note that the clock (with its shimmering sunlike face) has no hands—did Bergman poach here, to give us his version of this painting, replete with handless clock, in *Wild Strawberries?*—while the bed is a riot of vitality

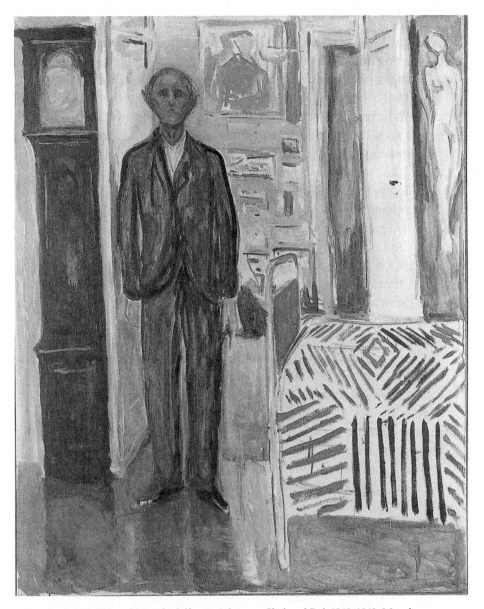

4.A.11. Edvard Munch, *Self-portrait between Clock and Bed*, 1940–1942. Munch Museum. © 2008 The Munch Museum / The Munch-Ellingsen Group / Artists Rights Society (ARS), New York

and pattern in its red/white/black geometric design. Tøjner (50) has likened its painterly and geometric independence and power to that of Jasper Johns, a half-century later.[21]

But the vitality of the bedspread pales, as it were, when contrasted with the golden luminosity of the room behind the frail old man, a splendidly rich yellow backdrop featuring the artist's children, his living, imperishable, never-aging progeny insolently taking their place on the wall, out there for the long haul. At this point one realizes, as well, that the backdrop is filled with corridors and passages, not only the doorway that opens on to this radiant golden setting (Munch's golden age, we might say), but the further door with its dark opening, functioning much like the ominous shadows of earlier pieces, beckoning to a further beyond, a further passage. Even here, there is nothing gloomy; on the contrary, the far right of the painting depicts one additional "child," this time the female body—admittedly shorn of features, oddly resembling the creature in *The Scream*—that was a rival source of energy in Munch's life/career, that now seems to preside over the secrets of death, as initiate and celebrant of all rites (of both flesh and soul). As said, this is a valedictory painting: it acknowledges the looming departure of one Edvard Munch, yet it rather grandly presents its stunning counter-evidence of the life spawned by this now decrepit man, a life that gleams with staying power.

Seen together, *Puberty*, *Self-portrait with Skeleton Arm*, and *Self-portrait between Clock and Bed* constitute the frieze at the core of my cubist argument. Each one is big with time, each one is resonant and many-tongued (as it were) about the thresholds and passages of a life, each one is a meditation about the beauty and evanescence of the human form, each one is about the majesty of painting as a way of capturing the actual "dance of life" in ways the retina cannot take in. These paintings are dimensional in a way that figurative painting rarely is. Ever since Lessing sorted out the domains of the spatial (painting) and the temporal (language), we have thought

that the harmonies and interplay of forms and colors on a canvas were, in some sense, frozen. Edvard Munch, the man for whom injury and trauma and experience were fluid and kinetic, offers us a surface that remains true to his psychic makeup. Looking in at these pieces, we find ourselves going in, traveling their circuits, taking the measure of life's arc, charting pathways that are ours as much as his.

It would be tempting to close this argument here, but the swirling energies of the Munch surface are more than temporal in nature. He is, as I said, Strindbergian in his volatility and exposure, as we know from the depiction of implosion/explosion that is *The Scream*, whereby psyche, eyes, ears, mouth, hands, land, sea, and sky are conjoined in a roiling paroxystic utterance that erases all boundaries between "inside" and "outside" (figure 4.A.12). Our dry modern term "subject" acquires its appropriate pathos in work like this, for we see the human subject as porous, at once invaded and spewing, functioning as combination generator/receptor in a *charged* world. Just as it is always in motion inside us via blood and electrolytes and synapses as well as feeling and thought, so is the Munchian schema mobile and kaleidoscopic. Fond notions such as agency or hegemony or even stability go up in smoke. Yet this is also a painting about multiple citizenships, about being *in* and *of* the world. Hence his paintings can be scenic in a structural (rather than decorative) way, for they illuminate pairings and kinships and sharings and twinships of the oddest sort.

Munch's world and his paintings are always charged (the way a magnetic field or an electrical storm is charged), and frequently the challenge in looking at his work—the call that brings us into his work—is one of *tracking* these imperious currents, for they constitute the underlying pattern (at once affective and aesthetic) of his art.[22] Sometimes this wears a familiar name such as *Anxiety* or *Jealousy*. We have long known these terms but have thought them conceptually fixed, housed in a recognizable place; Munch knows they are kinetic

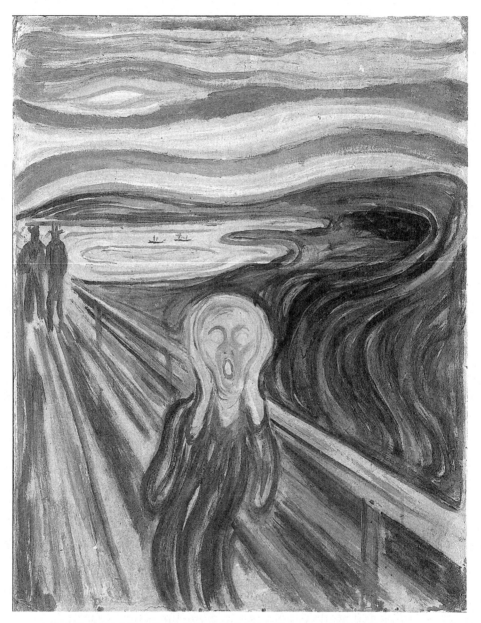

4.A.12. Edvard Munch, *The Scream*, 1893. Munch Museum. © 2008 The Munch
Museum / The Munch-Ellingsen Group / Artists Rights Society (ARS), New York

but graphic, even territorial as well, thus susceptible to visual representation. Hence the sinuous tribe of afflicted subjects in *Anxiety* explodes any notion of private malaise by going public, by demonstrating that anxiety is akin to social pestilence, lending to this pilgrimage of blank, ghoulish, ravaged faces *markings*, rigorously akin to the dreaded *tokens* of plague discourse (figure 4.A.13). We see here the same landscape as in *The Scream*, although it seems calmer, as if anxiety were the still before the storm. The dramatic foreshortening gives us the impression that this line of hounded creatures stretches to infinity, that they embody Thoreau's remark that "the mass of men lead lives of quiet desperation." The signature move in this canvas is the blankness of the faces (at least in the painting and lithograph versions; in the woodcut these wanderers bear on their faces, like stigmata, the indigenous yet estranged and signifying markings of the wood itself), announcing that Munch has elected not to represent pain or suffering via grimace or worked up expression but that he has presented something worse still, on the order of composed robots, disciplined machines, stately bourgeois manikins performing their quiet dance of death. Again it is a frieze: the troop of zombies, marching to some horrid drumbeat, on endless parade diagonally across their setting, looking nowhere, saying nothing, dazed, even stupefied, yet in palpable connection to the water, land, and sky where they have no footing whatsoever.[23] It is the *ensemble* that speaks most powerfully here, but it mandates our willingness to construct Munch's story out of the diverse elements he has put onto his canvas.

Our participation is still more required if we are to parse what is happening in *Jealousy* (figure 4.A.14). Not that this is difficult: every viewer realizes at once that the archetypal image of sexual congress/betrayal in the background—the faceless man and woman, he clothed in black, she with red robe parted to display her nakedness while she reaches for the apple from the tree as her lover's first gift—is, in fact, the mind screen of the sufferer of jealousy whose brooding face

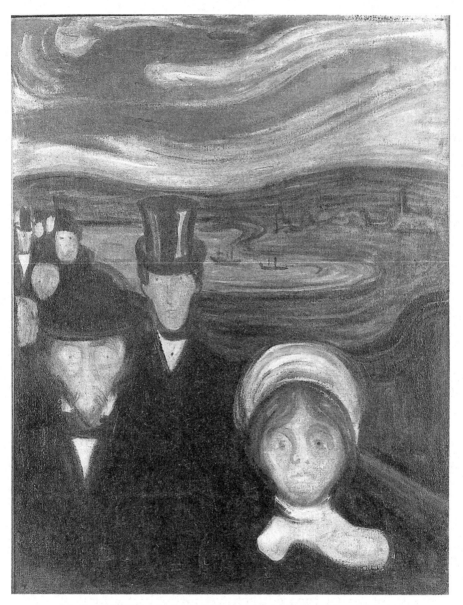

4.A.13. Edvard Munch, *Anxiety*, 1894. Munch Museum. © 2008 The Munch Museum / The Munch-Ellingsen Group / Artists Rights Society (ARS), New York

4.A.14. Edvard Munch, *Jealousy,* 1895. Bergen Art Museum. © 2008 The Munch Museum / The Munch-Ellingsen Group / Artists Rights Society (ARS), New York

looks out at us, filling half the canvas, articulated with care (possessing Przybyszewski's features, the face Munch invariably called on, to exhibit pain), dwarfing in size the drama in the background, yet chained to it, creating it, going through it nonstop. Perhaps all thinking entails projection, but Munch has hardwired it into the functioning of this painting, and has thus brought to visibility what is perhaps the most grisly feature of jealousy: it is spawned, it is bottomless, it is a creative fiction, it is an allegory of art inasmuch as it sovereignly births its own story.[24] One is not accustomed to reading paintings in this projective manner, at least not in the compartmentalized fashion we see here: half the piece is a hurting face, and the other half is what hurts it, with the added spice that the head is producing its hurt. It may not be pretty, but it is quite an economy. Once we have negotiated this painting, we see quite clearly what Munch has thought graphic: the dark

interior of the mind now brought to an exquisitely visual if biblical motif. One could cavil, by complaining that the painter has offered us a cliché, a well-worn topos, rather than creating a fresh scenario or motif for jealousy. But perhaps Munch felt that our suffering is what is most generic about us, what puts us in touch with the oldest icons in the tradition, makes us realize that they are serviceable as inner stage set, that they could be folded "naturally" into the depiction of a face in distress.

Perhaps the most mysterious of Munch's paintings are those where he is tracking something that has no recognizable or iconographic form. We encounter here a mix of familiar and less familiar works, and I start with a trio of canvases that seems to tell, cumulatively, a strange story. We begin with *Mason and Mechanic* (1908) (figure 4.A.15) which has a kind of multileveled insolence: the two figures seem posed and stare provocatively at us, appearing to move almost threateningly toward us (as if, once again, the road were spewing them out in our direction) while other minuscule figures move in the opposite direction away from us. The whole piece has an oneiric cast to it, in part because the two men are so symbolically paired, one dark, one light, one with features, one almost faceless, each provocatively taking on the viewer. Critics have sensed something on the order of an allegory of the divided self (Jekyll and Hyde, Dostoevskian and Conradian doubles, all come to mind). Given Munch's abiding use of shadows as portents, it is not surprising that he would flesh out this scheme even further. Having said all this, one is still stumped: why this pair? What are they about? Why do they seem to accost us? With what tidings? It is as if they were "signing" in some fashion, like semaphores, like a puzzle for which we have no key.

One reason they intrigue is that Munch continued their little career in the still more fascinating sequel *Drowned Boy* (1908) (figure 4.A.16). Our duo are back, in many senses: they now turn their backs to us, while they stare (intently?) at the

4.A.15. Edvard Munch, *Mason and Mechanic*, 1908. Munch Museum. © 2008 The Munch Museum /
The Munch-Ellingsen Group / Artists Rights Society (ARS), New York

4.A.16. Edvard Munch, *Drowned Boy*, 1908. Munch Museum. © 2008 The Munch Museum /
The Munch-Ellingsen Group / Artists Rights Society (ARS), New York

painting's background which is indeed the drowned boy of
the title, a limp figure one scarcely sees, carried by a man
across the street, as a group of roughly sketched women stand
and talk. It is very enigmatic. Munch, great master of in-your-
face frontal postures (*Puberty, Madonna, Sphinx, The Scream*,
etc.), has brazenly inverted things, and to great effect. To pre-
sent main figures from the back seems almost unheard of, in
my view, yet they seem to be even more provocative because
of this, making us endorse/imagine their vision, thereby serv-
ing to underscore the projections and displacements happen-
ing in this scene.

What projections, you might ask? Once again, as it was in
Death in the Sickroom, there is the *traffic of spirits* that dying
entails. The child's dead limp meager body does not seem
particularly charged, but the painting as a whole belies this,
through the astonishing activity in the foreground: a hastily
sketched, weirdly "transparent" horse that wanders into the

scene and looks directly at us, as animal-spirit ambassador from somewhere, sent to observe (the child? The mason and the mechanic? More likely: us).[25] As if one beast were not enough, an equally rough-sketched phantom dog seems thrown in as well, to give us a little dyad of animals, a pairing to match our human pair perhaps. They seem to know something, as if drawn instinctively to this moment of exit and witnessing. And then there are the peculiar blue-toned windows in the foreground, reflecting mirrors of a sort, taking up a third of the canvas, also receiving our gaze, injecting still a further spectral note into the mix. I called the piece "insolent" because it mocks all notions of narrative cogency, filled as it is with elements that do not in any obvious way fit together. But one feels that this grouping is not random, despite the tossed-off feeling of the horse and dog, that there is a plenary character to this funereal depiction, a shocking mix of life and death, so that the snuffed out life of the child is paired/balanced/overcome (?) by the spawned horse and dog, and that the whole consort is ratified by our dynamic duo who mutely, gravely (!), and passively look on. Could it be that *they* are the emissaries here, the loci of coursing spirit?

Whatever they incorporate or mediate, these two fellows are trouble, and are seen as such in the final piece of my triptych, *Uninvited Guests* (figure 4.A.17), where they receive their final comeuppance by being gunned down. *Uninvited Guests* was actually painted earlier, which tells me that this fantasia in black and white was permanently imprinted on Munch's mind. He returns to it in 1911, casting his duo in the snow, and there is a splendid late to-the-death version in 1935, *The Duel*, where they are out to kill each other. Now how would you kill a spirit? Munch seems to know exactly: you shoot him through the mirror, through the strange portal from which he doubtless emerged. "Self-defense" one might call this, or a last desperate effort to stop the infernal/internal traffic, to close up some of those channels and circuits through which one is so easily entered. And the impressive array of bottles and glasses taking their own pride of place next to the

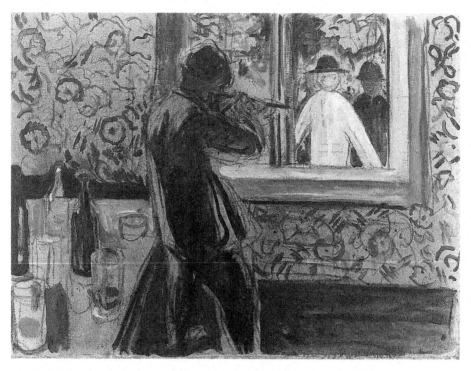

4.A.17. Edvard Munch, *Uninvited Guests*, 1905. Munch Museum. © 2008 The Munch Museum / The Munch-Ellingsen Group / Artists Rights Society (ARS), New York

shooter is also a likely source of visits and traffic. How does one stop this? Is this possible? The invaded, near-capsizing Munch is on record for seeking solace, for keeping unwelcome guests at bay, through these very same means: "Quick, need a drink, I thought. Ring the bell. Port wine, half a bottle. It helped. Coffee, a little bread. Another panic attack. Go outside. To the first restaurant. A glass. Get out into the street. It will get better." In some crucial sense, however, Munch does not want to be free of his demons, or visitors, for he seems to know that these are the pathways of his art as well as his shattered nerves and rent psyche.

In fact, we are in a position to claim that those *pathways* are the central business of Munch's paintings, the imperious flow to which he does homage over and over, the very iconography

of breakthrough. Sometimes this power assumes virtually de-
monic form, as in *Galloping Horse* (1910) (figure 4.A.18), where
we measure the puniness of human constraints in curbing the
unleashed forces of nature, as the crazed horse rages headlong
toward us who are caught in its path. Once again the tossed-
off, sketched features of the human bystanders (including the
"driver," also only a bystander) eloquently contrasts with the
brilliantly rendered demiurgic violence of the animal (god). A
seemingly more serene version of these affairs is *The Yellow
Log* (1911) (figure 4.A.19) that rushes diagonally across the
canvas, like a careening train, establishing its own route,
headed (once again) our way, cargoing all the potent magic of
the natural world, liberated, building up tremendous speed (I
know it is stationery, but you need merely look at it to see that
it moves), amassing energy from its tiny pointed origin on
through its full tubular length, showing us its gun barrel face.
One wants to duck. We are in its path.

Edvard Munch's "roads" are like a cresting river at flood
time, sweeping up all manner of debris in its furious onrush.
Consider the enigmatic *Murderer in the Avenue* (1919) (figure
4.A.20), a deceptively placid landscape of a tree-lined road,
reminiscent of an allée, shaped once again in the form of a
widening triangle that moves implacably toward us. This wa-
tercolor piece is structured vertically by the stately trees, but
there appears to be one crucial infraction, one transgressive
horizontal: it is the inert form of a corpse, lying in a heap, one
arm stretched out, *signaling* the crime. Just as the ghostly
horse and dog were brought, late and in see-through fashion,
to the scene of the drowned boy—death attracts specters,
functions as a magnet—so, too, is the murderer (sketched in,
face the very color and texture of the road, pin-point eyes [one
still dripping paint], line for a mouth) caught forever at the
scene of the crime, forever foiled in his escape, reminding us
of Andreas who eternally seeks to exit the sickroom where
Sophie died.

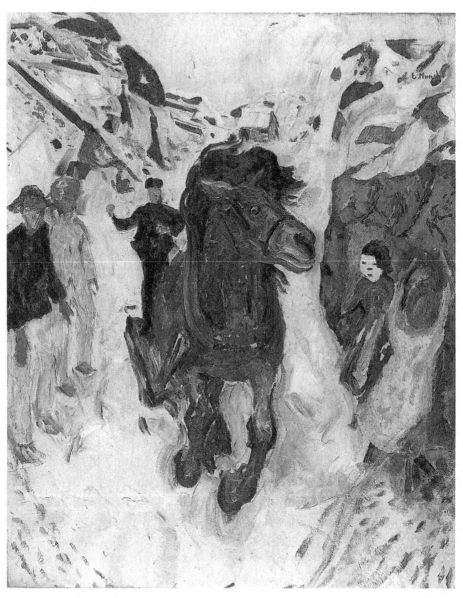

4.A.18. Edvard Munch, *Galloping Horse*, 1910. Munch Museum. © 2008 The Munch Museum / The Munch-Ellingsen Group / Artists Rights Society (ARS), New York

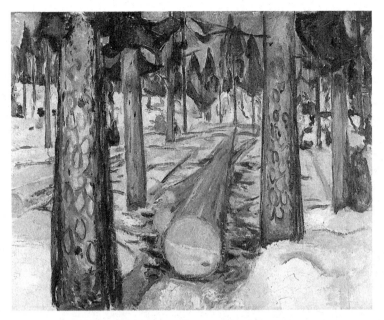

4.A.19. Edvard Munch, *Yellow Log*, 1911–1912. Munch Museum. © 2008 The Munch Museum / The Munch-Ellingsen Group / Artists Rights Society (ARS), New York

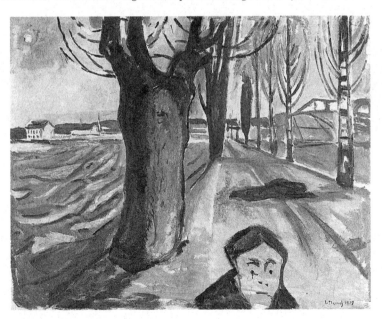

4.A.20. Edvard Munch, *Murderer in the Avenue*, 1919. Munch Museum. © 2008 The Munch Museum / The Munch-Ellingsen Group / Artists Rights Society (ARS), New York

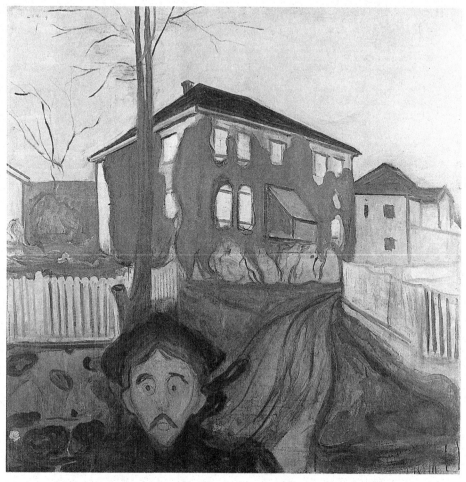

4.A.21. Edvard Munch, *Red Virginia Creeper*, 1898–1900. Munch Museum. © 2008 The Munch Museum / The Munch-Ellingsen Group / Artists Rights Society (ARS), New York

Perhaps the most perfect, most inscrutable pathway paint-ing is *Red Virginia Creeper* (1898) (figure 4.A.21). Again we en-counter the usable, "liminal" face of Przybyszewski, more blank this time than in *Jealousy* (though still haunted), looking, as usual, head-on at us, as if to defy us to make sense of what is behind him. What is behind him? It is, of course, a house covered with red Virginia creeper. Nothing strange

here, one might say, just a slice of life. But those critics who have been disturbed by this house, who have seen it as not only haunted-looking, but as afflicted with skin cancer (so violently red is the vine that has battened onto almost the entire surface of the dwelling) and outfitted (like children's drawings) with eyes, nose and a mouth: well, those critics make some sense. The inflamed, raging house sports an extremely barren, almost mutilated tree, and the white picket fence has an aura of jail bars. And then there is the crucial path that begins in front of the house and moves forward with force, carrying Przybyszewski with it. Is he the expulsed occupant of the house? For he is expulsed, on the move. Once you see the piece this way, it becomes shockingly kinetic, as if the human face were onrushing debris, caught—like Andreas leaving the sickroom, like the murderer in the avenue—in its midst before being swept away forever.[26] I admire this painting especially for its symphonic nature, its melding of house, vine, tree, fence, road and face into a powerful (if bizarre) whole, as if a new language, a new syntax, a new constellation were coming into visibility. As always, we are obliged to negotiate a work like this, to ponder its strange parts and their odd fit, to realize that Munch has assembled familiar things in such a way as to connote something far beyond them. This piece breathes threat, anxiety, dread, bad news of every stripe. Looking at this piece, I am reminded of Oliver Sacks's lovely title for one of his collections, *An Anthropologist on Mars*; Munch manages to "martianize" our old familiar world, not via some "shock of recognition," but rather as the result of a canny recombinant strategy, a hypnotic fusing of disparate pieces together, so that the whole is not merely greater than the sum of its part, it is a quantum leap beyond its parts altogether.

Munch's road paintings bring to mind Blake's poem, "London": "I wander through each chartered street, / Near where the chartered Thames does flow, / And mark in every face I meet / Marks of weakness, marks of woe." These words seem

made to order for Munch. Earlier pieces such as *The Scream* and *Anxiety* present the same iconography—a diagonal pathway on which the parade of the damned makes its way directly toward us—and we grasp ever more clearly that his people are marked by weakness and woe, and that his paintings virtually choreograph the flowing forces which surround and penetrate them, the inroads, as it were, that life makes upon the living.[27] At bottom, this is a heightened form of narrative painting, for it tells a story of encroachment, porosity, and boundary smashing that we viewers are asked to "construct." Blake knew that streets could be chartered but that the Thames could not. We too know, when the tsunamis and hurricanes and earthquakes and volcanic eruptions come, that the human subject is indeed *subject*, caught in a force field that dwarfs him. Munch seems to have known this from childhood on, calling it sometimes the angels of death and disease and insanity, calling it other times a scream that convulsed nature, seeing it even in the fallen easel that faraway Strindberg knocked over. His world was tentacular and arrested, inextricably *meshed*, just as the woman's hair encircles the man's head who believes he is parting; getting clear does not happen. Yet the work itself gifts us with its own mesh, its "magic web," to use the term Shakespeare gave to the archaic handkerchief entrusted by Othello to Desdemona: it contains within its weave primitive powers, he warned, powers one dare not toy with. And Munch: neither sun nor night nor time nor death could undo what he wrought, of that he was sure, for they had been captured live in the art itself. Magic web indeed: it is not a bad metaphor for the paintings of Edvard Munch.

B. The Case of Ernst Josephson

Edvard Munch is such a familiar part of the Scandinavian legacy that in the previous section I could count on a reader's basic familiarity with his achievement. But, who—besides

Scandinavians—has heard of Ernst Josephson?[1] And what is his "case"? Josephson is largely regarded as a leading Swedish portraitist in the latter nineteenth century, but that characterization fails entirely to take his measure or to indicate why he matters. I see him as the supreme embodiment of my *genombrott* argument, the most extreme instance of a body of work that challenges what we regard as visible, that registers the drama of breaking through. In my earlier chapter, "Scenes of Genombrott," I attempted to show how *going through the wall* is the central mystery and tragedy of both his life and art, linking him to Strindberg and Bergman. But the larger Josephson story is richer even than that, and requires a fuller view of this man's career and odyssey, if we are to gauge his true significance, to render legible the lines of force that this man's strange life and art signal to us.

"Graphing Power," my title to this section, is literal: in Josephson's work power is graphable, is finally *seen*. These matters have been front and center in this volume: Kierkegaard, Ibsen, Strindberg, Munch, Hamsun, Lagerkvist, Bergman are all mapmakers of sorts, committed to a new kind of portraiture in which the human subject is depicted in all his porosity and extendedness, comes to us as caught in an ecosystem that cashiers any sense of autonomy or hegemony. Josephson belongs here not by design but by fate; what the others saw, believed, chose, and expressed (in words, paint, film), he suffered and rendered. He was broken through entirely by the powers he registered. But his work makes visible a kind of traffic—with spirits, with feelings, with flesh, with gods—that reorders what we take to be real. He is worth knowing.

As I have said, Josephson (1851–1906) is known, if at all, for a body of work, largely "realist" in style, enjoying minor canonical status in Scandinavia, but absurdly unknown to the general English-speaking audience. But he comes fully into this book because of the radical shift that takes place in his artistic manner and vision as of 1888, when he goes (documentably) mad on the island of Bréhat off the coast of

Brittany, but continues, infirm, (barely) living in Stockholm, to make art, leaving us with two radically distinct bodies of work: the first, a very accomplished realist production consisting of many superb (and admired) portraits, along with some more puzzling pieces that now seem premonitory; and then, in what is called the "Sickness Period"—roughly the last eighteen years of his life—a body of enigmatic, often breathtaking, visionary pieces, annunciatory of much of the future breakthroughs of modernism, expressionism, and even cubism.

Josephson is, in some respects, reminiscent of Van Gogh, despite the difference in their styles, in that each went off the map of European realism; we shall see that Gauguin also comes to mind, in the later production of Josephson. In Scandinavia, he is most often paired with his equally mad contemporary, Carl Frederick Hill, whose work has garnered considerable attention in recent years; but the primitivism of Hill's "sickness work" bears no resemblance to Josephson's uncanny mix of religious and ecstatic pieces, on the one hand, and his pathological renditions of the body, on the other, giving one the sense that Josephson's work of the Sickness Period is somehow recasting (utterly recasting) the "Tradition" itself. It is no surprise that the best critical work on Josephson is often psychologizing in nature, focusing on the issues and events in the painter's life that led to his breakdown in 1888, in order to ground the later work in some logical system.[2]

What interests me here, as noted, is indicated in my title, "Graphing Power." I believe there is a pattern in the overall career of Ernst Josephson, a principle of coherence that may draw on the life experiences but ultimately comes to us as a mode of vision and representation. Josephson's sickness—diagnosed as paranoid schizophrenia—rends his psyche and reshapes his artistic manner, and it thereby enables him to present a radically new perceptual world. I say "enables" even though it is far from clear what Josephson "willed" (or could have "willed") in his sickness work, and many critics

place the emphasis squarely on the pathological, claiming that the so-called distortions and peculiarities of the late work essentially mirror the compulsions of his disorder, obey the generic dictates of his altered *soma* and skewed neural equipment.[3] We will never know how much of this late work is "intentional" or not, nor do I think it matters much (just as it does not ultimately matter how much of Shakespeare's or Picasso's work was intentional). What does matter is what this work can show us—not so much about the artist's life, which is admittedly one of the catalysts here, but about the central issues of this book: the rival logic, "grammar," and vision of art as choreography, as mapping of circuits and frequencies and visitations unknown or undetectable to "realist" notation; and also the emerging plenary vision of Josephson's cumulative practice, an unfurling view of what can and cannot be seen as one moves from sanity to madness, especially when it comes to the flowing forces that govern both psyche and culture.

One great risk I run here is that of glorifying Josephson's sickness. There is something heartless as well as cheap and reductive in linking sickness or madness to genius. "Man äger ej snille för det man är galen," as the Swedish poet Kellgren wrote; "one does not have genius just because one is crazy," and the old connection between neurosis and art is philistine in its ignorance of the suffering that accompanies mental illness, and is downright goofy in its ignorance of the huge numbers of unhappy, schizophrenic and paranoid humans who are utterly devoid of artistic talent. Thus any rosy, dewy-eyed picture of an ecstatic Josephson savoring his otherworldly visions is far from the mark, as we shall see; moreover, Josephson was always an artist, both before and after the onset of his schizophrenia. Nonetheless, this life curve absolutely obliges us to theorize some kind of connection between before and after, some explanatory principle that would help us to account for the mind-boggling work that is produced during the Sick Period. These strange, often distorted, often inscrutable pieces beckon to us with uncommon

mystery, power, and beauty, offering vistas that few of us have seen before. To take the measure of this late phase—not to trace its etiology but to understand it as art—it is indispensable to examine Josephson's entire career, at least briefly. It is a career well worth examining, and my hope is that it will cap this study of Scandinavian literature and art, by gifting us with new lenses, maybe even a new sentience, a richer awareness that there is only one reality, and that visionary art can deepen our purchase on it.

Josephson was born in 1851 into a Stockholm family of Jewish bourgeois origins, with a pronounced liberalism and interest in the arts. One uncle, Jacob Axel Josephson, was a well-known composer and music director in Uppsala (who converted to Christianity in mid-life, an event the broadminded, albeit principled, family was able to accept), and another uncle, Ludvig Josephson, became a renowned theater director and was to play an important role in Ernst's life. Jewishness remains a key component of Ernst's moral thinking, and we will see in the late work a vivid sense of the Old Testament stories; on the other hand, Christianity—both the story of Jesus and the major iconographic elements of its doctrine—coexist with the Jewish legacy, giving us a sense that the great stories were somehow equivalent in the mind of the painter.

Ernst's father, Semmy, died when the boy was only ten, as the lingering result of an accident in which he was struck by a carriage (his injury was not great, but the shock to his system was to be ultimately fatal); Semmy Josephson comes to us as a soft, sweet man, a dreamer with little business acumen, and his death left a vacuum of fatherly guidance in Ernst's subsequent life. This death also propelled the mother, Gustava Josephson, into the role of sole parent, and her strong, disciplined, even severe personality led her to put considerable emphasis on will, duty, and propriety for her youngest child, the only boy among several older sisters. As we will see, a number of pieces from the Sickness Period give eloquent testimony to some form of Josephson family romance,

à la Freud, in which Ernst crossed some of his wires, seeing
the mother as censor, as lawgiver, and seeing also that he
could not easily live up to this idealized and repressive code.
In particular, sexual desire, especially in the form of mastur-
bation, is to appear as taboo, as evidence of weakness, law-
lessness, and sin. Ernst is to internalize this code, and to pay
for it all his life. But it is more complex than that: he is also
to conceive of art itself along lines of transgression and self-
pleasuring, at least in his subconscious (as later drawings will
substantiate), and we are also entitled to feel that this code of
denial, in the twisted way that all of us "process" our family
upbringing, suits Ernst Josephson, provides him with reasons,
even alibis, for future choices he will make.

Ernst, at an early age, decides on a career in art. At sixteen,
he is accepted into the *Akademien för de fria konsterna* where he
receives classical, conservative training in drawing, perspec-
tive, Swedish, and art history, as well as considerable expo-
sure to classical antiquity, including nude models and imita-
tion of famous works. He is also exposed to the beginnings
of national romanticism in Scandinavia, with its heightened
interest in Nordic history and folklore. Josephson is a diligent,
shy, committed, but hardly trail-blazing student. And yet his
schooling is to play a surprisingly large role in his further de-
velopment. Ernst's exposure to the Old Masters, in particular,
goes beyond ordinary parameters. His early fascination with
Scandinavian history and myth remains with him all his life,
infuses his well-known later paintings of the Water Sprite
with a sense of mystery, grandeur, and pagan nature worship,
and remains vital in the Sick Period, leading to obsessive ren-
ditions of kings and warriors, figures of myth and legend. But
the more fateful encounter is with the great painters of the
Renaissance: Raphael, whose idealism and sublimity he val-
ues; Michelangelo, whose titanic power and corporeal exuber-
ance will haunt his later work; and Rembrandt, who is to be-
come his god. There are also the inimitable colorists, Titian
and Velasquez, who remain luminaries for this young man

who was to become the sole great colorist of nineteenth-century Sweden. We know that all art students were traditionally exposed to the work of the Masters, but in Josephson's case, we have something that goes well beyond our easy notions of education and apprenticeship. There seems to be a kind of availability in Josephson, a receptiveness that goes deeper than anyone could have known (or intended), as if he were being scripted by these academic exposures and would spend his life working his way through them.

The young man travels to Eggedal, Norway, in 1871, to see firsthand the fresh unspoiled beauty of the Northern woods and streams, and he will be marked. In addition to rustic and bucolic scenes, experienced by Josephson with a veritable Rousseauist fervor, there is a fateful vision and poem about the water sprite, "Näcken," glimpsed as both the spirit of the place and as a fantasized figure of the rushing waters, unmistakably in collusion with the no less coursing desire of the young artist. The later consequences of this visionary episode are to be enormous. As for the Renaissance Masters, we have something rich and strange. Encountering them first in books, he then, in the early seventies, sees firsthand the Dutch, Italian, and Spanish greats, first in the museums of Berlin and Dresden, then at the Louvre, and finally through extended stays in Holland, Italy, and Spain (made possible by the small inheritance he receives at his father's death). Josephson's early imitations of Rembrandt, Titian, and Velasquez are staggering in their polish, seriousness, and passion, and were so noted even then. An exchange of larger dimensions is at hand here, something properly inspiriting. As stated, Rembrandt takes honors. "I shall be Sweden's Rembrandt or die," exclaimed the ecstatic young painter in 1871, and this *boutade* is to have its grisly truth. Josephson later spent six months in Amsterdam in the "service" of Rembrandt, a "service" not unlike that of the courtly knights of the Middle Ages paying homage to their Lady, and the young painter's own statement is larded with libidinal energy: "One can admire many beauti-

ful women, but love only one of them, and that one is Rembrandt Harmensz van Rijn."[4] In Rembrandt, Josephson discovered a kind of inwardness in painting, a luminosity and depth that live in and through the canvas. Moreover, the young Swede is attuned to the deep spiritualism of Rembrandt's work, the capacity of the Dutch Master to discern the presence and authority of soul in the simplest, even the meanest and most homely subjects; and he is drawn as well to the monumentality of Rembrandt, the artist's inward sense of stature and hierarchy, his genius for capturing the moral drama of history.

These exposures to the great European tradition were liberating for Josephson. During his travels we may surmise that the brilliance and sensual plenitude of Mediterranean art and life must have come as a jolt to this repressed man of the North. The Italian impact was to be lifelong; the Spanish was even more dramatic, and some of his most vibrant and picturesque work is based on Spanish motifs: the dancers, the blacksmiths, even the beggars and dwarves. There is something exotic and "in your face" with these last pieces, an impetuous romantic style—a "tourist" style, to put it unkindly—that advertises Josephson's delighted infatuation with peasants and gypsies, his envy of the earthiness and vigor of simple (warm-blooded) people. One is tempted to say that the Spain of Murillo (as opposed to the Spain of Velasquez) was a false step for Josephson, but a necessary one nonetheless, in its explosive power and exoticism, leading the Swede well beyond the "Düsseldorf" realism still in favor in his native land.

The first half of the 1880s constitutes the high point of Ernst Josephson's career. After the long apprenticeship with the Old Masters, after the formative stints in Norway, Holland, Italy, and Spain, Josephson settles (more or less) in the mecca of realism, naturalism, and all else that is cutting edge in the arts: Paris. Here is where the Swedish painter measures what he has seen against what is happening in his field; he admires Corot and Daubigny, but his views on the much talked about

Courbet are mixed, tinged with suspicion that the ringing calls of innovation and reform betoken both arrogance and ignorance about the sustaining classical tradition. But, soon enough, the French influences begin to show: the remarkable series of portraits done from 1880 to the breakdown on Bréhat in 1888—the most confident and achieved work that Josephson was to produce—shows traces of Renoir and very large doses of Manet, even though the classical echoes of Italy and Spain are also noticeable. On the surface, these rich canvases, even those that seem tossed off, are securely within the realist tradition, and we are not surprised that many of them garnered considerable praise among the Parisian critics.

Yet, during these same years when most of Josephson's aesthetic practice seems rather tame to us, momentous changes are nonetheless taking place. It is not too much to say that an entirely new figure is emerging, a man whom nothing really announces: this is the turbulent, politically engaged, charismatic artistic leader. In the mid-1880s we see the formation of a major opposition movement among young Scandinavian artists, especially those who were working and experimenting in France. These "young Turks" included many of Sweden's major artists—Richard Bergh, Carl Larsson, Anders Zorn, Georg Pauli, Karl Nordström, to mention the most well-known figures—and they shared much in common with the leading aesthetic and intellectual schools of the day, both realism and naturalism, with their focus on the common people, with their suspicion of the inflated idealism and classicism of academic art. But there was also a powerful romantic legacy at work here, a view of the imagination as supreme human faculty, of art as mode of liberation.

Ernst Josephson turns out to be the man of this moment, as if this gathering battle catalyzed all his hitherto concealed or repressed faculties, and we have accounts of his stupendous eloquence and passion, a fervor that seems to have been irresistible in its heat and light. Josephson writes a series of brilliant discourses on art for the Stockholm news-

papers, in which he sounds a clarion call about the noble pur-
poses of his calling, the need that society has for the visionary
painter who will play his ordained part. Josephson calls for
reform in the teaching practices of the academy, calls for a
widening of subject matter, challenges the narrow interests of
parochial schools, sounds for all the world like Arthur Rim-
baud in his famous "Voyant" letter in which the French poet
speaks of the new workers of the future who bequeath their
visions to us. Parisian ferment in the arts is contrasted with
the ossified teachings of the Swedish academy (those same
figures who taught Josephson); the volcanic, galvanizing Jo-
sephson is vividly captured in the contained but nonetheless
smoldering and seismic bust done by Per Hasselberg, to be
seen at the Thiel Gallery (figure 4.B.1). We glimpse in this
sculpture something of the titanic, even demonic force that
lives in Ernst Josephson, that is now beginning to make itself
seen and heard.

But the subtle and finely wrought portraits of this period
do not tell this story; if anything, they speak to us of what
Josephson might have remained, of the bounded though su-
perb craftsman that he was, rather than the tragic visionary
that he was to become. Nothing in this formulation denigrates
the portraits themselves, which amply reward our consider-
ation. Josephson's painterly gifts come to the fore here, as he
succeeds ever more handsomely in absorbing the lessons of
his French contemporaries while still honoring the colorist
tradition found in Titian, Velasquez, and others. These pieces
display Josephson's rich, sensual, almost tactile apprehension
of surfaces, now wedded to an increasingly sharp, penetrating
yet generous psychological vision of his subjects. As Ulf Abel
has pointed out, these figures meet us with a remarkably open
expression, even when one acknowledges the theatricality of
Josephson's manner.[5] Consider the stunning 1880 portrait of
Godfrey Renholm (figure 4.B.2), well-known art critic, which
yields something on the order of an allegory of urban intelli-
gence, in which the alertness of the critic—on the ready with

4.B.1. Per Hasselberg, *Bust*, 1883. Thiel Gallery, Stockholm

his pen and open *carnet*, head atilt in quizzical expression, personifying the new inroads of journalism while still honoring (as the sculpted relief in the background suggests) the legacy of classic art—seems luminous and of its moment, of a piece with the metropolitan lucidity registered in Baudelaire's prose poems or in the later cultural analyses of a Walter Benjamin. There is much to admire in Josephson's work during these years: the sensitive, serene, slightly wistful portrait of his mother, Gustava, with its mix of bourgeois respectability and delicate tenderness; or the remarkable portrait of Josephson's famous patron, Pontus Fürstenberg, conveying a melancholy and fatigue that both deepen and qualify our sense of

362

4.B.2. Ernst Josephson, *Godfrey Renholm*, 1880, 130 × 97 cm. National Museum, Stockholm

this man's worldly power. Or, finally, the supremely elegant and ironic portrait of Carl Skånberg—known for his wit, hump back and fatuousness—posed arrogantly with cane, gold chain, and heavy rings, against a rich brocade backdrop that gently mocks the subject's pretensions and reminds us of both Manet and Velasquez (figure 4.B.3).

Perhaps the masterpiece of these years is the portrait of Jeanette Rubenson (figure 4.B.4). Erik Blomberg has offered a splendid critique of this painting as a rare achievement of harmony and synthesis, a bringing together of the disparate elements of Josephson's life in a fashion that could not be sustained. Later, the fierce polarized drives would tear the painter apart, but here they coalesce: the sunny portrait without shadows melodiously works together the Nordic and the Semitic—the Scandinavian pastoral seen through the window, replete with garden and Dala structures, presented as accent to the Asiatic embroidery of the blouse, the almond shaped dreamy eyes, the exquisite hands busily at work (the real Jeanette Rubenson detested such work, was forced into this artisanal posture by the artist)—all yielding a soft, finely seen mix of reverie and reality, drawing on an almost exotic blue palette that remembers (again) Manet and Velasquez. Critics have been struck by the "Oriental" character of this exquisite painting, its confident sense of the painterly traditions of the past, its bold colorist power that already seems to beckon to Matisse. This painting converts into idyll all the strident and warring elements of Josephson's psyche: Jew vs. Swede, dream vs. reality, groundedness vs. exile. All of Josephson's skill and love affair with mimesis are on show here, producing a reverential, genial, and generous rendition of social and psychological reality. The softness and sweetness that came, not from Gustava but from Semmy, live on here, as they do in so many of the female portraits Josephson painted. This painting breathes a serene kind of composure, makes us believe in the project of capturing the likeness and texture of skin and fabric, animate and inanimate, even body and soul,

4.B.3. Ernst Josephson, *Carl Skånberg*, 1880, 220 × 124 cm.
Gothenburg Museum of Art

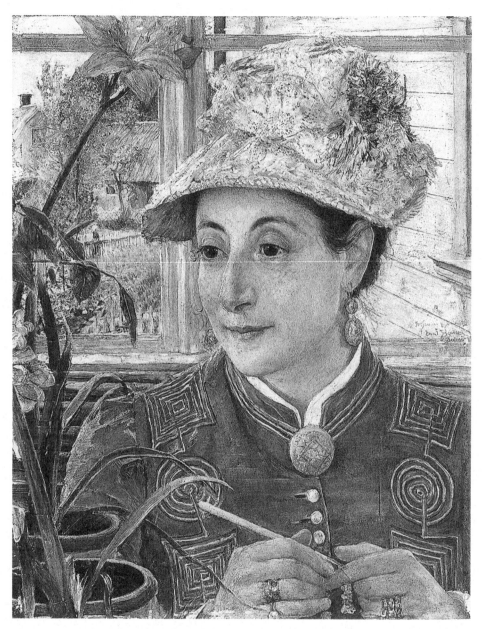

4.B.4. Ernst Josephson, *Jeanette Rubenson*, 1883, 41 × 32.5 cm.
Gothenburg Museum of Art

366

by dint of paint on canvas. There is an undeniable kind of triumph here about the claims of representation and the adequacy of the artist's tools.

I emphasize the wonderful, unproblematic containment achieved in the Rubenson portrait (and in the others as well), because it testifies to Josephson's continuing balance as person and as artist. Moreover, I do not feel that Josephson can have known about this process of marshaling, corralling, and packaging—a process inherent in the doing of art—because this aesthetic/ontological confidence only becomes visible when you have either lost it or cast it away. Jeanette Rubenson is *there*: both rendered and lodged within the space of the canvas and within the various representational modes that construct and frame her: line, color, conventions of space and time. Like most achieved portraits, this piece breathes a kind of mastery that we hardly notice, that comes into view only when contrasted with art where this covenant of containment is breeched, where the canvas seems to advertise its insufficiency or tentativeness or outright make-believe, seems to flaunt the excess or residual otherness of its "object," as if to say, "yes, you see what I've painted, but we both know it exceeds the frame, beckons beyond, speaks to us of something that color and line cannot capture or render." It is this quality—often maddening, always riddling—that we are about to encounter in Josephson's work.

Nothing is simple here. It is not merely a question of Josephson becoming ill/mad—as he is to do—and *then* painting enigmatic pictures. It is rather a reconceptualizing of what art can show, a reconfiguration that is radically exploratory and disturbing, seeking to "capt" something different from the complex material surface of Jeanette Rubenson or Godfrey Renholm, aiming—it would seem—to express or, perhaps, liberate something from within the human form or the represented subject. I say "disturbing" because such art broadcasts the (now visible) insufficiency of its means, tells us at once that the real issues here are not representable, and this dis-

turbs because it calls into question our tools of cognition and expression, gives us to ponder what can lie beyond the surface. Ultimately, however, the burden of this chapter is to show that such art can delight and awe us even more than it disturbs us, can gift us with a vision of things we cannot, on our own, truly see at all, but which we seem to glimpse through the renditions before us. Ernst Josephson's drawings and paintings of the Sickness Period—and indeed a few of his most significant pieces prior to his actual breakdown—inaugurate this modality, a modality we may call "visionary" but for which no adequate label actually exists.

Before turning to that body of work, let me summarize where we are. In the early 1880s Ernst Josephson is an increasingly precarious artist, a fissured being en route to a final breakdown that is to be both catalyzing and prophetic. The unresolved tensions of his family romance—early death of the soft father, mix of worship and unconscious resentment toward the severe mother, choked and twisted view of sexual desire—make up his libidinal baggage since childhood; this legacy receives its fateful turn of the screw in the fact and aftermath of Josephson's syphilis, a sexual "stain" he acquires in his twenties which then contributes to the great romantic / erotic abdication of his life: the failed—not even fully attempted—liaison with Ketty Rindskopf, well-to-do Dutch girl whom he painted, loved, and renounced. This history helps to explain the seismic turbulence and unsustainable identity of Josephson in the mid-eighties. And it may account, in part, for the violent mood swings between the dreamy, reclusive, hypersensitive Josephson and his Parisian other self: tumultuous, charismatic, autocratic, exalted leader of the "Opponenterna," natural chief of the "Pariser pöjkarna" ("the Paris boys") as they were known. This is a formula for disaster, and it is not long in coming.

We see its most conspicuous early signs in two of Josephson's (*now*) most acclaimed paintings of the early eighties, *Näcken* and its sibling *Strömkarlen*. These two works, and a

considerable number of sketches and other versions, seek to display the magic and pathos of a well-known figure of Scandinavian folklore, the "Water Sprite."[6] Josephson's own fascination with this motif dates back to his 1871 trip to Eggedal, Norway, where he wrote about a "vision" of this mythic personage, a vision he himself attributed to both the natural power and beauty of the water fall and also to a self-projection of the artist. Näcken's position in the Scandinavian mind goes far back to a pre-Christian past, and he is variously represented as a young water sprite or as an old master fiddler. His most famous literary incarnation is doubtless in the romantic poet Stagnelius's beautiful poem of 1819, where the old pagan is taunted by the young Christian boy, is informed that he will never enter God's eternal kingdom, ending in a final disappearance of the fiddler that can be likened to the death of Pan. Josephson himself will later, prophetically, play out his own personal version of the drama, on the Breton isle of Bréhat, where the great dead of the past beg for *his* permission to enter God's paradise. But still other features of Näcken matter here, namely Näcken as the supreme artist, the master fiddler whose music entranced all who heard it, whose power was such that you danced yourself into a frenzy, to death, when he performed his magic. In this light we may consider Näcken to be yet one more of the Old Masters, but demonic and dionysiac this time, possessed of a craft and power whose secret the apprentice artist must learn if he is to achieve greatness.

Finally, let us ask what it means to be a water sprite, to be a figure immersed in (and made of) the flowing elements. We are very far from the earlier portraits here, inasmuch as the rendition of the human figure no longer has the hardwired anthropocentric authority associated with the genre; on the contrary, the subject is one with the coursing waters, connected to them in as intimate and sustaining a fashion as he is with the air he breathes. There is a situational, territorial drama here, and it matters not whether Josephson consciously

saw it this way, because the folklore does it for him, offers him the setting that will perfectly mirror his burgeoning sense of precariousness and swirling forces. One feels that this motif chose Josephson, rather than the other way around, but it chose a man not quite prepared to hold up his end, a man inhabited by anxiety and unease. For that is what shows most vividly in these two seminal works: a portrait of exposure, vulnerability, and uneasy nurture. Yes, "nurture." We know that we begin our lives as tiny creatures floating in a womb, deriving sustenance through the liquid element, but our adult, daytime myths cause us to forget this earlier stage of being immersed and co-extensive with the world, for our eyes take in a bounded scheme (our bodies, a seemingly contoured world), and we are outfitted with a name and identity. Josephson seems to announce in the Water Sprite series that he is beginning to unlearn this dogma, that he knows himself to be brother to the swollen waters, and that he also knows himself to be unequal to the task. Yes, he is fed by the magic flow, but he also bids to be unhinged by it. Could there be a more perfect iconography of *genombrott* than this rendition of the human being as anxious amphibian?[7]

With these two now famous paintings Josephson's timing was impeccably bad.[8] The dark, mythic, melancholy *Näcken* (Water Sprite), done in various versions from 1880 to 1882, has a lyrical and romantic feeling to it, a sense of longing and yearning, that is utterly at odds with the naturalist work of the period (figure 4.B.5). Näcken looks the part of the artist, the Seer who lives on desire, the man-in-the-elements. Given these romantic elements, it has to have seemed passé when it appeared. But its sequel, *Strömkarlen* (also translatable as Water Sprite), completed in 1884, submitted to the Paris Salon and rejected, is far more spectacularly out of phase with all taste, whether popular, academic, or avant-garde (figure 4.B.6). The extreme posture of the naked youth, suffused with a certain languor and softness in the earlier piece, is now brilliantly, even insolently, illuminated and exaggerated by light

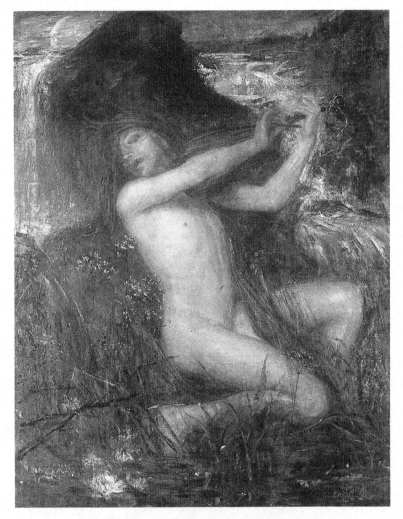

4.B.5. Ernst Josephson, *Water Sprite*, 1882, 144 × 114 cm.
National Museum, Stockholm

so intense as to appear cold and artificial. This contorted body—not terribly unlike a splayed male form lit up by klieg lights in a medical setting—so strangely (dis)placed against the rocks and the rushing water, so aggressively grasping and stroking the fiddle that is now of gold, stuns us in its shiny corporeality, its hieratic but proffered male body, its move-

371

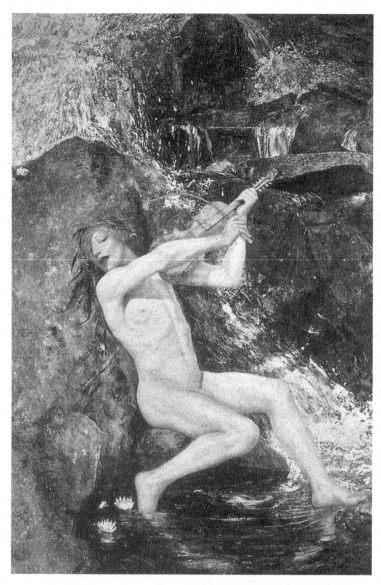

4.B.6. Ernst Josephson, *Strömkarlen*, 1884, 216 × 150 cm.
Waldemarsudde, Stockholm

ments spasmodic, its twisted face filled with ecstasy; it is off the charts. When pushed, we might recognize it as symbolist in character, possessing some colorist, purely decorative parallels with the Synthetist work soon to be inaugurated by Gauguin and the Pont Aven artists at about this time. Critics scoffed at the painter, ridiculed him in print; even his artist-colleagues were confused, discomfited, and unimpressed. Nine years later, in 1893, the culminating insult was to come when Prince Eugen, himself rather mystified by the painting initially back in 1885, purchased it and offered it to Stockholm's National Museum which (infamously) refused the royal gift.[9] No one who has ever seen this monumental painting—comprising one entire wall of the Prince's salon at Waldemarsudde in Stockholm (it is said that Eugen had the wall built to scale to the painting)—will easily forget its magnetic (almost hydroelectric) energy or its haunting power.

One is hard-pressed to assimilate these strange paintings into any kind of program, whether that of the Parisian Salon or the Swedish "Opponenterna" (with whom Josephson's relations were increasingly and tragically strained by 1886 because of his impetuosity and his strong suspicion of betrayal in many quarters, leading to something close to banishment and self-exile by 1887). What jumps out at us, in both these pieces, however, is Josephson's startling self-rendition as libidinal outlaw. Scandinavian folklore is put to quasi-therapeutic use in these two works, with their outright painful and discomfiting expression of forbidden feelings, of a tortured longing for release which may well come via the golden fiddle but never from public recognition or understanding.[10] We are now in a position to see these two paintings as Sweden's "portrait of the artist as young man," as rich, bristling representation of desire and art as inextricably interwoven, and one does not go astray in sensing the erotic and the onanistic in this conception, as becomes blatantly evident for us in a revealing later piece called *Satyr* (see figure 4.B.12). The psychological interpretations have not been wanting, and it is easy enough

to conjure up Josephson's repressive family background and tortured sexuality, with the added spice that masturbation is now synonymous with music making (art) and also castration. Above all, *Näcken* and *Strömkarlen* constitute Josephson's first articulations of the urgent need to break through, in that they are utterly cued to the need/impossibility of utterance and release: the water sprite announces the crucified Christ, the libidinally checked Josephson, the hounded subject whose art is inseparable from confession but whose confession no one wants to hear. Everything in these pieces breathes taboo, is transgressive, goes too far, provokes confusion and malaise, advertises the collapse of boundaries and controls; these two paintings tell us that the containment of the past, so evident in the superbly executed portraits, is no longer possible.

There is something strikingly mobile in the Näcken series, and the rushing water speaks to us, confirms our sense that these strong currents are of a piece with the subject's unspeakable secret, are themselves an energy system that is now on show. Josephson takes the Stagnelius material a quantum leap forward; the earlier pagan/Christian conflict has now become an allegory of art as well as a representation of libidinal repression and longing. We can say that Josephson is still doing portraiture, but now bereft of the adequacy and closure of the earlier work. Confusion, mystery, and hunger predominate, threaten to burst the canvas. But, far from being flaws, these features announce a new program, a liminal model that beckons beyond. That which is constricted, unsayable, dreamed, and desired is understood here as both the matter and manner of art. To be sure, the painter's complex, "complexed" situation as both individually repressed and as failed artistic messiah for his peers is eminently readable in *Näcken* and *Strömkarlen*, but that reading goes the wrong way, takes us back to Josephson, whereas we need to focus on the shocking work itself, now understood as affective tidings, as announcements of a rupture with conventional representation, as threshold toward something unprecedented. It is not surprising that Van

Gogh was drawn to this work, even though he never saw it, knew of it only through Theo's descriptions, because the visionary impetus is everything here, adumbrating a new artistic language altogether.[11]

One half expects Josephson to break down at exactly this juncture, once the fiasco of these two paintings is loud and clear, but the route toward collapse is more devious and indirect. Josephson is now becoming a pariah, quits the "Opponenterna," elects a form of self-exile in the French countryside, in the company (in the keep) of his friend, Allan Österlind, and Österlind's French wife, Eugénie. Normandy and Brittany—Gargilesse, Lépaud, Tréboul, and finally the desolate island of Bréhat—are the locales where Ernst Josephson completes his pilgrimage into madness and otherness.

As we approach Bréhat and the Sickness Period, a number of Josephson's paintings speak to us of the gathering storm. *Village Rumors* of 1886 signals the painter's sharp sense of victimization and evil tongues; *The Spinner* (1886) invites us into a quasi-Shakespearean view of sorcery and spirits, with its witch-like crazed figure who seems to preside over not only the fire and the smoke but the lives of mortals. And there is the apparently more serene work such as *Autumn Sun*, done on Bréhat, thought by some to have a Zola-esque sense of class consciousness, yet also readable as a Breton poem abut humans and stones, about a life that, now autumnal, is seen to be visually indistinguishable from the reflections of the shrinking sun, the play of shadow on walls and earth, the darkness within (figure 4.B.7). Still further in this vein is the last painting done by Josephson before his breakdown, *La Joie de Vivre*, his account of the coming extinction of a public servant, Bréhat's *facteur*, serenely lying on his death bed, attended by his equally serene, even happy family, attended as well by the joint news of the printed word (Parisian, no less) and the eerie diagonal light that seems to invade the death room, betokening the coming takeover and metamorphosis that are not far away (figure 4.B.8).[12] The tenderness and gen-

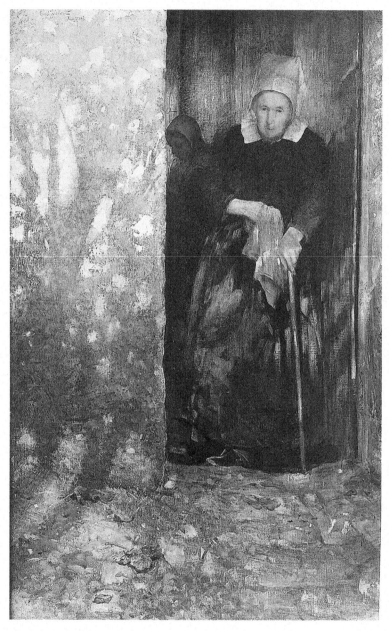

4.B.7. Ernst Josephson, *Autumn Sun*, 1886, 130 × 82 cm. Thiel Gallery, Stockholm

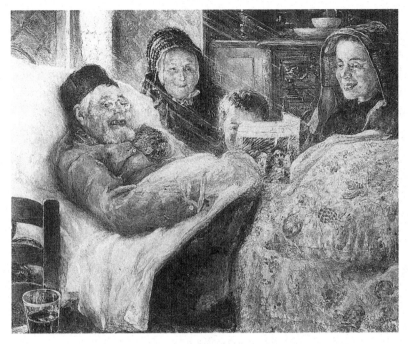

4.B.8. Ernst Josephson, *La Joie de Vivre*, 1887. 65.5 × 81.5 cm.
Danish National Gallery

erosity of these last two pieces seem riddled with a kind of spiritual hush, as if a terrible radiance were at hand, lurking just behind the beautiful but deceptive material veil that family love, conceptual routine, and the painter's own tools shore up but which is going to be rent entirely.

The setting is propitious. On this wind-swept Breton island where Josephson and the Österlinds sojourn in 1887, the painter is faced with ever more inhospitable conditions: a woeful lack of funds (not even sufficient for paint and canvas), smoldering resentment at the numerous "betrayals" he has suffered (Stockholm establishment, his patron, especially his brothers-in-arms), and fierce isolation (Josephson has, with borrowed money, bought a tiny, primitive hut on the northern coast of the island where he lives alone with the elements).[13] Not quite alone, however.

377

Through the good offices of Bréhat's resident medium, Mme Dupuis (who receives regular communications via the spirit world from her dead son), both Josephson and Österlind are initiated into the theory and praxis of Spiritism. Österlind has left us with a vivid account of these experiments, especially insofar as Josephson's art is impacted:

> Painting stopped entirely now, and it became increasingly impossible for Josephson to hold a brush, and even more impossible to use it for himself, because the spirits had entirely taken hold of him. Late during the night we would remain at the table and would follow Josephson's hand which was drawing and writing. I myself did not notice the abyss which grew deeper and deeper in front of our reason, and into which, one day, Josephson would plunge totally. From time to time I tried to restrain his spiritist experiments, but when I started to reason and criticize, he became angry, sometimes even furious. Instead of coming over to my place, he would remain, days on end, in his hut, utterly involved with spiritism.[14]

These visitations may have seemed initially quaint and innocuous, but matters quickly deepen when Josephson explains to Österlind's daughter, Anna, that God has instructed him to sacrifice her, in the manner of Abraham and Isaac. Österlind must have felt a considerable disarray at this turn of events; one remembers Kierkegaard's handling of these matters in *Fear and Trembling*, reminding us how uninstructed we are, how at a loss we must be, when God's command comes. At the same time, Josephson seems alternately persuaded that Österlind himself is, in truth and behind the veil, actually Jesus, a charade Österlind himself hesitantly supports, in fear that his comrade, now understood to be seriously deranged, may cause them all great harm. Again, remember Kierkegaard's warning: was it so simple a matter to recognize God? Josephson genuflecting in front of the horrified Österlind on a cloudy Breton evening in 1888 gives us some inkling of the confusions and catastrophes that a "liber-

ated" vision might provoke. The traffic is thickening.[15] Öster-lind, claiming that he is following God's injunction, under-takes measures to bring Josephson back to Sweden, a complicated journey over Paris to Stockholm, replete with a Josephson at times furious, at times hallucinating, at times pli-ant. He is returned to his family, where the extent of his in-firmity is only gradually recognized, culminating in a stint at the hospital in Uppsala (where Josephson is captured in a straitjacket and forcibly interned), from which the painter exits some months later—he simply walks out—to spend the remaining eighteen years of his life in some sort of twilight zone; in 1891 he is sequestered with two kindly, elder spin-sters in an apartment on Nybrogatan, permanently altered, sporadically active and creative, in occasional contact with his peers, thought of as more than half-dead, garnering a ghostly recognition in a solo exhibit in 1893, dying in 1906. It is during the long final stint, the Sick Period, that he produced some of the most remarkable art of his century or of the following one.

But what happened on Bréhat? And why is this career of interest? The Spiritism to which Josephson subscribed, at the hands of Mme Dupuis, was a familiar Zeitgeist in the last de-cades of the nineteenth century. Its mix of occult principles—spiritual migrations, table rapping, hypnosis, telepathy, sug-gestion psychology, unity of matter and spirit (as seen in al-chemical experiments)—can be seen as a last-ditch effort to resist the utterly materialist tenets of naturalism and empiri-cal science. In this light, the emerging school of psychology presided over by Charcot, the symbolist artwork in both painting and poetry, the search for "correspondences" be-tween mind and matter all share some common beliefs in a world of forces that exists behind our phenomenal scheme. Strindberg's tortured autobiographical fantasia of 1897, *In-ferno*, along with texts of Maeterlinck and paintings of Moreau and Redilon, come to mind as varied instances of this "school." But the case of Ernst Josephson, while entirely un-doctrinal, has great resonance here and deserves to be known.

Josephson has left us with quite an amazing collection of drawings composed on Bréhat during the onset of his dementia, now known as the *Spirit Protocol*. In quasi-legalistic fashion this series of drawings records the visits of the Spirits—drawn widely from the high and mighty throughout history (kings and queens, writers and artists), along with numerous dead members of the Josephson family—come now to Ernst Josephson beseeching his advocacy so that they might enter Paradise and see the face of God. (*See the face of God*: here is an injunction that surpasses all portraiture and mimetic art, and we shall have occasion to see how despotic and unhinging this "call" is, how it fuels much of the visionary work to come.) But the Bréhat drama has its own urgency. Josephson is manifestly acting out a power fantasy as Saint Peter guarding the gates of Heaven, and the delirious inversion of reality arrangements—Josephson the penurious, the scorned, betrayed, and unrecognized, now become the ultimate spiritual magnate granting access to God, acting as final dispenser or denier of grace—is unmistakable. In this light, Josephson's role in brokering the passage from flesh to spirit, earth to paradise, plays out the *genombrott* impulse with great clarity and force, even if we are hard put to distinguish between the religious, aesthetic, and psychotic dimensions of such a drive.

The *Protocol* has been largely interpreted along obvious psychological lines, as evidence of the delusions of grandeur accompanying the onset of the artist's paranoid schizophrenia (a mind-set said to be symptomatic of this infirmity). Worth noting, also, is the profusion of scabrous confessions made to Josephson by the assembled (unblessed, thus malodorous) "greats," confessions often of sexual taboos such as incest and homosexuality and pedophilia, confessions interpreted by the critics as so many projections of the artist's own repressed desires onto the creatures of his fantasized courtroom. A final feature of this libidinal outpouring that warrants our attention is the odd *double* mediation that characterizes it: not only does Josephson act as conduit to God, but his own crucial me-

diator in these affairs is the Swedish philosopher/theologian of the eighteenth century, Emmanuel Swedenborg, whose presence stamps these drawings via his special handwriting and signature (always in the left corner of the drawings), utterly different from that of Josephson, posited as a kind of scriptural mode of both access and authority, as if Swedenborg were literally "underwriting" this cavalcade of spirits seeking redemption at the hands of Ernst Josephson.[16] If ever one wanted an allegory of mediation and even textuality, this homage to another's script would be it. Mind you, this process extends all the way to us: Josephson felt that his being anointed by God was the divine righting of the record, the proof positive that now at last he was *understood*, and he went on to claim that this honor extended to his own viewers, that those who understood his (Josephson's) work—"even were they outright sinners," as he put it[17]—would also become angels in heaven. (Critics of the world, rejoice!)

From an aesthetic point of view, these drawings are of little interest; each spirit resembles the others (do we know what a spirit looks like?) as a bald, simplified human form in hieratic posture, without the least touch of specificity or psychological detail, sketched usually in seven firm lines. But they are fun anyway. Consider as piquant example Josephson's upside-down portrayal of Homer who now comes to beg the Swede to admit him into Paradise. Not so fast, our man decides, since this is an opportunity, after all, to right the record about the Greek bard, above all to bring out into the open his transgressions and shortcomings (as Ernst saw them), as we learn in Homer's (extorted) confession of malfeasance: "Be freed through you. I have stolen the manuscripts of others and have allowed them to go to posterity under my own name. A bad poet who envied my brothers" (figure 4.B.9). Swedenborg speaks for Ernst, Ernst speaks for Homer: nice work if you can get it. Hence one is tempted to regard this odd body of work strictly along pathological lines, and that is largely what the Josephson critics have done. A great exception is Peter

381

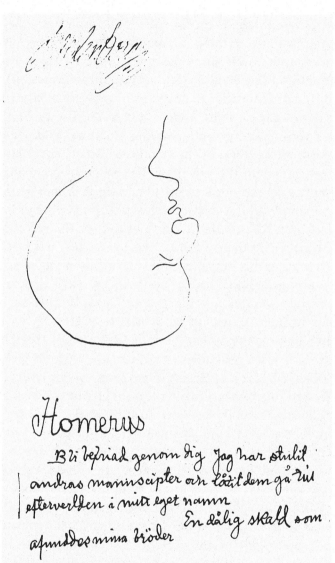

4.B.9. Ernst Josephson, *Homer*, 1888. Ink/pen, 166 × 115 mm.
National Museum, Stockholm

Cornell who, in his 1989 edition of the *Protocol*, reads Josephson's project essentially against the dual contexts of nineteenth-century spiritism and twentieth-century surrealism.[18] What has still been missed is the pathbreaking, often visionary rendition of Power itself in Josephson's work of the Sick Period, not without parallels to Strindberg (early plays as well as late, and of course *Inferno*), and it is this new, essentially ideological dispensation, this stunning representation of the human subject as part of a force field, as a being immersed in "traffic" with the "gods," that I wish to address now.

Before doing so, let me make two further observations. The first concerns Josephson's intuitive sense that Power is a substance of many stripes, that it comes packaged not only as military or political rank but also as somatic and libidinal imperative, and—not least—as aesthetic "tradition." Hence the seemingly diverse field of subjects in Josephson's "sick work"—warriors, kings, bards, painters, prophets, saints, but also a human body that is explosively energized—is not so diverse at all, in that it constitutes a sort of human and cultural geography, the territory where the human subject conducts its negotiations. My second, and determining, remark is this: Josephson's "sickness" is the fascinating and tragic key to this vision, for we cannot fail to see that the painter's "condition," whether we call it "paranoid schizophrenia" or madness or whatever, radically alters both his perceptual apparatus and his representational manner, radically changes his way of seeing and painting. It is as though Josephson, "touched," were eerily liberated, emancipated from those "mind forg'd manacles" that culture imposes on all of us who live within its mesh. No small irony here: the broken painter (no mistake here: he is permanently an invalid) is to be heir to a vision that is staggeringly holistic, and it is in this respect that his "career" caps my study of *genombrott*.

What does it mean to be visited by the spirits of the dead, especially by the high and mighty of history and art? A number of explanations have been adduced: pathological "delu-

sions of grandeur," projection of repressed libido onto the fantasized visitors, nineteenth-century occult and spiritist "business as usual." Earlier in this book I have argued that the core logic of Munch's paintings and Bergman's films is that of energized feeling, feeling so energized that it re-charts and reconfigures our geography. The human ramifications of this new dispensation can be fateful, as we saw in the misery of Strindberg's protagonist in *Inferno* or the fusion-drama of the two little girls in *The Ice Palace*. In the sick work of Ernst Josephson we begin to glimpse the ideological ramifications of such a vision. Josephson's visitations by Homer, Dante, Michelangelo, Walter Scott, Byron, and company constitute more than a pathological *fait divers*; they make visible to us the kind of incessant traffic between subject and culture that is the very medium of human consciousness, but which our individualist assumptions and empiricist grids conceal. The parade of "greats" who come to Josephson's primitive hut in Brittany announce the central theme and modality of Josephson's late work: the grids of "self" have loosened, and flux is the order of the day. Not unlike a nightmarish (or vaudevillian) version of a Great Books curriculum, Josephson finds himself interpellated, enlisted, communalized by the grandees of history. Those Old Masters whom he revered in his youth have swooped in on him, effecting a kind of cultural "return of the repressed," to assert their presence in his life and work.[19]

One thinks of the fluidity and traffic that James Joyce wrought in the "Circe" chapter of *Ulysses*, it, too, an ideological surrealist parade of sorts. Still more apposite is the example of Jean Genet whose work, most especially *Le Balcon*, explores (in a frequently shocking fashion) just how deeply inscribed the structures of power and societal order—king, bishop, judge, or what Genet calls the Nomenclature—are in the individual psyche. Not merely inscribed but enlisted, as triggers, as indispensable generators of libidinal energy. All private gesture turns out, on this model, to be public shadow play, to be (tragically?) dependent on fixed roles whose pow-

ers are virtually totemic, in that one's own energies cannot be marshaled or released without the Nomenclature's mediation within our fantasy or image world. (Ibsen's Alfred Allmers comes to mind as equally "plugged in," but the ideological stakes are much higher here.) In this light, Ernst Josephson's obsessions lay bare an entire scheme of personal and cultural exchange, networking, a "hookup," if you will, that sanctions and "possibilizes" both thought and action.

We often label such extravaganzas as Joyce's "Circe" chapter or Genet's *Le Balcon* "hallucinatory" or "surreal," but can we not see it the other way: a higher "realism" that finally does justice to the mobile and interrelational nature of subject formation and the circuits of power? The earlier docile encounter between student and master has become a graver, more urgent, virtually terrorist adult affair. It may seem to be decorous interplay, but soon enough it begins to look like something more invasive, on the order of plague. But again: how would one represent one's relation to Homer, Shakespeare, even one's mother or father? How could you *show* influence? And is this not another way of saying: what does power look like? We are not equipped to see electricity or infection, nor can we see the libidinal currents that link us to others and our world. Ernst Josephson is going to graph our commerce. Josephson's psyche, bereft of its proprietary uprights, goes wild, goes on a kind of cultural "outing"; or, one could phrase it the other way around: Josephson's psyche, bereft of its proprietary uprights, can no longer keep the riot of history, education, and culture at bay, finds itself under siege, discovers its hybrid and incestuous nature, realizes the fiction of all borders and boundaries. The law of this new territory is traffic, mediation, constant coming and going. And it is perfectly logical that the sensitive, brooding self-portrait done on Bréhat should be signed "Velasquez," just as the handwriting and tutelage of Swedenborg governs so many of the spirit visitations (figure 4.B.10). At stake here is a new understanding of agency itself, not merely as it pertains to artistic production

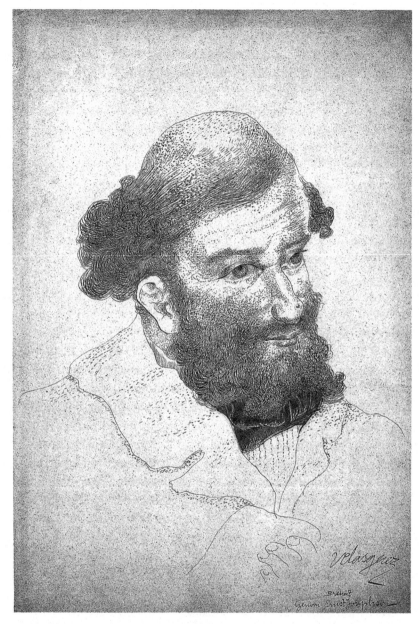

4.B.10. Ernst Josephson, self-portrait signed Velasquez, 1888. Norrköpings Museum.
Photo: Statens Konstmuseer

but more widely in the sense that all so-called individual thinking and doing are ultimately collective efforts, involving vital influxes that we might compare to psychic blood transfusions. And there is demonstrable reciprocity: in each drawing that Josephson signs with the name of another great painter— Raphael and Michelangelo have their turn, as well as Velasquez—one can actually see a kind of "shared" style in the finished product, documenting (if such a term can be used here) Josephson's conviction that *they* (and not he) were doing the work in question.

The traffic is two-way in still another sense: not only do the spirits visit Josephson but he also visits them, leaves his calling card there. Consider the portrait of J. P. Jacobsen in which the clear lines of the Danish writer's "gestalt" come to us as part of an odd diptych consisting of Josephson's own mirrored face (figure 4.B.11). In this sense, all portraiture (all painting) is self-portraiture, but not necessarily along the lines of narcissism usually alleged; rather, Josephson is exposing, once again, the circuitry and synergy that fuel art, in a way that Proust was to theorize when he claimed that all of Elstir's portraits resembled one another more than their subjects. Josephson's work finds a visual language for the borrowing and lending that comprise the human subject's psychic economy, as if consciousness were a sort of cultural marketplace, a force field that reconfigures individual agency.

It is worth recalling that Ernst Josephson's personal upbringing and artistic formation were profoundly conservative. He was a good boy. He read history books about kings and warriors. He studied piously (and with awe) the work of the Old Masters. He believed in the laws of the Fathers, all the more since his own father died so early. In short, he is an ideal product of bourgeois arrangements, and that is one reason why his coming apart is so illuminating: an entire order is suddenly on exhibit. Nothing in all of this is willed. What I have called two-way traffic is experienced, on the inside, as a

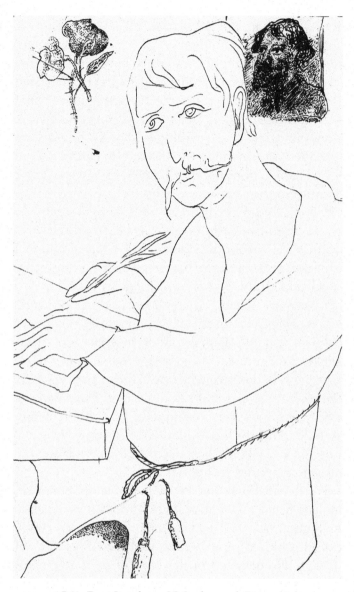

4.B.11. Ernst Josephson, *J.P. Jacobsen*, n.d. Pen and ink

form of utter confusion, of madness; at its peak, in 1892, it can sound like this:

man måste vara där man är, när man har sparlakansläxor i benen—förr i världen hade det varit en småsak att gå till så närbelägna städer för—*en jude*—tills nyligen den vandrande— klandrande naturens ordning att låta mina pengar sitta fast i Gud faders egna substanser kalfatrade och kritiserade av äganderättens demon det utsvultna helvetet självt. - - - -

Denken kannst du so viel du willst aber malen kannst du dich malen können haben das kostet uns zu viel tränen und hängt uns an den Zähnen. Du undrar säkerligen varför jag skriver på tyska, men i min stilla målföring tilldrager sig "fögor" av tilldragelser, vadan vardagslivets prosa torde bäst triangulera förståndet i avväxlad form på språklåda, ansjovis- låda, lax i låda, "låda" mig tjugufem öre och förakta mig sedan mycket! Lådhuggare trivas bäst i sin egen omgivning så är det och med dem som är lådna på norsk, d.v.s. dem som höra helvetet till. Du kan ännu i mitt brev spåra dragen av mitt för- tidiga vansinne —? Somliga tog det för överskott av kvickhet, själv vet jag inte riktigt under vilken kategori jag bör inskoja mig densamma, men torde dock pojkaktighet vara den sjuk- dom jag mest lider av—fast det inte är sagt att man därfär av- lider av samma smörjiga avkomma.[20]

(one must stay where one is, when one has pain in the legs— in the old days it was easy to walk to distant cities for—*a jew*— until recently the wandering one—indicting nature's ruling that my money is stuck in God's own substances, criticized by the demon of the law of possession, the famished Hell itself.

Denken kannst du so viel du willst aber malen kannst du dich malen können haben das kostet uns zu viel tränen und hängt uns an den Zähnen [You can do as much thinking as you like, but can you paint, painting has cost us too many tears, pulls at the skin of our teeth]. You wonder of course why I write in German, but in my discourse there are many bits of events, from which everyday prose ought best to triangulate reasoning

in various forms, in the speech box, the anchovy tin, salmon in a box, "box" [loan] me twenty-five cents, and despise me ever afterward! Box-breakers do best in their own environment, and so it is with those who are boxed [stuck] in Norwegian, i.e., those who are consigned to Hell. You can still perceive traces of my earlier madness in my letter? Some interpreted it as excess of wit, I myself don't know exactly what category I should joke it into, but childishness is probably the illness I most suffer from—although it is not said that anyone dies from such messy ailments.)

I quote this long passage, in Swedish as well as in my English translation, to show both the mobility and density of Josephson's tortured thoughts: nonstop verbal sorties and extended puns, coupled with flashes of insight and a shocking sense of himself as object of study as well as pity. (Is this not a self-portrait? Does it not call upon some of the same resources as the brilliant paintings of the past did?) Yet how far we have come. This mix of languages, voices, and registers, Hamlet-like in its self-consciousness and flirtation with madness, conveys fully the jangling, discordant, anarchic state of mind experienced by the painter. Here he complains of his poverty, positions himself as mythic victim, cursed via his painting, his earlier wanderings, his rheumatism, and, above all, destined to fall into and slip out of the cages ("lådor") in which he might be kept or defined. I use the term *traffic* to denote the flowing currents of Josephson's created world, but that term scarcely hints at what it must feel like, on the inside, to be a *carrefour* of prancing notions and one-liners and word play, to be invaded by spirits that do not knock before entering. The machine is on, the frequencies are there, and one is simply inhabited by them. What is more porous than the brain? Breakthrough refers to the promiscuous company we keep, the company that keeps us. We know that he was an altered man when he left Uppsala hospital, several months after his forced return to Sweden. The tumultuous, charismatic, impul-

sive artist—known by all his friends as "Joseph"—disappears, yielding his place to a mild, often fastidious, sometimes dazed, gentle, and ceremonious creature who still occasionally saw old acquaintances but fundamentally retired from the public arena.

Strindberg has left us with a haunting evocation of the lost "Joseph," known also as "Syrach" (from the Parisian tavern where the Scandinavians met during the "Opponent" years). Josephson-Syrach, the "Rembrandt son," is said (in Strindberg's "Gothic Rooms") to have been murdered alive by former friends and enemies, and in a party scene, a rose is thrown from the balcony and lands on a table where a lone figure sits: "It is Syrach, exclaimed Sellén, and everyone on the balcony looked at the solitary figure, who wore a red fez on his head and was dressed rather strangely. But Syrach didn't seem to recognize a single one of his old friends, but put the rose in his button-hole and continued rolling a cigarette." The group then begins to insult one another, as Syrach's fate is discussed, and the blame put on all "right-thinking" people who poisoned him, "took honor, bread and self-respect from him." Sellén then says, "Let Syrach sit in his dream world; he has it better there than we imagine, and moreover he doesn't recognize us." At this point a former friend of Josephson, Fritz Thaulow (called Lage Lang in the text), is so stung by the sight of Josephson that he "wanted to call forth a 'long live!' and 'hurrah!' for our greatest painter, but fortunately he was deflected, for the police would have been called, and moreover no one in the salon knew the painter, other than possibly as a silly, decrepit human being who was remarked on the streets for his red fez and his strange behavior. Syrach remained sitting; he sat now with his eyes directed over the group, as if he did not see them, but rather gazed in the distance overhead, surrounded by his dream images that he could not show to others."[21] With characteristic acuity, Strindberg perfectly defines Josephson's fate: a (defiled) visionary who saw what others could not see.

Josephson was thirty-six years old at the time of his breakdown on Bréhat. He was to live for an additional eighteen years, and during this period, most especially in 1889 and 1893, he produced the astonishing body of work I have been leading up to for some time. Aside from largely jettisoning oil paint, Josephson turns to drawing, and displays a prodigious capacity here. Yet features of these works—most notably the obsessive repetitive motifs, the pin-point detailed cross-hatch scratchings, and, most telling perhaps, the recurrent deformations of anatomy, especially concerning legs, feet, arms, and hands—have been labeled "pathological," that is, the result of a motor or neurological or psychic disorder often seen in the drawings of schizophrenic patients.[22] But many years ago, in a strikingly insightful essay written in 1903, Josephson's friend and brother artist, Richard Bergh, pointed out that even the strangeness of Josephson's work might be thought of in social and cultural terms, as opposed to the optic of medical diagnosis.[23] We are at a crossroads here, because much of what we will consider in the pages ahead can indeed be regarded as "pathological" or "regressive." It all depends on what you are diagnosing: Josephson's own psychic condition or the strange vision and strange art that emerged from it.

But even in the 1890s, especially at the occasion of the large retrospective arranged by Georg Pauli, Richard Bergh, and Prince Eugen in 1893, many were stunned by the sheer beauty and alterity of these pieces, the mysterious cryptic soundings and sights of a mind and eye gone elsewhere, and now serving up for us a version of history and culture, indeed of body and soul, that is radically strange. I am concerned to extend Bergh's cultural reading, to go beyond the diagnostic sickness model, in order to map the new terrain that Josephson offers us. As said, I do not wish to glorify schizophrenia; we know enough of Josephson's life then, and we know enough of mental illness today, to reject any facile equation of madness and genius. But let us investigate this sick work in a different spirit altogether, in the hope of fashioning a larger view of a life and

career, larger both personally and ideologically. A plenitude comes into view here. As Josephson's constraints and grids—those of bourgeois subject and European painter—start to slip and slide, he seems to enter a new territory, as if he were moving beyond the Saint Peter role he had played in the *Spirit Protocol* and were now effecting the great voyage himself.

Some of this work is not enigmatic at all but, on the contrary, is strikingly clear and emphatic, even if disturbing in its message. I am thinking especially of the revelatory drawing, *Satyr*, which complements in hoary fashion the *Näcken* and *Strömkarlen* series (figure 4.B.12). *Satyr* is hardly a masterpiece, but it is certainly emancipated and uncensored in its depiction of fiddle playing as a combination of masturbation and castration. The expression of ecstatic yearning that characterizes the two earlier canonical works now receives an unmistakable sexual valence, entailing both illicit pleasure and sharp punishment. One can refer this piece back to the Josephson family arrangements, especially the taboos that must have regulated the young Ernst's boyhood, but one is equally entitled to see this drawing in terms of the libidinal economy that drives art. The making of music, indeed the making of art, comes across as onanistic in itself, as a substitute for self-pleasuring, and as rending punishment. Perhaps the most striking feature of the corporeal drama here is the admission that art comes from the body, that the musician's—or painter's—arms and legs, hands and fingers, are themselves erotically charged implements. Josephson's sick work frequently foregrounds the very making of art as primitive somatic drive with complex moral ramifications, suggesting that Ernst suddenly became terribly transparent and visible to himself, that his drives and inner equipment—including their danger signs, their price tag (as it were)—came fully into view.

If *Satyr* illuminates the motive forces behind *Näcken*, what can we say of the fearful reworking of this motif, *Näcken and the Virgin* (*Water Sprite and the Maiden*), in which a grim meditation about the body-in-time seems to have taken place

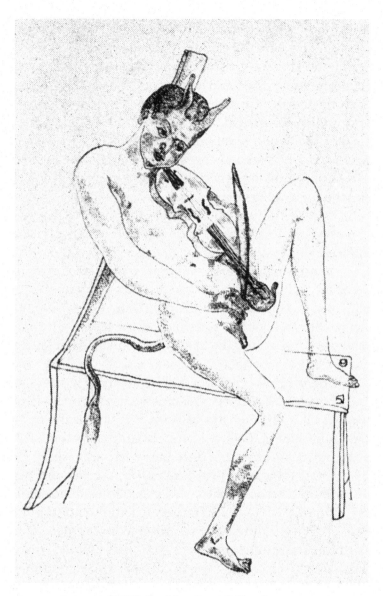

4.B.12. Ernst Josephson, *Satyr*, n.d.

(figure 4.B.13). No longer a young and beautiful male, this Näcken has aged—much as Josephson himself aged in shockingly short compass, grew fat and bald, lost the physical grace that is so noticeable in his youth—and his tired, slack flesh is patently no match for the fearsome virgin who mounts him, an utterly unidealized female of powerful limbs and bulk, who thrusts her desire and her sex at the anxious, incapacitated male. Fear and inadequacy shine through in this painting, making it clear that Näcken has come onto rough times, has moved from a mix of ecstasy/fear to straight-out fear. But is this not what the magic fiddle ultimately (viciously) portends? That you are at once Maker and Victim, Prospero and Caliban, source of demiurgic power and target of it as well? This anxiety is to become a trademark in the "sick" paintings, telling us that the compact with the gods may be Faustian but it is also unhinging and two-directional, that "breakthrough" boomerangs into "broken through."

Both *Satyr* and *Näcken and the Virgin* are confessional works, in that they express both longings and fears that were unrepresentable—unfelt? unconscious?—in the artist's "healthy" period. These two pieces are larded with avowals and recognitions, and they are marked by a brutality that we will see more of. It is as if the painter were now obeying compulsions of a different order, as if life itself were being defined as an affair of compulsions. Whatever "complex" lies behind these works is less interesting, I think, than the new uses to which the canvas can be put, the new vistas that are coming into view. Admittedly, these two works engage us in their psychological explicitness, but it is by no means the case that the sick work is to be seen primarily as self-regarding. If there is psychology in *Satyr* and *Näcken and the Virgin*, it is about art, not about Josephson; it speaks to us about costs, about what you pay, to be Näcken. The most ambitious claims to be made for it are painterly, not personal. But not everything is dark; the "sick" Josephson has more registers than one might think.

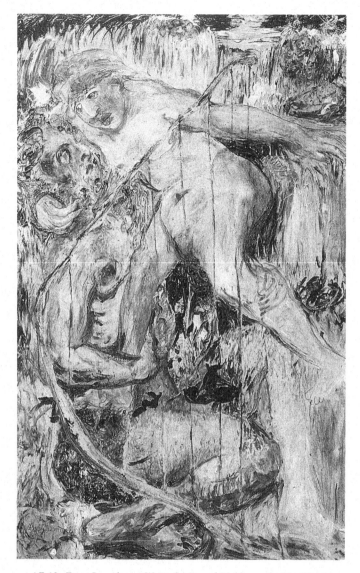

4.B.13. Ernst Josephson, *Water Sprite and Maiden*, n.d., 54 × 34 cm

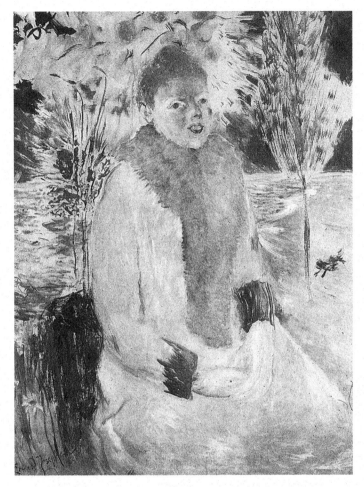

4.B.14. Ernst Josephson, *Portrait of a Lady,* 1889–1890, 222 × 87 cm.
National Museum, Stockholm

Consider now *Portrait of a Lady,* one of the most ethereal, elegant, and surrealist of the sickness pieces (figure 4.B.14). It is instructive to recall the earlier realist masterpiece, the portrait of Jeanette Rubenson, to measure what is and what is not happening in Josephson's two manners. The Rubenson portrait, as indicated, is a high point in Josephson's mimetic style: the acute psychological portrayal, the delicacy of both feeling and palette, the subtle symbolism of Swedish and Jewish cul-

tures, the contrast between outside and inside, between dreaming and craft, all this is finely seen and finely wrought. *Portrait of a Lady*, on the other hand, seems downright interplanetary: this stylized, floating figure is utterly unanchored in time and space, comes to us as a kind of decorative fantasia, with her blank eyes, rouge hair, shiny cheeks, coquettish air, her beautiful fur ruff and fashionable gown, all ensconced within an idyllic arrangement of flora and fauna (seemingly there as accoutrements to the lady), shimmering with a sense of airiness, against a mix of sand, sea, and deep sky, almost of *l'heure bleue*. Josephson's *mondaine* has nothing in common, say, with the realist confections of a Sargent or a Renoir, or the more graphic, poster-like renditions of a Lautrec; there is, instead, something oneiric here, a glittering inner realm of glamour and frivolity, of portrait of desire become ease. And "portrait" itself has now come to mean something quite distinct from the retinal data that the eyes of most of us take in; Josephson's sights are elsewhere, both beyond and within, as if the Water Sprite's lucky, elegant, and sophisticated sister had materialized out of thin air, before disappearing into the next waltz.

But the masterpieces of the late period are, for the most part, not secular but spiritual. "Spiritual" is doubtless one of the most problematic terms to use in either everyday parlance or professional criticism, because it is so close to cliché, so easily cheapened or exaggerated. What can it mean to label something "spiritual," when we inhabit carnal bodies, live in a phenomenal world of three dimensions, and create a surface art of two dimensions. Line and color represent our ocular purchase on this material scheme. How can we know or represent something beyond matter? Josephson's great mentor, Rembrandt, is among the rare artists who routinely convinces us that such a realm—the realm of spirit—is real, even though he works, as he must, along strictly material lines; his genius is to infuse the meanest profane figures (just markings on a surface) with a luminosity that seems to come from more than

paint. It is not until *Näcken* that Josephson becomes concerned with spirit (with its incursion into our life, with its upending power), but his manner is scarcely that of Rembrandt. Josephson does something rather different: he is out to render the shock itself of spirit, the scandal that is brought about when the material façade of things is rent and something else appears. Breakthrough. His finest work is about the eruption of the spiritual, the transcendent and luminous, into a scheme that is unprepared, unfit for it. This work complicates Strindberg's claim that Josephson gazed at things no one could see, because it brings exactly this drama and trauma to the laws of visibility. And, in this respect, nothing surpasses *Gåslisa*, otherwise known as the *Shepherdess's Vision* (figure 4.B.15).

Here, if ever, we encounter an Ernst Josephson who has broken entirely with the work of the past, with the self of the past. Psychoanalytic critics have suggested that Ernst frequently represents himself in Christ-like fashion in the late work, and this is true enough. Of course, this piece is referable to the Annunciation motif, but how far will that take us? The painting stuns us especially in its explosive celebration of vision radically at odds with mimesis or realism, a vision steeped in folklore and legend, where the Christ story cohabits an exquisite pastoral landscape, attended by the heraldic goose and bird, radiantly illuminated by the fiery halo and currents of light that background the angelic Christ child. This beautiful boy seems to emerge from fire and light, almost a creation myth of sorts, with his crown of thorns and lovely necklace broadcasting the work of culture, his arms hieratically folded in on his breast, his slender, graceful body, and his feet already marked by stigmata, as if the crucifixion—the primal suffering—were there, inscribed, from birth on. This child looks out at us, as does the shepherdess Lisa whose vision this is, and her posture still more hieratic and mysterious than his: her right arm seems extended in a protective gesture (against what? her vision? spirit itself?)—not so unlike that of Näcken—while her hand combs the exquisitely fine gold hair

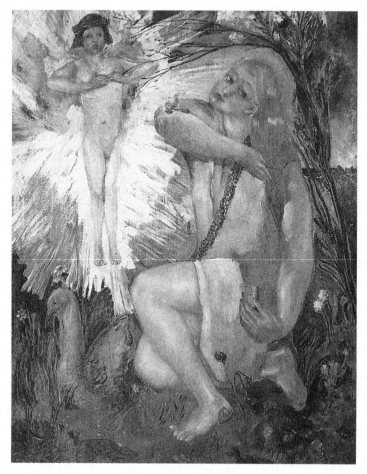

4.B.15. Ernst Josephson, *Gåslisa* [*The Shepherdess's Vision*], 1888–1889, 72 × 58 cm. Waldemarsudde, Stockholm

in a gesture of sensual delight, whereas the left arm seems strangely elongated, as if its purpose were to frame and shield her body (frame and shield: a haunting sense of the rationale of boundaries, contours, in experience and in representation; the very iconography of *genombrott*), so much so that the comb itself, poised in her upward turned hand, seems whimsical and gratuitous. The painting has a dazed, hypnotic feel to it: it advertises the *impact* of visionary experience, and although it may not have the virulence of Rimbaud's *dérèglement de tous*

400

les sens, it seems to me that it goes comparably far in its tidings of rupture and wreckage.[24]

The color scheme of this painting, done in 1889 in the first creative burst of energy during the Sick Period, explodes with light: the sumptuous almost orange flame-like light that streams out of, and behind, the Christ child's body, and seems to dazzle and dapple the surface of the girl's body, leading almost to a chiaroscuro effect on her feet, legs, arms, and face. The whole consort is stamped with exoticism: the enigmatic birds, the staggering emergence of the child of light, the haunting and swaying plants, especially the tall growth that seems (in obedience to the painting's magnetic pull, as well as its cautionary view of vision) to cradle and encircle the shepherdess, extending over and around her head, inward toward the golden child, as if drawn by light. *As if drawn by light.* This is a magic landscape, animated by forces that have little to do with our familiar gravitational pull that gives heft to realist art, confirms our sense that material things are properly anchored in their material setting, equipped with the de rigueur density that we know objects to have. Nothing of the sort here: the irresistible pull on show here is the pull of light, as elemental as the life-giving radiance of the sun, the primal energy of photosynthesis, but the painting is as insolently decorative as the Synthetist art of Gauguin in the 1890s, and although it lacks the explosive color sonorities of the Frenchman's Breton and Tahiti work, it bespeaks a primitive spiritual awe that fully matches Gauguin's finest paintings, and it seems to broadcast patterns of congruence and kinship that are to become Josephson's signature.

We are heir to an otherworldly vision in *Gåslisa*. The two mysterious and serene figures look at and through us, suffused as they are with certitude and truth, as if challenging us to apprehend the radiance that one of them is, that the other perceives. Christian iconography is present but wonderfully reconfigured toward riddling legends to be found in no books. And our central query is indeed central here, self-

aware in a way that has nothing to do with aesthetics: how could one depict spirit? the perceptual and epistemological scandal of spirit? These two creatures are frozen into a kind of sacred dance, a dance of the elements—the birds, the plants—and of history: the Redeemer emerges as fire and light to the stunned gaze of the shepherdess, forever initiating her Arcadian world into a regime of suffering, sacrifice, and transcendence, as if to complete the Stagnelius prophecy expressed in his poem, "Näcken." This apprehension of light and grace is properly transfigurative: it reconfigures the girl's body into a posture of obeisance and annunciation, and it operates its magic onto an Edenic landscape with heraldic flora and fauna, all suffused with the mystery of revelation, turned into markers and "players" in this luminous moment of truth. There is no hint of consciousness in this painting. Whereas Josephson's earlier portraits suggest psychological or emotional depths, the Christ child and the shepherdess are no more "inward" than the goose or the bird or the flowers or the plants. They are initiated, and they look at us, to initiate us.

Into what? More, I think, than a traditional Christian belief or iconographic system. More, even, than into Ernst Josephson's peculiar fantasy and symbol world. "Gåslisa" is annunciatory of the reality of spirit—its heat, its light, its coercive and spellbinding power—that informs our everyday world, even though it leaps out at us only in isolated moments of visionary grace. An astonishing opening of the world is at hand here, as the fiery child irrupts onto the Arcadian scheme. This is a new Josephson who seems to tell us that the purpose of painting is to convey the awe and majesty that attend the lifting of the phenomenal world's curtain, the piercing of the veil. Hence it will not do to label such work "naïve," because it investigates the very purposes of art, because it hammers home just how traumatic and invasive the visionary experience must be. The three-dimensional world, sumptuous and beautiful though it is, becomes here a stage-set awaiting the

entry and emergence of its fourth-dimensional *vedette*. What, we may well wonder, has happened to this man's way of thinking? We cannot know, but there can be no question that we have Josephson's "sickness" to thank for this vision.

Again, let me repeat: I am not glorifying Josephson's psychic disorder. He paid the supreme price for his visions: the price of membership in our workaday world. As Strindberg wrote, old Syrach was lost in the vision of things we cannot see. But *Gåslisa*—and other visionary pieces we will consider—is about revelation in a double sense: the shepherdess's vision, and ultimately the spectator's vision. Josephson comes full circle, gifting us with images of places we have never been, putting into miraculously material form experiences and transcendent spiritual moments that are not material at all. He comes full circle, in that his sickness work wonderfully extends the realist work, shows us how capacious, how colonizing, the inward gaze can be by making off with the treasures it sees and moving them back across borders into a scheme the uninitiated can see. He is a self-poacher, and he makes apprehendable, perceivable to us a regime beyond the precincts of things as we know them.

To see is, of course, the unstated mission of all visual art— to make us see—and Josephson's late work does not give the lie to our normative perceptions but instead spells out their limits by unlocking a storehouse of forces, an energy world under the surface of things, not unlike the play of electrons and protons that course through the armature of the atom, or indeed the flowing blood that animates human life. The vision brought on by sickness reconceives Josephson's earlier work by transfiguring it. All that was off-limits to the retina—all the magic—can now be captured, erupts onto the stage, takes over the scene. Doors have been opened, never to close again. Religious motifs now come to the fore in Josephson's practice, not because of some conversion or new kind of faith but because the story of pure spirit, the radiance of pure spirit, has to be told, and Christian iconography is tried and true for

those purposes. The man who worshiped at the altar of the Masters, who therefore had profound knowledge of the sensuous and beautiful biblical paintings of Leonardo, Raphael, and Michelangelo, of Rembrandt, now gives us his version of these events but in a new key, dematerialized, as it were.[25]

Consider, for example, *The Holy Sacrament* as Josephson's further entry into immateriality (figure 4.B.16). This painting is shimmering and ethereal in its rendition, at once fervent and enigmatic, of Jesus, bread, and wine. The central space of this piece seems to be pure air—a kind of whiteness or blankness before matter and color, oddly reminiscent of Melville's meditation on whiteness in *Moby Dick*, a leprous state of truth where all the externals have been peeled away—so that Christ's golden arms, aura, and halo leap out at us, so that the elongated beautiful angel in green, peering heavenward, seems both to bear witness and to frame the scene (a haunting economy so often found in Josephson), providing a vibrant color frontier that contours the almost transparent activities within.[26] Jesus's head is tilted, his eyes seem large and stunned, and his elongated yet rounded, fleshly arms appear to be ribbed with radiance. As always, the shock of vision is parceled out among the players, so that the impossibly tall figure who stares up is twinned by the angled, open gaze of a Jesus who is virtually recoiling: one wants to know what they are looking at. Further, one needs to look closely in order to perceive fully the figures in white, the small golden angel, "signaling" with the hieratic gesture of the hand behind the body, and the altogether more disturbing, almost ghostly form of Mary as reproachful, chastising Mother figure of the Law. Critics have alluded to the painter's ambivalence toward his own severe mother, and suggestive references have been made to the sensual, indeed phallic loaf of bread that Jesus seems to be guiltily palpating, as if this were a veiled scene of onanism decked out in religious colors.

Like *Gåslisa*, *The Holy Sacrament* is first and foremost a painting about astonishment and vision. Jesus's look is one of

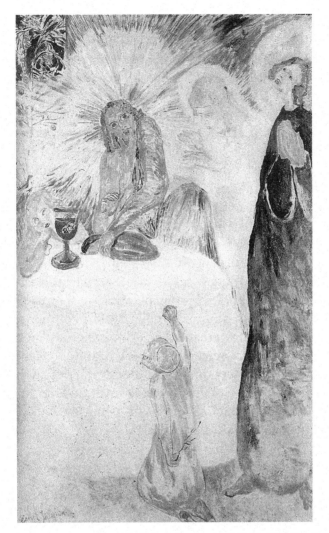

4.B.16. Ernst Josephson, *The Holy Sacrament*, 1889–1890, 127 × 76 cm.
National Museum, Stockholm

both wonder and surprise, and the entourage of others is there to convey their collective amazement and homage. Even the scandalous libidinal interpretation of Jesus's caressing of the bread is ultimately compatible with the piece's larger aims: to depict the miracle of transubstantiation, to make us see that the bread and the wine can actually be the body and

405

the blood. (Is it too much to say that masturbation is cued to comparably drastic displacements and projections?) The majesty of the painting resides in its awed awareness and notation of metamorphosis, of material objects and beings as counters and conduits in a spiritual scheme, a circuit of flowing forces. This is the mystery of the sacrament, the moment when the veil is pierced and the radiance issues forth, transfiguring the mortal players into a holy family.

Josephson spoke often of the redemptive and holy value of suffering during his sick period, saw himself as singled out, as brother to the crucified one who was called upon to redeem things. Yes, we can call this "delusions of grandeur" or medicalize it as a symptom of paranoid schizophrenia. But a more generous reading is also possible. We can surmise that Josephson, sick, saw Jesus anew, saw a figure rather different from the icon of Renaissance religious painting, in that he grasped the enormity of this figure's crippling yet revolutionary role as bearer of spirit, as creature of flesh who was more than flesh. Again, such a perception is devastating, constitutes a scandal, because it upends all our sensory data. As noted, everyone in *The Holy Sacrament*—Jesus included—is stunned, shocked, because material things are being imploded to release their unsuspected spiritual cargo.

It is useful here to think back to *Näcken* and *Strömkarlen* in this regard: the Water Sprite plies his magic art in the midst of the rushing waters, and his ecstatic expression signals all the transformations at hand: the occulted self-pleasuring with its mix of transcendence and fall, the transmutation of the flowing waters into flowing sounds, the miraculous shift from green to gold, the release of bursting energy and desire into the air and water, onto the canvas, effecting a kind of artistic insemination. Josephson-Näcken-Jesus both presides over these mysteries and incarnates them; he is both origin and vehicle. It is as if, broken, he becomes horribly wise about what breaks us, what rends us. The fables of myth, folklore, and religion provide narrative conduits that are made to order. But

the price is high: I am reminded of Borges's fine story, "The God's Script," in which the suffering, broken, imprisoned priest actually *sees* the god's script but is annihilated by his vision, as if the perception of the godhead spelled out the collapse of that cluster known as "self." Yes, Josephson has what has been called a "god-complex," but it is a mobile complex, hospitable to Näcken as well as Jesus, insisting only on ruin as its trademark signature.[27]

Nowhere is the suffering Christ more harrowingly depicted than in the weird outright expressionist drawing where the hair is curled in dreadlocks, the drops of blood stream down the face, the mouth is twisted totally out of shape (not without the hint of a bizarre smile), the face is filled in with the *petit point* manner of the breakdown period, and the eyes—the eyes!!—are staggeringly deformed, widened and half-closed, with heavy, heavy lids, one more opened than the other, seeming at once anguished and drugged out (figure 4.B.17). This portrait of creatural suffering is rendered all the more poignant and disturbing by the impossibly long arm that encircles Jesus's head (to caress him? to protect him? against whom? us?), providing yet again one of the odd cradling frames that we saw in *Gåslisa* and *The Holy Sacrament*; yet this arm is still more macabre because of the brutally cropped face of its owner in the top corner, a face that looks on at Jesus with an expression that mingles longing, pity, and horror. What kind of iconography is this? Who is this naked figure that caresses Christ?

It is as if the Passion Play were being reconfigured, so that the parts and players could be re-imagined, with room for Josephson to insert himself or his surrogate as part of the action, brought in to shield the Savior, hence making visible for us the strange investment of the painter himself in his product, just as the earlier portrait of J. P. Jacobsen carried Josephson's own face on the wall as visual aid/signature. This "secret sharing" is perhaps most blatantly visible in the mesmerizing drawing titled *Sun God* that Josephson did late in life, in

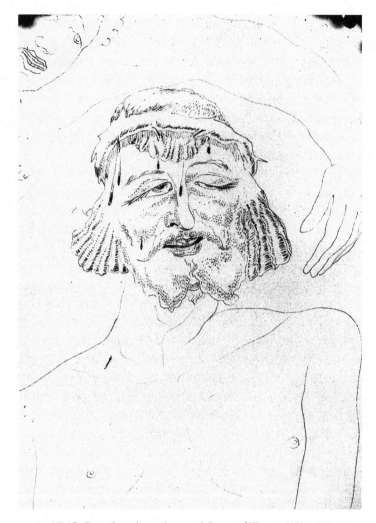

4.B.17. Ernst Josephson, *Jesus and Crown of Thorns*, 1889–1890

which the pagan figure sports a mirror reflecting—guess who?—the swarthy Semitic features of Ernst Josephson (figure 4.B.18); eye-to-eye, these two racially (and ontologically) divided figures exchange their gaze, broadcast—in addition to the sly but desperate effort to fuse the pagan and the Semitic—the enabling, inspiriting current of energy that is the genesis of this drawing, show the artist at work. Boundaries

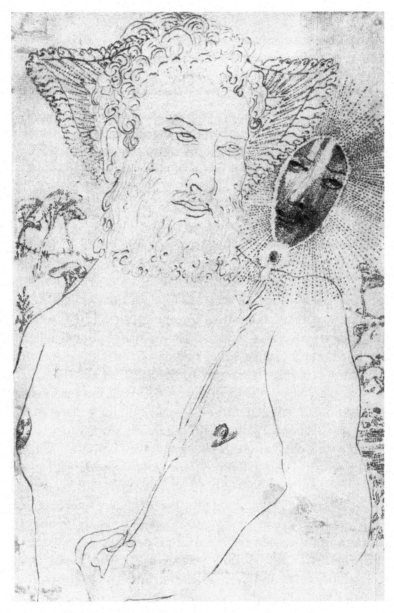

4.B.18. Ernst Josephson, *Sun God*, 1889–1890, 30.5 × 20 cm

have been collapsed, so that the riotous, incestuous traffic that attends both thought and creativity can be depicted.

We are left confused by the strange liberties Josephson takes with traditional iconography, as if he now saw how fluid and mobile these old stories really are, how his own personal suffering and family romance were also insertable into older paradigms, were perhaps fated instancings of precisely these paradigms. He seems to be telling us that we are trafficking with spirits, with transcendence, enacting sacramental gestures, playing out ancient roles, all our lives. In this respect, he reconfigures our relation to the divine, suggesting that the surface arrangements we take to be the sole Real— that he took to be the sole Real in his earlier, "healthy" work— must now be seen through, must have the artist's mirror held up to them (as the Sun God looks into the mirror to see Josephson's dark visage), if they are to yield their spiritual contents. We are dead center here in nineteenth-century spiritist land, because time and space no longer avail in this dispensation. The haunting piece titled *Ecstatic Heads* is no less than a family reunion, one that rights the wrongs, erases the severances meted out by history (figure 4.B.19); all the Josephsons are at last onstage together for a curtain call: the beloved dead sister, Gelly, is center stage, with the dead father and mother, Semmy and Gustava, wistfully looking on, while Ernst himself, the infirm prodigal crazed son, takes his rightful place within the group, melancholy (that they are dead) yet proud (that he has brought them together). Yet they are altered: these mildly Jewish Swedes are now fully Semitic, rid of their secular trappings, reunited in an ancient covenant.

First truths and last truths emerge in the sick work, overturning all pieties and certainties that otherwise govern our rational lives. The Nomenclature is everywhere. Josephson sees traffic, mediation, and power wherever he looks, sees the human subject as player in a rich, legendary cosmos where spirit is on the move, where the grand events are still happening. I feel that this is a noble vision, in that it blithely

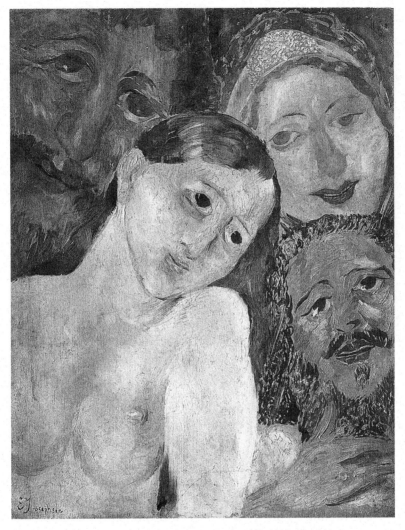

4.B.19. Ernst Josephson, *Ecstatic Heads*, 1889–1890, 41 × 31 cm.
© National Museum, Stockholm

(without fanfare) calls the bluff on the reductive material scheme that most of us take to be real. Josephson, thanks to his sickness, helps us to a larger, more spirited, more generous, more dimensional, even if more terrifying, view of the company we keep.

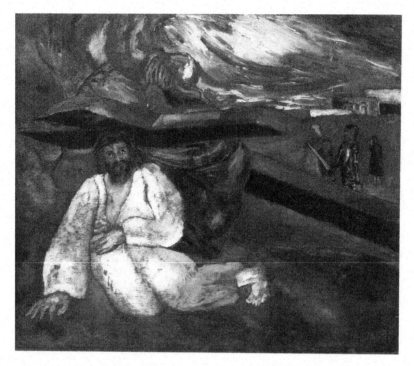

4.B.20. Ernst Josephson, *Jesus*, 1889. Thiel Gallery, Stockholm

He can be boldly schematic in this. The sequence titled *Triptych* is—despite its small scale—a monumental reverie and representation of Power, of the various guises and institutional frames in which power is clothed. When one considers the rich history of political theory, especially as found in thinkers such as Machiavelli, Hobbes, Rousseau, Marx, Freud, and the moderns, how refreshing and dazzling this triptych appears in its sublime economy, its prodigious equation that erases all boundaries between realms, by showing that Jesus, Mohammad, and Charles XVI are *kindred figures*, constitute among themselves a new kind of family romance, a dance of the Nomenclature.

Let us begin with Jesus (figure 4.B.20). Portrayed with the telltale dreadlocks, he seems crushed by the weight of the cross, as well as by Simon of Cyrene who, lifting the cross,

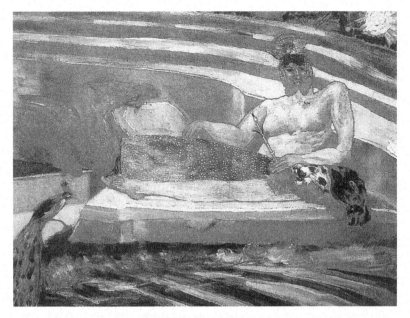

4.B.21. Ernst Josephson, *Mohammad*, 1889. Thiel Gallery, Stockholm

looks down in pity at the stunned redeemer, left arm bent in the recognizable (now dysfunctional?) protective posture, body almost splayed, head bowed, atilt, and dazed, all this against an apocalyptic fiery backdrop of swirling reds, oranges, and whites, creating a blaze of luminosity that seems to contour Christ's body as well, as if he were on fire. A world is in collapse here, an epochal failure is being signaled, for we feel (as we so often do with Josephson) that this sovereign victim is demonstrably unequal to events, bewildered by his own role in them.

Such questioning is seemingly absent from *Mohammad*, one of Josephson's most astounding creations (figure 4.B.21). There is something delirious in this celebration of imperial power, as located in the *superbe* reclining royal despot, reminiscent more of decadent Roman emperors (as implied by the amphitheater backdrop) than an Oriental magnate. If one thinks of the broken, prematurely aged, reclusive painter, or of the crushed Jesus laboring under the cross, as figural coun-

terparts, then the insolent, mad grandeur of this figure becomes even more noteworthy. Godlike in his physical beauty and strength, with a massive torso rakishly emphasized by the raised left shoulder, the long legs stretched out in rest, the face with its red beard looking full throttle at us, the brocaded clothing demurely covering the genitals, Mohammad is a figure of Herculean force, an absolutist reverie with Michelangelesque overtones, not vibrant and corporeally bursting at the seams in the manner of the Florentine but somehow crueler, possessed of infinite and pernicious strength, yet "delicious" as brother to Jesus, brother to Ernst. "Delicious" also because of the malice and wit that Ernst has put into this piece: the heraldic bird is not just folkloric décor but carries a mirror so as to underline the vanity and illusion of all mortal goods, so as to reflect (Mohammad, us) back to the sacrificial figure next door. Finally, the coloration of this piece, like its sibling, *Jesus*, is magnificent: these oranges and reds part way utterly with any realist palette (whether it be Rembrandt's or Courbet's) and offer parallels with Gauguin, while pointing toward to future work of the Nabis and the Fauves. Josephson cannot have seen anything of this sort in 1889 in his confined quarters on Nybrogatan. With visionary brilliance he has combined aspects of Renaissance grand history painting with legendary and folkloric motifs of his own making to produce a fantasia about the parade of power.

Now to the most inscrutable part of the triptych, the narrow sibylline portrait of Charles XVI who links Jesus and Mohammad as figures of failed or flaunted authority (figure 4.B.22). Foppish dandy, with his extravagant red chapeau and outsized plume, stony-eyed figure with orange hair and beard, rigidly frozen in hieratic posture (not out of place at Mme Tussaud's) behind what seems a veil-like coat of threaded wispy mail, Charles XVI stares out at us with his great secret: he is the missing link between Jesus and Mohammad. We know that Josephson referred to himself as Charles XVI, and in some evident structural fashion, he is the mediat-

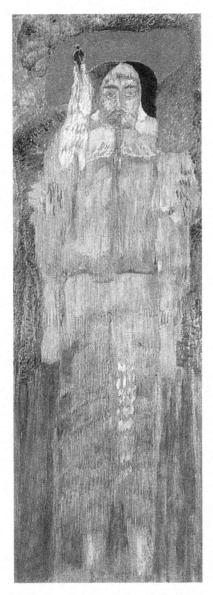

4.B.22. Ernst Josephson, *Charles XVI*, 1889.
Thiel Gallery, Stockholm

ing figure between Jesus and Mohammad.[28] But why this pe-
culiar rendition of Charles XVI? Josephson's confection of
Charles, trumped up in the riotous finery of high fashion (as
if mail-ordered from *Vogue*), casting a lugubrious and unfor-
gettable light on his ideological brethren, spells pure hubris
and vanity, as if to say: *this* is the paraphernalia of power, *this*
is the evanescent froth of all stature, *this* is the Nomenclature
as fashion parade.

One is dumbfounded by this triptych. Where did Josephson
the pious student of history and legend come into such
cynical wisdom? What must happen to you, to make you see
the suffering Christ as brother to both despot and fop, while
eerily honoring them all? Sickness? Breakthrough? Power is
being graphed *democratically*, so that it makes perfect sense
that "authority" in areas as diverse as religion, politics, litera-
ture, art, family, and school would be revealed as always/
already just plain old power. Josephson seems to have gone
through the looking glass, to have gone over, under, and
around his era while still believing in it. He continues to
love pomp and circumstance no less than he did when young,
but a maniacal element of play has entered the picture,
lending wit and irony to these depictions of grandeur. We
begin to see elements of whimsy and tenderness in many of
the drawings of the Sick Period, and it is evident that Joseph-
son's understanding of victimization has broadened, moving
from the melodramatic to something harder to define, some-
thing closer to a notion of children caught up in a world they
never made.

Consider the rendition of the folkloric hero of nineteenth-
century Finnish military romance, Sven Duva (figure 4.B.23).
Josephson produced an entire set of spirited, tossed-off draw-
ings for an edition of Runeberg's *Fänrik Ståls Sägner*, but none
quite catches the madness of war and heroism, the cultural
folly at work here, so perfectly as this depiction of the hapless
Sven Duva (traditionally seen as icon of valor), now viewed
as *pauvre type*, the little man of good-will utterly unequipped

4.B.23. Ernst Josephson, *Sven Duva*, n.d.

for his role. Jesus under his cross is now the helpless soldier with rifle and bayonet, and once again there is self-portraiture in the Jewish-looking military man with a top hat, standing quizzically at the ready, prompting us to ask, "what is a nice boy like you doing in a place like this?" as we see in the background a tiny horse leaping down with its gallant officer in place. This drawing is so at odds with Runeberg's famous lines about the martial Sven Duva that an almost Brechtian feeling emerges here, as we gauge the disconnect between *l'homme moyen sensuel* and Great Events.[29] Educated Swedes remember especially the famous last line of the poem: "Ett dåligt huvud hade han, men hjärtat, det var gott" ("he had a bad head, but the heart, it was good"); might this be emblematic of Josephson himself?[30]

We see in these drawings a rare fusion of childishness, good-will, and absurdity, as if Josephson were taking a second look at the diet he has absorbed. At the other end of the "private truce," schlemiel-like pieces, we find that Josephson can produce an overheated militarist phantasmagoria of his own, when need be, but he locates his violence in the body, not in the culture. Here we consider a battery of drawings that foreground the human body's indwelling power and libidinal wants and fears, in ways that are just as startling and unpredictable as the religious depictions of revelation and miracle. Perhaps the body is ultimately as shocking, as uncharted, as off-limits to traditional mimetic practice as the soul is. Josephson seems to be hinting that traditional realist work loses on both fronts: it cannot depict either spirit or matter. It is as if all the earlier work were a kind of practice run, a longish stint with surfaces, but now it is time to go for the essentials. Let me recapitulate what is at stake in this argument: the experience of "sickness," in this case paranoid schizophrenia, reshapes Ernst Josephson's personal and artistic vision, leading to radical versions of both soul and body. Norms (the agreed-on lineaments and contours that shape familiar things) go up in smoke. The mania here testifies to a roiling, volcanic view

of somatic life, telling us that poise and control are whimsical fictions. This is what Josephson now knows. Why not connect it to the gods?

Hence, the most explosive and "far out" body of body work in Josephson is his series of drawings of Norse gods. We are now at the utter antipodes of the spiritual and immaterial radiance of *Gåslisa* and *The Holy Sacrament*, although the meditation on "godhead" remains constant. This time, all is corporeal: wildly, extravagantly energized and violent FLESH. Josephson renders the Norse gods as if they were a conflation of Neanderthal man and today's iron-pumping body builders, with the added caveat that these creatures seem crazed, possessed, "berserk" as it were, bent on pleasure and mayhem with an emotional frenzy that is off the charts. We might be tempted to label this sequence "primitive," but it has a physiological and roiling power that make the work of, say, Picasso in the twenties, look static and serene. And it blows to smithereens any polite, romanticizing, nostalgic view of the ancient Nordic past, as is usually served in a time of national romanticism. (Consider Carl Larsson's enormous murals in the stairwell of Stockholm's National Museum as prime exhibit of such a nostalgic view.) In fact, the figure whom Josephson strangely calls to mind in these rollicking portrayals is Rabelais, another visionary who put his gods on parade, in the form of bloated giants and lusty fornicators. Needless to say, the nineteenth-century, choked-checked bourgeois Swede cannot marshal the sixteenth-century Frenchman's boisterous and bawdy exuberance, but each one is fashioning an "anatomy" of sorts, a rendering of the great forces that animate both their world scene and their private psyche.

Let us start with *Odin's Entry into Sweden*: this stocky, bicep-bulging, naked warrior leads a parade of naked and craven slaves, as well as fellow soldiers, and this figure of bursting manly power looks head-on at us, as if hypnotized by his own might and prowess (figure 4.B.24). There is nothing gracious about these bodies but much that we can recognize in our

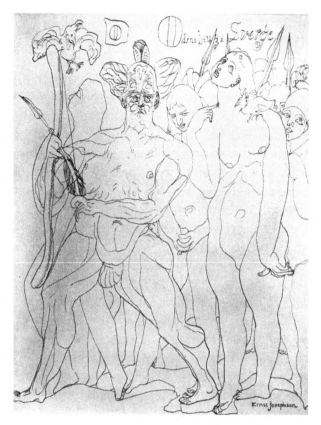

4.B.24. Ernst Josephson, *Odin's Entry into Sweden*, n.d., 31 × 24 cm.
Waldemarsudde, Stockholm

own contemporary era of body fetishizing, of cultist adoration
of limbs, muscles, and biceps. We have little problem under-
standing here that the body is the locus of godlike power:
Odin's authority is strictly, dazzlingly physical. The bodies
depicted in this series are not only over-endowed, they are
also "caught" in bouts of furious, sometimes deadly activity.
Still more extreme along these lines is the Rabelaisian rendi-
tion of Fjolner: gargantuan body, depicted magisterially in the
swoop of a single unswerving line that shapes buttocks, toes,
and protruding gut with great vigor, and then offers a com-
plex, almost capsized view of the thrown-back torso, the two

420

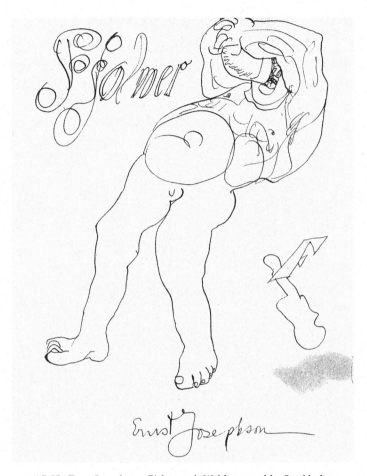

4.B.25. Ernst Josephson, *Fjolner*, n.d. Waldemarsudde, Stockholm

huge arms clutching the horn filled with drink that seems to be almost rammed down the throat of the figure's open mouth, belonging to a face that consists only of lips, tongue, teeth, and part of one eye (figure 4.B.25). As if to compensate for his truncated and audacious portrayal, Josephson has thrown in a fanciful "F" on the bottom that seems to cut across a phallic-like protuberance, making us realize that Fjolner's genitals are otherwise undrawn on the body itself.

That the carnal violence of these drawings has a sexual dimension is evident in *Ingjald Illråda*, a depiction of crazed

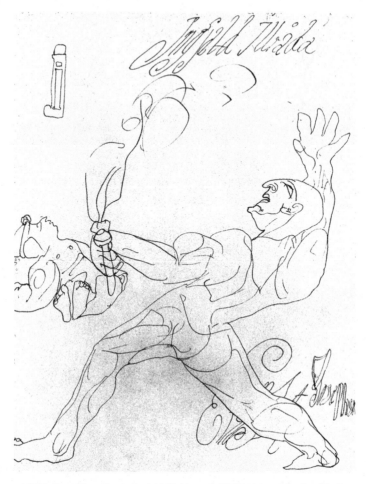

4.B.26. Ernst Josephson, *Ingjald Illråda*, n.d. Waldemarsudde, Stockholm

rapine energy, with the powerful, arched, bursting male body, replete with outsized hand and burning torch, balanced by a supine female figure, either dead or unconscious, lying strangely askew (figure 4.B.26); the composition is completed, once again, by a weird tubular, organ-like structure very like a penis, floating by itself at the top of the piece. Carnal frenzy, overdeveloped, knotted, sinuous and bulging tissue, muscle and vein, seem to coexist with sexual anxiety, as we see even more acutely in the rendition of Niord, Norse god of fertility,

422

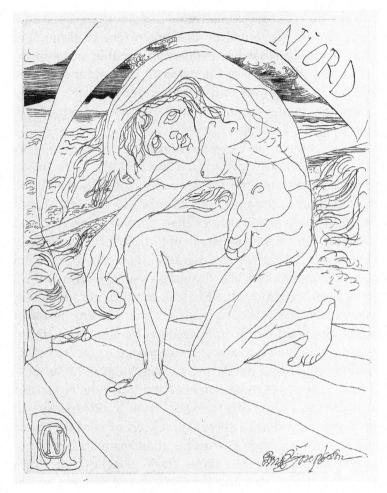

4.B.27. Ernst Josephson, *Weather God Niord*, n.d. Pen and ink.
Waldemarsudde, Stockholm

whose rippling body is bent into a posture of self protection—
putting him in the family of Näcken, Gåslisa, and others who
are threatened by what must be their own performances and
visions, by the tumult they inhabit (and which inhabits
them)—with the sail replicating the cradling position of the
arm (figure 4.B.27); in this case, however, the threat is perhaps
reified in the penis-like rudder that Niord grasps in his right

hand, as if the true and unavowable directionality of his body and power were governed by that organ. The castration scenario readable in *Satyr* has evolved in peculiar ways in this series, in that the displaced penis is all the wilder and more potent for being cut off and drawn independently, despotically energizing and commanding these hulks of muscle and tendon to do its bidding.

Much is obscene and excessive in these renditions of the human body—a body now goaded and flaunted in its physiological lineaments and mechanical parts, a body that is simply unthinkable and certainly unviewable in the realist portraits—as if Josephson's sickness had opened his eyes to bodies (starting with his own), made him discover how intricate, grotesque, authoritative, and maniacal they can be, as is evident in an uncensored late drawing of 1892 (figure 4.B.28). Short of pornography, very little serious art depicts men with erections, but one is struck, here, by the seeming independence of the erect penis, unthreatened by the saber, its upward thrust unrelated to any expression in the face (but ready for service, regarding the fleshly crowned female at his side), as if this energy system had no need to inform the brain of its doings. He then turns this frenzied vision to the spectacle of history and legend, and shows us a kind of carnal extravaganza, not unlike today's wrestling matches with their bulging, over-the-top rippling stars. These sketches must have seemed sick or demented in the 1890s, but they have an odd propriety a century later, fitting nicely into a cartoonish culture of body worship and exercise mania. Is he holding up a mirror to our age? Maybe, oddly enough, he is: our mix of body mania and New Age spirituality has plausible parallels with the dual perspective encountered in Josephson's work.

Let me close this discussion of the body by referencing one of Josephson's most beautiful and achieved drawings, *The Judgment of Paris*, in which the full, rich forms and volumes of the female body attain a kind of classical harmony and serenity that look back through Botticelli to Antiquity, and for-

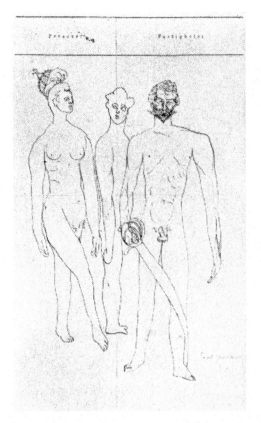

4.B.28. Ernst Josephson, center image from *Three Drawings*, 1892. Pen and ink

ward to the work Picasso is to produce three decades later (figure 4.B.29). Here, as elsewhere, Josephson's deformations of the classical nude—elongated arms and legs, hieratic postures, frozen rites, blank expressions—take on a kind of haunting beauty, as if to show us a prior world of physical grace that preceded the advent of consciousness, a world we might call classical or even Edenic. Whence come these deformations? Does it really help to label them "symptomatic" of his schizophrenic condition, to reduce them to unwilled pathological gestures? We will never know what the sick painter intended, but we do know that human form is transfigured in this late work, and that our own eyes are opened

425

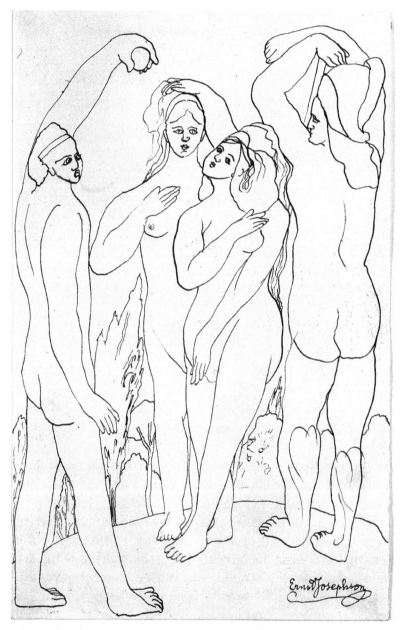

4.B.29. Ernst Josephson, *Judgment of Paris*, n.d. Pen and ink, 35.8 × 22.6 cm.
National Museum, Stockholm

to possibilities of violence and beauty beyond the pale of mimetic art. Finally, when one aligns the religious, visionary pieces with their shimmering immateriality alongside the sinewy, exhibitionistic, corporeal exercises (or, indeed, the gracious anatomical dance, as in *The Judgment of Paris*), we feel that a new kind of logic and art are coming into focus. This new vision of the artist quietly (mutely) suggests that the accomplished early work was fenced in, locked into a representational code that had, finally, no access to either soul or body. That Josephson's sickness opened these doors of perception seems undeniable, even if it cannot be proved.

As we saw in the triptych equating Jesus, Mohammad, and Charles XVI, Josephson's sick work is drawn to the modalities of power, something no less visible in the drawings of the Norse gods. This obsession with power may be thought of as a kind of nineteenth-century cultural anatomy, the work of a mind saturated with the images and icons of the Great and Grand, now reconfiguring them through the lenses given to him by his sickness. To reduce this work to some version of "storhetsmani" ("obsession with greatness"), as some have suggested, seems to miss out on the larger project of making visible the gods that rule the Western psyche. This project is more, not less, interesting and engaging, when we factor in the fear and anxiety present in much of this work. Of course, we can put him on a couch and explain his anxieties in terms of a family romance, but it makes more sense to focus on what this vision yields (rather than on its genesis). Josephson saw himself as the chosen Redeemer, but also as the hapless, under-equipped Son, called on to rival as well as depict the omnipotent Father. His eerie and enigmatic drawing of *David and Goliath* underscores the brutal lopsidedness of this agon (figure 4.B.30). The frizzy-haired, overtaxed David seems crushed by his task, as evidenced by his hunched and slack body, and by the weird strings that seem to tie his weapons (his balls) to his nose, on the order of an oxygen supply that is malfunctioning, showing us an almost maimed figure

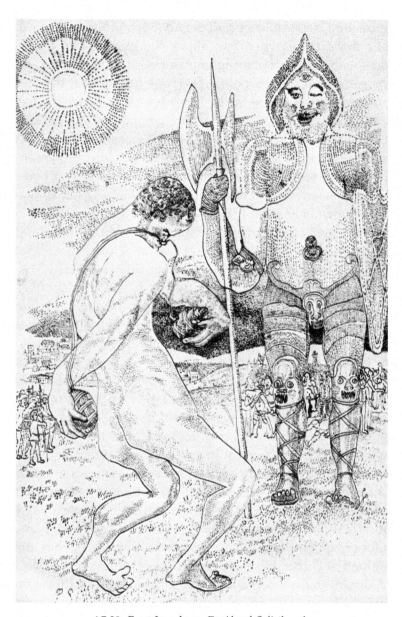

4.B.30. Ernst Josephson, *David and Goliath*, n.d.

caught up in his own mesh; meanwhile, his powerful antago-
nist, outfitted with three eyes, massive armor, and a host of
sharp-teethed mocking faces (located at critical junctures such
as navel, genitals and knees), looks on leeringly.[31] Is this fair?
No shield imaginable here. No contest.

Further, the stupendous depiction of *The Creation of Adam*
bears definitive witness to the Oedipal crisis at hand (figure
4.B.31). This piece, obviously modeled on Michelangelo's
grand tribute to the new divinity of Man, is a tragic study in
contrasts: Josephson's Adam—supine, fearful, balding, frizzy-
haired, body slack, splayed, and awry, genitals unknown but
sprouting flowers—is unmistakably a portrait of the artist,
whereas God the Father is a huge, fearsome, radiant, all-en-
compassing, all-indicting divinity of smoke, air, and cloud,
looking down in contempt at his sorry creation, almost burst-
ing the very canvas that barely contains his divine counte-
nance. The inspiriting breath from God to Man may well be-
stow life, but not hope or dignity or a fair chance to the
hapless creature who seems to foreshadow Eliot's famous
line, "like a patient etherized upon a table."[32]

"Etherized" is perhaps the right word for the sick Joseph-
son, a god-struck man both dazed and crazed by majesty, as
is memorably recorded in the photograph of the sick artist,
decked out with scotch cap and toy sword and apartment
drapes, ready to march in front of the Royal Guard on the
streets of Stockholm (figure 4.B.32). Josephson the walking
wounded, Josephson the crippled Renaissance artist lost in
time, Josephson the infirm man who nonetheless dared the
gods through his demiurgic art, is visible in the late self-por-
traits, most provocatively in the rendition where the artist's
brush creates (*through* rather than *on* the canvas, one wants to
say) a lethal, bleeding dagger, just as the artist's hand pene-
trates the palette, reaches out further and still further, accom-
panying the anguished eyes and the pursed mouth, both en-
listed as sources of vision, utterance, and art (figure 4.B.33).
Breaking through is inseparable from broken through. The

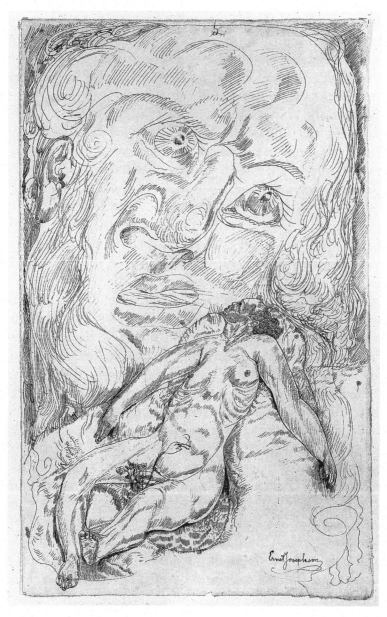

4.B.31. Ernst Josephson, *Creation of Adam*, after 1893, 38.5 × 24 cm.
© National Museum, Stockholm

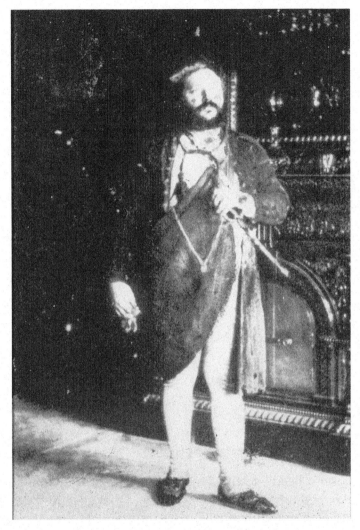

4.B.32. Photo of Josephson, early 1890s

poignant, late sketch of Beethoven, tossed off (by the otherwise bedridden artist) shortly before his death, in response to hearing a sonata played by a friend—hand clutching heart while bloody musical notations come forth, gather mass and energy, lay waste to the face, move into space, all under the gaze of a gentle protecting spirit that holds its hands over the

431

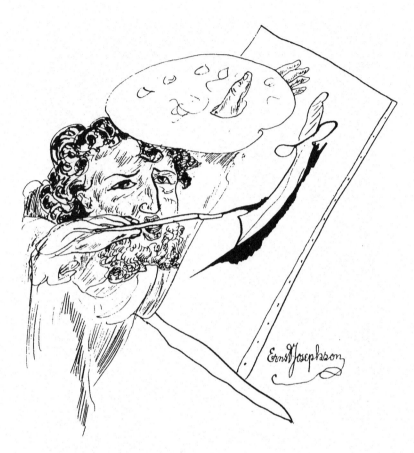

4.B.33. Ernst Josephson, self-portrait with palette, n.d.

composer's head—testifies to the same tragic view of art as godlike medium of suffering, a message that goes all the way back to *Näcken* (figure 4.B.34). Holding this ink drawing still wet, Josephson declared he had received a visit from the master, and he had responded.

The final Josephson work I discuss is, in my view, his greatest and also his most triumphant achievement: the fiery portrait of his uncle, Ludvig Josephson, done in 1893 (figure 4.B.35). In this final portrait of the Father, Josephson returns to the full vigor of oil paint—the works of the Sickness Period are mostly drawings and water colors—but this portrait re-

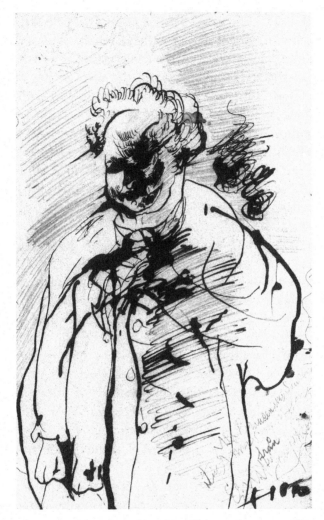

4.B.34. Ernst Josephson, *Beethoven*, 1905

sembles no other Josephson canvas. Ludvig, acclaimed the-
ater director (and lifelong mentor to Ernst, true ersatz-father),
is shown directing a rehearsal for *A Midsummer Night's Dream*,
his left hand poised over the Shakespearean text, his exalted
face staring intently and demandingly into the distance,
while his right hand rings the bell, signaling the actors to
come. The brown and red leather tones, as well as the hiero-

433

glyphic-like background, evoke a rich, Oriental setting, as does the traditional fez worn by the visionary man of the theater. Millner's description of the background is worth citing: he compares it to "the disintegrating wall of a catacomb, its color rich and effulgent as if age and time had conspired to contribute to its texture" (55), stating that we are far from the contemporary realms of either realism or plein-air impressionism. Against this remarkable backdrop the figure of Ludvig seems to burst through—rapt face, electrified expression, visionary force—as if propelled by its own indwelling force. Blomberg rightly compares this exalted, explosive figure to the Moses of Michelangelo.

Arguably the most astounding feature of the piece is that right hand with the bell, because it seems to spring, full-blown, without arm, without debt to human anatomy, from the shoulder of Ludvig, hurtling, almost like a missile, from his body toward the viewer. Yes, we are of course free to pathologize this remarkable hand, to brand it a symptom of Josephson's psychic disorder—and a number of the drawings from the Sickness Period have gross anatomical inaccuracies, such as limbs in erroneous positions or out of proportion—but it makes ultimately more sense to see this as a spectacular form of artistic liberty, to link it to the epochal breakthroughs in spatial representation that modernism and cubism are to bring.

With this portrait, we are witness, once again, to the spectacle of Power. Jesus's spiritual force, Mohammad's fierce strength, the Norse gods' unbridled energy: all is present here, recast as the drama of art itself. Josephson is reverencing the miracle of creation: Ludvig's (peremptory) summoning of actors, Shakespeare's tale of feeling and/as magic, and the painter's own valedictory tribute to these tutelary spirits, to his uncle, to himself. Likewise, with some poetic license, we can say that the stage is set for the ultimate spiritist séance: the traffic of spirits, the flow of life, over time and space, from Renaissance England to 1893 Stockholm, from letter to life.

Not unlike Näcken's golden fiddle, the white page with the black markings is a source of enchantment, an instrument that awaits its master so that the spell can be cast. Ludvig possesses that mastery, as we see in his exalted expression and his active hands: one ringing a bell, the other fingering a text. So, too, does Ernst now possess that same mastery, as the painting itself demonstrates. The miracle of trans-substantiation is at hand: Ernst the son celebrates the power of Ludvig the Father, but he, too, comes of age here, shares in the potency that generates life through words and paint.

As I have suggested, nothing conveys this breakthrough more forcefully and prophetically than that exploding hand that comes like a meteor out of the body, out of the canvas, with the brilliance and insouciance to be seen in the cubists several decades later. The sick Josephson once declared that God has no hands; a Freudian reading would refer to onanism and to the prohibitions suffered by the young painter. But a painter is preeminently a person with hands, with demiurgic hands, and there is something profoundly right about this insolent hand that seems to be soaring toward us. With that hand Josephson *breaks through*, bursts into modern art. We are now far from the familiar cradling and shielding posture of so many of Josephson's works, a posture that denotes the unfaceable, upending forces that besiege the Josephson subject, whether it is Näcken or Jesus or Niord. This insolent, triumphant, empowered hand announces a new authority; just as Ludvig himself stands confident of his magic, so, too, does Ernst, not unlike Prospero, the ruler of his domains, not unlike Obe-Wan Kenobe in sovereign command of The Force.

Still more shocking is the actual disposition of the hand on the canvas, because we see, upon closer inspection, that it emerges from (is painted over) something already there: an entire figure of a man, an executioner in fact, belonging to a much earlier canvas, a historical tableau, that Ernst had painted and is now reusing, turned upside down. But that is not all: the hand grows, quite perfectly, from between the

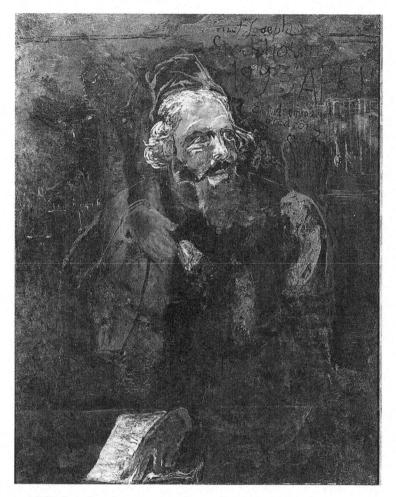

4.B.35. Ernst Josephson, portrait of stage director Ludvig Josephson, 1893, 137 × 109 cm. National Museum, Stockholm

legs of the executioner (an arrangement one sees quite clearly when the painting is subjected to infra-red treatment), leaving us with Josephson's final allegory of art and power (figure 4.B.36).

The artist's hand emerges from between the executioner's legs; the creative organ of the artist is indeed the hand, not the penis (certainly not the penis of the anxious Ernst Josephson). The hand makes life, makes art, makes the past live,

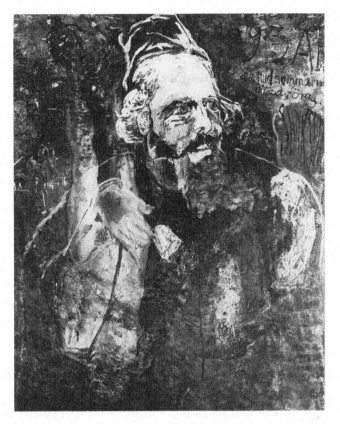

4.B.36. Infra-red photo of Ernst Josephson portrait

makes the uncle eternal, makes Ernst a life-giving, siring art-
ist. One is stunned by the serendipitous poetry at work here.
The sick artist—who, in the past, often imagined himself cru-
cified, sometimes literally executed—overturns and over-
comes the deal-dealing power of the Fathers, transforms the
business of execution into the production of life and art.[33] This
"Executioner's Song" signals back, I think, to the pent-up
enigma, the constrained libidinal wellsprings already present
in the Water Sprite paintings of a decade earlier, but now
Näcken's throes are over. Sexual desire and artistic creation
are fused in a scene of great mastery, a summoning of spir-
its—textual, theatrical, animal, religious—that moves trium-

437

phantly beyond the judgment scenario of *Andeprotokolen* and carries Ernst himself into the Promised Land. *Genombrott.*

The portrait of Ludvig is Ernst Josephson's supreme achievement, in that it links together the facts and fictions of his life, pays homage to his family, keeps covenant with the line of earlier portraits, honors the Great Dead of the past, and is at the same time a masterpiece of transfigurative art, boldly remaking the human form, bearing witness to the passage and flow of spirit. This painting—unthinkable in the healthy years—is at once searing (in its double propulsion into the beyond and the within) and homing (in its boosting of Ernst into his estate, at last). Yes, this work is a visionary product of Ernst's sickness, but it enables him to make a figure of his entire life.

And that is how I want to conclude. The art of Ernst Josephson's Sickness Period enables us, the viewers, to reconceive our arrangements with body and spirit, our negotiations with Power and Nomenclature. Josephson's example epitomizes the rationale of this volume: this art refigures over time—over his time from sanity to sickness—what it means to have a body, what it means to have a soul. Josephson's madness pulls him out of the circulation of life, but his art during this period tracks exactly that: the circulation of life. Seemingly injured for good, seemingly undone, Josephson actually resembles Orpheus, or that Sun God whom he rendered as his double. Like so many of the figures treated in this book, he is drawn to the power of life, a power he reverences in all its guises: artistic, sexual, political. Out of this pursuit emerges, bit by bit, something like a new human map, one that charts our traffic with the spirits. Such work deserves to be known. Every life is shot through with such gleamings and contacts, but for most of us, it all remains opaque, in the dark. Josephson gifts us with a landscape that is, ultimately, as much ours as his, and in the strange pieces delivered in pain we may see our own lives, transfigured.

— 5 —

CONCLUDING THE BOOK

Introducing Strindberg the Painter

It may well be thought that the coloration of Scandinavian literature and art, as seen in the various works selected here, is bleak, essentially reaffirming the common cliché that the Nordic mentality is a brooding, depressed proposition. There is not a great deal of oozing happiness in these works, few gratifying endings, little celebration of human potential and human savvy, minimal uplift in general. Even the children's books of Astrid Lindgren have a foreboding sense to them, inasmuch as Mio and Rusky pay a high price (the highest price, one could say) for the achievements they carry out, and Ronia's maturity and prospects entail a painful and permanent break with the Father. Nothing particularly cheery in sight. No one rides off into the sunset or lives happily ever after.

My group of writers and artists may also appear to be a God-haunted bunch receiving a good deal of punishment: with the exception of Kierkegaard's Abraham (himself tested to the core), the rest seem either bruised or destroyed: Eyolf and Unn die outright, but we have also seen a parade of broken or damaged figures whose futures seem unchartable,

such as Ibsen's Allmers or Strindberg's Captain or the hallucinating visionaries of both *Inferno* and *Hunger* or wrecked pythia of Lagerkvist or Siss the haunted survivor or the dyad of nurse/actress in *Persona*. Then there is the long-lived Munch who seemed to be (creatively) nursing his injuries throughout a lifetime, and we cannot forget the mad Josephson whose most fascinating art grew out of his total undoing. If we tally the destinies of these figures, it must seem that *genombrott* is a well-nigh fatal concept—breaking through appears almost inseparable from being broken through—and this Scandinavian fare is tough medicine indeed.

Well, it is tough medicine. But it is medicine, and it is tonic for just that reason. Reconsider, in this light, the concept of *brooding* which seems to apply to so many of these works and artists. Having taught these materials for close to three decades, I am familiar with the knee-jerk response so often accorded to a Bergman or a Munch or a Strindberg: why go there? (as they say today). "Why go there?" means, among other things, that life is dark enough without adding to the murk by studying a culture of gloom. My answer is: brooding is a good thing. Brooding has nothing to do with navel gazing or self-absorption. Brooding betokens a willingness to think through the events that befall us, and to stay focused on them long enough to begin to take their measure. Brooding goes against the American grain, as is so evidenced by the inevitable advice we are given when we are down: *get on with it.* Brooding entails a respect for the depths of human experience—the depths, not the pits—and its corollary is: one does not saunter into either knowledge or wisdom. Brooding is a way of taking life seriously. "You have to rake up the leaves before you have the bonfire," Faulkner wrote in *Absalom, Absalom!* and, to me, this defines the very rationale and raison d'être of difficult art: it obliges us to work—to work for our bread, as Kierkegaard wrote—and it does so because otherwise we go hungry. Otherwise there is no bonfire. Hence I suggest that there is a special light in Scandinavian literature

and art: it emerges through the darkness, and it is the light of labor and reflection, the light of *earned truths*. Let us talk about that light.

At a moment of desperate lucidity, Strindberg's undone Father (in the play of that name) says, "my thoughts dissolve into mist, and my brain grinds emptiness until it catches fire." It is worth noting the agrarian verb Strindberg enlists: to *grind* emptiness, as one might grind corn or wheat, in order to transform it into something else: a production of energy, a combustion. The luminosity of these texts is often of this order. On the far side of suffering and dramatic action, it tells us of the vital residue that unhinging experience brings and leaves. The Father says "emptiness" to indicate the riddle of his condition, but there is nothing whatsoever empty in this depiction of patriarchy's props collapsing, one by one: law, fact, language. We are far from some Mallarméan sibylline verse or even Shakespearean blankness; instead, an entire ideological order is spectacularly in flames, as male pretensions are undone. The ideological order—indeed the cosmic order—is what is at stake in every one of the texts studied in this book. Kierkegaard uses his narrator, John of Silence, to brood on the impossible cogency of Abraham, the man asked by God to slay his own son, and this act of brooding charts the utter breakdown of ethical codes when it comes to grasping the nature of the sacred. We the readers are like those churchgoers who Kierkegaard says would be scandalized if anyone *actually* committed the deeds God commanded. *Fear and Trembling* explodes the precincts where we keep house, and puts us on notice that our measuring sticks are worthless, that the fables we grow up with and give lip service to—Abraham's pact with God, Mary's divine birth, the life and death of Jesus—are unhinging and terrifying once we brood on them, take them seriously, imagine them happening to us.

The stature and nobility of these Scandinavian materials derive from their unflinching gaze, their principled exploration of our larger circumstances, and of our fit or misfit within

those circumstances. All these characters—not merely Abraham—are, in some vital sense, *tested*, put on trial, as the cost of citizenship in a larger scheme. Lagerkvist's story of the pythia shows us that the god can lodge in our bodies but that this economy kills us, annihilates any possible self-knowledge. Strindberg's writhing figure in *Inferno* bitterly describes himself as the tool of the gods, the *jouet* they play with, much the way Lear understood their divine sport. Willpower and self-determination are the first and most enduring casualties in this body of work (no matter how inscribed those fine virtues may be in Scandinavian values). Ibsen's Ratwife explains to the soon-to-die Eyolf that the governing force in life is *må*, not *vil*, "must" not "want." *Må* is the driving power that takes Unn into the Ice Palace for her fatal undoing. Edgar, in *The Dance of Death*, goes through his death throes repeatedly, as recipient of what Swedenborg would have called a *vastation*, an annihilation of all human and personal design under the onslaught of the divinity. Hamsun's hungering protagonist claimed that God had touched him too hard, had poked an unfillable hole inside him, which he seeks (manically) to fill through his performances. Ernst Josephson was touched even harder on Bréhat, and spent the remainder of his life finding ways to show what he saw when the gods and the great came visiting. Munch knew himself to be an initiate of inhuman forces—sickness, madness, and death, he called them—and devised a pictorial language for them. Bergman's cannibalistic fantasia in *Persona* puts paid to fond notions of bounded identity, as we watch these two women dance their crazed pas de deux. Even the children take their place on the larger stage, a place bigger than self or human design. With heartbreaking immediacy, the young heed the call: Eyolf goes under, as he enters the elements, and Unn cannot resist the majesty of the Ice Palace. Sometimes the forces aid them: Mio receives help from the natural world at critical moments. Rusky fights tuberculosis, evil, and death, in that order, and finishes with a second leap from life. Cronqvist's emancipated children seem

to be a new species altogether: at home on the beach, in the water, while playing sovereignly with the toy parents they utterly control, they display the ease of an alien. None of these works comforts us.

One of Cronqvist's most haunting paintings is a self-portrait where she appears to hold the marionette girls by the strings—except there are no strings. It is an arresting image of the fate of the subject in this Northern fare. We are buffeted by forces within and without, but we cannot see them, just as we cannot see molecules or love or hate. One is a manikin, a toy, a *jouet*. It is the fate of Abraham and the Sibyl, of Eyolf who is drawn into the deep, of the Captain as he enters the straitjacket. One finds oneself to be a *speaking tube*, as Strindberg memorably shows at the end of *Miss Julie*, where the Count's power is concentrated, totem-like, in that domestic implement; one might locate a great deal of Strindberg in that image, including the protagonist of *Inferno* who listens in at the electric wires, who is lifted from his bed by electric currents. Josephson thought himself (with good reason) a figure hanging in the wind, beset by forces, filled with voices; in *Näcken* he placed the feeling subject (physically and affectively) in the flowing waters. We are puppets, but no one sees the strings. We move others, but no one sees the strings. These texts bear witness to our immersion in a force field beyond our ken. They report on what it feels like to be in the maelstrom.

The early Swedish response to Ingmar Bergman's great questing films was something on the order of embarrassment. Why, people wondered, is this man so obsessed with God? Why is he so driven? In a culture that took pride in its rational order, its evolved sense of social justice, Bergman's tortured work seemed either purple or archaic. It should be clear that I am on Bergman's side of this debate, since I believe he is among the great spiritual explorers. He rocks the boat. So, too, did Kierkegaard, Ibsen, Strindberg, Munch, Josephson, Hamsun, Lagerkvist, Cronqvist, and (even) Lindgren. Each is a car-

tographer of sorts, bent on charting our whereabouts in a scheme we did not invent: our own bodies and minds, the stage we are put on, the forces that both inhabit and assault us. Breakthrough over and over. Tough medicine, I said, but exhilarating as well, for it revises, upward, the mean equations one thought to be operative in life. Reason does not prevail, common sense does not take the measure, docile appearances contain surprises, our seemingly closed contours are in fact porous and home to much traffic. No one is massaged exactly by these tidings, but we are shocked into a more generous view of our arrangements.

The view I present of Scandinavian literature and art is not likely to attract droves of tourists to the shores or woods or fjords or hotels of these northern countries. This body of work offers few easy gratifications. And yet, I would argue, these rich and strange performances are irresistible in their own way. They open our vision, extend our purview. Things are larger than one suspected. What things, you might ask? For starters: our view of marriage and human relations. Strindberg's *Father* and Ibsen's *Little Eyolf* explode the family unit in the same way nuclear fission breaks the armature of the atom, and, lo and behold, fathers are undone, become children; comparable explosions and transformations are to be found in Vesaas's account of two eleven-year old girls' passionate infatuation or in Bergman's monstrous double-face of two women merged together. And the actors may be more than human: God commands the death of Isaac as well as the ravishing of the Sibyl; the Rat-wife escorts Eyolf into the deep waters; and Unn is drawn to a rendezvous with the Sun God. Munch graphs the forces along libidinal lines—scream, jealousy, anxiety—and Josephson finds/loses himself as host to invading spirits.

Power—which escapes visibility in our normal scheme of things—wears garish colors in these works: it comes through walls as electricity and sucks at the heart of Strindberg's protagonist in *Inferno*; it bores a hole in Hamsun's starving writer

444

and triggers his mania; its rites are enacted through effigies and dolls in Cronqvist's series of despotic girls; and it is homicidally unleashed in Bergman's *Fanny and Alexander* as the boy kills his stepfather through desire alone. None of these displays is particularly pretty, but they get our attention, because they transform our everyday arrangements into something bristling and charged. One is *shocked*—conceptually, emotionally, one wants to say electrically—by these materials.

I have elected to close this argument, and this book, with a brief look at a body of work that offers what may be the purest expression yet of the operation of Power in the Scandinavian scheme: the paintings of August Strindberg. I would surmise that many of my readers are unaware that Strindberg painted—or that his paintings warrant our attention. Like so much else in this book, these paintings have yet to garner the recognition they deserve; yes, they are known and valued by the connoisseurs within the art world—although they were considered largely incomprehensible when he produced them—but the general literate Western public thinks of Strindberg exclusively as a writer.[1] What kind of painting would come from a person thought to be egomaniacal and possessed of a number of toxic compulsions (misogyny only the most well known)? Surely one would expect a series of self-portraits,[2] or, at the least, some kind of figurative work depicting Strindberg's grand but assailed condition. Do not forget that he was in very close contact with Munch during the eventful Berlin months in 1892–93, that they even exhibited together in Berlin. For all these reasons, and more, the Strindberg paintings (of the early 1890s and a decade later) amaze.[3] They are virtually nonrepresentational. They seem to exist on a different planet from most other nineteenth-century paintings, with the possible exception of Turner's work which Strindberg saw only *after* he had already established his basic model (although his visit to London in 1893, where he encountered Turner's work face to face, clearly left its impact).[4] Strindberg's paintings look unmistakably forward to the mid-

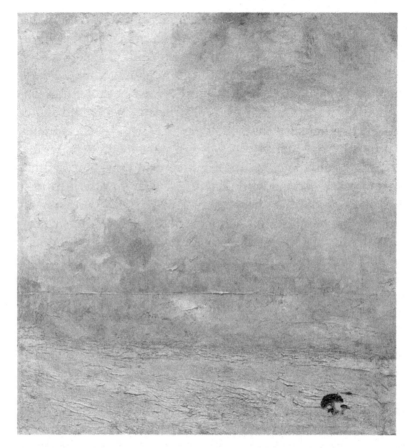

5.1. August Strindberg, *Lonely Mushroom*, 1893, 47 × 45 cm

twentieth century's love affair with abstract expressionism and action painting.[5]

Let me begin with what I take to be the funniest work Strindberg ever wrought: a painting done in Berlin in 1893, *The Lonely Poisonous Mushroom* (figure 5.1). Done in what seems initially a mature impressionist style, this piece mixes its registers so that the familiar merging of beach/water/sky (which owes so much to the depiction of light) is carried out by a tactile, sensuous, indeed rugged rendition of surfaces, so that the sand almost seems like clay and the whole painting possesses a thickness of surface, with little ridges and excres-

cences and layered markings of astonishing density (as if laid on directly by palette knife), pointing already to the work of a Dubuffet. There is a stunning materiality here that is quite at odds with the airier productions of impressionism, yielding a viscous world in which sand and water and air are all thick and scaly and heavy. The painting also sports what is to be Strindberg's trademark: an insolent horizontal border (established by a thin razor-like ridge of paint) that slices across the middle of the piece; one feels Rothko already waiting in the wings. What is there to laugh at? The lonely poisonous mushroom, of course, tucked away in the bottom-right-hand corner, insisting on growing and surviving in this utterly inhospitable landscape. Not just one mushroom, however, but rather a little family, consisting no doubt of toxic daddy with his large red umbrella cap, and then the little guys growing under his wing. Here is the representational Strindberg: a minimal rendition of a familiar substance but chosen in such a way as to invite personification, as if this were an oneiric family portrait, recasting the tempestuous leonine Strindberg as small-but-venomous element holding his own (and protecting his own) in a harsh world.

The next work to examine is *Underlandet*, roughly translatable as either "The Underworld" or "The Land of Miracles"; both titles seem right (figure 5.2). This piece was done in Dornach in 1894, a time of unrest but also of sustained marvelous paintings, when Strindberg and his second wife, Frida (expecting a child), had a short but idyllic stay, visiting her family. We note immediately that it has the shape of a wreath, of a thickly interwoven natural setting that encircles a wondrously luminous "hole" in the center. In his important essay on the role of chance in artistic production, Strindberg describes the way that this work was both conceived and executed.[6] He starts with an undetermined motif, some form of shaded forest interior from which one glimpses the sea at sunset. To achieve this, he takes his palette knife (he owns no brushes), spreads his paints on the board (no canvas),

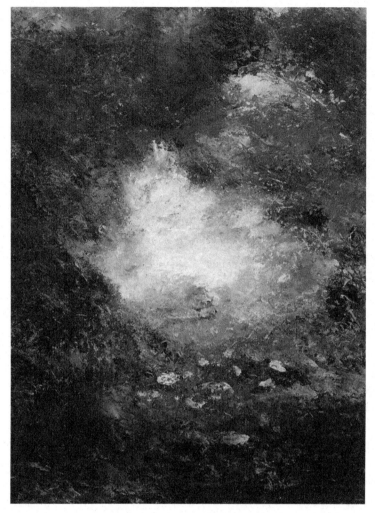

5.2. August Strindberg, *Underworld*, 1894, 73 × 53 cm

working quickly to achieve a sea horizon in the middle and greenery, brush, treetops spread out in color groups (always harmonious, he assures us) around it. Time to step back and look. Hmm, no sea; but in its stead a luminous opening with an infinite perspective of pink and bluish light, giving the impression of airy, immaterial elves dancing about. And the forest? It has become a dark underground grotto, while the fore-

448

ground appears as rocks covered by lichen, while the knife work has smoothed out the colors, now resembling reflections on a water's surface, a pond—marvelous! What is left? A strange pink spot. Hmm? Ah yes, it's a rose! Time now to work a few seconds more with the knife, so that the pond is now framed by roses, roses, nothing but roses. The work is completed by a bit of finger action, bringing any resistant colors together, blending and refining the rest, and voilà! The painting is done.

My faithful paraphrase of Strindberg's description is meant to convey what mattered most to Strindberg here: painting as an unleashed form of spontaneous creativity: making art the way nature makes life. *The way nature makes life*. Freudian critics have not failed to see in this wreath-like structure a kind of womb to which the painter seeks to return. Further, the piece exercises a kind of fascination on the viewer, since we encounter it as something of a tunnel that sucks our vision in, with the result that the luminous center seems like a far-away vision, a paradise of sorts on the far side of the resistant undergrowth through which we must make our way. Symbolic, this: both art and interpretation are figured as arduous quest, indeed as arduous birthing. Nothing in Strindberg's own language suggests the allegorical reading I am proposing, yet the piece shimmers at us with suggestiveness, with invitations.[7] A number of Strindberg's most accomplished paintings of a later period—*Inferno* done in Stockholm in 1901 and *Yellow Fall Painting* done at the same time—repeat (in radically different color schemes) this structural pattern of a circular arbor-like, grotto-like weave through which we glimpse light and peace on the far side. One does not know how to classify work of this sort. Söderström has claimed that Strindberg refrained from taking the ultimate step of producing paintings that are exclusively about painting itself but that he goes right up to that threshold (*Underlandet*, 14–16). I agree. The description of the genesis of *Underlandet* tells us as much about the inherent authority and power of paint and color as

it does about the painter's program. Let the colors speak! Liberate them (with knife and fingers) so that they replicate Nature's dance. Don't even try to corral or control these demiurgic forces.[8] Yes, this is still representational, if you will, but just barely.

Other pieces go still further. *Golgata* (Dornach, 1894) is a remarkable rendition of sea and sky as tumult of black and white pulsions, each having its indwelling force, locked in an embrace of swirling currents and pulsating energy (figure 5.3). One looks hard at this piece to see if there is anything in it other than sea and sky. Some have claimed to see the contours of a man in a flowing cape looking out onto the sea.[9] What is certain, however, are the three minuscule white crosses just perceivable over the edge of the water. Is this a three-mast ship in the throes of going under? Or could this be the three long-ago crosses at Golgotha? It is hard to imagine a more eloquent depiction of the fragile human scheme (replete with its spiritual and scientific programs) up against a monstrously empowered natural world that knows nothing of it.[10] I have sought, throughout this book, to highlight the remarkable depictions of *power* found in Scandinavian literature and art, and I can think of few paintings that more perfectly convey to us the roiling demonic powers of the world as the ultimate truth of art.[11] The word "titanic" has sometimes been used to characterize Strindberg, and one imagines that it pleased him, but it is crucial to recognize that the painting *Golgata* is not about Strindberg's own psyche as such—not his private torment, not his infinitely vexed life and opinions—nor is it some kind of intellectualized symbolist composition; rather, it stands as a revelation of the material Creation itself.[12] But look at those three crosses, and remember: marionette, manikin, *jouet*. "Strindberg" is but the conduit of cyclonic forces far beyond his own thoughts and feelings. His art is in the service (is a version) of this ceaseless natural power. He is a medium.

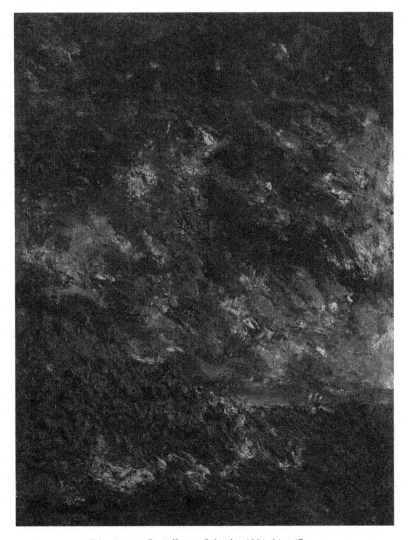

5.3. August Strindberg, *Golgatha*, 1894, 91 × 65 cm

Even more powerful is *Hög sjö* (*High Sea*) done in Paris in 1894 (figure 5.4). This time there are no crosses, no human contours in sight. Just the tempestuous ocean speaking its rude and imperious and sublime language. It has a spiral-like form that conveys the endless unfurling energy of the sea when it is worked up, a source of power that knows nothing

451

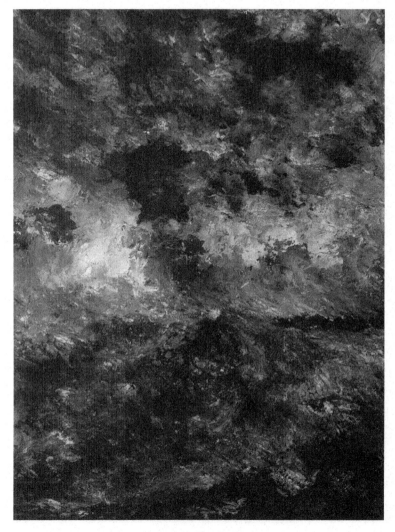

5.4. August Strindberg, *High Sea*, 1894, 96 × 68 cm

of fatigue or purpose or design but has its own pattern of rising and falling, tumescence and spending, as long as the winds will. Söderström thinks that Strindberg experimented with plaster in his paint to produce the striking relief one perceives in the actual piece. The entire painting has a roasted burnt effect (a surprising and persuasive tonality for water at

the pitch of paroxysm), which Strindberg achieved either through a real burner or a lamp. *A burning sea*: we are not accustomed to thinking of "our" environment (as if possessive pronouns had the slightest traction in this scheme) in such drastic elemental terms, yet these magnificent paintings do homage to the fierce, untamable, inhuman forces that animate the world we live in. Could they be also a figure for the roiling sensations that rend and rack us on the inside? Could these pieces be Strindbergian equivalences of Munch's prodigious *Scream*? If so, it seems essential to recognize that Strindberg has omitted the human figure altogether from his work. One could claim that this piece is about the power of paint as much as the power of the ocean (or of some Creator behind it). One cannot conceive of a human scale in the piece itself, however. The only human presence here is through the art itself. Power-and-Expression: Power-as-Expression. Yes, ultimately Strindberg is titanic, because he is the maker/conduit of these titanic spectacles.

If *High Sea* can pass as a Turner-inspired seascape—which it is and isn't—what is there to say about *Vågen IX* (*Wave IX*; figure 5.5) done in Stockholm in 1903? Once again we see the impudent horizontal line that adjudicates the volumes of air, liquid, and solid, but those volumes themselves are now altered. The ocean is a massive block of thick, inky substance, capped with cavalier white froth, the whole delineated clearly on both ends, rising almost like a submerged land mass out of the grey water. Over it we see layered, down-rushing clouds, viscous-like in the thick paint that gives them swirl and heft, moving from gray and white at the bottom up to darker, almost black flowing segments on top, coming like unfurling waves. One feels these clouds are out to crush the sea, to make impact and throttle their ancient adversary. These cloud formations are painted with thick gobbets of color, laid on massively by the palette knife, conveying the feeling of some huge curtain of air and liquid, with the weight of velvet or some comparable fabric, shot through with oil and glints

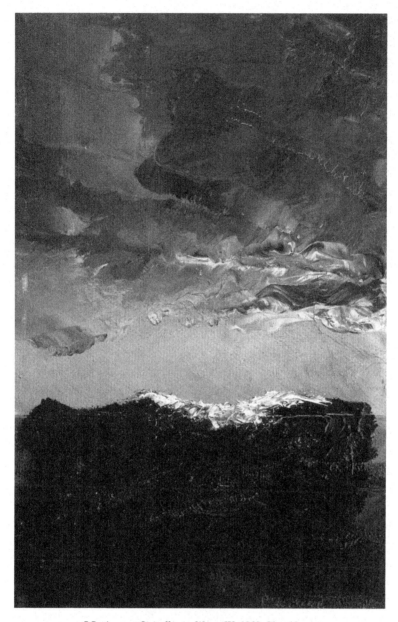

5.5. August Strindberg, *Wave, IX*, 1903, 21 × 13 cm

of light, en route to the rising mass of black sea water that seems to offer an embrace. And in between: a sulfurous yellow patch of air, with a circular wave pattern, working as the thinnest possible buffer, so thin that the canvas itself shows through the paint, as if to advertise: this is paint on cloth, not air/sea/cloud. All told, this painting has a rare formal insolence, insisting on its character of artifact, of made thing, of representation only. But this also confers a kind of biblical hush on the entire scene, reminiscent of that fateful incipit in Genesis when the Lord divides up the world into sea and land, for so it is that we perceive Strindberg's dispensation: a world of integral forces and substances, forced here into fusion, primeval.

A more decorous version of this piece is *Sol går ned uti hav* (*Sunset over Sea*) (Stockholm 1903) (figure 5.6). A black-and-white representation cannot do justice to the oriental gold palette that characterizes the striated heavens in this painting, as the colors move from gray and white at the top on through increasingly rich and ocher-like yellows, down finally to the orange sliver of sun that now sinks into the grey-green water. True to form, Strindberg gives us a straight-line horizon, using the sea this time as buffer, for there is a rugged, rounded expanse of rock at the bottom of the canvas, depicting what is hard and molded and ridged, in this concert of elements and substances. The fleeting light is still captured on the upper rocks, while the lower part is already in ominous shadow, so dark that it almost appears as water. Aesthetically speaking, this depiction of sunset is less "emancipated" than the pieces done in Dornach and Passy a decade earlier, yet it has a kind of golden aura that is immensely appealing and serene, conjuring gradations of pure, evolving, diminishing light as it moves from the heavens to the sea to the sand and stones.

I close with my favorite Strindberg painting: *Staden* (*The City*), done in Stockholm in 1903 (figure 5.7). This piece is minimally representational: we see the familiar, still majestic and

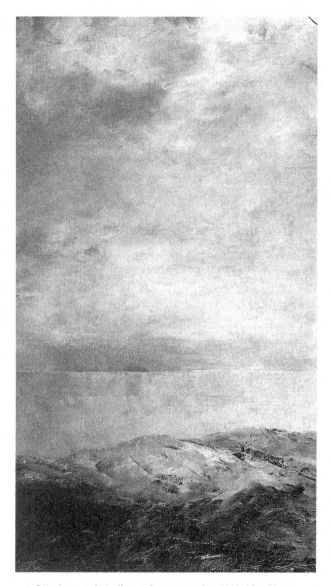

5.6. August Strindberg, *Sunset over Sea*, 1903, 95 × 53 cm

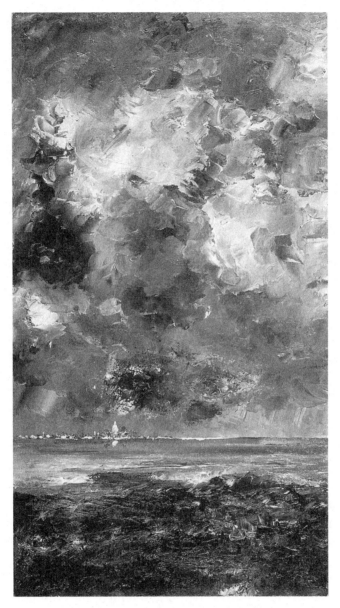

5.7. August Strindberg, *The City,* 1903, 95 × 53 cm.
© National Museum, Stockholm

tumultuous play of light and dark and swirling forces in the grand depiction of the clouds that constitute the great bulk of the painting. And again the defining horizontal line that divides the elements, this time bounding a serene strip of water that is but a narrow ribbon of calm, since the ceaseless play of nature animates the bottom part of the painting with its dark, rugged, restless action. It is not entirely clear whether the base of the painting depicts agitated sea or rocky beach, but unmistakable is the concert of the elements whose motion and sovereign sport seem to contain altogether what is in between, as if they could (and are about to) join forces to swallow the world in their wave action.

What is in between? Posed atop (on half of) the horizontal line separating water from sky are tiny illuminated human structures, as minuscule as the components of a faraway dollhouse: diminutive structures of buildings both horizontal and vertical, match-like in their dimensions, except for the one larger dominating luminous dome with surrounding greenery rising over the toy building and conferring its toy authority onto the scene. It is a church. It may be Katarina Church in Stockholm; it may be a memory of Venice. It shimmers in this stormy setting, as if it captured all the light the cosmos had to offer, but we the viewers (of the empowered sky and sea) must feel that the amount is not very great.[13] The light of human culture and religion is real, but it is dwarfed by the elemental forces surrounding it. The fragility of human civilization—its edifices, its proud structures, its seeming domination of nature—is unforgettably rendered in this philosophical painting. Yes, human doing is real, but it is merely a speck of light in this roiling tempest of cosmic forces. The role of art is to break through the complacent forms—the dollhouse, as Ibsen might have said—which have molded so many of our received views about self and world. Whereas Strindberg's poem "Street Scenes III" closes with the discovery of a humming generator that works in the dark to grind light for the world around it, his paintings move directly out

into that world itself in order to depict the primal Olympian power scheme that laughs at latitude, longitude, and all human pretension.

One needs to remember *The City* when the name Strindberg is brought up, and he is proclaimed as some kind of swollen-headed genius (or tyrant or misogynist). Where is Strindberg in these paintings? He is the speaking tube, the conduit of the elements, the medium.[14] One recalls Mallarmé's beautiful line about the whereabouts of Verlaine in the funerary poem he wrote for the dead brother-poet: "Verlaine il est parmi l'herbe Verlaine." Or Whitman's lovely closing line: "If you want me again, look for me under your boot-soles." Strindberg is, like Shakespeare before him and Faulkner afterward, an unparalleled connoisseur of "sound and fury": the Captain throws a burning lamp at his wife and finishes up in a straitjacket; the paranoid, hallucinating protagonist of *Inferno* is buffeted and jolted by storms of all stripes, electrical and psychic. But in these paintings we no longer see the tortured human subject at all. Instead, we are witness to the royal spectacle of Nature's unbridled, inhuman power. Why royal? Because our situatedness in a world of this violence and beauty confers dignity and stature on us as well. Let me cite one final poet, Wallace Stevens: "From this the poem springs / That we live in a place that is not our own / And much more nor ourselves / And hard it is in spite of blazoned days."

Strindberg, like so many of the Scandinavian writers dealt with in this book, is less a partisan of blazoned days than he is of storm and tempest. Yet his paintings are a supreme illustration of what it can mean to live in a place that is not our own. Finally, he is true to the American poet's injunction: "from this the poem springs." The alterity of both world and self is, amazingly, a generative formula for poetry, for art. Please note: it is not an invitation to depression or suicide, despite all our clichés about the Scandinavian mind-set. Darkness seeds light. Freedom does not disappear: it is refigured. From Kierkegaard to Cronqvist, these writers and artists en-

459

liven our sense not only of the stage on which we are put but also the reaches of our own being. They break through the notional precincts we have thought real. Their stubborn, unblinking engagement with Power and their radical achievements in expressing what they saw and felt deserve to be known more widely. They do us honor. They startle.

Notes

2.A: Speaking God

1. For a superb overview of modern receptions of Kierkegaard, see Roger Poole, "The Unknown Kierkegaard: Twentieth-century Receptions," in *The Cambridge Companion to Kierkegaard*, ed. Alastair Hanny and Gordon D. Marino (Cambridge: Cambridge University Press, 1998).

2. Much of the critical debate on *Fear and Trembling* divides up into what may be called "soft" and "hard" readings. The "soft" readings seek essentially to retrieve Kierkegaard for both reason and ethics, as a way of taming this fierce text. As will be seen, I choose instead to emphasize the uncompromising and shattering vision of this text.

3. Bruce H. Kirmmse reprises my crucial *genombrott* [break-through] paradigm in his account of Kierkegaard's vexed place within his cultural moment, by evoking the philosopher's coming to terms not only with contemporary cultural heavyweights such as Grundtvig, Heiberg and Mynster but also with the portentous figure of his own father, who seems to have personified secure adulthood in the mind of his son. See Bruce H. Kirmmse, " 'Out with It!': The Modern Breakthrough, Kierkegaard, and Denmark," in *The Cambridge Companion to Kierkegaard*. As for the complex dimensions of "sacrifice" itself, see Sylvain Agacinski, *Aparté: Conceptions and Deaths of Søren Kierkegaard*, trans. Kevin Newmark (Tallahassee: Florida State University Press, 1988); and Jacques Derrida, *The Gift of Death*, trans. David Wills (Chicago: University of Chicago Press, 1995).

4. Such writing absolutely mandates that Kierkegaard be read as *literature* rather than as dogma, not merely because of the famous strategies of indirection (which militate against any single authoritative readings) but because of the shattering of language itself. See, in this regard, Mark Taylor, *Journeys to Selfhood: Hegel and Kierkegaard* (Berkeley: University of California Press, 1980); and idem, *Altarity* (Chicago: University of Chicago Press, 1987).

5. See Kirmmse, " 'Out with It!': The Modern Breakthrough, Kierkegaard, and Denmark," passim.

6. Mark C. Taylor, "Sounds of Silence," in *Kierkegaard's "Fear and Trembling": Critical Appraisals*, ed. Robert L. Perkins (Tuscaloosa: University of Alabama Press, 1981), 185.

7. Roger Poole devotes some wonderful pages to skewering the host of "Blunt Readings" that have been penned in order to give us a clear, distinct, univocal Kierkegaard ("The Unknown Kierkegaard," 58–66).

8. Philip Weinstein, in *Unknowing: The Work of Modernist Fiction* (Ithaca and London: Cornell University Press, 2005), makes a brief but brilliant case for the relevance of Kierkegaard in the ensuing work of writers as distinct as Kafka, Proust, and Faulkner.

9. Søren Kierkegaard, *Fear and Trembling*, trans. Alastair Hannay (London: Penguin, 1985), 67. Subsequent quotations are drawn from this edition and cited parenthetically in the text.

10. The weaning passages have elicited surprisingly little critical commentary. See Linda L. Williams, "Kierkegaard's Weanings," *Philosophy Today* (fall 1998), for a view that the weaned child might indeed be Abraham himself.

11. Even though much of the Lagerkvist criticism has a religious orientation, I feel that the *punitive* force of his writing has been undervalued. Leif Sjöberg's early monograph, *Pär Lagerkvist* (New York: Columbia University Press, 1976), offers a balanced treatment of these matters.

12. *Contrapuntal* is my term; in his *Pär Lagerkvist* (New York: Twayne, 1973), Robert Donald Spector suggestively invokes Hebrew antiphonal poetry as analogue for the structure of *The Sibyl*. Rikard Schönström has gone the furthest in exploring this structural issue, by reading Lagerkvist in the light of Bahktin's dialogic theories, in *Dikten som besvärjelse: begärets dialektik i Pär Lagerkvists författarskap* (Stockholm: Symposion, 1987).

13. Pär Lagerkvist, "Det är vackrast när det skymmer," in *Dikter* (Trondheim: Bonnier Pocket, 1991), 28. My translation.

14. Pär Lagerkvist, *The Sibyl*, trans. Naomi Walford (New York: Vintage, n.d.), 10. Subsequent references to this work are cited parenthetically in the text. For the most part, Walford's translation renders with great pith the mix of anxiety, breathlessness, and passion of Lagerkvist's Swedish. The few instances where I take issue with her renderings are noted.

15. I cite Kierkegaard here to reassess the "commonsensical" vision; it is all too common in Lagerkvist commentary to lambaste the perspective of an Ahasuerus as "secular," and hence as the target of the author's critique; for a recent version of this argument, see Jeff

Polet, "A Blackened Sea: Religion and Crisis in the Work of Pär La-gerkvist," in *Renascence: Essays on Values in Literature*, 54.1 (fall 2001): 47–65.

16. Wandering is a short step from questing, once you put some urgency into it; see Spector, *Pär Lagerkvist*, passim, for discussion of the quest motif in Lagerkvist's fictions.

17. One can, as Polet does ("A Blackened Sea," 59–60), interpret the rendition of the Temple as Lagerkvist's general indictment of the institutionalized Christianity of his time (hence resembling the earlier broadside mounted by Kierkegaard).

18. Here is an instance where Lagerkvist's Swedish outruns the English. "Att vara besatt av gud" he writes (*Sibyllan* [Stockholm: Bonniers, 1956], 70), and Walford's "possessed" only gets half the meaning across, inasmuch as "besatt" also signifies "obsessed."

19. For a fascinating account of hysteria's multifaceted grip on late-nineteenth-century French culture, including the phenomenon of theatricalization to which I am referring, see Mark S. Micale, "Discourses of Hysteria in Fin-de-Siècle France," in *The Mind of Modernism*, ed. Mark S. Micale (Stanford: Stanford University Press, 2004).

20. The Swedish reads: "Min lidelse var som en vild klyfta som ville uppsluka honom" (135–136). "Engulf" simply misses the creatural violence of "uppsluka," which signifies "devour," in the sense of "swallow up."

21. It should be clear that my emphasis on the somatic is at odds with a great deal of Lagerkvist criticism. In my view, there has been too much talk of a hidden god, of questers who never find what they seek, of enduring mystery, inasmuch as the antics of the human creature are the site where the god becomes visible, written into our flesh, utterly "clear and distinct."

2.B: The Play of Patriarchy

1. It is a famous and puzzling literary fact that these two Scandinavian giants never met. And they could have. Strindberg might have met Ibsen in Rome, and at other times as well. We know that Strindberg bore considerable rancor in connection with Ibsen's stature as trailblazer (relegating Strindberg to "respondent"), claiming that a number of his plays served as models for Ibsen, rather than the other way around, and he frequently vented his bile on this topic, as we see in his sweet remarks to Karl Nordström in 1891: "And now the decrepit old troll seems to hand me the revolver a

second time! But his shit will rebound on him. For I shall survive him and many others, and the day *The Father* kills *Hedda Gabler*, I shall stick that gun in the old troll's neck!" (quoted in Michael Meyer, *Strindberg* [New York: Random House, 1985], p. 235). It is also the case that Ibsen's example was a fertile irritant for Strindberg, and he stated quite clearly that he wrote *The Father* as an overdue, last-ditch effort to stop those she-devils that Ibsen's (alleged) feminism had let loose. I cannot help feeling that the vexation was mutual; one knows the anecdote of Ibsen purchasing one of the Krogh portraits of Strindberg, hanging it in his writing room, with the explanation, "To have that madman staring down at me helps me. He is my mortal enemy and shall hang there to watch what I write" (quoted in Sue Prideaux, *Edvard Munch: Behind the Scream* [New Haven: Yale University Press, 2005], 146). I do not know if Strindberg was aware of this, but if so, I am confident he would have found it quite appropriate as a recognition of his power.

2.B.i: Child's Play

1. For the Swedish text, see August Strindberg, *Fadren, Fröken Julie, Fordringsägare* (Stockholm; Almqvist &Wiksell, 1984), Vol. 27 of *August Strindbergs Samlade Verk*, 98. Quoted from *Strindberg: Five Plays*, trans. Harry G. Carlson (New York: New American Library, 1984), 49. Subsequent quotations from the play are drawn from Carlson's translation (with exceptions noted), and cited parenthetically in the text.

2. For a fascinating account of Bertha as medium, see Eszter Szalczer, "Främmande röster; besatthet och exorcism i Strindbergs dramatik," *Strindbergiana* 19 (2004): 30–41.

3. Harry G. Carlson suggestively links the mysterious script here to the "languages of the dead and of the dark world of unconscious impulses" (*Strindberg and the Poetry of Myth*, Berkeley: University of California Press, 1982, 52).

4. John Eric Bellquist sees in the song the presence of death ("Strindberg's *Father*: Symbolism, Nihilism, Myth," in *Modern Drama* 17 [1986], 538).

5. Barry Jacobs ("Strindberg's *Fadren* ["The Father"] in English Translation," in *Yearbook of Comparative and General Literature* 35 [Bloomington: Indiana University Press, 1986], 113) has remarked that both telephones and spectroscopes were brand new to Sweden at the time of Strindberg's play, and that Strindberg's interest in per-

ception and communication, clothed here in bold technological language, is notoriously difficult to render in translation (as Carlson's English shows).

6. Bellquist ("Strindberg's *Father*," 536) refers to the child as an anchor that serves as a ballast against the free-floating "characterlessness" that Strindberg saw as the essentially modern condition.

7. In a well-known article, "Kvinnohat och mansångest" in *Bonniers litterära magasin* 56 (1987), Johan Cullberg offers a sweeping psychoanalytic analysis of Strindberg's conception of women, claiming that Laura is not to be understood as a dimensional character in her own right but rather as a projection of the good/evil mother figure who haunts and partly regulates the author's libidinal world.

8. Gail Finney argues astutely that the female sense-bound world proves to be more powerful than the male conceptual scheme (*Women in Modern Drama* [Ithaca, N.Y.: Cornell University Press, 1989], p. 214).

9. Carlson's translation misses the balletistic interaction of knowing and believing—*veta* and *tro*—Strindberg achieves here. Let me cite the Swedish: "Man vet aldrig någonting, man tror bara, inte sant Jonas? Man tror så blir man salig! Jo det blev man! Nej jag vet att man kan bli osalig på sin tro. Det vet jag (85)." It is an amazing utterance: one never knows anything, one only believes, belief will save you, or at least it did in the past, but now we know the belief is a curse. The modern note is clear: "belief" itself has acquired a well-nigh lethal psychological valence, a form of never-ending doubt that has no truck with religious faith and, worse still, spells the end of all fact-based knowledge, the entire realm of *veta*.

10. Nietzsche wrote to Strindberg that he was much moved by the play, and that it confirmed precisely his own views of love and/ as war, what he calls the "Todhass der Geschlechter" (cited by Karin Hoff, " 'Die Frauenfrage scheint mir überschätzt zu werden': Der Kampf der Geschlechter bei August Strindberg," *Skandinavistik* 33/ 2 [2003]).

11. For an interesting view of *The Father* as implicitly "bisexual," see Robert Gordon's "Rewriting the Sex War in *The Father, Miss Julie,* and *Creditors*: Strindberg, Authorship, and Authority," in *Staging the Rage: The Web of Misogyny in Modern Drama*, ed. Katherine H. Burkman and Judith Roof (Madison, N.J.: Farleigh Dickinson University Press, 1998), 139–157.

12. The most thoroughgoing and authoritative Darwinian account of Strindberg (and Ibsen, for that matter) is doubtless Ross

Shideler's *Questioning the Father: From Darwin to Zola, Ibsen, Strindberg, and Hardy* (Stanford: Stanford University Press, 1999).

13. Barry Jacobs ("Strindberg's *Fadren* ["The Father"] in English Translation," passim) passes in review the (sometimes insuperable) obstacles that hound English translators of Strindberg, and the menial use of the Swedish third person in these exchanges between the Captain and Margret ranks high on the list.

14. What I am calling a collapse of reason can be—and has been—thought of as the most paradigmatic aspect of this text. Ulf Olsson argues this quite persuasively in "The Madness of Fiction: Psychiatry and Narrative in Strindberg's *Fadren*," *Strindberg and Fiction*, ed. Göran Rossholm et al. (Stockholm: Almqvist & Wiksell International, 2001).

15. Still another Shakespearean candidate for inclusion would be Lady Macbeth, and Gail Finney has made a persuasive case for the parallelisms between her famous "unsexing" (and the resultant feminization of her husband) and the gender/power arrangements between the Captain and Laura (223–225). The Captain's unrestrained display of emotional vulnerability and weakness has led Robert Gordon to assert that *he* "becomes the archetypal 'madwoman' of nineteenth-century sexual narrative" ("Rewriting the Sex War," p. 146).

16. Once again one is reminded of Strindbergian "characterlessness" (as it is articulated, for example, in the preface to *Fröken Julie*), and it becomes clear that these views of the subject, of the cultural construction (and destruction) of identity, are astonishingly close to much current thinking about subjectivity.

17. Arthur Miller, himself a vital heir to the Strindberg legacy, reviewing the English translation of Olof Lagercrantz's magisterial Strindberg biography, *Strindberg* (Stockholm: Wahlström & Widstrand, 1979), has captured something of the irony and modernity of these strange cosmic landscapes: "the hallucinatory world Strindberg saw seems much closer now to being real. We really walk the moon, and with the press of a button can really crack the planet, and if we have mastered the physics of this magical power, the morals of it are, if anything, farther from us than from Strindberg" ("The Mad Inventor of Modern Drama," *New York Times*, 6 January 1985). Strindberg himself experienced a comparable giddiness and precariousness upon completion of *The Father*, as we know from a letter written to Lundegård on November 12, 1887, two days before the premiere in Copenhagen: "It seems to me that I walk in my sleep—as though reality and imagination are one. I don't know if *The Father*

is a work of the imagination or if my life has been; but I feel that at a given moment, possibly soon, it will cease, and then I will shrivel up, either in madness and agony, or in suicide. Through much writing my life has become a shadow-play; it is as though I no longer walk the earth, but hover weightless in a space that is filled not with air but with darkness" (cited in Michael Meyer, *Strindberg* [New York: Random House, 1985], 182). Rarely have the trade-offs between life and art been presented with more clarity.

18. Inga-Stina Ewbank has linked the fragmenting of one's own voice to the procedures of modernism, claiming that the Captain's self is, "like J. Alfred Prufrock's, made up of remembered snatches; his voice is a borrowed one" ("August Strindberg," in *Aspects of Modern Swedish Literature*, ed. Irene Scobbie [Norwich: Novik Press, 1999], 57).

19. Here, too, the translator is defeated by Strindberg's prose. "Can't be done again" rightly says Carlson, but the Swedish "kan inte göras om" is far nastier, since it also means "can't be undone." This sweet double punishment is what the author had in mind: that those who (may) have injured us are dead doesn't diminish in any way the harm they continue to cause in our psyches—we claim they cannot hurt us again, but each time we claim it, we prove it false; and we also wish it were "undoable," but that is still further beyond our reach. This is the kind of snake pit one reconnoiters when reading Strindberg.

20. The image of the mind as generator is at the heart of Strindberg's city poem, "Gatubilder, III (*Ordalek och småkonst och annan 1900-talslyrik* [Stockholm: Almqvist & Wiksell, 1989], 52 (Vol. 51 of *August Strindbergs Samlade Verk*), which is worth citing as further evidence of the Kuhnian or technological dimension of Strindberg's view of power, especially via the metaphor of "mal ljus" ("grinds light") which perfectly captures the shifting registers (from agrarian to hi-tech) that define the human brain's status as energy source.

21. Strindberg's views on this subject at this time have been amply documented; see Olof Lagercrantz, *Strindberg*, 191–208; and Meyer, *Strindberg*, 168–178.

22. Margaretha Fahlgren has persuasively argued that the collapse of Patriarchy in this play yields to a version of Matriarchy that is little less than an *inverted* image of the original system ("Fadren-fantasin om patriarkets sammanbrott," *Edda* [1992]: 272–279).

23. The movement toward infantilization is clearly open to a Lacanian analysis; I have referenced Lacan several times already, but

it should be clear that my ultimate quarry has a more Derridean cast to it, even a more anthropological cast.

24. Needless to say, Omphale has received various critical commentaries. Carlson (*Strindberg: Five Plays*, 55–60) has seen her in terms of the Good Mother vs. the Terrible Mother, whereas Lagercrantz (*Strindberg*, 193–196), following psychoanalytic studies of the play, has delved into the Oedipal dimensions of the twin stories: Hercules "serving" Omphale, and the Captain's son/lover relation to Laura.

25. Carlson (*Strindberg: Five Plays*, 54–55) has drawn attention to the extended imagery of nets, webs and shawls in this play, and Jacobs ("Strindberg's *Fadren* ["The Father"] in English Translation, 115) has made suggestive links between male and female lines, "spear side" and "distaffside," or, as the Swedish significantly has it, "svärdsida" and "spinnsida" ("spin-side" as in spinning thread).

26. Probably the most unusual reading of "mantles" in Strindberg's play is that of Lilian Monk Rösing, "An Ethics of Skin and Gender," *NORA* 3.10 (2002).

27. See Lagercrantz (*Strindberg*, 194) for a similar reading of the uniform/straitjacket. Such a view fits perfectly into Lagercrantz's image of Strindberg as vacillating between the masculine and feminine components of his makeup; but the metamorphic, anthropological, and theatrical dimensions of this "child's play" have not been sufficiently recognized.

2.B.ii: Metamorphosis in Ibsen's *Little Eyolf*

1. Let me reference Toril Moi's new study, *Henrik Ibsen and the Birth of Modernism* (New York: Oxford University Press, 2006), which makes a sustained and vigorous case for the centrality of Ibsen in our moment. Her Ibsen is a figure wrestling with the powerful nineteenth-century tradition known as "Idealism," and hence she feels that the entire modernist neglect of Ibsen—owing in part to a contempt for what was seen as his rather shabby "realism," coupled with a dislike for theater in general—is entirely wrong-headed.

2. Henrik Ibsen, *Little Eyolf*, in *The Oxford Ibsen*, trans. James W. McFarlane, Vol. 8 (Oxford: Oxford University Press, 1977), 48. Subsequent references to the English translation are from this edition, with page numbers inserted parenthetically in the text. The Norwegian text, *Lille Eyolf*, is in *Henrik Ibsen: Samlede værker*, Vol. 5 (Copenhagen: Gyldendalske Boghandel, 1908), quote at 246. Occasional ref-

erences to the original Norwegian are from this edition. References to other Ibsen plays are taken from *Ibsen: The Complete Major Prose Plays*, trans. and ed. Rolf Fjelde (New York: Penguin, 1978).

3. Errol Durbach, *"Ibsen the Romantic": Analogues of Paradise in the Later Plays* (Athens: University of Georgia Press, 1982), 110.

4. I am indebted to Harald Naess for this insight into Ibsen's figurative language.

5. Michael Meyer, in his translation of the passage—see *Little Eyolf*, in *The Plays of Ibsen*, Vol. 4 (London: Methuen, 1980)—has spoken of the rats in terms of "thousands of them," suggesting something of an invasion or epidemic; I think he is right to take this liberty.

6. See Kathy Saranpa Anstine's "Ibsen's *Little Eyolf*: Did Alfred Allmers Marry a Troll?" (*Ibsen Yearbook 7* [1991]: 231–243) for a full-fledged argument along these lines.

7. James McFarlane has written persuasively of the sea changes that *Little Eyolf* underwent during the process of revision. Not only did Ibsen only gradually achieve his dense drama of naming and sexual displacement, but the figure of Allmers undergoes several avatars during the writing, ending up as the effeminate and carefully deceived/deceiving figure we have in the final version.

8. Franz Kafka, "The Metamorphosis," in *The Complete Stories*, ed. Nahum Glatzer (New York: Schocken Books, n.d.), 89.

9. Robin Young's superb volume on the issue and ramifications of child sacrifice in Ibsen's work, *Time's Disinherited Children* (Norwich: Norvik, 1989), rightly offers a corrective lens to Durbach's thesis, by claiming that the English romantic model is *not* likely to have been influential for Ibsen. Young goes on to argue that the very postures of romantic yearning are Ibsen's supreme target in most of his work.

10. See James E. Kerans, "Kindermord and Will in *Little Eyolf*," in *Modern Drama: Essays in Criticism*, ed. Travis Bogard and William Oliver (New York: Oxford University Press, 1965), for a provocative reading of Ibsen along Freudian lines.

11. See Meyer, introduction to *The Plays of Ibsen*, 4:439–440.

12. Barry Jacobs, "Ibsen's *Little Eyolf*: Family Tragedy and Human Responsibility," in *Modern Drama* 27:4 (1984), 604–615, quote at 607.

13. The infant left on the table is doubtless sleeping, and one may likely assume that his eyes are closed. But who is to know? Perhaps the activity of his parents awakened him? Perhaps he "saw"? He certainly "fell." *Whatever*, as they say in today's parlance, the staggeringly open-eyed Eyolf who haunts his parents after his death tells us a great deal about his unbearable presence as witness.

14. See Meyer, introduction, 429. These matters are dealt with more fully in Meyer's *Ibsen: A Biography* (New York: Doubleday, 1971).

15. Michael Goldman, in his brilliant article, "Eyolf's Eyes: Ibsen and the Cultural Meanings of Child Abuse" (*American Imago* 51, no. 3 [fall 1994]: 279–305), has denoted this pivotal moment as "alienated memory," and gone on to posit that Ibsen made it "the cornerstone of modern acting" (298).

16. The phrase is that of Jacobs, "Ibsen's *Little Eyolf*," 608.

17. One can scarcely be surprised that Allmers's relationship to Asta, as well as his arrangements with Rita, do not fare too well among Ibsen critics; in one of the earlier assessments of Ibsen's late plays, Orly L. Holtan claimed that what was most perverted about this brother/sister relationship is "not primarily that it is incestuous but rather that it is essentially childish" (*Mythic Patterns in Ibsen's Last Plays* [Minneapolis: University of Minnesota Press, 1970], 120).

18. William Faulkner, *The Sound and the Fury* (New York: Vintage, 1954 [1929]), 413. It is to be noted that Faulkner's words are from the famous "Appendix" which was actually written (and tacked on) in 1942, some thirteen years after the novel itself was published.

19. McFarlane's observations about *Eyolf* extend to more than irony, inasmuch as he reads the play as a tragedy of "inauthenticity," showing how specious each one of Allmers's portentous postures are: brother, husband, father are all "bracketed" positions ("Drama and Individual Integrity: 1893–1899," in *Ibsen and Meaning: Studies, Essays & Prefaces 1953–87* [Norwich: Norvik, 1989], 327); published earlier as the introduction to volume 8 of *The Oxford Ibsen*.

20. Meyer, *The Plays of Ibsen*, 3:63.

21. Richard Kuhn has called attention to the significance of Asta's *locked* portfolio in the opening scene, rightly claiming that Ibsen is signaling, early on, the need for uncoding, deciphering, and interpreting, if we are to get Asta (or the play) right; see "The Owl of Minerva Catches the Rats: Little Eyolf Dreams of Hegel and Freud" (*Colloquium Helveticum.* 21 [1995]: 83–103).

22. Woolf's assessment is quoted by Muriel Bradbrook in *Ibsen the Norwegian: A Revaluation* (London: Chatto and Windus, 1948), 98.

23. Jacobs has also interpreted Rita's final behavior in terms of a reversal of the Rat Wife/Pied Piper motif, although he is less interested in the idea of metamorphosis itself.

24. Kuhn claims that act 3 is essentially a return to political obligations in the wake of destruction wrought by sexuality (93). Whether this is credible is another matter.

25. Probably the hardest-hitting critique is that of Michael Goldman who sees the new moral order of the ending as specious, as reminiscent of the inflated claims made for Løvborg's history of the world or even Captain Alving's "home for sailors." It seems, moreover, that Ibsen himself harbored doubts about the efficacy or credibility of his ending; at a performance of *Eyolf*, he is said to have asked a friend afterward, "Do you think that Rita will carry on with the unfortunate boys? Don't you think that it is just a holiday mood?" (Holtan, *Mythic Patterns in Ibsen's Last Plays*, 132). It is, I think, a thin remark, even if it comes from the Master himself. If Ibsen's ultimate bare-bones truth is a truth about substitutions, then what most matters, I think, is that some are better than others, and that we should pause before indicting the efforts of this husband and wife to climb out of the abyss into which they have been staring for some time. To insist on utter purity of motive here, to brand this autumnal decision as hypocritical, brings the reader/critic awfully close to that crowd of absolutists and truth seekers who create such havoc in Ibsen's plays. Time for peace, I'd say.

2.C: The Powers and the Self

1. Martin Lamm, *Strindberg och makterna* (Uppsala: Svenska kyrkans diakonistryrelses bokförlag, 1936), p. 93. My translation.

2. Lars Gustafsson, "Strindberg as a Forerunner of Scandinavian Modernism," in *The Hero in Scandinavian Literature*, ed. John M. Weinstock and Robert T. Rovinsksy (Austin and London: University of Texas Press, 1975), 136.

3. See Lamm, *Strindberg och makterna*, passim.

4. See Anne Charlotte Gavel-Adams, *The Generic Ambiguity of August Strindberg's* Inferno: *Occult Novel and Autobiography* (University of Washington Press, 1990); Piotr Bukowski, "August Strindberg's *Inferno* and the Absence of the Work," in *Strindberg and Fiction*, ed. Göran Rossholm et al. (Stockholm: Almqvist & Wiksell International, 2001), 97–104; and Inga-Stina Ewbank, "August Strindberg," in *Aspects of Modern Swedish Literature*, ed. Irene Scobbie (Norwich: Norvik Press, 1999), 31–73.

5. See Evert Spinchorn's *Strindberg as Dramatist* (New Haven: Yale University Press, 1982) for a wide-ranging account of the interplay between experience and art in Strindberg's work.

6. Mary Sandbach, in her fine introduction to *Inferno* (Harmondsworth: Penguin Classics, 1979), argues persuasively that Strindberg

was suffering from psoriasis but was afraid that it would be regarded as syphilis if it were publicly known (38).

7. August Strindberg, *Inferno and From An Occult Diary*, trans. Mary Sandbach (Harmondsworth: Penguin Classics, 1979), 127. All subsequent quotations are from Sandbach's translation, with page numbers given parenthetically in the text. The general reader may well be unaware that Strindberg wrote *Inferno* in French initially; it was then translated into Swedish by Eugene Fahlstedt in 1897. Things then get more complicated: Strindberg objected vigorously to many of Fahlstedt's Swedish renderings; and the French version itself was reprised by Marcel Réda in 1898, with a view toward regularizing Strindberg's command of French. The well-known Landquist edition of Strindberg's works—*Inferno* came out in 1914—introduced further changes. I retain Sandbach's English because it was published by Penguin (and is thus easily available), but she is basing her version on Landquist, whereas the new "definitive" Swedish version, edited by Anne Charlotte Gavel Adams as volume 37 in *August Strindberg: Samlade Verk*, differs considerably from Landquist, for it takes into account all the differing versions of this text and offers the closest thing to an "original Swedish" volume that we are likely to have.

8. I am especially indebted to Mona Sandqvist's superb article, "*Inferno* som alkemistroman," *Strindbergiana* (1995): 147–172.

9. William Blake, "The Marriage of Heaven and Hell," in *Selected Poetry and Poetry and Prose of Blake* (New York: Modern Library, 1953), 129.

10. See Carl Olov Somar, "Strindbergs *Inferno*: Att inte kunna författa" (*Svensk Litteraturtidskrift* [Stockholm: Almqvist & Wiksell], 1983), 11–26.

11. Lamm, *Strindberg och makterna*, 64–65. My translation.

12. *Strindbergs Brev*, ed. Torsten Eklund, vol. 11 (Stockholm: Bonniers, 1969), 268–269. The translation comes from Mary Sandbach's introduction to Inferno (56).

13. See Sandqvist, "*Inferno* som alkemistroman," 149, for a discussion of this key motif.

14. August Strindberg, *Inferno* (Stockholm: Norstedts, 1994), 115 (see note 7). All subsequent quotations from the Swedish are from this edition, with page numbers noted parenthetically in the text.

15. Strindberg's comparison of earth to a "straffkoloni" is well known, and there is no great step to be taken in order to arrive at Kafka's grisly parable "In der Strafkolonie," it, too, being a medita-

tion on language and power, as well as on guilt and knowledge. It is worth noting that Kafka doted on Strindberg; moreover (unlike any other reader one can imagine), he found the Swede *soothing*, as we see in a diary notation: "Ich lese ihn nicht um ihn zu lesen, sondern um an seiner Brust zu liegen. Er hält mich wie ein Kind auf seinem linken Arm" ("I read him not to read him, but to lie at his breast. He holds me like a child on his left arm." My translation.) I am indebted to Susan Brantly for this marvelous reference, which proves that "darkness" is always a relative proposition.

16. See Sandbach's subchapter in her introduction titled "The Veracity of *Inferno.*"

17. Gunnar Brandell, *Strindberg in Inferno*, trans. Barry Jacobs (Cambridge, Mass.: Harvard University Press, 1974).

18. See Karl Jaspers's famous *Strindberg und Van Gogh: Versuch einer pathographischen Analyse unter vergleichender Heranziehung von Swedenborg und Hölderlin* (Munchen: Piper, 1950), passim, for an old, but nonetheless compelling, systematic interpretation of Strindberg's "testing" mania along lines of neurosis and persecution mania.

19. See also, in this context, the famous eighth scene of *Till Damaskus, I*, in which Strindberg presents two-headed portraits of Boccaccio, Luther, Gustav Adolf, Schiller, Goethe, Voltaire, Napoleon, Victor Hugo, Leopold von Stolberg, Lafayette, and Bismarck, demonstrating not so much an ironic reading of these historical figures as a profound skepticism regarding the so-called unified self, the integral self that stands unequivocally for one thing.

20. Lamm has pointed out the relentless egoism of Strindberg's project: "Having undergone this religious crisis, he is more than ever convinced that everything that happens to him or to his surroundings has only one meaning: to tempt, to try, to punish or to reward himself" (*Strindberg och makterna*, 138). My translation.

21. Göran Stockenström, in *Ismael i öknen: Strindberg som mystiker* (Uppsala: Acta Universitatis Upsaliensis, 1972), has suggested that the "humming" and "God's mills" are connected in Strindberg's mind to a process of purification: "The concept of the 'Mill of the universe' symbolizes in Strindberg the awareness of one's guilt as the last stage of the moral purification process that is administered by the avenging angels under the supervision of the Eternal one" (192). My translation.

22. As Spinchorn and others have pointed out, Strindberg later "discovered" these symptoms to be exactly what Swedenborg had described in the experience of "vastation."

23. The Swedish has, to my ear, an even more Gothic tinge to it:

Mörk är backen, mörkt är huset—
mörkast dock dess källarvåning—
underjordisk, inga gluggar—
källarhalsen är båd' dörr och fönster—
och därnere längst i mörkret
syns en dynamo som surrar,
så det gnistrar omkring hjulen:
svart och hemsk, i det fördolda
mal han ljus åt hela trakten.

Quoted in Lars Gustafsson, *Strandhugg i svensk poesi* (Kristianstad: FIB, 1977), 23. The English version is that of Robert Rovinsky, in his English translation of Gustafsson's text, *Forays into Swedish Poetry* (Austin: University of Texas Press, 1978), 21.

24. Ibid., 25. Translation by Rovinsky, *Forays into Swedish Poetry*, 23.

25. In the chapter on *Inferno* in his *Novels of August Strindberg* (Berkeley: University of California Press, 1968), Eric O. Johanneson refers suggestively to Edgar Allan Poe (whose soul Strindberg claimed he had inherited) as a prior and influential figure drawn to mesmerism, chimeras, phobias, fascination with dying, and the like (including diabolical machines).

26. Lamm has commented on the common propensity in Swedenborg as well as in Strindberg to label each and every personal or chance occurrence a sign of the powers: "Toothache, itching, lack of appetite, unpleasant taste experiences are caused by spirits in Swedenborg and by powers in Strindberg" (*Strindberg och makterna*, 143; my translation). In his biography of Strindberg, Michael Meyer recounts the following wonderful episode, as told by Strindberg's Parisian acquaintance Frederick Delius:

His [Strindberg's] interest in spirits caused Leclerc and me to play a joke on him. I asked them both to my rooms one evening, and after dinner we had a spiritualist séance in the form of table rapping. The lights were turned down and we joined hands around a small table. After ten minutes' ominous silence the table began to rap and Leclerc asked it what message the spirits had for us. The first letter rapped out was M, and with each letter Strindberg's interest and excitement seemed to increase, and slowly came the momentous letters "MERDE." I do not think he quite ever forgave us for this. (cited in Meyer, *Strindberg*, 335)

27. The epilogue to *Inferno* is intriguing along these lines, since Strindberg comes to view his own travails finally as a cog in the great Machine. He quotes the Bible, "Och jag skall vända mitt ansikte emot en sådan man och slå honom med förfaran, så att han skall bliva till en varnagel och till ett åtlöje för alla, och jag skall utrota honom utur mitt folk, och i skolen erfara, att jag är Herren" (174–175) ("And I will set my face against that man, and will make him a sign and a proverb, and I will cut him off from the midst of my people, and ye shall know that I am the Lord" [272]). Sandbach has pointed out that the word for "åtlöje" in the 1822 French Bible from which Strindberg was quoting is "jouet," which she terms "laughing-stock," but which can also be translated as "toy," in the sense of marionette, plaything. I reprise these terms in my conclusion, since they seem emblematic of the position of the Scandinavian subject in a number of the major works of art and literature under discussion.

28. Proust's entire *Recherche* can be thought of as a map of projective errors, as Marcel goes through his interpretive odyssey, reading and misreading others according to his own private need. Joyce's Bloom is more whimsical and more aware of his fictions, but one of the chief delights of *Ulysses* is the nonstop ruminations of its wandering protagonist as he annexes sights and scenes into his own story.

29. Strindberg and Munch scholars—especially those with any prurience at all—are aware of the remarkable tissue of personal, psychological and sexual linkages that connected Strindberg, Munch, Przybyszewski (himself a fascinating figure: pianist, Satanist, author), and the "femme fatale" of the group, Dagny Juel, in their steamy and intense exchanges at the noted watering hole, Zum Schwarzen Ferkel, in Berlin in 1892–93. Munch introduced Dagny, fellow Norwegian, to this group, and it is thought that his famous paintings of *Jealousy* depict himself and Dagny together, under/imagined by the suffering eye of Przybyszewski; the Pole claimed that he was the lover in question (and they eventually became a quasi-permanent couple); Strindberg, never at a loss when it came to defending his sexual honor, claimed that *he* was Dagny's lover, thereby winning out over both the Norwegian and the Pole. The comedy becomes almost surreal in *Inferno* as Strindberg takes over the reins again, and offers his little sea change for his two male friends/rivals: Munch is now spoken of as the humbled "Danish artist," whereas Przybyszewski becomes Russian, with a new moniker: Popoffsky. It is hard to see much deep philosophical or intellec-

tual payoff in examining this faraway episode of moving chairs/ beds, but it does add a generous dollop of libido and gossip to ordinary aesthetic inquiry. And it puts some oomph into my notion of "energy," inasmuch as there must have been a considerable dosage of pulsions still at work in Strindberg, three or four years later, in Paris now, when he re-orchestrates their dance in the form of an electrical haunting.

30. One of the most intriguing interpretations of this hotel-room sequence, along the lines of "involuntary techno-addiction," is to be found in Mats Björklin's "Remarks on Writing and Technologies of Sound in Early Cinema," in *The Sounds of Early Cinema*, ed. Richard Abel and Rick Altman (Bloomington: Indiana University Press, 2001), 32–38. Björklin characterizes the narrator's strange behavior as a form of "electro-hysteria."

31. Quoted by Somar, "Strindbergs *Inferno*," 23.

32. Olof Lagercrantz, *August Strindberg* (Stockholm: Wahlström & Widstrand, 1979), 442–446.

33. Consider, in this regard, a remarkable letter written by Strindberg to Lidforss in 1894:

> Do you know what *sansclou* are? Buffon writes that fructified eggs have been found in men's penises. *Sansclou* are a *Dröppel*. A *Dröppel* is a heap of male semen found in a vagina. Now, if one mounts a woman over-filled with semen, a man can get another man's semen in his penis or testicles, and so the seeds grow and the *sanscloued* man finds himself in a perverse state of pregnancy which, however, is stopped by the lowering of temperature (ice-bags!) . . . Everything is in everything, and everything moves, even semen. Wombs are only birds' nests in which the cock lays his eggs. (Quoted in Meyer, *Strindberg: A Biography*, 288–289)

One doesn't know whether to laugh or cry at this mix of folklore, masculine anxiety, and scientific pretension. There is an amazing sense of multi-directionality expressed in this letter, and we can see that Strindberg's exquisite sense of vulnerability stems, at least in part, from a materialist view of the world as absolutely "charged," bristling with anarchic energy, fertile in all the wrong ways, reversing all traditional paradigms of active/passive or actor/recipient or subject/object.

34. Sandbach, introduction to *Inferno*, 23.

35. Sandqvist, "*Inferno* som alkemistroman," 171.

36. Lars Gustafsson, *Tennisspelarna* (Stockholm: Norstedts, 1977), 8–9. Swedish references are from this edition, with page numbers included parenthetically in the text. The English I am using is from Yvonne Sandstrom's translation, *The Tennis Players* (New York: New Directions, 1983), 2. All subsequent English quotations are from this edition, with page numbers noted parenthetically in the text.

37. Gustafsson's interest in machines is, of course, well known from his brilliant poem of that title, where he displays his uncanny mix of erudition, lyricism, and anthropological savvy, by construing machines as discursive signs, as "a foreign language that no one has spoken," as the residual logic and surprising index of faraway times and places. For the entire poem, see Lars Gustafsson, *En privatmans dikter* (Stockholm: Norstedts, 1957), 100–101; and Yvonne Sandstroem's fine translation in *Lars Gustafsson: Warm Rooms and Cold* (Providence, R. I.: Copper Beach, 1975), 45–46.

3.A: Going Through the Wall

1. Cited by Erik Blomberg, *Ernst Josephson: Hans Liv* (Stockholm: Lindströms, 1951), 317. Blomberg's magisterial work on Josephson (published in some five books and a dozen articles over four decades) is the mother lode for all subsequent critics.

2. For more consideration of the scholarly discourse on *The Father*, see the earlier chapter, "Child's Play: The Cradle Song in Strindberg's *The Father*."

3. In Alf Sjöberg's canonical early film of *Fadren*, there is a real, if unsuccessful, effort to confer a sense of great violence to this gesture: given that the text speaks of sawing noises in the Captain's room, Sjöberg actually produces sounds of carpentry.

4. Some critics have scrutinized the Captain's texts more carefully and found that Strindberg takes a few liberties here, especially in the reference to Pushkin which is at odds with the known record.

5. For an extended account of Strindberg's version of the medieval "dance of death" motif, see Patricia Scott, "Vampires, Death, and Marriage: Strindberg's *The Dance of Death I* and *The Dance of Death II*, 1900–1901," in *The Symbolism of Vanitas in the Arts, Literature, and Music: Comparative and Historical Studies* (Lewiston, N.Y.: Mellen, 1992), 67–84.

6. Susan Brantly has pointed out that Strindberg was much preoccupied with Paul's *Letter to the Romans* at the time of writing this play, and she has suggestively read its seesaw movement in Pauline

terms of "sin" and "death." Brantly sees Strindberg trying to bend naturalist protocols to his increasingly subjective and symbolic ends. See Brantly, "Naturalism or Expressionism: A Meaningful Mixture of Styles in *The Dance of Death (I)*, in *Strindberg's Dramaturgy*," ed. Göran Stockenström (Minneapolis: University of Minnesota Press, 1988), 164–174.

7. It is evident that I am arguing for a Darwinian reading at some remove from the position taken by Ross Shideler in his superb *Questioning the Father: From Darwin to Zola, Ibsen, Strindberg, and Hardy* (Stanford: Stanford University Press, 1999). I am quite aware that the more "ludic" and even "subjunctive" argument I am making would scarcely stack up as Darwinian in the traditional sense, yet survival is indeed what is at stake, and going-through-the-wall may be conceived as a weird survival strategy, an alternative to fact, a reprieve from empirical reality.

8. I am obviously in some disagreement with the more traditional "naturalist" readings of *Dance of Death*, such as Marilyn G. Robinson's "Prisoners at Play: Form and Meaning in Strindberg's *The Dance of Death* and Beckett's *Endgame*," *Journal of European Studies* 15, no. 1 (March 1985): 31–48, which focuses on the self-reflexiveness of Strindberg's play but fails to pick up on what is ludic and generative.

9. The Strindberg biographies make it amply clear that Edgar's mix of suicide and dinner coincides with Strindberg's own rollercoaster feelings. His Herculean correspondence often reveals letters hinting suicide followed (on the same day) by others discussing food or current events. Could one go a step further and suggest that hinting suicide is a way of working up your appetite? It is hard to posit some kind of "bottom line" in Strindberg, for he seems to have been—a bit like Ibsen's onion-like Peer Gynt—histrionic through and through, seeing his own life as material for observation, as a theoretical field.

10. I call this "vitalism," but others have approached it from the other end, as it were, and labeled it "retardation": see Peter Egri's intriguing comparative essay, "Epic Retardation and Diversion: Hemingway, Strindberg, and O'Neill," *Neohelicon* 14.1 (1987): 9–20, for a view of "retardation and diversion" as related to a "thematics of failure" (11–12)—failure, that is, to enact what is signaled. But what if the signals are specious? Or just that: signals, not binding reality?

11. James Joyce, *Ulysses* (New York: Random House, 1986), 162.

12. *A Dream Play* seems larded, as it were, with references to denied/repressed (and therefore endlessly desirable) food and sex, not

merely in the famous late scene representing Fingal's cave or the remarkable (ejaculatory?) blossoming chrysanthemum at play's end, but in early sequences as well, such as the Officer's memory of the closed pantry door and the milk and strawberries given to him by the parson's wife after the bee sting. And there is, of course, the opening scene where Indra's Daughter gently removes the saber from the Officer's hands, literally preventing him from continuing to beat the table, figuratively preventing him from onanism.

13. Josephson experienced his internal affairs and external fate in a fashion as dizzying as Hamlet's. See the exemplary letter cited in the chapter 4, section B.

14. Blomberg asks, at one point in his biography, the rhetorical question: could there be a dosage of homophobia in the public's initial repudiation of both *Näcken* and *Strömkarlen*? Not a bad question, even if one can hardly offer a clear answer. We do know that the contemporary reviews of *Strömkarlen* were drawn to this male body, even if they had few good things to say.

15. This forthcoming analysis of *Fanny and Alexander* reprises the central arguments in an earlier study of mine, *A Scream Goes through the House: What Literature Teaches Us about Life* (New York: Random House, 2003), 58–71.

16. As Lynda K. Bundtzen has noted, this warm, popular, valedictory film found great favor with the general public but was not a hit among the Bergman critics ("Bergman's *Fanny and Alexander*: Family Romance or Artistic Allegory," *Criticism* (winter 1987): 89–90. Vernon Young, John Simon and Stanley Kaufmann, all Bergman supporters, thought the film too melodramatic, too "schmaltzy," too self-indulgent, too pandering to popular taste.

17. Morton Jostad offers the most provocative "theatrical" reading I have seen of the film, showing how the *theater* becomes a potent place of magic and power ("'I den lilla världen': Ekdahlerne og teatret," *Samtiden* [1985], 40–46).

18. Jostad ("Lilla världen," 44) points out that Bergman boldly uses elements of pure farce in this extraordinary scene: Isak as the (seemingly) avaricious Jew is a figure who might have stepped out of a medieval play. Still another aspect of Isak's "makeup" is the softness, indeed the quasi-feminine side of his temperament, whereby he stands in great contrast to the more brutal and phallic Edvard. See Marilyn Johns Blackwell, *Gender and Representation in the Films of Ingmar Bergman* (Columbia, S.C.: Camden House, 1997), 211, for pertinent remarks on Isak as children-saving "adversary of the Lutheran patriarchy."

19. Here, in the hope that it is pertinent, I recount a personal story about Erland Josephson's performance. I was in Stockholm a number of years ago, occupied with the work of Ernst Josephson, and had a burning conviction that Erland, (roughly) the great-great nephew of Ernst, had the famous portrait of Ludvig (also his relative) in mind when he took on the role of Isak in *Fanny and Alexander*. To prove this contention, my wife and I invited Erland Josephson to come by for a drink; I indicated in my invitation that I was writing on both Ernst and Bergman. He came. Charming, congenial, willing to talk about all topics, he nonetheless denied that he had had this famous painting in mind when he performed his role. Indeed, he denied this until we completed our last glass of wine, at which point he allowed that it just might ... in fact ... have been possible that this image was there, deep in his subconscious. At that point the visit was over. Much later, in researching this book, I came upon Josephson's novel of 1988, *Färgen*, which contains three tormented fictionalized renditions of Ernst's complex relationship to Ludvig, bubbling with envy, contempt, and self-contempt, documenting the actor's own obvious fascination with this old story; it also made me realize that Erland was unquestionably toying with me a bit, when we had our little chat. No matter. This book is perhaps not an ideal place for speaking about such things, but it gives me great pleasure to express my admiration for Erland Josephson's extraordinary work in Bergman's films, and it makes one believe in the notion that some families—such as the Josephsons of Sweden—are astonishingly gifted.

20. This scene was especially singled out by the initial critics as "hocus pocus" or mystifying. A particularly interesting account of this episode is found in Jarrod Hayes's article, "The Seduction of Alexander Behind the Postmodern Door: Ingmar Bergman and Baudrillard's *De la séduction*," *Literature/Film Quarterly* 25, no. 1 (1997): 42–43.

21. See Marilyn Johns Blackwell for a thoughtful account of androgyny as both a dissociative and catalyzing force in the film ("Gender and Creativity in Ingmar Bergman's *Det sjunde inseglet* and *Fanny och Alexander*," *Tijdschrift voor skandinavistiek* 20, no. 1 [1999], 121–132).

22. Bundtzen rightly takes her cues from Ishmael's biblical name, "a wild man," and argues that this encounter stages Alexander's coming into contact with his own inner "wild man" (108), a necessary final stage in his development as "empowered" artist. Linda Haverty has linked this encounter to a Strindbergian discourse of

divided souls and eroded integrity ("Strindbergman: The Problem of Filming Autobiography in Bergman's *Fanny and Alexander,*" *Literature/Film Quarterly* 16, no. 3 [1988]: 179).

23. For a complex argument about Alexander as figure of seduction—and the frequency with which adolescents perform this role in Bergman's films—see Hayes's Baudrillard-argument ("Seduction," 44–46). Ruth Milberg-Kaye has discussed the issue of Alexander's adolescent fluidity in an equally systematic fashion in "*Fanny and Alexander:* A Kleinian Reading," in Maurice Charney and Joseph Reppen, eds., *Psychoanalytic Approaches in Literature and Film* (Rutherford, N.J.: Fairleigh Dickinson University Press, 1987), 180–191.

3.B: The Child's Revenge

1. See James E. Kerans's early "*Kindermord* and Will in *Little Eyolf,*" in *Modern Drama: Essays in Criticism,* ed. Travis Bogard and William I. Oliver (New York: Oxford University Press, 1965). Robin Young's more recent volume, *Time's Disinherited Children* (Norwich: Norvik Press, 1989), attacks the entire Ibsen corpus as invested in a sacrificial discourse, involving not only the scapegoating of children but also the infantilizing of adults; Nora, Hedda, Rosmer, Allmers, and others come across as impetuous spoiled children, busily constructing their little egocentric games, refusing to grow up.

2. The influences on Ibsen are a tricky matter, since the criticism ranges between the most sweeping claims, on the one hand (the Greeks, the Bible, Goethe, the entire "tradition"), and, on the other, a no less persuasive contention that the wily playwright was telling the truth when he said he read only newspapers. The name of Kierkegaard has often been adduced, nonetheless, as a crucial nexus for Ibsen, yet the Kierkegaard text most often proposed as geminal is *Either/Or;* I obviously believe that *Fear and Trembling* is a better choice.

3. I am putting myself a bit between a rock and a hard place in arguing that Helene Alving is indeed responsible for a portion of the family horror show, inasmuch as her strict obedience to the repressive code she grew up with led her, without question, to deny her husband whatever of "pleasure" they might have had. She herself says as much, and it seems tendentious to overrule her. But many feminist critics have rightly cried "foul" at just this maneuver, this classic trap whereby the woman once again takes the rap, says it is her fault things went badly, agrees that she somehow failed her

man. Joan Templeton's brilliant *Ibsen's Women* (New York: Cambridge University Press, 2001) tackles this head-on, and makes the strongest case one can for "innocenting" Helene and grasping the ideological stakes of this interpretation.

4. It is well known that *Pippi Longstocking* had its detractors when it first appeared. The bourgeois reading public in 1945 was understandably rattled by the appearance of this "wild child" who broke all the rules, while sporting two attributes that no child could fail to want, and that no child could expect to have: endless money and endless physical strength.

5. For a provocative account of the "Pippi-phenomenon" as evidence of burgeoning changes in the fields of child care, child education, and child psychology in Sweden in the 1930s and 1940s, see Ulla Lundqvist, "The Child of the Century: The Phenomenon of Pippi Longstocking and Its Premises," in *The Lion and the Unicorn* 13, no. 2 (1989): 97–102.

6. Here, as elsewhere in my readings of Scandinavian literature, I am deeply indebted to my Swedish wife, Ann Cathrine Berntson Weinstein. Her love and profound knowledge of Swedish literature were, I suppose, not merely a wedding gift of sorts, but my own genie in the bottle, my own ticket to Farawayland, inasmuch as I have been sampling this culture, with both an outsider and insider perspective, during the entire four decades of our marriage. Whereas I grew up essentially unlettered and started reading seriously only in college, she absorbed these books, especially the Lindgren books, almost from infancy on, and *they*—rather than the predictable Anglo-American fare—were the books we read to our children. As is her wont, she reads with great acuity, and saw the autistic element in *Mio* straightaway, and then helped me to see it.

7. For commentary on the ending, see Søren Vinterberg's "Fantasiens vingar—kan de bære en realistisk forstælse av omverdenen?" in *Barneboka—fantasi og virkelighet*, ed. Greta Rongved and Irja Thornenfeldt (Oslo: Pax, 1979), 85. For a "maturational" argument, see Erika Frank's "Parallella världar i svensk barnlitteratur," *Tijdschrift voor skandinavistiek* 23, no. 2 (2002): 238.

8. See Eva-Marie Metcalf's "Leap of Faith in Astrid Lindgren's *Brothers Lionheart*," *Children's Literature* 23 (1995): 168–169, for a fine discussion of both death and the still more taboo subject of suicide (in children's books); Metcalf argues that Lindgren is challenging societal norms in her championing of "quality of life" over "holding on at all costs" (174).

9. That Lindgren's creatures of fable might have a political sub-text is borne out by an entry in her diary in 1941: "National Socialism and Bolshevism—they are like two giant lizards fighting each other" (cited in Vivi Edström, *Astrid Lindgren: A Critical Study* [Stockholm: R&S Books, 2000], 261).

10. This story has also been read in terms of character development; consult Bo Møhl and May Schack, *När barn läser. Litteratur upplevelse och fantasi* (Stockholm: Gidlund, 1981). Møhl and Schack see the trip to Nangilima as a further installment in the adventure story, a voyage to the territory ahead, as it were (184). See Egil Törnqvist, "Astrid Lindgrens halvsaga. Berättartekniken i *Bröderna Lejonhjärta,*" *Svensk Litteraturtidskrift* 38, no. 2 (1975), for a fuller account of the narrative techniques in the story.

11. As said, Lindgren consciously tackled the issue of how one discusses death with children. Clara Juncker has pointed out that whereas the subject of death has been taboo in twentieth-century children's literature, it was a staple item in earlier times, whether as pedagogic tool (deathbed confessions in eighteenth-century tales) or as inevitable endpoint (in nineteenth-century materials) ("The Ultimate Fantasy: Astrid Lindgren's *The Brothers Lionheart,*" in *The Fantastic in World Literature and the Arts: Selected Essays from the Fifth International Conference on the Fantastic in Literature and the Arts,* ed. Donald E. Morse [New York: Greenwood, 1987], 59).

12. For a good discussion of Cronqvist's early work, see the introductory essay, "Målaren," by Ingela Lind, in *Lena Cronqvist: Målningar 1964–1994* (Stockholm: Lars Bohman Galleri, 1994). See also the superb essays by Mårten Castenfors and Eva Runefelt, as well as the interview with the artist conducted by Eva Ström, in *Lena Cronqvist* brought out by Sveriges Allmänna Konstförening (Stockholm: Wahlström & Widstrand, 2003). For the theme of self-conception in Cronqvist's early and middle phases, see Maj-Brit Wadell, "Om att söka sitt jag—ett tema i Lena Cronqvist's konst," *Konsthistorisk Tidskrift* 55 (1986): 27–37. Then came the brilliant if disturbing series, during the 1990s, of works focusing on the antics of the two girls. It is doubtless still too early to speak of the final shape of her work, but the recent exhibit at Bohman's Gallery in Stockholm, *Lena Cronqvist: Självporträtt* (January 2006), of her latest work seems to announce a crucial turning point: the famous emancipated little girls are still there, but no longer in the dominating, tyrannical mode as before, since the central focus is now on Cronqvist herself. It is here one sees the splendid self-portraits featuring the artist and her "dependents," whether wild children, dead parents, or dead

spouse, but one has little doubt that the final authority (and final responsibilities) lie with Cronqvist herself, as both creator and caretaker.

13. Toril Moi has written about the ramifications of the "doll figure" in Ibsen's famous play. Taking her cues from the work of Stanley Cavell, Moi offers a fine discussion about agency and liberation in this play, tracing the very notion of dolls back to the Cartesian suspicion of "automatons" that might or might not be human (*Henrik Ibsen and the Birth of Modernism: Art, Theater, and Philosophy* [Oxford: Oxford University Press, 2006], 235–236).

14. I am well aware that my apology for cradling and nurturance as the most mature gestures of human life may have a dubious ring for any feminist-oriented criticism, since women have been forever trapped in just these role models. Yet one cannot help feeling that Cronqvist's last paintings breathe a kind of moral richness, almost a Shakespearean "ripeness," on the far side of either entrapment or self-assertion.

3.C: Hamsun's *Hunger* and Writing

1. Introduction to Knut Hamsun, *Hunger*, trans. Robert Bly (New York: Farrar, Straus and Giroux, 1967); subsequent references to *Hunger* are from this edition, with page numbers noted parenthetically in the text. Occasional references are made to the original Norwegian text, *Sult* (Olso: Gyldendal, 1953), and page numbers are also noted parenthetically in the text.

2. At the outset I want to acknowledge the quite remarkable interpretation of *Hunger* provided by William Mishler more than three decades ago, "Ignorance, Knowledge and Resistance to Knowledge in Hamsun's *Sult*," *Edda*, 74 (1974): 161–177. Mishler's argument—to my mind the best discussion I have read on the novel—differs considerably from mine, inasmuch as he constructs a fine-grained Oedipal reading, whereby the protagonist gradually comes to understand the world's ultimate contingency but fails to resolve the Father/Mother symbolic drama into which he is cast: to slay the various "old men" of the text while "fathering" his own subjecthood.

3. As Mishler splendidly puts it, "Hence no matter where he looks, the hero is in fact looking to the sky" (162).

4. I do not want to overstate the "wound" notion, since the protagonist also asserts that he was somehow under God's protection

nonetheless, that this hole was simply part of his equipment. None-theless, "et aapent Hul" has a nasty ring to it.

5. The parallels to Kafka have interested numerous Hamsun crit-ics, and it is but a short step to move from the notion of a suffering Hunger Artist to a full-fledged sacrificial figure, on the order of Jesus or Job; see Martin Nag, "Sult—en Messsias-roman?" *Kirke og Kultur* 70 (1965): 299–304, for a reading along these lines.

6. I cannot let this passage stand without expressing my (lifelong) admiration for its economy: "die mir geschmeckt hätte" is simply unrivaled in pith, since the conditional "hätte" spells out to perfec-tion the exiled condition of the human body, desiring spiritual goods while marooned in a material scheme.

7. Other critics have also noted this distinct feature of the text; see Per Maeleng, "Fysiognomier; Kommentarer til kroppen som skriftens scene: Lesning av Knut Hamsuns *Sult*," *Edda*, 2 (1994): 120–133, where the processing of food is suggestively compared both to anorexia and (especially) bulimia, not merely as physiological pro-cesses but also as textual dynamics.

8. "Vomiting" is the English, but *emptying oneself*, "tømte mig igen" is how the Norwegian has it. "Fulfillment" is not to be had in this scheme.

9. Not surprisingly, Mishler (171) codes the finger-biting moment along Freudian lines as a symbolic castration. He goes further still with the incident where our hero's foot is injured, predictably seeing in this an echo of Oedipus himself, the man with the swollen ankles and the telltale wound.

10. An argument has been made for reading *Hunger* as a text about "decadence," and hence comparable in some fashion to Huysman's *A Rebours*, with its aesthete hero, des Esseintes. See Linda Hamrin Nesby, "Knut Hamsuns *Sult* (1890)—et eksempel på dekadanselitteratur?" *Nordlit: Arbeidstidskrift i litteratur* 13 (spring 2003): 77–98.

11. As mentioned, Mishler, passim, reads Ylayali as the threaten-ing and undoing Mother figure of the text whose power unmans our man. This makes sense, too.

12. The Norwegian has more character: "Maa jeg bare faa se litt . . . litt . . ." (141), with its nice combination of "must" and "allow," along with the pleading repetition of "little."

13. The Norwegian is fiercer: the sun "burns sharply" at his tem-ples; it even "steams and glows" in his brain (127).

14. About advertising, Mark B. Sandberg's "Writing on the Wall: The Language of Advertising in Knut Hamsun's *Sult*," *Scandinavian*

Studies 71, no. 3 (1999): 265–296, emphasizes the new mobility achieved by advertising in newspapers, suggesting not only that language got into intimate domestic spaces but that readers were faced with the semiotic/experiential challenge of connecting words to real stores and sites on city streets (270).

15. It is here, in the reading of the "Kuboå" episode that I part ways entirely with Mishler, who sees this experience in the pitch-black cell as a dark night of the soul for the protagonist. Mishler argues that our man *fails* here to validate himself as "generator of meaning"; instead, he "labors in distress for the word to reveal its *inherent* meaning" (167). In the same vein, Mishler construes "Kuboå" as Hamsun's version of the Riddle of the Sphinx, a riddle that this hero cannot properly answer. Yes, this is intelligent criticism, but it shuts down shop on what is the most joyous and affirmative energy of this text: the ludic, the emancipated language that seems everywhere to be going on holiday. Maeleng ("Fysiognomier,"; 129) is closer to my view of these matters, but he inscribes the semiotic production in a larger "bulimisk" discourse. Perhaps the sweetest authorial genealogy of "Kuboå" and its siblings is proposed by Sandberg when he rehearses some of the Hamsun tall tales from his early Chicago period as streetcar driver, most notably that Hamsun would be reading classic literature while he drove, and that "his notoriously bad geographic sense led him to confidently call out the wrong street names and let people off at the wrong stops" ("Writing on the Wall," 281–282).

16. My Baudelaire reference is to the poet of ecstatic states, the poet whose greatest poem is called "Le Voyage." But there is another Baudelaire, the prose-poet of *Le Spleen de Paris*, whose notations about both the misery and poetry of modern urban life have distinct parallels also with *Hunger*. See Julie K. Cease, "Semiotics, City, *Sult*: Hamsun's text of 'Hunger,'" *Edda* 2 (1992): 136–146.

3.D: Stories of Fusion

1. Tarjei Vesaas, *The Ice Palace*, trans. Elizabeth Rokkan (London: Peter Owen, 1992), 5. Page numbers of subsequent references to this work are cited parenthetically in the text. Rokkan's translation of the poetic original is of very high quality, but occasionally I cite the Norwegian as well, *Is-slottet* (Oslo: Gyldendal, 1963); page numbers to this source are also cited parenthetically in the text. Vesaas remains perhaps the single greatest *unknown* figure examined in this

volume. His books were out of print for a time in English but are now available again. I gather that he has his supporters throughout the world, since a friend just reported having seen *The Ice Palace* at Shakespeare and Company in Paris and, upon inquiry, was told that this Norwegian novel was one of their great finds.

2. Rakel Christina Granaas's provocative article, "The Body and Nobody in Tarjei Vesaas's Novel *The Ice Palace, Edda* no. 4 (2004), posits that this initial presentation of forehead, heart, ears, and feet is meant to evoke fear, and that the body parts themselves already point to themes of fragmentation and dissolution, akin to psychosis (316).

3. For a reading of Vesaas's work along the lines of animism and primitivism, see Frode Hermundsgård, *Child of the Earth: Tarjei Vesaas and Scandinavian Primitivism* (New York: Greenwood, 1989).

4. *Through Naked Branches: Selected Poems of Tarjei Vesaas*, trans. Roger Greenwald (Princeton, N.J.: Princeton University Press, 2000), 81. Subsequent references are to this edition.

5. Vesaas's Norwegian is sleeker than Rokken's English, and puts into adjectives what must appear as similes in translation: "knivs-male revner" ("knife-narrow fissures"), he writes, and "djupt nedig-jennom" ("deeply down/through") is pure directional energy (7), requiring no noun such as "depths."

6. Greenwald, *Through Naked Branches*, 113.

7. The Norwegian is more urgent: "*Denna må eg treffe!*" is itali-cized to underscore its imperiousness.

8. I am indebted to the fine recent essay of Atle Kittang, "Kuns-tens kalde fortrolling," in *Kunstens fortrolling: nylesningar I Tarjei Vesaas' forfatterskap* (Oslo: Landslaget for Norsk Undervisning, 2002), 193, for this observation. The gleams and radiance of these four eyes have also a literary resonance, and have led Dagne Groven Myhren to reference Paradise, a paradise of shimmering souls of the sort Dante had in mind, "En studie i Tarjei Vesaas' roman *Is-slottet*. Symbolikk og folkloristiske allusjoner," *Norskrift*, 53 (1987): 45.

9. Granaas, "The Body and Nobody," 317.

10. In his feisty and pertinent article, "Hva er det med Unn? En liten apologi for Is-slottets tragiske helt," *Edda*, 2 (1988), Petter Myhr picks up Siss's remark, "What is it about Unn?" and warns about the risk of oversexualizing this magical text; in particular, Myhr rightly rejects all readings that either construe both girls as abnormal or else interpret their infatuation as proto-lesbian.

11. Myhr compares their unique entente to the I/Thou relation-ship theorized by Martin Buber (159).

12. This phrase is too haunting to go without comment: "og det romet var å finne, så sikkert som at ho var Unn," for it initially signals the "self-evident"—the certainty of finding a new room is akin to the certainty of who you are—in order then to make us understand, rather queasily, that just these certainties are coming apart.

13. Drawing on the ideas of Julia Kristeva, Granaas suggestively argues that the entire novel is a meditation and exploration of the strange adolescent female body; hence the Ice Palace itself would be a figure for Unn's body, a womb whose "inside is not safe, warm and protective; it is, on the contrary, dark and ice cold—dangerous and out of control—'at the sides of the road'" (327). In this sense, the danger at the core of the story would not be so much Unn's death or Siss's mourning, but rather the terror evoked by the female body in a male culture.

14. As Granaas says, this is her second undressing in the text (319); there won't be a third.

15. Giulia Grimstad, in an early commentary on the novel, "Is-slottet av Tarjei Vesaas," Edda 1 (1971), , 47–50, points to the mythical forces that inhabit Vesaas's landscape: "nøkken" and "havfruen," the river sprite Näcken (whom we will examine in considerable detail in the chapter on the painter Ernst Josephson), and the "lady from the sea" (who entranced Ibsen enough for him to devote a play to her). One can go further still in this direction and link Unn's sojourn in the Ice Palace to Peer Gynt's entry into the Home of the Mountain King; here—especially in Ibsen's rendition, rather than Grieg's more romantic version—would be the threatening magic world, the "testing" troll-world, where human form comes undone and human markers disintegrate. Myhren has evoked the entire "Bergtaking" tradition of luring the innocent into the realm of the trolls, mentioning H. C. Andersen's Snow Queen as well as Norwegian folk songs about Margit Hjukse and Liti Kjersti, both abducted by dark forces (63).

16. Kittang has put this wonderfully: "Paradox though it is, here at the center of cold, so to speak, of the novel, the temperature of Vesaas's art is at its highest" (189). My translation.

17. Every critic has tried his or her hand at defining the Ice Palace: Death? Art? Cold? Emblem of Unn's own body? One of the arresting earlier phrases is that of Ellisiv Steen: "the cathedral of solitude, cold and death" ("Tarjei Vesaas: Is-Slottet," Edda 51 [1964]: 126). Johan Borgen and, later, Atle Kittang, have persuasively claimed that the Ice Palace represents also the "place" and the modality of art. The reader, Borgen writes, is led by Unn into "the ice

palace's inside, to the core, to art" ("Slottet Vesaas bygget," in Jan Erik Vold, ed., *Tarjei Vesaas* [Oslo: Gyldendal, 1964], 170–171).

18. In leaving this text, let me again display its magical superiority in Norwegian: "Snø-tid og døds-tid og stengde kammers hadde det vori—og så kjem ein altfor bums på andre sida av det" (120). Vesaas's compact idiom compresses snow and death and closed rooms into something time-drenched and fateful, standing at the head of the phrase, so that he can then lift off into the miracle of going beyond, finding oneself "bums" on the other side. No volition in sight, just the wisdom of the elements, which turn out (this time) to be on life's side, "the other side."

19. As will be clear to Bergman scholars, a good deal of my interpretation builds on Susan Sontag's remarkable essay devoted to the film, originally published in *Styles of Radical Will* (New York: Farrar, Straus and Giroux, 1969), and then reprinted.

20. John Simon's commentary on this remarkable image is worth citing: "the two half-faces do not look merely like disparate, unrelated forms arbitrarily juxtaposed; rather, they look like one face, but a sick, monstrous face that does not quite hang together—that contradicts itself, wants to split apart, is struggling against an enforced oneness. It is as terrible as seeing an object—a lamp, a table, a painting—straining to disintegrate; as if the atoms constituting our everyday reality suddenly became visible, only to start flying off in different directions" (*Ingmar Bergman Directs* [New York: Harcourt, Brace, Jovanovich, 1972], 298).

21. Simon has written at length about the *doubling* that seems to be at the core of Bergman's film (ibid., 208–312).

22. See Brigitta Steene, "Bergman's Persona through a Native Mindscape," in Lloyd Michaels, ed., *Ingmar Bergman's Persona* (Cambridge: Cambridge University Press, 2000), 24–43.

23. *Strindberg: Five Plays*, trans. Harry G. Carlson (New York: Signet, 1981), 209.

24. Marilyn Johns Blackwell has seen in the child's yearning to reach/blend with the two maternal faces a key instance of what she calls *mergence*, the desired-but-fictive "mingling" between separate subjects (*Gender and Representation in the Films of Ingmar Bergman* [Columbia, S.C.: Camden House, 1997], 133–164).

25. *Bergman: Persona and Shame: The Screenplays of Ingmar Bergman*, trans. Keith Bradfield (New York: Grossman, 1972), 41–42. Subsequent citations are drawn from this edition, with page numbers noted parenthetically in the text.

26. Blackwell has rightly credited Bergman's pluck in assigning this role of institutional authority to a *woman doctor* (*Gender and Representation*, 146). And no small part of this speech's seductive authority is due to the stunning presence of the actress herself, Margareta Krook, whose inflections and nuances are unforgettable.

27. Simon rightly calls the psychiatrist's speech a "master stroke," inasmuch as she establishes, from the get-go, the impossibility of getting clear of *acting*, of ever leaving the theater (*Ingmar Bergman Directs*, 265).

28. In one of the earliest and best studies of Bergman, Robin Wood makes the observation that the overall impact of *Persona* has to do with "liberated" feelings and the psychic penetration of a world where representations of unthinkable violence are now commonplace (*Ingmar Bergman* [New York: Praeger, 1969]), 143–159.

29. Bruce F. Kawin has rightly called attention to the parallels this scene has with the old Gothic genre of horror films, replete with nocturnal visits of vampires and the like (*Mindscreen: Bergman, Godard and First-Person Film* [Princeton, N.J.: Princeton University Press, 1978], 124).

30. Simon interprets the episode with Herr Vogler as pendant to the orgy on the beach: an instance of erotic mediation, so that the union between the man and the woman serves as a conduit between the two women. I think even this reading is too "bounded," too inattentive to the promiscuity and unleashed nature of eros, as Bergman sees it (*Ingmar Bergman Directs*, 274).

31. Given how familiar Bergman is with the Ibsen corpus, one has to think that the figure of Hedda Gabler—filled with revulsion by the sordid fact of her pregnancy—was lurking somewhere in the filmmaker's imagination.

32. Michaels, *Ingmar Bergman's Persona*, 79. Sontag's essay, reprinted in Michaels as "Bergman's Persona" (66–86), is, as mentioned, deservedly known throughout the film world as an exemplary critical performance. I am happy to acknowledge again my indebtedness to this fine essay which was published at roughly the same time as the film appeared, hence without any "help" from existing critical work; Sontag's gift lay in that direction: interpreter of the New.

33. In his richly articulated study of Bergman, *Ingmar Bergman and the Rituals of Art* (Ithaca, N.Y.: Cornell University Press, 1982), Paisley Livingston builds a substantial argument on the twin views of *mask* theorized by Marcel Mauss and Georges Bataille.

4.A: Breakthrough, Time, and Flux in
Edvard Munch (the Cubist)

1. It turned out that even Munch's supporters among the younger painters defended him largely on the grounds of *politesse*, arguing that it was rude and ungentlemanly to invite him to Berlin and then to shut down the exhibition.

2. For a notable account of the "Black Pig" experience and its ramification, in terms of how Munch was seen in the early days, see Carla Lathe, "Munch and Modernism in Berlin, 1892–1903," in *Edvard Munch: The Frieze of Life*, ed. Mara-Ellen Wood, 38–44 (London: National Gallery Publications, 1992).

3. Munch felt Strindberg's presence throughout his life, and in his own desperate bouts of mania he resembled ever more frighteningly the figure we see in *Inferno*, prey to visitations and hallucinations, pursued by fiends. For a full-scale effort to depict the Munch-Strindberg relationship over the years, see Reidar Dittmann's "Art and Passion: The Relationship between Strindberg and Munch," in *Structures of Influence: A Comparative Approach to August Strindberg*, ed. Marilyn Johns Blackwell, 92–120 (Chapel Hill: University of North Carolina Press, 1981).

4. Cited by Sue Prideaux, *Edvard Munch: Behind the Scream* (New Haven: Yale University Press, 2006), 175.

5. The psychic gestalt that I assign to Munch and Strindberg might, I agree, be interpreted along broader, more cultural lines. Patricia G. Berman does exactly that in her recent "Edvard Munch's 'Modern Life of the Soul'" (published on the occasion of the 2006 MOMA exhibit of Munch's works), in *Edvard Munch: The Modern Life of the Soul*, ed. Kynaston McShine, 35–51 (New York: Museum of Modern Art, 2006), where she links his peculiar mental makeup to a nascent urban mentality, as theorized specifically by Georg Simmel in his pathbreaking work (along with Tönnies, Durckheim, and others). But one has trouble putting the (still village-like) Christiania of the latter nineteenth century in the same league as Paris or London or Berlin. Berman seems to me to be following in the footsteps of a Benjamin, but Munch is not Baudelaire.

6. The veteran Munch commentator Reinhold Heller calls *The Scream* "egolessness personified" in his recent " 'Only Could Have Been Painted by a Madman'—Or Could It?" in McShine, *Edvard Munch: The Modern Life of the Soul*, 30. Heller goes on to make the striking argument that *The Scream* is unique in Munch's repertory, that the "de-individualizing" rendition of its central figure makes it

stand utterly alone, as a kind of promontory Munch reached only once, and never returned to.

7. Munch's diary richly illustrates his dementia, and it is here that he calls to mind so clearly the hallucinating protagonist of *Inferno*, showing us what it means to inhabit a world of coursing spirits. He thought himself pursued by "fiends," felt that people he saw were in disguise, were actually in pursuit of him, recorded one conversation where his interlocutor spoke Esperanto in order to get him into his nets. Here is his account of a train trip to Copenhagen:

> A strange man with a bird's head, spindly bird-legs, wings and a cloak flew into the railway carriage. Detective.
> We chatted.
> "What is your metier?" I asked.
> "I am a psychiatrist from Vienna."
> "You can advise me then," I said. "I'm afflicted by nerves and drink. Shall I admit myself to a clinic?"
> "Better say you're a drunkard," he said. "Tell them it's nerves and you'll go from institution to institution,"—like Laura [Munch's increasingly demented sister]—"God knows when you'll come out."
> I shivered.
> The rages were coming more and more often now. The drink was meant to calm them, especially in the morning but as the day wore on I became nervy, angry . . . I noted small paralyses particularly at night. Arms and legs went to sleep. In the daytime I noticed heaviness in my right leg. It dragged a little, and then there were the strange voices and visions. I asked the doctor for advice. He looked it up in a book.
> "In the end it will go to your head. You will have a stroke."
> I had these tearing pains under my heart, terror in the morning, giddy when I stood up. Quick, need a drink, I thought. Ring the bell. Port wine, half a bottle. It helped. Coffee, a little bread. Another panic attack. Go outside. To the first restaurant. A glass. Get out into the street. It will get better. (quoted in Prideaux, *Behind the Scream*, 245–246)

The mix of anxiety, hallucination, and (unintended?) humor is amazing. One imagines Dr. Freud encountering on the train the sick Edvard. How not to remember the crazed figure of *Inferno* who enters his room at night and finds it occupied with the living spirits of "others" who got there first?

8. This view is not unlike the position Heller argued at the occasion of the 2006 MOMA exhibit ("'Only Could Have Been Painted by a Madman'"), urging that one avoid seeing Munch's work as essentially therapeutic or confessional but rather as a kind of prism for communicating something more generic, citing Munch's admonition of 1929 that his writings and paintings "'are intended to seek out the hidden powers ... within the machinery that is called a human life'" (30).

9. Prideaux, *Behind the Scream*, 86.

10. Munch himself referred to this piece as "sjaelemaleri," "soul painting" (ibid., 84).

11. The death theme in Munch is scarcely unfamiliar territory. Arne Eggum has a chapter titled "The Theme of Death" in *Edvard Munch: Symbols & Images* (Washington, D.C.: National Gallery of Art, 1978), 143–184. As for my contention that Munch constantly *relives* this death, as evidenced by his obsessive return to this scene, I admit to being in speculative territory. Munch himself was extremely sensitive to the charge of being obsessed with certain images, and in 1932, when he did his fifth version of *The Sick Child*, he defended himself in a letter to Jens Thiis, his chosen biographer: "A painting and a motif that I struggle with for an entire year are not expended in a single picture. If it is of such significance to me, why should I not then paint and vary a motif five times? Just look at what other painters depict over and over again ad infinitum: apples, palm trees, church towers, haystacks?" (cited in Reinhold Heller, *Munch: His Life and Work* [Chicago: University of Chicago Press, 1984], 21).

12. Poul Erik Tøjner makes the point that the actual focus of this painting is on the mother figure, not the dying child, thereby conveying what is ultimately most terrible about her death: to be left behind (*Munch: Med Egna Ord*, trans. Peter Carlsson [Stockholm: Prisma, 2001], 14). But being left behind is anything but a passive proposition in Munch's scheme; it is, rather, an Ibsen-like form of living death. Tøjner's views appear more than once in these notes, so let me say that my own thinking about Munch is the result of two decades of teaching and research, but that Tøjner's volume, which I happened upon in 2003, was a startling discovery of a kindred spirit who brought a professional art-historical perspective to his topic and yet zeroed in (time and again) on the existential and psychic issues that matter most to me. Often Tøjner takes his argument in directions I do not follow, but I am happy to signal my ad-

miration for his splendid introductory essay to the journal writings of Munch himself.

13. Munch's decision to "age" his subjects is not limited to *Death in the Sickroom*; something comparable is on show in the various renditions of *Girls on a Bridge*, in which the girls are presented, again *in real time*, in 1901, 1912–13, and 1924–25, so that we feel the painting itself is aging, maturing, evolving, as the girls turn into women.

14. Munch wrote: "Terror of life has laid waste to me ever since the idea first came. Precisely like the sickness I have borne since birth: both inherited. It has lain there like an unjust curse that followed me. Nonetheless I often have the feeling that I need this terror, that it is necessary for me, and that I would not want to be without it. Often I also feel that sickness was necessary. During periods without terror and sickness I have felt like a rudderless vessel sailing in too much wind: and asked myself: where to? Where will I be beached? (Tøjner, *Munch: Med Egna Ord*, 98; my translation).

15. See Prideaux, *Behind the Scream*, 187–200, 221–225, for a fuller account of the tempestuous affair with Tulla Larsen.

16. Perhaps one-on-one personal relations were too demanding for Munch to bear; we know that he loved both Tante Karen and his sister Inger immeasurably, but he avoided their actual company, could not abide actually seeing them, as if it would be too much. One feels he knew exactly how much intimacy he could manage. How shimmering is the contrast with his artistic "children," even when he subjects them to all manner of violence; here are the only relationships he can fully negotiate.

17. As early as 1892, Munch discovered the crucial "fit" between his disparate pieces: "I placed them together and found that various paintings related to each other in terms of content. When they were hung together, suddenly a single musical note passed through them all. They became completely different from what they had been previously. A symphony resulted" (quoted in Heller, "Munch: His Life and Work" [Chicago: University of Chicago Press, 1984], 103). As someone who has been studying Munch for close to three decades, I confess that I have never yet grasped this larger "gestalt," this "conversation" between single works, with real clarity; perhaps this essay is my way of articulating the Munch family portrait.

18. Ragna Stang, *Edvard Munch: The Man and the Artist* (London: Gordon Fraser, 1979), 227.

19. David Loshak has gone over some of this same territory but with a different perspective and different conclusions ("Space, Time, and Edvard Munch," *Burlington Magazine* 131 [1989]: 273–282).

20. Munch to Jens Thiis, quoted in Prideaux, *Behind the Scream*, 179.

21. Tøjner, *Munch: Med Egna Ord*, 50.

22. Tøjner expresses the Munchian project of getting psychic material into/onto a two-dimensional canvas with considerable pith, "ytlig, på djupet" (as the Swedish translation has it; "deep surface" is a rough equivalent); there is a clear strategy in place here: "he knew that only where the surface is 'achieved' can the depths be brought to expression." Tøjner takes this concept from Nietzsche's remarks about Greek art, and he cites, "Oh these Greeks! . . . These Greeks were 'on the surface'—*through depth*," wonderfully calling attention to Nietzsche's *Oh* "which is so filled with longing for a time when surface and depth seemed to enter an interwoven immediate pact" (ibid., 11). I can hear echoes even of Schiller's argument about Greeks and Moderns in his "Über naïve und sentimentalische Dichtung," whereby the modern project of interiority is contrasted to an art and an ethos in which inwardness existed in the phenomenal world so loved by the Greeks. It is intriguing to place Munch in this trajectory.

23. Tøjner, commenting primarily on *The Scream*, elevates the *parity* of Munch's arrangements—the ecosystem in which subject and landscape interact, are made up of each other—into a memorable judgment on expressionism itself, claiming that its paradoxical consolation consists of the interplay of person and setting, adding that this relation can nonetheless be unbearable inasmuch as there can be no exit, no hiding room, no refuge (ibid., 22).

24. Whether Munch himself understood jealousy as the creative phenomenon par excellence cannot be said, but his *confrère* Strindberg, a true specialist in this area, pronounced magisterially on this issue and this painting, in French no less, in *La Revue Blanche*, June 1, 1896, for the benefit of the Parisian public who just might (he thought) be mystified by Edvard's rendition: "*Jealousy.*—Jealousy, holy feeling of purity of soul which despises being conjoined with another of the same sex by the mediation of another person. Jealousy, legitimate egoism, stemming from the preservation instinct of both self and race. The jealous one says to his rival: leave, deficient one; you will warm yourself in the flames I have ignited; you will breathe my breath from her mouth; you will imbibe my blood and

you will remain my slave since it is my spirit that will control you through this woman, now become your master" (reprinted in French, in Söderström, *Strindberg och bildkonsten*, 304; my translation). I happen to believe that this is a world-class utterance, and it goes a long way toward displaying just how deep the spiritualist and occultist beliefs could cut, when it came to "fusion" of souls. When I used the word *interpenetrate* in conjunction with Munch and Strindberg, I had in mind the kind of displacements and conjunctions on show in this citation. On this head, jealousy is not merely a creative fiction, it is also a form of triangulated sexual congress, brought on by astral waves and the like; Strindberg's entries in his *Occult Diary* provide a fascinating account of his beliefs in this area, especially at the time of the collapse of his third marriage, when he writes to Harriet Bosse that he could *feel* not only other men's desires for her, but even worse: he "experienced" (as it happened) her intercourse with other men, which defiled him, propelled him into beds and embraces and fantasies he neither wished nor elected to enter but found himself experiencing nonetheless.

25. It has been pointed out that Munch was drawn to this kind of "metatextual" play as early as *Military Parade on the Karl Johan* (1889), where the finished painterly surface of the serious bourgeois out on parade is cut by the hastily sketched face of the boy figure at the bottom right corner, as if to signal: don't be fooled by this parade (of people, of painterly prowess), I'm here to "un-finish" the piece, ha! There would seem to be a kind of Brechtian-gamin inside Munch, a trickster who enjoys exposing the wiring, who delights in reworking photographs by inserting himself in them via hasty little impromptu sketches and additions.

26. Tøjner has used the term "glidbana" (as the Swedish has it: slippery path, slope) to characterize the perspective that governs so many of Munch's painting, including some of his most dazzling portraits, suggesting that the canvas seems to be hurtling its image at you, the spectator, and that the human figures within this setting are thus precarious, subject to falling, falling out of the picture (*Munch: Med Egna Ord*, 24).

27. Other "late" Munch work also honors this same triangular presentation of forces that move toward the viewer, in river-like fashion; see Elizabeth Prelinger, *After the Scream: The Late Paintings of Edvard Munch* (New Haven: Yale University Press, 2002), 60, where an important work of 1916, *Cabbage Field*, reflects a similar artistic strategy.

4.B: The Case of Ernst Josephson

1. Ever since 1893 efforts have been made to bring Josephson to a wider audience, first within Scandinavia, and later—in the early years of the twentieth century—within the larger Western educated public. International exhibits of his work have taken place over the past half-century. Yet, even within Sweden (where he is thought of as either sane portraitist or "sick" visionary), I suspect that his larger story remains unknown, even though his finest work is on show in both Stockholm and Gothenburg.

2. The most distinguished early critic of Josephson is Erik Blomberg whose two major volumes are *Ernst Josephson: Hans liv* (Stockholm: Wahlström & Widstrand, 1951) and *Ernst Josephsons Konst. Från Näcken till Gåslisa* (Stockholm: Norstedt, 1959). Blomberg himself drew on reminiscences from a host of figures—both critics and painters—who were closer in time to Josephson's actual life: Richard Bergh, Georg Pauli, Karl Wåhlin, among others. Blomberg's distinguished successor is Hans Henrik Brummer, the current director of Waldemarsudde and brilliant Josephson commentator in his own right, who has written what is probably the definitive Josephson study of our time, *Ernst Josephson: Målare och Diktare* (Stockholm: Norstedts, 2001).

3. There is a substantial medical literature on the artwork of schizophrenics, with mention of Josephson in particular. See Ernst Kris's *Psychoanalytic Explorations in Art* (New York: International Universities, 1952), Kay Redfield Jamison's *Touched by Fire: Manic Depressive Illness and the Artistic Temperament* (New York: Simon and Schuster, 1993), and Philip Sandblom's *Creativity and Disease* (New York: Marion Boyars, 1992). More specifically, some of the telltale features of Josephson's "sick work"—the rigidity and deformation of the human body, the blankness of facial expression, the excessive amount of detail and ornament in matters of dress—can arguably be regarded as symptoms of paranoid schizophrenia.

4. This passage is cited in Simon L. Millner's *Ernst Josephson* (New York: Machmadin, 1948), 15. Millner's is the single major English-language study of Josephson, and it is a superb introduction to his work.

5. Ulf Abel, *Ernst Josephson* (Stockholm: Natur och Kutur, 2004), 34–35.

6. All Josephson critics have attended to this central motif. For the most recent overview of this figure in the Scandinavian cul-

tural imagination, see Brummer, *Ernst Josephson: Målare och Diktare*, 82–87.

7. It is curious to note how frequently Josephson likened his condition to that of a *snail*. Ingrid Mesterton, in her fine early study of Josephson's religious "fantasy world," *Vägen till Försoning* (Gothenburg: Wettergren & Kerbers, 1957), cites a letter of 1874 in which Ernst tells his uncle, Ludvig, that he yearns to be a snail, so that he "could crawl back into [his] house when it began to hail," and that his "house" would protect him from the sun as well (50).

8. For a fine account in English of the contemporary Swedish rejection of Josephson's *Näcken* and *Strömkarlen*, see Michelle Facos, "A Controversy in Late Nineteenth Century Painting: Ernst Josephson's *The Water Sprite*," in *Zeitschrift für Kunstgeschichte* 56, no. 1 (1993): 61–68.

9. The story of the refusal of the royal gift is a chapter in itself, giving us much to ponder about the politics and evolution of artistic taste, as well as the role of public institutions such as national museums. For a full discussion of this débacle, see Facos, "A Controversy," passim, and Brummer, *Ernst Josephson: Målare och Diktare*, 212–232.

10. Brummer traces the evolution of the Näcken figure in Josephson's sketches, letters, poems, and sketches, and he rightly claims that the two key (now canonical) versions—*Näcken* in 1882 and *Strömkarlen* in 1884—ring an existential change in the traditional register (*Ernst Josephson: Målare och Diktare*, 74–95).

11. See the remarkable early article by Carl Nordenfalk, "Van Gogh och Josephson," in *Ord och Bild* 3 (1943), where the correspondence between Theo and Vincent is examined with great care, and where the allusions to the "Danish painter Josephson" unmistakably refer to Ernst. Vincent was especially angered by the Salon's refusal of *Strömkarlen* in 1884. I see these two painters as kindred figures, even if one moves more in a Spiritualist, God-haunted direction, drawn to visions, whereas the other invests the seen world with explosive oneiric and libidinal intensity. It is worth pointing out that Strindberg also identified powerfully with *Strömkarlen* and Josephson's trials. We know that these two key figures were friends, but almost all direct correspondence between them is lost; nonetheless, Strindberg's comments on Josephson, as seen in his essay "De Små och De Stora" (quoted in Göran Söderström, *Strindberg och bildkonsten* [Stockholm: Forum, 1990], 128) suggest that the writer felt the pangs of the painter's victimization more keenly than most of the painter friends.

12. Ulf Abel has found traces of Rembrandt in this startling rendition of diagonal light rays streaming in (*Ernst Josephson*, 62); Rembrandt light, Josephson is said to have remarked, is not daylight but sunlight. And perhaps it is even more than that.

13. Josephson's sense of abandonment is not imaginary: his letters from this period (before the breakdown/breakthrough) were alarming in their signs of disarray, and his friend, Richard Bergh, tried to solicit funds from the old comrades as well as from his patron, Furstenberg, and his beloved uncle, Ludvig, in order to arrange a trip back to Sweden; all refused. As for the irresistible romantic image of suffering-poet-on-desolate-isle, Brummer (*Ernst Josephson: Målare och Diktare*, 163) has rightly pointed out that Bréhat was not quite the primitive spot that legend suggests; it participated in a flourishing Breton fishing trade and had its links with "civilization." Nonetheless, as someone who has spent years in Brittany, I wonder if Brummer is right to demystify this setting. Josephson's letters home depict him literally as twisting and dangling in the wind, snapping his fingers, carrying out his crazy dance. And let us not forget that the Brittany of late nineteenth century was thought by the French themselves to be a mysterious faraway place with an ancient culture, both Druidic and Catholic, hospitable to ghosts and spirits; after all, Gauguin chose it as his first exit destination, and one can argue that his subsequent trip to Tahiti was no further than the one from Paris to Pont-Aven.

14. This key citation of Österlind is cited by Peter Cornell in his superb introduction to Josephson's "spiritist text," *Vid Himmelrikets Portar* (Stockholm: Gidlund, 1988), x (my translation). Brummer offers still more of Österlind's correspondence at this key juncture (179–181).

15. Josephson's fluid sense of God's whereabouts has an obvious personal tinge: *he* is the anointed one. We find him writing that God was Abraham, then David, then Peter, then Horace (?), then "Ernst Abraham Josephson" and an angel in heaven (Brummer, *Ernst Josephson: Målare och Diktare*, 183).

16. *Andeprotokollen* brings onto the stage three distinct sets of visitors: the high and mighty of politics and power (kings, rulers, etc.), the grandees of culture (artists and writers), and extended members of the Josephson family clan. Each set humbly petitions the great Ernst for permission to leave the limbo they are in, so as to make it into Paradise. As for Swedenborg, Erik Blomberg has provocatively demonstrated parallels between the eighteenth-century mystic's own psychic disorders and those of Josephson, to the tune of finding

castration anxieties and homoerotic tendencies in each of them (*Ernst Josephson: Hans liv*, 645–647). Even where I part ways with him, I remain awed by Blomberg's general account of Josephson along Freudian lines; he also builds a rich and stunningly documented case of Ernst's "breakdown" in terms of infantile regression, irresolvable conflicts between libido and high idealism, and a "meltdown" triggered by two massive joint failures: the lack of recognition given to his work, and the political fiasco of his efforts to lead the "Opponenterna" in their battle with the Establishment.

17. Brummer, *Ernst Josephson: Målare och Diktare*, 183.

18. Peter Cornell, in his introduction to Josephson's *Vid Himmelrikets Portar*, argues vigorously that Josephson's strange text is a key document in the evolution of aesthetic practices from late-nineteenth-century occultism to surrealism. Cornell is especially drawn to the *automatic writing* that characterizes Josephson's trance-like performances, and makes suggestive parallels with André Breton's arguments put forth in the various surrealist manifestoes.

19. This reading of the sickness work in terms of power and revelation is at odds with the Freudian thesis of paranoid schizophrenia, but it is not incompatible with it, inasmuch as it seeks to move *outward* from the work, asking not what produced it but what it might signify for *us*.

20. Blomberg, *Ernst Josephson: Hans liv*, 536.

21. The Strindberg passage comes from the prose piece, "Götiska Rummen," and is cited by Blomberg, ibid., 532–534.

22. Both Mesterton's *Vägen* and Blomberg's *Ernst Josephson* (both major volumes) are everywhere attentive to the riddle, the indeterminacy of what is caused by what in Josephson's work; yes, of course the disease is accountable for some of the telltale "deformations" in the late pieces—endless detail, cross-hatch mania, anatomical errors—but these features of the work are inseparable, I think, from its artistic value. It seems to me that such distinctions—this is willed, that is pathological—constitute, when it comes to works of art, a line in the sand that I am not willing to draw.

23. Bergh's seminal essay, "Målaren Ernst Josephson," in *Ord & Bild* (1893), is manifestly the thinking of a brother-artist and dear friend, and it amply warrants rereading even today, well over a century later.

24. Mesterton sees this dazed expression as a sign of the piece's limited register for feeling, and argues that this reduction in affect is a form of Josephson's pathology, a recurring feature of the "sick work" (*Vägen*, 98).

500

25. Blomberg perceptively invokes Fra Angelico and Giotto as tutelary figures in the serene rendition of legend and spirit that we see in Josephson's religious paintings of the Sick Period (*Från Näcken*, 200).

26. Blomberg's phrase here is worth citing: "What lifts the insistent sexual symbolism into a sphere of transparent, spiritualized beauty is the sublimation, the miracle of transformation, by which the artist, 'the highest spirit next to God,' out of his own carnal substance, out of imperfect matter, creates spirit and light" (ibid., 146 [my translation]).

27. See Mesterton, *Vägen*, 65.

28. Arne Törnqvist, in 1969, wrote a fascinating play, titled *Carl XVI Joseph*, in which he told the story of Josephson's entry into madness on the island of Bréhat; as to be expected, the besieged Ernst is visited by an entire host of spirits, most notably Swedenborg, but also his lost love Ketty Rindsdorf (and her father the Baron); Carl Larsson also makes a guest appearance.

29. Runeberg's poem evokes a battle crisis where the order to retreat is given, but the valiant Sven Duva ignores it and goes about felling huge numbers of the enemy against all odds, finally prompting the Officer to recognize his valor and to put him (poetically) into the pantheon of military heroes. The Officer's words go like this:

"Bra, bra," han ropte, "bra, håll ut, min käcka gosse du,
släpp ingen djävul över bron, håll ut en stund ännu!
Det kan man kalla en soldat, så skall en finne slåss.
Fort, gossar, skynden till hans hjälp! Den där har räddat oss!"
("Fine, fine," he called, "fine, don't falter, my bold lad,
Let not one devil over the bridge, stay with it just a bit more!
This is what we call a soldier, this is how a Finn fights.
Onward, lads, quickly to his aid, this man has saved us!")
(quoted in *Ernst Josephson och Fänrik Stål*, ed. Knut Evers and Ingrid Mesterton [Uddevalla: Bohusläningens Boktryckeri, 1990), 32 [my translation])

Now look again at Josephson's drawing.

30. I am indebted to Susan Brantly for pointing out the marvelous aptness of Runeberg's line as limning Josephson himself.

31. Blomberg sees this painting in Freudian terms, and interprets the sharp teeth as a kind of "vagina dentata," thus as further evidence of Josephson's castration anxiety (*Ernst Josephson: Hans liv*, 614) .

32. In a striking article, Göran Gunér claimed that Josephson's great delicacy in representing both women and children is a sign of his malaise with masculine stereotypes ("Ernst Josephson," *Antik & Auktion* 2 [1991]: 23–28); Gunér also made a fascinating film about Josephson in 1991. The parallels between this thesis and the fate of the Captain in Strindberg's *The Father*—a strong man "implodes," to be revealed as both woman/child—scarcely need emphasizing.

33. See Blomberg, *Från Näcken*, 162–164, for a superb discussion of this painting which he, too, sees as Josephson's masterpiece.

5: Concluding the Book

1. To be sure, Strindberg scholars have long known about this work, and the essential two studies are those of Göran Söderström, *Strindberg och bildkonsten*, first published in 1972 and then brought out by Forum (Stockholm) in 1990, and Torsten Måtte Schmidt, ed., *Strindbergs Måleri* (Malmö: Allhems, 1972), a bit harder to find. Schmidt traces the critical responses to Strindberg's painting, from the growing attention of the Swedish cultural elite in the early twentieth century to the international momentum that began to gather force as a consequence of the bold decision to include his work as one of the three key Swedish artists to represent Sweden in the international exhibit, "Les Sources du XXe siècle," shown in many places but most significantly at the Musée d'Art Moderne during its Parisian stay in 1960. A rewarding recent study of Strindberg's evolving aesthetic after the "Inferno crisis" is Harry G. Carlson, *Out of Inferno: Strindberg's Reawakening as an Artist* (Seattle: University of Washington Press, 1996). It is worth noting that Strindberg, in the 1890s, was arguably the most distinguished and acute art critic in Sweden, especially in connection with modern French developments. Strindberg, in fact, wrote two of the key introductory documents about Munch and Gauguin for the Parisian public. The (wild) Munch critique (published in 1896) is cited earlier in this book, and one feels that it says more about the Swede than the Norwegian. A year earlier, in 1895, Gauguin asks (the better-known) Strindberg to write the program for his upcoming auction/exhibit intended to finance the return trip to Tahiti; Strindberg graciously refuses but does so in the context of a brilliant account of Gauguin's work (and modern art in general), which is then indeed published as the preface to the catalogue for the auction. This delicious move on Gauguin's part reminds me of an earlier American gesture of comparable chutzpah:

Whitman's publishing (in the *New York Tribune* in 1855) of Emerson's personal letter declaring his enthusiasm for *Leaves of Grass*.

2. Portraits of Strindberg abound. The most famous is doubtless the one Munch did in 1893, where the frame is filled with spermatozoa and a woman's figure (thereby constituting the "force field" that this man actually negotiated [or mis-negotiated] all his life), and the name is intentionally misspelled as "Stindberg," meaning "mountain of hot air." It is said that August met with Edvard after this piece, to pose for further work, but brought a revolver with him and placed it on the table between them, never saying a word. Munch did an earlier portrait as well; Christian Krohg did no less than seven Strindberg-portraits. There is, in fact, an entire book on the subject: Alice Rasmussen, *Strindbergs Porträtt* (Södertälje: Fingraf, 1991).

3. Barry Schwabsky, "Strindberg's Dreamscapes," in *Art in America* (April 2002), 122–125, 162, comments on the strange advantage Strindberg reaped from his status as amateur: "the very fact that he was self-taught, that he was an amateur, seems to have freed him from all sorts of preconceptions about what a picture should be" (123). It is a commonplace in Strindberg criticism to say that he only painted when he was either bottled up or in a fallow writerly phase. Yet some of the most perceptive criticism of his paintings notes their sharp parallels to his literary work, sometimes even in prophetic form, as suggested by Ernst Harms's very early account ("Den målande Strindberg" in *Kunst und Künstler* [1927]), claiming that the paintings of the early 1890s (the most highly achieved of all) are a kind of prelude to his revolutionary theatrical efforts at the turn of the century (cited in Schmidt, *Strindbergs Måleri*, 283).

4. The debt to Turner is discussed briefly by T. G. Rosenthal, "The Paintings of August Strindberg," in Schmidt, *Strindbergs Måleri*, 16–19. Beyond that, his work veers away from the more conceptual models that increasingly dominated the art scene in the 1890s. Söderström puts it nicely: "At a time when the hegemony of ideas over form in art was widely preached, Strindberg's expressive but 'contentless' painting was quite simply not modern" (*Bildkonsten*, 264 [my translation]). Strindberg himself put it more bluntly in a letter to his friend, Mörner, in April 1896: "You have Puvis de Chavannes mythology—preRafaelite—figure—Symbolism now, but natural landscapes—without figural symbolism—I'm the only one to have done!" (quoted in Söderstöm, *Bildkonsten*, 302, [my translation]).

5. Schmidt's *Strindbergs Måleri* includes some keen commentaries by Jean Cassou ("Strindberg et les nuages," 13–15) and T. G. Rosen-

thal ("The Paintings of A. S.," 16–19), each rather awestruck in 1972 about the prophetic nature of the Swede's work and its parallels with mid-twentieth-century painting.

6. The essay, originally published as "Du Hasard dans la production artistique," in *La Revue des Revues* (November 1894), appears in Söderström, *Bildkonsten*, 234–235.

7. Kurt Fried makes the resonant point that the grotto scheme in this painting sends us all the way back to Plato's parable of the Cave, telling us the strange news that the visual world we see is a constructed arrangement ("Entdeckung des Malers Strindberg," in Schmidt, *Strindbergs Måleri*, 21).

8. Schwabsky, in "Strindberg's Dreamscapes," also acknowledges the parallels with Pollock, and he points out how precocious all this is: not only does Strindberg's emphasis on chance as factor of artistic creation antedate John Cage or the still earlier surrealists, it even precedes, by three years, Mallarmé's poetic opus, "Un Coup de Dés."

9. During the height of his occultist mania in 1886, Strindberg wrote to Hedlund about *Golgatha*, noting that he had discovered a silhouette of Rembrandt in the clouds *after* he had finished the painting, a finding then corroborated by two other viewers; therefore, he asks Hedlund (who is in Gothenburg where these paintings are now lodged) to check out this piece (and others), to see if he comes upon any further faces. Despite this, I stay with my conviction that the power of this painting stems from its absence of human figure.

10. The notion of humanity as a shipwreck reappears vividly in Strindberg's dramatic masterpiece of 1901, *A Dream Play*, where the references to the Flying Dutchman actually seed the late imagery of the play, yielding some astonishing passages inventorying the flotsam and jetsam that remain, floating on the surface: fine, hollow words such as "hope" and "truth," more surreal objects such as a floating windpipe. One feels that *utterance* itself is on the docket in this magnificent play, that the world is bursting with voices and sounds (natural, human, and cosmic), awaiting a poet who might be commensurate with them.

11. I agree fully with Schwabsky's contention that "this is the fundamental desire at the heart of all painting: the desire to breathe life into mere colored mud" ("Strindberg's Dreamscapes," 162). What a lovely phrase.

12. Söderström is quite persuasive about this last point: the persistence in Strindberg of a realist aesthetic/philosophy that never loses sight of the material world, and always seeks its anchor there

(*Bildkonsten*, 244). As for my contention that these pieces are, in some ultimate sense, "impersonal," cued to nature's power rather than to Strindberg's own inner tumult, I am a bit in a corner by myself. Most of the criticism makes the plausible argument that the tempestuous paintings offer a kind of "objective correlative" for what is going on inside the man; another critic has provocatively said that Strindberg's paintings are the most *naked* works he ever produced (an amazing remark, given his penchant for disguised and displaced autobiography). I see the truth of these positions but maintain my ground: he is a medium. And that has its own dose of sound and fury.

13. Rosenthal suggests that the tiny but luminous city is seen in a flash of lightning, and rightly adds that flashes of lightning are not an inappropriate figure for the shocking drama and illuminations of Strindberg's work ("The Paintings of August Strindberg," 17).

14. Kurt Jaensson puts it in similar fashion: "The storms, the dark vision and the poetry come forth in Strindberg's painting, cleansed from the all-too-human features of his nature" ("Strindberg som Målare," in Schmidt, *Strindbergs Måleri*, 23 [my translation]).

Index

Abel, Ulf, 361

Abraham and Isaac story, 3, 10–11, 12, 36, 111, 173, 200–201, 202, 441; and the absurd, 15–16; gullibility of Abraham in, 15; Kafka's view of, 14–15; Kierkegaard on Abraham's faith, 14, 21; Kierkegaard's mini-narratives of, 19–22; and the maternal body, 20–21; and the problem of recognizing God in, 14–15; subjectivity of, 24; and the transgression of the ethical, 14; Woody Allen's view of, 15

Absalom, Absalom! (Faulkner), 219, 440

absurd, the, 11, 36; and faith, 15–16

Agamemnon, 14, 25

agency, and artistic production, 385, 387

agon, coercive view of, 170

Albee, Edward, 41, 172

Alexandria Quartet, The (Durrell), 98

Allen, Woody, 15

Andalusian Dog (1929), 293

Andersson, Bibi, 294, 296

"Ångest, ångest är min arvedel" (Anguish, anguish is my inheritance [Lagerkvist]), 28, 30

Anthropologist on Mars, An (Sacks), 351

Anxiety (1894), 337, 339, 352

anxiety of influence, the, 189

art, 1–2, 8, 393; as choreography, 355; egoism and exploitation of, 300–301; as a form of nourishment/energy, 270; Greek, 495n22;

mission of visual art, 403; and neurosis, 355; and the pagan/Christian conflict, 374; resources of, 172–73; role of, 458; of schizophrenics

Artaud, Antonin, 174, 310; on action as cruelty, 309; on myth, 309, 311

artists: and psychology, 379; and the transformation of feelings, 196–97

At the Deathbed (1895, 1896), 326–27

Auden, W. H., 27

August, Bille, 199

Autumn Sonata (1978), 294

Autumn Sun (1886), 375–76, 499n12

Bad Seed, The (March), 228

Bakunin, Mikhail, 146

Balzac, Honoré, 117, 198

Barabbas (Lagerkvist), 28

Baudelaire, Charles-Pierre, 117, 267, 314, 486n16

Beckett, Samuel, 124, 172

Beethoven (1905), 431–32

Benjamin, Walter, 61

Bergh, Richard, 177, 360, 392, 500n23

Bergman, Ingmar, 6, 7, 8, 130, 174, 176, 334, 353, 384; interest of in ghosts, 190–91; major themes of his films, 293–94; Strindberg's influence on, 296–97; Swedish response to his work, 443; vertigo of, 296; work of in the theater, 298–99

"Bergman's Persona" (Sontag), 489n19, 490n32

Berman, Patricia G., 491n5

Bernhardt, Sarah, 35

Berntson, Ann Cathrine, 482n6

Bildungsroman, phenomenon of in the nineteenth century, 198

Blackwell, Marilyn Johns, 489n24, 490n26

Blake, William, 204, 275, 351–52

Blomberg, Erik, 162, 434, 497n2; Freudian interpretation of Ernst Josephson, 499–500n16, 501n31; on Josephson's religious paintings, 501nn25–26

Bloom, Harold, 189

Bly, Robert, 258, 269

Borgen, Johan, 488–89n17

Borges, Jorge Luis, 113, 407

Bosse, Harriet, 141

boundary smashing, 5–6. See also *genombrott*

Brandell, Gunnar, 122

Brandes, Georg, 1

Brantley, Susan, 477–78n6, 501n30

brooding, 440–41

Brothers Lionheart, The (Lindgren), 6, 211; complex narrative of, 222; death of Jonathan in, 221; freeing of Orvar in, 222–23; Jonathan in, 221, 222, 223–24; Jonathan dying "again" in, 224; Katla in, 222, 223; Katla as metaphor for nuclear weapons, 223–24; Orvar in, 221–22; plot of, 221–24; political nature of, 222; Rusky in, 221, 222, 223–24, 439, 442; Tengil in, 221, 222, 226, 227; theme of dying children in, 220–21

Brummer, Hans Henrik, 497n2, 499n13

Bundtzen, Lynda K., 479n16, 480–81n22

Buñuel, Luis, 293

Camus, Albert, 83

Carl XVI Joseph (Törnqvist), 501n28

Carlson, Harry G., 54, 57, 465n9, 467n19, 468n25

Charcot, Jean-Martin, 35

Chekhov, Anton, 74, 75

children, 483n11; American, 198; amoral curiosity of, 238; empowerment of, 6, 228; evil, 228; revenge of, 228, 238, 245 (*see also* Cronqvist, Lena, "two little girls" series of paintings); revenge of through play, 241–42; rights of, 200–201; socialization of, 197–98; Swedish, 198

children, in Scandinavian literature, 199–200; annihilation of in Ibsen's plays, 201–2, 204–9, 469n9, 481n1; the Ash Lad in, 199, 217; complexity of in the work of Lindgren, 227–28; disappearance of, 219–20; as foundlings in Ibsen's plays, 207–8; and *Kindermord*, 108, 202. See also *Brothers Lionheart*, theme of dying children in

Christiana Bohême, 313

Clytemnestra, 14

Coleridge, Samuel Taylor, 68

Cornell, Peter, 381, 383, 500n18

Courbet, Jean, 177

Creation of Adam (1893), 429

Cries and Whispers (1972), 294

Cronqvist, Lena, 6, 228, 442–43, 483–84n12; and the agency of children, 242; children as a late subject of, 229, 242–43; and the concept of freedom, 230; cradling theme of, 230; family as a central motif of her later work, 231–35; and the loss of agency because of "patienthood," 231; Madonna-themed paintings of, 230; mental breakdown of, 230–31; metamorphosis in her work, 236–37; and

mother/child gestalt, 230, 236;
nurturance theme of, 245,
484n14; reality of adult suffering
as a subject of, 229–30; and the
St. Jörgen's Hospital paintings,
230–31. *See also* Cronqvist,
Lena, "two little girls" series
of paintings
Cronqvist, Lena, "two little girls"
series of paintings, 235; *The Cage*
(2000), 239; *Girl, Daddy-doll,
Mommy-doll and Gorillas* (1992),
235–37; *Girl with Papa Doll* (1996–
1997), 237–38; *Marionnettes, II*
(2004–2005), 242–43, 443; *Nurses*
(2001), 239, 241; *Two Girls with
Mother* (1999), 238–39
cubism, 354
cuckoldry, 64
Cullberg, Johan, 564n7
Curie, Marie, 111

Dance of Death (Strindberg), 140,
169–70, 176, 442; "acrobatics" of
Edgar and Alice in, 169, 171, 172;
as a comic instead of tragic play,
170; death of Edgar in, 171–72,
478n9; Edgar's wordless inter-
mezzo scene as Pauline illumina-
tion, 171; Edgar's wordless
intermezzo scene as self-erasure,
170–71
Dance of Life, The (1899–1900), 78,
327
Dante, 121
Darwin, Charles, 51
David and Goliath (n.d.), 427, 429
"Dead, The" (Joyce), 99
Death in the Sickroom (1893), 319–20,
344, 494n13
Dehmel, Richard, 315
"Der Rattenfänger" (Goethe), 82
Derrida, Jacques, 62, 63, 260
Dickens, Charles, 198
Dickinson, Emily, 111, 125, 128

différance, 62, 260
Doll House, A (Ibsen), 102, 484n13;
Nora's exit from her marriage in,
203; theme of childishness in, 203
Doom's Day (1980), 232
Drachmann, Holger, 315
Dream Play, A (Strindberg), 121,
124, 125, 142, 168, 176, 181, 296;
image of humanity as a ship-
wreck in, 504n10; oneiric logic
of, 175; references to repressed/
desired food and sex in, 478–
79n12; and the world of the
dream as porous/fluid, 196
Drowned Boy (1908), 342; role of the
traffic of spirits and the animals
in, 344–45
Durbach, Errol, 88
Durrell, Lawrence, 98

Ecstatic Heads (1889–1890), 410
Eden, 40–41
Education sentimentale (Flaubert),
247
Eggum, Arne, 493n11
Ekström, Pelle, 161, 162, 177
Eliot, T. S., 179, 429
Emerson, Ralph Waldo, 118
Enemy of the People (Ibsen), 102
Ernst Josephson (Blomberg), 500n22
Ewbank, Inga-Stina, 467n18
Exorcist, The (1973), 228
expressionism, 354, 495n23

Face to Face (1976), 190
Fadren (1969), 477n3
faith, 3, 10, 17–18; and the absurd,
15–16; as a commodity, 18; and
the discourse of madness-as-
knowledge, 12; and fear and
trembling as the true indexes of,
13; ineffability of, 17; loss of, 22;
murder as a condition of, 17–18;
mystery and terror of, 17; sub-
jectivism of, 17

Families Without Hope (Bang), 199

Fanny and Alexander (1982), 6, 10,
112, 162, 190, 245, 294, 299, 445;
Aaron in, 195; Alexander in, 191,
192–93, 197, 481n23; Alexander
as Hamlet, 194, 195; Alexander's
progress as an artist in, 193; anti-
Semitism of Edvard in, 194;
causality of hatred/violence in,
195–96; Edvard in, 191, 192–93,
195, 197; Emilie in, 191, 192; en-
counter between Alexander and
Ishmael in, 194–96, 480–81n22; in-
fanticide/parricide in, 191; invo-
cation of *Hamlet* in, 191, 192–93;
Isak the Jew saving the impris-
oned children in, 193–94, 479n18,
480n20; magic lantern scene in,
192; plot of, 191–92; public recep-
tion of, 479n16; and the spirit of
Weltanschauung, 190, 192; theme
of artistic freedom in, 192, 193

Fänrik Ståls Sägner (Runeberg), 416

Färgen (Erland Josephson), 480n19

Father, The (Strindberg), 4–5, 6, 10,
441, 444; armor as decoration
motif in, 72, 166; Bertha in, 46–
47, 52, 70, 139, 168, 245; blockage
imagery in, 49; the Captain
(Adolf) in, 47, 48–49, 50, 51, 54,
64, 66–67, 70–71, 72, 91, 98, 102,
128, 189, 193, 196, 467n18; the
Captain's bursting through the
wall in, 164–65, 477n3; the Cap-
tain's loss of control of his child
in, 52–53; cashiering of the father
in, 53, 164–65, 168; "characterless-
ness" of the father figure in, 59,
466n16; child's play in, 47–48, 74,
92, 468n27; the child's spirit writ-
ing in, 46–47, 464n3; the "clock-
work winds down backwards"
image in, 54, 62, 167–68; collapse
of the fathering principle in, 62–
63, 65, 66, 167–68, 467n22; and
the collapse of reason, 55,

466n14; the cradle song (child's
voice) in, 46, 47–48, 74, 92; deci-
mation of the male protagonist
in, 66–67; descent of the Captain
into dementia in, 55–56, 166–67,
173; and the dilemma of origins,
48; dismantling/disrobing motifs
in, 52, 59, 73; emotional vulnera-
bility of the Captain in, 57–58,
466n15; and fatherhood as a
façade, 52; Grandma in, 46;
"grinding light" metaphor in,
65–66; imagery of nets and webs
in, 468n25; infantilization theme
in, 70, 166, 467–68n23; knowing
and believing in, 51, 465n9;
Laura in, 49, 52, 53, 56, 57, 62, 71,
164, 165, 168, 465n6; Laura's preg-
nancy as a "crime," 170; Laura's
view of the Captain, 58–59; male-
ness/virility in, 59, 65, 72; Mar-
gret in, 53–54, 69–70, 165; meta-
morphosis (shape-shifting) theme
in, 45, 60, 67–70; metaphysical
collapse in, 67; mutilation imag-
ery in, 49; as a naturalist work,
44, 45, 51, 60; the Pastor in, 64,
66; as a performative work, 44–
45, 63; and the phallocentric
order/worldview, 66, 72; as a
play about mantles, 73–74; psy-
chic disarray/combat in, 65–66;
and the quashing of the male
principle, 60–61, 166; Queen
Omphale and Hercules scene in,
70–72, 166, 468n24; and reversal
of the Cartesian *cogito*, 51; self-
awareness of the Captain in, 54–
55; severance imagery in, 48–49;
sexuality in, 56–58; shifting
nature of male ego in, 49–50;
straitjacket image in, 74, 468n27;
substance and sign motif in, 72–
73; textuality as a theme of, 46,
47, 63, 66; trope of awakening in,
61–62; and the *Ursprache* of, 47;

as a war between the sexes, 45–46; and women as keepers of the life principle, 59–60

"Father and I" (Lagerkvist), 28

Faulkner, William, 100, 219, 440, 459, 470n18

Faust (Goethe), 76

Fear and Trembling (Kierkegaard), 3–4, 10–11, 25–26, 91, 200, 378, 441; and the Attunement's narrative quest for Abraham, 18–19; critical debate concerning, 461n2; as a gateway text, 11; as a *genombrott* text, 28; and the ineffability of faith, 17; John of Silence narrator in, 13–14, 16, 25, 28, 200; and judging actions by their outcomes, 23; and the "knights" of faith, 15, 22; and the "knights" of resignation, 15; and the loss of faith, 61; and the maternal body, 20–21, 27; mini-narratives of Abraham and Isaac in, 19–22; mini-narratives as *tests*, 22–23; and the modality of knowledge, 11–12; open-endedness of, 16; perspectival nature of, 16; and the reality of faith, 11, 13; and the rights of children, 200; significance of, 4; "swimming" passage of, 16–17, 23; the "weaning" passages of, 21–22, 35, 61

Finney, Gail, 465n8, 466n15

Flaubert, Gustave, 124, 198, 268, 314

Freud, Sigmund, 42, 52, 59, 89, 321

Fried, Kurt, 504n7

future, tragedy of (*framtidens tragedi*), 162, 167, 168, 173, 178

Galloping Horse (1910), 194, 347

Gardner, John, 29

Gåslisa (1888–1889), 193, 399–403, 404, 407, 419; color scheme of, 401; and the impact of visionary experience, 400–401; other-worldly vision of, 401; and the reality of spirit in, 402–3; remaking of Christian iconography in, 401–4

Gauguin, Paul, 354, 373, 502–3n1

Genet, Jean, 384, 385

genombrott (breaking through), 1–2, 8, 9, 28, 40, 167, 172, 175, 180, 189, 195, 269, 353, 440, 461n3; crashing through paper walls as the heart of, 163; iconography of in *Gåslisa*, 400; iconography of in the water sprite myth, 369–70; rationale of, 197; and the revelation of spiritual power, 185; reversal of, 168

Geworfenheit (loss of all bearings), 22

Ghost Sonata, The (Strindberg), 172, 176, 297

Ghosts (Ibsen), 55, 56; Captain Alving in, 90, 101; Helene Alving in, 100–101, 103, 481–82n3; Helene as main protagonist of, 203–4; Oswald in, 204; "sightedness" and ghosts in, 103–4

God, 1, 3, 40, 380, 381, 441, 499n15; and infanticide as the will of, 3, 4; language/utterance of, 11. *See also* Abraham and Isaac story

"God's Script, The" (Borges), 407

Goethe, Johann Wolfgang von, 198

Golgata (1894), 450, 504n9

Gordon, Robert, 466n15

Granaas, Rakel Christina, 487n2, 488n13

Grimstad, Giulia, 488n15

Guernica (1937), 310

Guest in Reality (Lagerkvist), 28

Gunér, Göran, 502n32

Gustafsson, Lars, 5, 113–14, 128, 143–44; in Austin, 146; interest of in machines, 155, 477n37; on Strindberg criticism, 114–15

Hamlet (Shakespeare), 43; Hamlet in, 6, 43, 163–64, 197; Hamlet's father's ghost in, 165, 166, 173, 189; and play, 181

Hamsun, Knut, 7, 18, 130, 353, 442; influence of on twentieth-century authors, 246; as a proto-Beat writer, 272; tortured sense of concerning human love/relations, 253; travels of, 271–72

Hansson, Ola, 315

Hasselberg, Per, 161, 177, 361

Haverty, Linda, 480–81n22

Hedda Gabler (Ibsen): and the burning of Løvborg's manuscript/child in, 206–7, 208; Hedda's suicide in, 206

Hegel, G.W.H., 51

Heiberg, Gunnar, 315

Heller, Reinhold, 491–92n6, 493n8

Henrik Ibsen and the Birth of Modernism (Moi), 468n1

Herzen, Alexander, 146

Hill, Carl Frederick, 354

Hitler, Adolf, 314

Hög sjö (1894), 451–53

Holy Sacrament, The (1889–1890), 184–85, 193, 404–6, 407, 419

Homo ludens, 43, 44, 91; as the ultimate revolutionary figure, 43

Hour of the Wolf (1968), 294

Hugo, Victor, 92

humanity/humans: and encountering the divine, 18; human doing versus human utterance, 18

Hunger (Hamsun), 7, 12, 112, 192, 440, 485n10; biographical elements of, 271–72; as a "breakthrough" text, 246, 270; and the "burning brains," 270; centrality of the J. A. Happolati episode in, 263–67, 270; "city messengers" motif in, 257–58; and the creation of *Kuboaa*, 259–60, 270, 486n15; depiction of God's punishments in, 247–48, 484–85n4; and the "electric prayer book," 264–65; erotic subplot of with Ylayali, 252–56, 485n11; and *genombrott*, 269; hunger and throwing up in, 249–50, 485n8; on the inappropriateness of food, 250; language as primal source of energy in, 256–57, 485–86n14; manic behavior in, 257; namelessness of the protagonist, 258–59; and the paper cornucopia episode, 269; polarized feelings of the reader concerning, 270–71; as a prophetic novel, 246; the protagonist's claim to be Andreas Tangen, 259, 260, 269; the protagonist's relationship to money, 250–51; the pursuit of Joachim Kierulf in, 267–69, 270; as a quest to overthrow the physiological bondage (hunger) of the human body, 248; and the "real-world" power of language and imagination, 263; as reprising the revolutionary energies of the year 1848, 246–47, 260, 269–70; role of the ludic in, 258, 270, 271, 272; and romanticism, 246, 262; and the search for freedom in a materialist world, 256, 266; signification in, 257–58; and the sordidness of the physical world, 251–52; storytelling motif of, 254, 255–56; subversive/anarchic nature of language in, 260–62; symbolic castration in, 485n9; travel and freedom as solipsistic in, 271; war with God as the elemental agon of, 247–48; *wildings* in, 267; writing as three-dimensional in, 262–63; Ylayali's breasts as representative of physical and sexual nourishment in, 254–55

"Hunger Artist, The" (Kafka), 248–49, 485n6

Ibsen, Henrik, 3, 4, 5, 6, 41–42, 74, 75, 91, 111, 170, 171, 314, 353; animosity toward Strindberg, 463–64n1; childhood of, 201–2; and the collapse of patriarchy, 42; on displacement and sublimation of the psyche, 100–101; as a figure for our time, 75, 468n1; influences on, 202, 481n2; motif of slaughtered/dead children (*Kindermord*) in his works, 108, 201–2, 204–9, 469n9, 481n1; and realism, 105; and the reinvention of the theater, 42–43; and the "sexual/nexus" of his plays, 84; on the stature of fathers, 101–2; and the subject of the damaged "father," 44

Ibsen's Women (Templeton), 481–82n3

Ice Palace, The (Vesaas), 7, 245, 273–74, 297, 384, 487n2, 488–89n17, 489n18; description of the ice palace in, 284; desire in, 277, 278, 279, 280, 287; and the "desire to enter," 284–85, 286; desire for fusion in, 279; dignity in, 276; exalted view of childhood in, 290–91; and the exploration of the adolescent female body, 488n13; and the fiction of a bounded self, 292; formation of the friendship of Siss and Unn in, 277–78; fusion of Unn and Siss in, 288–89; light as the medium of vision/photosynthesis in, 274, 278; and the meaning of Unn's death, 292; mirrors and erasure in, 280–81, 288, 487n8; mystery of fusion in, 282; reincorporation theme in, 292; rendezvous episode of, 279, 283; as a rite-of-passage fable, 290, 292; search for Unn in, 288–89; simplicity of, 275; Siss in, 273, 277, 280–81, Siss's mourning/melancholia in, 288–90; Siss's vis-

its to the ice palace in, 291–92; as a tale of initiation and fulfillment, 275; Unn in, 280–81, 439, 442; Unn's exit from the human community, 283–87; Unn's secret in, 281–82, 287, 289, 292, 487nn10–11; Unn as seen by her Creator, 286–87

"In der Strafkolonie" (Kafka), 472–73n15

incest, 88

Inferno (Strindberg), 5, 12, 113, 114, 115, 116–17, 148, 149, 154, 160, 185, 196, 258, 316, 379, 284, 440, 442, 492n7; authoritative tone of, 132; chase scenes in, 136–38; criticism of, 115–16; "doubles" motif in, 131–32; dynamo/current image in, 128, 129; electricity metaphor in, 5, 134–39, 142, 175–76; epilogue of, 475n27; flow of energy in, 140–41; as a form of the alchemical quest, 143; fusion/writing motif in, 135–36, 138–39; humming of energy motif in, 134, 155; importance of signs in, 130; *Inferno* and *The Tennis Players* as mirrors, 158; "grinding light" metaphor in, 128; "joker thesis" in, 175; and the logic of paranoia, 136, 140–41; and man's place in the world, 130; medical explanations for the hallucinations recorded in, 121–22; as a "metatext" with *The Tennis Players*, 116; "Mills of God" passage in, 125–27, 473n21; Mr. X in, 133, 135; Munch as the "Danish artist" in, 475–76n29; and personalizing of the self, 132–33; Popoffsky (i.e., Stanislaw Przybyszewski) in, 133–34, 475–76n29; relation of power to language in, 139–40, 141–42; and "re-scripts," 132; spirit world of, 130; and suffering, 120–21; thesis of that all

Inferno (Strindberg) *(cont.)*
explanations fail, 122–23; thesis of that matter and spirit are inseparable, 122; and the transcendent power of the spirit, 134; as a visionary text, 117–18
Inferno (1901), 449

Jacobs, Barry, 92, 470n23
Jaeger, Hans, 314
James, Henry, 106, 133, 282
Jansson, Tove, 235
"Jantelag," 197
Jaspers, Karl, 473n18
jealousy, as creative fiction, 341, 495–96n24
Jealousy (1895), 337, 339, 341–42, 350, 475–76n29
Jesus and the Crown of Thorns (1889–1890), 407
Johanneson, Eric O., 474n25
John Gabriel Borkman (Ibsen), 91, 112; emancipation of Erhart Borkman in, 208
Johns, Jasper, 336
Josephson, Jacob Axel, 356
Josephson, Erland, 194, 480n19
Josephson, Ernst, 6, 7–8, 18, 112, 130, 161, 162, 164, 165, 174–75, 194, 352–53, 442, 443, 444, 497n1, 498n7; admiration of Corot and Daubigny, 359; and the *Andeprotokollen* (*The Spirit Protocol*) series of drawings, 179–80, 183, 393, 499–500n16; on Bréhat, 180, 182, 353–54; "breakthrough" art of, 180–81, 429, 435; as a Christ-like figure in his own work, 399; conservative upbringing of, 387; critics of, 497n2, 497–98n6; death of his father, 356; depictions of the human body in his work, 424–25, 427 (*see also* Josephson, Ernst, drawings of the Norse gods); depictions of Christ in his work, 406–7, 412–13; desire to be Sweden's "Rembrandt," 358–59; devotion of to the Old Masters, 178, 183, 357–58; and the double meditation with God and Swedenborg, 380–81, 499n15; echoes of Renoir and Manet in his work, 360; education of, 357; as the embodiment of *genombrott*, 353, 380; "etherized" as a description of the sick Josephson, 429; family life of, 356–57; and Genet's idea of Nomenclature, 384–85, 410, 412; homosexual longing in his work, 183; iconography in his work, 401–4, 410; influence of the Mediterranean on, 359; imitation of the Old Masters by, 358; isolation of, 377, 378, 499n13; Jewishness and his moral thinking, 356; lack of playacting resources in his work, 181–82; late work of as "intentional," 355; as a medium of Velasquez, 178–79; Näcken ("Water Sprite") motif of, 182–83, 358, 368–69, 497–98n6, 498n10; opinion of Courbet, 359–60; paranoid schizophrenia ("madness") of, 354, 378–79, 383, 392, 402, 406, 435, 500n19; paranoid schizophrenia and the reshaping of his artistic vision, 418–19, 425, 427; "pathological" nature of his work, 392–93, 500n22; personality change in, 390–91; and power, 380, 410, 412, 413, 434–35; power as graphable in his work, 353, 416; pre-breakdown work of, 375, 377; precarious personality of, 177–78, 354; psyche of, 385; realist style of, 353, 354; and the reconfiguration of art, 367–68; religious works of, 184–85; repressed sexuality of, 180–83, 188; resentment of, 377; "secret sharing" in his work, 407–8, 410; self-exile of in France,

375; "Sick Period" of, 12, 176–77, 187, 188–89, 354–56, 367–68, 410–11, 416, 432, 434, 438, 501n25; slashing/breaking of the paper walls (*genombrott*) incident at Ville Vallgren's residence, 5–6, 162, 174–75, 176–77, 179, 182, 188, 196; *Spirit Protocol* drawings of, 380–81, 383; and Spiritism/spirits, 378, 379, 383–84; spiritual nature of his late work, 398–99; as spokesperson for the "Opponenterna," 177, 368; strained relationship of with the "Opponenterna," 373, 375; and syphilis, 368; and "two-way" traffic, 387, 389–91, 410; and victimization, 416; views of power in his work, 185–87; visionary rendition of power in his work, 383; visitation of by the artistic spirits of old, 384–85, 387; "Water Sprite" motif of, 368–71, 373; writings of concerning art, 360–61. *See also* Josephson, Ernst, drawings of the Norse gods; Josephson, Ernst, as a portraitist

Josephson, Ernst, drawings of the Norse gods, 419; *Fjolner* (n.d.), 420–21; *Ingjald Illråda* (n.d.) 421–22; *Odin's Entry into Sweden* (n.d.), 419–20; sexual/carnal dimension of, 421–24; *Weather God Niord* (n.d.), 423–24

Josephson, Ernst, as a portraitist, 361–62, 364, 367, 374; portrait of Carl Skånberg (1880), 364; portrait of Godfrey Renholm (1880), 361–62; portrait of Homer (1888), 381; portrait of Jeanette Rubenson (1883), 364, 367, 397–98; portrait of J. P. Jacobsen (n.d.), 387, 407; "Portrait of a Lady" (1889–1890), 397–98; portrait of Ludvig Josephson (1893), 187–88, 432–38; portrait of Ludvig Josephson as

supreme achievement of his work, 437–38; portrait of his mother Gustava, 362; portrait of Pontus Fürstenberg, 362, 364; self-portrait with palette (n.d.), 429; "Velasquez" self-portrait (1888), 178–79, 385

Josephson, Gustava, 356, 364
Josephson, Ludwig, 187–88, 194, 356, 433
Josephson, Semmy, 356, 364
Jostad, Morton, 479n17–18
Joyce, James, 99, 104, 133, 174, 384, 385
Juel, Dagny, 133, 315, 475–76n29
"Judgment, The" (Kafka), 201
Judgment of Paris, The (n.d.), 424–25, 427
Juncker, Clara, 483n11

Kafka, Franz, 201, 248–49, 256; admiration of for Strindberg, 472–73n15
Kawin, Bruce F., 490n29
Keats, John, 19
Keller, Gottfried, 198
Kierkegaard, Søren, 1, 3–4, 6, 36, 38, 40, 112, 204, 353, 378, 440, 461n4; critique of professors, 13–14; critique of rationalism, 13–14; and the definition of Abraham's faith, 14, 173; as a dialectician, 19; on effort and reward, 26–27; and the reconception of "understanding," 4; relevance of to other writers, 462n8; on the religious sphere, 14, 21; on the world of the spirit, 26
King Lear (Shakespeare), 228; Lear in, 205
Kirmmse, Bruce H., 461n3
Kittang, Atle, 487n8, 488n16, 488–89n17
knowledge: acquisition of, 24–25; modality of, 11–12; as *other*, 12
Kristeva, Julia, 488n13

Krohg, Christian, 315
Krohg, Oda, 315
Kuhn, Richard, 470nn21 and 24
Kuhn, Thomas, 128–29

"La Conscience" (Hugo), 92
La Joie de Vivre (1887), 375, 377
La Peste (Camus), 83
Lagercrantz, Olof, 139
Lagerkvist, Pär, 4, 12, 28–29, 353,
 440, 462n11; as democratic, 40; as
 the "exile-from-life," 31; polythe-
 ist interests of, 29; and the theme
 of the Crucifixion in his work,
 29–30
Lamm, Martin, 114, 115, 118–19,
 473n20, 474n26
Larsen, Tulla, 321, 327
Larsson, Carl, 177, 360, 419
Le Balcon (Genet), 384, 385
"Le Musée des Beaux-arts"
 (Auden), 27
Lehrer, Tom, 275
Liebestod, 279
Lindgren, Astrid, 6–7, 18, 112–13,
 439, 483n9, 483n11; funeral of,
 209, 210; popularity of, 209–10
literary criticism, 158
"Little Disturbance, A" (Vesaas),
 287–88
Little Eyolf (Strindberg), 4, 44, 91,
 444; Alfred Allmers in, 77, 80, 87,
 88–90, 97–98, 99, 101–2, 105, 110,
 111, 208; the Allmers' marriage
 in, 85–87, 99–100; Asta in, 88, 93,
 97–98, 99, 105, 470n21; children
 as invisible in, 207; crippling of
 Eyolf in, 96–97; criticism of, 106,
 470n17; criticism of the play's res-
 olution, 110, 471n25; "crutches"
 motif in, 89, 90, 102–3; "dead
 child" motif in, 108, 110–11,
 469n9; discovery motif in, 79–80;
 Eyolf in, 85, 90, 100, 109, 207,
 439, 442; and the *fylgja* folklore
 tradition, 81; gnawing metaphor

in, 81–82; and incest, 88, 98; and
 the infant's "witnessing" of sex-
 ual intercourse, 92–93, 469n13;
 irony in, 101; and the *Kindermord*
 theme, 90; lack of ideology in,
 102; and the "law of change," 88,
 89; metamorphosis theme in, 87–
 88, 105, 106, 107–8, 110; multiple
 languages of, 83; myth of the
 foundling in, 207–8; people/ani-
 mal motif in, 81–82; as a perform-
 ative work, 44–45; possibility of
 Alfred Allmers's impotency in,
 91–92; Rat Wife (*Rottejomfruen*)
 scene in, 76, 77–78, 80, 81–82, 86–
 87, 106, 108–9, 444; and the Rat
 Wife in theory and practice, 84–
 85; rebirth theme in, 106–7; Rita
 Allmers in, 77; 80, 90, 105, 106–
 10, 111; sexuality in, 78–79, 86–87,
 89, 92–93, 96–97, 99, 100, 469n7;
 strange childhood of Alfred and
 Asta in, 93–96; as a tragedy of
 "inauthenticity," 470n19; wolf/
 werewolf imagery in, 84–85, 86,
 87, 106
Livingston, Paisley, 490n33
logic, 173; oneiric logic of free asso-
 ciation, 175
"London" (Blake), 204, 351–52
Lonely Poisonous Mushroom (1893),
 446–47
Lyotard, Jean-François, 167

Madame Bovary (Flaubert), 268
Madonna, 78
Maeterlinck, Maurice, 379
Magician, The (1958), 112, 190
Mallarmé, Stéphane, 70, 171, 459
Marx, Karl, 51
Mason and Mechanic (1908), 342
Master Builder, The (Ibsen), 207;
 death of the twin babies in, 205;
 Hilda in, 91, 205–6; Ragnar in,
 206; Solness in, 91, 101, 205
Master Olof (Strindberg), 123, 124

masturbation, identification of with music-making, 374, 393

materialism, 18

Matrix, The (1999), 115

McFarlane, James W., 79, 84, 101, 469n7, 470n19

McLuhan, Marshall, 119

Merchant of Venice, The (Shakespeare), 165

Mesterton, Ingrid, 498n7, 500nn22 and 24

metamorphosis, 45, 87–88, 196, 236–37; and signifying, 258. See also *The Father*, metamorphosis (shape-shifting) theme in; *Little Eyolf*, metamorphosis theme in

"Metamorphosis, The" (Kafka), 201

Meyer, Michael, 91

Military Parade on the Karl Johan (1889), 496n25

Miller, Arthur, 41; on Strindberg, 466–67n17

Millner, Simon L., 434

Mio My Son (Lindgren), 6, 18, 211; death of Sir Kato in, 218; disappearance motif in, 219–20; "doubling" in, 213; evil and Faraway Land in, 213; Faraway Land as the interior of the soul, 220; Karl Anders Nilsson in, 212, 213, 216–17, 219; Mio (Prince Mio) in, 213, 215–16, 442; Mio's fixation on his earlier broken life in, 218–19; and *genombrott*, 220; Mio's mission in, 213–14; Miramis in, 216; mythic nature of, 212; Pompoo in, 214, 215–16; presentation of evil in, 213, 215; as a rites-of-passage fable, 214–15; and the saving aspect of nature in, 215; Sir Kato in, 213–14, 215, 226, 227; as the story of a "disappeared child" (orphan), 212; triumph of, 217–18; weakness of Mio and Pompoo in, 216–17

Mishler, William, 484nn2–3, 485n9

Miss Julie (Strindberg), 140, 443; Julie's suicide in, 168

Moberg, Verne, 114

Moby Dick (Melville), 404

modernism, 354, 467n18

Moi, Toril, 468n1, 484n13

Moreau, Gustave, 379

Mother, The (1975), 229–30

Mother and I (1987), 232–33

Mother, Picture, Children (1988), 233–35

"Mourning and Melancholia" (Freud), 288

Munch, Edvard, 7–8, 12, 86, 112, 133, 353, 384, 440, 442, 444, 493n8, 494n14, 496n26, 503n2; arrested (in time) nature of, 317, 320–21, 352; art as a manifestation of his psyche and affect, 321; cubist effects in his work, 331, 336–37; death of his mother, 319; dimensionality and his painting, 336–37, 495n22; his paintings as his "children," 321, 324, 326; his paintings as his "soldiers," 326; "horse cure" treatment of his own paintings, 324–25; impact of his sister's death on, 317–21; late work of, 496n27; and the "life frieze" theory, 324, 333, 494n17; love for his aunt Tante Karen, 319, 494n16; love for his sister Inger, 494n16; "metatexual" play in his work, 344–45, 496n25; neurotic fixations of, 317; painting in "real time," 320, 326, 494n13; pathways/roads of his art, 346–47, 350–52; photographs of, 321; place and time of his "breakthrough" as a painter (the Munch Affair), 313–14, 491n1; poor health and mental instability (dementia) of, 316–17, 320–21, 492n7; portraits of children by, 324; refusal of to marry, 321; relationship with Strindberg, 315–16,

Munch, Edvard *(cont.)*
491n3, 491n5; and the reliving of death, 319–20, 493n11; as a reverse Freudian, 321; and the "Schwarzen Ferkel" group of artists, 314–15, 475–76n29; as a self-portraitist, 333–34, 336; temporal density of his work, 329; theme of time made visible in his work, 326–27; tracking the charged currents in his work, 337
Murderer in the Avenue (1919), 347
Myhr, Petter, 487nn10–11
Mysteries (Hamsun), 253

"Näcken" (Stagnelius), 402
Näcken (1882), 182, 185, 368–71, 373–75, 399, 406, 432, 443; critical reception of, 183, 479n14
Näcken and the Virgin (n.d.), 393, 395
naturalism, 68, 74, 360, 379
nature, 112
negative capability, 19
Niels Lyhne (Jacobsen), 199
Nielsen, Betzy, 319
Nietzsche, Friedrich, 51, 112, 141, 144; on Greek art, 495n22
Night Wanderer (1923), 334
Nordström, Karl, 177
Notes from the Underground (Dostoevsky), 253

Obstfelder, Sigbjørn, 315
Ockulta Dagboken (Strindberg), 141, 476n33, 495–96n24
Oedipal/anti-Oedipal regimes, 245
Oedipus, 50–51
Olivier, Laurence, 170
O'Neill, Eugene, 41
"Opponenterna," 177, 368, 373
Orestes, 14
Österlind, Allan, 375, 377; and Spiritism, 378
Österlind, Anna, 378

Österlind, Eugénie, 375, 377
Othello (Shakespeare), 51, 55, 352; and the human mind as a place of defilement, 84; Othello's feelings for Desdemona in, 83–84

Pan (Hamsun), 246, 253
Paradoxe sur le Comédien (Diderot), 299
"Parisian boys," 177, 368
patriarchy, 1, 45, 101, 111; abhorrence of play in, 43; collapse of, 42, 59
Pauli, Georg, 360, 392
Peer Gynt (Ibsen), 76–77, 105; Peer Gynt in, 90
Pelle the Conqueror (Nexö), 199–200
Persona (1966), 7, 18, 174, 245, 440, 490n28; Alma in, 296, 297; Alma as artist and Elisabet as her "material," 308–9; Bergman's original title for (*Kinematografi*), 293; cannibalism motif in, 301, 311, 442; and the carnage of history (historical images scene), 310–11; dark nature of the film, 309–10; desire/vampirism motif of, 299, 301, 311; the drama of authenticity in, 300, 301, 302; egoism and inhumanity of art in, 300–301; Elisabet in, 296, 297, 310; Elisabet's child in and the double-filming of this scene, 307–8; fluidity of, 309; and the interactions of individual bodies, 296; intimacy of Alma and Elisabet in, 301, 304–5, 490n29; "joint face" (double-face) theme in, 294–96, 304, 309, 489n20; maternal figure(s) in, 297, 489n24; as a meditation on cinema, 294; merging of Alma and Elisabet in, 306, 307–8, 311–12; muteness of Elisabet in, 298–300; mythic aims of, 310; and the nature of sexuality, 304, 306–7;

"normalcy" of Alma in, 300, 302; orgy on the beach scene in, 302–4; sexual encounter between Alma and Mr. Vogler in, 306–7, 490n30; trompe-l'oeil effect of, 297–98; violence in, 305

"phallogocentrism," 4, 35, 39

Picasso, Pablo, 419

Pietà (2001), 243–45; maternal love/compassion displayed in, 244–45

Pilgrim at Sea (Lagerkvist), 28

Pippi Longstocking (Lindgren), 210, 226, 482nn4–5; vulnerability of Pippi in, 211

Plato, 262, 504n7

plein-air painting, 177, 434

Poe, Edgar Allen, 70, 267, 474n25

poets, 262

Pollock, Jackson, 8

Poole, Roger, 462

Portrait of the Artist as a Young Man (Joyce), 192

power, 5, 8, 129, 152, 166, 192, 444–45, 449; circuits of, 385; guises of, 111; and language, 139–40, 141–42, 157; power relations and play, 43–44, 158; and sacrifice, 10–11; and Scandinavian literature, 111–12, 450; scientists as power figures, 116, 155; spiritual, 185. *See also* Josephson, Ernst, views of power in his work

"Power" (Rich), 111

Prideaux, Sue, 331

Prince Eugen, 183, 373, 392, 498n9

"Protestant Imaginary," 12, 18

Proust, Marcel, 75, 104, 133; opinion of Elstir's portraits, 387; on time as visible in human beings, 326

Przybyszewski, Stanislaw, 133–34, 314–15, 341, 350, 351, 475–76n29

psychology, 127; "school" of among artists, 379

Puberty (1894), 327, 331, 336

qui perd gagne (loser wins) paradox, 167, 172

rationalism, 13–14

realism, 74, 360, 385, 434

Recherche (Proust), 192, 475n28

Red Virginia Creeper (1898), 350–51; symphonic nature of, 351

Renholm, Godfrey, 177

revenge, 228; revenge of children through play, 241–42

Rich, Adrienne, 111

Rimbaud, Arthur, 257, 272, 400–401; "Voyant" letter of, 361

Rindskopf, Ketty, 368

Rokken, Elizabeth, 486–87n1, 487n5

romanticism, 246, 262, 419. See also *Liebestod*

Ronia the Robber's Daughter (Lindgren), 6, 211, 224–25, 439; absence of villains in, 225; Birk in, 225; Birk and Ronia as agents of change in, 227; complexity and potency of the children in, 227–28; Matt as father/tyrant in, 226–27; political/emotional backdrop of, 225–26; Ronia in, 224–25, 226

Rosenthal, T. G., 503n4

Rougemont, Denis de, 279

Rosmersholm (Ibsen), 76, 101, 102; Ulrik Brendel in, 91

Runeberg, Johan Ludvig, 418, 501n29

Sacks, Oliver, 351

Saint Paul, 13, 286

Sandbach, Mary, 472n7

Sandberg, Carl, 486n15

Sandqvist, Mona, 143

Sandström, Yvonne, 152

sansclou, 476n33

Sartre, Jean-Paul, 23

Sarvig, Ole, 329, 331

Satyr (n.d.), 183, 373–74, 393, 395, 424

Saussure, Ferdinand de, 261
Sawdust and Tinsel (1953), 294, 299
Scandinavia: culture of, 197, 198, 439–41; opposition art movement in, 360–61. *See also* Scandinavian literature
Scandinavian literature, 1–2; luminosity of, 440–41, 444; nobility of, 441–42; and power, 1, 111–12, 450
Scenes from a Marriage (1973), 294
Schiller, Johann Friedrich von, 61
schizophrenics, artwork of, 497n3
Schönström, Rikard, 462n12
Schwabsky, Barry, 503n3, 504n8
science, 18, 112, 379. *See also* power, scientists as power figures
Scream, The (1893), 18, 38, 130, 194, 316, 336, 337, 339, 352, 495n23; and egolessness, 491–92n6
Self-portrait (1909), 333–34
Self-portrait at 2 a.m. (1940), 334
Self-portrait Between Clock and Bed (1940), 334, 336
Self-portrait with Cigarette (1895), 333
Self-portrait in Hell (1903), 333
Self-portrait with Skeleton Arm (1895), 273–74, 331, 333, 336; as a "sepulchral tablet," 331
Self-portrait with Spanish Influenza (1919), 334
Self-portrait at the Window (1940), 334
Self-portrait with Wine Bottle (1906), 333
Seventh Seal, The (1957), 294, 299
Shakespeare, William, 174, 181, 187, 325, 352, 459
Shepherdess's Vision, The (1888–1889), 184
Sibyl, The (Lagerkvist), 4, 11, 29, 245, 462n12, 463n21; Ahasuerus in, 31, 39, 41; and Ahasuerus's "secular" perspective, 462–63n15; animality theme of, 38–39; fusion of Christian and pagan in, 39;

motifs of, 30–31; and the oracle as institution, 31, 32; "phallogocentrism" in, 35, 39; repudiation of Pauline Christian doctrine in, 39, 463n17; and the revelation of the divine through penetration of the female body, 34–39; role of the priests in, 32, 36; role of the Temple in, 38; sexual character of the pythia in, 32–34, 38–39; Sibyl as the voice of the Oracle in, 12; on the superiority of the spirit over flesh, 39–40; and the Temple as a political structure, 31–32; wreckage as a theme in, 41
Sick Child, The (1886), 317–19, 493n11, 493–94n12
Silence, The (1963), 294
Simmel, Georg, 491n5
Simon, John, 489nn20–21, 489n27, 490n30
Singer, Isaac Bashevis, 246
Sjöberg, Alf, 477n3
Skånberg, Carl, 177
Smiles of a Summer Night (1955), 112, 190–91
Söderström, Göran, 449, 504–5n12
Sol går ned uti hav (1903), 455
Sontag, Susan, 301, 309, 310–11, 489n19, 490n32
Sophocles, 59, 62
Sound and the Fury, The (Faulkner), 7, 470n18; incest/sexuality theme in, 100
Spector, Robert Donald, 462n12
Spielraum, 45, 52
Spinchorn, Everett, 174
Spinner, The (1886), 375
Spiritism, 378, 379, 383
Staden (1903), 455, 458–59, 505n13
Stagnelius, Erik Johan, 47, 402
Stang, Ragna, 326
Stendhal (Marie-Henri Beyle), 198
Stevens, Wallace, 213, 274–75
Stockenström, Göran, 473n21
Stockholm National Museum, 373

Stoppard, Tom, 29
"Street Scenes, 3" (Strindberg), 127–28, 135, 458, 467n20, 474n23
Strindberg, August, 4–5, 6, 8, 41–42, 74–75, 91, 111, 115, 154, 161, 162, 179, 188–89, 257–58, 314, 353, 443; ability of to transform damage into gain, 181; animosity toward Ibsen, 463–64n1; and the collapse of patriarchy, 42 (see also *The Father*); conception of women, 564n7; as a connoisseur of "sound and fury," 459; "cosmic landscapes" of, 466–67n17; and the cosmology of the self, 124, 473n20; criticism of, 141, 142; as Darwinian, 171, 478n7; "double vision" of, 118–19; on dreams and hallucinations, 119–20; egomania of, 140, 141–42, 159; feminist criticism of, 66; "flowing power" as the key to his life and work, 175–76; "grinding" metaphors of, 65–66, 128, 441, 458; "guinea pig" theory of, 174–75; health of, 471–72n6; on Hell, 121; histrionic nature of, 478n9; influence of on Bergman, 296–97; interest of in language and communication, 139, 464–65n5; interest of in Saint Paul's *Letter to the Romans*, 477–78n6; interest of in spirits, 474n26; interest of in telepathy/mesmerism/hypnotism, 129–30, 504n9; on jealousy, 495–96n24; "joke theory" of, 123–25; and the "mind as generator" image, 66, 467n20; misogyny of, 46, 165; monism of, 117, 120, 142; nervous collapse of, 113; opinion of Ernst Josephson, 498n11; paranoid logic of, 140–41; and play, 181; portraits of, 503n2; "post-*Inferno*" work of, 46; and the realization that history is virtual, 174–75; and the reinvention of the theater, 42–43; relationship with Przybyszewski, 133–34, 475–76n29; relationship with Munch, 315–16, 475–76n29; scientific interests of, 117; and the subject of the damaged "father," 44; and the "Syrach" evocation of Ernst Josephson, 391, 403; translators of, 466n13, 467n19, 472n9; vigorous rhythms of his work, 168–69; vitalism of, 172, 478n10; writing for him as a form of outbreak, 139. *See also* Strindberg, August, as a painter
Strindberg, August, as a painter, 42, 112, 315, 445, 459–60, 502–3n1, 503n3, 505n14; and the authority and power of paint and color, 449–50; belief in making art the way nature makes life, 449; forward-looking nature of his work, 445–46; influence of Turner on, 445, 503n4; and material Creation, 450, 504–5n12; parallels of with Pollock, 504n8; trademark horizontal borders in, 447, 458
Strömkarlen (1884), 182–83, 185, 368–71, 373–75, 393, 406, 498n11; critical reception of, 183, 479n14
Stronger, The (Strindberg), 173–74, 297
Sun God (1889–1900), 407–8, 410
"Sunday Morning" (Stevens), 213
surrealism, 383, 385
Sven Duva (n.d.), 416, 418
Swedenborg, Emmanuel, 117–18, 121, 123, 180, 381, 474n26; and the experience of "vastation," 442, 473n22

Taylor, Mark, 16
Templeton, Joan, 481–82n3
Tennis Players, The (*Tennisspelarna* [Gustafsson]), 5, 113–14, 115, 143, 159–60; Abel in, 149; and the appeal of America in, 144–45; as

Tennis Players, The (cont.)
autobiography, 114; Chris in, 149, 152–53; computers and power in, 153–54; depiction of Frisbee in, 152; Doobie in, 149; effect of Texas/America on Gustafsson, 149–50; icon of the cowboy in, 150–51; *Inferno* and *The Tennis Players* as mirrors, 158; and *Mémoires d'un Chimiste* in, 147–48, 157; as a "metatext" with *Inferno*, 116; and the modalities of power, 152; and nineteenth-century Europe, 145–46; Polly in, 149; and the relationship of man to God, 155–57; revolvers/computers distinction in, 153; tennis court/American court motif in, 149; as travel literature, 114; treatment of the tower in, 151, 153; treatment of Strindberg's *Inferno* in, 147–48, 157; and the Vietnam War, 151–52; view of Texas in, 144, 149
theater, 52, 75, 91, 104–5, 168; and agon as the soul of the theater, 181; end-stop logic of, 175; and the moving (kinetic) stage as a *Spielraum*, 45; nineteenth-century, 98; and the "suspension of belief," 68
Three Drawings (1892), 424
Through a Glass Darkly (1961), 294
Time's Disinherited Children (Young), 481n1
To Damascus (Strindberg), 124, 139, 142, 176, 181, 473n19; chiasmic form of, 173
Tøjner, Poul Erik, 493–94n12, 495nn22–23, 496n26
"Tonio Kröger" (Mann), 192
Törnqvist, Arne, 501n28
"Tradition and the Individual Talent" (Eliot), 179
Triptych (Jesus; Mohammad; Charles XVI [1889]), 185–87, 412–14, 416:
coloration of, 414, 427; depiction of Charles XVI in, 414, 416; depiction of Jesus in, 412–13, 414; depiction of Mohammad in, 413–14
Tunström, Göran, 245
Turn of the Screw, The (James), 282

"Über naïve und sentimentalische Dichtung" (Schiller), 61
Übermensch, American view of, 144
Uhl, Frida, 139
Ullmann, Liv, 294, 296, 299
Ulysses (Joyce), 384, 385
Underlandet (1894), 447–50, 504n7
Uninvited Guests/The Duel (1905), 345–46

Vägen (Mesterton), 500n22
Vågen IX (1903), 453, 455
Vallgren, Ville, 161–62
Vampire, The, 86
Van Gogh, Vincent, 354, 374–75, 498n11
van Rijn, Rembrandt, 358–59, 398
"vastation," 18, 442, 473n12
Verein Berliner Künstler, 313, 314
Vesaas, Tarjei, 7, 18, 112, 130, 444; critical conception of his worldview, 276; mythic forces in his work, 488n15; translators of, 486–87n1, 487n5; on the undoing of life as we live it, 276–77
Victoria (Hamsun), 246, 253
Vid Himmelrikets Portar (Ernst Josephson), 500n18
Vietnam War, 310
Village Rumors (1886), 375
violence, 11
"Voyage, The" (Vesaas), 276–77

Weinstein, Philip, 16, 22
When We Dead Awaken (Ibsen), 208–9
Whitman, Walt, 331, 459, 502–3n1

Who's Afraid of Virginia Woolf? (Albee), 172

Wild Duck, The (Ibsen), 92, 110; Hedwig in, 205; Hjalmar in, 101, 205; Old Ekdal in, 90–91

Wild Strawberries (1957), 190, 294, 334

Wilde, Oscar, 314

Wilson, Robert, 176

women, and the maternal body, 20–21, 27

Wood, Robin, 490n28

Woolf, Virginia, 105

Yellow Fall Painting (1901), 449

Yellow Log, The (1911), 347

Young, Robert, 481n1

Zola, Emile, 51

Zorn, Anders, 360

Zum Schwarzen Ferkel group of artists, 314–15, 475–76n29